f**P**

ALSO FROM FREE PRESS/SIMON & SCHUSTER

The Elements of Style:
A Practical Encyclopedia of Interior Architectural Details
from 1485 to the Present
Edited by Stephen Calloway and Elizabeth Cromley

THE
ELEMENTS
OF DESIGN

A Practical Encyclopedia of the Decorative Arts
from the Renaissance to the Present

General Editor Noël Riley

Consulting Editor Patricia Bayer

FREE PRESS

NEW YORK LONDON TORONTO SYDNEY SINGAPORE

*f*P

FREE PRESS

A Division of Simon & Schuster Inc.
1230 Avenue of the Americas
New York, NY 10020

First published in Great Britain in 2003
by Mitchell Beazley, an imprint of
Octopus Publishing Group Ltd,
2–4 Heron Quays, London E14 4JP

For information about special
discounts for bulk purchases,
please contact Simon & Schuster
Special Sales:
1-800-456-6798 or
business@simonandschuster.com

Printed and bound in China by
Toppan Printing Company Limited

1 3 5 7 9 10 8 6 4 2

Library of Congress Cataloging-in-
Publication Data is available.
ISBN 0-7432-2229-6

Commissioning Editor:
Mark Fletcher

Managing Editor:
Hannah Barnes-Murphy

Executive Art Editor:
Christie Cooper

Copy Editors:
Mary Scott, Penny Warren, Theresa
Bebbington

Editorial Assistant:
Caroline Dyas

Designer:
John Round, Lovelock & Co.

Picture Research Manager:
Giulia Hetherington

Picture Research Team:
Jenny Faithful, Maria Gibbs, Claire
Gouldstone, Sophie Hartley, Sarah
Jenkins, Anna Kobryn, Helen Stallion,
Jo Walton

Production:
Angela Couchman, Gary Hayes

Indexer:
Hilary Bird

Set in Palatino and Helvetica Neue
Condensed

Contents

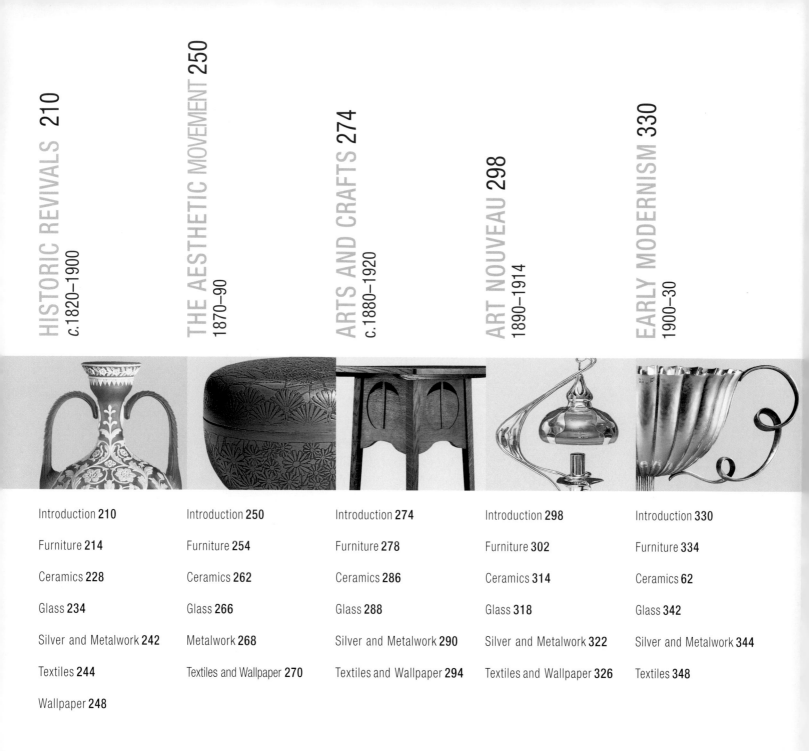

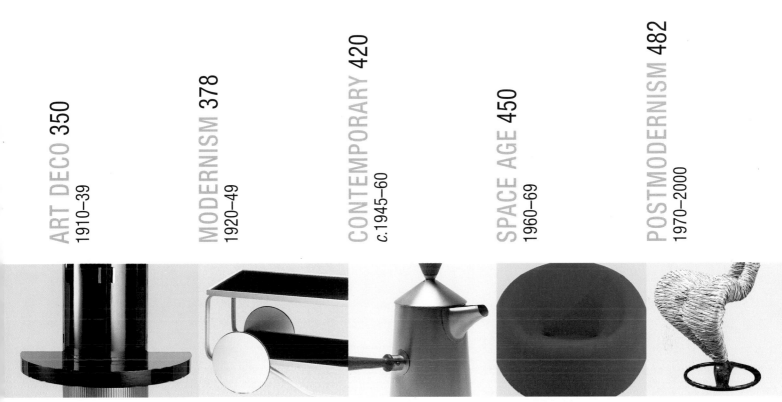

Foreword

The aim of this book – to present in digested form the major styles in the decorative arts over a five hundred-year period – is an ambitious one. It might appear foolhardy to attempt to cover such a huge sweep, embracing continental Europe as well as Britain and America from the Renaissance to the Postmodern era, but the value of the project lies in its breadth, tracking the ebbs and flows of design and the many cross-currents of influence in the main disciplines of interior decoration – furniture, ceramics, glass, metalwork, and textiles. The book is a practical guide to design movements, with the focus on the form and decoration – the shapes and ornamental motifs – that distinguish one style from another. In tracing this path through changes in fashion and taste, the nurture and development of techniques, the inspiration of materials, and the influence of designers who harnessed all the other factors to make their impact, the text and the illustrations are of equal importance.

The Elements of Design is a sequel to *The Elements of Style* which, over the twelve years of its existence, has proved itself to be an invaluable reference for period architectural style and details in Britain and The United States. Where *The Elements of Style* was concerned with the fixtures and accessories of domestic buildings, *The Elements of Design* looks at the furnishings and decoration inside them. Combined with the architecture, these create a period's visual impact.

In covering both earlier and later periods we are able to show how consistently the past informs what follows in design, and yet it can still emerge with a fresh face. For example, early 19th-century Neoclassicism echoes the Baroque in its light-dark contrasts and grandeur of intention; the ghosts of 18th-century Rococo naturalism live on in 1890s Art Nouveau, and the clean-lined elegance of the Biedermeier style re-surfaces in 1920s Art Deco. Sometimes, in the hands of the exceptionally gifted, new design appears dazzling in its originality. Scratch the surface, however, and period influence will almost always reveal itself. The search for novelty is constant throughout design history and, particularly since the 19th century, changing tastes have been directed as much by the steering wheel of commerce as by the impulse to keep up with the Joneses. In the 17th and 18th centuries, new ideas in the decorative arts were spread far and wide by engraved books of designs and patterns, while from the 19th century onwards, major exhibitions have also played a significant part in the commercial dissemination of innovative design.

We have purposely given emphasis to 20th-century styles – too often treated in isolation from earlier periods. The time-scales expand as the book progresses, so that the first few chapters deal with long stretches of a dominating style – Baroque or Neoclassicism, for example – while the 20th-century chapters cover twenty- or even ten-year periods.

Much of the focus in earlier chapters is on royal or aristocratic examples: this is inevitable since these invariably represented the cutting edge of style in their time; people lower down the social scale generally acquired watered-down versions, often somewhat later. Even in more recent periods, the style gurus have tended to appeal at first to an élite whose startlingly up-to-the-minute possessions eventually become the must-haves of the masses. Thus some of our illustrations may appear modern, even many decades later: in their time they were distinctly avant garde.

While individuals may favour one style of decorative art over another, an understanding of the periods before and after, of the materials and technical developments that made them possible, and a knowledge of the designers and their inspiration, provides the vital context for informed choice.

In such a digest of design style as this, some objects will appear ugly, preposterously overblown, of exaggerated proportion, or impractical, while others will enchant with their beauty, tickle with their wit, or appeal for their unabashed usefulness. William Morris's powerful dictum, "Have nothing in your house that you do not know to be useful or believe to be beautiful" leaves some room for subjectivity. For every user of this book there are likely to be favourite periods or styles: "I could live with that" or "I would not give it house-room" are frequently heard responses to the more

extreme manifestations of any style. And as we show how these period styles came into being within the domestic setting, we are bound to illustrate some of the more striking, original, and often grand examples that inspired a particular look.

While not intended specifically as a guide to collectables, this book, through its analysis of period design, is an important reference tool for collectors as well as today's designers and decorators, and students of art history. A clear understanding of the details of form and decoration is an essential broad-spectrum framework, whatever an individual's particular enthusiasm or artistic calling may be.

Each chapter covers a separate design style, beginning with a general introduction and continuing in an established sequence – furniture, ceramics, glass, metalwork, and textiles. Within these sections the focus varies according to the impact of different countries, groups, or technologies. We have included a glossary of terms for quick reference and, for those interested in design sources, a list of the contemporary pattern books and other style guides mentioned throughout the text.

Noël Riley

Renaissance
1400–1600

Design in the 15th and 16th centuries was dominated by the concept of imitating the art of the ancient world. This imitation was combined with new technical discoveries in glassmaking; in ceramics, with the introduction of tin-glazed earthenwares; and in textile production. Renaissance humanists, in a revival of the principles espoused by the Greek philosopher Aristotle, argued that a virtuous ruler should display magnificence through his expenditure on works of art, which would in turn enhance his reputation.

As the princes rapidly gained control over the Italian city-states and established their dynastic succession, they used art as a statement of their wealth, their generosity, and their position. They erected great monuments and buildings, encouraged artists to come to their courts through their patronage, and set up new manufactures of luxury goods.

At first the study of classical monuments led to the copying of specific ornaments such as scrolling foliage, swags, garlands, putti, and particularly the candelabrum motif. This last was a form of vertical foliage emerging from a vase or candlestand. Donatello (1386–1466) played with various combinations of these classical designs in his *Cantoria*, or singing gallery (1433–9), for Florence Cathedral. By the end of the 15th century they were used by almost all artists and applied in a variety of combinations for the decoration of interiors, furniture, ceramics, glass, and metalwork.

In Venice, contact with the Islamic countries encouraged another form of decoration. Geometric or interlace patterns, sometimes using highly stylized foliage motifs, created flat patterns of ornament particularly suitable for book binding, metalwork, and textiles. Pattern books of these Moresque motifs appeared in Venice in the 1520s; and in 1530 Francesco Pellegrino published his highly influential book, *La Fleur de la Science de Pourtraicture*.

As architects began to analyze the buildings being excavated in Rome, they understood more fully the principles of classical design. The two approaches of understanding and emulation led to the concept of *all'antica* (in the spirit of the ancient world). Bramante (1444–1514) and Raphael (1483–1520) designed the façades and the arrangement of domestic palaces in Rome following detailed analysis of Roman treatises on architecture, most importantly that by Vitruvius. They created a perfect harmony and balance in designs for buildings such as Bramante's Palazzo Caprini, *c.*1510, or the Palazzo Brancone dell'Aquila by Raphael (before 1520); buildings were based on classical proportion and the repetition of similar units.

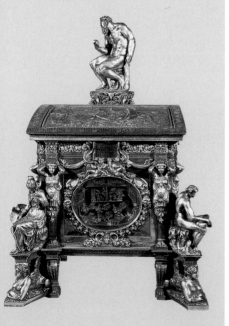

Left: this striking casket of silver-gilt, lapis lazuli, and rock crystal plaques was made for Cardinal Alessandro Farnese, 1543–61, to hold his rare manuscripts. The piece was possibly designed by Francesco Salviati, whose debt to Michelangelo is clear in the distribution and complex arrangement of the figures. Bastiano Sbarri (d.1563) was responsible for the metalwork and Giovanni Bernardi (1496–1553) for the engraved mythological scenes. Ht 49cm/19¼in.

Opposite: Vittore Carpaccio's (c.1450–1520) Dream of Saint Ursula (detail), 1495, depicts an Italian interior with a four-poster bed, simply furnished with the furniture placed against the wall, but showing the principal types found in an interior of this date, including a cassone (chest). Sculptures were placed over the doors, as here, and on shelves.

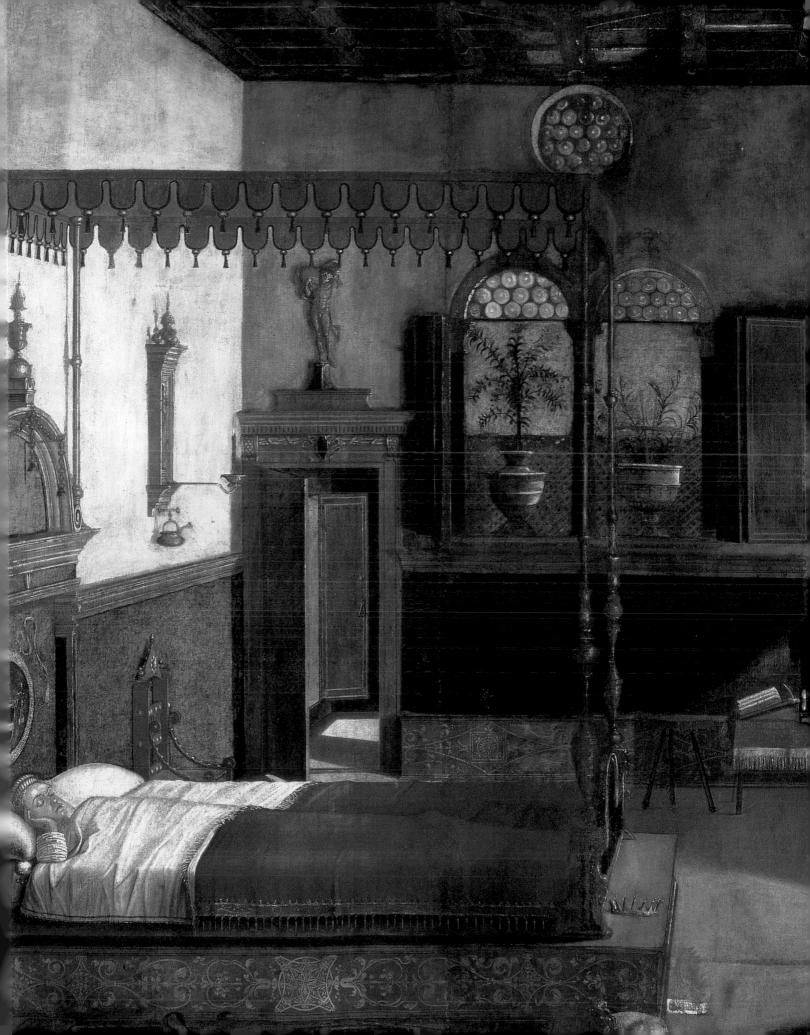

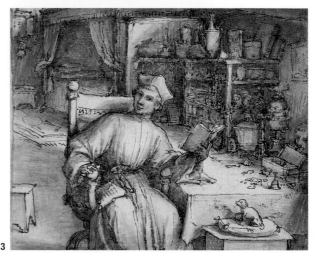

1 *Design after Perino del Vaga, Rome, c.1530, depicting the candelabrum motif combined with putti, trophies, and other* all'antica *themes.*
2 *The designs by Cornelis Floris such as this, engraved by Hieronymus Cock in Antwerp, 1556, of a cartouche of fauns, nymphs, and satyrs in a strapwork frame, were an important source for northern decorative arts.*
3 *Drawing of an ecclesiastic in his study by Lorenzo Lotto (c.1480–1556), c.1530. Note the collection of antique medals on the table and the shelves of objects.*

Raphael's decoration of Bramante's loggetta in the Vatican, *c.*1516–17, imitated the paintings of Roman interiors, first known to Renaissance artists through the discovery of Nero's Domus Aurea. This gave the term "grotesque" to such paintings, from the belief that they had been created for underground grottoes. Grotesque ornament incorporated mythological animals – fauns, and satyrs – masks, which were joined together and framed with bands and garlands. Thus it had the advantage over the candelabrum motif in that it was not limited to a vertical axis but could be used over any size or type of surface.

In 1519 Raphael praised the concept of *maniera* (style); thirty years later the painter, architect, and biographer Giorgio Vasari (1511–74), writing in his *Lives of the Artists* (1550), singled it out as an essential ingredient of the art of his day. Elegance and sophistication combined with virtuosity gave 16th-century art its superiority, so they believed, over previous generations, even the Romans. They described Giulio Romano (*c.*1499–1546), Raphael's most famous pupil, as not only equalling but surpassing the ancients in his imagination and skill. In the same way, Michelangelo (1475–1564)

broke the rules of classical architecture and sculpture in new and varied ways. The effect on design was to emphasize the novel and the unusual, and to create complex patterns of dense, intricate subject matter. These characteristics constitute what is generally known as Mannerism. The audience for whom these works were intended understood the rules that had been broken and admired the sophisticated skill with which the artists had carried out their ambitions.

The overwhelming acceptance of Italian Renaissance concepts throughout Europe can to some extent be explained by the need felt by princes and rulers to express the concept of personal rule through reference to the classics, which was incorporated into the medieval framework that relied solely on authority from God. These concepts, first stated in Italy, were developed by the humanist teachers and writers of the 15th and 16th century throughout Europe. The speed with which these ideas were taken up depended on political and economic considerations as well as the ambitions of the different rulers, but by the middle of the 16th century the revival of classical antiquity was generally accepted as part of the established repertory of

design. Printed designs disseminated these ideas; without the discovery of the printing press, designs could not have spread so quickly. In addition, there was a network of intersecting paths across Europe, as the result of changing political boundaries, movements necessitated by war, or shifting alliances because of religion. Trade routes acted as another means of spreading ideas of fashion and taste. The homogeneity of Renaissance design was a result of the acceptance of a classical vocabulary. Its variety stems from the fusion of those ideas with an indigenous tradition.

France was one of the first countries to adopt Italian Renaissance ideas. After his triumphal progress to, and conquest of, Naples in 1495, Charles VIII brought twenty-two Italian craftsmen back to France. His successor Francis I, who was determined to be a true humanist prince, invited Leonardo da Vinci (1452–1519), Benvenuto Cellini (1500–71), Francesco Primaticcio (1504–70), and Rosso Fiorentino (1495–1540) to his court at Fontainebleau. He also bought numerous paintings and sculptures from the greatest artists in Italy. The decoration of Fontainebleau (executed by Primaticcio and Rosso between 1530 and 1547) introduced Italian elegance and diversity to France. Moreover, in the long gallery, Galerie François I, a new form of ornament was introduced. The frames to the paintings were conceived as three-dimensional bands with curved, metal-like scrolls which came to be known as strapwork. Deriving from Italian cartouche borders, this new style of decoration was taken up by every designer in the second half of the century. In the Netherlands, designers such as Cornelis Floris (1514–75), Cornelis Bos (active

1540–54), and Cornelis Matsys (active 1531–60) developed a form of imaginative grotesque work of figures captured in metalwork bands. Hans Vredeman de Vries' highly successful publications, reprinted by his son, ensured that strapwork remained part of the decorative vocabulary of the northern countries – The Netherlands, Germany, and England – until well into the 17th century.

Flemish and French designs were also very important as sources of inspiration in England, particularly towards the end of the century. Henry VIII had introduced Italian Renaissance decoration into his interiors and with the arrival of foreign artists, such as the Italian Pietro Torrigiani and the Swiss Hans Holbein, his court was the equal to that of contemporary European princes.

England became a haven for many refugees from both The Netherlands and France, who brought with them the knowledge of Renaissance motifs as well as technical expertise. Foreign silversmiths, cabinet makers, and textile workers in London, Norwich, and Canterbury transformed these industries and were protected by the crown in spite of protests from the English guilds.

4 *The Galerie François I at Fontainebleau, designed by Rosso Fiorentino and Francesco Primaticcio, 1530–34, established the new Italianate design in Northern Europe. The allegorical paintings were framed in ingenious stucco sculptures of caryatid figures, putti, and garlands of flowers. This was the first use of strapwork, which was to dominate late 16th-century decoration all over Europe.*

4

Italian Furniture

The Use of Classical Motifs

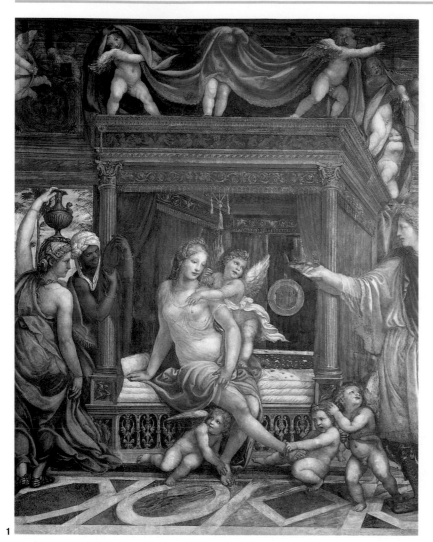

1 *This detail of the fresco* Marriage of Alexander and Roxana *by Sodoma (Giovanni Bazzi), c.1517, located in a bedroom of the Villa Farnesina in Rome, depicts a magnificent four-poster bed in the* all'antica *style.*
2 *The* sgabello *(backstool) was placed against the wall in reception rooms in Renaissance palaces. This example in walnut, c.1550–90, is typical of the Venetian form, with its high lace-like back and carved term figures. Ht 74cm/29in.*

Interiors in the 15th century were still sparsely furnished. The main types of furniture included *cassoni* (chests) and chairs. The most expensive item was the bed, richly hung with silks and embroideries, which, along with its accompanying chest, was often given as a wedding present. Equally significant were highly decorated portable objects such as writing cabinets. These were decorated in the technique known as *intarsia*, developed in Italy: coloured pieces of wood or other materials were inserted or laid into the background.

The 16th century saw an increase both in the variety of types of furniture and in the richness of decoration, essential to the concept of magnificence. Although there was no single room set aside for dining, the *credenza* (display buffet) became an architectural cupboard on which expensive objects were arranged. Leading architects such as Polidoro da Caravaggio, Perino del Vaga, and Giacomo da Vignola, all active in Rome in the mid-16th century, used antique ornament to develop new, extravagant forms of decoration. Sculpted term

figures were used as supports and decoration for tables and chairs. Elongated figures based on Michelangelo's work appeared in or above cartouches and contributed to the sense of elegance. Walnut was preferred, often stained or partly gilded, because of the fine carving that could be achieved. The concept of *maniera* (style) also led to increasingly varied interpretations of grotesque ornament. This could be combined with arabesque decoration, popular in Venice and northern cities.

Pope Julius V introduced the taste for porphyry (a reddish-purple stone) in the interior of the Villa Giulia (begun 1551), and it was copied by rulers such as Cosimo I in the Palazzo Vecchio, Florence (1555–65). This Roman revival encouraged table tops of *pietre dure* (hardstones) and marble, appearing first in Rome in the mid-16th century, for the Farnese family, and in 1588 Francesco de' Medici set up a workshop in Florence, which became the Opificio delle Pietre Dure. The first designs were geometric and stylized, but Florentine ornamentation became more naturalistic towards the end of the century.

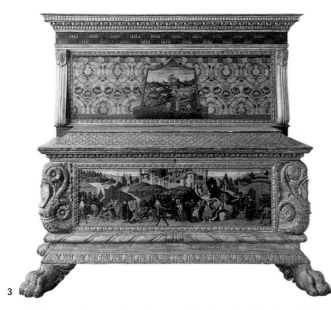

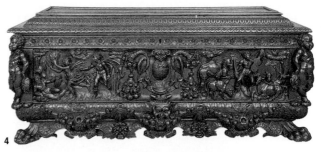

4 *Mid-16th century* cassoni *were often carved in high relief and gilded. This example, either Roman or Florentine, depicts battle scenes from Roman friezes, with* all'antica *garlands and putti. L. 169.2cm/66⅝in.*

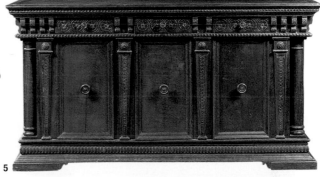

3 *This painted* cassone *bears the arms of the Florentine Morelli and Nerli families, 1472. The paintings by Biaggio di Antonio and Jacopo del Sallaio, show scenes from Roman history. Ht 2.12m/7ft 3in.*
5 *This Florentine walnut* credenza *(sideboard) from the second half of the 16th century was used for display as well as storage. The simple design and the architectural framework are typical of Florence. Ht 1.13m/3ft 9in.*

The Development of New Forms

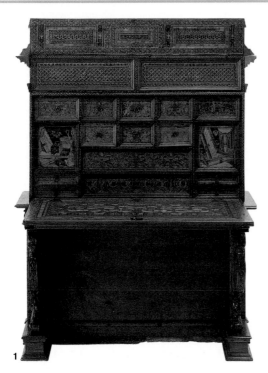

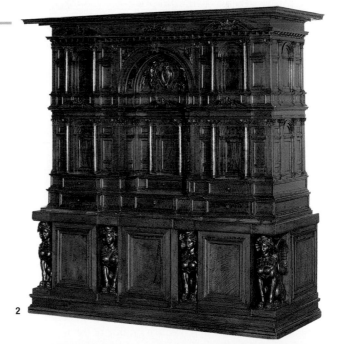

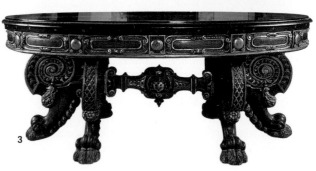

1 *Writing cabinet with intarsia inlaid into walnut, c.1520, its exterior with roundels depicting Roman emperors and battle scenes. Possibly made in Ferrara (the stand is late 19th century). Ht 2.06m/6ft 8in.*
2 *Walnut architectural cabinet, c.1580, with the arms of Cardinal Alessandro Farnese, by the Flemish cabinetmaker Flaminio Boulanger. Ht 2.30m/7ft 6¼in.*
3 *The importance of this table, probably made for Cosimo I de' Medici, while Cardinal in Rome, lay in its geometric marble top. The scrolled curving legs with lions' paw feet reflect the designs of Bernardo Buontalenti (1531–1608). L. 5.18m/17ft.*

Furniture from the European Courts

France

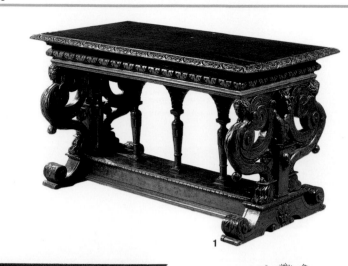

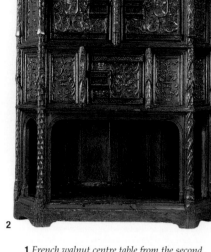

1 *French walnut centre table from the second half of the 16th century; the design incorporates antique motifs from Roman altars for the ends, while the centre rail is decorated with the architectural baluster form. Ht 83cm/32¾in.*
2 *In this French dresser of carved oak, c.1500–25, the Gothic form was decorated with grotesque ornament in an assimilation of early Italian Renaissance design. Ht 1.42m/4ft 8in.*
3 Armoire *attributed to Hugues Sambin, who worked in Dijon, Burgundy, 1549–c.1580. In his* Oeuvre de la diversité des termes *(1572), Sambin called term figures, which decorate this wardrobe, the "French order," claiming it was a new addition to the classical repertoire. Ht 2m/6ft 7in.*
4 *Design for a* meuble à deux corps *(double cabinet) by Jacques Androuet Du Cerceau, Paris, c.1580. Such elaborate designs reflect the French adoption of Italian architectural forms.*

Francis I of France brought Italian artists to Fontainebleau, and it may have been their influence that caused French furniture to imitate Italian so closely. Some types of earlier furniture continued to be used, such as the *dressoir* (buffet) and the *armoire* (cupboard). The earliest of these kept the same form, but changes arose in the decoration, from the medieval linenfold panelling to the new Renaissance motifs: of the roundel, based on a classical medal portrait, and the candelabrum. After *c.*1550, shapes began to change to incorporate the new *all'antica* motifs and sculpted features into the design. The cabinet developed in France in a more individual style. Rather than being a free-standing moveable object, it was generally placed on a low cupboard with two doors. This *meuble à deux corps* is one of the most distinctive types of French furniture. The designs of Jacques Androuet Du Cerceau (1515–*c.*1584) include a wide variety of cabinets and cupboards, which would have been executed in carved walnut, often inset with small marble rectangular panels.

Spain had a highly important non-Italian tradition deriving from the Arabs and Moorish craftsmen working there and using arabesque or moresque designs. Both types of design were based on classical antiquity but they had evolved into highly patterned linear decoration in furniture, in which small pieces of ivory were inserted into the solid carcase.

The *sillón de fraile* was a Spanish type of chair whose form evolved, in the second half of the 16th century, into the standard armchair used in Europe. It was a wooden structure with leather bands for the back and seat, which gradually developed into an upholstered chair with arms. Another key type of furniture to develop in Spain was the *papeleira* (writing cabinet), often known by its 19th-century name of *vargueño*.

Antwerp was the most important centre for design in the north. Designers such as Hans Vredeman de Vries (1526–*c.*1604) combined French and Italian motifs with large geometric patterns of octagons, squares, and rectangles. Cupboards and chests were often decorated

Spain

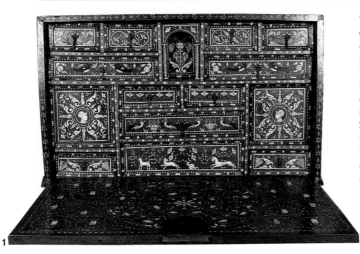

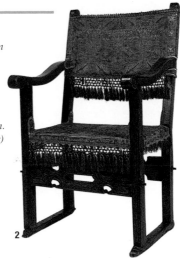

1 *Portable* papeleira *(writing cabinet) with Moorish decoration by Lucas Hornebolte inlaid in ivory onto walnut, c.1525–27. The fall front could be used for writing, while the drawers hidden behind could house small valuables. Ht 1.52m/60¼in.*
2 *The* sillón de fraile *(armchair) was a frontal chair of walnut with an embroidered back and seat. The design became the standard armchair throughout Europe, c.1550–1650. Ht 1.13m/3ft 8½in.*

The Netherlands

1 *Design for beds by Hans Vredeman de Vries from his* Differents Pourtraicts de Menuiserie *(c.1580). This shows the adaptation in the north of Italian Renaissance motifs. The animal feet are taken from French designs and refer back to antique Roman tables and chairs.*
2 *The two-storey cupboard was a common type of storage furniture in Northern Europe. This Flemish example in oak, c.1500–50, stylizes elements from the candelabrum motif, vases of flowers, and* paterae *(decorative roundels or ovals) for its decoration. Ht 1.19m/46⅞in.*

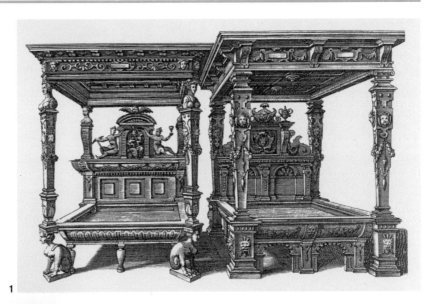

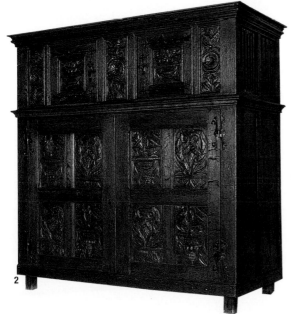

with term figures while tables featured large bulbous legs. Distinctively Flemish is the use of (imported) ebony inlay into oak, reflecting Antwerp's position as a trading centre.

In the German states, artists in the cities with closest access to Italy incorporated Renaissance ideas into their furniture first, and by the middle of the 16th century were using classical motifs and three-dimensional sculpted classical images. In Augsburg, the cabinetmakers took the intarsia writing box and converted it into the two-door cabinet, which they decorated with marquetry veneers of *memento mori* scenes of ruins and blasted trees. The creation of marquetry in the German states was one of their most important contributions to the development of furniture techniques.

The most significant types of German furniture remained the *schrank* (cupboard) and the chest. Later examples were decorated with Mannerist architectural designs of volutes and broken pediments, as well as the all-pervasive strapwork, usually taken from pattern books. Once established, the forms continued well into

The German States

1 *This stylized version of the Italian* sgabello *was made in Dresden, c.1600, for Christian V of Saxony, by the Italian Giovanni Maria Noseni, who came to Dresden in 1575. The back is inlaid with serpentine panels.*
2 *Writing cabinet from Augsburg, c.1575–1600, made in marquetry of pearwood, ash, and sycamore veneered onto a pine carcase. Marquetry was a development of the Italian intarsia technique. W. 1m/3ft 4in.*
3 *Design by Lorenz Stoer in Augsburg, 1567, showing the inventive use of strapwork, scroll motifs, and geometric shapes that were incorporated into* mementi mori *(ruined scenes).*

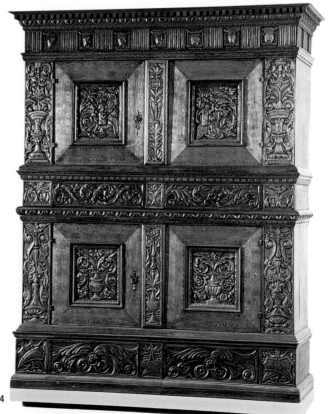

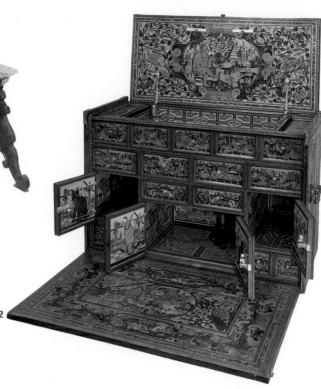

4 *The* schrank *(cupboard) remained an important type of storage furniture in 16th-century Germany. This one, in oak and ash, is dated 1541. Based on a design by the Nuremberg artist Peter Flötner (c.1490–1546), it shows his understanding of Renaissance motifs and ordered composition. Ht 2.35m/7ft 8½in.*

the next century, no doubt helped by the conservatism of the powerful guild system in the cities.

Medieval traditions continued well into the 16th century in English society. The great hall remained a centre of social activity and large, joined tables were used for the huge banquets, with benches or forms hidden underneath when not in use. Armchairs generally had wooden seats and carved backs, with turned legs appearing in the second half of the century. Jointed stools, also with turned legs, were a common form of seating. Oak remained the primary wood and must have often been painted. Decoration consisted of stylized geometric patterns, jewel motifs, and strapwork. An innovation towards the end of the century was the use of ornaments derived from French and Flemish pattern books: heraldic beasts, term figures, and the cup and cover. German craftsmen working in Southwark, London, are thought to have brought marquetry decoration into fashion, usually using stylized views of castles and pinnacles to decorate chests, which have become known as Nonsuch chests.

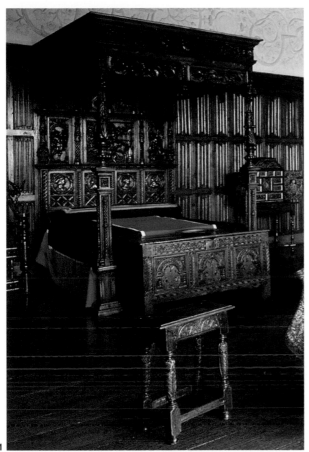

1 *Four-poster bed, c.1530–50, of oak with carved panels. The design of the posts is based on the Italian candelabrum motif, but may have reached England through French engravings. Ht 2.4m/8ft.*
2 *Writing desk, c.1530, which belonged to Henry VIII. The artist used Italian sources for the putti, while the figures of Mars and Venus are based on engravings by Hans Burgkmair of Augsburg. W. 40.5cm/16in.*

3 *Oak Nonsuch chest, c.1590, with architectural scenes in marquetry developed from intarsia decoration and geometric panels of inlaid stained woods. The technique was probably German; such chests may have been made by German craftsmen working in Southwark, London. Ht 74cm/29in.*
4 *Oak centre table, c.1590, showing the "cup and cover" motif that was taken from Flemish engravings. Ht 81cm/32in, l. 6.40m/21ft.*

5 *Carved oak court cupboard, c.1590–1600, with inlaid decoration and cup and cover supports. The term "court" is from the French for "low" and distinguishes it from the normal type with doors. Ht 1.85m/6ft 1in.*

Pottery

Hispano-Moresque Wares and the Early Tin-Glaze Tradition

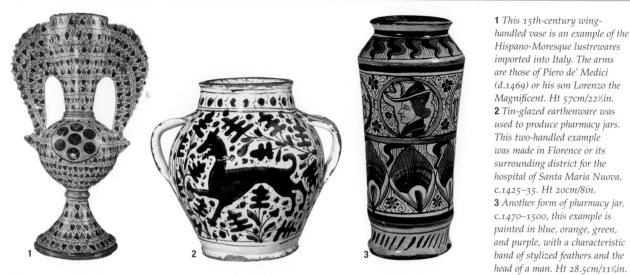

1 *This 15th-century wing-handled vase is an example of the Hispano-Moresque lustrewares imported into Italy. The arms are those of Piero de' Medici (d.1469) or his son Lorenzo the Magnificent. Ht 57cm/22½in.*
2 *Tin-glazed earthenware was used to produce pharmacy jars. This two-handled example was made in Florence or its surrounding district for the hospital of Santa Maria Nuova, c.1425–35. Ht 20cm/8in.*
3 *Another form of pharmacy jar, c.1470–1500, this example is painted in blue, orange, green, and purple, with a characteristic band of stylized feathers and the head of a man. Ht 28.5cm/11¼in.*

Early Istoriato Wares

1 *Produced in Faenza, the most dynamic centre for early istoriato painting, this bowl was made c.1515–1525. The central scene is Christ manhandled by soldiers, from a woodcut by Albrecht Dürer. Diam. 19cm/7½in.*
2 *This c.1525 dish was painted with the arms of Isabella d'Este, one of the greatest art patrons of the Renaissance. The scene represents the story of Phaedra and Hippolytus from Ovid's* Metamorphoses. *Diam. 27.5cm/10¾in.*

Ceramic production in the 16th century was dominated by the development of Italian maiolica. The word maiolica describes an earthenware body coated with a glaze that has been opacified with tin-oxide to provide a smooth white surface suitable for painting. It was used at first to describe the finely painted lustred pottery imported into Italy from southern Spain in the 15th century via the island of Majorca. These luxury items were often commissioned by wealthy Italian families and helped to raise the status of pottery as a display item. Later, the word was adopted to describe all Italian tin-glazed wares, whether lustred or not, and, as the technique spread throughout Europe, it became known by other names, which will be discussed in later chapters.

One of the most distinctive early designs on Italian maiolica was a pattern of heraldic creatures among stylized oak leaves, painted in a thick cobalt blue. During this period, the pigments were painted directly onto the raw glaze and had to withstand the heat of the glaze firing. These were restricted to blue from cobalt, green from copper, yellow from antimony, purple from manganese, and orange from iron. Characteristic motifs on early polychrome wares were stylized peacock feathers and portrait heads in roundels. The latter, derived from antique coins and medals, was one of the most widespread of all Renaissance motifs, appearing in almost every branch of the decorative arts.

An overriding interest in antiquity in the 16th century and the more widespread availability of printed source material, coupled with increased drawing skills, encouraged the maiolica painters to use the whole surface of their pottery for narrative painting, both biblical and mythological. This style became known as *istoriato*. Although capable of being used, these pictorial pieces must have been intended for display or as collectors' items and were often commissioned by wealthy patrons. Two important sources of inspiration were a series of woodcuts illustrating Ovid's *Metamorphoses*, published in Venice in 1497, and the engravings of Marcantonio Raimondi (*c*.1480–*c*.1534) after the work of Raphael. In

Design Sources

1

1 The Abduction of Helen, *an engraving attributed to Marcantonio Raimondi (c.1480–c.1534), is possibly after the work of Raphael. Engravings such as these became one of the most popular sources of inspiration for maiolica painters.*
2 *This dish, made in Urbino in 1533, was signed by Francesco Xanto Avelli, one of the most well-known and prolific maiolica painters. The subject is* The Marriage of Alexander and Roxana *from a print after Raphael. The arms are those of Federigo Gonzaga, Duke of Mantua.*
3 *An Urbino documentary piece, this signed charger, dated 1543, was painted with a battle scene by Orazio Fontana, another prolific and highly successful maiolica artist.*

2

3

Scrollwork and Interlacing Ornament

1

1 *This c.1510–40 storage jar is painted in blue, yellow, and green, with a central band of grotesque ornament, incorporating fantastic monsters surrounded by foliate scrollwork. This type of ornament, known as* all'antica, *reflects the widespread interest in ancient Rome.*
Ht 34.5cm/13½in.
2 *The blue ground of this dish, made in Faenza in 1536, is known as a* berettino, *and it was particularly used in Faenza and the Veneto. The rim is painted with dolphins among interlaced ornament.*
Diam. 31cm/12¼in.

2

Other Popular Ornamental Motifs

1 *The decoration on this Castel Durante plate consists of military trophies arranged symmetrically as a border surrounding the central well, which contains the arms of the person for whom the plate was commissioned.*
2 *The workshop of Maestro Benedetto, in Siena, produced this plate c.1510. The central scene depicts St. Jerome in the Wilderness, and it is surrounded by a type of interlaced ornament known as arabesque. Diam. 24.5cm/9¾in.*

Lustrewares: the Revival of Lustre Techniques

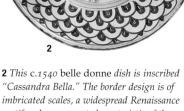

1 *The painting on this 1524 plate is of a river god in a landscape. The plate has the addition of a gold and reddish lustre, which was applied in the workshop of Maestro Giorgio in Gubbio. Diam. 24cm/9½in.*

2 *This c.1540 belle donne dish is inscribed "Cassandra Bella." The border design is of imbricated scales, a widespread Renaissance motif and a recurrent characteristic of the wares made in Deruta. Diam. 34.5cm/13½in.*

3 *Another dish of belle donne type, this one has a low foot and is painted with the portrait of a woman with an accompanying scroll. The dish was lustred in 1530 in the workshop of Maestro Giorgio, Gubbio. Diam. 22.5cm/8¾in.*

some cases, painters took figures from several different engravings and reworked them into new compositions.

Another source of inspiration was the Roman wall paintings found in the Golden House of Nero in 1488. This "grotesque" style of painting, which incorporated fanciful creatures and bizarre monsters among scrolling foliage, was used by many artists and designers, most notably Raphael in his decoration of the Vatican Logge (1518–19), and it spread to all branches of the decorative arts. Other *all'antica* motifs used in the designs include trophies of arms, laurel leaves, and putti, combined with interlaced arabesque ornament from Islamic art.

The technique of painting with metallic lustres, which had characterized the early Hispano-Moresque wares imported from southern Spain, was introduced in the 16th century, particularly in Deruta and Gubbio. Oxides of silver or copper were applied to the twice-fired pottery and re-fired at a lower temperature in a smoky atmosphere to produce an iridescent metallic surface, which varied from pale, silvery yellow to ruby red. Lustre was

characteristically applied to the large dishes painted with female portraits accompanied by an inscription on a scroll, known as *coppe amatorie*, or "love dishes." They are sometimes known as *belle donne* (beautiful women) plates and were traditionally given as betrothal gifts.

Two developments in the middle of the century indicate a move away from the fashion for istoriato pottery. One was the production in Faenza of wares left almost entirely in the white with slight, sketchy decoration in a limited palette of colours, known as *compendiario*. A parallel development in Urbino was a fashion for all-over, small-scale grotesques on a white ground, strongly influenced by the work of Raphael.

Many of the different types of Renaissance ornament used by the maiolica potters are illustrated in Cipriano Picolpasso's *Three Books of the Potter's Art*, written c.1557. He included a design described as *alla porcellano*, a reference to the huge impact that Chinese blue-and-white porcelain was to have on European design, which will be discussed more fully in the next chapter.

Later Developments in Renaissance Design

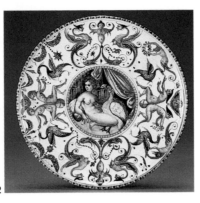

1 *In the centre of this pierced dish, which is painted in blue, yellow, and orange, is a slightly drawn figure of a putto against a white background. This decoration is typical of the wares produced in Faenza in the late 16th century. Diam. 23.5cm/9¼in.*
2 *Made in Urbino in the late 16th century, the story of* Leda and the Swan *has been painted in the centre of this dish, within a broad border of grotesque ornament in a predominantly yellow palette against a white background. Diam. 25cm/9¾in.*

The Pattern Drawings of Picolpasso

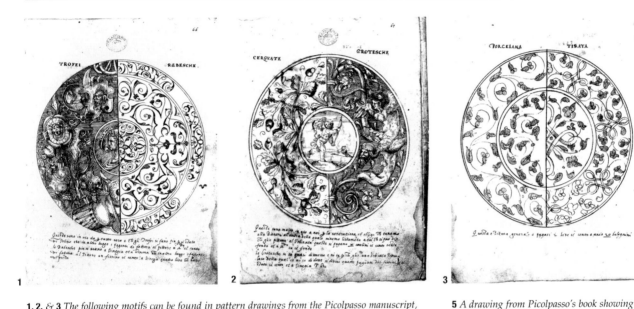

1, 2, & **3** *The following motifs can be found in pattern drawings from the Picolpasso manuscript, written c.1557:* Trofei/Rabesche *(trophies and arabesques),* Cerquate/Grotesche *(oak leaves and grotesques), and* Porcellana/Tirata *(porcelain and strapwork). Such designs were used by many maiolica painters.*

5 *A drawing from Picolpasso's book showing a brush handle and two brushes. The text describes the materials from which the brushes were made and the manner of painting.*

4 *The decoration on this plate, made in Cafaggiolo c.1510, depicts a maiolica painter decorating the rim of a plate, observed by the couple whose portrait will, perhaps, appear in the centre. Notice the six saucers with separate brushes for different pigments. Diam. 23.5cm/9¼in.*

6 *Although the decoration on this broad-rimmed bowl, made in Cafaggiolo c.1510–1525, consists of bands of interlaced arabesque ornament, the blue and white colours reflect the growing influence of Chinese porcelain. Diam. 24.2cm/9½in.*

1 *Although it was produced in Nîmes, France, this pharmacy jar, c.1570, is of Italian type. The subject, a portrait head between bands of grotesque ornament, is similar to Italian examples, but the "bubbled" green is peculiar to this factory. Ht 24cm/9½in.*

2 *This dish, dated 1582, resembles the istoriato wares produced in Urbino, but the subject, Aaron changing a rod into a serpent, derives from an illustrated Bible that was printed in Lyons. Diam. 41.5cm/16¼in.*

3 *Bernard Palissy or one of his followers produced this moulded earthenware dish c.1580–1620. The elongated central figure, symbolizing Fecundity, is characteristic of the French court style developed at the palace of Fontainebleau. L. 50cm/19¾in*

4 *Characteristic of Bernard Palissy's rustic wares, which were produced 1556–1590, this oval dish has green, yellow, and brown lead glazes and moulded creatures. L. 53cm/20¾in.*

During the 16th century Italian potters settled in France, Spain, and the Low Countries, where they introduced maiolica-making techniques and helped to establish a new tradition of pottery. These wares followed contemporary Italian styles and can be difficult to distinguish. Characteristic Renaissance motifs included profile heads and biblical and mythological subjects treated in the *istoriato* manner. Gradually, each country developed its own style, which will be discussed in the next chapter.

More idiosyncratic was the work of the French potter Bernard Palissy (1510–90), who produced lead-glazed earthenwares and developed a range of translucent polychrome glazes. He is noted for the production of display dishes, relief-moulded with mythological subjects derived from contemporary prints, and "rustique figulines," basins and dishes with applied frogs, lizards and crustacea, many cast from nature, surrounded by water, shells, and rockwork. These latter elements can also be seen in contemporary metalwork and represents an interest in garden grottoes, which spread from Italy to France. The style of Palissy's work continued through the 17th century and was revived in the 19th century.

Characteristic Renaissance ornament, including interlaced bands of strapwork and arabesques, derived from engraved sources and contemporary metalwork, can also be seen in a group of pale cream-coloured earthenwares with moulded, stamped, and inlaid designs, known as Saint-Porchaire wares, made in France *c.*1525–70. These refined objects, which include ewers, candlesticks, and salts, were luxury items reflecting French court taste.

German salt-glazed stoneware is another type of 16th-century pottery. Its high-fired, vitrified body was impervious to liquids and suitable for making wine bottles and drinking vessels. Cologne wares are characterized by a golden-brown wash and a distinctive pot-bellied jug with an applied mask, known as a *Bartmannkrug*. Other areas produced a pale grey body, sometimes with a glaze partially stained blue with cobalt, and used incised and applied ornament with strapwork, armorials, and profile heads. These types continued into the 17th century.

Saint-Porchaire Wares

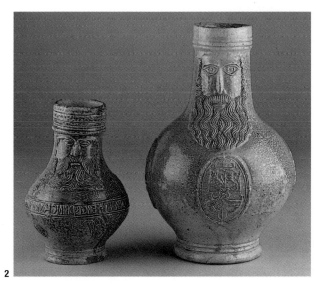

1 *These three bands of arabesque ornament by the German engraver Balthasar Sylvius (1518–1590) were published in 1554. This type of Renaissance ornament was widespread throughout Europe in the mid-16th century, and designers working with a variety of materials incorporated them into their work.*

2 *An extremely elaborate example of the group of highly refined French earthenwares known as Saint-Porchaire wares can be seen in this c.1545–1560 jug. It is decorated with bands of complex interlacing ornament deriving from contemporary print sources. Ht 34cm/13½in.*

German Salt-Glazed Stonewares

1 *Finely moulded stoneware jugs of this type, which was made in Raeren in 1588, are characteristic of the productions of Raeren and Westerwald. They frequently display Renaissance motifs derived from engraved sources. Ht 35.5cm/14in.*

2 *These bottles of bulbous form with a light brown iron wash under a salt glaze are known as Bartmannkrugen. The bearded mask on these vessels, made in Cologne c.1540, is one of the most distinctive decorative motifs of Cologne and Frechen potters of the 16th and 17th centuries. It may derive from Roman sources or the northern European folk tradition of the Wild Man. Ht (left) 16.5cm/6½in, (right) 25cm/10in.*

Glass

Renaissance Venice

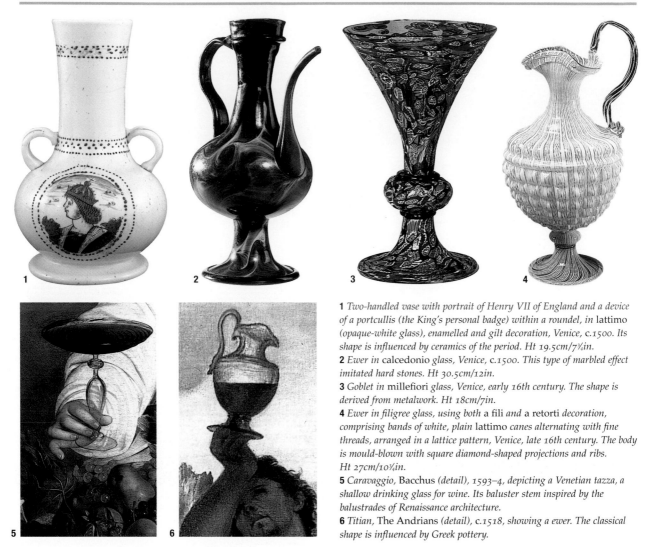

1 *Two-handled vase with portrait of Henry VII of England and a device of a portcullis (the King's personal badge) within a roundel, in* lattimo *(opaque-white glass), enamelled and gilt decoration, Venice, c.1500. Its shape is influenced by ceramics of the period. Ht 19.5cm/7¾in.*
2 *Ewer in calcedonio glass, Venice, c.1500. This type of marbled effect imitated hard stones. Ht 30.5cm/12in.*
3 *Goblet in* millefiori *glass, Venice, early 16th century. The shape is derived from metalwork. Ht 18cm/7in.*
4 *Ewer in filigree glass, using both* a fili *and* a retorti *decoration, comprising bands of white, plain* lattimo *canes alternating with fine threads, arranged in a lattice pattern, Venice, late 16th century. The body is mould-blown with square diamond-shaped projections and ribs. Ht 27cm/10¾in.*
5 *Caravaggio,* Bacchus *(detail), 1593–4, depicting a Venetian tazza, a shallow drinking glass for wine. Its baluster stem inspired by the balustrades of Renaissance architecture.*
6 *Titian,* The Andrians *(detail), c.1518, showing a ewer. The classical shape is influenced by Greek pottery.*

Venice was the most powerful trading nation of the late Medieval and early Renaissance world. From the 12th century onwards it developed, on the small island of Murano, a luxury glassmaking industry that was to become the envy of the world. The industry was highly organized and regulated by the Guild of Glassmakers. Its success was based on strong quality control, stimulation of technical developments, the protection of its trade secrets, and excellent market possibilities, provided by the Republic's vast trading fleet.

The most important technical development in glass was the production of an almost completely colourless sort of glass, clearer and purer than anything seen before, which was named *cristallo*, after naturally occurring rock-crystal. Its invention around 1450 was credited to the pioneer glassmaker Angelo Barovier. *Cristallo* became almost synonymous with Venetian glass, combining the material's most essential characteristics of clarity and transparency with ductility, allowing the material to be formed into complicated shapes.

Technical developments went hand in hand with the creation of new shapes and object types. Shapes were often borrowed from other materials such as metalwork or ceramics. Gothic lines continued into the 16th century to be gradually replaced with more classical and fluid shapes, which are characteristic of the Renaissance period (see 4 and 6 above).

For decoration, Venetian glassmakers drew from a whole array of techniques, some newly invented, some re-invented Roman techniques, and some copied from Byzantine or Middle-Eastern glassmaking.

Most typically Venetian are the "hot" decorative techniques, where the decoration forms an integral part of the making of the object, and which are carried out by the glassmaker while shaping the objects at the furnace. Venetian glassmakers made frequent use of dip-moulds to create rib patterns.

The subtle fluid lines of a glass object could be further enhanced by the glassmaker applying details in hot glass and tooling them into intricate ornament.

2 *Goblet depicting river gods in colourless glass, enamelled and gilt, Venice, first quarter of the 16th century (the foot is a replacement). Ht 20cm/8in.*

1 *Chalice and cover in colourless glass with added detail in coloured glass, enamelled and gilt, Venice, late 15th century. Ht 24.5cm/9¾in.*
3 *Detail of a dish in colourless glass with* lattimo *(opaque-white glass) canes, gilding, and diamond-point engraving, bearing the arms of Pope Pius IV (1559–65), Venice, 1559–65. Diam. 27cm/10½in.*

Venice also specialized in decoration incorporated in the glass itself. *Calcedonio* glass, for instance, has a marbled appearance achieved through a complex process of blending different colours of glass and heat treatments. Invented around 1460, it resembles semi-precious stones such as agate or chalcedony, after which it is named.

To make *millefiori* (thousand flowers) glass, a bubble of hot colourless glass on the blowpipe is rolled over a flat surface on which sections of prepared, multi-coloured glass canes are randomly scattered. The colourful pieces of glass stick to the surface and are rolled into the surface until it is smooth, after which the bubble can be further inflated and shaped. The resulting effect is one of brightly patterned coloured patches incorporated in clear colourless glass. Both *millefiori* and *calcedonio* glass were rare precious techniques. Filigree glass was a more widely used hot technique. It involved incorporating thin opaque-white canes into the colourless glass. The resulting glass could have a simple striped decoration (*a fili*), but more intricate variations were made with twisted

canes (*a retorti*), and the effect could be further complicated by combining it with patterned moulds, which would distort the white lines during inflation.

"Cold" techniques are those where a decoration is added on the finished glass. Diamond-point engraving involves decorations being scratched into the glass surface with a sharp diamond splinter. Patterns include arabesques and grotesques, and are usually drawn in outline filled with parallel hatching. Cold reverse painting was practised on dishes and plates; the results were detailed but vulnerable, prone to scratching and flaking.

Enamel could be painted onto the surface using pigments based on ground glass. The decoration was fired onto the surface by gently reheating the decorated object and re-introducing it into the furnace until glass and enamels became soft and fused together. The coarse enamel paste allowed only crude painting and was most suitable for simple dot patterns. Gold leaf could be stuck to the surface with a sticky substance and fired together with the enamels.

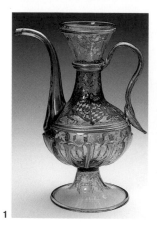

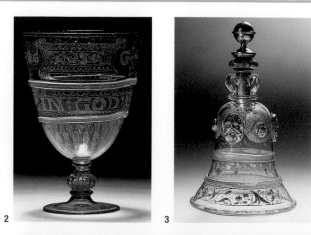

2 *Goblet of colourless glass with diamond-point engraving, horizontal lattimo threads, and traces of gilding, made in the workshops of Giacomo Varzelini with engraving by Anthony de Lysle, London, 1586. Ht 17cm/6¾in.*

3 *Bell-shaped goblet of colourless glass decorated with moulded masks and prunts, turquoise beads, and gilding, with a silver-gilt mount, last quarter of the 16th century, probably Antwerp. Ht 19cm/7½in.*

1 *Ewer in colourless glass with a grey tint, cold-painted and gilt, produced by the glasshouse of Wolfgang Vitl, Hall-in-the-Tirol, Austria, 1535–8. Ht 31.5cm/12½in.*

4 *Osias Beert,* Still Life *(detail), early 17th century, depicting Venetian-style goblets filled with red and white wine. The stems consist of hollow knobs with elaborate hot-worked decorations.*

5 Tazza *of colourless glass with a yellow tint, enamelled, c.1560– 1600, Barcelona. The colour scheme of pale green, yellow, and white is typical of Barcelona glass. Diam. 22.5cm/8¾in.*

RENAISSANCE | GLASS

With the rise of the reputation of Venetian glass, so grew the desire of foreign rulers to start their own production of luxury glass in the Venetian style. Although the Venetian Guild tried to keep its working methods secret, its glassmakers were regularly lured with generous incentives to leave their country and settle elsewhere. By the end of the 16th century, Muranese glassmakers had set up furnaces in several countries north of the Alps. Because they tried hard to produce glass *à la façon de Venise* (in the Venetian manner), just as they had made it at home, it is very hard to distinguish their products from those made at Murano.

The glasshouse in Hall-in-the-Tirol, Austria, was one of the very first Venetian-style glasshouses outside Italy. Some glasses can be attributed to it because of the coats of arms they bear. The Tirol glasshouse seems to have specialized in cold-painted decorations, while the shape of its products is entirely Venetian.

Antwerp became one of the main centres of Venetian glassmaking in northern Europe. Most of the master glassmakers working there were Venetians, working in the Venetian style. However, some local shapes did develop, especially during the 17th century.

From Antwerp, Venetian glassmaking spread to many other places. The Italian Giacomo Verzelini (1522–1606), for instance, went on to London. Some extraordinarily fine glasses of the 1580s can be attributed to his workshop. Their engraving was almost certainly done in London by the Frenchman Anthony de Lysle. Makers from Altare in north-west Italy, a rival glassmaking centre, introduced the Venetian style of glassmaking into France. They produced slightly different, often angular shapes, and the figurative enamelled decorations are more naively drawn.

In Spain, strong local traditions were only partially influenced by Venice. The glass used often has a strong honey colour. While enamelling went out of fashion among Venetian glassmakers after the first quarter of the 16th century, the Spanish continued to practise the technique, developing their distinctive style

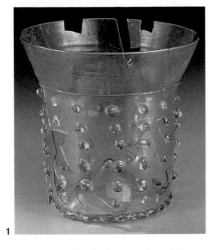

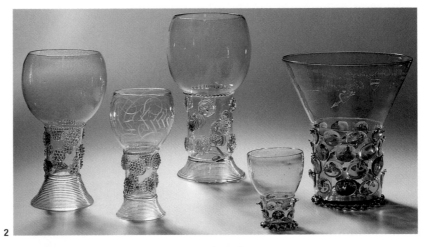

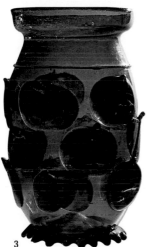

1 *Prunted beaker of pale green glass with a flaired rim, from Germany or Switzerland, late 13th or early 14th century. Ht 17.5cm/7in.*

2 Berkemeyers *(left)* and Roemers *(right) of green glass decorated with prunts, two with diamond-point engraving, from Germany or the Netherlands, 1590–1675. The Berkemeyers have applied frilled foot-rings. Ht (tallest) 23cm/9in.*
3 Krautstrunck *of clear green glass, Germany, 15th century. Ht 4.5cm/1¾in.*
4 *Pieter Claesz,* Still Life with Roemer and Herring *(detail), dated 1647. The pale green glass of Roemers enhanced the golden colour of white wine. Dutch painting in the 17th century welcomed the challenge of depicting the colour and reflections in glass.*

incorporating leaf designs in bright green, with stylized animal figures.

In the great forests of central and northern Europe, a distinctive style of glassmaking developed from the late Medieval period onwards. The forest provided the fuel and the glasshouses moved on to a new location when their surrounding area was cleared of trees. The main raw materials were locally gathered sand and the ashes of beech trees and ferns. These contained high levels of iron oxides which resulted in a glass with a strong green colour known as *Waldglas* (forest glass).

The forest glasshouses mostly produced drinking glasses for wine and beer in a limited variety of types. Most of these are derived from the basic Medieval type of beaker, which was conical or barrel-shaped, with an applied foot-rim, often decorated with pincered points. Such glass is decorated with prunts, or small blobs of glass applied in a regular pattern. These prunts are decorative as well as functional, providing extra grip when the glass is held with greasy fingers.

The most common type of drinking glass in the 15th and 16th centuries was the so-called *Maigelein*, a squat barrel-shaped beaker decorated with moulded honey-comb or rib patterns.

During the 16th century, several types of glasses developed from the prunted beaker. The *Krautstrunck* (cabbage stalk) was a barrel-shaped beaker decorated with large prunts which were pulled out with pincers into a pointed shape. Another variation was the *Berkemeyer*, a beaker on a low foot, the main body of which consists of a more or less cylindrical lower part and an everted upper section.

The *Roemer*, one of the most popular drinking vessels of the 17th century, developed from the *Berkemeyer* in the early 17th century. The top part of the *Roemer* is spherical or oviform and, from about 1620 onwards, it developed a higher splayed foot, which was made by spinning a thread of hot soft glass around a wooden template. *Roemers* were especially popular for drinking white wine, the green glass greatly enhancing its colour.

Silver and Metalwork

Architectural Background

1 *The architectural and sculptural composition of this silver-gilt altar candlestick, completed in Rome by Antonio Gentile in 1581, is strongly influenced by the Mannerist style of Michelangelo, who may have designed it. Ht 1m/3ft 3in.*

2 *The engraver Valerio Belli made this silver-gilt and crystal casket for Pope Clement VII in 1532. The classical subjects of the engravings and the disciplined proportions of the mounts epitomize the Renaissance style. Ht 15cm/6in.*

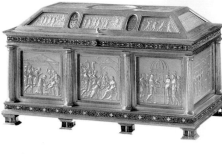

3 *Antonio Pollaiuolo made this massive altar cross for Florence Cathedral in 1457–9. Its design is transitional: Gothic in the base and cross; Renaissance in the stem. Ht 2.5m/8ft 2in.*

4 *The Renaissance connoisseur Piero de' Medici of Florence collected precious hardstone vases for which he commissioned silver-gilt mounts. The design of these mounts is still Gothic but looks forward in certain details. Ht 42cm/16½in.*

In Medieval Europe there was no recognized distinction between artists and craftsmen. Artists were those who practised *ars*, or skill, and the art of the goldsmith was rightly regarded as the queen of crafts. The materials in which they worked – both gold and silver – were highly valued, and the objects they created were not only utilitarian tablewares, but sumptuous and refined pieces that testified to the status of their owners, or were made for that greatest of patrons, the church.

This did not change with the advent of the Renaissance. Princes and prelates continued to offer lucrative commissions, and many leading painters and sculptors such as Lorenzo Ghiberti (1378–1455), Andrea del Verrocchio (c.1435–88), and Antonio Pollaiuolo (c.1432–98) also trained and worked as goldsmiths throughout their lives. North of the Alps, too, well-known figures such as Albrecht Dürer (1471–1528), Hans Holbein (1497/8–1543), and Nicholas Hilliard (c.1547–1619) were either trained in the craft or came from a goldsmithing background. Partly for this reason and also because precious metals were often melted down to be re-made in the latest fashions, many significant innovations in design were reflected first in goldsmiths' work. The survival of such works, especially from the 15th and early 16th centuries, has been almost negligible, especially from Italy, but many drawings survive and show the application of Renaissance design principles to vessels and other objects.

Renaissance architecture was conditioned by a rational approach to proportion, expressed through the language of ancient Roman architecture and through the vocabulary of the classical orders. Just how different the resulting style was from its ancient inspiration, however, is clear from the surviving buildings of architects such as Leon Battista Alberti (1404–72) and Filippo Brunelleschi (1377–1446), for whom surface decoration is as important an element in the overall effect as rational proportion and classical detail. A similar concern for classically inspired design and proportion is evident in designs for silver but, in seeking to emulate classical vessel forms, the Renaissance goldsmith was handicapped by the fact that

Gothic to Renaissance: Northern Europe

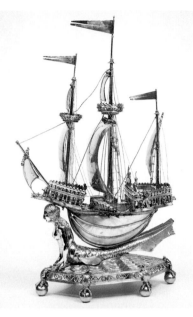

1 *Albrecht Dürer was one of the most famous German Renaissance artists, but the overall form and all the details of his 1526 double-cup design are still Gothic.*

2 *Published in about 1540 in Fulda by Hans Brosamer, the careful horizontal divisions of this cup design and all its details are wholly Renaissance in conception.*

3 *This silver-gilt and nautilus shell nef, or ship model, made in Paris in 1528, is designed as a ceremonial salt cellar. It is still Gothic in character, although some details like the claw and ball feet are Renaissance.*

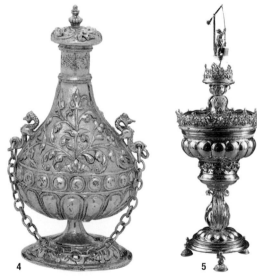

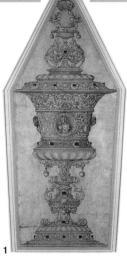

4 *This rare casting bottle, for sprinkling scented water, was made in London in 1553 for the middle market. It does not show the influence of the courtly designs of Holbein, but rather that of the prints of Hans Brosamer. Ht 14.5cm/5 ¾in.*

5 *Ludwig Krug was one of the most famous early 16th-century goldsmiths of Nuremberg and one of the pioneers of the new style. This covered cup still has Gothic details, but the horizontal emphasis of its form is Renaissance. Ht 44cm/17¼in.*

Hans Holbein and the English Renaissance

1 *Holbein came to England in 1526 and promoted a sophisticated courtly version of the Renaissance style, epitomized by his design for a gold cup to celebrate Henry VIII's marriage to Jane Seymour in 1536, which incorporates classical medallions, moresque foliage, putti, and vase forms.*

2 *One of the few surviving pieces designed by Holbein, this gold, enamel, and rock-crystal cover for a bowl is densely packed with strapwork, classical figures, moresque foliage, and jewels. Ht 16cm/6¼in.*

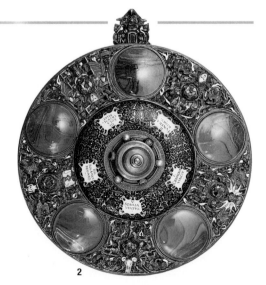

Cellini and Romano

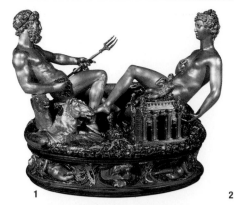

1 *Benvenuto Cellini made this gold salt cellar for Francis I in 1543. The rich symbolism, with the two figures representing the earth and sea, and the precariously balanced composition, epitomize the Mannerist style. Ht 6cm/2½in.*

2, 3 *Some of the earliest designs for silversmiths in the Mannerist style were by Giulio Romano, who worked for the dukes of Mantua as an architect and painter as well as a designer of goldsmiths' work, jewellery, and tapestries. These designs for a candlestick and a salt cellar, dating from about 1525–40, use the vocabulary of Roman architecture – acanthus foliage, lions' masks, and flutes – but they appear in a completely new and playful way.*

Italian Mannerism

1, 2 *Some of the most influential Italian Mannerist ornament designs were the series of ewers, vases, and candlesticks by Enea Vico in the 1540s and 1550s. These designs use classical Roman motifs, but the visually unstable foot of the ewer, its bizarre half-human handle, and the fine junction of foot and stem on the candlestick are typical of the style.*
3 *Most special commissions were based on a drawing by the craftsman, but occasionally the design was represented by a three-dimensional model. This terracotta modello for a ewer is a rare survival.*
4 *This mid-16th-century design for a silver basin, from the school of the Florentine goldsmith Francesco Salviati, shows the densely packed figural composition that was key to his style, but also provides a variety of alternative treatments for the border.*

1 *Rosso Fiorentino and Francesco Primaticcio invented strapwork for the Galerie François I at Fontainebleau, c.1540. It was disseminated by prints such as this cartouche design of 1563 by René Boyvin after Léonard Thiry.*

2 *Very little 16th-century Parisian silver survives, but the sophisticated jewel-like workmanship of this gold and enamel mounted onyx ewer, c.1560, shows the quality for which it was so famous. Ht 27cm/10⅝in.*

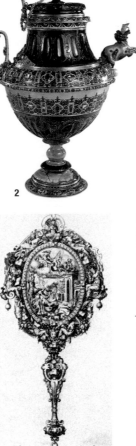

3 *Androuet Du Cerceau was probably the most important French designer working around 1540, and this salt cellar design illustrates the disciplined clarity of his style.*

4 *Du Cerceau's design for a table fountain has great definition, but also dense and complex ornament and a sense of humour, all important elements of Mannerism.*

5 *Similar mirror backs to this survive in carved boxwood, but the intricacy of this design of 1561 by the Paris artist Etienne Delaune shows that it must have been made for execution in precious metal.*

at that time no ancient plate had come to light. As a result the essential inspiration for most cups, ewers, candlesticks, and so on is the vase form, articulated with decorative details drawn from architecture. Rationality in design is reflected in balanced compositions divided into clearly defined horizontal zones corresponding to the various component parts; ornament is restricted to a limited range of motifs including flutes, dentilations, acanthus foliage, and roundels incorporating classical medallions. Pollaiuolo's 1457 altar cross in Florence, for example (see p.30), is almost entirely architectural and, while in basic form akin to its Gothic antecedents, the designer has checked its sense of verticality by imposing a strong series of horizontal divisions.

In northern Europe, the impact of the Renaissance was later and different. The already fully developed Italian style made a powerful impression on visiting artists such as Dürer (see p.31), which resulted in the early 16th century in a hybrid, transitional style incorporating both Renaissance and Gothic features. By the end of the first

quarter of the century, Nuremberg artists like Ludwig Krug (see p.31) and Peter Flötner had marshalled a more fully integrated form of the style. This retained certain features of Gothic ornament, but was mainly characterized by horizontally zoned construction and a predominant ornamental language of flutes and gadroons (decorative lobed edging), frieze ornament, and classical or mythological allusions. The interest of patrons in the classical past, and their princely identification with imperial Rome, is symbolized by the incorporation of emperors' busts or even ancient silver coins into silverware.

The role of princely patrons in accelerating the development of style is nowhere more clearly evident than in the patronage of the English and French kings, Henry VIII and Francis I. The ambition of both to lead what would be seen as the most brilliant court in Europe led to overtly competitive displays of lavish grandeur and events such as the Field of the Cloth of Gold (1520), which provided work for innovative artists capable of projecting the image of the king and were the subject of diplomatic dispatches

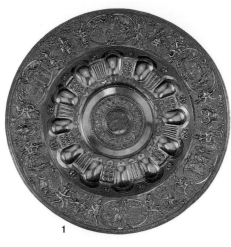

1 *Antwerp silver of the mid-16th century was among the most splendid in Europe. The squat proportions and grotesque details of this ewer and basin, c.1550, illustrate Antwerp's contribution to Mannerism. Ewer ht 34cm/13⅜in.*

2 *This silver-gilt covered* tazza, *made in Antwerp in 1558, is decorated with ornaments symbolizing water. Its proportions are Renaissance, but the symbolism and ornament are Mannerist. Ht 38.5cm/15¼in.*

5 *Adriaen Collaert's patterns for ornament circulated widely, and this spice plate design shows his interest in fanciful sea monsters.*

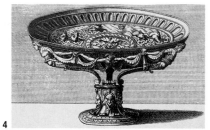

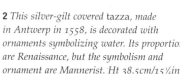

3 *The Antwerp artist Cornelis Floris (1514–75) produced an original series of ewer designs in the 1540s, incorporating grotesque compositions of human figures, strapwork, and inventive abstract vessel forms.*
4 *Hans Vredeman de Vries was another influential Antwerp artist whose work included a series for silver, such as this 1563* tazza.

across the Continent. Francis I scored a symbolic point over Henry in securing the services (or, more accurately, the presence) of the aged Leonardo da Vinci (1452–1519) and, later, the sculptor and goldsmith Benvenuto Cellini (1500–71). A more signal event, however, was his appointment of the two Florentine artists, Rosso and Primaticcio, to whom we shall return later. For his part, Henry VIII's most brilliant court artist was the German painter, Hans Holbein, who worked in London for several decades from the 1520s until after the king's death in 1547. His chief role was as designer, both of decorations for court entertainments, and also for what might broadly be termed furnishings. Almost nothing of the magnificent gold and silver made to his designs survives, but a number of the designs themselves do, such as the gold cup made in 1536 for Henry VIII's wedding to Jane Seymour (p.31). They show an easy command of Renaissance proportion and a repertoire of ornament that includes certain new features, most notably moresque foliage, which was adapted from saracenic metalwork.

The presence of this feature is a reminder of how wide-ranging Renaissance designers were in their efforts to expand the repertoire of available ornament. Ewers, dishes, and other decorative wares in brass were evidently imported into Europe through Venice in quantity during the early 16th century, and their typical decoration of densely engraved abstract scrolls soon became a stock-in-trade throughout much of northern Europe.

The designs for courtly objects like this, or exceptional survivals such as the Cellini Salt (see p.32), are also reminders of the collaborative nature of the finest goldsmiths' work. Objects made for royal patrons often incorporated other precious or exotic materials like carved rock crystal or rare seashells from the tropics. Equally, enamel was used to enhance the effect of decorative plate. Often this would be restricted to simple opaque enamels or *niello* (a compound of sulphur, silver, lead, and copper, used to fill incised decoration) for coats of arms or inscriptions; occasionally panels of decorative or pictorial enamel would be incorporated.

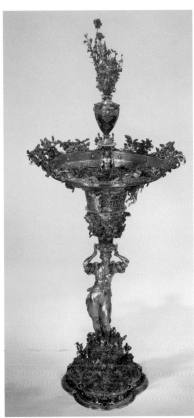

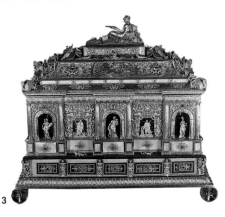

1 The Nuremberg goldsmiths' guild required that an aspiring master produce a cup of a particular form before being accepted into full membership. This design of c.1600 by Paul Flindt is of the prescribed form, but with new ornament designed to show his skill.
2 The most influential German goldsmith of the second half of the 16th century was Wenzel Jamnitzer. The massive Merkel centrepiece of about 1549 is densely crowded with complex quasi-philosophical symbolism. Ht 1m/3ft 3in.
3 The architectural proportions of this Jamnitzer jewel casket, c.1570, are typically Mannerist in the virtuoso compactness and symbolism of its ornament. W. 54cm/21¼in.

4 One of Jamnitzer's most brilliant creations, this ewer frames two seashells in a composition of disparate elements that abandons all semblance of rules. Even the normal relationship of scale between the eagle and the snail is discarded. Ht 33cm/13in.

5 Hans Petzold was one of Nuremberg's leading goldsmiths in the generation after Jamnitzer. This cup, made for the patrician Nuremberg family of Imhoff, incorporates the family crest into the stem and finial of the cup. Ht 46.5cm/18¼in.

6 Petzold was at the forefront of a popular Gothic revival in Nuremberg, epitomized by this early 17th-century cup in the form of a bunch of grapes. Ht 50cm/19¾in.

7 This elaborate and virtuoso cup by Christoph Ritter is a variation on the model of the Nuremberg masterpiece cup. Many of its fine casting patterns derive from Jamnitzer. Ht 25.5cm/10in.

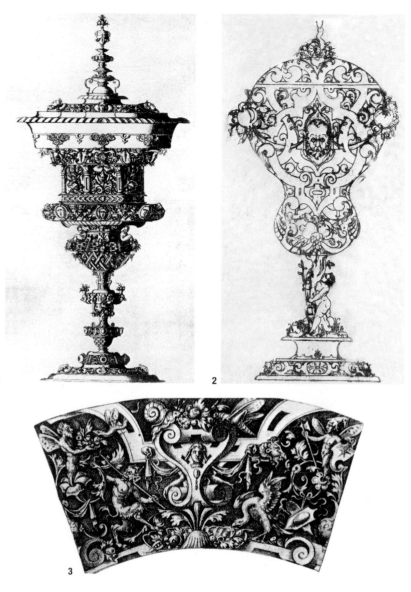

1 *The well-organized form and ornament of this 1551 cup design by Matthias Zündt of Nuremberg represent the standard of work achieved by the best goldsmiths. Zündt's work was widely disseminated, and elements of this design appear on the English cup on p.37.*
2 *The gourd-shaped cup in this design of 1581 by Bernard Zan is a revival of a Medieval form, with contemporary strapwork ornament. It was widely circulated and was probably familiar to the maker of the English gourd cup (see p.37).*
3 *Virgil Solis of Nuremberg was a prolific ornament artist in the 16th century and produced large numbers of detailed patterns for goldsmiths, such as this mid-century panel of strapwork and foliage.*
4 *This magnificent rock-crystal and silver-gilt tankard, made by Diebolt Krug of Strasbourg, c.1560, draws on a variety of international printed graphic sources. Ht 26cm/10¼in.*

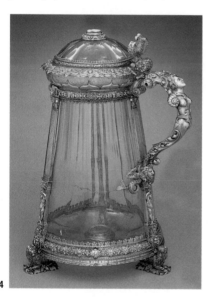

At the same time as Holbein was perfecting the northern European expression of the Renaissance style, artists in Italy such as Giulio Romano, Enea Vico, and Francesco Salviati were producing designs for goldsmiths' work that reflected the new and very different preoccupations of the Mannerist style. Two of the main features of this style were invention and virtuosity, a notion embraced by the Italian word *difficultà*. But while these priorities in themselves make it difficult to define the style in terms of specific features, certain broad principles of design can be recognized. One of these, characteristic of Giulio's candlestick design (p.32), is a use of the vocabulary of classical design and architecture in a way that is non-classical in its effect: the putti and lions are classical motifs, but the way in which they struggle to escape from the acanthus foliage is not. In Enea Vico's ewer (p.32), the density of ornament, the top-heavy sense of imbalance created by the small foot, and the attenuated proportions of the handle are all features of Mannerist design that would be taken to extremes as the century progressed.

Mannerism migrated to northern Europe much more quickly than had the Renaissance style. This was partly due to Francis I's great project for the decoration of his gallery at Fontainebleau and to the revolutionary designs produced for it by Rosso and Primaticcio (see p.33). The elaborate stucco compositions of strapwork (a decorative motif resembling cut and curling strips of leather) and elongated figures were intended as a framework for the painted canvases, but became the dominant feature of the gallery. They created such a sensation that within a few years strapwork had become an ubiquitous decorative motif throughout northern Europe.

The main reason for the rapid dissemination of design in the second half of the 16th century was the growth in the market for sheets of printed ornament, which were used by leading goldsmiths throughout Europe. The version of strapwork decoration that travelled across Europe around the middle of the century was not so much a copy of the Galerie François I as an interpretation of it by French artists such as René

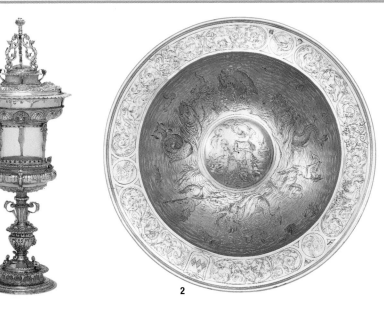

1 *Made in London in 1568, this rock-crystal cup and cover bear the mark of one of the royal goldsmiths and show awareness of the latest continental pattern books. Ht 43cm/17in.*
2 *The design of this London-made spice plate of 1573, from a set of six, is closely based on the designs of Adriaen Collaert. Diam. 15.5cm/6in.*
3 *Much surviving English Elizabethan silver fails to equal the standards of the best continental work, and the embossed strapwork of this 1581 salt cellar is a poor reflection of contemporary design developments, probably taken at second hand rather than directly from a pattern book. Ht 27.5cm/11in.*
4 *Like the rock-crystal cup (1), this gourd cup is of exceptional quality for Elizabethan silver, and was possibly made by a foreign-trained silversmith working in London. Its maker probably knew the Bernard Zan print opposite, or one similar. Ht 30cm/11¾in.*

Spain: Herrara Style

1 *This silver-gilt chalice is typical of a style that developed in early 17th-century Spain. Named after the architect, Juan Herrara, it combined a richness of material and ornament with an austerity of form that is not found elsewhere. Ht 28cm/11in.*

Boyvin and Androuet Du Cerceau (see p.33). Other centres of print production and goldsmiths' work in the middle and late 16th century were Antwerp, Augsburg, and Nuremberg. The published designs of prolific artists and engravers like Cornelis Floris, Hans Vredeman de Vries (p.34), and Virgil Solis (see p.36) did much to define the character of high style Northern European goldsmiths' work for the rest of the century.

Prints by graphic artists were not the only source of innovation during the 16th century. The art of design was an important part of the training of a goldsmith under the German guild system, and the most outstanding and skilled goldsmiths would have been largely responsible for their own designs. Enough of the works of the Nuremberg goldsmiths Wenzel Jamnitzer and Hans Petzold survives to substantiate the brilliant reputation they had during their lifetimes. Works by Jamnitzer such as the Merkel centrepiece of c.1549 (see p.35) epitomize the virtuosity as well as the excesses of the style: arguably ill-proportioned as a whole, it is

nevertheless a triumph of finely executed detail, combining a wealth of densely arranged ornament with a programme of intellectual content.

The Renaissance goldsmith, however, was both a leader and follower of trends in the complex interactions that made up the European artistic scene. The background of artists such as Pollaiuolo and Cellini ensured that some of the techniques they used for goldsmiths' work were also applied to bronze, and perhaps the most virtuoso of all Italian works in metal of the period are the brilliant sculptural parade armours of damascened steel made in the Negroli workshops in Milan. In northern Europe, a role in the dissemination of Mannerist ornament was also played by works in base metal, most notably the spectacular ewers and dishes made by the French pewterer, François Briot, and his Nuremberg imitator, Caspar Endelein. The fact that these wares were made of relatively inexpensive pewter, and were cast rather than being individually raised and chased, ensured a significantly wider market and thus a greater social impact.

Textiles

Stylized Networks

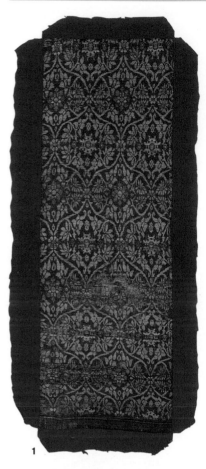

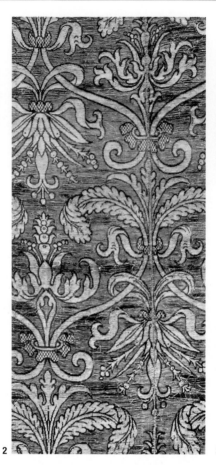

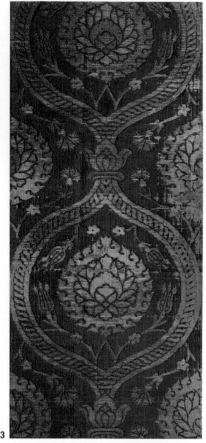

1 *Woven silk, possibly western India for export, 1400–1600, with the classic ogee form, in which each downward row of tear-drop shapes creates an intermediate downward row.*

2 *Silk brocade, Spain, 16th century. Here, the ogee motif is delicate and discontinuous. Through the Hapsburg dynasty, Spain was stylistically influential on design of the period.*

3 *Hand-woven silk velvet with metal thread, Ottoman Turkey, 1550–1600, illustrating the large-scale, bold ogival framework and stylized pomegranates typical of many Renaissance patterns.*

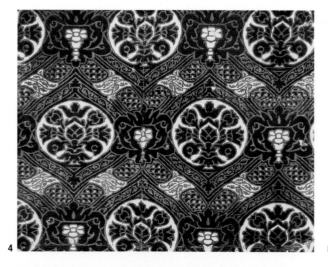

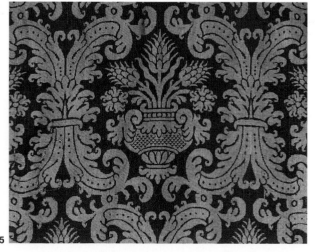

4 *Silk velvet, Italy, 16th century. The small-scale pattern makes the geometric plan more apparent, while the textural detail shows the close relationship between textiles and metalwork designs of the period.*

5 *Silk damask, Italy, late 16th century. European origin is usually indicated by the inclusion of a recognizable object, here a vase. The elaborate ogival framework with foliage resembles architectural details.*

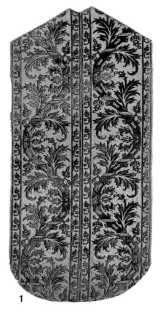

1 *Silk velvet chasuble (outer vestment worn by a priest), Genoa, late 16th century. The meandering vine was a prominent element of later Renaissance patterns.*

2 *Designs from* Gli Universali di tutti e bei dissegni, raccami e moderno lavori *by Zoppino (Venice, 1532). These images from a book of embroidery patterns show a Renaissance grotesque design, a band of strapwork, and a band with an adaptation of an arabesque pattern.*

3 *Embroidered bordered panel, Britain, late 16th century. This border, on an amateur embroidery, features the meandering vine motif, which injects a fluidity into the design that nevertheless retains a strong visual structure.*

4 *Embroidered antependium (altar frontal), Valetta, Malta, c.1600. The meandering vine is illustrated again here, intertwined with arabesque elements.*

Renaissance textile patterns contain both conservative and novel elements. The pace of adoption could be slow, depending on the circulation of cloths, or relatively rapid and extensive, as a result of the publication of books and single sheets of wood-engraved designs. However, whether loom-woven cloths, lace, or embroidery, their designs – large and small – have a robust appearance and a clearly marked-out structure.

The patterns on woven textiles range from small geometric repeats to large designs that occupy the entire width of the cloth, then about 51cm/21in wide. The latter are the most well known, surviving in fair numbers and also depicted in numerous paintings. These cloths, the damasks and velvets, typically show highly stylized yet multi-faceted motifs, which are most commonly variations of the pomegranate or, less usually, vases. The arrangement is often organized within a framework that is essentially teardrop-shaped. This so-called ogee already existed in textile designs but during the Renaissance took more various forms: fine vines, curling leaves, or broad ribbon-like bands, for example. Such stylized networks reveal their geometric basis more clearly in smaller-scaled repeats, especially those destined for use in *reticella* lace and embroidery on linen shirts and chemises, a result of the fact that both were produced by using the base cloths' own grid-like structure to count out the placement of the pattern.

Variations of the ogee designs emphasize the leafy and flowering vines, which might meander in a regular fashion from left to right, or intertwine. As in the more formal patterns, the stems can be given prominence by embellishments such as cross-wrappings and infilling with motifs, perhaps scales, coiling vines, or prominent textural marks indebted to repoussé metalwork. Simplified vines also often form the basis for strapwork patterns, at their boldest illustrating Middle-Eastern and Moorish influences. The influences of humanism and classicism are also apparent, particularly in embroideries which, being a free-hand technique, most readily illustrate the impact of the development of perspective.

Baroque

c.1600–1730

The word Baroque refers to the style of art and architecture that developed in Rome during the final years of the 16th century, and it is used, more loosely, to describe all art of the 17th century, and some later, with different expressions in different countries. Baroque art was used at first as a means of reasserting the attraction of the Roman Catholic church and as a means of promoting the Counter Reformation; but the impetus gradually moved from Italy to France, which had been growing in economic and artistic importance in the first half of the 17th century, and it was used instead to underline the concept of absolute monarchy.

Patronage, both religious and secular, continued to be of prime importance in the 17th century, but it was not restricted to the Church and leading monarchs. The wealthy and powerful merchant classes in Holland had also acquired a taste for luxury goods and their patronage cannot be ignored. In general, it can be difficult to attach stylistic labels to decorative art objects, and not all the pieces discussed in the following pages can be described as truly Baroque, but they will reflect aspects of the period also seen in architecture, painting, and sculpture.

As a style, the Baroque reflects an admiration for and a familiarity with the art of classical antiquity, particularly the grandness and monumentality of Roman architecture, which is seen in 17th-century churches and palaces alike. State apartments were painted with vast illusionistic scenes of classical gods and goddesses and filled with antique sculpture, reflecting both the taste and the status of the owner. The decorative arts frequently demonstrated a similar interest in architectural and sculptural detailing that was based on a knowledge of antiquity, and there was a general enlargement in the scale of the ornament. A liking for boldness and solidity of form, rich colour contrasts, and the use of costly and exotic materials were also prevalent. The overall effect of an Italian Baroque interior was one of grandeur, opulence, and theatricality, whereas French interiors, while equally grand and sumptuous, tended to exhibit a greater formality and balance.

Another aspect of the period, which was reflected in the decorative arts, was a fascination with light, which can be seen particularly in Dutch still-life paintings, but also in the incorporation of mirror glass into the interior and the desire for highly reflective surfaces. There was also a great interest in movement, which can be seen, for example, in the taste for furniture supports in the form of twisted columns. These twisted forms and the appreciation of ripple-carved mouldings also show a general liking for curving lines and an interest in how light moves over undulating surfaces.

Left: the body of this silver ewer by Paul van Vianen, made in Utrecht in 1613, is decorated with pictorial scenes related to the goddess Diana, but the foot, neck, and pouring spout are composed of curious, abstract fleshy forms characteristic of the Auricular style. Ht 34cm/13½in.

Opposite: the detail of this tapestry after Charles Le Brun (1619–90) shows the famous visit of Louis XIV to the Gobelins factory in Paris in 1667. The Gobelins factory employed skilled craftsmen such as weavers, goldsmiths, cabinetmakers, and sculptors to produce luxury goods for the royal palaces. Here, the king is being presented with some of these sumptuous objects.

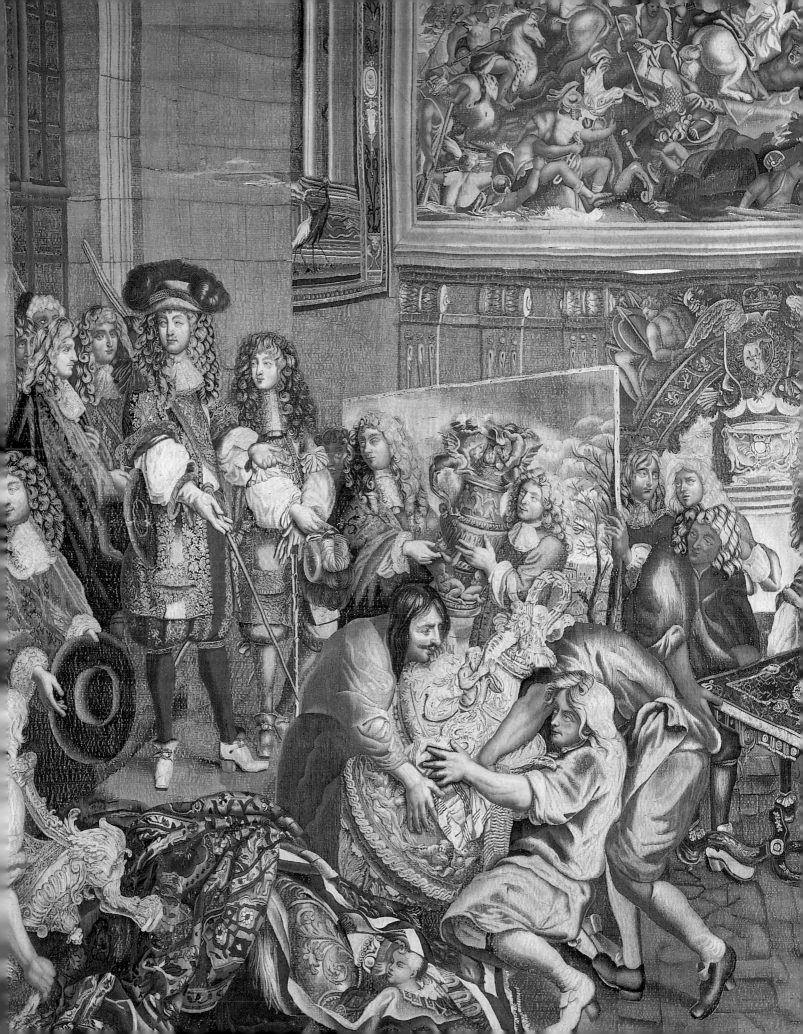

3 *The blue and white colours of this late 17th-century Dutch delft panel show the influence of Chinese export porcelain, but the framework of acanthus and strapwork derives from an engraving by Daniel Marot. Ht 60cm/23½in.*

1 *In this still life of a table laid with cheese and fruit, by the Dutch painter Floris van Dijck, c.1615, the fascination of 17th-century artists for the way light moves over different surfaces can be seen. Notice, in particular, the Chinese blue-and-white porcelain, the green glass* Roemer, *and the fine, white stoneware jug.*
2 *The British architect Inigo Jones sketched this design, c.1637, for an extravagant fireplace for the Queen's House, Greenwich, based on a design by Jean Barbet. Note the studies of putti.*

An interest in light and movement can also be seen in the development of the Auricular style in early 17th-century Dutch silver. Named because of its similarity to the human ear, Auricular ornament is composed of abstract fleshy forms and the effect of rippling water, sometimes incorporating strange monsters, which reflects the interest in bizarre and fantastic ornament that was fashionable in the second half of the 16th century. The play of light over the undulating surfaces of the silver gives a disturbing effect of malleability, as if the metal is actually melting. Although it is seen almost exclusively in Dutch silver, Auricular ornament does also appear in furniture, and very occasionally on textiles and ceramics.

Another key factor in the development of the decorative arts in the 17th century was the establishment of a flourishing trade with countries in the Far East. The various trading companies set up from the beginning of the century began to supply the European market with lacquer, porcelain, and silks, which helped to establish a new taste for all things exotic. Although these goods were costly and affordable only by the wealthy, the demand became so widespread that cheaper imitations, particularly of lacquer and blue-and-white porcelain, began to be produced in European countries. At first, these imitations followed the oriental prototypes fairly closely, but gradually the designers, while retaining an exotic mood, moved further and further away from the originals, and developed the style now known as chinoiserie. Because western knowledge of the Far East was very sketchy, the designers had to use their imagination when it came to the subject matter of the decoration. This led to greater and greater freedom of expression, which developed into a fantastic and highly inventive decorative vocabulary that had a profound effect on the development of the decorative arts in both the 17th and 18th centuries. Conversely, blue-and-white wares gradually began to follow more traditional European forms.

Another widespread interest of the period was in flowers, and this will be reflected again and again in the decorative arts. New and exotic species were introduced into Europe, botanical gardens were established, and illustrated herbals began to proliferate. This not only established a fashion for displaying cut flowers and a demand for new forms of the flower vase, but it

also provided artists and designers with a huge new vocabulary of decorative motifs. In the first half of the century the trade in tulip bulbs reached its height and depictions of tulips, both accurately rendered and highly stylized, began to be engraved on silver, woven into textiles, translated into marquetry furniture, and painted onto earthenware.

The other motif derived from both nature and antiquity that dominated 17th-century ornament was the acanthus. Although the most widely used of all forms of foliate ornament and not particularly associated with any one period, the lobed and serrated leaves of the acanthus seemed to appeal particularly to Baroque designers, and it appeared in architectural detailing and almost every branch of the decorative arts, becoming one of the leading decorative elements of the Baroque style.

The last quarter of the century was dominated by the more restrained and formal style of Baroque classicism, which was adopted by the French court and, in particular, the work of French designers and ornamentalists. The work of these designers was widely disseminated in the form of prints, particularly engraved panels of ornament, which could be translated into different materials, and they became a powerful source of inspiration for the decorative arts well into the early years of the 18th century. The spread of the French court style was further assisted by the Revocation of the Edict of Nantes (1685). This new ruling meant that French Huguenots could no longer freely worship or hold any position of authority, with the result that many thousands of Protestants fled from France to Protestant countries such as Holland and England. Among these refugees were many skilled designers and craftsmen who brought with them up-to-date knowledge of contemporary French taste.

An important aspect of the work of the French ornamentalists at the end of the 17th century and beginning of the 18th century was a revival of grotesque ornament. These designs were composed of acanthus tendrils, lambrequins, and fanciful creatures, symmetrically arranged within delicate bandwork borders. Although derived from 16th-century examples, these designs tended to be more delicate and linear and introduced a new element of airy lightness and elegance that, in many ways, foreshadows the Rococo style, which will be discussed in the next chapter.

4 *The Gallery of the Palazzo Colonna, Rome, which was created between 1654 and 1665, with its vast allegorical ceiling painting, extravagant use of mirror glass, and boldly carved gilt-wood side tables, is the epitome of the grand Baroque interior.*

4

Italian Furniture

Early Developments in Florence

1 *A Florentine silver casket of elegant proportions made in c.1620. It shows the emphasis on architectural and cubic forms that can be found in much European design of this period.*
2 *This table was designed in around 1709 by G.B. Foggini, the leading sculptor and architect in Florence. Shown is the top of the table with birds and flowers in* commesso di pietre dure, *a technique developed in Florence that used thin slices of stone – * pietra dura *means "hard stone" – to create mosaic pictures.*

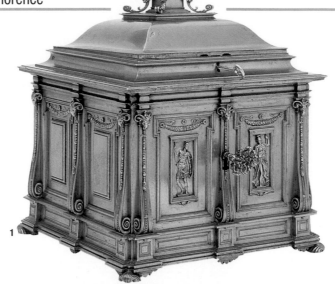

3 *This carved, gilded frame was probably made in Florence c.1640. It closely reflects the designs for cartouches published in c.1634 by Agostino Mitelli, who worked at the Pitti Palace. Such auricular elements were used for Florentine frames throughout the century. Ht 96cm/37¾in.*

The reaction to the more exaggerated and fanciful forms of late 16th-century Mannerism first appeared in Italy. Under the influence of artists such as Giambattista Bernini (1598–1680) and Alessandro Algardi (1598–1654), the design of furniture in Italy began to feature foliage and carved human figures. Rome was the centre of the new style, where the interiors of the Roman palaces with their vast reception halls demanded an appropriate flamboyant style of furniture, particularly for tables and cabinets. Families such as the Barberini, Borghese, Chigi, Ludovisi, and Pamphili commissioned opulent furniture of a grandeur that could not be matched elsewhere in Europe. Carlo Fontana (1638–1714) and Johann Paul Schor (1615–74) designed sculpted forms, *I Forme*, particularly for tables, in which human figures and trophies taken from antique and architectural motifs were combined to create symbols of power and strength.

This fully Baroque style was developed in the second half of the 17th century throughout Italy. In Genoa, Domenico Parodi (1672–1742) created rich, organic masterpieces of sculpture. Giambattista Foggini (1652–1725), the leading sculptor in Florence of his day, was responsible for the great architectural cabinets produced in Florence at the end of the century, in which ebony, ivory, gilt bronzes, precious stones, and carved wood were combined in sumptuous magnificence. In its use of architectural forms, however, Florentine work was often more restrained than in other parts of Italy. The most famous Venetian carver and furniture maker, Andrea Brustolon (1662–1732), is famous for his detailed carving in boxwood of stands and chairs, in which graceful figures combine with naturalistic carving of trees or stems of plants.

Italian furniture exploited the used of rare materials such as precious stones. The *Opificio delle Pietre Dure* in Florence made tables and cabinets both for the Medici rulers, as gifts to other princes, and for those, such as John Evelyn, who travelled to Italy. Florentine design featured vases with flowers, bird, and plant forms combined with the traditional arabesque forms.

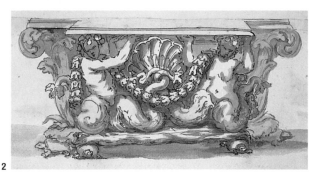

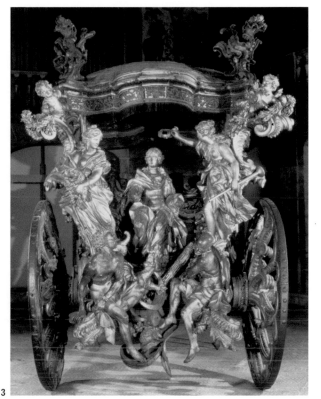

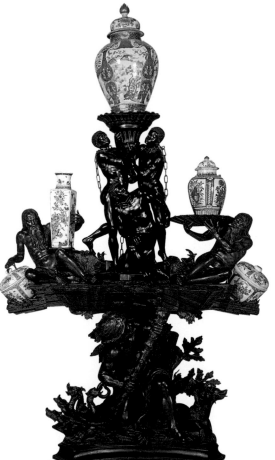

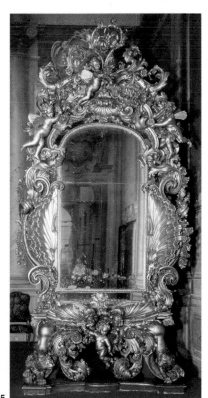

1 *A cabinet of simple classical design made c.1630 with pietre dure plaques made in the grand ducal workshops in Florence. Florentine work developed the repertory of birds and flowers, whereas Roman emphasized geometric motifs. L. 68.5cm/27in.*

2 *A design of c.1660–90 from the circle of Johann Paul Schor, a pupil of Bernini, for a table with supporting full-scale figures. It shows the strong Baroque trend in Roman furniture.*

3 *Rear view of one of three coaches made in Rome in 1716 for the Portuguese ambassador, the Marquis de Fontes. Coaches, a powerful status symbol of the 17th century, were often designed by artists such as Bernini or Pietro da Cortona. They would have been made by the same carvers and sculptors who worked on tables and chairs. Ht 7.28m/23ft 11in.*

4 *The elaborate shape of this sculpture, c.1684–96, festooned with trees, flowers, and other motifs, is taken from nature. It was made by the Venetian furniture maker and sculptor, Andrea Brustolon, who was known for his detailed carving, generally in boxwood. Ht 2m/6ft 6in.*

5 *Intended for great galleries, pieces such as this carved gilt pier glass from Genoa by Domenico Parodi (made c.1690 to 1710) were designed to impress. The design features richly carved scrolling foliage and putti. Ht 5.25m/17ft 2½in.*

French Furniture

Cubic Symmetry

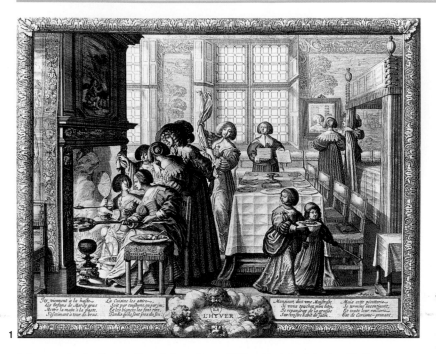

1 *An engraving by Abraham Bosse (1602–76) of an interior c.1640 shows the columnar forms, cubic shapes, and geometric design which were typical of northern European homes from 1620 to 1650. The chairs would have been richly upholstered in silks or velvets.*
2 *This cabinet of floral marquetry veneered in ivory, ebony, and coloured woods was made for Philippe, duc d'Orleans, the brother of Louis XIV, in around 1660 by Pierre Gole, who made floral marquetry fashionable across Europe. Ht 1.26m/4ft 1½in.*

3 *The cabinet stand developed in France as early as 1620. This example, c.1645–50, has been attributed to Jean Macé (1602–72), who went to Flanders to learn the technique of veneering in ebony, or to Pierre Gole. The rusticated columns of the stand emulate those on the façade of the Palais Luxembourg, designed c.1615 for the Queen Regent, Marie de' Medici. Ht 2.12m/6ft 9½in.*

In the first half of the 17th century, furniture design in France showed a new sense of balance and regularity of proportion which was in keeping with the emphasis on classicism espoused by architects such as François Mansard (1598–1666). Trophy motifs and garlands of naturalistic fruits and flowers were carved onto cupboards, while the column became a popular form for the legs of tables and chairs. As early as the 1630s, turnings appeared on chair legs and stretchers and sometimes on the stands for cabinets. The ebony cabinet became the symbol of status and wealth and was conceived on a grander scale than before. Although of a plain rectangular form, it was richly decorated with carved scenes and was combined with a matching stand.

With the return of Simon Vouet (1590–1649) and Charles Le Brun (1619–90) from their travels in Italy, French design became more sumptuous, rich, and grandiose. The Italian Domenico Cucci (*fl.*1660–98) was brought to the Gobelins workshops for his skill in hard stones (*pietre dure*) and was responsible for some of the architectural cabinets made for Louis XIV. Pierre Gole (1620–84), who was born and trained in the Netherlands, developed decoration in floral and metal marquetry. New forms of furniture such as the *bureau mazarin* appeared in both techniques. These experiments culminated in the designs of André Charles Boulle (1642–1732), who worked for the king, the dauphin and leading members of the French court. His development of tortoiseshell and brass marquetry still bears his name – *boullework*. His published designs show new forms of furniture appearing by around 1700, in particular the *bureau plat* and the commode.

By the end of the 17th century, design had moved from the robust forms of Le Brun to more restrained, linear outlines. These trends towards classic designs led to closer imitation of forms such as the sarcophagus-shaped commode. Jean Bérain (1640–1711), the court designer, created new forms of strapwork decoration derived from classical and Renaissance grotesque designs in which bands of strapwork were combined with acanthus leaf foliage, masks, shells, and C-scrolls.

Baroque Classicism

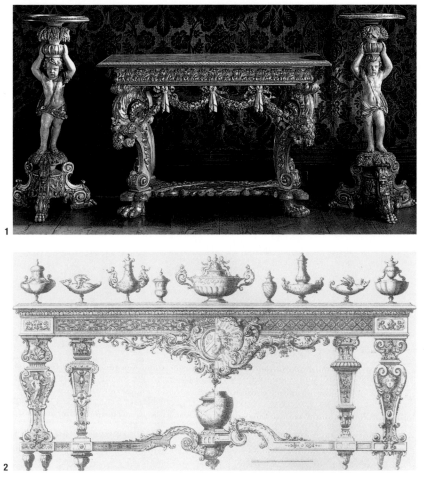

1 This suite of table and stands would have been placed under a mirror next to the wall between the windows. This example is probably that supplied to the French crown in 1671 by Pierre Gole, who made the metal-inlaid top, Mathieu Lespagnandelle, who carved the frames, and David Dupré, who gilded the piece.
2 Design for a side table by Bérain c.1690 using balusters and tapering columns from classical architecture. Tables of this type were placed in the Galerie des Glaces, Versailles, c.1690 to replace silver furniture that had been melted down.
3 A c.1700 French carved and gilded stool of elegant proportions, whose fine detailed carving is based on motifs used in Jean Bérain's published designs.

Boulle Marquetry

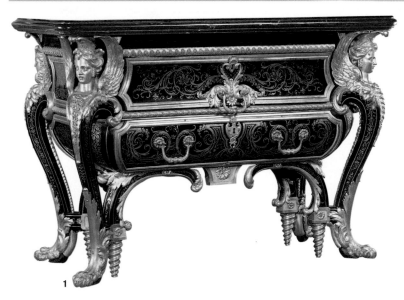

1 The only surviving piece that can be firmly attributed to André Charles Boulle, this commode (one of a pair) was delivered to the Grand Trianon in 1708. The shape is based on a Roman sarcophagus. Ht 87cm/34⅓in.

2 André Charles Boulle and his contemporary Bernard van Risenburgh I specialized in clock cases such as this, made by Boulle, c.1695, veneered in brass with an exquisite marquetry design. Ht 2.23m/7ft 4in, w. 37.5cm/14¾in.

English Furniture

Carved Decoration

2 *This carved oak chair of traditional form can be dated to c.1620–50 because of the use of columnar forms for the legs and arms, the cubic proportions, and the design of a spray of flowers carved on to the back.*
Ht 73cm/28¼in.

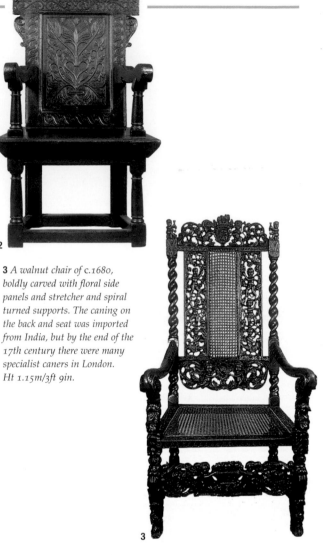

3 *A walnut chair of c.1680, boldly carved with floral side panels and stretcher and spiral turned supports. The caning on the back and seat was imported from India, but by the end of the 17th century there were many specialist caners in London.*
Ht 1.15m/3ft 9in.

1 Sgabello *chairs (1625) made either by an Italian or an Englishman for the Earl of Pembroke. Inigo Jones (1573–1672) revived this 16th-century Italian design, typical of the court style of Charles I. Ht 1.10m/3ft 6in.*

In contrast to the traditional oak furniture produced in England throughout the century in parallel with furniture made in the Netherlands, the court style of Charles I (*c*.1625–40) followed Italian and French models. This is most noticeable in the revival of the 16th-century *sgabello*. The introduction of upholstered armchairs, either with X-frame legs or with box-like stretchers, was in keeping with Inigo Jones' emphasis on the cube, and was similar to French design at the court of Louis XIII. Charles I also owned foreign cabinets in exotic materials such as ivory and amber.

Furniture in the second half of the century assimilated contemporary Baroque features from Dutch and French designs. Carved cherubs in naturalistic foliage on tables, stands and chairs were inspired by Dutch carving, and turned legs of both spiral and baluster shapes were very popular. Chairs combined these motifs and introduced caning for the backs and seats, a technique taken from the East. Walnut was the preferred timber for fashionable furniture, with beech or pine used as a base for gilded pieces. Also from the East came the taste for lacquered furniture, imitated in Europe by japanning or painting. Carcase furniture was decorated in walnut, kingwood and other exotic woods in oyster veneers. Floral marquetry appeared by the 1670s. Typical of English taste and manufacture is the way the marquetry is applied in separate panels, to facilitate the number that were made.

The influence of Daniel Marot (1663–1752) and French Protestant émigré craftsmen such as the Pelletier family brought French taste to England, as seen in the carved and gilded furniture made for Hampton Court, *c*.1700. Furniture shapes were derived from the French classical style, and strapwork and grotesque motifs were taken from Jean Bérain. A different taste emerged with new plain forms, perhaps as a result of the influence of Chinese furniture. Chairs with curved backs, known as "India-backed" chairs, also used the new cabriole leg and goat's foot. The bureau cabinet was a straight-sided fall-front desk with cabinet above, decorated with plain walnut quartered veneers, or embellished with colourful japanning.

Floral Marquetry

1 This walnut table with turned legs and an X-shaped stretcher was made c.1670 to 1680. The top is decorated in floral marquetry and has oyster veneers, in which the wood is cut into ovals that are in turn placed in a decorative fashion over the surface. Ht 73cm/28¾in.

2 Long-case clocks such as this were highly prestigious and were bought by rich merchants as well as by aristocratic patrons. It is decorated with floral marquetry based on French designs, with birds, vases of flowers, and scrolling foliage. Ht 2m/6ft 6in.

French Influences

2 This walnut chair with its curved back was known as an "India-backed" chair. The shape was taken from Chinese chairs, while the legs were curved in the cabriole form, ending in goat's feet. The earliest reference to these chairs was for the dining room of George I at Hampton Court in 1717; they were supplied by Thomas Roberts.

1 This blue-and-white painted table (1692) after designs by Daniel Marot was probably made for Queen Mary's water gallery at Hampton Court. Here she also had her dairy decorated in blue-and-white Delft tiles and, next to it, a bathing room furnished with an angel bed that had blue-and-white silk hangings and matching chairs. Ht 80cm/31½in.

3 A carved and gilded, gessoed table made c.1690–1700 by René Pelletier for Ralph, Duke of Montagu who, as Master of the King's Wardrobe, was an important figure in the introduction of French design and French craftsmen at the court of William and Mary. Ht 81cm/32in; l. 1.27m/4ft 2in.

Dutch and Flemish Furniture

Antwerp and Amsterdam

1 *The interior of a Flemish merchant's house, c.1620, painted by Frans Francken II (1581–1642). It shows the richly coloured textiles on the walls and the carpets on the table that were highly regarded in the 17th century. The low cupboard against the wall is based on designs by Hans Vredeman de Vries (1526–1604) and was one of the most popular types at this time.*

2 *Cabinets with painted interiors such as this were a speciality of Antwerp cabinetmakers, indicating a close association with the painters' guild. This c.1620 example would have had a severe exterior in black ebony with ripple-carved moulding.*

The northern provinces of the Netherlands won independence from Spain in 1648 after the Treaty of Westphalia. In both southern and northern Dutch provinces traditional forms of furniture throughout the 17th century included tables, cupboards, and chests made in oak. These were decorated with carved foliage patterns and geometric forms, which were sometimes picked out in stained oak or ebony. Features such as bulbous supports for chairs and tables, carved term figures, and large volute shapes continued to be used during this period.

In the southern Netherlands, exotic materials such as ebony, ivory, tortoiseshell, and metal mounts were used from an early date to decorate cabinets, a practice that reflected the importance of Antwerp as a centre of international trade in these commodities. Cabinets were also painted in the manner of Rubens. Ripple-carved moulding in small geometric patterns decorated the exterior, while the interiors opened to show more elaborate, richly colourful scenes.

The Auricular style, so-called because of its similarity to the human ear, was one of the most influential forms of decoration to appear in the north. It was combined with extraordinary realism in carved fruits and flowers, particularly in Amsterdam. Floral marquetry was equally naturalistic in its design. The northern provinces made use of rosewood and ebony for cabinets, which gave a rich sombre flavour to the interior. Herman Doomer (c.1595–1650) in Amsterdam specialized in ebony veneers inlaid with mother-of-pearl flowers. By the end of the 17th century, floral marquetry was in fashion, as shown in the highly naturalistic work of Jan van Mekeren (c.1690–c.1735).

In 1685 the French Huguenot Daniel Marot (1663–1752) came to the court of William and Mary, bringing the French design of Versailles first to Holland and later to England. In Holland more rectilinear forms were often combined with realistically carved figures. Both chair backs and mirrors rose to new heights and appeared with crested tops at the end of the century.

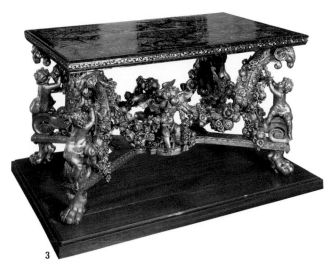

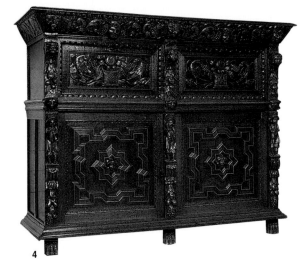

3 *This magnificent table by Pieter de Loos and Michel Verbiest, dated 1689, was one of the most elaborate produced in Antwerp. The technique for the tortoiseshell and metal-inlay top was developed from French boullework.*

4 *This oak cupboard was typical of ordinary furniture in Flemish merchants' houses. Distinguished from earlier forms by the deep, naturalistic carved decoration, these were conservative pieces of furniture. Ht 1.42m/4ft 6in.*

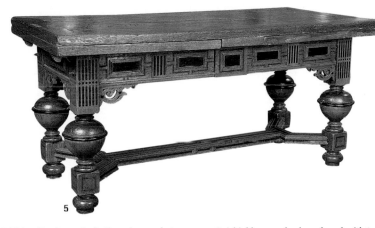

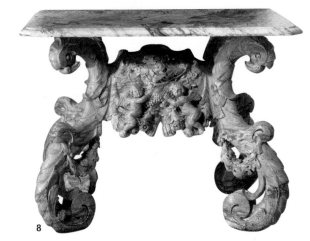

5 *This table shows the bulbous legs and strong abstract design typical of Dutch furniture. The rectangular panels of bog oak imitate 16th-century French fashions. Ht 81cm/32in.*

6 *A highly carved oak cupboard with term figures on the upper tier, c.1620–30. This type of furniture was found throughout northern Europe in the 17th century. Ht 2.20m/7ft 2in.*

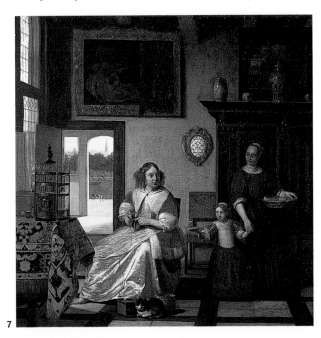

7 *Painting by Pieter de Hooch (1629–84) of an interior in the second half of the 17th century depicting a large ebony and rosewood Utrecht wardrobe. Such furniture was typical of rich merchants' houses in Amsterdam.*
8 *The Auricular style can be clearly seen on this table. It was used for furniture made in Amsterdam, often in combination with deeply carved, realistic swags of fruits and flowers. Ht 84cm/33in.*

German and Iberian Furniture

Opulent German Furniture

1 This detail of a dolls' house from Nuremberg, 1639, shows part of the interior of a wealthy merchant's house, in which the cabinet in the hall was an important piece of furniture containing the family linen.

2 The elaborately decorated Cabinet of Mirrors, c.1714–18, from Schloss Pommersfelden was by Ferdinand Plitzner. The floor is of elaborate parquetry while the table and mirrors are based on Jean Le Pautre's engravings of tables supported by term figures.

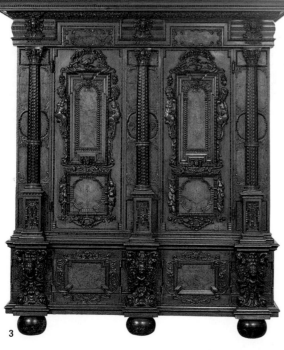

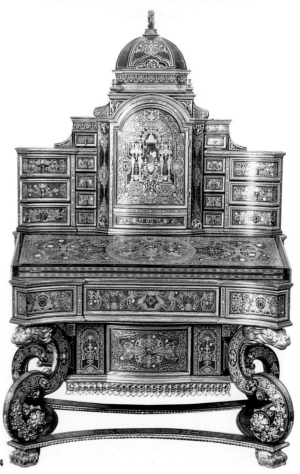

3 This wardrobe, c.1630, from Hesse in Germany, is veneered in Hungarian ash and sycamore with walnut carving. It retains the complex architectural treatment of earlier pieces, and is influenced by the designs of Hans Vredeman de Vries. Ht 2.24m/7ft 3½in.

4 By the 1690s the bureau cabinet was very fashionable. This example, c.1690, in the Boulle technique, has marquetry based on Bérain's engravings. The monumental and exaggerated form, however, is quintessentially German. Ht 2.05m/6ft 8½in.

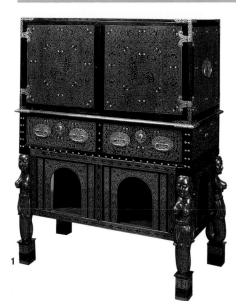

1 *Goa and the East Indies exerted a strong influence on Portuguese furniture as shown in this* contador *(cabinet) on a stand, of teak, ebony, ivory, and Indian sandalwood. While the formalized designs derive from Indian patterns, the use of sculpted supports reflects the Baroque interest in the human form. Ht 1.26m/4ft 1in.*

2 *Ebony first appeared in Portuguese furniture in the 16th century, and it came to dominate European taste. This late 17th-century cabinet is decorated with ripple moulding and incised diagonals. The bulbous supports of the rosewood base are from Dutch furniture, reflecting the importance of trade connections at this date. Ht 1.5m/4ft.*

3 *Portuguese chairs were strongly influenced by English designs, only they were typically made with embossed leather backs. This late 17th-century example in carved walnut has a crested back and a high stretcher. Ht 1.2m/3ft 11in.*

4 *From the 16th century onwards, the Spanish used a particular type of folding table, supported by metal rods joined to the legs. This example of c.1680 is painted with stylized floral motifs taken from Indian chintzes in imitation of oriental lacquer.*

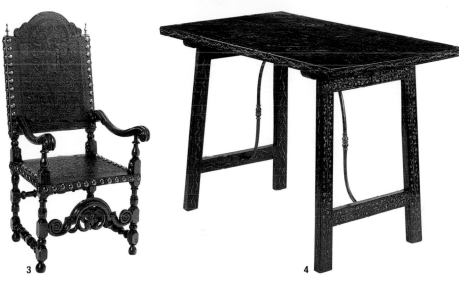

After the end of the Thirty Years War in 1648, lavish Baroque pieces were ordered by the rich burghers of the principal German towns or by aristocratic rulers wishing to demonstrate their wealth and patronage. Pieces were made in the Baroque style, featuring marquetry in ivory, ebony, or pewter set in walnut veneers. Forms often had a boldness and excessive movement not found elsewhere in Europe. Augsburg specialized in marquetry cabinets of ivory and ebony of great sumptuousness and court cabinetmakers throughout Germany specialized in high quality marquetry in many techniques.

The northern German states generally remained more conservative and followed Dutch and English taste, as seen in the use of turned legs or walnut veneers, or in the emphasis on carved floral decoration. Cabinetmakers in city-states such as Frankfurt and Mainz specialized in the large wardrobe, sometimes in rosewood and ebony.

Design in the southern German states followed the more elaborately decorated furniture style found in France – Jean Bérain's designs were an important decorative source. Court cabinetmakers such as Ferdinand Plitzner (1678–1724) in Pommersfelden, or Johann Matusch (*fl.* 1701–31) in Ansbach developed a personal style of increasingly vigorous forms, taking the Baroque well into the 18th century.

More than most European countries, Spain remained close to earlier 16th-century cabinet forms such as the *papeleira* or *vargueno*. Only at the very end of the 17th century did sculpted forms appear, or the high-backed chair. Leather-backed chairs remained a speciality of both Spanish and Portuguese cabinetmakers.

Taking advantage of trading routes, Portuguese cabinetmakers used exotic materials such as rosewood from South America and ebony from Africa or the East Indies. Bulbous, complicated turned legs were much in evidence in Portugal, possibly as a result of trade with the Netherlands. A singular form of cabinet, the *contador*, contained many small drawers and was decorated with a distinctive ripple-cut motif, known as *tremido* carving.

American Furniture

The William & Mary and Queen Anne Styles

1

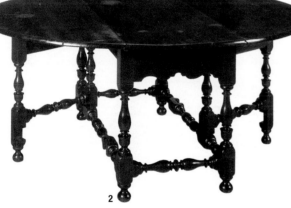

2

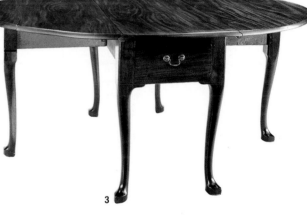

3

1 *The arched back and turned legs on this upholstered daybed, made in Philadelphia c.1720–35, are emblematic of American baroque furniture. The back supports, stretchers, and legs were made of maple, while the rails forming the seat frame were made of oak. Daybeds were often made with accompanying chairs, upholstered in rich imported fabrics. Ht 97cm/38¼in, l 1.75m/69in.*

2 *This oval-topped gate-leg table, made in New York City, 1749–63, represents the more informal dining habits of the late 17th and 18th century.*

3 *Oval walnut drop-leaf table with cabriole legs, New York 1730–50. Adaptable tables like this could be moved about the room as needed. Ht 68.5cm/27in, l. 1.24m/4ft.*

<div style="writing-mode: vertical-rl">BAROQUE | AMERICAN FURNITURE</div>

As is often the case with American decorative arts, the primary design influence came from Europe. Baroque design trends reached the Anglo-American colonies from the royal courts of England and Holland during and after the reign of William & Mary (1688–1702), signalling a discernible growth in prosperity and elegance in furnishings, especially in urban centres such as Boston, New York, Newport, and Philadelphia.

By the beginning of the 18th century, design was moving away from the simple beginnings of the Puritans, when only the plainest necessities such as beds, tables, and chests furnished the colonists' houses. While much American furniture continued to be made in vernacular styles, often reflecting distinctive regional characteristics from British or other northern European furniture, a diluted version of Baroque courtly styles can be seen in the high arched chair backs and trumpet-turned legs of furniture made in New York and New England between 1700 and 1730. Furniture with a strong verticality, together with curving patterned ornament and a profu-

sion of elaborate carving and turning suggests the Baroque, often referred to as the William & Mary style, even into the early decades of the 18th century.

Foliage and scrolls set in a symmetrical context were favoured motifs, and the later, so-called Queen Anne, period (c.1720–50) saw the introduction of cabriole curves for the legs of tables and chairs. The restrained use of sculptural forms and architectural elements such as shells, plumes, vase shapes, scrolls, and volutes were part of a new classical vocabulary, while the claw-and-ball foot was a favourite terminal. These forms, inspired from Europe, were often interpreted with notable exuberance in America.

Walnut was the fashionable wood, but maple, cherry, and, later, mahogany were used for high-style pieces, many of them veneered. Painting or staining of furniture, a distinctively American form of embellishment, continued, but the showiest cabinets, mainly emanating from Boston, were decorated with japanning, sometimes elaborately, in imitation of oriental lacquer.

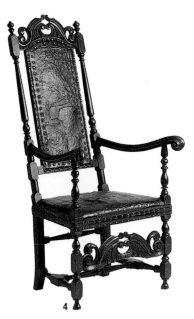

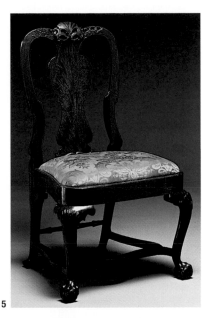

4 *This beech armchair with carved top rail and stretcher, turned supports, and leather upholstery was made in Boston, c.1700–15. It was influenced by 17th-century Dutch models. Ht 2.09m/6ft 11in.*

5 *The graceful curving cabriole legs, baluster splat and rounded seat of this mahogany side chair from New York, 1750–65, all typify the late Baroque. Ht 1m/3ft 3in.*

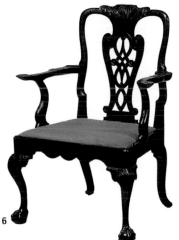

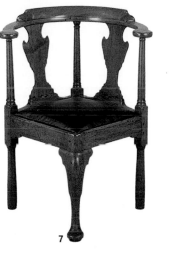

6 *This armchair from North Carolina, c.1745–65, shows early signs of the Rococo with its cabriole legs, carved openwork splat, and curved arms. Ht 99.5cm/39¼in*

7 *An interesting smoking chair, made of black walnut, from Tidewater, Viriginia, 1740–50. The chair was designed to fit into the corner of a room. Its vase-shaped splats are distinctive of the late Baroque. Ht 84.5cm/33⅓in.*

8 *This high chest of drawers was made of maple and pine by John Pimm in Boston in 1740–50, and japanned by an unknown decorator. The design incorporates the shell motif, cabriole legs that end in claw feet, and a broken pediment with vase-shaped finials. Ht 2.43m/7ft 11¼in.*

9 *The deep apron and complex turnings of the legs of this dressing table from Philadelphia, c.1715–25, are simplified characteristics of Baroque design from the court of William and Mary. Ht 75.5cm/29⅛in.*

10 *The bold shaping of the panels and deep profile of the mouldings on this walnut wardrobe or Kas from south eastern Pennsylvania, c.1745–60, reflect both Dutch and north German vernacular traditions. Ht2.13m/7ft.*

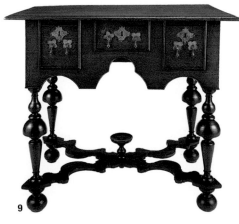

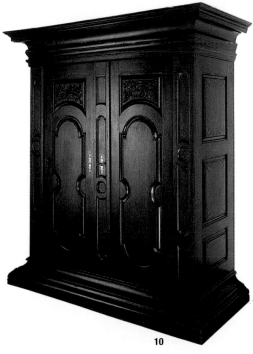

Furniture Techniques

Veneering with Marquetry

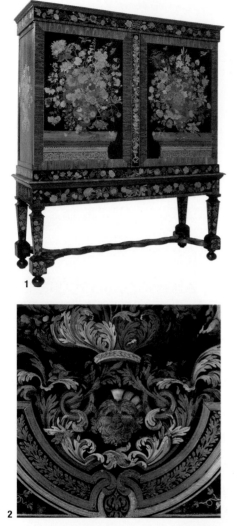

1 *This cabinet, c.1700, attributed to Jan van Mekeren of Amsterdam, is veneered in floral marquetry of various woods set into kingwood and walnut. Dutch floral marquetry was noted for its highly realistic design. Ht 2.05m/6ft 7in.*

2 *This detail from a table by André Charles Boulle shows how he combined floral marquetry of the highest quality with pewter, tortoiseshell, and brass in a more classical style.*

3 *Made in Würzburg by Jacob Arend and Johannes Wittalin in 1716, this walnut bureau cabinet is decorated with marquetry panels of ebony and various woods, with pewter and horn panels in the top cupboards. Ht 1.80m/5ft 9in.*

4 *One of the earliest examples of elaborate marquetry, this cabinet, c.1590, is attributed to Jacopo Fiammingo, a Fleming working in Naples. It is veneered in ebony with ivory panels engraved by Jacopo Curtis. Black and white decoration was admired in Naples. Ht 87.9cm/34½in.*

5 *The marquetry of this writing desk (1694) made for the English king William III is of kingwood background with arabesque designs picked out in a lighter wood. The technique is thought to have been developed by the court cabinetmaker, Gerrit Jensen.*

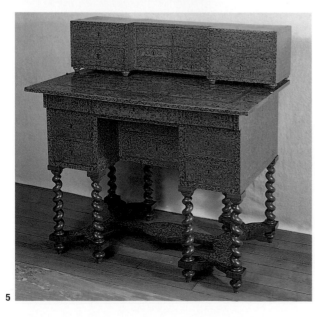

As the 17th century progressed, patrons demanded increasingly more luxurious pieces of furniture, which was commonly carved and gilded. Sculptors, for example, carved elaborate bases for tables and stands for cabinets. Spiral legs became very popular and were turned on a lathe. Louis XIV ordered silver furniture for Versailles, which was imitated in other countries by covering the wood carcase with sheets of silver *repoussé*.

As well as the new manipulation of furniture forms, the century saw the importing of exotic materials into Europe from Africa, the East, and the West Indies. Ebony from Asia and Africa appeared first in Portugal and the Spanish territories – the Netherlands, Sicily, and Naples. Cabinetmakers in France, southern Germany, and Antwerp learned to veneer not only in ebony, but in West Indian turtleshell (commonly called tortoiseshell), metals, ivory, and coloured woods. In northern Europe it was more common to use marquetry of different woods, especially walnut, olivewood, or kingwood (a form of rosewood).

Painted Surfaces

1 *Taken from the side of an English mirror, c.1700, this detail of a bérainesque design was made using a French technique called* verre églomisé, *developed by Jean Baptiste Glomy (d.1786). The back of the mirror was covered with gold leaf, which was then scratched away and painted with a colour such as red, black, blue, or green.*
2 *Furniture was often painted and gilded in the 17th century, sometimes with elaborate scenes as in this detail from the late 17th-century Swedish royal coach.*

1

2

Veneering with Stones

1

1 *A collector's cabinet, c.1680, in ivory with silver-gilt mounts and lupis lazuli, probably by the Augsburg cabinetmaker, Melchior Baumgurtner and decorated with Florentine* pietre dure *panels (hard stones). Ht 80.5cm/31¼in.*
2 Scagliola, *in which ground marbles and glue were used to fill in the hollowed base or as a covering for the whole surface, was developed as an alternative to* pietre dure. *This panel is attributed to Simone Setti of Carpi (fl 1650–1700). W. 1.37m/4ft 6in.*
3 *This elaborate* pietre dure *top for a table in the Galerie d'Apollon, c.1660, may have been designed by Charles Le Brun (1619–90).*

2

3

One technique used was oyster veneer: small branches of timber were cut into oval shapes and assembled into geometric patterns. Floral marquetry was another; it was made by assembling individual pieces of contrasting naturally coloured or stained woods, which could be shadowed by dipping the edges into hot sand or engraved in order to create still-life compositions. In France, marquetry with metal veneers or turtleshell and brass in contrasting patterns was occasionally combined with materials such as horn or mother-of-pearl.

In Florence and Rome, tables and cabinets were decorated with *pietre dure* (hard stones such as jaspers, agates, and marbles). Florentine craftsmen developed the 16th-century technique of cutting the stones and assembling them on the surface of the piece to produce an effect somewhat similar to marquetry; this technique was known as *commesso* work. *Scagliola* was another technique developed in Italy whereby a coloured paste of ground marble and selenite (a form of gypsum) was applied, almost like paint, on to the base. Dutch,

2 *Baroque craftsmen decorated furniture with gold leaf. The wood was covered with gesso and then painted with red clay, or bole, on to which the gold leaf was applied. The detail was cut into the gesso and the gold leaf was burnished to create textures and low-relief patterns. This table, c.1710, was made my James Moore.*

1 *Furniture made of silver was the most luxurious possible. Louis XIV had a set made for the Galerie de Glaces at Versailles in around 1670, which was subsequently melted down. Other examples such as this suite of table, mirror, and stands were made c.1700 for the ruler of Kassel. It was covered in mirror glass, carved, silvered, and gilded. Table ht 82cm/32¼in; stand ht 1.15m/3ft 9½in.*

Flemish, and English craftsmen all used this method of imtitating inlaid marble.

Imported Japanese lacquer chests, cabinets, and screens had a profound effect on European furniture. In their use of black, these pieces were particularly suitable for the Baroque interior, and their lacquer with its highly polished sheen was much admired. Japanese lacquer was made by applying layers of a syrupy substance derived from the sap of the lacquer tree or *rhus verniciflua*. Export wares often depicted landscapes with mountains and temples and were decorated with *maki-e* (gold flakes or dust). Original Japanese lacquer cabinets were generally displayed on European stands, while Japanese lacquer panels were often cut up and mounted on the most luxurious European furniture.

The natural sap of the lacquer tree was unobtainable in the West and the imitation of oriental lacquer, known as japanning, was taken up throughout Europe in the second half of the 17th century. As well as Japanese examples, European prints such as those by Jan Nieuhoff

(1655) were popular sources of design inspiration. In England John Stalker and George Parker published their *Treatise of Japanning and Varnishing* in 1688; this was one of several technical manuals on the subject. The japanning recipes varied, but included ingredients such as shellac, gum-lac, or seed lac. Numerous coats were applied, sometimes on the wood directly, and sometimes on to a gesso base. Relief effects could be achieved by applying extra layers of gesso, sometimes with gilded highlights. Mother-of-pearl was occasionally included in imitation of Japanese abalone shell.

Japanning was mostly carried out in black, but red was also popular and Gerhard Dagly (c.1687–1714) in Berlin specialized in white lacquer with scenes painted in green, red, and other colours. Pierre Gole may have been one of the earliest to create simulations of lacquer, although he did not use oriental motifs. Gerrit Jensen (*fl*.1668–1714) in England made many pieces of japanned furniture for the crown, especially for Queen Mary, whose passion for Japanese lacquer equalled her love of oriental ceramics.

Lacquer and Japanning

1 *Cabinets of Japanese lacquer are illustrated in this picture, c.1675, of Louis XIV's mistress. The taste for the exotic, for the more private spaces in great houses, led to the importation of oriental wares and to their display.*

2 *This japanned chair from the Queen's anteroom at Ham House, England, bears the crest of Elisabeth Dysart, 1672. The chairs are unusual in their attempt to emulate a Chinese motif for the back, although the overall appearance is European. Ht 1.23m/4ft.*

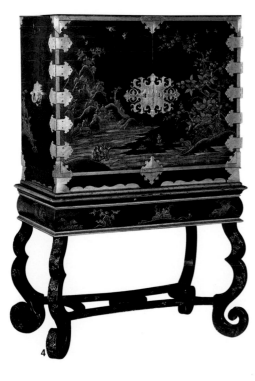

3 *Cabinetmakers often cut up genuine oriental lacquer to fit European shapes as in this example by Gerrit Jensen, c.1690. The legs and surrounds are japanned to match. Ht 74cm/29in.*

4 *This cabinet on a stand dates to around 1700 is attributed to the leading maker of japanned furniture in Germany, Gerhard Dagly, who worked in Berlin. Cabinet ht 60cm/23½in.*

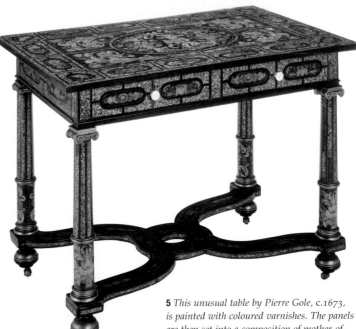

5 *This unusual table by Pierre Gole, c.1673, is painted with coloured varnishes. The panels are then set into a composition of mother-of-pearl to imitate Japanese abalone shell.*

Upholstery and Beds

The Upholstered Chair and Settee

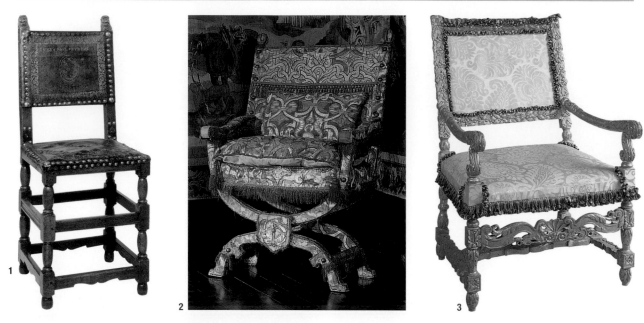

1 *The chair in the first half of the 17th century was often upholstered in leather as in this example, c.1630, which has the cipher of Peter Paul Rubens. The large studs were part of the decoration.*
2 *The chair of state, or X-frame chair, derived from Italian Renaissance prototypes. This example of English royal furniture may have been made for James I and is upholstered with Genoese silk, cut and stitched on to the silk background. It is decorated with silver spangles and red fringing.*

3 *A rare survival of original upholstery, this chair was part of a set bought in Paris by Count Nils Bielke (1644–1716) from Jacque Heref and Anne du Four (probably the upholsterer) in 1680.*
4 *A design for a French royal daybed, c.1690, or Grand Canapé, upholstered with panels, each bordered with a contrasting fringe, possibly of silver or gold thread.*

5 *This settee, made c.1700 by the Huguenot upholsterer Philip Guibert for Thomas Osborne, 1st Duke of Leeds, is upholstered in imported Genoa velvet of crimson and green. It has matching fringes, which often cost as much as the material itself. L. 20.8m/6ft 8in.*

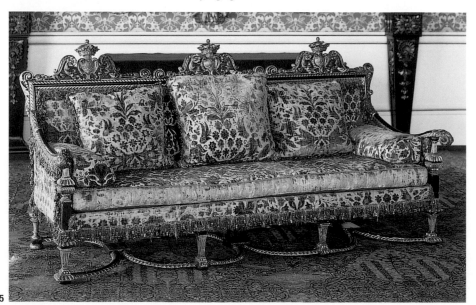

Lavish Expenditure

1 *The angel bed, 1672, designed by Jean Bérain for the Trianon de Porcelaine in the grounds of Versailles, made use of elaborate flying curtains, and was intended only for private spaces. Daniel Marot developed the elaborate crested top for his English state beds.*
2 *The French state bed had a simple, geometric profile which was combined with the richest fabrics. This bed was made in France for James II on his marriage to Mary of Modena in 1673.*
3 *This detail of the state bed made for George, Ist Earl Melville, in c.1700 by the Huguenot upholsterer, Francis Lapierre, shows the way in which fabric was glued on to the carved headboard to create elaborate shapes, while the hangings were stuffed to create a greater sense of volume, and were richly fringed and embroidered.*

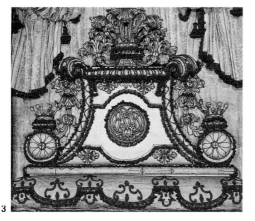

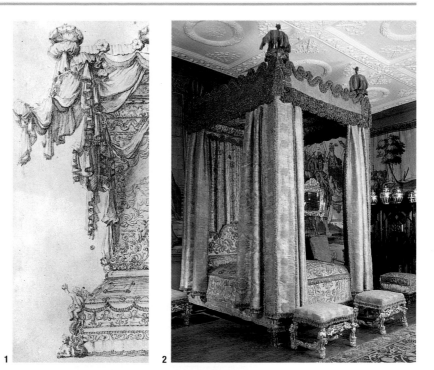

4 *As well as beds, coaches were an important statement of power, and their interiors were crafted by the royal upholsterers. The embroidery of the state coach for Charles XI of Sweden (c.1696–9) was made to designs by Jean Bérain.*

In the 16th and 17th centuries, the greatest sums of money spent on furnishing the interiors of houses and palaces were for textiles and fringing. Rooms were hung with luxurious panels of silk and velvet, bordered with embroidery or fringes of gold and silver threads, and beds and chairs were upholstered in sumptuous fabrics. Inventories show that in the second half of the 16th century in Rome, furniture was supplied en suite – complete with the hangings. This practice was introduced into France in the 1620s as contemporaries emulated the famous blue rooms of Madame de Rambouillet (1588–1665) who, like the French queen, was Italian.

The square form of the state bed remained fashionable until 1800. In France, more elaborate shapes were created for the private rooms or garden pavilions such as the Trianon de Porcelain. Daniel Marot in turn used these for inspiration when he designed elaborate state beds in the English royal palaces c.1700. The crested headboards and carved testers were covered with sumptuous fabrics, in designs closely based on those of Jean Bérain.

Based on the Roman campaign chair, the X-frame chair had always been the chair associated with rank and was therefore sought after for palaces and aristocratic houses. A second popular type of chair was an armchair, often called *sillon de fraile*, as the square frontal form probably originated in Spain. During the 16th century, the frame was covered with fabric, and the seat cushion and arms were upholstered in hessian and horsehair, with large nailheads acting both as decoration and for fastening the material. Silk and gold fringes hung from the sides and across the centre of the back. This shape lasted more or less unchanged until the middle of the 17th century.

During the second half of the 17th century, as the backs of chairs grew taller and the frames were more elaborately carved, the role of upholstery became more important in providing the silhouette of the Baroque chair. The backs were stuffed with horsehair and were given a three-dimensional shape. The armchair also developed a more architectural form with wings on the sides and scrolling lower sections.

Pottery

Design Sources for Later Tin-Glazed Wares

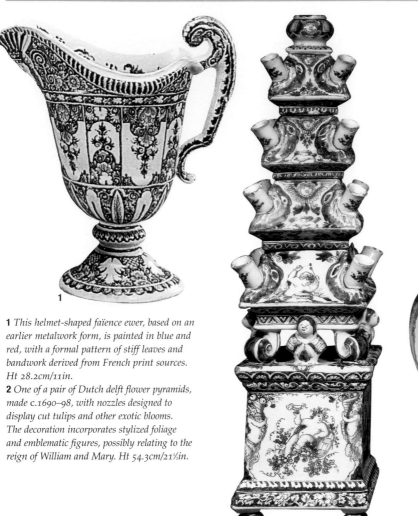

1 *This helmet-shaped faïence ewer, based on an earlier metalwork form, is painted in blue and red, with a formal pattern of stiff leaves and bandwork derived from French print sources. Ht 28.2cm/11in.*

2 *One of a pair of Dutch delft flower pyramids, made c.1690–98, with nozzles designed to display cut tulips and other exotic blooms. The decoration incorporates stylized foliage and emblematic figures, possibly relating to the reign of William and Mary. Ht 54.3cm/21¼in.*

3 *This inscribed London delft tankard is dated 1638. The central motif derives from a late Ming design traditionally known as* Bird on Rock *and is one of the earliest examples of the influence of Chinese blue-and-white porcelain on English ceramics. Ht 14cm/5½in.*

During the 16th century Italian potters took their skills to France, the Low Countries, and England, where the material became known variously as faïence, Delft, and English delftware. The production of tin-glazed earthenware continued to dominate European ceramics in the 17th century, but it began to move away from the Italian Renaissance style and develop distinctive new characteristics. In the 1640s potters working in Nevers, France, continued to produce display plates in the *istoriato* tradition, but now followed the work of contemporary French artists; later French decorators favoured small-scale, repetitive patterns derived from engraved sources. These formal, lace-like designs, including stiff leaves and lambrequins, are characteristic of French design in the late 17th century.

Imported Chinese blue-and-white porcelain also inspired the 17th-century tin-glazed earthenware potter, and most of them strove to imitate both the material and the colour scheme, while modifying the forms or subject matter to suit European taste. Characteristic of later Dutch pieces are the great flower pyramids created for William and Mary, which combine the 17th-century love of blue-and-white with the fashion for exotic flowers. The tulip became a widespread 17th-century motif, appearing on English delftware and slipware. Particular to English earthenware were royal portrait dishes.

Stoneware, both unglazed red stoneware made in imitation of Chinese Yixing ware and salt-glazed stoneware, also dominated 17th-century pottery. A particular type of salt-glazed ware made in Westerwald, Germany, had an all-over pattern of stamped motifs and a glaze stained blue with cobalt. However, Cologne continued to make the brown stoneware bottles discussed in the last chapter. These had been imported into England in the 16th century but were only copied there when John Dwight of London (*c*.1635–1703) was granted a patent in 1672. Dwight also made red stoneware and, in an attempt to discover the secret of porcelain, created a refined white stoneware, which, as well as being used for table wares, was used to make busts and figures in the Baroque style.

Tulip Mania

1 The central motif of tulips in a vase on this English delft dish, or charger, made in 1661, is European in style, but the division of the border into panels is inspired by earlier Chinese export wares. Diam. 48.5cm/19in.

2 The tulip as a fashionable device spread to every branch of the decorative arts, and it appears as the dominant motif on this English slipware posset-pot or loving-cup, dated 1709. It is inscribed "the best is not too good for you." Diam. 21.5cm/8½in.

3 Paintings such as this still life of a rose, tulips, and orange blossom by Daniel Seghers of Antwerp (1590–1661) were a rich source of inspiration for designers working in a variety of materials.

Stoneware

1 John Dwight's pottery in London made this greyish-white bust of Prince Rupert of the Rhine (1619–1682) c.1673–5. Ht 75cm/29½in.

2 The red material of this English red stoneware teapot, made c.1690 with a loop handle and acorn knop, was used to imitate a type of Chinese teapot commonly imported at the time, and underlines the impact that trade with the Far East had on European decorative arts in the 17th century. Ht 12.5cm/5in.

3 A later style of Westerwald stoneware with a regular diaper of stamped motifs picked out in blue can be seen in this painting by Nicholas Maes of a little girl rocking a cradle, c.1654–9.

4 A strong German influence can be seen in this English salt-glazed stoneware bottle made in London c.1675. Ht 21.5cm/8½in.

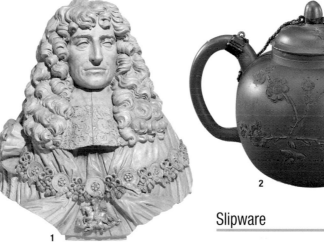

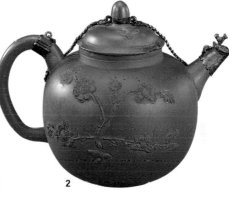

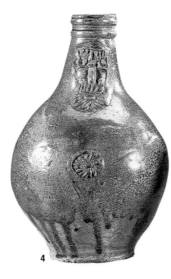

Slipware

1 This English slipware dish, made by Thomas Toft c.1660–1675, depicts the future Charles II hiding in an oak tree to escape the Roundheads. Both the subject matter and the robust style are typical of the period. Diam. 50cm/19¾in.

Porcelain

Red Stoneware and Early Porcelain

1 *The earliest Meissen ceramic material was used for this Böttger red stoneware tea caddy, c.1710–15. The simple form follows Chinese ceramics and contemporary silver. Ht 10.4cm/4in.*
2 *This white Böttger porcelain vase and cover, c.1715, designed by Johann Jakob Irminger, has an architectural shape, with Baroque gadrooning. Ht 51.5cm/20¼in.*
3 *A du Paquier vase, c.1725–30. The baluster shape with animal mask handles echoes the Baroque style, as do the motifs, including the tassels. Ht 29.5cm/11¼in.*

Chinoiserie and Harbour Scenes

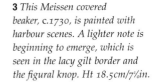

1 *The body of this Meissen teapot is based on German Baroque silver. It is painted with coloured enamels, showing a chinoiserie scene within a Baroque* Laub und Bandelwerk *border. Ht 11.5cm/4½in.*

2 *The quality of J. G. Höroldt's designs, derived from the c.1720* Schulz Codex *(European translations of Chinese scenes), can be seen on this c.1725 Meissen teabowl and saucer.*

3 *This Meissen covered beaker, c.1730, is painted with harbour scenes. A lighter note is beginning to emerge, which is seen in the lacy gilt border and the figural knop. Ht 18.5cm/7¼in.*

An artificial porcelain was first made in the late 16th century in the Medici factory near Florence. Later, at the start of the 18th century, following years of experiment at Meissen in Saxony – by the alchemist Johann Friedrich Böttger (1682–1719) and his mentor Ehrenfried Walter von Tschirnhaus (1651–1708) under the auspices of Augustus the Strong, king of Poland and elector of Saxony – a fine red stoneware was produced. Pieces were decorated with baroque motifs from the designs of Jean Bérain (1637–1711). Others were based on contemporary gold or silver examples, and applied with masks inspired by Balthasar Permoser (1651–1732), court sculptor at the Zwinger, Dresden. Benjamin Thomae, another sculptor, modelled small busts and bas-reliefs based on ivories and *Commedia dell'Arte* figures.

After further experiments, the first hard-paste, or true, porcelain was made at the Meissen porcelain factory in January 1710. Meissen's white, translucent porcelain was introduced in 1713. It was made with a white-burning china clay from Colditz, mixed with feldspathic stone similar to Chinese *petuntse*, fired, then covered with a thin feldspathic glaze. It was used to make tea and coffee wares and small, grotesque figures inspired by the engravings of Jacques Callot (1592–1635) or by imported Chinese *blanc-de-Chine*.

Johann Gregor Höroldt (1695–1775) developed bright enamel colours derived from metallic oxides in the 1720s. They were used to depict chinoiseries on tablewares and vases, orientally inspired exotic flowers and harbour scenes, and *Kakiemon* designs copied from Japanese originals. Many of these were enhanced by coloured grounds.

In 1727 Augustus asked Johann Gottlob Kirchner (*b.*1706) to model lifesize figures of birds and animals. He was assisted by a young sculptor, Johann Joachim Kaendler (1706–75), who joined the factory in 1731.

Two Meissen workmen absconded to Vienna in 1719, and Claudius Innocentius du Paquier established a rival porcelain factory there. The wares were of near-Eastern metal shape, while others were architectural in style, with painted Baroque decoration.

Other Popular Ornamental Motifs

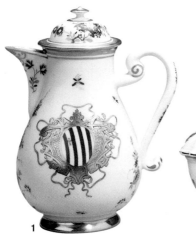

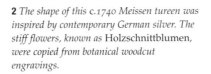

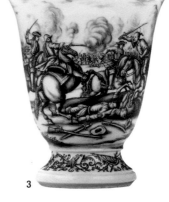

1 *Made as a diplomatic gift for Pietro Grimani c.1723, this Meissen hot milk jug has an armorial on a symmetrical, yet flamboyant Baroque cartouche. Ht 17.3cm/6¾in.*

2 *The shape of this c.1740 Meissen tureen was inspired by contemporary German silver. The stiff flowers, known as* Holzschnittblumen, *were copied from botanical woodcut engravings.*

3 *The bold rendering of a battle scene on this Du Paquier (Vienna) vase is typical of Baroque decoration of a historical subject in* schwartzlot *decoration (black).*

Sculptural Forms

1 *The somewhat naïve style of early figures, and the painted decoration used on them, can be seen on this early Meissen chinoiserie group, which was modelled by Georg Fritzsche, c.1725. The influence is Chinese, as seen through the eyes of a German artist.*

2 *This Meissen figure of Harlequin with a beer tankard, from the* Commedia dell'Arte, *was modelled by J. J. Kaendler c.1733. It clearly reveals his training as a sculptor in the Baroque tradition, with its dynamism and eloquent strength. The vibrant primary tones of the enamels are also typical of the Baroque. Ht 16.1cm/6¼in.*

3 *The bold colouring on the vulture is a typical Baroque feature. The large size underlines the search in early porcelain for an identity.*

Glass

Venice and Façon de Venise

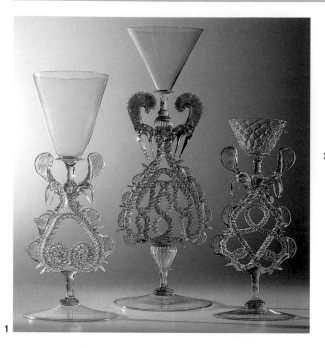

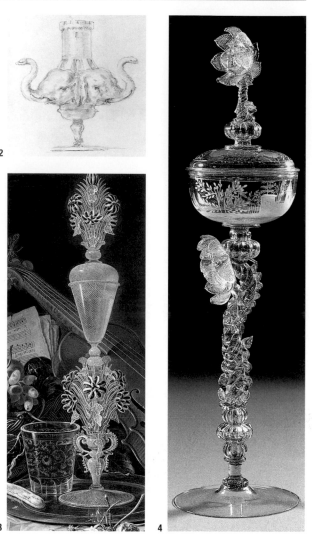

1 *Three "serpent" goblets in colourless glass with incorporated coloured glass threads, Germany or the Netherlands, 17th century. Ht (highest) 35.5cm/14in.*
2 *Stefano della Bella, design for a fantasy vessel, Florence, c.1650–75. The elephant trunks serve as spouts through which the contents could be poured or drunk.*
3 *Gabriele Salci,* Still Life with Parrot *(detail), Italy, dated 1716. The tall goblet is similar to surviving examples in Rosenborg Castle, Copenhagen.*
4 *Goblet of colourless glass with wheel engraving, southern Netherlands or Bohemia, c.1680. Ht 44.3cm/17½in.*

During the 17th century glass became generally more widely available. Colourless glass was made in ever greater quantities, using cheaper materials and simpler designs. But at the same time, the luxury market was served with ever more complicated shapes and intricate decorations. Venetian-style glass was now successfully made in most northern and central European countries.

In the Netherlands, tall "serpent goblets," with elaborately tooled stems in the shape of sea serpents, appealed to the Baroque taste for grandeur and display. Doubtless these were used only for special occasions and for presentation and, as a result, quite a few of them have survived. Similarly complicated pieces were wrought in Germany and Bohemia.

As Venetian glass was successfully copied in many northern countries, the local industry in Murano responded with increasingly complicated shapes and effects. Traditional *calcedonio* glass, for instance, was sparked up by adding a random pattern of gold-coloured

aventurine speckles, created with copper powder. At the Florentine glasshouse owned by the Medici family, which was entirely staffed with Venetians, court artists designed fantasy goblets and centrepieces intended for ostentatious displays at parties.

The swan-song of Venetian glassmaking came in around 1700, when the style, with its use of ultra-thin glass worked in elegant and often complicated shapes, was abandoned throughout Europe in favour of more robust styles. During that period the Muranese glassmakers produced some of their most fantastically elaborate designs.

Display goblets combined blown filigree glass with *reticello* or fine network patterns with a profusion of hot-worked detail, incorporating whole bouquets of flowers. King Frederik IV of Denmark received a gift of a large number of such glasses when he visited Venice in 1708–9. Most of these can still be seen in a special room, designed to house this collection, at Rosenborg Castle in Copenhagen.

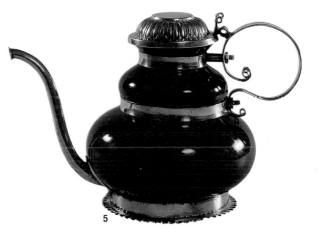

1 *Christoph Weigel (attrib.),* The Glass Engraver, *Germany, c.1680. The engraver holds a goblet beneath a copper wheel powered by a treadle, which the artist of this print has omitted. On the table are several other wheels and bowls of abrasive paste.*
2 *Caspar Lehmann, panel with an allegorical depiction of a lion (detail), colourless glass with wheel engraving, signed and dated 1620. Ht 23cm/9¼in.*

3 *Hermann Schwinger (attrib.), goblet and cover in colourless glass with wheel engraving, Nuremberg, c.1660–70. Ht 31.8cm/12½in.*
4 *Friedrich Winter, colourless glass goblet and cover with* Hochschnitt *wheel engraving, featuring the Schaffgotsch coat-of-arms, Petersdorf, Silesia, c.1700. Ht 38cm/15in.*
5 *Ruby-red glass teapot with wheel engraving and silver-gilt mounts, southern Germany, c.1700. A small number of glass teapots were made around this time, but were obviously impractical. Ht 21cm/8¼in.*

Glass engraving with the aid of fast-rotating small copper wheels, fed with an abrasive, was first practised at the imperial court in Prague. Caspar Lehmann (1565–1622), who worked there as an engraver of gems and rock-crystal, is credited with first using the technique on glass around 1600. The decoration is cut into the glass, creating a negative relief which stands out matt against the undecorated parts of the surface.

Through Georg Schwanhardt, a pupil of Lehmann, the art of wheel-engraving passed to Nuremberg, where it blossomed throughout the 17th century. Tall standing lidded goblets in Venetian style were decorated with finely detailed land- and seascapes, sometimes incorporating allegorical scenes. The full potential of the technique was achieved only towards the end of the century, when a new glass material had been developed which could be blown much more thickly, allowing a deeper, more three-dimensional relief decoration.

At Potsdam, near Berlin, a glasshouse operated under the protection of the elector of Brandenburg from 1674. It was here that the famous glassmaker Johann Kunckel conducted experiments. He developed a dark ruby-red glass by adding gold powder to the raw materials. The elector also employed two of the most renowned engravers of the time, Martin Winter (d.1702) and Gottfried Spiller (c.1663–1728). They engraved massively thick lidded beakers and standing cups with distinctive reliefs of putti and grape vines.

Other centres of engraving emerged during the last quarter of the 17th century under courtly patronage, such as those at Kassel in Hessen and in Silesia. Martin Winter's brother Friedrich had a water-powered cutting mill at Hermsdorf, Silesia, where he created some remarkable pieces of Baroque glass. They were blown very thickly, and their whole surface was cut, leaving the main decoration standing out higher than the deeply cut background. This type of cutting, known as *Hochschnitt*, often used bold asymmetrical floral decorations. Designs gradually became lighter, but asymmetry and deep cutting remained popular in Silesia until about 1750.

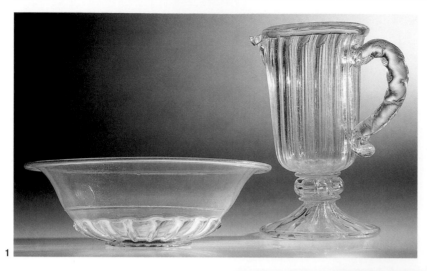

1 *Basin and ewer in colourless lead glass by George Ravenscroft's glasshouse, London, c.1676–7. The basin is marked with a raven's-head seal. Although Ravenscroft added his seal only to pieces he thought free of "crizzling", or glass disease, these objects have deteriorated over the centuries: this is the case here. Jug ht 27.6cm/10¾in.*

2 *Philip Mercier, Sir Thomas Samwell and Friends, c.1733. The heavy baluster-stemmed glasses in the picture might predate the painting by one or two decades. The man in the middle is holding a slightly larger glass which was probably used for communal toasting and drinking.*

BAROQUE | GLASS

3 *Colourless lead-glass goblet and cover with diamond-point engraved inscription: "St Simon Boosington," England, c.1700. Ht 37.4cm/14¾in.*

4 *Baluster-stemmed goblet in colourless lead glass with a tear in the base knop, England, early 18th century. Ht 24.7cm/9¾in.*

5 *English baluster glass of colourless lead glass, c.1740. During the course of the 18th century, stems became less heavy. Balustroid glasses, like this, have a tall stem consisting of several solid balusters and or knops. Ht 25cm/9¾in.*

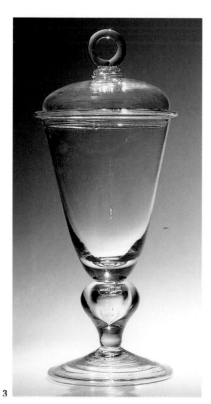

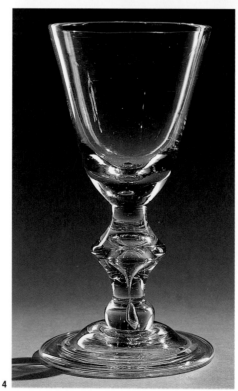

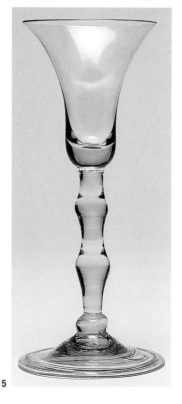

The Netherlands

1 *Willem Mooleyser, goblet of colourless glass with diamond-point engraving, Rotterdam, signed "WM" in monogram and dated 1685. Ht 16.4cm/6⅜in.*
2 *Willem van Heemskerk, decanter bottle of greenish-blue glass with diamond-point engraving, Leiden, western Netherlands, signed and dated 1677. Ht 23.5cm/9¼in.*

3 *Aert Schouman, goblet of colourless lead glass with diamond-point stipple engraving, bearing a portrait of Stadtholder Prince William IV, Netherlands, signed and dated 1750. The glass is probably English. Ht 25cm/9¾in.*
4 *Beaker and cover with coats-of-arms of the governors of the City Theatre, Amsterdam, of colourless lead glass with wheel engraving, Netherlands, 1731. The glass is probably English. Ht 39.1cm/15½in.*

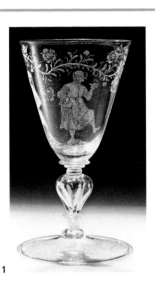

1

2

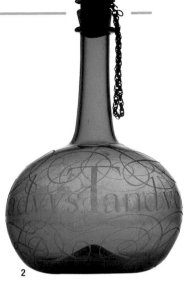

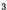

5 *Simon Jacob Sang, goblet, of colourless lead-glass with wheel engraving, showing the arms of two Amsterdam families, possibly to commemorate a marriage in 1748. Made in Amsterdam, Netherlands, signed and dated 1752. Ht 22.4cm/6¾in.*

3

4

5

Venetian-style glassmaking was well established in London from the late 16th century, but Venetian imports continued during the 17th century. From the 1670s, it seems there was a demand all across Europe for thicker, sturdier glasses. The most successful attempt to make "a perticuler sort of Christaline Glasse resembling Rock Cristall" was made by George Ravenscroft.

Around 1677 he overcame his initial problems with the instability of his glass by adding lead oxide to the raw materials. This resulted in a heavy colourless glass, clearer and purer than ever seen before. Ravenscroft's glass was soon copied by other glasshouses in Britain, but the style of their products was still Venetian. This new glass had different properties when it was blown and shaped. It stayed hot for longer, making it unsuitable for thinly blown glass with detailed decorations. A quintessential English style was born around 1700, of simple shapes that focused attention on the refractive quality of the finest clear lead-glass. Goblets had heavy baluster stems of solid glass.

In 17th-century Holland, glass engraving became a favoured art form, practised mostly by well-to-do *dilettanti*. With a diamond point they scratched line decoration standing out matt against the shiny glass surface. Apart from heraldic and allegorical subjects, jolly scenes of dancing and drinking were especially popular. Calligraphic decorations proved particularly suitable for the curved surfaces of drinking glasses and decanter bottles. Willem van Heemskerk, a Leiden cloth merchant, engraved hundreds of such objects in his spare time.

When English lead glass came into fashion in the 18th century, diamond-point engraving was adapted to suit the new medium. The soft and shiny glass surface allowed decorations to be stippled on, each picture being built up from thousands of dots. The centre of stipple engraving was Dordrecht, where a group of *dilettanti* included the painter Aert Schouman. Wheel engraving continued to be practised, mostly by professional engravers who had come from Bohemia or Germany to the Netherlands, where the demand for engraved glasses seemed insatiable.

Silver and Metalwork

The Van Vianens and the Auricular Style

1 *Adam van Vianen of Utrecht was one of the most original and virtuoso goldsmiths of all time. His eccentric Auricular style reached a wide audience when his designs for ewers and other vessels were published by his son, Christian, in 1650 under the title* Modelli Artificiosi.

2 *This design by Daniel Rabel from* Cartouches de différentes inventions *(c.1625), retains a fleshy Auricular aspect to the mask at the lower centre, but has incorporated it into a more structured Baroque composition.*

3 *This dish by Paul van Vianen was made in 1613 for Emperor Rudolf II and combines fluid Auricular ornament with an accomplished mastery of pictorial embossing.*

4 *Rubens's design, c.1630, for a silver-gilt dish made for Charles I is comparable with Adam van Vianen's, but has no abstract ornament. The high relief of the design and its strong figural emphasis are Baroque.*

The period of art history known as the Baroque does not denote a single style so much as a phase, embracing a cluster of more or less similar stylistic types. The emergence of the Baroque from Mannerism during the first quarter of the 17th century, and its eventual displacement by the Rococo in the early 18th, were less emphatic or clear-cut events than the great stylistic revolutions which came earlier and later. The earliest movement of the 17th-century goldsmiths to constitute a radical break with the past, the Dutch Auricular style of the second decade of the century, is in some senses a continuation of the Mannerist principles of invention and virtuosity.

Other aspects of the Baroque had very different and not always mutually compatible priorities, such as the strongly sculptural approach that was favoured in Italy and later in northern Germany, the botanically studied decoration that became fashionable in France, Holland, and Britain during the third quarter of the century, and the formal, architecturally inspired ornament popularized by Huguenot artists around the turn of the century.

The Auricular style is, more than almost any other, associated with a single family of goldsmiths and specifically two individuals, the brothers Paul (*c.*1568–1613) and Adam (*c.*1665–1627) van Vianen of Utrecht. Paul travelled across Europe and worked in the court workshops at Munich, as well as the court of the Emperor Rudolf II in Prague, until the latter's death in 1613. His majestic dish (see 3 above) and ewer have the proportions and the mythological subject matter typical of Mannerism, but are quite new and indeed revolutionary in the fleshy and abstract modelling of the borders, foot, and handle. These abstract qualities of modelling and their implied technical virtuosity were taken further still in the extraordinary ewer (see the design, 1, above) made by Paul's brother Adam in 1614, but the dissemination of the style was due in part to Charles I's patronage of Adam's son Christian during the 1630s, and to the latter's publication of a series of

Sculptural Baroque

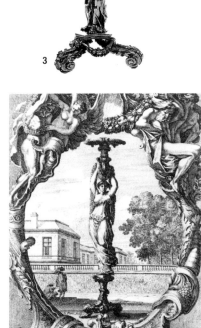

1 *Caryatid figures were a favourite Baroque device for candlesticks and torchères. This 1642 design by the Neapolitan goldsmith Orazio Scoppa achieves extra height and drama by incorporating two struggling figures, recalling the sculpture of Giambologna.*

2 *Table fountains were among the most spectacular products of baroque goldsmiths and, in Italy, were often reduced versions of large public fountains. This design is typically Baroque in its sculptural and architectural elements.*

3 *This silver candelabrum was made in Britain c.1680, almost certainly adapting the designs of Jean Le Pautre. Ht 37cm/14½in.*

4 *Jean le Pautre's series of designs for caryatid torchères was published in Paris c.1660 and re-issued in Britain in 1674. Their formal sculptural style was highly influential on silversmiths.*

Seventeenth-century Floral Style

1 *A major feature of Baroque design was the naturalistic floral style that developed in France and Holland, and is found on furniture and ceramics as much as on silver. This print of floral ornament typifies the scientifically studied character of the ornament.*

2 *Most 17th-century French silver was melted down; this toilet service of 1670, by Pierre Prévost, was saved by its export to Britain. It bears the arms of William and Mary and is embossed with floral ornament.*

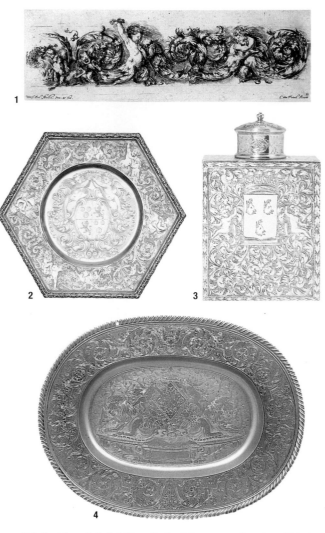

1 *Stefano Della Bella's prints of frieze ornament, published in Paris in 1648, were used for embossed and engraved decoration and for casting patterns.*
2 *A richly decorated dish by the London goldsmith Benjamin Pyne, 1698. The embossed border is based on a Della Bella print of 50 years earlier, but the elaborate central cartouche was probably executed to his own design by the French engraver Simon Gribelin. W. 21.5 cm/8½in.*

3 *Gribelin was probably also responsible for the superb engraving on this silver-gilt tea caddy of 1706 by the London maker Isaac Liger. Ht 11.5cm/4½in.*
4 *A feature of Baroque engraving is its density. This dish, from a sumptuous toilet service by the Huguenot goldsmith Pierre Harache, was made in London in 1695. W. 40.5cm/16in.*

5 *A sheet from Gribelin's* New Book of Ornaments *(1704), published in London. These designs, incorporating lively figures and scrolling foliage, were adapted and plagiarized by engravers of silver and clock cases.*

prints in 1650 after his father's designs. The sheer technical demands of the fully developed Auricular style, and its strangely deviant taste, placed it outside the purview of most patrons and goldsmiths, but in a more diluted form the style continued to exert great influence throughout Europe until as late as the third quarter of the 17th century.

New and forward-looking too is the pictorial treatment of the surface of Paul van Vianen's dish. Whereas the approach of a Mannerist goldsmith was to orientate the design around the centre of the dish and to chase the scenes with jewel-like precision, van Vianen has treated the dish as a single plane, with the subject orientated around the vertical axis like a picture, and has executed it in a more painterly manner, with high relief and a more subtle suggestion of aerial perspective than would have been the case in the 16th century. In both these respects the dish is prototypical of much mainstream Baroque design and was taken up, for example, in Peter Paul Rubens's oil

sketch for a silver dish for Charles I, executed in about 1630 (see p.70).

In Rome, the powerhouse of Baroque art, the most important commissions were for grandiose schemes of church decoration, like the Jesù and Santa Maria Maggiore. Works in precious metal and gilt bronze played an important part in these schemes, and many of the leading artists of the day, such as Gianlorenzo Bernini and Giovanni Giardini, were involved. Their focus was architectural and sculptural and, because of their different purpose, their character is quite distinct from contemporary northern works. But there was nevertheless significant exchange between artists and craftsmen in Flanders and Italy and, although almost nothing of Italian secular Baroque silver survives, a good idea of its character can be formed from surviving plaster casts of a lost series of silver dishes, made for presentation to the Grand Duke of Tuscany, preserved in the Pitti Palace in Florence. These bear a likeness in approach to a number of ewers and dishes

Random Variables

French Architectural Style

1, 2 Proper Ornaments to be Engraved on Plate *was published by C. de Moelder in London in 1694 and provided British goldsmiths with a wide range of decorative motifs, not only for engraving but for casting.*

3 *The so-called monteith bowl appeared in the 1680s and was used for cooling wine glasses in cold water. This example of the bowl, made in London in 1684, is flat-chased with chinoiserie scenes, a kind of caricature of oriental designs that were popular in British silver for a short while. Diam. 29cm/11⅓in.*

1 *The Neoclassical character of late 17th-century French Baroque silver and its interest in antiquities is illustrated by this silver-gilt ewer made in Paris by Nicholas Delaunay in 1697. It is a rare survival: Delaunay made a great table service for Louis XIV, which was melted down in 1707. Ht 33cm/13in.*

Daniel Marot

1, 2 *Two designs by Daniel Marot, William III's court architect, illustrate the disciplined style that he introduced around 1700: a close integration of form and ornament, a rigid formality of design, and a repertoire of motifs that were drawn largely from classical architecture. The sheet on the right is the title page to his influential book* Nouveaux Livre d'Orfèvrerie, *published in 1712.*

3 *The career of the Huguenot goldsmith, Paul de Lamerie, spanned about 40 years. This silver-gilt sconce (one of a pair) was made in c.1717; it was probably based on a design by Marot. Ht 55.5cm/21¼in.*

British Huguenot Silver

1 *This two-handled cup and cover of 1717 by Paul de Lamerie (1688–1751) epitomizes Huguenot design, displaying dignified proportions, a careful balance between plain and decorated surfaces, and a skilful use of cast ornament. Ht 29cm/11½in.*
2 *The so-called pilgrim bottle was one of the grandest types of display silver in late 17th-century France. This example was made in London by the Huguenot goldsmith Pierre Harache in 1699, and combines bold sculptural ornament with typical Huguenot features such as "cut card" flutes around the base. Ht 52cm/20½in.*

French Regent Style

1 *The French artist Jean Bérain was largely responsible for introducing a range of forms and decorative motifs that lightened the formality of the Baroque style. This design for a buffet of plate shows many of the forms in vogue at the beginning of the 18th century.*
2 *This silver tureen, made in Paris in 1714 by Claude Ballin, reflects the lightening of ornament introduced under Bérain's influence. Ht 20cm/7½in*

made in Genoa during the second and third decades of the century, which were in turn probably made by a silversmith from Antwerp.

Whilst sharing the same basic sculptural and chiaroscuro character as the Italian Baroque, the style in much of northern Europe developed along distinctly regional lines, reflecting political and economic blocks of influence. In northern Germany and the Hanseatic states, a strongly sculptural style developed, especially for large tankards and other vessels made for display, which is derived more from the German tradition of ivory carving than from bronze or stone sculpture, and takes on a distinct character accordingly. This style found its way to Britain too, through immigrant goldsmiths, notably the German, Jacob Bodendick.

In France, Holland, and Britain, distinct features emerged which set them apart. The centralizing of French royal patronage in the Gobelins workshop, established in 1663 by Louis XIV, led to a strong homogeneity in the decorative arts. The floral style,

reflecting contemporary interest in botany and well suited to polychrome furniture marquetry, was adopted also for embossed ornament in high relief on silver, which by the third quarter of the century was widespread throughout much of northern Europe. The inspiration being observable nature, it was perhaps less dependent than other styles on the availability of prints, although a version of the style incorporating putti and animals amidst scrolling foliage was disseminated through the engravings of Stefano Della Bella and his imitators (see p.72).

One of the high points of this style was the polychrome painted enamel decoration that was taken to unprecedented levels of achievement in Blois and also in other centres during the third quarter of the 17th century. The principal application of this specialized art form tended to be for watch cases but, as the technology of watchmaking changed in the 18th century, these cases were to become redundant. Such was their acknowledged artistic merit, however, that

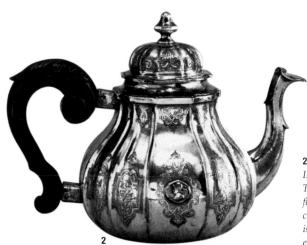

2 *Silver-gilt teapot by Esaias III Busch, Augsburg, 1729. The combination of panels of flat-cased strapwork and applied classical portrait medallions is typical of the Augsburg expression of the Régence style.*

1 *Massive set-piece displays remained an important function of royal silver into the 18th century and, in this 1707 design for King Frederick I of Prussia's buffet by Eosander von Goether, the design of the individual pieces is secondary to the overall architectural display.*
3 *The Augsburg goldsmith Johann Erhard Heiglein published a series of designs for practical decorated domestic silver in 1721, which did much to establish the southern German Regent style.*

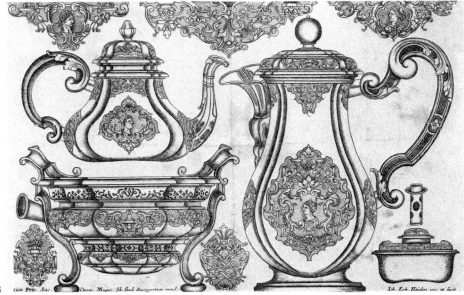

many survived by virtue of being converted into gold snuffboxes in the middle of the 18th century.

By the last quarter of the 17th century, a new sense of classicism was established in France, largely through the influence of Charles Le Brun, who was appointed head of the Gobelins workshops. The little surviving French royal silver from this period is perhaps epitomized by the austere precision of a ewer of 1697 by Nicolas Delaunay (see p.73), in which ornament is restricted to the repertoire of classical architecture and carefully controlled two-dimensional geometric motifs.

The dissemination of this style abroad was largely due to the French Protestant Daniel Marot (see p.73), who worked in both Holland and Britain as court architect to William of Orange. But his task was made easier by the simultaneous arrival in Britain of thousands of Huguenot refugees from France with the skills and background to promote radically new styles and designs.

Partly because of the wealth of ornament prints associated with this phase of the Baroque, the architecturally inspired style also found expression in other areas of metalwork. Marot's designs were taken up not only by silversmiths, but by clockmakers and bronze workers, and closely parallel design solutions to those found on British and French silver also occur in such disparate areas as bracket clocks, ormolu lighting appliances, and cast-iron garden furniture. Equally, the flow of ideas was not all in one direction; goldsmiths and other craftsmen readily borrowed designs and motifs devised originally for quite different contexts. One of the most influential ornament publications of the late 17th century was a series of designs for wrought-iron gates by the Huguenot artist Jean Tijou (*fl*.1689–1712). His most famous work was the gates at Hampton Court, but details from his designs were widely plagiarized during the first two decades of the 18th century, translated into both two- and three-dimensional contexts.

Textiles and Wallpaper

Energy

1 *Silk velvet, Italy, c.1600. Early Baroque patterns moved away from the clarity of structure characteristic of Renaissance designs. The surface pattern on this velvet retains a geometric pattern, but introduces a new rhythmic arrangement.*

2 *Linen* punto in aria, *Italy, c.1635. The openwork of such needle-made lace emphasizes the marked contrast between background and pattern, and was widely imitated as far away as Britain, Flanders, and Scandinavia.*
3 *"Irish" embroidery by Elizabeth Parker, Pennsylvania, 1763. This flame-stitch bag shows the Baroque taste for lively all-over pattern. W. 15cm/6in.*
4 *Trade card for Abraham Price's wallpaper company, the Blue Paper Warehouse in Aldermanbury, Britain, c.1715. Flame-stitch and other all-over patterns are depicted at the warehouse frontage.*

Baroque surface patterns on textiles fall into four broad categories: lively, energetic designs, those showing exotic influences, vine-based arrangements developed from the previous period, and those with bold outlines. Despite these divisions, they share in being highly rhythmic in character and, in general, the results give an all-over impression.

The most energetic of Baroque patterns appear in those that are relatively small in scale. Most typical in the earlier 17th century are contrapuntal arrangements of spike-edged leaves, flowers, and seed pods plus, in embroidery, insects and animals. A dynamic quality is also apparent in elaborate embroidered variations of stepped patterns, known since the 14th century and by various names, but becoming a standard during the 17th century and remaining popular virtually ever since, such as the flame-stitch pattern. Lace edgings – having now emerged as a free-standing technique as opposed to a cloth-based one – echoed these tendencies up to about 1640, having distinctive jagged shapes along one side (the

other edge, for attachment, being straight). By the mid-1600s broader laces were being made and these, like loom-woven cloths and embroideries before them, displayed swirling floral vine motifs. Such patterns achieved long use on wallpaper, which was in limited use in Europe from around 1500 but was not commonly available until the later 17th century.

Contrapuntal all-over designs continued to be developed after 1650, but were modified under the impact of Indian and oriental influences. Exotic blooms, rendered from imported textiles (most notably chintzes), porcelain, lacquerware, or actual botanical specimens, were combined close together or attached along wandering stems or trunks. Their scale was often giant in comparison to the figures or birds which were scattered amid them, lending an incongruous air to such patterns. Intertwined with these trends was the impact of the copperplate engraving of design sources for silks and wallpapers. Its extreme delicacy of shading favoured half-tone effects, which were adapted to good use by

Exoticism

1

2

1 *Painted silk, France, c.1680. By the 1660s, Indian and Far Eastern-inspired patterns emerged. Some looked like assemblages of sketches in a traveller's notebook, covering the entire surface with a seemingly random arrangement of floral or pictorial imagery, and could be hand-painted, as here, using plain Chinese silk as the canvas.*

2 *Copperplate printed wallpaper, Britain, late 17th century. When printed on cloth or wallpaper, the motifs often related to booksellers' blocks or engraved plates.*

3 *Gros point lace, probably Spain, c.1670. In constructed textile patterns such as lace, and also loom-woven cloths, pictorial motifs were rare. Instead, informal but crowded arrangements incorporated patterning within motifs.*

4 *French brocaded silk, c.1690–5, in which the pattern of floral motifs is densely arranged, as in 3 above.*

5 *Curtain from a set of bedhangings embroidered in wools on a cotton and linen ground (detail). Possibly from Wattisfield Hall, near Bury St Edmunds, Britain, 1700–10, its internal patterning was typical of such crewelwork, itself directly influenced by imported Indian textiles.*

6 *Wool plush lampas (compound weave), France, c.1680–1700. Such formal large designs for interiors often included exotic jagged-edged, leaf-like patterning in and around the motifs.*

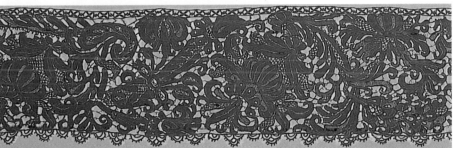

3

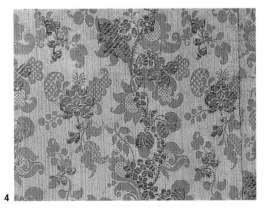

4

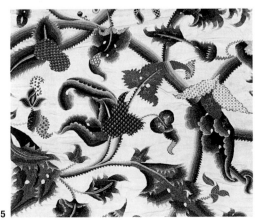

5

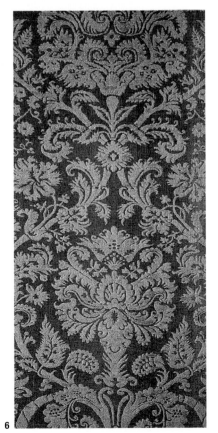

6

1 *Chain and back-stitched embroidered coverlet, Indo-Portugal, 1650–1700. Ogees and meanders were still the basis for the designs used in luxury textiles, like carpets and wall-hangings, but energetic coiling vines also provided a lively contrast, as here.*

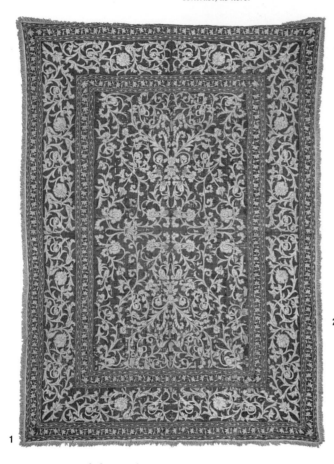

1

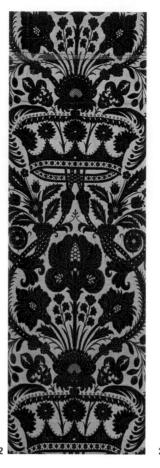

2

3

2 *Brocaded velvet hanging, Venice, c.1660–1700. Influenced by Mannerism and the related development of state apartments, textile designs grew longer, typically with the addition of a second design element placed between an ogee-framed motif.*

3 *Silk velvet, Italy, mid- to late 17th century. The large scale highlights the forceful impact of exotic blooms and internal patterning, set off by strong colour contrasts.*

weavers and lacemakers in particular, to extend the perceived tonal range of single- or two-coloured damasks and all-white laces.

Vine-based designs in the Baroque period are characterized by a light, almost lyrical movement through the patterns they bind together. Nevertheless, the patterns are still formal in composition, with their vertically mirrored motifs clearly discernible. In cases such as embroidery, appliqué, and loom-woven textiles with bobbin-inserted colours, a horizontally mirrored repeat may also be present. In the late 17th century vertically mirrored (or point) designs often also incorporate incongruously sized elements, but the major change appears in the size of the repeats in weaves and wallpapers, which become extremely long, often three to four times longer than the repeat width.

While all the designs discussed above are still found in the early 18th century, the characteristic patterns new to the years 1700 to 1715 have bold outlines and often very detailed in-fillings. These take their lead from two

sources. The first is lace, now so fashionable that lace-like designs also appear on loom-patterned cloths and stamped velvets (plain velvet embossed by impressing with a wooden block). In these the lace-like elements may vary from the incorporation of half-tone filigree effects and exotic elements to the virtuoso representation of lace in *trompe l'oeil* manner. The second influence relates to the en suite decor developed in response to the earlier emergence of state apartments, especially the work of the Huguenot engraver and ornament designer Daniel Marot (*c*.1663–1752). Active in Holland from the 1680s (and at times in Britain from the 1690s), his publication of volumes of engraved prints in 1709 and 1713 ensured an international impact. He is credited with the fashion for extremely long designs, already discussed. In addition, Marot melded the pre-existing trends into a distinctive style that transformed solid outlines into architectural forms; his interpretation of niches filled with classical imagery, of columns and arches, and of festoons, remained influential into the 1740s.

Infills and Outlines

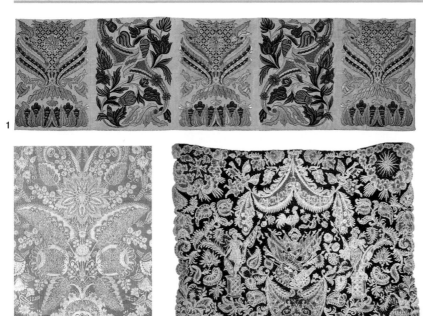

1

1 *Embroidered altar frontal, Italy, c.1735, silk chenille with silver thread. By the end of the period, large-scale designs placed complete emphasis on internal patterns and majestically coiling vines. L. 1.12m/3ft 8¼.*
2 *Silk damask in lace style, Lyons, c.1700, showing the influence of bobbin lace on contemporary French tastes.*

2 **3**

3 *Bobbin lace, Brussels, 1700–15. Around 1700, laces began to display delicate gauzy infill patterns, festoons and other aspects of state apartment interiors.*

4 *Wallpaper, red flock in a large design of conventional foliage in two shades of red, Britain, the Queen's Drawing Room, Hampton Court Palace, c.1735. An extremely elongated ogee is barely apparent in the design.*
5 *Utrecht stamped woollen velvet, north-east France, c.1700. Mercantile wealth broadened demand for fashionable textiles, reflected in elaborately patterned humbler fabrics.*

4

5

6 *Designs by Daniel Marot. Around 1700, Northern European patterns ceased to be evidently ordered around the ogee principle, instead developing a vocabulary of robust arch, cartouche, canopy, and strapwork motifs, seen also in the Spitalfields silk velvet (no.7).*
7 *Cut and uncut silk velvet attributed to John Leman, Spitalfields, London, 1708–14, which features cartouche and canopy motifs.*
8 *Needlework bedhanging panel, France, 17th–early 18th century. This incorporates imagery that both depicts and is indebted to contemporary architecture.*

6 **7**

8

BAROQUE | TEXTILES AND WALLPAPER

Rococo

c.1715–70

Rococo design, which originated in France in the first half of the 18th century, is characterized by its organic nature and the curving, serpentine movement of its composition. The motifs used are based on shell and rockwork, or *rocaille*. In addition, there are suggestions of wave or flame motifs that often create a sense of flickering movement and asymmetry. Essentially a style associated with interior decoration rather than with architectural theory, Rococo patterns were open to a high degree of personal interpretation on the part of designers and craftsmen.

Some claim that the Rococo style began before the end of the reign of Louis XIV in 1715. The second generation of architects working at the French court after the death in 1690 of Charles Le Brun developed their ideas from those implicit in the late style at Versailles. The *Salon d'Oeil de Boeuf* (Bull's Eye Room) by Pierre Le Pautre of *c*.1703 is often considered to be one of the first examples of the new taste. It was decorated in white-and-gold painted woodwork with curved profiles for the windows, door frames, and chimneypieces. A further source of inspiration for Rococo can be found in the grotesque designs of Jean Bérain (1640–1711). The C- or S-scroll designs used by Bérain provided the necessary frame for the floral tendrils and wave motifs of early designers such as Claude Audran III (1658–1734) or Jean-Antoine Watteau (1684–1721).

A third source can be found in the plasterwork of northern Italy at the end of the 17th century where asymmetry or irregular cartouches formed part of the design. The goldsmith Thomas Germain (1673–1748) and Gilles-Marie Oppenord (designer to the duc d'Orléans, the French regent from 1715 to 1723) brought the implicit sculptural, naturalistic qualities within Italian Baroque design back to France and adapted it.

The fully developed forms of the Rococo, known as the *genre pittoresque*, began to emerge in French design at about the same time as Louis XV began his rule in 1723. During the regency, society had returned to Paris, providing an opportunity to create new apartments in the old *hôtels*, or palaces, that had been abandoned under Louis XIV. Juste-Aurèle Meissonnier (1695–1750) created some of the most dramatic forms of Rococo design, which are featured in his published engravings (1723–35). These show the possibilities of complete asymmetry and sculptural movement based on naturalistic ornament. Nicolas Pineau (1684–1754) created interiors of a lighter nature, drawing designs for woodwork panels of elegant proportions, with floral tendrils, wave motifs, and rockwork elements that flow lightly over the space. Nature, children, nymphs, and shepherdesses populate

Left: the asymmetry and rockwork motifs used in this cartel clock by Charles Cressent, c.1747, are the essence of Rococo decoration. The figure of Father Time with his scythe lies naked across the front, while a young Cupid, representing Love, looks down from above. Ht 1.35m/4ft 5in.

Opposite: the Salon de la Princesse, *in the Hôtel Soubise, Paris, was designed by Germain Boffrand c.1737–40. In the spandrels are paintings by Boucher, Nattier, and others of scenes taken from classical mythology. The fusion of decoration of ceiling and walls is one of the most advanced statements of rocaille naturalism.*

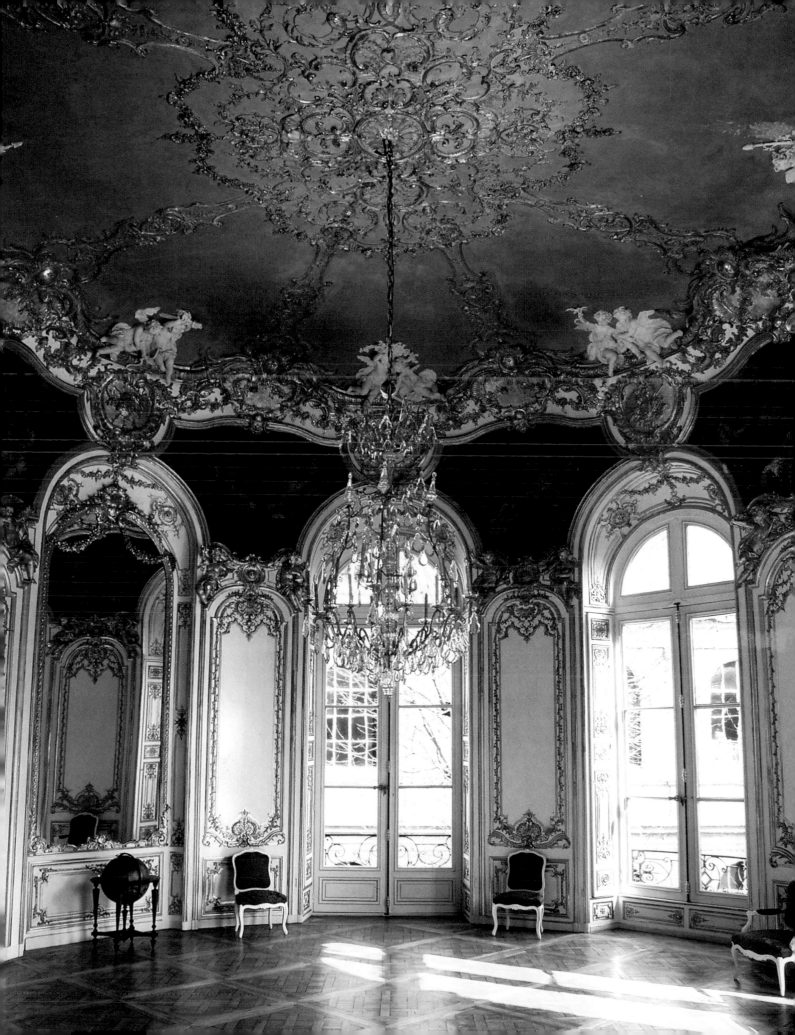

1 The Nursery of Apes, *attributed to Claude III Audran, c.1709, in red chalk and pencil. The monkeys are placed under a trellis decorated with flowers and C-scrolls, emphasizing the informal and the natural. Ht 69.7cm/27½in.*

2 *The trade card for Thomas Gardner, a London goldsmith, shows the impact of French Rococo design in England. It lists the type of goods he could provide. Such cards were often engraved by leading designers in London.*

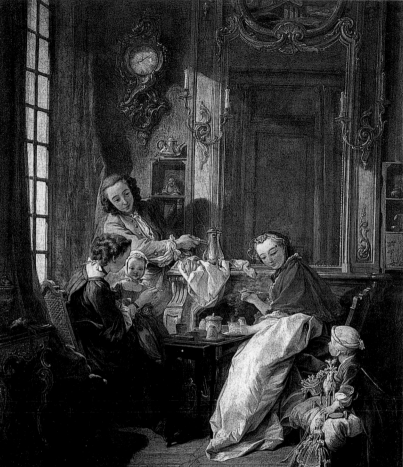

3 The Breakfast *by François Boucher depicts an interior of c.1740. The group gathers around a table with a coffee or chocolate service. The clock is typical of the highly sculpted and asymmetrical style of Charles Cressent (1685–1758)*

the paintings of François Boucher (1703–70), many of which were intended to form part of a Rococo interior.

Eastern exoticism introduced elements of fantasy – deemed suitable for private rooms – to Rococo design. Christophe Huet (1700–1759) created the cabinet rooms at Chantilly decorated with painted panels depicting monkeys acting out human activities (*singerie*). Another form of exoticism was chinoiserie. Bérain depicted oriental figures based on engravings of the Chinese court, adapted to European taste. In the closet of the duchesse de Berry, Watteau expanded the repertoire, using figures of Chinese goddesses. Boucher's designs for tapestry took the Rococo genre from incidental decoration to the scale of paintings.

As early as 1737 Jacques-François Blondel (1705–74) published his treatise, *De la distribution des maisons de plaisance et de la décoration des édifices en général*, in which he criticized the excesses of Rococo and argued for a more restrained style. This led to designs in which form kept its naturalistic curving movement, but in which ornament became more controlled and was less frequently used.

In the second or third decades of the 18th century Rococo design began to impinge on the indigenous Baroque traditions of different parts of Europe. French

manners and customs dominated the courts of Europe with a resulting increase in smaller, more intimate rooms. Porcelain rooms, tea pavilions, and other exotic creations were to be found in the lavishly decorated palaces created by the princes and nobility of Europe, whose wealth was expressed in an unprecedented scale of building.

Architectural concepts for exteriors remained clearly influenced by 17th-century fashions. The interior spaces, too, remained strongly Baroque, especially in the retaining of staircases, reception rooms, and great halls surmounted by illusionistic ceiling paintings. The decorative motifs in these rooms, though, were increasingly influenced by French *rocaille* design and were often even more expressive and individual than their French counterparts.

Italian design of this period is sometimes called *Baroquetto* to emphasize the continued influence of Roman Baroque designers such as Gianlorenzo Bernini (1598–1680) and Pietro da Cortona. Italian design, even when adopting French forms, retained its sculptural richness. The royal hunting lodge outside Turin, the Stupinighi, is one of the most impressive of the works by the Sicilian architect Filippo Juvarra (1678–1736). Its towering central hall exemplifies Juvarra's combination

of Baroque space and French Rococo ornament, lavishly applied over the surface. At Caserta in Naples (built in 1751–56 for Charles V), Luigi Vanvitelli arguably moved from Baroque strength to classical harmony. The decoration, however, includes a profusion of naturalistic and exotic decoration. This was repeated at the Royal Palace in Madrid (c.1761–66), where the rooms were decorated by fellow Italians, such as Mattia Gasparini (*fl*.1765–1780) and Giambattista and Giandomenico Tiepolo, who painted the ceilings.

The end of the War of Spanish Succession in 1713 brought a surge of building activity in the Holy Roman Empire. In Vienna, Lukas von Hildebrandt (1668–1745) was one of the first to incorporate elements of Rococo in his decoration of the Upper Belvedere, Vienna, built for Eugène of Savoy. Later, Empress Maria Theresa created fully fledged Rococo interiors at her palace of Schönbrunn (1745–49). Many rooms were decorated in oriental lacquer because of her passion for this exotic material.

One of the first German princes to take up French design was Max Emanuel, elector of Bavaria, who had been exiled in Paris. Both his court architects, Joseph Effner (1687–1745) and, more famously, François Cuvilliés (1695–1768), had studied in Paris. Cuvilliés' designs for interiors and furniture were closely based on French sources, but were combined with more direct expressions from nature. The Amalienburg hunting lodge (1734–39) in the grounds of the Nymphenburg Palace is perhaps one of the most perfect Rococo interiors. Cuvilliés also worked further afield at Schloss Brühl (1728–40) and Schloss Wilhelmstahl (1743–49). At Würzburg, Balthasar Neumann (1687–1753) created a magnificent residence.

The series of state apartments were decorated with energetic and descriptive stucco work by Antonio Bossi while the paintings on the staircase and in the Kaisersaal (1752) are among the Tiepolos' grandest works.

The latest examples of the Rococo occurred in Prussia, in the work of the architect Georg von Knobelsdorff (1699–1753) and designer Johann August Nahl (1710–85), who worked for Frederick the Great until 1746 at Schloss Charlottenburg in Berlin and Sans Souci and the Neues Palais in Potsdam. The interiors are characterized by their sparse, light, and highly naturalistic motifs. However, the new sense of structure and order underlying the designs of their successors, Johann Michael (b.1709) and Johann Christian Hoppenhaupt (1719–c.1780), reflects the move towards more classical theories.

In England, the Rococo was one of several styles. Rococo design was more likely to be found in the decorative arts than in architecture, but interiors might be decorated with *rocaille* plasterwork. However, classicism in the form of revived Italian Renaissance style was paramount in architectural design and Palladianism dominated taste until at least 1740. At that time, pattern books appeared showing the French style, which was rapidly taken up by silversmiths and carvers, while the newly established porcelain factories offered imitations of continental services or figures. There was also an interest in reviving Gothic and oriental styles, which were alternative expressions to French naturalism.

4 *The mirror room at Würzburg was designed by the architect Balthasar Neumann, c.1740. The colour and material reflect the German passion for highly elaborate, grandly conceived interiors.*

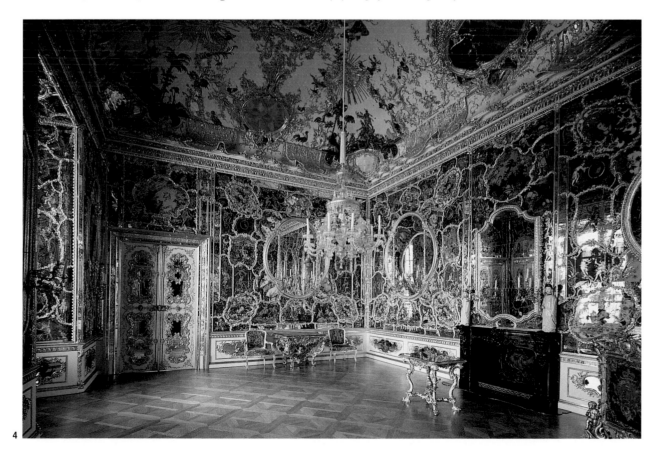

4

French Furniture

The Role of the Designer

1 *This design for a wall in the Grand Cabinet at the Hôtel de Rouille, from Jean Mariette's* Architecture Française *published in 1727, shows the placement of a console table under the mirror, and the way in which the shape was integrated into the design of the wall decoration.*

2 *This pair of blue painted and parcel-gilt tripod candlestands (guéridons) c.1730, taken from designs by Jacques-François Blondel (1705–74) shows the formality still to be found in early Rococo pieces. The design of the tripod feet owes much to examples from the late 17th century. Ht 1.6m/5ft 3in.*

3 *The commode for the king's bedroom at Versailles (delivered 1739). It was designed by the royal sculptor, Antoine-Sébastien Slodtz (c.1695–1754), and executed by Antoine Robert Gaudreau (c.1680–1751) in kingwood parquetry, while the mounts were provided by the leading sculptor Jacques Caffiéri (1673–1755). Ht 89cm/35in.*

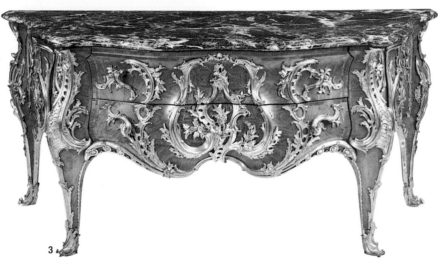

The first years of the 18th century saw the development of several new types of furniture, published among the engravings of André Charles Boulle (1642–1732) between 1697 and 1730. These included the flat writing desk (*bureau plat*), the chest of drawers (commode), and the low bookcase or cabinet (*bas armoire*). In 1737 the critic Blondel described three sets of rooms: *apartements de parade,* or state rooms, entertaining or social rooms, and private rooms. Each required furniture that reflected their status and purpose. Social life required tea and side tables, gaming tables and chairs, and chairs for the *salon* or for small-scale private functions. This gave rise to a profusion of new forms, such as the small toilette and writing table, the *bonheur du jour,* or specific types of chairs including the *bergère* and *duchesse.*

Tables and chairs, and sometimes commodes, were designed to be part of the interior, and were intended to reflect the motifs and shapes of the panelling. The first tables, as shown in designs by Oppenord or Pineau, reflected the gradual softening of shape from the architectural forms used in the 17th century to curving serpentine shapes. At the corners might appear dragons or female heads, which were replaced by more abstract forms of foliage and shell motifs as the style developed. By the 1760s, designs developed a new rigidity while the Rococo motifs were combined with classical decoration.

There were two main types of chairs, those for display against walls, which had to fit in with the design of the panelling, and those for shifting around for use. Comfort was a key issue, with a resulting interest in upholstery. The daybed evolved into a comfortable settee, often with a detachable footstool (*duchesse brisé*). The Rococo chair was characterized by the use of the cabriole leg, introduced early in the century, and by decorative shell motifs and C-scrolls. By the 1740s the arms emerged from the frame in one continuous movement.

Chairs were made by joiners who created the outline shapes. The decoration was carved by specialists, many of whom were sculptors, or men who had been trained in design as well as carving. Once joined together chairs

Two Console Tables

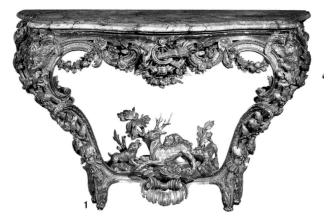

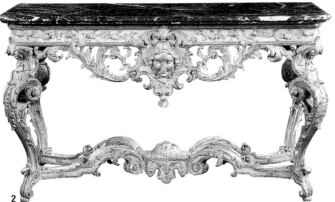

2 *Although it has the naturalistic motifs and curved forms of the new style, this table of c.1720 retains elements from late 17th-century design such as the straight top and frieze and the female mask in the centre. Ht 80.5cm/31in.*

1 *The heavy carving and unified design of this c.1755 table are typical of later Rococo furniture. The hunting motifs are taken from paintings by Jean-Baptiste Oudry (1686–1755). Ht 88cm/34½in.*

Chairs

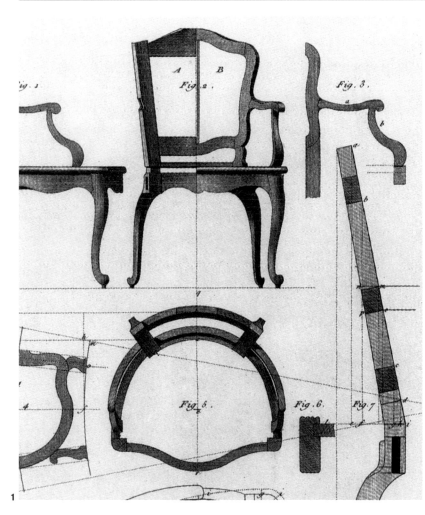

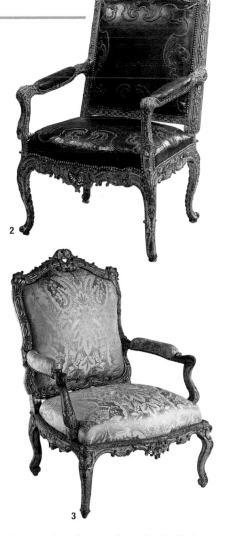

1 *A pattern for a chair* en cabriolet *from* L'Art du Menuisier *by André-Jacob Roubo, 1772. Each section was cut using 9mm/⅜in-thick wooden sheets (*calibres*) as patterns for the various shaped parts of the chair.*

2 *This chair of c.1720 was made for the rich collector Pierre Crozat (1661–1740). Its carved frame and cabriole legs are already Rococo, while the straight lines of the back indicate its early date. It has its original leather covering.*

3 *An armchair of c.1730 of carved and gilded beechwood. The cartouche-shaped back is typical of French chairs. The chair is* à la reine *(with a straight rather than a curved back) and it has a drop-in seat so the upholstery could be changed.*

1 *A library bookcase c.1720 by Charles Cressent, executed in rosewood and framed in purplewood. By designing his own mounts, Cressent could establish his own style as well as control the unity of design and execution. The sculpted term figures are typical of his style; they represent the four continents. Ht 1.64m/3ft 4in, w. 2.72m/8ft 110m.*

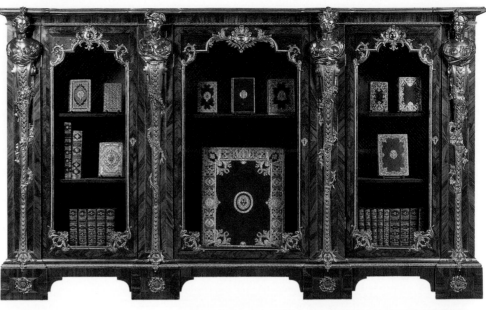

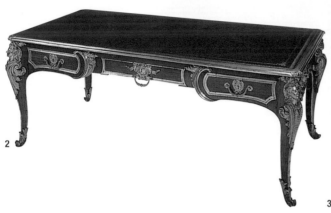

2 *This writing desk, or* bureau plat, *in* bois satiné *with applied female term figures retains the formality of design c.1720, as indicated by the straight top of the desk. Ht 78cm/30¾in.*

3 *This writing table by Joseph Baumhauer shows the continuous, unified design of the 1750s. Such furniture, decorated with Japanese lacquer panels, was extremely fashionable in France. Ht 83cm/32¼in.*

were either coloured to match the panelling or gilded. The specialist nature of French furniture can be clearly seen in the division within the guild of joiners between those who worked in solid wood (*menuisiers*) and those who worked with veneers (*ébénistes*).

The commode, which developed into one of the most important pieces for the 18th-century interior, began as a chest of drawers with three or four drawers down to the ground (*commode en tombeau*). Boulle and Bérain designed a classically based form of a sarcophagus shape, which developed into the two-drawer commode (*commode à la Régence*). By the 1730s this had become the standard two-drawer bombé form.

At the beginning of the 18th century, cabinetmakers turned to new exotic woods from the colonies for their veneers. Kingwood (a form of rosewood), *bois satiné*, and purpleheart were frequently used in the early stages of the Rococo, with tulipwood coming into fashion in the 1730s and 1740s. The earliest decoration consisted of geometric patterns of parquetry which acted as a foil to

the gilt-bronze mounts. During the 1740s, floral marquetry reappeared. The sprays of flowers covered the surface emphasizing the light and decorative quality of the piece. Mounts of gilt or lacquered brass – and less frequently of bronze – were applied to the surface, usually in an open, scrolling cartouche shape.

One cabinetmaker to develop the new forms was Charles Cressent (1685–1758). Trained as a sculptor, he made his own mounts for furniture and clockcases, and specialized in sculptural fittings. Another, Gaudreau, worked on key royal pieces. His forms were often quite restrained, but the decoration of the mounts was generally extremely rich. Several cabinetmakers worked primarily for *marchands merciers* such as Poirier or Granchet. They were responsible for many fashionable pieces of furniture such as the *bonheur du jour*, and also for new types of decoration using Japanese lacquer or Sèvres porcelain plaques. Many leading Parisian cabinetmakers, such as Bernard van Risenburgh II (B.V.R.B., *c.*1696–1766) and Joseph Baumhauer (d.1772) worked for them.

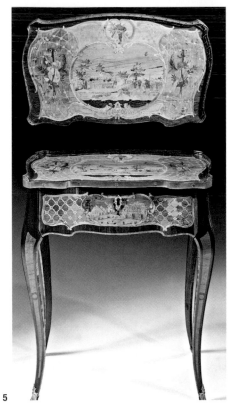

1 This commode was executed by Mathieu Criaerd (1689–1776) for the Mailly apartment of Louis XIV's mistress and was delivered in 1738. It imitates the lacquer of the Orient with painted surfaces. The central cartouche is typical of commodes of the high Rococo.
2 A drop-front secrétaire of c.1760 by B.V.R.B. in marquetry of bois de bout (end-grain rosewood) set into central panels of tulipwood, and bordered with amaranth. L. 1.32m/4ft 4in.

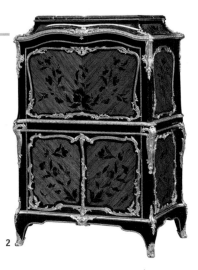

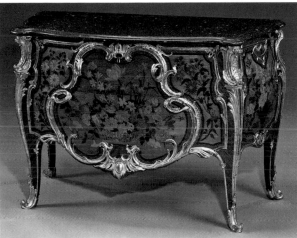

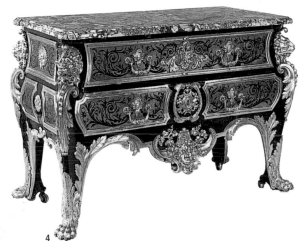

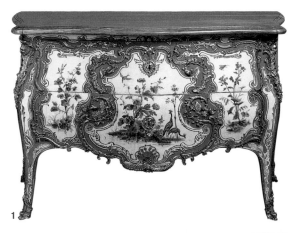

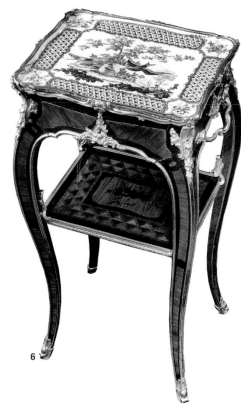

3 This floral marquetry commode of tulipwood was made c.1757 for the Chambre de la Dauphine at the Chateau de Choisy-le-Roi and is attributed to Jean-Pierre Latz (c.1691–1754) or Jean François Oeben (c.1721–63). Ht 90cm/35½in.
4 A commode à la Régence, c.1720, with drawers set into the frame, showing the traverse rail separating them. This model in tortoiseshell and brass, with lion-head mounts, is derived from the Boulle workshop and may have been made by André's sons.
5 This small writing table in tulipwood banded with amaranth is typical of the luxury objects made in the 18th century for use in private rooms. Made by Roussel c.1760, the box-like parquetry and simple outline are characteristic of the late Rococo. Ht 74cm/29in.
6 Setting Sèvres porcelain into furniture was one of the highest forms of luxury. This small work table in tulipwood and purplewood was supplied by B.V.R.B. c.1760–64 to Poirier. Ht 67.5cm/26½in.

German Furniture

High Rococo Design

2 *Design by Johann Michael Hoppenhaupt II for a console table c.1760 showing the strongly curved lines and depth of naturalistic ornament typical of German furniture. The icicle motifs used on the base are often found in his drawings.*

3 *A carved and gilded console table made by Wenzeslaus Miroffsky (1733–4). Designed by François Cuvilliés for the Residenz in Munich, it retains its sculptured ornament and strong curves. L. 1.73m/5ft 8in.*

1 *This room in Schloss Sans Souci, Potsdam, contains chairs designed by Johann Michael Hoppenhaupt II in around 1760 and a commode in floral marquetry by the Spindler brothers, who were famous for their veneering skills.*

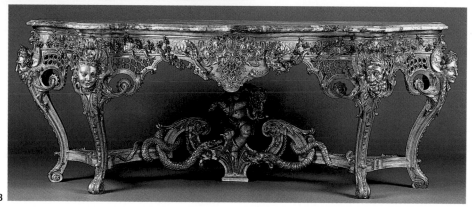

With its many states, German furniture presents an extremely wide range of styles generally using French Rococo ornament and shapes. At the beginning of the 18th century, André Charles Boulle remained highly influential. Johann Puchweiser (d.1744) in Bavaria, and Johann Matusch (fl.1701–1731) and his pupil Martin Schumacher (1695–1781) from Ansbach, specialized in metal (brass and pewter) and tortoiseshell marquetry; the latter to create an especially exotic look.

A key piece of German furniture was the bureau cabinet, with an upper cabinet of drawers and a lower slant-top desk above drawers. Its design was often controlled by the guilds, leading to conservative, dated forms, although decoration was often elaborate.

Furniture from Munich can often be distinguished by being carved, painted, and gilded rather than veneered. François Cuvilliés was one of the first in Munich to design furniture in the French Rococo style. The furniture made by court cabinetmakers such as Johann Adam Pichler was richly carved with nature motifs.

Abraham Roentgen (1711–93) was undoubtedly the most famous German cabinetmaker. A Moravian, he settled in Neuwied c.1750. Having spent time in London, he often used English techniques combined with typical dynamic German forms. He is recognized for the quality of his work and for the complicated mechanisms he developed for tables and writing cabinets.

In Dresden, the use of japanned decoration stemmed from the electors' passion for Japanese art. At first many shapes were taken from English models; later, French taste dominated. The court cabinetmaker, Martin Kümmel (1715–94), looked to Parisian models, imitating their gilt-bronze mounts and using tulipwood and kingwood.

Berlin and Postdam, the centres of late Rococo, and where the linear elegance of the Hoppenhaupt brothers (Johann Christian and Johann Michael) emerged. In 1764, the Spindler brothers (Johann Friedrich and Heinrich Wilhelm) arrived. In addition to floral marquetry, they worked in tortoiseshell and silver with the sculptor Melchior Kambli (1718–83), who supplied the mounts.

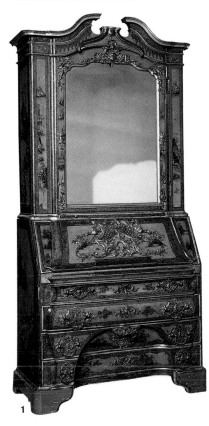

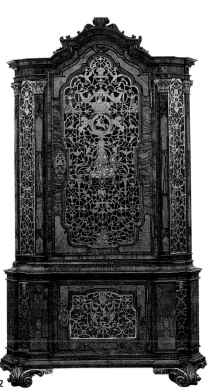

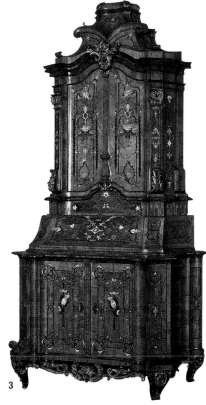

1 The japanning in blue and gold on this c.1730 bureau cabinet is in the English style. It can be attributed either to Martin Schnell (fl.1703–40) or to Christian Reinow (1685–1749), both active in Dresden at this time.

2 This collector's cabinet in walnut was made in 1725–30 for the Duke of Brunswick's castle at Sulzdahlum. Its remarkable gilt-bronze fretwork doors were based on designs by Jean Bérain.

3 The Mainz area was famous for its bureau cabinets. This walnut example was made in 1738 with marquetry of ivory and exotic woods and carved decoration. The strong lines develop earlier Baroque forms.

Chairs

1 This chair was designed by François Cuvilliés, c.1730, for the principal apartments in the Munich Residenz. It retains a French sense of proportion and balance. Ht 84cm/33in.

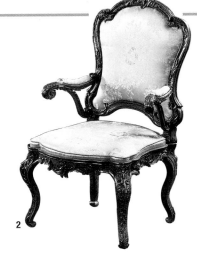

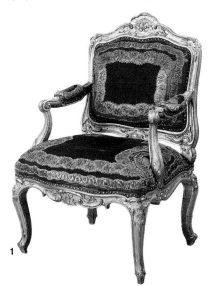

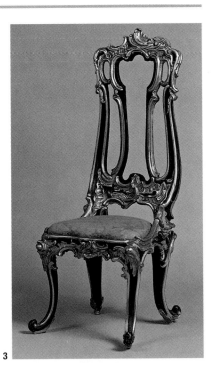

2 A chair probably carved to designs by one of the Hoppenhaupt brothers, c.1760. The unusual arms, with their emphasis on naturalistic motifs, are typical of the designers' work.
3 The organic, asymmetrical decoration of this chair takes its naturalistic source to an extreme. It was made for Schloss Fasanerie in Fulda.

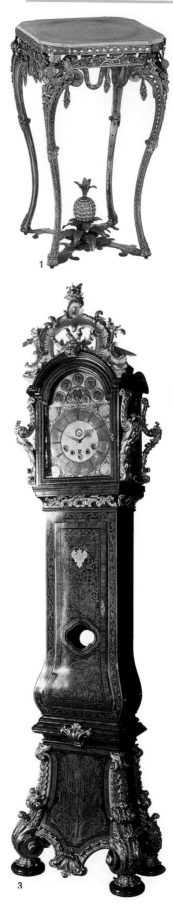

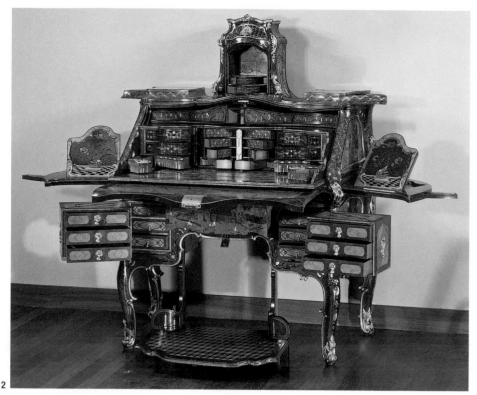

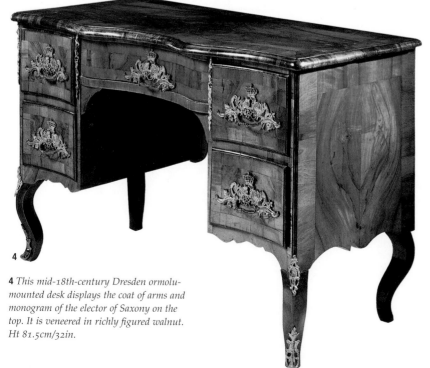

1 This elegant carved and gilded table by Wilhelm Gottlieb Martitz c.1769 combines motifs from antiquity with the naturalistic curves and floral decoration of the Rococo.

2 A showpiece of ingenious mechanical work, this desk veneered in exotic woods, ivory, and mother-of-pearl was made by Abraham Roentgen, c.1760, for the elector of Trier. Ht 1.49m/58¾in.

3 Although the basic form of this clock is English, c.1741, its complex carved and gilded decoration is entirely German. It was made by C.M. Mattern (fl.1733–70), famous for his use of marquetry. Ht 3.1m/10ft 2in.

4 This mid-18th-century Dresden ormolu-mounted desk displays the coat of arms and monogram of the elector of Saxony on the top. It is veneered in richly figured walnut. Ht 81.5cm/32in.

North East Europe and Spain

Different Techniques

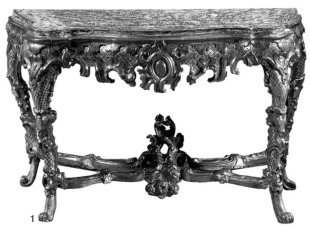

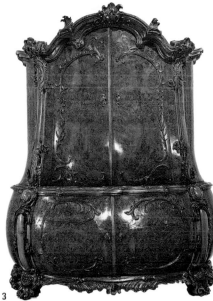

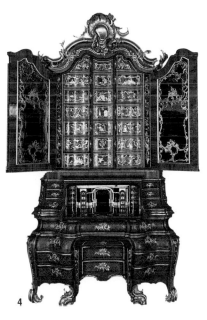

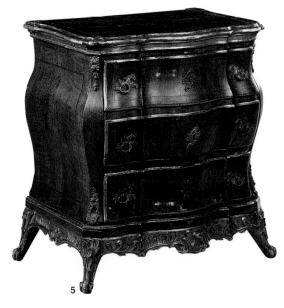

1 *The robust form of this c.1750 giltwood and silvered Spanish console table (see p.92) seems at odds with the fragmented and broken carved decoration, and may reflect the influence of Neapolitan design. Ht 78cm/30¾in.*
2 *A Russian couch from the imperial collections, c.1760, reflecting the sculptured Rococo forms of the royal architect Rastrelli (1700–1771).*

3 *This Amsterdam combined walnut chest and cabinet, c.1760, exemplifies the Dutch interest in voluptuous, organic movement. The fine carving is associated with the work of Anthony Grill. Ht 2.45m/8ft.*
4 *A Danish bureau cabinet by C.F. Lehmann, c.1755. It is based on German forms but is made even more sumptuous through its use of exotic woods, lively gilt-bronze mounts, and floral panels in different metals, ivory, and mother-of-pearl. Ht 2.65m/8ft 8½in.*
5 *This Danish walnut commode, c.1750, is based on French Régence shapes, with slightly exaggerated sides and carved ornament on the base. Swedish commodes have three drawers and similar shapes, often decorated with a gold band between each drawer. Ht 1.25m/4ft 1in.*

Dutch furniture combined designs from France and England with a residual sense of Baroque movement, characterized by its pronounced curves and strong carving. One of the most important pieces was the kast or cupboard. Dutch chairs are close to English, but often mix features from earlier periods in their design. By 1750 the French fauteuil appeared, although made in walnut or mahogany. Very typical was floral marquetry for cupboards, chests of drawers, and after 1750, commodes in the French manner.

In Scandinavia, Baroque forms continued until the 1730s. Influences from England, Holland, and Germany were important, especially in long-case clocks, fall-front desks, and chairs. Danish cabinetmakers such as Mathias Ortmann and C.F. Lehmann made pieces with Germanic features. In Sweden, the court taste was French and designers such as the architect Carl Harleman (1700-1753) trained in Paris. As late as 1770, the Swedish cabinetmaker, Nils Dahlin (*fl.*1761–87) made a filing cabinet for Queen Louisa Ulrika, adapting French secrétaires.

Italian and Iberian Furniture

Venetian Decoration

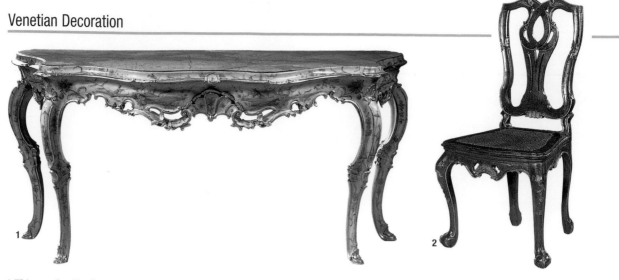

1 *This console table of c.1750 has a piece of* giallo antico *marble on the top and is painted with chinoiserie hunting scenes on a pale green lacquer ground. The technique was extremely popular in Venice. Ht 83cm/32¼in.*

2 *The design of this Venetian partly gilded, walnut chair, c.1750, shows eclectic influences. The overall shape of the back is taken from French examples, but the central back splat is clearly derived from English chairs.*

Baroquetto

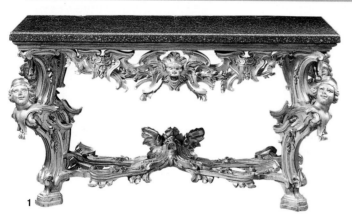

1 *This elaborately carved and gilded console table was probably executed in around 1725 to 1750 in Rome, where the interest in sculpted forms continued well into the 18th century. The green porphyry top with gilt edge is a typical Roman feature.*

2 *Combining* rocaille *decoration of C-scrolls, flowers, shells, and female masks with traditional sculpted figures, this Florentine mirror expresses the refinement of Italian carving by the middle of the 18th century.*

Italian furniture continued to use bold Baroque sculptural decoration and flowing movement well into the 18th century. Sculptors such as Antonio Corradini (1668–1752) in Venice made highly elaborate, figured pieces and cabinetmakers such as Pietro Piffetti (c.1700-77) in Turin kept the boldness of Baroque forms as late as 1760. Carved, gilded console tables also retained the sculptured forms of the previous century.

New types of furniture became popular in the 18th century, including many delicately carved, small pieces for the fashionable mezzanine apartments, the bureau bookcase (called *trumeau* in Venice) based on the English type, and the commode, developed from French designs. Chairs copied both the carved frames of English chairs and the upholstered *fauteuil* from France. Walnut was preferred for veneered furniture, but in Genoa cabinetmakers used imported tulip and rosewood, while in Turin, Piffetti created elaborate marquetry in exotic woods, ivory, and mother-of-pearl. One of the most distinctive forms of Italian decoration was painted furniture. In Venice a new technique, *lacca povera* involved cutting and pasting prints on to the surface of furniture and then colouring and varnishing it.

In Spain, the new Rococo style was mostly found only in royal furniture. Some of the most ambitious was designed for the royal palace in Madrid by Filippo Juvarra (1678–1736) and shows the continuing use of Baroque sculpted forms. Philip V set up royal workshops at Buen Retiro, Madrid, bringing the Neapolitan designer Mattia Gasparini to work there in 1768. Richly decorated and carved, the furniture expresses an understanding of *rocaille* forms and decoration.

Notably, Portuguese furniture used exotic woods – jacaranda and rosewood besides mahogany. The chest of drawers looked back to curved sacristy chests, being taller, with four drawers and splayed upwardly curling feet. English forms were important in northern Portugal. In Lisbon, during the reign of Joseph I (1750–77) French taste came into fashion with carved Rococo motifs mixed with Chinese or Gothic themes from English designs.

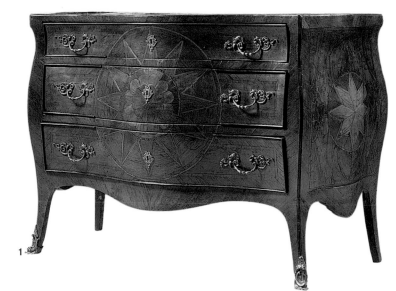

1 *A Milanese commode in walnut, veneered with a star inset into a roundel, c.1760. Its shape is clearly inspired by English examples.*
2 *The work of the cabinetmaker Pietro Piffetti was characterized by marquetry in ivory and mother-of-pearl. In this piece, c.1760, the scenes are based on engravings of the Siege of Troy.*

3 *This* trumeau *(bureau bookcase), c.1730, is decorated with hunting scenes that have been pasted onto the painted background and varnished in a technique called* lacca povera.
4 *Genoese furniture was often based on French forms, as in the lower part of this bureau book case, c.1750. The central motif of four leaves is typically Genoese. Ht 2.44m/8ft.*

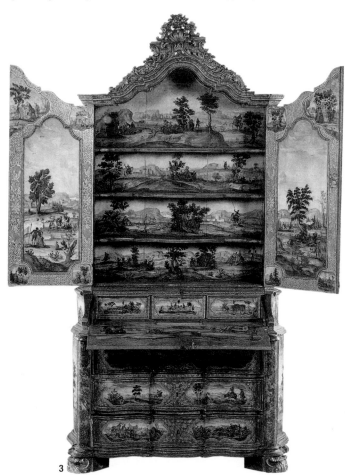

1

2

3

4

British Furniture

Carvers' Work and Seat Furniture

1

2

3

2 Ince & Mayhew created the design for these candlestands, which was published in The Universal System of Household Furniture, *1762. Increasing delicacy and naturalistic detail show a confident Rococo style.*
3 This pier table, made of carved and gilded pine, is part of a suite of tables, stands, and sconces carved by James Pascall for the gallery of Temple Newsam House, Yorkshire, 1745.

1 A design for a pier glass frame by Matthias Lock, published in Six Sconces, *1744. Sinuous lines and naturalistic detail reflect the introduction of the Rococo style in English carvers' work from 1740.*

International Rococo design began to influence British furniture significantly from c.1745 and continued until the late 1760s. The first penetrating and most permanent use of Rococo decoration was in carving, especially for picture and mirror frames, pier tables, candlestands, and chairs. Among the first British carvers and gilders to use the style was Matthias Lock (c.1710–65), who published designs for such pieces in 1744 and 1746.

In the 1750s designers and carvers developed the style into a lighter, more sinuous form, employing delicate flowers, leaves, branches, rockwork, animals, birds, and human forms. The overall effect was one of lightness and grace, giving a sense of fantasy and delight. Smaller-scale elements were introduced and some of the most delicate work was executed in gesso. Pieces designed for rooms used in the evening and lit by candlelight were often gilded or finished in white paint with partial gilding.

After 1750 the British Rococo style developed more distinctively by including Chinese and Gothic motifs and the French-inspired *genre pittoresque* characteristics of asymmetry and naturalism. The Gothic style is seen at its most sophisticated in Horace Walpole's fantasy villa, Strawberry Hill at Twickenham.

The dissemination of the style owed much to the influence of Thomas Chippendale's innovative pattern book *The Gentleman and Cabinet-Maker's Director* (1754, further eds 1755 and 1762), which included designs for pieces in the Chinese and Gothic taste as well as the "modern" or "French" style. Subsequent pattern books include Ince & Mayhew's *Universal System of Household Furniture* (1762) and the Society of Upholsterers' *Genteel Household Furniture* (1760–2). Highly distinctive were the designs of Thomas Johnson between 1755 and 1761, an exaggerated and spiky version of the highly naturalistic French style.

Fully upholstered armchairs, settees, and side chairs made of beech or pine and painted or gilded were known as French chairs. Their upholstery was sinuously shaped with shallow, tufted stuffing and fixed to the frame with small gilt brass nails. Fabrics for upholstery included Italian silk damasks with formal patterns, embroideries,

4 *This design for a frame by Matthias Darly was published in* A New Book of Chinese Designs, *1754. Chinoiserie elements of figures and decorative details derived from Chinese ceramics, lacquer, and wallpaper are blended with the French style.*

5 *The design for this mirror, made of carved and gilded pine, c.1762, for Lord Methuen at Corsham Court, Wiltshire, was inspired by designs by Thomas Johnson published in* One Hundred and Fifty New Designs, *London, 1758. Ht 2.67m/8ft 9in.*

6 *The carved frame of this gilded beech armchair with modern silk damask upholstery is attributed to Matthias Lock, c.1755. The chair belonged to the artist Richard Cosway and appears in some of his portraits.*

7 *One of a set of eight, this 1755–60 armchair was made for Sir Matthew Featherstonhaugh, Uppark, Sussex. The carved and gilded beech frames were made by John Bladwell and the tapestry covers depicting scenes from Aesop's Fables were made by Paul Saunders.*

8 *Thomas Chippendale made these designs for parlour chairs c.1760, which were engraved and published in* The Gentleman and Cabinet-Maker's Director, *3rd Edition, 1762. Each of the designs offers many options for shape and detail in the backs, legs, and seat rails, allowing the client or carver to select his personal preference.*

1 *This detail of carving on a mahogany settee, c.1760, is after a 1754 design by Thomas Chippendale. The delicate acanthus leaves, cartouche, and scroll foot on this cabriole leg are typical Rococo details.*
2 *Designs for parlour chair backs and spandrels by Robert Manwaring were published in* The Chair-Maker's Guide, *1766. The simplified style was for modest commissions – detailed carving was expensive.*
3 *The Rococo style on this c.1760-5 commode, one of a pair, is understated, but it exists in the subdued serpentine shape and elaborate ormolu mounts.*

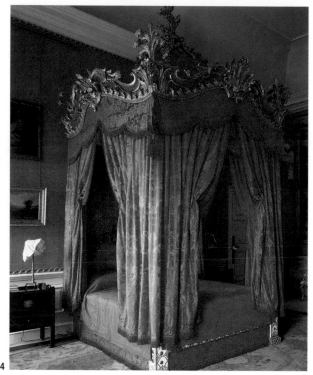

4 *This carved and gilded pine state bed, c.1760, by Norman & Whittle was made for Lord Egremont at Petworth House, Sussex, after a design by Thomas Chippendale. The upholstery is largely modern.*

and tapestry-woven panels. Most distinctive were chairs with open backs carved with interlace patterns, offering the craftsman endless opportunities for variety and virtuosity of ornament during the 1750s and 1760s.

The British tradition for free-standing four-posted beds continued. Bedstead frames were carved with some of the most expressive Rococo ornament, including trees, branches, leaves, flowers, animals, and birds in the *genre pittoresque*, while others used Chinese or Gothic inspiration. Accompanying chairs, stools, and settees continued the stylistic look to provide a theme for each room.

In general British Rococo cabinetwork was more restrained than some of its continental counterparts. The architectural discipline and purpose of many cabinet pieces in dining rooms and libraries, as well as the use of mahogany for construction, influenced the design of such items as bookcases, desks, and sideboards. The most obviously Rococo pieces were the fine commodes, or chests of drawers, inspired by French examples, intended for bedchambers and withdrawing rooms. Some adopted

a French serpentine shape for the sides as well as the front and were ornamented with highly decorative gilt brass or bronze mounts, but these rarely obscured the woodwork to the same extent as French versions. Commodes created by the French-trained cabinetmaker Pierre Langlois bore the closest similarity to French types, but those made by Thomas Chippendale and John Cobb in the 1760s were restrained, relying on detailed carving, finely figured mahogany, and high-quality gilt mounts for their effect.

Other large pieces of cabinetwork remained subtle in their general outline, but much Rococo ornament was included in carved detail. Smaller items such as tea tables, pembroke tables, china shelves, night tables, and dressing tables were more expressively decorated with delicate Chinese lattice work or small Gothic crockets, and cusped tracery for glazing bars. However, by about 1765 the most asymmetric or contorted carving styles of the Rococo style were receding and a more controlled style of decoration had developed, appearing in most fashionable British furniture.

5 *These designs for a lady's secrétaire by Ince & Mayhew were published in* The Universal System of Household Furniture, *1762. Gothic and chinoiserie decorative elements were often applied to smaller pieces of cabinetwork with standard shapes.*

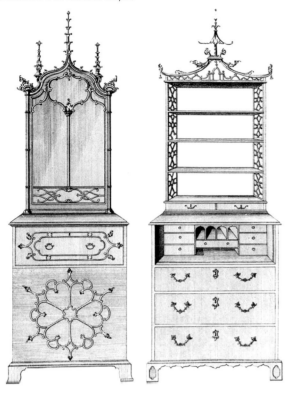

5

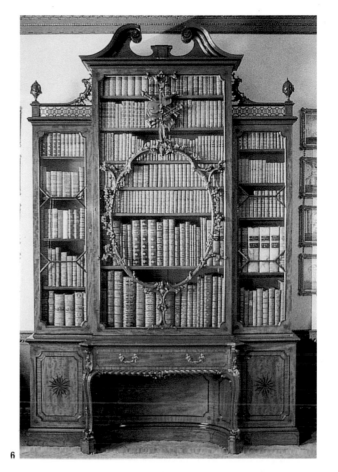

6

7

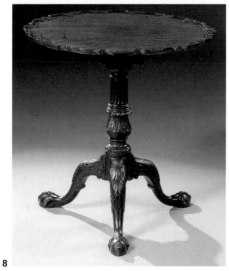

8

6 *Known as the Violin Bookcase, this mahogany with ebony inlay desk and bookcase was designed c.1760 by Thomas Chippendale for Wilton House. The central carved panel in the upper section was inspired by Rococo designs for frames.*
7 *A fretwork cage beneath the top of this mahogany pembroke table, made c.1765, is given a chinoiserie character through the use of lattice designs.*
8 *This tripod tea table was made of mahogany, c.1760–5. The wavy edge of the top reflects shapes in contemporary porcelain plates in the Rococo style. Ht 71.5cm/28¼in.*
9 *A c.1765 Chinese lacquer cabinet is mounted on a mahogany stand with delicate lattice fretwork.*

9

American Furniture

Pre-Revolutionary Style in the Colonies

1 *This mahogany chair made by Benjamin Randolph or Thomas Affleck, in Philadelphia, 1760-75, is carved with scrolling leaves and has cabriole legs and claw-and-ball feet in the Rococo style. The vigorously detailed carving and the shaping round the seat are typical of Philadelphia craftsmanship at its best. Ht 94cm/37in.*

2 *Plate XVI from Thomas Chippendale's The Gentleman & Cabinet-Maker's Director (1754). Such designs were directly influential on Philadelphia high-style furniture.*

3 *Tassel-back, or tassel-and-ruffle, chairs, made only in New York. They follow English and Irish models and were among the most popular patterns. The busy carving and weighty cabriole legs with their pronounced curves are noted characteristics of American furniture. Ht 97cm/38¼in.*

4 *Wall brackets such as this pine example by James Reynolds of Philadelphia, made 1765–75, rarely survived due to the fragility of the elaborate carving. This example includes scrolls, foliage, and stalactites above the bird's head. Ht 41.5cm/16¼in.*

In American furniture the Rococo style is most apparent in the art of the carver, the signature of the style being the realistic portrayal of elements from nature such as shells and rockwork, scrolling leaves, and flowers and fruit, all combined with C-and S-scrolls. Sometimes trefoil or quatrefoil shapes suggest the Gothic style, and piercing or blind fretwork the Chinese taste. The predominant influence was Chippendale's *The Gentleman & Cabinet-Maker's Director* (1754, further eds 1755 and 1762), which inspired large numbers of exuberantly carved chairs with cabriole legs, shaped top rails, and pierced splats.

In the major cities of the pre-Revolutionary American colonies, cabinetmakers created distinctive local styles, sometimes guided by immigrant craftsmen. One of these was Thomas Affleck (1740–95) who came to Philadelphia from Britain in 1763. He and other cabinetmakers, most notably Benjamin Randolph, produced case furniture and chairs in what they called the "New French Style," and ensured Philadelphia's leading position in the production of fine furniture during America's Rococo period; this began in the 1760s and continued at least until the 1780s.

Most of this furniture was made of mahogany, with carved panels, frequently including shells, placed centrally on chests of drawers or on the knees of cabriole legs. Looking glasses, sconces, and other carvers' showpieces were usually gilded, or partially gilded, like their European counterparts. The high chest of drawers, or highboy, was quintessentially American, with its deep curving broken pediment embellished with scrolled terminals and finials above, shaped apron below, and vigorously carved cabriole legs supporting the piece.

Emanating from Newport, Rhode Island, was the block-fronted secretary. Whether taking the form of a simple kneehole desk or a tall bureau cabinet, it was characteristically carved with shell headings to the panels and set on ogee bracket feet. Boston's version is plainer, with fluted side pilasters and sometimes a Dutch-influenced bombé lower section supported on short cabriole legs and claw-and-ball feet.

5 *A substantial mahogany library bookcase, made in Charleston, South Carolina, 1755–75. Its inspiration was plate XCIII in Thomas Chippendale's* The Gentleman & Cabinet-Maker's Director *(1754). Ht 1.05m/3ft 5in.*

6 *A high chest of drawers of the type known as a highboy in America. It has a scrolled broken pediment, shaped apron, and cabriole legs, and is attributed to Eliphalet Chapin of Connecticut. Ht 2.22m/7ft 3¼in.*

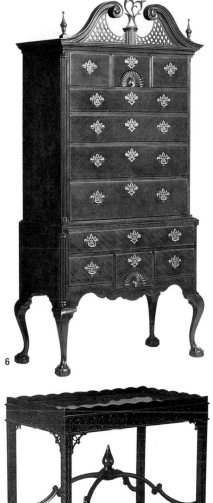

7 *British influence is paramount on this china table of 1765–75, attributed to the English cabinetmaker, Robert Harrold, who worked in Portsmouth, New Hampshire, centre of the New England timber trade. Ht 72.5cm/28½in.*

8 *This round tea table on a tripod base expresses the ultimate urbanity in Rococo design. When not in use it could be tilted into a vertical position and pushed into a corner. Ht 72.5cm/28½in, diam. 76cm/30in.*

9 *A back leg swings out to support the folding top of this finely carved serpentine card table, attributed to the workshop of Thomas Affleck in Philadelphia, 1770–71. The scrolling decoration along the apron is Rococo. Ht 71cm/28in.*

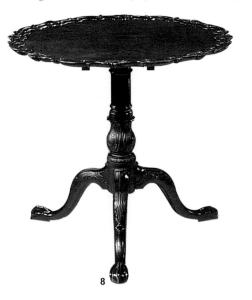

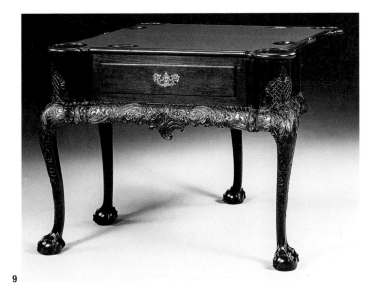

German Porcelain

Early Rococo

1 *This Meissen teapot, modelled by J.J. Kaendler, c.1740, exemplifies the Rococo fashion for* trompe l'oeil. *It blurs the line between fantasy and reality, nature and art in a frivolous, contemporary way. Ht 14cm/5½in.*

2 *J.J. Kaendler's Meissen group of* Harlequin and Columbine *from the* Commedia dell' Arte, *made c.1741, still shows the strong colours of the Baroque style, but the modelling of the pair from the contemporary theatre shows the light mood of the period. Ht. 15cm/6in.*

3 *A Meissen coffee cup and saucer from the Swan Service, modelled by J.J. Kaendler and J.F. Eberlein c.1737–40; they are from the service made for Count Brühl. His name meant "marsh," thus the aquatic theme, with shells, water, and reeds – all Rococo motifs.*

Developments in Rococo

1 *This c.1745 Meissen figure of a* Map Seller *is part of a series of the* Cris de Paris, *taken from engravings by the Comte de Caylus, after drawings by Edmé Bouchardon, and modelled by J.J. Kaendler. They were formed from multiple small press-moulded components and joined with liquid slip. Ht 16.5cm/6½in.*

2 *The exoticism of the Rococo style can be seen in this c.1750 pair of Meissen figures of* Malabar Musicians, *by F.E. Meyer. By the middle of the 18th century, figures could be made with more elaboration and detail, such as the sense of movement being suggested by the swirling robes. The asymmetrical feathery C-scrolls on the bases emphasize the Rococo style. Woman ht 17.5cm/7in.*

By the end of the 1730s, the grandiose Baroque style had run its course. It was replaced by the playful, feminine Rococo style, which generated a new feeling of frivolity, energy, and movement. It was a style suited to porcelain, with its brittle, yet plastic qualities, and its ability to take brilliant, glossy colours. In J.J. Kaendler's hands small models reflecting scenes at court, Italian *Commedia dell'Arte* characters (from a type of improvised folk drama), peasants, craftsmen, miners, beggars, street vendors, Turks, Persians, and Chinese were fashioned from wax or clay. From these, plaster-of-Paris moulds were made, from which came press-moulded porcelain figures, used to replace figures for table decoration made of wax, marzipan, or sugar paste. No longer did porcelain seek to compete with hardstones, metal, or marble sculpture – it had found an identity all of its own.

Early figures stood on flat mound bases applied with flowers to disguise firing faults. Gradually, bases became more Rococo in style, with flamboyant gilt scrollwork. By the 1760s, they were raised on high scrolled feet with pierced decoration to give an illusion of fragility. The enamels changed from the strong Baroque colours to a paler palette of pinks, lilacs, primrose, and turquoise, and clothing on the figures was painted with oriental flowers.

Between 1737 and 1741, Kaendler and Johann Friedrich Eberlein (b.1696) designed for Count Brühl, chief minister of Augustus III, an armorial service of over 1,000 pieces, each decorated in low reliefs with swans. By the 1750s, tablewares were pierced with trellis or basketwork and painted with flowers, birds, hunting scenes, and amatory subjects after Watteau and Teniers.

Small *galanteriewaren* (toys), such as scent bottles, *étuis*, and snuffboxes, previously the province of the goldsmith and enameller, were now made in porcelain.

Before long, Meissen's closely guarded secret had spread all over Germany, and rival factories opened up under royal patronage. However, all were surpassed by the brilliance of Franz Anton Bustelli (*c*.1720–1763), at Nymphenburg, whose series of figures from the *Commedia dell'Arte* epitomized the spirit of the Rococo.

1 *The sense of nervous, asymmetrical energy emerging from natural forms is evident in the high scrolling crest of the clock, which is surmounted by the figure of a water nymph, while C-scrolls composed of water reeds flank the sides, and the high S-scroll feet suggest fishes' tails. The painting of lovers after Watteau and the gilding add to the effect. Ht 40.5cm/16in.*

2 *The shape of this Meissen scent bottle, made c.1750, is typically Rococo in its asymmetry, as is the object itself. Watteau, Pater, and Teniers provided inspiration for the scenes on Meissen wares. Ht 14.5cm/5¾in.*

3 *Contemporary silver inspired the design of this c.1750 pair of Meissen vases. They display an inventive use of C- and S-scrolls, outlined in monochrome and gilding to create an elegant, restrained effect. Ht 12cm/4¾in.*

4 *This slightly later pair of Meissen vases for pot-pourri, made c.1755, was modelled by J.J. Kaendler in the full-blown Rococo style, with flamboyant scrollwork and pierced decoration. In comparison to the vases above, they are neither restrained nor elegant. The vases represent* **Earth** *and* **Air** *from a set of elements. Ht 42cm/16½in.*

5 *The Rococo love of natural forms can be seen in this Meissen* **schneeballen** *(snowballs) teacup and saucer, made c.1745, with the outer surface of both pieces being encrusted with mayflowers.*

6 *Puce, or pink, was a characteristic colour for painting* **en camaieu** *(in monochrome simulating a cameo) during the Rococo period, and it enhances the femininity of this pair of Meissen chocolate cups on a tray, made c.1750, as do the curved outline of the tray, the pierced* **trembleuses** *galleries (to hold the cups steady when handled by trembling hands), and the Watteau vignettes. W. 28.5cm/11¼in.*

French and Italian Porcelain

Early Developments in Vincennes

1 The bombé form of this Vincennes vase and the scrolling acanthus leaves that flow round the body are typical of the Rococo love of sinuous and natural forms. The use of gilding was restricted to the Vincennes and Sèvres factories.

2 These Vincennes flowerheads, mounted on painted tôleware stems and leaves, display the Rococo love of imitating nature. Produced from c.1745, the flowerheads were among the most successful of the early wares, because their small size presented no firing problems. A special studio that employed the women and girls who made each separate petal and stamen was set up for their production.

Porcelain was first made in France at Rouen, St. Cloud, Chantilly, Mennecy, and at Vincennes. French porcelain was different to the hard-paste porcelain of Germany and the Orient. Kaolin was not discovered until 1768 at St. Yrieux, near Limoges, but the French created a soft-paste, or artificial, porcelain from a glassy frit mixed with white-burning clays. It was prone to cracks and blemishes.

The Vincennes (later Sèvres) factory was taken over by royal administration in 1759. It took six years to master the firing of biscuit (unglazed porcelain) and the lead glaze, and in 1748 a kiln was invented to fire enamels. The factory hired enamellers to develop colours to be mixed with shaded *fondants* (pastes) and fused with the glaze. In 1748 gilding was also discovered. Among the earliest wares were lifelike porcelain flowers that were mounted on tôleware stems. From 1751 small pieces were decorated with an underglaze-blue (*bleu-lapis*) ground, and birds and flowers were painted in reserved panels with gilt scroll-edged Rococo borders. Other colours – turquoise (*bleu-céleste*), pink (*rose Pompadour*), and green (*verd*) – followed.

Madame de Pompadour, Louis XV's mistress, was responsible for moving the Vincennes factory to Sèvres in 1756. She took an interest in its development and helped to employ top French designers and craftsmen, including Juste-Aurèle Meissonnier (1675–1750) and the sculptor Etienne-Maurice Falconet (1716–91), whose influence was seen in the swirling use of natural forms in tureens and vases, and biscuit figures used as table decorations, some adapted from the paintings of François Boucher (1703–70). Scenes from Boucher's work were translated onto wares and vases by the Sèvres painters and expressed in the spirit of the Rococo, with putti, shepherdesses, and nymphs. These costly wares reflected the opulence of aristocratic life in pre-Revolutionary France.

Of the other French factories, St. Cloud excelled in bérainesque decoration in underglaze-blue, while Chantilly specialized in Kakiemon-inspired motifs painted on a white tin glaze. Mennecy's softly coloured flowers were highlighted by rims painted in yellow, blue, and puce, since only Sèvres was allowed to use gilding.

1 The use of the luscious colour grounds on this ewer and basin was a particular feature of Sèvres during the 1750s and 1760s. The pattern projects a sense of movement typical of the Rococo style.

2 This Sèvres rosewater ewer and basin, made c.1755, emphasizes the curvaceous nature of Rococo design in porcelain. The turquoise (bleu-céleste) ground colour was invented in 1753. It was very expensive to use, partly because its high copper content could damage other pieces in the kiln.

4 The thick base and somewhat indistinct modelling of this Mennecy group show some of the problems associated with soft-paste porcelain, which was fragile and often collapsed in the kiln. Ht 14cm/5½in.

5 A Capodimonte (Carlo III) figure of a woman dancing, modelled by Giuseppe Gricci c.1750. The object shows distinctly the soft, melting quality of soft-paste porcelain and its disadvantages for the modeller. Ht 14.5cm/5¾in.

3 The underglaze gros-bleu was the first ground colour to be invented in 1752 at Vincennes, and it complements rich gilding. As many as three layers were often applied. The form copies the orange tree tub of the time. Ht 14cm/5in.

A German Comparison

1 This outstanding example of a chinoiserie group was made in Höchst, Germany, in 1765. The particularly sharply detailed modelling and piercing was possible because the group was made of hard-paste porcelain. In comparison, figures made of soft-paste porcelain (see 4 & 5 above) seem blurred.

English Porcelain

Early Soft-Paste Porcelain

1 *A silver prototype by Nicholas Sprimont, the founder of the Chelsea factory, inspired the making of this goat and bee jug c.1745. As in the earliest wares of all factories, it lacks the technical refinement of colour and gilding and relies on the creamy soft paste for its aesthetic impact. Ht 11.9cm/4¾in.*

2 *This small Chelsea figure symbolizes* Winter *from a set of the* Four Seasons, *made c.1755. The base has been applied with flowers in the style of Meissen, but also serves to disguise small imperfections that commonly occur during the firing of soft-paste porcelain. As with many early English figures, it is somewhat crude and static. Ht 13.5cm/¾in.*

Ornamental Influences

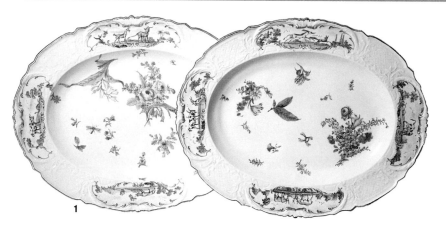

1 *These Chelsea dishes, made c.1755, are painted with scroll-moulded vignettes of scenes from Aesop's fables in the style of J. H. O'Neale. The scattered flower sprays, which are in Meissen style, are placed to cover black specks, bubbles, and firing cracks. W. 43cm/17in.*

2 *The pattern on this Bow leaf-shaped dish, c.1755–6, is copied from a Japanese* Kakiemon *original or its Meissen copy. The shape reflects the Rococo love of natural forms. L. 25cm/10in.*

3 *Moulded all over with vine leaves, this Longton Hall teapot, c.1755, is a Rococo fantasy. The crabstock handle and spout are found on porcelain and earthenwares of the mid-18th century. Based on a crab apple branch, the handle is flimsy for the weight of a full pot, but it was very fashionable. Ht 13.5cm/5¼in.*

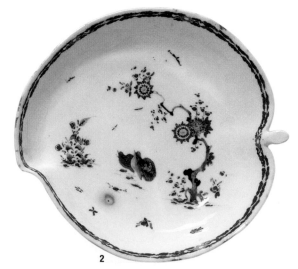

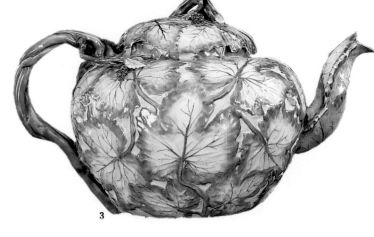

Triumphs and Failures of Later Developments

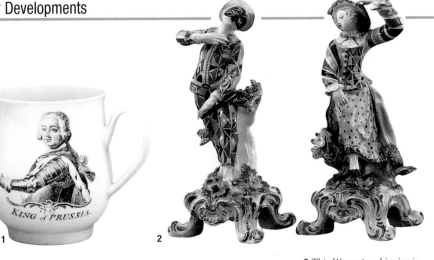

1 *One of England's greatest contributions to the ceramic world was the technique of transfer printing, which enabled copper-plate engravings to be transferred to porcelain and pottery. This speeded up the decorative process, and made porcelain, with decoration printed under or over the glaze, more freely available to the middle classes. This Worcester mug, c.1757, is printed with a portrait of the king of Prussia. Ht 10.2cm/4in.*
2 *This pair of Bow figures of* Harlequin and Columbine *from the* Commedia dell'Arte, *made c.1765, stand on high scrolled Rococo bases, which were popular during the late 1760s. Although these are based on Meissen models, they are crude and doll-like in comparison with the originals.*

3 *This Worcester chinoiserie teapot, made c.1755–60, shows the neat potting and strength of body that became possible at Worcester after the introduction of soapstone to the paste. The steatitic body proved ideal for useful wares, and this practical design is typical. Ht 12cm/4in.*
4 *The body of this Bow coffee pot, made c.1760, is covered with moulded Rococo C- and S scrolls. The clumsy serpent spout with overlarge tip, the mask below the neck, the knop, and the splayed scroll feet all make for an object that aspires to sophistication, but fails dismally, although with a certain charm. Ht 30.5cm/12in.*

If continental porcelain was elegant, its English counterpart was pedestrian. This was partly due to the soft-paste porcelain and an English conservatism in the arts, but also because the factories had no royal patrons paying for experiments. Like the French, the English soft-paste porcelain was made by mixing white-burning clay with a glassy frit. Instability in the kiln produced warping and firing cracks. The glaze was thick and difficult to control.

England's first porcelain factory was at Chelsea in London. Nicholas Sprimont (1716–71), a Huguenot silversmith from Liége, designed early pieces influenced by Huguenot Rococo silver. On tablewares of the 1750s, flowers, landscapes, and harbour scenes were adopted from Meissen, and Japanese Kakiemon patterns were also copied. Aesop's fables were painted on tea and coffee wares by Jeffreyes Hammet O'Neale (d.1801), and a series of botanical wares named after Sir Hans Sloane were remarkable for their uninhibited flamboyance.

Moulded borders became popular, and the Rococo taste for natural forms was seen in leaf and flower-shaped dishes, as well as boxes and tureens modelled as fruits, vegetables, birds, and animals. Figures were influenced by Meissen, and many were modelled by Joseph Willems (1715–66). By the mid-1760s, large figures were supported by sturdy, flower-encrusted back supports, or bocages.

In the 1760s luscious colour grounds with exotic birds and flowers in frames of heavy Rococo tooled gilding were popular. Some of these efforts at sophistication were clumsy and beset by technical problems. In 1769 the Chelsea factory closed after only twenty-four years.

The Bow factory was founded in 1744 and catered for a middle-class clientele. Kakiemon-style decoration and blue-and-white chinoiseries were cheap and popular, as were white wares copied from Chinese *blanc-de-Chine*. Bone ash was added to the Bow paste to give stability. This allowed for high Rococo bases on large figures.

Other factories made soft-paste porcelain, but it was at Worcester that a new formula was discovered. Dr Wall's porcelain body included soaprock (steartite) and his wares became more functional, with neat, heat-resistant shapes.

Pottery

The Continuing Fashion for Blue-and-White

1 *A delicate linear pattern incorporating putti and scrolls can be seen on this French faïence stand painted in cobalt blue, c.1720. The design closely follows the style of contemporary French prints. Diam. 21cm/8¼in.*

2 *In this panel of ornament by Jean Bérain, c.1690–1720, the design is reminiscent of 16th-century grotesque ornament, but it has a lightness that characterizes the Rococo style.*
3 *This Portuguese tile panel, made 1720–30, uses blue-and-white colours but depicts European figures within a frame of curves.*

Changing Tastes in European Earthenware

1 *The scattered bunches of naturalistic flowers arranged asymmetrically on the surface of this plate, made in Strasbourg c.1755, and the dominant rose pink are characteristic of French faïence in the middle of the 18th century. They reflect the influence of German porcelain. Diam. 24.5cm/9¾in.*
2 *The design elements of this cartel clock, made in Strasbourg c.1750–1760, incorporate broken curves and lively, twisted female busts, which recall earlier French furniture mounts and the work of the designer Juste-Aurèle Meissonnier. Ht 1.10m/3ft 7in.*

3 *This lively and realistic tureen and cover, made in Marseilles c.1770, is in the form of a turkey. It is a late example of the widespread interest in naturalistic forms, which can be seen in every branch of the decorative arts. Ht 38.5cm/15in.*

1 *The shape of this Staffordshire red stoneware coffee pot, inscribed Joseph Edge and dated 1760, derives from silver, but the naturalistic treatment of the handle and spout and the asymmetrically placed sprays of flowers are typical of English pottery. Ht 21.3cm/8⅜in.*
2 *This thinly potted, salt-glazed stoneware sauceboat, made in Staffordshire c.1755, has scrolling lines and naturalistic flowers painted in enamel colours such as rose pink. L. 16cm/6¼in.*
3 *This large, salt-glazed stoneware punch pot, made in Staffordshire c.1755, combines a naturalistic crabstock spout and handle with Chinese figures picked out in an intense rose pink. Ht 18.5cm/7¼in.*

The Emergence of Cream-Coloured Earthenware

1 *Wedgwood made this cream-coloured earthenware teapot c.1763 in the form of a realistic cauliflower, with the lower part in a rich green glaze. Other pieces were made as melons and pineapples. Ht 12cm/4¾in.*
2 *Applied Rococo-style decoration, including shells and ribbon-tied branch handles, can be found on this cream-coloured earthenware tureen, cover, and stand, made in Leeds or Staffordshire c.1770. L. 42cm/16½in.*

An awareness of the emerging Rococo style can be seen in the development of French faïence in the 18th century. Early wares continued to be painted directly onto the unfired glaze, using high-temperature colours, particularly cobalt blue, and to favour symmetrical designs derived from engraved sources but developed into a lighter, more delicate style. This was superseded in the middle of the century by the development of low-temperature colours, which were applied onto an already fired glaze and given a third firing in a muffle kiln. This technique allowed for a wider and more delicate range of colours, in particular, a rose pink enamel derived from chloride of gold. This softer, more delicate colour scheme was combined with the random placing of naturalistic ornament and a pronounced liking for asymmetry of form, reflecting current fashions in porcelain. A taste for utilitarian objects modelled in the shape of animals and birds reflected an interest in naturalistic forms.

In England, Rococo forms and motifs deriving from continental silver and porcelain can be seen in the stone-wares and earthenwares produced in Staffordshire in the second half of the century. These often appeared ten or more years after they had gone out of fashion for items made in other materials.

The use of S- and C-shaped curves, a liking for asymmetry, and an interest in forms derived from nature, which had already been used by the English porcelain factories, can be seen in both the revived red stonewares of the 1750s and 1760s and in the thinly potted, white salt-glazed stonewares developed from the early experiments of John Dwight, which were discussed in the last chapter. Although often relying entirely on moulded decoration, these white wares were occasionally painted in enamel colours, once again looking to European and oriental porcelain for the colour scheme and subject matter.

The material that dominated English pottery in the second half of the 18th century was a refined cream-coloured earthenware, which will be discussed more fully in the next chapter, but which continued to exhibit Rococo tendencies well into the 1760s.

Glass

Eastern Europe and Holland

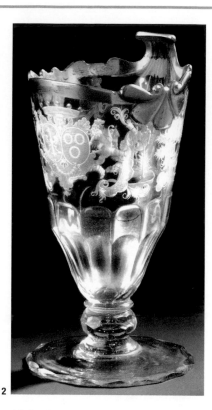

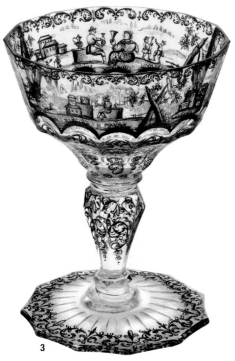

3 *Sweetmeat dish with Schwartzlot (black-lead) enamelled drinking scenes by Ignaz Preissler, c.1730. Preissler's motifs, often drawn from contemporary engravings, were frequently embellished with iron-red, gilt, and scratched highlights. Ht 12cm/4¾in.*

1 *Bohemian Zwischengoldglas (gold under glass) lidded goblet, decorated in enamel and silver and gold leaf sandwiched between two layers of glass, with a huntsman on horseback, c.1740. Ht 21cm/8¼in.*
2 *Scalloped "ambrosia" sweetmeat dish, theoretically intended for supping the nectar of the gods; the archetypal Rococo vessel. Silesian, c.1750. Engraved with scrolls and family armorial crest flanked by lions. Ht 15cm/6in.*

Glass proved a perfect vehicle for Rococo decoration, typified by intimate, colourful, elegant, and often dream-like images executed in enamels, gold, and engraving. Its principal themes were courtly love, the countryside, ships, ruins, and exotic, supposedly Chinese, Indian, and Turkish scenes.

Vessel glass could not be formed into Baroque and Rococo's curves and lattices. Indeed, the shape of its standard vessels, beakers, goblets, decanters, and *Pokalen* (covered goblets) remained constant throughout most of the 18th century. However, the scalloped "ambrosia" sweetmeat dish, descended from medieval rock crystal, proved the archetypal vessel of Rococo glassware.

Many Rococo trademarks, including scrolls, strapwork, and grids, were culled from pattern books, notably those of the Parisian architect draughtsman, Jean Bérain. His work was plagiarized and published in 1759 in England by Paulus Decker whose *Chinese Architecture, Civil and Ornamental* and *Gothic Architecture Decorated* became, together, the Rococo decorator's style bible.

Sponsored by noble patronage, the small region encompassing Bohemia and Silesia became Europe's most influential and leading producer of finely decorated glassware. The taste of the Hapsburg Empire's aristocrats ensured a gradual shift from ponderous Baroque to Rococo's lighter, more frivolous themes. Backed by centuries of experience, Bohemian glass decorators proved masters at the three main forms of Rococo embellishment: enamelling, gilding, and engraving (see p.110). Their work ultimately eclipsed previous centres of excellence, including Berlin, Nuremberg, Thuringia, and Dresden.

Bohemian Rococo glass decoration proved so alluring that, by the mid-18th century, the *façon de Bohème* had become ubiquitous across most of Europe. The glass industries of several countries, including Italy, Spain, Portugal, Russia, Holland, and France, became virtual fiefdoms of Bohemia, with its migrants supervizing local production and decoration. By *c.*1750, Bohemians operated 50 foreign glassworks across Europe and North America and had effectively captured the world market.

4

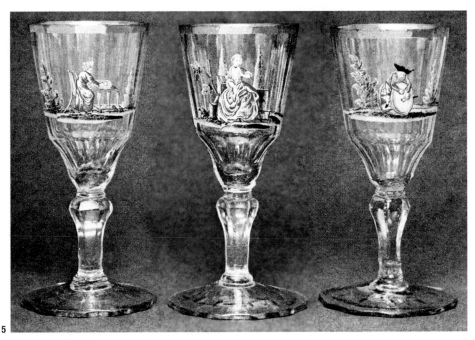

5

4 *Flute-cut Bohemian beaker decorated with a woman dressed as a shepherdess, a man as a huntsman with his dog, and an obelisk framed by Rococo shells in polychrome enamels, c.1760. Ht 9.5cm/3¾in.*

5 *Three goblets decorated with typical Bohemian Rococo polychrome enamelling, of a clown, a woman in a pink gown, and a man in a turban, probably executed by a* Hausmaler *(home decorator), 1735–40. Ht 14cm/5½in.*

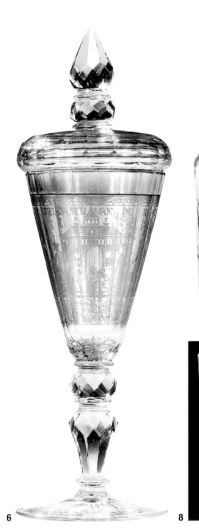

6

7

8

9

6 *Bohemian Zwischengoldglas lidded goblet decorated for the Dutch market with a continuous scene of a house, ship, and harbour, and a commemorative inscription, c.1730. Ht 27cm/10½in.*

7 *Average quality Bohemian cylinder decanter with a ball stopper and Rococo gilding of a man walking his dog, framed by trees and scrolls, c.1770–80. Ht 25cm/9¾in.*

8 *Venetian tumbler decorated in polychrome enamels in the Bohemian style with the arms of the da Ponte family, the Rialto bridge, and a coronet, attributed to Osvaldo Brussa, c.1770. Ht 11.5cm/4½in.*

9 *Two Bohème-style decanters, made and/or decorated in Spain by Bohemian migrant craftsmen, with Rococo floral gilding and hollow Kugel "scoop" cutting (hollowed cuts as if made by a fingernail). Left: ht 20cm/7 ¾in. Right: ht 23cm/9in.*

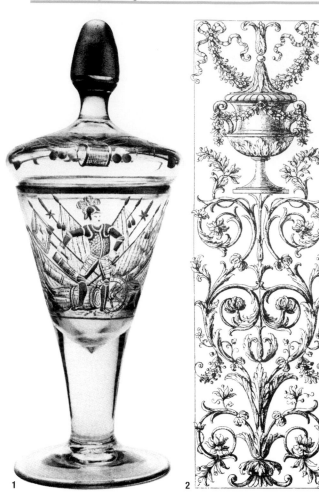

3 *Chinoiseries, birds, flowers, insects, and ruins were among thousands of ideas illustrated in the pattern book published under the twin titles,* The Ladies' Amusement *or* The Whole Art of Japanning *(1762).*

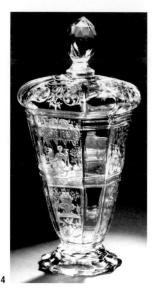

4 *Silesian pokal, c.1745, engraved with* Hope *in the figure of a maiden, ships at sea, and the inscription, "Now Is Hope Soon To Be Fulfilled," framed by bérainesque strapwork and scrolls. Ht 19.5cm/7¾in.*

1 *Military heroes were favoured glassware motifs. This Potsdam engraved and gilt pokal, c.1740, features a victorious commander in polished Tiefschnitt (deep carving) engraving heightened with gold. Ht 30cm/11¾in.*
2 *Typical pattern book design by Jean Bérain. His drawings proved one of the strongest influences over the Baroque and Rococo styles and were widely applied across the decorative arts.*

Rococo glass engraving was inspired by techniques and themes pioneered by Caspar Lehmann in Prague from c.1600. Cheaper and more stable than the previous medium, mineral rock crystal, glass proved perfectly suited to Rococo's light, superficial airs.

Drawing on a range of some 40 differing wheels applied with abrasive paste, the engraver gradually scored images, often drawn from Bérain and other pattern books, in straight and curving lines. The effect was heightened by selective polishing, gilding, and cutting, and in differing profiles ranging from light scratches to deep grooves. The main characteristic of Baroque and Rococo engraving was the proliferation of scrolls and *Laub und Bandelwerk*, literally, "leaf and strapwork."

The central European nobility adopted decorated glassware as relatively cheap wealth statements, inadvertently sponsoring the development of sumptuous engraving in the rock-crystal style, notably on lidded goblets, or *Pokalen*. The genre proved so popular that the number of engravers working in the Silesian spa town of

Warmbrunn, for example, rose from six to over 40 in the decade to 1743.

The proliferation of capable craftsmen encouraged many to seek fame and fortune in Denmark, Norway, Sweden, Poland, Spain, Russia, Hungary, Bulgaria, and Britain. This migration contributed to a general stylistic uniformity in European glassware, c.1700–70. The exceptions were British and Dutch engraving: the former for its mediocrity; the latter for its quality and individuality.

Continuing the 17th-century Dutch tradition for diamond point calligraphy, Frans Greenwood (1680–1761), David Wolff (1732–98), and others produced an outstanding series of unique stippled portraits and figurative work. However, the most notable Dutch-based wheel-engravers were the Bohemians Simon and Jacob Sang (d.1783), members of a dynastic family of glass decorators, who worked in Amsterdam from c.1753. Their Rococo wheel engraving on lead-based Angleterre-style Dutch-made baluster goblets, include some signed commemorative and ornamental pieces.

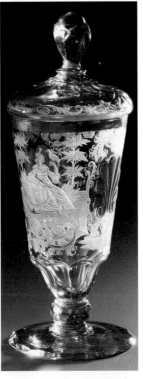

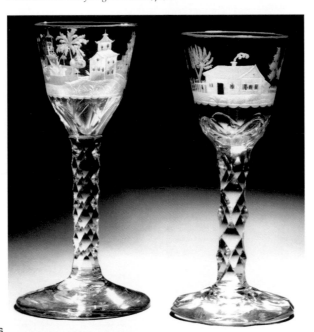

5 *Amethyst-tinted Silesian engraved, cut, and gilt pokal, c.1760. The bowl is cut with chevrons and petals, and engraved with figures amid Rococo scrolls and foliage. Ht 20cm/7¾in.*

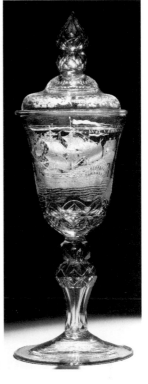

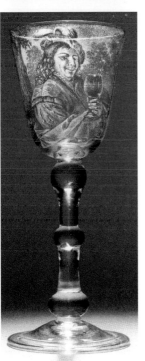

6 *Two chinoiserie engraved British facet-stemmed drinking glasses, more attractive for their naive charm than quality of execution. Ht 15.3cm/6in.*
7 *Dutch lidded goblet engraved with a ship in full sail, the stem and lower bowl cut with Angleterre (English-style) cut motifs, c.1765. Ht 35.6cm/14in.*

8 *An English-style baluster glass with a stipple-engraved portrait after Frans Hals, signed and dated Frans Greenwood, 1745. In stipple-engraving the image is created by repeatedly tapping at the glass with a pointed tool. Ht 25cm/9¾in.*
9 *Fine, large Thuringian covered goblet engraved with a continuous scene of a rider in woodland by Andreas Sang, father or brother of Jacob, signed and dated 1727. Ht 18cm/7in.*

10 *Angleterre-style facet-stemmed drinking-glass, the bowl stipple-engraved with a friendship scene, c.1775. Ht 16cm/6¼in.*
11 *Light baluster drinking-glass engraved with a Dutch inscription and Rococo scrolled cartouche, signed on the foot "Jacob Sang inv et Fec, Amsterdam 1760." Ht 18.2cm/7¼in.*

British Glass

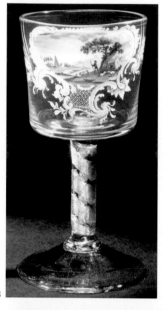

1 *Pair of tall candlesticks, c.1765, the epitome of British Rococo cutting. The stems cut in hollow-diamond facets, the feet and nozzles in shallow slices, creating a series of flat and diamond-shaped motifs. Ht 36.8cm/14½in.*

2 *Cobalt-blue ewer, c.1765, typical of British cutting during the Rococo period. British craftsmen had yet to develop curved cut motifs and remained stylistically restricted to straight lines, shallow slices, and large stars. Ht 23.5cm/9¼in.*

3 *Goblet with an air-twist stem, the bowl decorated in polychrome enamels by the Beilbys. A pastoral scene is set within a cartouche of scrolls. Ht 8.2cm/3¼in.*
4 *Sugarloaf decanter with a Rococo cartouche for BEER and decorated with hops, barley, and a butterfly in opaque-white and turquoise enamels by the Beilbys, c.1770. Ht 28cm/11in.*

5 *Giant baluster glass, probably Dutch, in polychrome enamels, with William of Orange's arms within Rococo borders, signed "Beilby Newcastle," c.1766. Ht 36cm/14¼in.*
6 *Opaque-white stemmed British drinking glass, the bowl decorated by the Beilbys with fruiting vines. Ht 15.2cm/6in.*

7 *Sugar bowl decorated in opaque-white enamels by the Beilby family, with a shepherd guarding his flock while sheltering under a tree, c.1765. Ht 10cm/4in.*

Britain, which mistrusted both France and Catholicism, initially resisted the Rococo style that was associated with both. Besides, Baroque had been superseded in Britain by the sober Queen Anne style, *c.*1710, and its Protestant people preferred plain or shallow-cut glassware to Bohème glass decoration, regarding it as ostentatious, effeminate, and foreign. Even at the height of Rococo's popularity in Britain, *c.*1755, the critic Robert Morris lampooned its whimsical airs with a *Treatise on...elegant Pig-Styes, beautiful Henhouses and delightful Cow Cribs... according to the TURKISH and PERSIAN manner.*

Some British silverware was embellished with asymmetrical scrolls as early as 1730, at least a decade before Rococo's earliest manifestations on the nation's glassware. Even then, cut facets and slices, and enamel and air-twisted drinking-glass stems paid it only minor allegiance, the former being more *Angleterre* than *Bohème*, and the latter harking back to the *Venise*.

The finest British Rococo glass decoration was executed in enamels and gold. The leading British

8 *The Beilbys were not Britain's only Rococo enamellers. This cordial glass, c.1770, with bawdy polychrome enamelling by an unidentified Scottish hand, bears the name and insignia of the Beggar's Benison, an Edinburgh-based gentleman's drinking club. Ht 13cm/5in.*

9 *British opaque-white candlestick and tea canister decorated in polychrome enamels probably in south Staffordshire, c.1760. The popularity of opaque-white waned from 1777 when changes in the tax law raised its price. Candlestick ht 22.8cm/9in. Caddy ht 12.7cm/5in.*

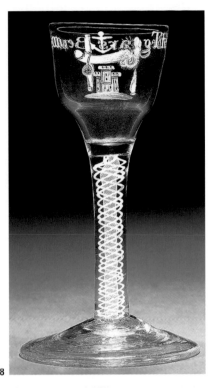

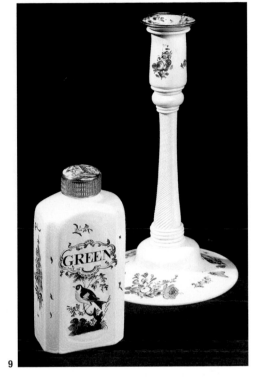

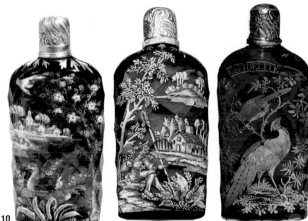

10 *Coloured and cut-glass smelling bottles, decorated in the workshop of James Giles, c.1760–5. Ducks, blossom, imaginary landscapes, chinoiseries, and game-birds were standard motifs of the British Rococo vocabulary. Ht (approx.) 8cm/3¼in.*

11 *Emerald-green vase, shaped in the manner of Chinese porcelain, decorated in gold with young lovers as haymakers, by James Giles, c.1760–5. Ht 40cm/15¾in.*

12 *A transitional piece; Neoclassically shaped urn decanter decorated with Rococo scrolls and lattices in gold by James Giles, c.1765–70. Ht 21.7cm/8½in.*

enamellers were William and Mary Beilby of Newcastle, active between *c.*1760 and 1778. Working in a polychrome and bluish opaque-white palette, mostly on drinking wares, they applied Rococo motifs including heraldic crests, ships, shepherds, ruins, and so on, in a quality that at least matched the finest in Europe.

Opaque-white glass, itself typical of British Rococo, was painted with polychrome vitreous enamels in several centres, including Bristol and Staffordshire, and was widely advertised between 1743 and 1767. Favoured subject matter included pattern-book flowers and insects, applied to vases and tea canisters.

Britain's most versatile glass decorator, James Giles of London (1718–80), was also among its leading porcelain painters. Working between *c.*1755 and 1776, Giles applied a distinctive range of Rococo and, later, Neoclassical motifs on to all manner of glassware in gold and polychrome enamels. Giles's repertoire ranged from unique geometric mosaic patterns to typically British Rococo floral sprays, scrolls, chinoiseries, and the exotic.

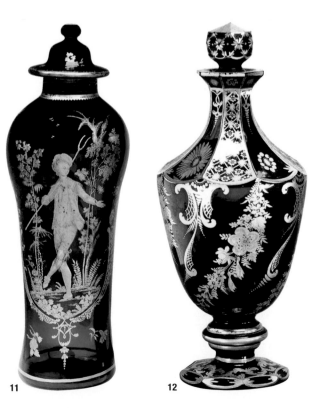

Silver and Metalwork

Meissonnier and Early French Rococo

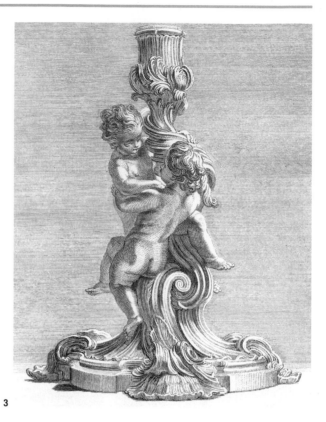

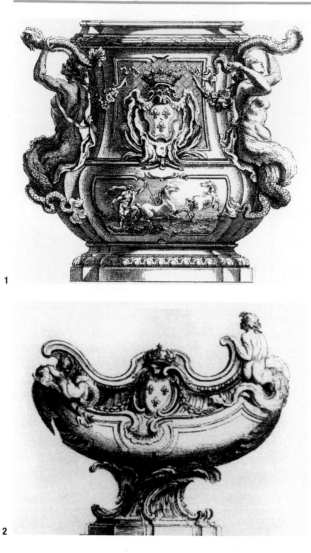

1 *Juste-Aurèle Meissonnier's design for a wine cooler made in 1723 for the duc de Bourbon is transitional between the Régence and Rococo styles. Some ornamental forms, like the basketwork behind the coat of arms, are conventional, but the cartouche and the handles are more energetic.*
2 *The nef, or ship model, traditionally marked the place of the king or great noble at table. This curvaceous and sculptural nef was by Meissonnier for Louis XV, c.1725.*
3 *Meissonnier's 1728 candlestick comprises two putti amid rising scrolls. Its composition is so complex that he drew it from three different angles.*

In France, Britain, and much of northern Europe around 1720, design was dominated by the ornamental style now known as Régence, after the duc d'Orléans who served as regent during the minority of Louis XV. Effectively a lightening of the architectural Baroque style of Daniel Marot and others, this was led by artists such as Jean Bérain, whose widely circulated ornament prints influenced design in all areas of the decorative arts.

Into this relatively stable environment, the new Rococo style erupted as one of the most sudden and startling developments in the history of design. Its application to the decorative arts is largely identified with Juste-Aurèle Meissonnier (1695–1750), the son of a prominent Turin goldsmith, who came to Paris in about 1715 and who was appointed *Dessinateur de la Chambre du Roi* in 1726. This appointment and his commissions from patrons like the duc de Bourbon ensured a high profile for his original and astonishingly inventive designs.

Largely a French phenomenon, the Rococo style derives its name from *rocaille*, meaning rockwork, but its roots were in Italy. It emerged in part from late Baroque architecture, especially the work of Carlo Borromini and Filippo Juvarra and in part from the irregular forms found in nature and long used to decorate fountains and grottoes. Its essence, as illustrated by the title page of Meissonnier's *Oeuvre* (1748), or by his 1728 design for a candlestick, is a radical re-working of the familiar building blocks of ornament – scrolls, cartouches, classical architectural motifs, and shells – combined with naturalist motifs, and used in such a way that symmetry is abandoned, while the whole composition conveys a lively sense of movement and energy. Although apparently random and free, the style in fact demanded considerable intellectual dexterity, if the balance between the appearance of freedom and the necessary tension to hold it together was to be retained.

Very few of Meissonnier's works in gold and silver survive, and it is difficult to assess the full extent of his influence, but he was not alone among the Parisian artistic community in having been exposed to the late

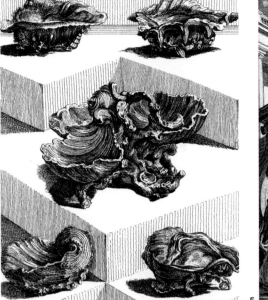

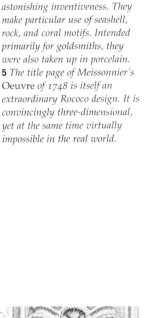

4 *This series of designs for salt cellars shows Meissonnier's astonishing inventiveness. They make particular use of seashell, rock, and coral motifs. Intended primarily for goldsmiths, they were also taken up in porcelain.*
5 *The title page of Meissonnier's* Oeuvre *of 1748 is itself an extraordinary Rococo design. It is convincingly three-dimensional, yet at the same time virtually impossible in the real world.*

6, 7 *The suite of silver centrepiece and two soup tureens designed for the 2nd duke of Kingston in 1735 and partly executed over the next several years is one of the few major Meissonnier commissions to survive. The tureens are completely asymmetrical and bear no trace of traditional classical ornament, depending solely on a combination of abstract scrolls and shells and carefully studied vegetable and animal forms. The centrepiece was probably never made. Tureen ht 37cm/14½in.*
8 *Three-light candelabrum designed by Meissonnier for the duke of Kingston and made in Paris in 1734–5 by Claude Duvivier. Like the tureens, the design has replaced the language of classical ornament with an energetic but cohesive composition of interacting scrolls and shell motifs. Ht 38.5cm/15¼in.*

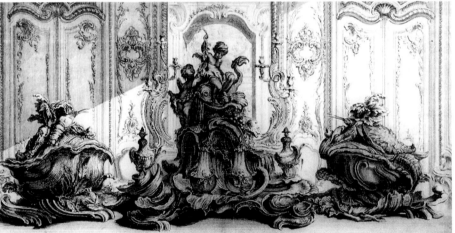

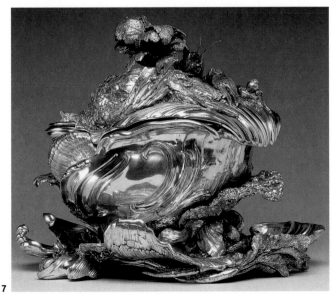

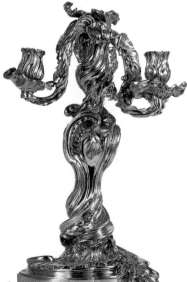

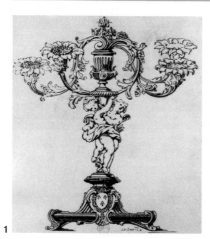

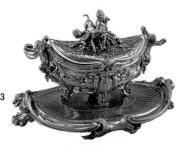

1 Thomas Germain's design for a gold candelabrum was commissioned for the king in 1739 and is composed of putti supporting floral branches. It is highly Rococo but more symmetrical and conventionally structured than Meissonnier's designs.
2 Germain's earlier work breaks more radically with convention than his later designs. This wine cooler of 1727 was a royal commission and is composed entirely of stylized shell and vine motifs. Ht 22cm/8¾in.
3 François-Thomas Germain supplied this magnificent silver-gilt tureen to Joseph I of Portugal in 1757. It combines strong sweeping Rococo scrolls with classical motifs and a symmetrical plan. Plateau w. 58.5cm/23in.

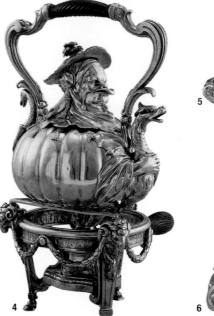

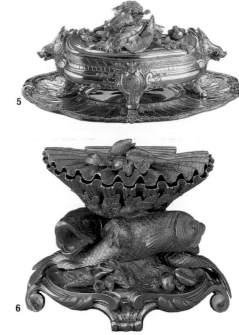

4 Part of the Portuguese royal service by François-Thomas Germain, this kettle of 1757 combines Rococo ornament with chinoiserie elements like the dragon spout. Ht 47.5cm/18¾in.
5 This tureen and cover of 1733–4 by Thomas Germain is typical of his combination of classical, sculptural, and Rococo ornament with a well-judged sense of form and proportion. Tureen w. 48.5cm/19in.
6 This gold salt cellar of 1764 by François-Thomas Germain from the Portuguese royal service probably copies a design by his father and translates the style of the great tureens to a smaller scale. Ht 5.5cm/2¼in.

Italian Baroque. The great goldsmith Thomas Germain (1673–1748) had trained in Rome and was also back in Paris by about 1715. He had worked under Giovanni Giardini on the church of the Jesù and his earlier works in silver, such as a wine cooler of 1727, are conceived in a radical sculptural Rococo manner.

The success of any style, however, depends as much on its acceptability to patrons as the creativity of artists, and the evidence is that in general the vigorous organic style of the most fully developed Rococo did not appeal to all. The style of Germain's earlier works, for example, was not maintained throughout his career, and his later works – and those of his son François-Thomas (1726–91) – are generally of a rather more accessible nature.

In one form or another the Rococo enjoyed a vogue across most of Europe, although in some areas, especially in eastern Europe and Russia, its adoption was later than in France and Britain. Meissonnier's *Oeuvre* of 1734 was one of the first of many Rococo pattern books for the use of goldsmiths, cabinetmakers, and other craftsmen

published all over Europe. Although a style identified in large measure with France, there were nonetheless strong regional characteristics. In southern Germany, a form of the style was developed under architects such as François Cuvilliés and Balthasar Neumann, while its application to the needs of goldsmiths was typified by the prints of Caspar Gottlieb Eissler (*fl.c.*1750). The most ambitious designs in silver, such as the grand service of tureens and centrepieces made by Bernhard Heinrich Weyhe (1701–82) in Augsburg for the Prince Bishop of Hildesheim, have a more staccato and less organic character than the styles of Meissonnier and Germain.

The aesthetic of fluid scrolls and shell forms that largely defined the Rococo style was equally well suited to other metalwork, and was particularly exploited by workers in ormolu. Intricate works in gilt bronze were difficult to cast and costly to work up and gild. As a result they were considered almost the equal of silver in terms of luxury but, since they were not made of precious metal, they have tended to survive in larger and more

Claude Ballin II

1 *Elaborate silver centrepieces, or* surtouts de table, *became fashionable in France in the early 18th century. This design by Claude Ballin II (1661–1754) combines candle branches, casters, cruets, and salt cellars with a central sculptural canopy in transitional Régence style derived from Jean Bérain.*

2 *Drawing of a* surtout de table *by Ballin II in the Hermitage. It is similar to the adjacent design but has substituted the central canopy for a tureen-shaped bowl.*

3 *These wine coolers of 1744 by Ballin II originally formed part of the same service as the Germain boar's-head tureens (see p.116), and combine conservative Régence ornament (panels of basketwork and reed-and-tie mouldings) with inventive handles in the form of poodles above applied sprays of bulrushes. Ht 25.5cm/10in.*

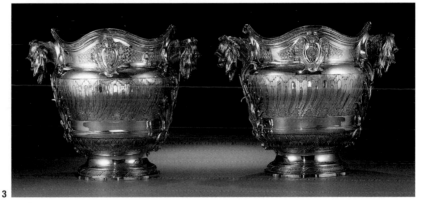

Later French Designs

2 *This design by Jacques de Lajoue (1686–1761) was published in Paris in 1734. Although in the form of a ship, it was probably meant to be used as a cartouche.*

1 *Design for a soup tureen from* Eléments d'Orfèvrerie *by Pierre Germain (1748). This pattern book did much to disseminate a slightly diluted version of the Parisian high Rococo style. Pierre Germain was not related to the famous goldsmiths of that name.*

1

1 Designs for vases at a large country house, anon., after J.B. Fischer von Ehrlach.
2 This sheet of flatware designs, from a series by Johann Baur (1681–1760), represents the same typically German interpretation of the Rococo as the larger pieces on this page.

2

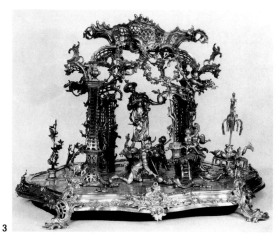

3

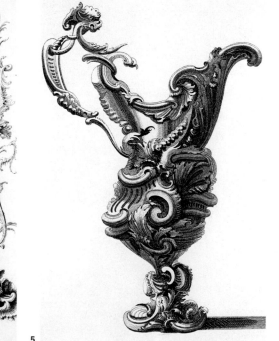

4 5

3 One of the centrepieces from the great dinner service made by Bernhard Heinrich Weyhe for the prince bishop of Hildesheim, c.1759–61. The tightly entwined scrolls and openwork of the design are very different in character from French Rococo. Ht 54cm/21¼in.
4 This ewer design forms the title page of a pattern book published by the Augsburg artist Christian Friedrich Rudolph (1692–1754), c.1750. Its densely packed and spiky quality is typical of the German response to the Rococo.
5 Caspar Gottlieb Eissler's ewer design was published in Nuremberg around the same time as Rudolph's pattern book, and is superficially similar but altogether more fantastical. Its exceptionally high relief has echoes of the Auricular designs of Adam van Vianen (see p.70), while the handle is reminiscent of the Mannerist style.

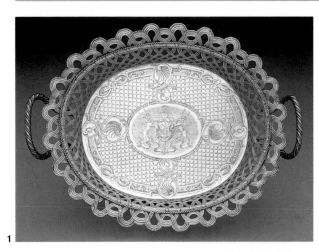

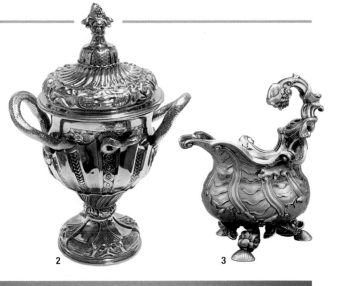

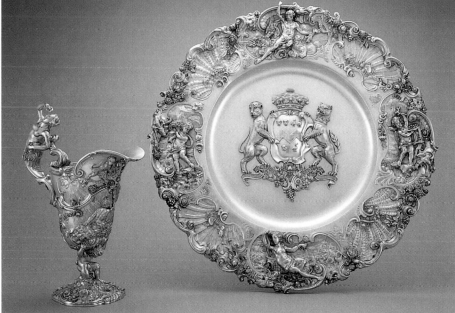

1 This 1731 silver basket is among Paul de Lamerie's earliest flirtations with Rococo. The basket imitates simple basketwork, but the engraving around the coat of arms includes small panels of slightly asymmetrical scrolls. W. 33cm/13in.
2 A highly inventive two-handled cup, 1737, by de Lamerie draws on elements of French Rococo and (in the grotesque mask on the foot) of 17th-century Auricular designs. Ht 36cm/14¼in.
3 This unmarked cream jug of about 1735 is probably by de Lamerie and includes some of his most typical motifs – scalework and a scroll handle terminating in a grinning mask. Ht 12cm/4¾in.
4 This 1742 ewer and dish by de Lamerie is densely decorated with the arms of the patron and ornament symbolizing the riches of the earth and sea. Dish diam. 75.5cm/29¾in.

representative quantities than silver. Other than pure sculpture, gilt bronze was most often employed as mounts to furniture and oriental porcelain, but it was also used for entire objects such as vases, candlesticks, and chandeliers. Because bronzes were not generally signed, the names of its practitioners are not as well known as those of silversmiths, but one of the most outstanding artists working in the medium was Jacques Caffiéri, whose 1751 chandelier in the Wallace Collection is one of the greatest works of the Rococo style.

In Britain, the style was also distinct from that of France, although the French origins of London's large Huguenot community are betrayed in a style that is more French-orientated than that of Germany. Leading goldsmiths such as Paul de Lamerie (1688–1751) and Paul Crespin were clearly aware of current trends in Paris and evidently made use of French pattern books. But they were eclectic and wide ranging in their sources. Not all goldsmiths of foreign extraction in London were French, and others, such as Nicholas Sprimont (1716–70), Charles

Kandler, and James Shruder introduced the influence of other countries, namely Belgium and Germany. Equally, native artists such as William Hogarth aspired to create a British Rococo of their own, and his St Martin's Lane Academy served as a catalyst and forum for their ideas. Many of the most original contributions to British Rococo silver, however, are anonymous, because they were the work of modellers who left neither drawings nor signatures. The artistic character of many of Paul de Lamerie's most ambitious works during the late 1730s and early 1740s, for example, is due principally to the anonymous modeller who was responsible for the relief ornament that enlivens what would otherwise be relatively standard forms.

Another important element of British Rococo silver is the engraved decoration that was generally in the hands of specialists, most of whom are also unknown to us. Books of cartouche designs and other two-dimensional ornament were published all over Europe during the second quarter of the 18th century, and most engravers

Silver Engraving

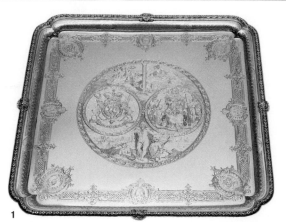

1 *The Rococo character of much British silver depends on its engraving. Most of this is anonymous, but the engraving of the centre of this large 1728 salver by Paul de Lamerie has been attributed to the artist William Hogarth.*
W. 48.5cm/19in.

Sprimont and Moser

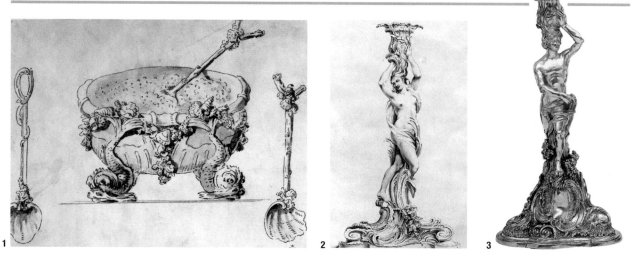

1 *The contribution of the Flemish goldsmith Nicholas Sprimont to British Rococo silver and porcelain was very distinctive, and this unsigned design for a salt cellar is typical of his sculptural approach to form.*

2, 3 *Another important figure was the immigrant artist, chaser, and enameller George Michael Moser. This silver candlestick, together with Moser's design for its pair, represent the myth of Daphne and Apollo, in which Daphne is transformed into a tree, a moment that Moser brilliantly represents by merging the figure with amorphous scroll-like ornament. Candlestick ht 37cm/14½in.*

made extensive use of these sources. Some original artists, however, engraved silver. William Hogarth (1697–1764), for example, began his career as an armorial engraver – though he found it too limiting – and occasionally signed works are found by engravers such as Joseph Sympson.

A particular field in which the British Rococo style flourished was that of gold and silver chasing, especially in the medium of luxury watch cases. These were often unsigned and their makers anonymous, but among the most prominent exceptions was the immigrant artist George Michael Moser (1706–83), who is known to have made both watch cases and gold snuffboxes. Moser is of particular interest because he worked not only as a chaser but also as an enameller. His exquisitely painted enamel scenes are among the most accomplished of all made in England during the 18th century.

The art of the enamellist enjoyed a marked resurgence during the Rococo period over much of Europe, with skilled practitioners working in London, Paris, Vienna, and a number of centres in Germany. Their trade was closely allied to the demand for gold snuffboxes, and decorative as well as pictorial enamels were made in both opaque painted and translucent enamel.

The Rococo, however, was not to everyone's taste. In France the Goût Grec began to appear as early as the 1750s, and in Britain it fell to William Kent (c.1685–1748), Hogarth's nemesis, under the patronage of Lord Burlington, to promote a form of Palladianism that amounted in many ways to a precursor of the Neoclassicism of the 1770s. Illustrated by Chiswick House and by his designs for plate which were published in the 1740s, these eschew both the decorative vocabulary and the compositional principles of Rococo in favour of a more sober kind of grandeur. In other countries, notably Russia, the Rococo was so far removed from traditional forms of ornament that it never filtered much below the restricted circle of court patronage. The empress Elizabeth's enthusiasm for the Rococo was very soon supplanted by that of Catherine for Neoclassicism.

William Kent and the Palladian Reaction

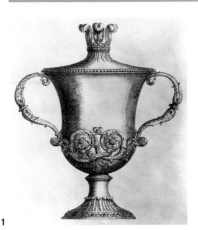

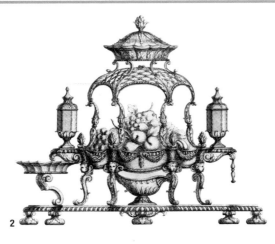

1, 2 *Designs by the architect William Kent for a gold cup and a centrepiece. Kent's designs for silver and furniture were published by William Vardy in 1744; they are characterized by a disciplined classicism that in some ways is the antidote to the Rococo, and which was preferred by some British patrons.*

Later British Rococo

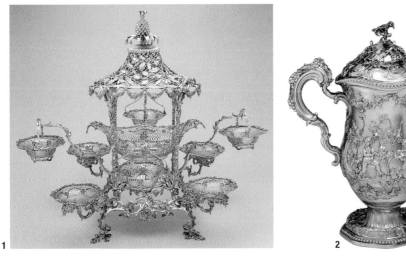

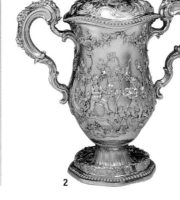

1 *The silver centrepiece, or epergne, was one of the most spectacular forms of Rococo silver. This example, by Thomas Pitts, 1763, is based on a series of dishes and baskets suspended from scroll branches and clustered around a central pagoda structure. Ht 66cm/26in.*

2 *This cup and cover by Lewis Herne and Francis Butty (active from c.1757) represents a distinctive form of British late Rococo decoration, characterized by scroll handles reminiscent of German pattern books, and well-defined representational ornament in applied relief. Ht 33.5cm/13¼in.*

3 *The career of the royal goldsmith Thomas Heming (c.1726–c.1795) spanned the transition from the Rococo to Neoclassical style, and this toilet service, made in 1768, contains elements of both styles. Mirror ht 71cm/28in.*

4 *The origins of the London goldsmith James Shruder are not known, but he was possibly German. The spiky handle of this 1752 hot-water urn is clearly influenced by contemporary German pattern books. Ht 56cm/22in.*

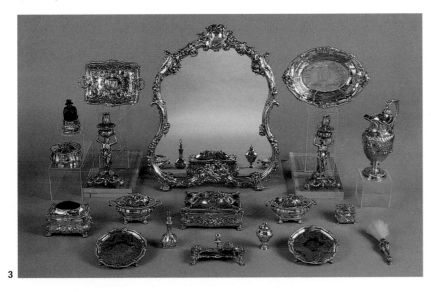

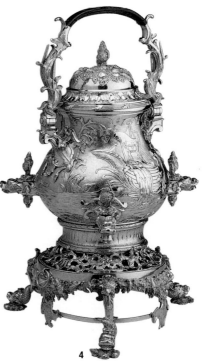

Textiles and Wallpaper

Chinoiserie and Japonaiserie

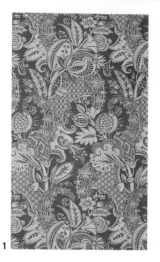

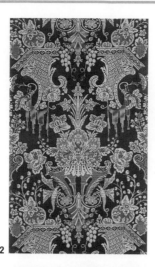

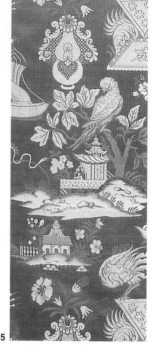

1 *Silk damask, Lyons, early 18th century. The pomegranate motif, transformed into an oriental pod, was a key feature of "bizarre" design, c.1700–20. With these came a Rococo feature of patterns arranged along parallel meanders.*
2 *Silk design, Daniel Marot, early 18th century. In architecturally inspired patterns, oriental elements were included, and here, too, parallel meanders appeared when these single-width patterns were joined.*
3 *Bobbin lace lappet (part of female head-dress), Brussels, c.1725. As stately Baroque curves developed Rococo C-shapes, arrangements became more asymmetrical.*

4 *Design for a Spittalfields brocaded silk, London, by James Leman, c.1715–25. From c.1725, oriental scenic patterns grew larger.*

5 *Brocaded silk satin with metal thread, Lyons, c.1735. As scenes gradually became more separated, inconsistency in scale remained a feature.*

Because of their significantly higher survival rate, the development of Rococo textile designs is more accurately charted than those of earlier periods. The intertwined developments of production and a wider consumer base also means that a greater range of tastes was catered for than hitherto was possible. Out of the vast range of surviving designs, it is possible to understand the general trends of the period by focusing on the use of oriental elements and their scale; naturalistic motifs; and Indiennes features and their pattern arrangement.

Chinoiserie can be found in designs throughout the 18th century and is an important element of the Rococo. The flowing asymmetrical curves typical of all true Rococo patterns are deliberately anti-classical and thus compatible with large parts of the Eastern design vocabulary; they may even have been inspired by it. The touch of whimsy, another characteristic of Rococo designs, is equally indebted to non-Western sources. This can be seen in the transitional and so-called "bizarre" patterns, which show Baroque forms combined with

fantastic shapes and unusual features, such as elongated pods, parasol forms, and insects. More recognizable orientalist elements such as figures or buildings are also present from the beginning of the century, when they are incorporated as visually continuous designs. By the 1730s such motifs are often the sole component, arranged as floating islands.

In scale and distribution over the background of the design, the trend was to move away from the dense, all-over patterns that characterize the early 18th century. By the 1730s much more background is unadorned. Simultaneously, entire blossoming chinoiserie trees or their branches become popular designs, the former especially sought after in wallpapers. Such patterns continue to become more widely spaced and, by mid-century, slim vines or decorated ribbons also provide the continuous motion, typically with mixed floral sprays falling away from these at an opposing angle. The appearance of these sprays was most widely influenced by the last well-known painter, decorator, and designer of

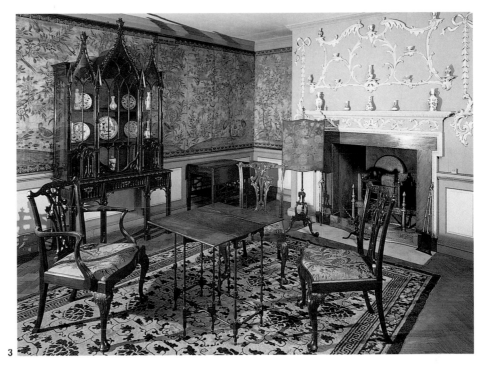

1 *Gold and silver brocaded damask, Lyons, c.1735. From c.1725–85 orientalist patterns – and textile and wallpaper designs generally – became more open and delicate.*

2 *Painted silk, Chinese, 1740–50, probably for a European market, featuring a similarly open and light pattern to the brocaded damask above.*

3 *The Wotton Room, Berkeley House, c.1740, Wotton-under-Edge, Gloucestershire. This panelled room of pinewood is furnished with its original orientalist wallpaper, which rises from dado rail to ceiling without repeating.*

Lighter Floral Designs

1 *Brocaded silk, Lyons, 1750–60. Engravings of designs circulated widely, influencing even the mirror repeating patterns, now usually for use in churches.*
2 *Parasol-shaped floral design on a plate issued by Jean-Baptiste Pillement, c.1755–60. Such sources as this and the adjacent engraving were important for cotton and cotton/linen printers, the boom industry during the 1760s and 1770s in Britain and France.*

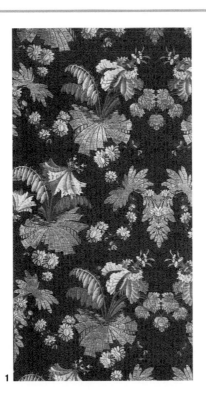

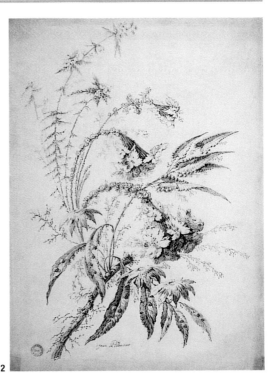

1 *Linen sampler embroidered in silk, Nuremberg, Germany, early 18th century. The capacity for realism inherent in most textile techniques was gradually brought to the fore in this period. Previously, realism was associated with methods in which an image was worked strand by strand, as in tapestry, lace-making, and embroidery, as here.*

2 *Brocaded silk damask, Spain, 1720–30. The vogue for scenic designs brought forth loom-woven cloths enhanced by naturalistic delicate shading and a relaxed flow in the arrangements of flowers.*

3 *Floral wallpaper from a house in Brentford High Street, Middlesex, England, 1755, colour print from wood blocks. Printers readily capitalized on their pictorial origins, often showing off lush mixed bouquets amid more stylized favourite motifs such as vases and scrollwork.*

4 *Cotton block-printed by A. Quesnel of Darnétal, near Rouen, 1780s. Counteracting the move towards naturalism was the continued influence of Indian printed, woven, and embroidered textiles.*

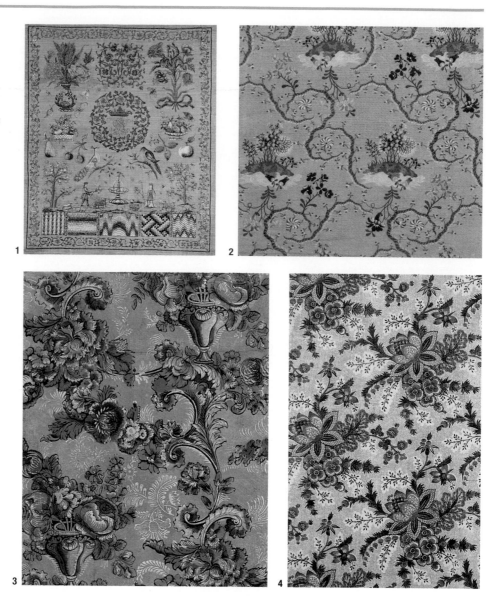

Rococo chinoiserie, Jean-Baptiste Pillement (1728–1808). During the period from about 1750 to 1760 he had editions amounting to well over 200 engraved plates issued in both France and Britain, illustrating Chinese ornamentation and, in particular, flowers in the Chinese style intended for manufacturers of both silks and printed chintzes. These engravings, with their three-dimensionality and shading techniques, another feature of true Rococo patterns and also introduced in the 1730s, continue into the 1780s to provide the basis for chinoiserie designs, which become increasingly light and open in character. Pillement's motifs themselves appear in textiles manufactured as late as 1808.

The same mutations found in chinoiserie patterns – floating islands, flowering branches, sprays of vines, three-dimensionality, meanders, and increasing delicacy – also appear within other styles of textiles and wallpaper during the period. However, the treatment of floral motifs between about 1700 and 1790 generally moved towards naturalism. Although very realistic elements become noticeable in the 1730s, they are often of incongruous scale in relation to each other. As this tendency decreases it is replaced by mid-century with the introduction of subsidiary patterns of simply rendered naturalistic ornament or mixtures of several very different flowers, vines, or trees, or the introduction of vases, ribbons, or scenic tableaux.

Such inventive combinations are another key Rococo feature. So too, at the end of the period, is the use of motifs derived from Indian embroideries and painted and printed cottons. So-called Indienne motifs, notably internally patterned flower petals and splaying ferns and the like, constituted entire designs or were added in Rococo fashion to other compositions. Such leafy elements were well used in meander designs, which were particularly fashionable from the 1740s to 1770s; in wallpapers and some woven textiles these can be very large. Meanders were gradually succeeded by arborescent designs, indebted to Indian tree-of-life patterns and representing the final move towards naturalism.

Meanders

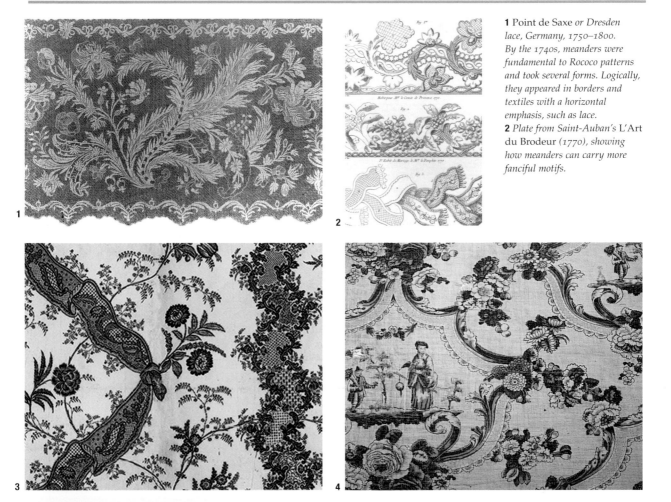

1 Point de Saxe *or Dresden lace, Germany, 1750–1800. By the 1740s, meanders were fundamental to Rococo patterns and took several forms. Logically, they appeared in borders and textiles with a horizontal emphasis, such as lace.*
2 *Plate from Saint-Auban's* L'Art du Brodeur *(1770), showing how meanders can carry more fanciful motifs.*

3 *British plate-printed textile design, Bromley Hall, Middlesex, 1770s. Typically, the parallel meander style was made more lively by inserting a second band undulating at a different pace; these very often depicted ribbons and lace.*

4 *Block-printed* siamoise, *French, 1770s, showing a Chinese-inspired scene amid floral motifs and scrolls.*

Arborescent

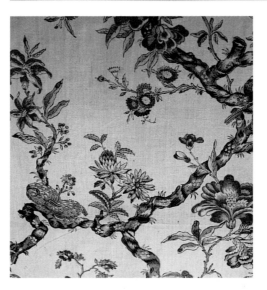

5 *Mock flock paper, 17 Albemarle Street, London, c.1760. Large furnishing patterns often abandoned the remaining sense of order that meanders provided. Here, vines appeared solely to link together large exotic leaves.*

1 *Block-printed Indian cotton, France or Britain, 1775–1800. In later arborescent designs, gnarled branches displayed an array of blooms and birds.*

Neoclassicism

c.1760–1830

Neoclassicism developed through the inspiration of antiquity and as a conscious reform of the perceived excesses of the Rococo style. The term was coined in the 1880s and is generally considered to cover the period from c.1760 to c.1830. Neoclassicism was both a historical revival and a search for a timeless style – hence the emphasis in contemporary writings to the notion of a "true style." By its end these concepts had become subsumed into a romantic notion of the grandeur of the past and antiquity became one of several possible historicist revivals.

The first theorists stressed the importance of inspiration rather than imitation. Writing in Rome, Johann Joachim Winckelmann in his *History of Ancient Art* (1764) evoked the nobility of the classical past as exemplified by Hellenic art, and Giovanni Battista Piranesi (1720–78) published his influential engravings of the antiquities of Rome, *Antichità Romane* (1756) and *Vedute di Roma* (1748–78). Neoclassical theory was assimilated into Enlightenment philosophy. Rousseau and Diderot's concerns to restore the moral values of contemporary society was reflected in Abbé Laugier's *Essai sur l'Architecture* (1753), in which he evoked the primitive hut as the source of architectural purity.

The excavations at Herculaneum (from 1738) and Pompeii (from 1748) offered a new repertory for artists, as did the discovery of the temples of southern Italy and the Middle East published by Robert Wood and James Dawkins in the 1750s. Future patrons travelled to Rome on their Grand Tour and to Naples and Greece. The collections of antiquities and artists' sketches created a huge repository of classical ideas for the decoration of interiors, to create works of art imitating antique forms or to provide ornament for furniture, silver, and porcelain.

The forms created by early Neoclassical designers were determined by the artists studying in Rome. French designers at the Académie St. Luc in the 1740s returned to Paris inspired by Piranesi. The architect Jacques-Ange Gabriel (1698–1782) travelled to Rome to see Roman architecture first hand. Among the English in Rome were Robert Adam, James "Athenian" Stuart, and William Chambers. The first attempts at a reformed classical style appeared in both England and France before 1760.

In France the earliest forms of Neoclassical design – Goût Grec – emphasized geometric forms and decoration in accord with the "simple and majestic manner of the ancient architects of Greece." Jean-François Neufforge (1714–91) began to publish his classical designs in *Recueil Elémentaire d'Architecture* in 1757. Goût Grec motifs include volutes, bay leaf swags, vitruvian scrolls, palmettes, and the guilloche pattern.

Left: the c.1774 design of this jasper and gilt-bronze perfume burner by Pierre Gouthière is based on the antique tripod, taken from The Cupid Seller, *painted by Joseph-Marie Vien in 1763. This version was designed for the duc d'Aumont by François-Joseph Bélanger and sold on his death in 1782 to Marie Antoinette. Ht 48.3cm/19in.*

Opposite: detail from the c.1800 painting by Jacques Louis David of Napoleon in his study, showing the new styles of furnishing introduced at the beginning of the 19th century by the designers Charles Percier and Pierre-François-Léonard Fontaine.

1 An early example of Neoclassical design, this engraving was published by Giovanni Battista Piranesi in 1769. The clock and table have motifs from different classical sources.

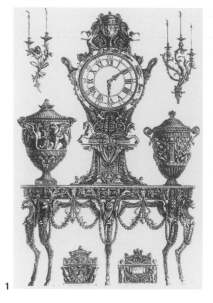

2 The c.1767 watercolour design for the ceiling of the circular dressing room at Harewood House, Yorkshire, shows Robert Adam's lively treatment of interiors. He allowed the client to choose from one of several colour palettes.

3 Percier and Fontaine designed this small closet for the Casa del Labrador in the Royal Palace of Aranjuez, outside Madrid. The mirrored panels act as a backdrop for painted roundels, derived from Roman interiors.

In the 1770s design became more fluid and elegant. Interiors were decorated in wood panelling incorporating classical motifs or painted with imitations of the grotesque ornament revived in the Renaissance by Raphael (often called *arabesque* in France). Designs incorporated naturalistic motifs, flowers, and scrolling vines in light colours.

A further range of motifs – the Etruscan style – was inspired by the decoration on Greek vases, at the time thought to be Etruscan. François-Joseph Bélanger (1744–1818) and Jean-Démosthène Dugourc (1749–1825) expressed in their designs the revival of the antique with clarity and delineation of line. In the final phase of the *ancien régime* (c.1780–92), buildings emphasized geometry and simple forms for exteriors but remained elegantly decorative in the interior.

Design under the revolutionary governments of 1792–1803, known as Directoire and Consulate, was inspired by simpler forms of Roman art. This heroic simplicity was partly inspired by Jacques Louis David's paintings, for example, *The Oath of the Horatii* (1785). Napoleon's invasion of Egypt in 1798 was also a source of decorative ideas.

The reassessment of classical sources led to the imitation of Roman architecture and design, best expressed by Charles Percier (1764–1838) and Pierre-François-Léonard Fontaine (1762–1853), Napoleon's architects from 1794 to 1814. Their publication, the *Recueil de décorations intérieures* (1801), formed the basis of much European design of the early 19th century. They wanted to "imitate the antique in its spirit, in its principles, and in its precepts, which are timeless" and "to adhere to the classical models, not blindly, but with discernment." Architectural forms returned to the simplicity of early Greek and Roman monuments, but interiors were decorated in rich, contrasting colours. Marbles, gilt-bronze furnishings, silk, and velvet damasks were appropriate for an emperor: Napoleon's imperial style spread throughout Europe.

In England, James Stuart's decoration of the painted room at Spencer House (c.1761) is one of the first to take Roman wall painting as a source. However, Robert Adam (1728–92) synthesized classical motifs derived from Roman architecture with a sense of elegance and lightness, concentrating on harmonious proportions. Adam also created the first Etruscan room at Derby

House in 1773. He was a prolific architect and dominated English design until the 1780s.

Adam's style was continued by his pupil Joseph Bonomi (1739–1808), who created one of the first interiors to be decorated in a revival of a Pompeian wall painting at Packington Hall, Warwickshire (c.1780). James Wyatt (1746–1813) also developed Adam's decoration into a more austere form of design, with an emphasis on linearity and pure space. Henry Holland (1745–1806) adopted French motifs and forms of decoration, as well as using immigrant French craftsmen at Carlton House, London, built for the Prince of Wales, 1783–96. George, Prince of Wales, later became the Prince Regent (1811–20) and then George IV (1820–30). Because of the prince's powerful influence on all aspects of the decorative arts, the period c.1790–1830 is often referred to as the Regency in Britain.

Of great importance to new architectural theories was the development of the picturesque, which emphasized the greatness of nature and man's role in perfecting it. This led to a conflict between those arguing for symmetry and regularity and those espousing the asymmetrical. It also encouraged the development of anti-classical styles such as Gothic, Chinese, and Indian.

In the early 19th century, design was dominated by the search for the archeologically authentic. Thomas Hope in his *Household Furniture and Interior Decoration* (1807) purified and developed the forms and ornament first promoted by Percier and Fontaine.

Until Napoleon's campaigns and the subsequent redefinitions of territories, the map of Europe remained much as it had been at the beginning of the 18th century. Design in the various kingdoms, principalities, and regions depended on the affiliations and taste of individual rulers, following developments in England and France, often with variations. Giuseppe Valadier (1762–1839) in Rome expressed the grandeur of archeological classicism and was no doubt an influence on the designs of Percier and Fontaine. During the 19th century Pelagio Palagi (1775–1860) took the Etruscan style to its limits in his revivals for the interiors of palaces in Turin.

The Neoclassical style in the German states mainly coincided with important political changes and with the rise of national consciousness but had first appeared at the Prussian court of Frederick the Great, where the early Neoclassical architect Jean Laurent Le Geay (1710–c.1786) designed the Neues Palais in Potsdam in the 1760s. Later, after the Treaty of Versailles (1815), reorganization of the German states lead to new civic building in a fully developed Neoclassical style.

The Empire style flourished from c.1805 onwards. The architect Karl Friedrich Schinkel (1781–1841) kept the monumental simplicity of French visionary architecture but emboldened it with a strong sense of light. His vision of the grandeur of simplicity and the importance of interior space is best expressed in the Altes Museum, Berlin (1826–36). In a similar manner, the interiors of Leo von Klenze (1784–1864) exemplify the 19th-century taste for unornamented walls with bold painted decoration taken from Pompeian interiors.

4 *Marie Antoinette's cabinet at Fontainebleau was designed by Rousseau de la Routière in 1790 with ornament based on Raphael's grotesques in the Vatican Loggia of c.1510. The furniture is by Riesener and Séné.*

French Furniture

Goût Grec

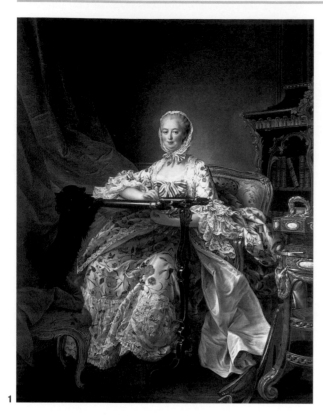

1 *The portrait of Madame de Pompadour by Drouais, c.1763, shows a work table by Oeben with Goût Grec motifs such as the ram's head.*
2 *Earlier classical styles can be seen in this c.1765 console table, based on designs by Jean-Charles Delafosse. The scale of the vitruvian scroll may be influenced by English Palladianism. Ht 86.5cm/34in.*
3 *The bureau plat for Lalive de Jully was designed by Le Lorrain (1715–59), with mounts by Jacques Caffiéri (1673–1755). Its black and gold decoration evoked the grand manner of Louis XIV. Executed in 1756–7, the set was the first example in Paris of the new antique taste.*

The first set of furniture to be made in the new taste, which the French referred to as Goût Grec, was for the cabinet of Lalive de Jully, 1756–7. The style favoured strong, rectilinear forms, occasionally retaining a restrained curve, with large-scale decoration in the bold mounts of vitruvian scrolls or guilloche patterns, as can be seen in the designs of Jean François Neufforge (1714–91) and Jean-Charles Delafosse (1734–91). Masks or term figures were often placed on the corners. Seat furniture and tables were just as massive, often with straight or columnar fluted legs.

Contemporary with this architect-designed furniture was that made for Madame de Pompadour by her favourite cabinetmaker, Jean-François Oeben (c.1721–63). This was in a more conservative taste, showing a gradual transition from Rococo forms to the new rectilinear approach required by classical theorists. Seat furniture in this transitional style often retained the cartouche back and cabriole leg of the Rococo, but the rails were decorated with the classical motifs and swags of the new style.

Oeben worked extensively for the crown, creating many innovative types of furniture such as the roll-top desk (*bureau à cylindre*) and mechanical *toilette* tables. He adapted the commode and other carcase pieces to Neoclassical form – tripartite with the central shallow breakfront decorated with a panel of figurative marquetry – and developed the fall-front sécretaire. He introduced new techniques in marquetry, which were taken up by, among other cabinetmakers, his brother-in-law, Roger Vandercruse, called Lacroix (1728–99) and his two pupils Jean-Henri Riesener (1734–1806) and Jean François Leleu (1729–1807).

Riesener took control of the workshop on his marriage to Oeben's widow in 1767, and he completed many of Oeben's original commissions. He continued to work for the crown as *ébéniste du roi* until an attempt to economize led to his dismissal in 1780. Riesener developed an easily recognizable vocabulary of floral marquetry panels, trellis motifs, and floral gilt-bronze mounts which he designed and had made in his workshop.

Decorated Elegance

1

2

3

1 *A writing table decorated in green* vernis martin *(a form of japanning) by René Dubois c.1769. The unusual mermaid legs may reflect the designs of Charles de Wailly (1730–98). It was owned by Catherine the Great. Ht 75.4cm/29¼in.*

2 *The roll-top desk of 1779 by François Leleu for the prince de Condé at the Palais Bourbon, Paris, is veneered in trellis parquetry into which is set an oval of floral marquetry. The tapering legs and restrained use of mounts are typical of this date. Ht 1.06m/3ft 5¾in.*

3 *This coin cabinet for the comtesse de Provence c.1780 by Jean-Henri Riesener has gilt-bronze mounts set against a rich mahogany veneer. The caryatid figures and arrow legs appear in rooms for Marie Antoinette. Ht 2.65m/8ft 8¼in.*

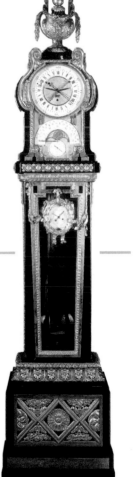

The Influence of Boulle

1 *Made for the Hôtel de Choiseul-Praslin c.1770, this ebony long-case astronomical clock by Balthazar Lieutaud (master in 1749) is dominated by the mounts after antique ornament by Philippe Caffiéri (1714–74). The shape of the clock pays homage to Boulle's designs. Ht 2.66m/8ft 8¼in.*

2 *This bookcase by Etienne Levasseur (1721–98) c.1790 is an adaptation of Boulle's original design and updated by the striking bands of ebony.*

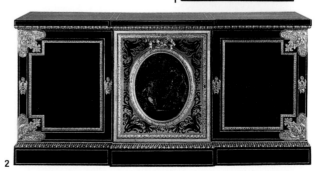

1

2

4 *Riesener's successor, Jean Ferdinand Schwerdfeger (fl.1760–90), made this cabinet, 1788, probably to designs by J.D. Dugourc. The Wedgwood plaques and gouache paintings are based on Roman sources. Ht 2.46m/8ft 1in.*

New Forms

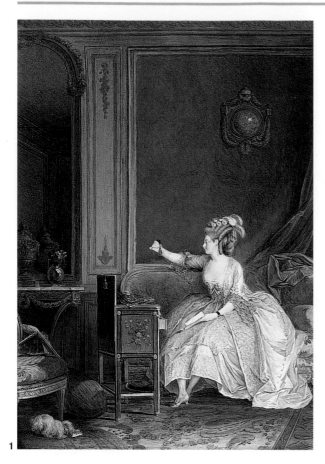

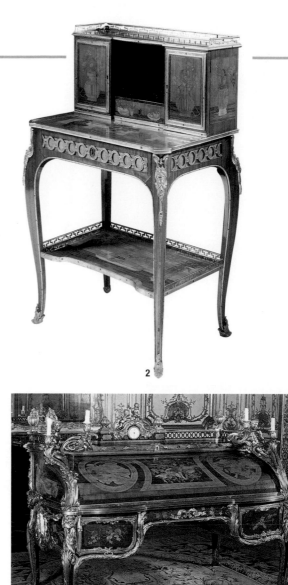

1 *In this painting of an interior, a woman is shown seated at a small writing desk in a newly furnished fashionable interior. The constant invention of new types of furniture and forms of decoration reflected the importance of fashion and luxury in late 18th-century Paris.*
2 *A c.1760 bonheur du jour (writing table) by Roger Vandercruse. This piece is transitional in its use of curving legs. Ht 71cm/28in.*
3 *The roll-top desk designed for Louis XV's study, c.1760. Oeben created the marquetry, while the gilt-bronze mounts were designed by Jean-Claude Duplessis (d.1774).*

Design under Louis XVI (1774–89), whose name is often inappropriately given to the entire period of Neoclassicism in France, continued its emphasis on decorative elegance. Motifs derived from classical sources were usually combined with floral motifs, garlands, or ribbons. Ornament was continually refined, becoming smaller in scale and tighter in execution – the jewel-like quality associated with Riesener's later work or the gilt bronzes of François Rémond (c.1747–1812) and Pierre Gouthière (1732–1814). Furniture supplied by the leading *marchands merciers* featured innovative materials. Poirier and Daguerre commissioned the Sèvres porcelain factory to make porcelain plaques and bought 17th-century Japanese lacquer and panels of Italian *pietre dure*, which were mounted into secrétaires and cabinets by Joseph Baumhauer (d.1772), Martin Carlin (1730–1785) and Adam Weisweiler (c.1750–1810).

Chairs had square backs with rectangular seats, the fronts of which were generally modified by curved seat rails. Georges Jacob (1739–1814) and Jean-Baptiste-

Claude Sené (1748–1803) created sets with variations of their decorative details for the many apartments redecorated for Marie Antoinette. Increasingly the motifs became stiffer and tighter, with small pointed leaves, tightly scrolled ribbons, or the bead and reel motif replacing the earlier floral garlands.

Furniture designed in the 1780s began to show a reaction to this delicacy and refinement, becoming stronger and introducing classical motifs seen in Roman wall paintings and Greek vases. Bélanger and Dugourc designed furniture in the new taste, with elegant caryatid figures on pedestals at each side and legs imitating a quiver-full of arrows. The arms were set at right angles to the back, resting on thin columnar supports or, occasionally, classical sphinxes. Decorative features included imitations of Roman cameo motifs, either painted or using Wedgwood plaques. Increasingly, however, marquetry panels were replaced with plain panels of plum mahogany (used extensively in France for the first time) or thuya wood.

The Commode

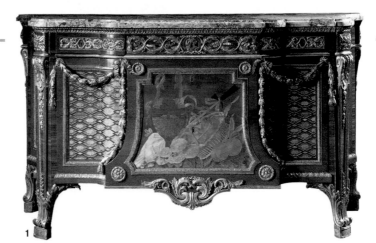

1 *This tripartite commode, made by Jean-Henri Riesener in 1778 for the king's apartments at Fontainebleau, was veneered in tulipwood and sycamore. It retains the original form invented by Oeben. The trellis marquetry with cut daffodil is typical of Riesener. Ht 95cm/37½in.*

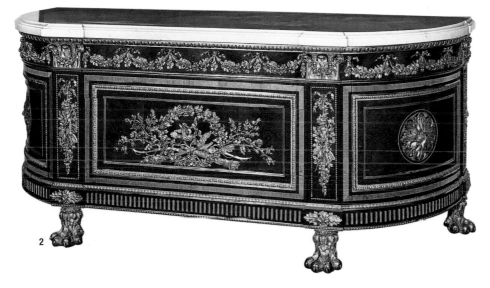

2 *A semicircular or drum commode in mahogany, kingwood, and tulipwood, supplied in 1786 for the king's bedchamber at Compiègne by Guillaume Benneman (fl.1784–1811) to designs by Jean Hauré (fl.1774–96). The new style introduced more robust shapes and decoration. Ht 92.2cm/36¼in.*

Chairs

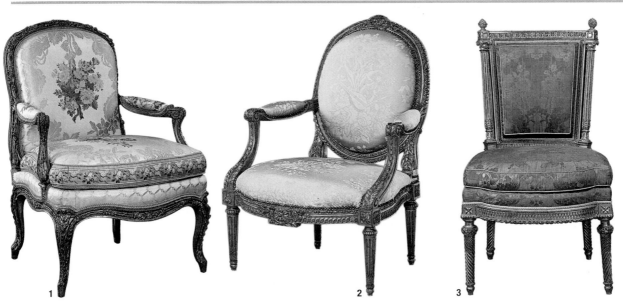

1 *Transitional chair, made c.1760–70. The shape remains Rococo while the decoration takes on more classical motifs associated with Neoclassicism. Ht 1.12m/3ft 8in.*

2 *The oval back chair became increasingly popular from c.1768. This example by Jean Baptiste Tilliard (1723–98) shows the classical, balanced proportions of high-quality French menuiserie (carpentry). Ht 1.1m/3ft 7in.*

3 *By the 1780s the emphasis was on refined decoration and rigid shapes, as in this chair designed by Hervé and made by Claude Sené for Marie Antoinette's apartments at St Cloud in 1787. Ht 81cm/32in.*

Goût Étrusque

1 *This chair in the new antique style with sickles and sheaf motifs was made by Jean-Baptiste-Claude Sené and reflects the influence of English design. Anglomanie (a craze for all things English) was a fashionable concept at the end of the ancien régime.*
2 *Designed by Hubert Robert for Marie Antoinette's dairy at Rambouillet in 1787, this mahogany chair by Georges Jacob was called Etruscan, because the motifs such as the lozenge pattern on the back and seat derived from the decoration of Greek vases. H95cm/37½in.*

Consulate and Directoire

1 *The furniture commissioned by Madame Récamier for her bedroom was based on designs created by Jacques Louis David for his paintings. The simplicity of the design of this chair is based on early Roman forms of the* klismos *chair. It was made in* citronnier *contrasted with bands of purplewood in 1798 by Jacob Frères. Ht 85cm/33½in.*
2 *This c.1795 stool, derived from the Roman republican folding campaign stool, is painted black and gilded. The choice of earlier prototypes was deliberate, although the campaign stool had been used as a source of chair design as early as the Renaissance. Ht 72cm/28¼in.*

The incipient classicism associated with the Goût Étrusque of Dugourc, which was inspired by what was thought to be Etruscan decoration, was swept away by the Revolution. Most noticeably, furniture was stripped of its decoration. At the same time, the revival of classical forms, such as the Greek *klismos* chair, already underway during the *ancien régime,* was even more popular with the new republican governments. Furniture known as Directoire (1793–99) and Consulate (1799–1804) reflecting changes of government, continued to develop in archeologically correct forms.

The furniture made by Georges Jacob (1739–1814) who, with his sons, was the leading cabinetmaker of the period, imitated Roman couches, tripods, and stools. A new kind of table, the *guéridon,* with a round top and pillar or tripod support, was introduced, and the fall-front secrétaire was now the chief form of writing furniture. Bernard Molitor (1755–1833) developed cabinets, chests of drawers, and secrétaires that retained the forms of the previous generation but were plainer, the

only decoration being columns or simple architectural motifs. Simplified paw feet, derived from antique seat furniture, replaced the twisted, tapering feet of the Goût Étrusque. After Napoleon's invasion of Egypt in 1798, Egyptian motifs were added to the repertory of design, augmenting the geometric restraint inherent in the pieces.

With France at war, it was often difficult to obtain imported, exotic woods and, except for luxury items, native fruitwoods were often used. Mahogany remained extremely fashionable, but *citronnier* (pale yellow satinwood), which had been used on the interiors of cabinets by craftsmen such as Weisweiler, was now found on the exterior. Such decoration as there was took the form of contrasting inlaid motifs of laurel wreaths or anthemion (honeysuckle).

The revolutionary government did away with the guild structure of manufacture in 1791, so firms of furniture makers could provide both carved and veneered furniture. The firm of Jacob Desmalter (set up in 1803 by the son of Georges Jacob) provided most of the

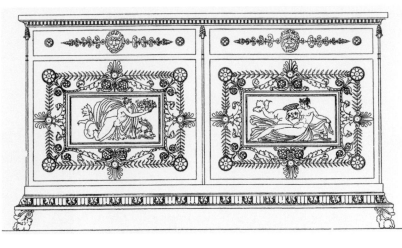

1 *This fall-front secrétaire by Bernard Molitor, c.1811, reflects the emphasis on frontality of early 19th-century design. The block feet are typical of later Empire furniture. Ht 1.37m/4ft 6in.*

2 *A design from the Recueil de décorations intérieures by Percier and Fontaine, showing the monumentality of the Empire style. The ornaments would be made in gilt bronze.*

Georges Jacob and the Early Empire Style

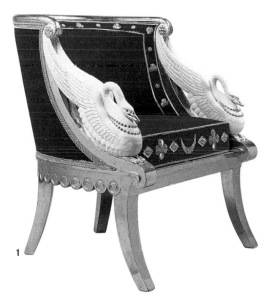

1 *The swan chair was designed by Percier and Fontaine and made by Jacob Frères for the empress Joséphine at Malmaison, 1803. Taking its shape from the Greek klismos chair, the addition of the swans from Roman imperial furniture gives it grandeur. Ht 77cm/30¼in.*
2 *A mahogany drop-front secrétaire by Jean Guillaume Benneman, made to designs by Percier and Fontaine c.1800. At this date the term figures were placed at an angle on the corner, while the feet are still based on animal forms.*

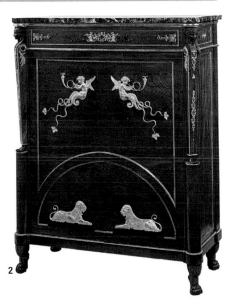

3 *This c.1800 daybed is in the Egyptian style and is made of mahogany and satinwood, with gilt-bronze mounts. It is stamped "Jacob Frères," as the firm was called 1796–1803, when Georges Jacob was working with both his sons. Ht 1.1m/3ft 8in.*

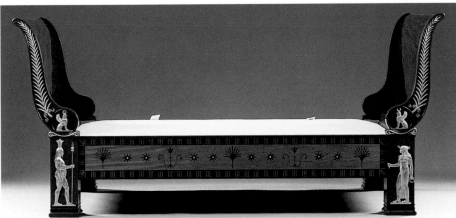

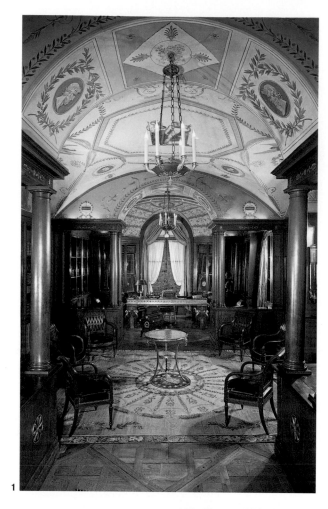

2 A meuble d'appui (low cupboard), made in 1810 in mahogany and gilt bronze by Jacob Desmalter, which provided most of the furniture for Napoleon. Ht 98cm/3ft 2½in.

3 Sphinx supports in ebonized wood can be seen on this mahogany and gilt-bronze console table in yew, backed with a mirror, made c.1807 from designs by Percier and Fontaine. Ht 1.03m/3 ft 4½in.

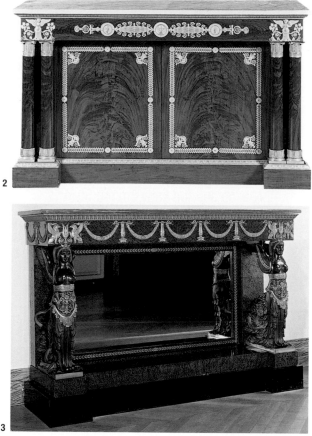

1 The library at Malmaison was designed in the Pompeian style by Percier and Fontaine in 1800 for Empress Joséphine.

furniture for Napoleon's residences. Gilt bronzes reached a height of excellence in the work of *ciseleur-doreurs* such as Pierre-Philippe Thomire (1751–1843), and Paris remained the centre from which wealthy Europeans ordered their clocks, candelabra, and other furnishings in gilt-bronze.

Napoleon's two premier architects, Charles Percier (1764–1838) and Pierre-François-Léonard Fontaine (1762–1853) based their ideas for furniture on Roman forms, imitating them closely and taking up the simpler, bolder elements of design. Egyptian motifs were also highly popular, the figures of corner mounts often showing Egyptian styles of dress. Imperial ornament such as wreaths of laurel, rods, or medallions of profile portraits were set against a plain background.

Seat furniture returned to square, frontal designs, generally simply decorated with motifs such as stars or balls. The legs and arms were generally more substantial than previous periods and the backs plainer. One of the most innovative designs was the gondola chair which

appeared with swan arm supports. Another favoured image was the sphinx. The bed took on new importance and was set in an alcove under a canopy, the design based on the Roman couch. The upholstery emphasized the severity of shape, with large borders and heavy fringes adding to the magnificence of the furniture.

For tables and sideboards the monopod leg with stylized panther head, sphinx, or Egyptian mask was placed frontally on a plinth, beneath a simply decorated frieze, thereby emphasizing the geometric solidity of design. The mirrors above pier tables now extended downwards forming the back of the table itself. Different parts of the furniture were either gilded or ebonized to contrast with the flame mahogany veneer. Secrétaires and chests of drawers were treated in a similar way.

The French Empire style was most effectively summarized in the *Collection de meubles et objets de goût*, published in instalments by Pierre La Mésangère between 1802 and 1835, which ensured the perpetuation of the style all over Europe into the mid-19th century.

Towards the End of the Era

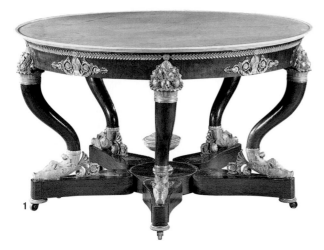

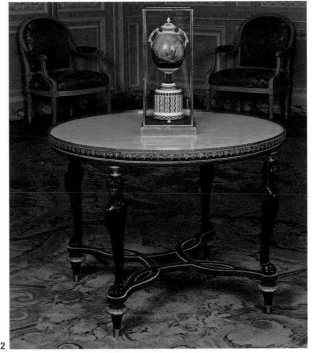

1 *A c.1834 centre table by Jean-Baptiste Gilles Youf (1762–1838) showing the continued influence of Empire design. The increased emphasis on weight and large ornament was typical of this period. Ht 82cm/32¼in.*

2 *This table in mahogany with legs decorated in the Egyptian style was executed c.1810 for the château of St Cloud by Bernard Molitor. Ht 1m/3ft 3in.*

The Use of Exotic Materials

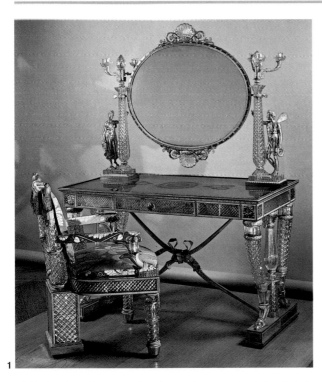

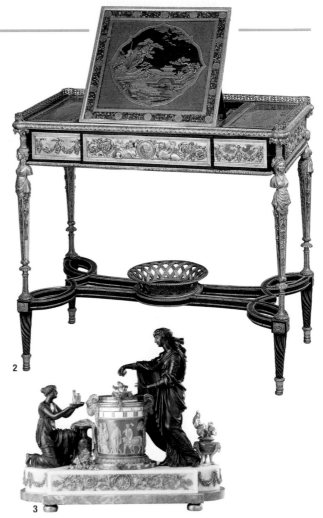

1 *This dressing table, c.1820, in rock crystal, verre eglomisé, and steel was designed by Percier and Fontaine for Mme Désamond-Charpentier, owner of a specialist glass shop in Paris. Ht 92.7cm/36½in.*
2 *The love of Japanese lacquer never disappeared, as indicated in the commission for Marie Antoinette for this sophisticated writing desk, made c.1784 by Weisweiler with mounts by Rémond. Ht 73.7cm/29in.*
3 *This gilt–bronze ornament was made by the leading chaser of the early 19th century, Pierre Philippe Thomire (1751–1843). Ht 58.5cm/23in.*

British Furniture

Archeological Influences

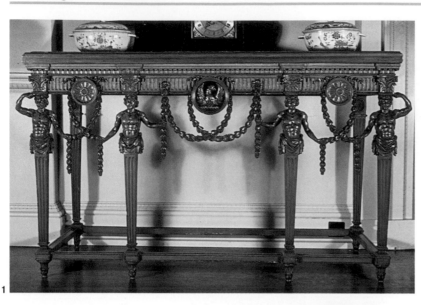

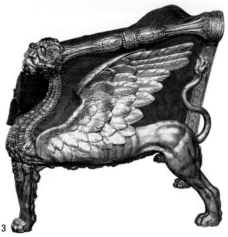

1 *This mahogany pier table with term figures was designed by Robert Adam and probably made by Thomas Chippendale in 1775. The table, with its term figures linked by festoons, demonstrates the increasingly light and slender Neoclassical style preferred by Adam during the 1770s.*

2 *The President's chair of the Royal Society of Arts was designed by William Chambers in 1759–60. The chair is more rectilinear in outline and uses archeologically correct details in its carved ornament. Ht 1.37m/4ft 6in, w. 65cm/25¼in.*
3 *A sofa for the Painted Drawing Room, Spencer House, London, made in 1759–60 of carved and gilded pine, designed by James Stuart. The winged creatures forming the sides of the sofa are drawn directly from archeological sources. The crimson damask cover is modern.*

The Neoclassical style, which dominated British furniture throughout the period between 1775 and 1830, had its beginnings in the 1750s, when design all over Europe was affected by the revival of interest in a purer classical style, stimulated by new discoveries of ancient remains, particularly the excavations at Pompeii and Herculaneum. During this period designers in France and Britain were reacting against the excesses of the Rococo style and, drawing on both the Palladian and Rococo inheritance in outline, they began to introduce restrained classical ornament to furniture.

The architects William Chambers and James Stuart are credited with the earliest pieces of Neoclassical furniture, before 1760. They used more rectilinear forms and archeologically correct decorative details drawn from direct observation of Greek and Roman originals. The most famous of the early practitioners of the Neoclassical style were the architects Robert and James Adam, who dominated British furniture design from the late 1760s until the late 1780s. Many of their designs were made by the cabinetmakers Thomas Chippendale, William & John Linnell, and Ince & Mayhew.

The distinctive and original classical style of the Adam brothers, in their own words, "captured the spirit of antiquity," but gave it a fresh and modern interpretation. The style was light, highly decorative, and often small in scale, concentrating on linear and two-dimensional ornament rather than heavy carving. Motifs included the tripod and vase, mythological creatures such as sphinxes and gryphons, classical figures, masks, and bucrania (ox skulls), as well as smaller patterns such as Greek key and vitruvian scroll borders, festoons of wheat husks, laurel wreaths, paterae, and anthemia. These ornaments were carried out in marquetry in woods of contrasting tones and in sculptural relief with carving or plasterwork.

British cabinetwork adapted gradually to the introduction of the Neoclassical style during the 1760s, and thereafter it developed into a confident expression through the use of controlled rectilinear shapes, skilled craftsmanship in wood, and fine metal mounts.

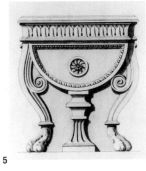

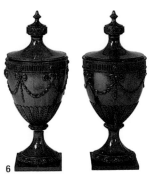

4, 5 *This 1768 design by Robert Adam is for a stool for Shelburne House. Adam's design is in a severe and restrained Neoclassical style, often used by him for the decoration and furniture of halls.*

6 *A pair of English knife urns made of mahogany, carved with festoons and ribbons above stiff-leaf borders, c.1780. Mahogany provided a perfect material for finely carved forms and details in the Neoclassical style.*

7 *James Stuart made this design for a pier table and tripod for Spencer House, London, c.1757. Archeological influence is evident in the rectilinear form of the table and the direct use of antique forms and decoration in the tripod incense burner on the table top.*

8 *George Richardson published this design for a candlestand in* Designs for Vases and Tripods, *1793. It was intended to be executed in gilt metal or wood, and the attenuated design includes many elements derived from archeological sources.*

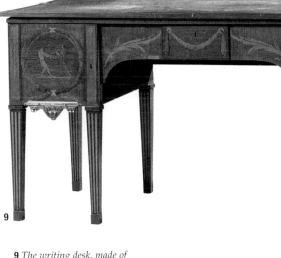

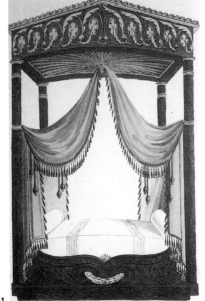

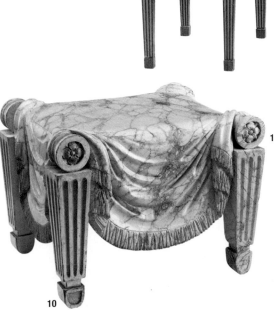

9 *The writing desk, made of mahogany and veneers of other decorative woods, is attributed to the cabinetmaker Christopher Fuhrlohg, c.1775. Although the desk is contemporary in shape, it is given a pure Neoclassical treatment in the design of its legs and decorative marquetry depicting classical figures, palm leaves, and festoons. W. 1.49m/4ft 9½in.*

10 *This beech stool, painted to simulate drapery and woodwork carved in marble, was possibly made by the firm of Marsh & Tatham. It is copied from a Roman original drawn by C.H. Tatham, published in* Etchings of Ancient Ornamental Architecture, *1799.*

11 *An 1816 design for a bed, published in Rudolf Ackermann's monthly magazine,* Repository of Arts. *Drapery in the classical Greek and Roman style dominated textile furnishings in the early 19th century.*

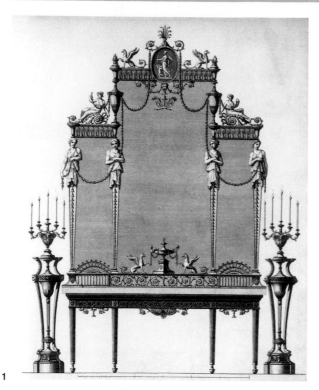

1 *Robert Adam made this design for a pier table for the Earl of Bute, 1772. It was published in the third volume of Robert and James Adams'* Works in Architecture, *1822. The magnificent suite of table, frame, and stands was to be executed in pine and gilded. Large panels of mirror glass dominate the delicate Neoclassical ornament of the frame.*

2 *This engraving for a pier glass frame designed by B. Pastorini was published in* A New Book of Designs for Girandoles and Glass Frames, *1775. The design follows the style of Robert and James Adam, in their published designs of 1772–8.*

3 *The top of this pier table was veneered in satinwood with painted decoration, c.1790. The silvery figure of satinwood reflects the later 18th-century taste for paler colours, and the painted decoration follows contemporary styles found in marquetry. Ht 79cm/31¼in.*

4 *John Carter made this design for a statuary marble table inlaid with Japan paintings, which was published in* The Builder's Magazine, *1777. The elaborate top would have been supported on a gilded or painted frame with straight legs and stretchers.*

Publications such as *The Works in Architecture of Robert and James Adam* (1773–79) and *The Cabinet-Maker and Upholsterer's Guide* by George Hepplewhite (published by his widow, Alice, 1788) popularized the style, not just in Britain but in other parts of Europe and the United States.

A distinctive feature of cabinetwork throughout the period was fine marquetry, incorporating delicate classical roundels, ovals, and shields, enclosing classical figures, mythological creatures, symbols, and surrounded by two-dimensional bands of architectural ornament. Painted decoration in similar styles and light colours was also used, sometimes covering an entire piece, in others only in panels or borders.

By about 1770 straight square-section or columnar legs tended to replace cabriole shapes. Carved chair backs incorporating classical lyre, oval, and shield shapes were adorned with small-scale ornament of paterae, medallions, wheat husks, and laurel. Gilding continued to be used for the grandest pieces but painted decoration on beech chair frames using a palette predominantly of

green, blue, white, and grey was popular. Silk damasks, or sometimes painted silk panels, covered luxurious seat furniture for drawing rooms and the best bed chambers; horsehair and leather were used for dining and library chairs; and printed cottons were increasingly popular for light bedroom chairs to match window curtains and bed hangings. Patterns for furniture cottons favoured classical medallions, flowers, and ribbons.

Gilded frames were regular in shape, either oval or rectangular, with narrower borders enclosing larger sheets of silvered glass. Accompanying pier tables corresponded in their design, usually with columnar legs, straight friezes, and tops of marble, painted wood, or marquetry decorated with delicate classical motifs. Occasional tables for writing, tea equipment, and card games were simple and elegant, with slender straight legs and decorative marquetry borders in light-coloured woods such as satinwood and harewood. Mahogany continued to be used, but lighter shades of the wood were favoured. Cast-metal mounts, usually of gilt-brass or

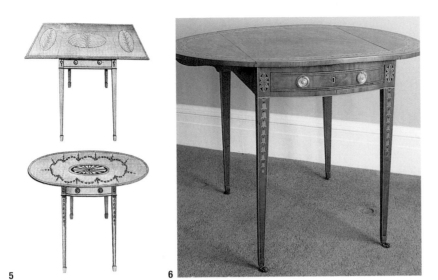

5 *The designs for these pembroke tables by George Hepplewhite were published by A. Hepplewhite in* The Cabinet-Maker and Upholsterer's Guide, *1788. Hepplewhite stated that such tables "admit of considerable elegance in the workmanship and ornaments."*

6 *This pembroke table was made of mahogany with veneer of satinwood and other woods, c.1780. The delicate ornament of the border is stained and inlaid in Neoclassical patterns of leaves and tendrils. Ht 73cm/28½in.*

7 *Thomas Hope, a connoisseur of Greek and Egyptian style, designed this round table with a columnar support in a shape popular in the early 19th century. The bands of decoration on the top are typical of late Neoclassicism.*

8 *This sofa table has the rectilinear form and slender legs associated with Neoclassicism, as well as bands of marquetry in woods of a lighter colour. The side supports and single stretcher were used from the 1800s. Ht 76cm/30in.*

9 *The decoration on this satinwood writing table is concentrated on the swags on the central drawer front and upper section of the table. The slender legs are tapered and supported by casters, which were used increasingly from the mid-18th century to allow the furniture to be moved with ease. The round handles are decorated with a classical motif on the backplate. Ht 90cm/35½in.*

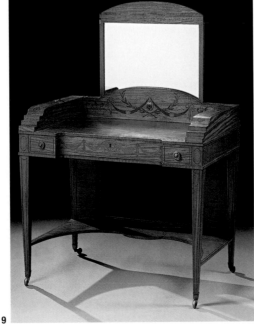

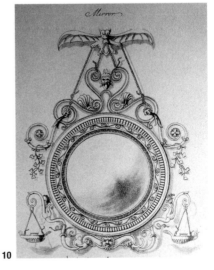

10 *This design for a mirror by George Smith, published in his* Collection of Designs, *1808, indicates the use of convex glass and a carved and gilded frame inspired by classical forms; the bat symbolized night.*

1 *Thomas Chippendale made this carved and gilded beech sofa with crimson silk damask upholstery for Sir Lawrence Dundas in 1765. Although still curvilinear in outline, the carving on the frame is in a more archeologically derived style. W. 2.18m/7ft 1½in.*

2 *The armchair is made of mahogany with satinwood inlay and has a cane seat, squab cushion, and ormolu mounts. It was made by John Linnell for Robert Child, Osterley Park House, Middlesex, c.1767. The chair incorporates such Neoclassical motifs as the lyre in the back and vitruvian scroll on the seat rail.*

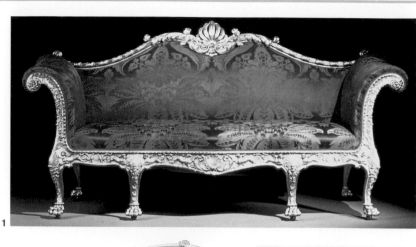

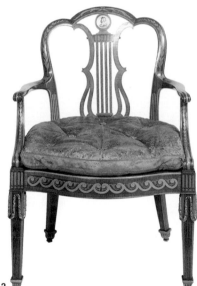

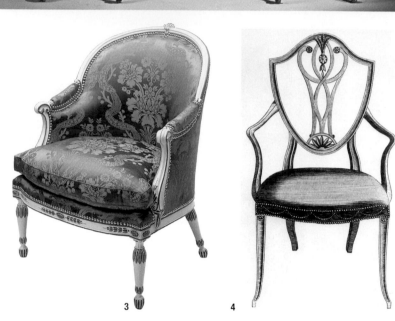

3 *The painted* bergère *chair, designed by Robert and James Adam, c.1770, was made by Thomas Chippendale for the actor David Garrick. The shape is French inspired but the decoration typically English.*

4 *This design for a parlour chair by George Hepplewhite was published by A. Hepplewhite in* The Cabinet-Maker and Upholsterer's Guide, *1788. The shield shape was popular in the 1770s and 1780s.*

ormolu, complemented the furniture. Handles were oval or round, their backplates decorated with motifs such as paterae, wheat sheaves, or sunflowers.

The high quality of British cabinetmaking during the period enabled the developing enthusiasm for mechanical devices for compartments, spring-loaded slides, and secret drawers. Thomas Sheraton's designs for elegant and often complex tables, published in his *Cabinet-Maker and Upholsterer's Drawing Book* (1791–94), illustrate the taste for such pieces. This collection and his *Cabinet Dictionary* (1803) were important in presenting the current styles to a wide public. The *Drawing Book* embodied the French-influenced taste favoured by the Prince Regent and his architect Henry Holland, and the *Cabinet Dictionary* reflected the renewed interest in archeological form in the early years of the 19th century.

Archeological sources for furniture design received a further boost in the 1790s through the publication of both ancient forms and their decorative detail, drawn from Roman originals by C.H. Tatham (1772–1842). After 1800

this influence was seen most clearly in the use of tripod and sarcophagus shapes and zoomorphic elements in furniture, created in a more solid and heavyweight style than that of the Adam brothers.

In addition to the standard Roman sources, many designers and patrons were increasingly attracted to Greek decoration. The Chinese and the Gothic styles, exotic alternatives to classicism, were used to create specific decorative themes, and Egyptian and Indian styles were also introduced under the enthusiastic leadership of the Prince Regent.

A leading exponent of both the Greek and the Egyptian styles was the connoisseur Thomas Hope (1769–1831), who published designs for furniture for his own houses in *Household Furniture and Interior Decoration* (1807). This was soon followed by George Smith's *Collection of Designs for Household Furniture and Interior Decoration* (1808). Rudolph Ackermann's monthly magazine, the *Repository of Arts* (1809–28), was also influential on early 19th-century design.

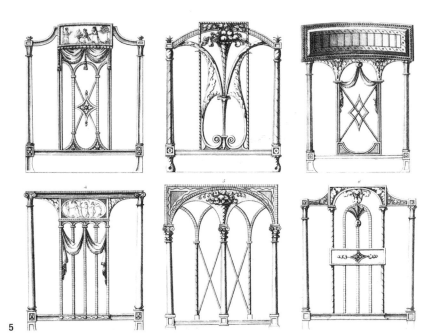

5 *Engravings of chair backs designed by Thomas Sheraton, published in the first edition of* The Cabinet-Maker and Upholsterer's Drawing Book, *1793. The square shapes of the backs reflect the new style introduced from France during the late 1780s and early 1790s.*

6 *This pair of parlour chairs, c.1780, have oval backs carved with an anthemion motif and square-section legs. Bands of gilding highlight the frames of the chairs.*

7 *An ebonized and gilt chair from a set made in the early 19th century. The Greek style of X-formed legs has been adapted for its design.*

8 *Inspired by designs published by Thomas Hope in* Household Furniture and Interior Decoration, *1807, this gilded beech armchair, made 1808–10, is japanned in a dark green to simulate bronze and has a cane seat and squab cushion. The frame expresses the prevailing Greek taste in the use of winged figure supports for the arms.*

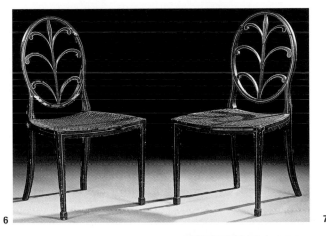
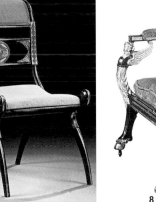
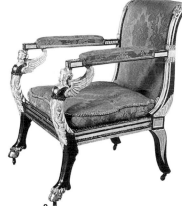

9 *Thomas Chippendale made this carved and gilded beech state bed with green silk damask hangings for the 1st Earl of Harewood, Harewood House, Yorkshire, 1773. One of the grandest expressions of the Neoclassical style is shown here in the elaborate use of carved detail and drapery.*

10 *The engraving for this design of a bed by George Hepplewhite was published by A. Hepplewhite in* The Cabinet-Maker and Upholsterer's Guide, *1788. Hepplewhite suggested that the ornaments on the cornice might be japanned, with festooned drapery on the lower valances.*

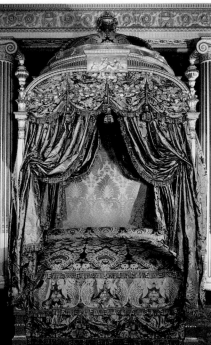
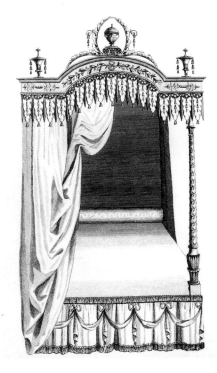

NEOCLASSICISM | BRITISH FURNITURE

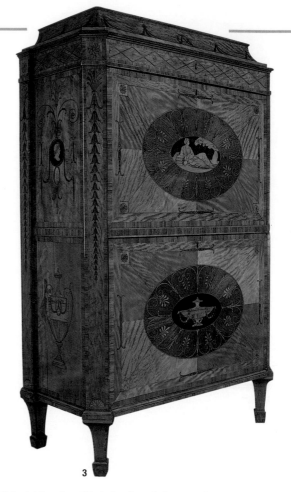

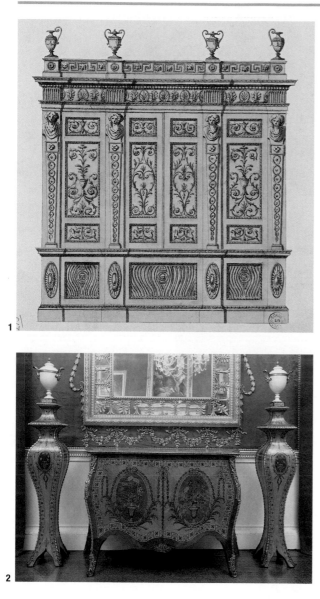

1 Robert Adam drew this design for a clothes press for Lord Coventry, 1764. The massive form of the piece reflects the previous Palladian classical style but the ornament of the front panels is Neoclassical.
2 One of a pair of commodes and torchéres by John Cobb for Lord Methuen at Corsham Court, Wiltshire, 1772. The pieces are Rococo in shape, but their decoration is in a Neoclassical style. Commode ht 95cm/37½in.
3 Mahogany secrétaire with satinwood and veneers by Thomas Chippendale for Harewood House, Yorkshire, 1772. The shape is French, but the marquetry panels are English Neoclassical. Ht 1.41m/4ft 7½in.

In the early 19th century new shapes for tables were introduced in response to changes in the arrangement of withdrawing rooms. These included central round tables on tripod or columnar supports, with elegant inlays of brass or ebony, and rectangular sofa, games, and writing tables with folding flaps, on supports in the form of Greek lyres or linked columns joined by a single stretcher. Darker, richer woods such as rosewood, zebrawood, and dark-toned mahoganies, and simulated ebony surfaces became highly fashionable, making strong contrasts with gilt mounts or brass inlays. Most tables and many chairs were fitted with casters for ease of movement.

In the period 1800–30 gilding continued to be used extensively for mirror frames, on which mouldings and other carved decoration became larger in scale. In addition the newly developed convex mirror glass was used with circular frames.

From the 1790s British chair forms had responded to French influence in the use of much more rectilinear shapes for chair backs and seats, replacing rounded seat and back upholstery with square-edged, or "French," stuffing. After 1800, chair design adapted again to the fashionable Greek style through the use of tablet-shaped backs and sabre or X-form legs, with classical figure or zoomorphic supports for arms. Canework with loose squab cushions for seats increased a sense of lightness and mobility for chairs, but strong plain colours were favoured for upholstery textiles.

Fashionable designs for beds also adapted to modern classical ideas with the introduction of couch beds, or *lits en bateau*, with elaborate drapery, although traditional four-post beds with fine classical pillars continued in use throughout the period.

The early years of the 19th century were also marked by notable developments in travelling or campaign furniture, stimulated as much by Britain's colonial expansion as by the needs of campaigning soldiers and sailors. Compact pieces combining several functions, or knock-down furniture that could be conveniently packed for travelling, were both ingenious and elegantly made.

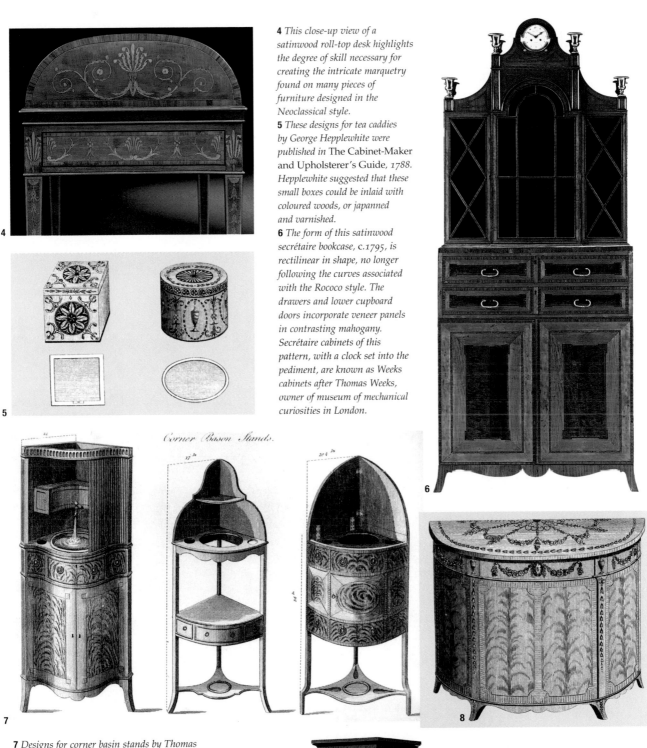

4 This close-up view of a satinwood roll-top desk highlights the degree of skill necessary for creating the intricate marquetry found on many pieces of furniture designed in the Neoclassical style.

5 These designs for tea caddies by George Hepplewhite were published in The Cabinet-Maker and Upholsterer's Guide, 1788. Hepplewhite suggested that these small boxes could be inlaid with coloured woods, or japanned and varnished.

6 The form of this satinwood secrétaire bookcase, c.1795, is rectilinear in shape, no longer following the curves associated with the Rococo style. The drawers and lower cupboard doors incorporate veneer panels in contrasting mahogany. Secrétaire cabinets of this pattern, with a clock set into the pediment, are known as Weeks cabinets after Thomas Weeks, owner of museum of mechanical curiosities in London.

7 Designs for corner basin stands by Thomas Sheraton were published in The Drawing Book, 1793. Sheraton stated that these pieces, in fine figured wood, "may stand in a genteel room without giving offence to the eye, their appearance being somewhat like a cabinet."

8 This Hepplewhite design for a commode, 1788, echoes in a simple form the more elaborate Neoclassical commodes made to designs by Robert Adam in the 1770s.

9 The fashinable cabinetmaker, George Bullock (fl.1804–1818), designed this cabinet for Blair Atholl, Scotland. His use of native larchwood contrasted with ebony gives bold emphasis to the stylized plant ornaments and borders.

Furniture from the German States

Variety in the 18th Century

1 *A carved and gilded beech oval chair, made in Koblenz c.1770. The frame is decorated with vitruvian scrolls and interlace in the Goût Grec style. Ht 117.3cm/6ft¼in.*

2 *In this transitional marquetry secrétaire cabinet by Abraham and David Roentgen, c.1768-70, the lower section is Rococo, but the upper section stresses the clarity of line and order of Neoclassicism. The floral marquetry was coloured and engraved. Ht 185cm/72¼in.*

3 *A commode in tulipwood with marquetry panels by the Prussian Johann Gottlob Fiedler, c.1786. The use of geometric mounts and compartmentalization of the marquetry are typical of German design. Ht 89cm/35in.*

4 *Commode by Heinrich Wilhelm Spindler with metalwork by Melchior Kambli in tortoiseshell, mother-of-pearl and ivory, with silver mounts, made in Prussia for Frederick the Great in the 1770s.*

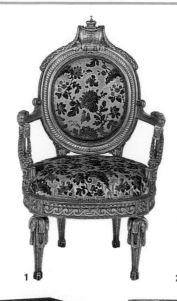

1

2

3

4

5

6

5 *Karl Auguste Grossmann's 1770s design for a sofa shows the possibilities in the Goût Grec style. The swags give a monumentality at variance with the more delicate back.*

6 *This elegant walnut secrétaire was made in Thuringia c.1770. It combines an early 18th-century top with a more geometric and Neoclassical base. Ht 2.6m/8ft 6¼in.*

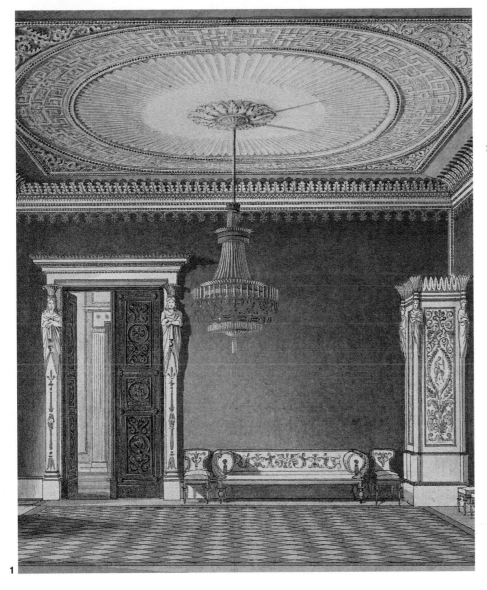

1 *Karl Friedrich Schinkel's design for the drawing room of Prince August was built 1815–17 in the Empire style. The wall paintings after antique Roman designs and the massive furniture created for the palace are based on interiors by Percier and Fontaine. Schinkel travelled from 1801–3 in Italy and to Paris.*

2 *This design for a chair to be made in mahogany by Schinkel was for the Chamois Room in the royal palace, Berlin, c.1807. It was one of the first commissions for the crown and shows strong French influences.*

Many of the rulers of the German states decorated their palaces in a modified Rococo style into the 1770s, and German Neoclassicism only developed towards the end of the century. The two main influences came from France and England, and 18th-century Neoclassical design shows a wide variety of forms. The most important cabinetmaker working in Germany was David Roentgen (1743–1807). He developed a form of pictorial marquetry in which the pieces were individually tinted, then inset into the veneer so that the colour or grain of each segment of the marquetry created the design. This technique, en mosaïque, created a painterly effect.

Roentgen went to Paris, Berlin, and Russia, creating architectural pieces with sophisticated mechanical workings. His monumental forms of the 1790s were developed from classical architecture. By this time, Roentgen had foregone the decorative fittings previously supplied by Pierre Rémond, using simple mounts of great quality, occasionally decorated with antique scenes in bas relief, which were set against the flame mahogany veneers.

In Prussia Friedrich Wilhelm von Erdmannsdorff (1736–1800) designed furniture for the royal palace in Berlin, the Marmor Palace in Potsdam, and at Schloss Worlitz, near Dresden. Johann Christian Fiedler, the royal cabinetmaker, began work c.1775 in a Rococo style with only the decoration taking on classical motifs. He later evolved a severe style, with limited ornament. The designs of Hepplewhite and Sheraton were popular and led to an emphasis on elegant, elongated forms.

After 1805 the French Empire style was taken up in all the German states. The palace of Wilhelmhöhe, Kassel, was furnished for Napoleon's brother, Jérome, with some furniture from Paris and some made by Friedrich Wichman, c.1810, in a heavier style. Percier and Fontaine's designs were copied in publications such as Ideen zu Geschmackvollen Möbeln (Leipzig). Some German furniture of this period favoured lighter timbers such as satinwood, birch, or maple. Karl Friedrich Schinkel's designs were drawn from antiquity and he experimented with furniture in metal and in marble.

Austrian Furniture

Biedermeier Design

1 *The lyre shape was a Viennese interpretation of the Empire style, appearing c.1800. The penwork designs used to decorate this lady's secrétaire of mahogany, fruitwood, and ebony veneers appear in cabinetmakers' drawings, c.1806-10. Ht 2.09m/6ft 10¼in.*
2 *This burr-walnut and ebonized worktable, made c.1825, opens to reveal an architectural scene within. Ht 96cm/3ft 1¾in.*
3 *A c.1805 mahogany writing desk attributed to Josef Haupt, with ash and ebonized pear interiors and delicate gilt bronze mounts on the exterior. This piece combines a sophisticated use of ornament on the stand and in the interior with elegant geometric shapes.*

4 *The unusual back of this early 19th-century* klismos *chair reflects the way in which individual motifs from antiquity were given geometric clarity by enlarging the scale of each element.*
5 *This 1820–5 semi-circular desk by Joseph Danhauser shows the extreme plainness of geometric forms, with an absence of ornament, espoused by Biedermeier and later Neoclassical designers. Ht 129cm/4ft 2¾in.*

Some of the most inventive furniture of the early 19th century was created in Austria, where the classical bourgeois style known as Biedermeier took root c.1815, soon spreading to other parts of eastern Europe and Germany, and continuing until the 1850s. Biedermeier absorbed both the French Empire style and English Regency, working them into elegant forms distinguished by rounded or geometric shapes and sparing ornament. Light-coloured figured timbers such as birch, maple, and fruitwoods as well as mahogany were favoured, with decorative motifs and borders in contrasting ebony or ivory, or painted in black. Convenient, comfortable, and well made, most furniture was designed by craftsmen, of whom the most important was Joseph Danhauser of Vienna (*fl.*1804-30). Capacious desks with ingenious internal arrangements, multi-purpose tables, and chairs with fan-shaped backs were typical, while columns, lyre shapes, drapery swags, and volutes were themes. The practical, clean-lined simplicity of Biedermeier furniture gives it a strikingly modern appearance.

Spanish and Portuguese Furniture

An Elaborate Taste

1 *This sofa in carved and gilded wood formed part of a suite made for the ship in which the Portuguese royal family fled to Brazil in 1807. The central oval canvases are based on harbour scenes by Jean Pillement. L. 1.15m/3ft 9½in.*

2 *Designed by Dugourc for the Casita del Labrador, Aranjuez, Spain, this chair was executed in ebony and boxwood c.1790–5. Dugourc used the engravings of Charles III's Catalogo degli Antichi Monumenti (1759) for the painting on the back.*

Spanish Neoclassical furniture assimilated influences from Italy, France, and Britain, emerging with a distinctive flavour. The royal workshops, headed by the Neapolitan Mattia Gasparini from 1768, produced chairs, console tables, and commodes for the Spanish royal palaces in a bolder, slightly exaggerated version of the Italian style. Case furniture was decorated with marquetry or painted panels of Pompeian figures in the Milanese style, sometimes with small mirrors or ceramic plaques added to the ornament.

In the early 19th century, the arrival in Spain of the designer Jean-Démosthène Dugourc ensured the supremacy of the French style, with the use of sculptural motifs such as swans, sphinxes, and figures.

In Portugal, furniture makers followed French design extremely closely, although English influence was most important for chairs. A distinctive type of breakfront commode with marquetry panels and a deep apron is known as a Donna Maria commode. José Aniceto Raposo specialized in marquetry of trophies, arrows, and flowers.

3 *This Spanish corner table with marquetry, made late 18th or early 19th century, is based on designs by Giuseppe Maggiolini. Ht 81cm/32in.*
4 *The mirror, console table, and chairs in the Donna Maria room of the Ricardo do Espirito Foundation, Lisbon, exemplify the Portuguese interpretation of Neoclassicism – differences of proportion and an abundance of decoration. The commode is in the French style, c.1790.*

Italian Furniture

Furniture from the 18th Century

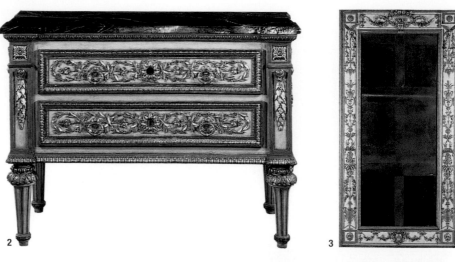

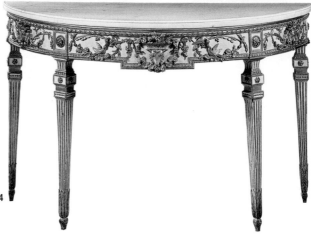

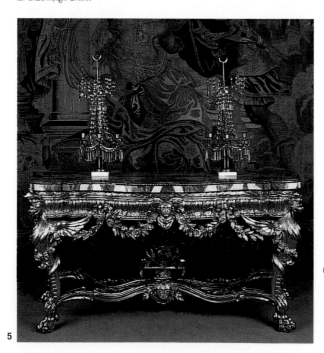

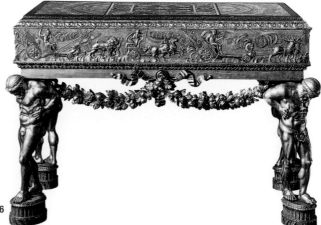

1 *A small commode, c.1800, veneered in various woods by the Lombard cabinetmaker Giovanni Maffezzoli reflects the dominance of Maggiolini's influence in north Italian design. It has an inset* verde antico *marble top and a frieze inlaid with vases and leafy scrolls. Ht 93cm/3ft ½in.*

2 *A pale green painted and parcel gilt carved commode from the circle of Giuseppe Maria Bonzanigo. The decoration includes bands of laurel leaves intersected by thyrsi, swags, medallions, beading, and paterae. L. 1.28m/4ft 2½in.*

3, 4 *This carved mirror and table, c.1795, painted white and gilded, are similar to pieces made for the royal family at Palazzo d'Avalos, Naples, with floral swags and a deer's head, suggesting they might have been for a hunting lodge. The designs of the frieze are taken from engravings by Giovanni Battista Volpone after Raphael's designs at the Vatican Loggia. Table ht 94cm/37in.*

5 *This highly sculpted giltwood side table from the Palazzo Borghese, Rome, was carved by Antonio Landucci, c.1775. Its transitional shape reflects the influence of Piranesi's designs. Ht.93.5cm/36¼in.*

6 *Made for the Palazzo Altieri in Rome c.1790–3, under the direction of the architect Giuseppe Barbieri, this table with full-length figures and carved decoration reflects the awareness of antique sources that influenced later designers such as Percier and Fontaine. Ht 98cm/38½in.*

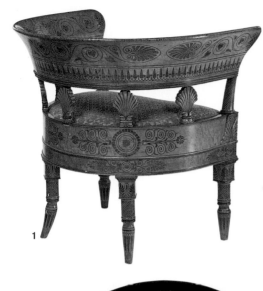

1 *Pelagio Palagi designed this chair for the Etruscan room at Castello Racconigi, Turin, 1834. Gabriele Capello revived the technique of inlay, which had completely disappeared in Italy.*

3 *The pure oval form of this c.1807 mechanical writing desk by Giovanni Socchi is an elegant reminder of the importance of geometry in early 19th-century design. The chair could be fitted into the desk to close it.*
L. 2.3m/7ft 6½in.

2 *Florence and Rome continued to produce work in hardstones throughout the 18th and 19th centuries. This Roman table top shows architectural scenes with classical buildings and ruins in the micromosaic technique. It is signed "B. Boschetti, 1829."*

NEOCLASSICISM | ITALIAN FURNITURE

Neoclassicism developed differently in Europe: Venice, Spain, and Portugal only came to it towards the end of the 18th century, while Rome, Turin, Genoa, and Naples evolved gradually towards classical forms. The main source of design was French. Giuseppe Maria Bonzanigo (1745–1820), the leading designer for the royal palaces in Turin, imitated French forms of the 1770s. His training as a miniaturist carver led to exquisite decoration on his furniture, generally of carved and painted wood.

Carved furniture – tables, chairs, commodes, and mirrors – was both gilded and painted. Roman furniture continued its emphasis on bold, highly sculpted forms, particularly in designs by Giuseppe Valadier (1762–1839). Roman tables had thick marble tops, typically veneered with a gilt-bronze edging. Chair designs were among the first to be on a large scale and influenced later designs.

The centre of cabinetmaking was Lombardy and the most famous exponent of veneered furniture was the Milanese cabinetmaker Giuseppe Maggiolini (1738–1814). The shapes of his commodes and cabinets developed from English rectangular forms, their fronts covered in fine pictorial marquetry. Followers such as Abbiati took these designs to Rome and the tradition of marquetry continued into the next century.

In the 19th century the French Empire style and the influence of Percier and Fontaine became dominant. The Bolognese designer Pelagio Palagi (1775–1860) and the Venetian, Giuseppe Borsato (1770–1849) both worked for leading members of the Napoleonic regime, producing high-quality furniture in a disciplined but often monumental classical style. Paolo Moschini (b.1789) developed complex decorative effects in marquetry imitating tortoiseshell, as well as intricate mechanical pieces. Elisa Baciocchi, Napoleon's sister, set up a royal manufacture in Florence directed by the Parisian Jean-Baptiste-Gilles Youf, which was the training ground for Florentine cabinetmakers such as Giovanni Socchi (fl.1807–39). Simplified French designs were given an architectural strength, in which the wood, often cherry or mahogany and decorated with ebony, was chosen for its rich grain.

North Eastern European Furniture

The Netherlands, Scandinavia, and Russia

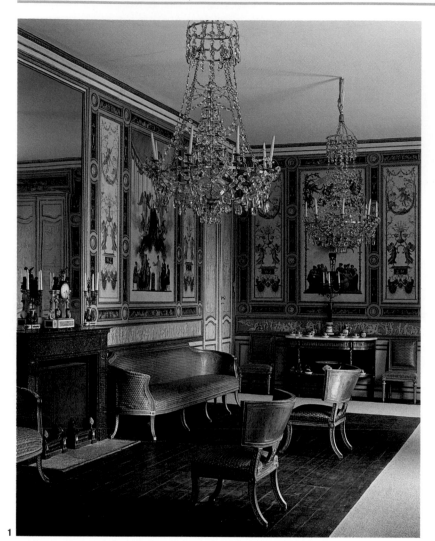

1 *The Grand Salon, Haga Pavilion, Sweden, designed by Louis Masreliez c.1786, was inspired by the Renaissance designs of Giulio Romano's Palazzo del Té. The furniture was executed by Eric Ohrmark in the antique manner. The side table is in French taste.*
2 *This* klismos *chair in gilt beech was designed by N.A. Abildgaard for the crown prince in Amalienborg Castle, Denmark, c.1790. The design was taken from a Roman wall painting published in* Delle Antichita di Ercolano Esposte, *1755–92, the official report of the excavation of Herculaneum.*

Dutch furniture, like German, remained conservative in Neoclassical design, for a long time simply adapting previous forms by changing the ornament to more fashionable antique motifs. It was not until the 1790s that the use of classical architectural sources created the linearity found in France and England two decades earlier. The cabinet on chest remained an important item for the Dutch interior and continued to be made in mahogany with carved decoration. Veneered furniture from the firm of Matthijs Horrix in the Hague was of a high quality, adapting both French and English forms. His marquetry made use of contrasting panels of ebony and light woods.

The Gustavian style in Sweden, so-called because of its association with Gustavus III, who admired French taste, paralleled developments in France. Some of the most important examples of French Goût Grec furniture are in Sweden, where the designer Jean François Neufforge (1714–91) was asked to provide designs for both private houses and the palace of Drottningholm. In 1769 the cabinetmaker Georg Haupt (1741–84) returned from a period in Paris, probably working under Risener, and a year's stay in London, to become the royal cabinetmaker.

The late 18th century saw the flourishing of furniture making in Russia with the patronage of Catherine the Great (1762–96). The Scottish architect, Charles Cameron (*c.*1740–1812) introduced the Pompeian style of Adam to the royal palaces and David Roentgen came to St. Petersburg in the 1780s bringing his fine mechanical pieces. His influence continued in the work of Christian Meyer and Heinrich Gambs into the 19th century. French furniture was also imported. In the early 19th century, the Russian designer Andrei Nikiforovich Voronikhin (1760–1814) looked back to furniture by Georges Jacob but used his own motifs such as intertwined serpents for the backs of chairs. Russian cabinetmakers continued to make pieces of exceptional quality and variety of design throughout the Neoclassical period. Particularly Russian is the use of malachite, lapis lazuli, and ivory to decorate fine furniture. In the city of Tula traditional techniques of working steel were used in furniture.

Northern Marquetry

1 *Matthijs Horrix (1735–1809), working in the Hague, Netherlands, developed his own variations on the commode form, with curving sides gradating to the central marquetry front. Ht 1.46m/4ft 9¼in.*

2 *Gustavus III of Sweden gave this mineral cabinet to the prince de Condé in 1774. It was designed by Jean Eric Rehn and made by Georg Haupt. The marquetry shows Haupt's characteristic bold design within rectangular panels. The high-quality gilt-bronze mounts, based on French Goût Grec forms, were made in Stockholm.*

Russian Imagination

3 *Voronikhin designed much of the furniture for Pavlosk Palace, near St. Petersburg, c.1805, such as this carved, painted, and gilded desk chair attributed to the workshop of Karl Scheibe.*

1 *The strong square back and highly carved decoration of this chair, c.1820, are typical of Russian style. Russian designers subtly changed the shapes of French models and added richer, bolder decoration.*

2 *This late 18th-century kidney-shaped centre table in tulipwood and purpleheart, decorated with marquetry of various woods and mother-of-pearl, shows the high quality of Russian work. Ht 75cm/29½in.*

4 *A set of furniture veneered in Karelian birch with gilt bronze mounts, showing the final stages of Russian Empire style. It was probably designed c.1820 by Carlo Rossi, an Italian working in Russia.*

5 *This small table of ebonized wood designed by Voronikhin, c.1807, is closely based on French shapes of the late 18th century and reflects the taste of the empress Maria Feodorovna. The bird head motif of the legs was one of the designer's favourite forms.*

American Furniture

Simplified Lines and New Forms

1 *The simplified lines of Samuel Willard's clock dating from c.1822–30 are based on the symbol of New England seafaring, the lighthouse. Willard's workshop was in Roxbury, Massachusetts, near Boston. Diam. 75.6cm/29¾in.*

2 *The centre* kylix *motif with swags of leaves and rosettes on the shield-shaped back of this walnut chair of 1760–70 was probably based on the designs of Robert Adam. Ht 95.3cm/37½in.*
3 *Ladies' writing desks such as this 1795–1810 Baltimore example made of mahogany and inlaid with satinwood and cedar were new forms in the late 18th century. The decorative devices in each panel display classical toga-bedecked women. Ht 158cm/62¼in.*
4 *Demi-lune card tables with richly grained veneers such as this one of 1800–20 were often sold in pairs. They were arranged symmetrically in the room. Ht 69.8cm/27½in.*

After the Revolution in the 18th century, Americans were involved in building a new nation that they hoped would be an ideal republic following the tradition of Rome. Early Classical Revival and Federal furniture provided a new identity that was ideally suited to a young nation. By the last quarter of the 18th century Americans had rejected the excesses of the Rococo style, with its elaborate carving and curving forms, in favour of the crisp lines and decoration of the Neoclassical style. Furniture designed during this period looks light and delicate. The slenderness and rectilinearity of chairs, tables, and case furniture often give them a fragile or even insubstantial appearance.

Carved ornament was superseded by geometric inlays and veneers in exotic woods. Mahogany or satinwood was most favoured for fine furniture, but cherry and walnut were sometimes used, while birch and maple were New England substitutes, sometimes stained to resemble mahogany. Rectangles, squares, ovals, and bands of stringing in the rippling grain of mahogany,

satinwood, or birch enhanced the smooth, two-dimensional appearance of this furniture, and classical motifs such as urns, acanthus leaves, husks, swags, volutes, and the inestimable symbol of the new republic, the eagle and shield, proclaim the style.

Imported pattern books such as Hepplewhite's *Cabinet-Maker and Upholsterer's Guide* (1788) and Sheraton's *Cabinet-Maker and Upholsterer's Drawing Book* (1791–4) did much to popularize classical design in the United States. The influx of European immigrants included craftsmen and patrons, as well as English and French furniture, and they added further ideas and designs. John Aitken (*fl.*1790–1840) and Ephraim Haines (1775–1837) in Philadelphia, John Seymour (*c.*1738–1818) and Samuel McIntyre (1757–1811) in Boston, and Duncan Phyfe (1768–1854) in New York were among the leading cabinetmakers, but many others catered for an increasingly eager and prosperous clientele.

Although Philadelphia and Boston remained the chief centres of fashionable furniture, Baltimore now became

Cabinetwork

1 *The smooth, sleek surfaces of early classical furniture were set off with inlays and veneers of exotic and luminous woods. On this 1813 desk and bookcase from Portsmouth, New Hampshire, decoration is set against mahogany in rosewood and birch veneers with ivory.*

2 *European immigrant craftsmen brought the new motifs and designs of Neoclassicism with them to the US. The Scotsman Duncan Phyfe, the maker of this 1810–25 mahogany sideboard, had an extensive workshop in New York City. Ht 152cm/59¾in.*

3 *The geometry that adorns late 18th-century furniture is expressed in the voids created by glass windows in the doors of this secretary bookcase.*

The Elegance of the Federal Style

1 *Attributed to the workshop of John Seymour, who first settled in Maine, then in Boston, this mahogany chair-back settee of 1805–10 has figured birch inlay. Ht 107.3cm/42¼in.*
2 *Samuel Gragg's side chair, an interpretation of the Greek* klismos *chair, made in Boston in 1808–15, was the first piece of American furniture to use bentwood as a structural element. Ht 85cm/33½in.*

Post-Revolutionary Seat Furniture

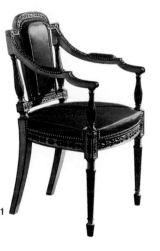

1 *After the American Revolution English and continental designs set the fashion, particularly in Philadelphia. This armchair of 1785–1815 with its upholstered back, double-scoop arms, and contrasting painted and gilded surface exemplifies both French and British influences. Ht 92.1cm/36¼in.*
2 *This sofa of mahogany and birch, made in Salem, Massachusetts, 1805–15, is among the most stylish forms for a drawing room or parlour in the first decades of the 19th century. Ht 97.2cm/38¼in.*

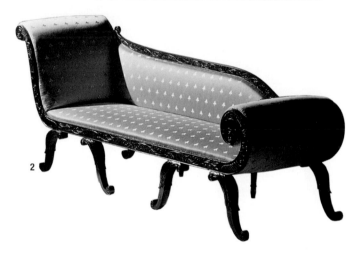

important, particularly for the production of "fancy" chairs with their attractive painted decoration, and Salem, Massachusetts, for its elegant secretaries combining a glass-fronted cabinet with a pedestal desk. An increasing variety in chests of drawers emanated from the Connecticut River Valley.

The Federal or early Neoclassical style was fashionable for a brief period. By 1815 the shift in emphasis from decoration to form in classical interpretations gave rise to the Empire style with its Napoleonic inspiration. Empire design in the United States continued to satisfy contemporary tastes into the middle of the 19th century, in spite of competition from other revival styles. The French flavour of much American Empire furniture was assured as much by the arrival in New York of émigré cabinet-makers such as Charles Honoré Lannuier (1779–1819) as by philosophical leanings.

In comparison to Federal furniture, large volume and sculptural ornament derived from classical sources characterize pieces in the Empire style. Craftsmen made

the most of materials such as shiny glass, metal mounts, and gilding to highlight bold sculptural ornament and to contrast with the luminous surfaces of highly polished mahogany veneers. Some furniture forms were direct copies of classical models such as the *curule* and *klismos* chairs, but most often the furniture incorporated decorative elements such as caryatids, columns, urns, and lyres to give a fashionably classical flavour to such items as cabinets, tables, and chairs.

Imported design books as well as furniture in the latest European taste all contributed to the direct copies as well as the hybrid expressions of the classical revival. The proliferation of pattern books after 1800 affected even the smallest workshops in American urban centres. Napoleon's designers Pierre Fontaine and Charles Percier published their designs in 1798. Other source material followed: Thomas Hope's *Household Furniture and Interior Decoration* (1807), Rudolph Ackermann's periodical *The Repository of Arts* (1809–1828), and Pierre La Mésangère's *Meubles et objets de goût* (1802–1835) were all influential.

Mediterranean Influences

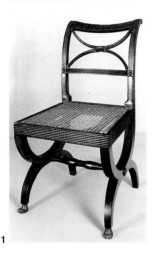

1 *The* curule *form was a significant design borrowed from antiquity. This New York version by the cabinetmaker Duncan Phyfe in 1810–20 incorporates the* curule *shape into the side supports of the chair. Ht 82.1cm/32¾in.*
2 *Italian mosaic tabletops embodied all that was antique and Roman. Anthony Quervelle of Philadelphia probably made this mahogany tripod centre table of 1825–35 to accommodate his client's Grand Tour souvenir. Ht 76.8cm/30¼in.*

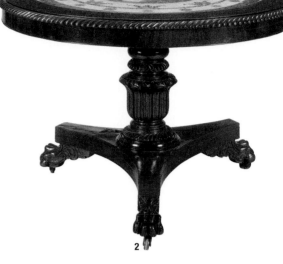

The Impressive Empire Style

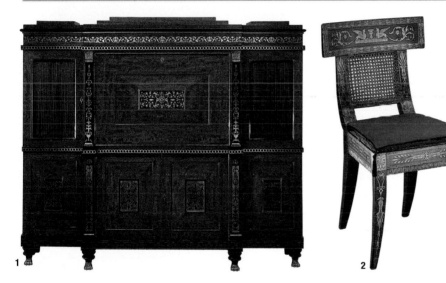

1 *The impressive form and darker mahogany of this secretary desk inlaid with ebony and brass, by Joseph Barry, c.1810–20, are attributes of the Empire style. Ht 167cm/65¾in.*
2 *What the ancient Greeks called a* klismos *chair was known as a Grecian chair in the 18th and 19th centuries. This side chair made by Benjamin Henry Latrobe of Philadelphia, 1808–10, is not only a dramatic expression of the sabre-legged* klismos *form but includes painted classical motifs on the tablet back. Ht 81.3cm/32in.*

The French Style of Lannuier

1 *The exotic satinwood veneers, the patinated dolphin feet, and the gilt-bronze mounts make this bed, made in New York City by the French immigrant craftsman Charles Honoré Lannuier, impressive. Ht 114cm/45in.*

2 *Charles-Honoré Lannuier incorporated gilded, winged carytids into pier tables, card tables, settees, and armchairs, such as this one of 1810–19. Printed sources of classical motifs were available in the early 19th century.*

Materials and Techniques

Exotic Materials and the Skilled Craftsman

3 *By using mahogany on this English, c.1780, parlour chair, the craftsman could create the slender forms popular in the Neoclassical period.*

4 *The surface of this 1772–4 secrétaire by Jean-François Leleu is entirely covered with highly elaborate marquetry composed of many different exotic woods and finished with ormolu mounts in the Neoclassical style Ht 1.3m/4ft 3½in.*

1 *Mahogany planks from the West Indies were cheap and provided British cabinetmakers and carvers with an ideal material for good-quality furniture of all types.*
2 *The workshop of Martin Carlin made this French music stand and writing table, 1777–85. It incorporates an oak carcase veneered in tulipwood, satinwood, and other woods, and is mounted with ormolu and a Sèvres porcelain plaque. Ht 78cm/30¾in.*

The craftsmanship and materials used in Neoclassical furniture were of the highest quality and were distinguished by complex construction and often elaborate decoration. In Britain, plentiful supplies of mahogany imported from the West Indies provided furniture makers with a stable, durable, and versatile wood for constructing into every type of furniture in the Neoclassical style. It permitted the development of exceptionally slender frames for cabinets, tables, and chairs, yet provided strength.

Exotic timbers from the East Indies and South America were also imported into Britain and Europe for use in decorative veneers which were originally very brightly coloured. Minute pieces were precisely cut and pieced together to form complex patterns, pictures, and borders. Ivory, mother-of-pearl, ornamental stones, and rich metals were also inlaid into wooden surfaces.

Painted and japanned decoration in the Neoclassical style was used extensively, often on softwoods, which were prone to decay. Techniques involved laying a gesso coating on the wood, applying oil-based colours, and finishing the surface with varnishes. In France and Germany, lacquer panels and porcelain plaques could be incorporated into the surfaces of tables and cabinets as an alternative to marquetry and paint.

Cast-metal mounts, in bright ormolu, or gilt brass were supplied by specialist founders, sometimes working for particular designers and craftsmen. Gilding on mirror, picture, table, and chair frames continued to be important for luxury furniture. Specialist craftsmen were employed to apply gesso and gold leaf with oil- or water-based techniques. Gilders often worked in close partnership with glass grinders and silverers, who provided increasingly large panels of mirror glass.

Upholstery was sophisticated during the Neoclassical period, with refined techniques and materials used to stuff and cover chairs. After 1800 the work of the uphol-sterer became more important when elaborate drapery in the Greek style was applied to beds, sofas, and cabinet-work, using rich fabrics and complex trimmings.

5 *This detail of a marquetry panel from a commode by Thomas Chippendale for Harewood House, England, 1773, shows the precision needed for such intricate work.*

6 *In this design by Robert Adam for a painted table for Lord Bathurst, Apsley House, London, c.1775, the detailed ornament shown is typical of Adam's Neoclassical style and is perfectly suited to painted decoration on furniture.*

7 *Detail of an English pembroke table, c.1780, of oak and satinwood. The table has marquetry inlays of mahogany and stained woods, with brass handles and plates. Skilled cabinetmaking techniques, decorative woods, and metal mounts produced furniture in a delicate Neoclassical style.*

5

6

7

9

8

8 *This design for a four-post bed includes sample materials. It is by John Stafford of London and Birmingham, 1816. Elaborate draperies in silks and cottons with intricate borders and fringes were an important feature of later Neoclassical furnishings.*

9 *Upholstery techniques were illustrated in Diderot's Encyclopédie ou Dictionnaire Raisonné des Sciences, 1771. Upholsterers employed skilled techniques to create elaborate shapes for seat furniture.*

Major Continental European Porcelain

A New Art

1 *A large Sèvres biscuit group of the* Judgement of Paris, *modelled by Louis-Simon Boizot, c.1780. The large size of the group was made possible by the development of hard-paste porcelain. In the 1760s Sèvres groups consisted mostly of children, but by the 1780s classical themes predominated. Biscuit porcelain was polished with hard stones for a silky finish. Ht 42 cm/16⅓in.*

Neoclassical Motifs

1 *This Sèvres ice-cream cooler is from a service made for Catherine the Great c.1778–9. It has typical classical scenes* en grisaille *and applied cameos, and the figural handles and band of leaves are also in the classical tradition. Ht 23.7cm/9in.*
2 *The medallions, swags, and Greek key pattern on this Sèvres* bleu nouveau *vase and cover, made c.1765, are all typical Neoclassical motifs. Ht 35cm/13¾in.*
3 *A formality of shape can be seen in this Sèvres vase, c.1771, decorated with a band of putti. The handles are simple loops and the cover is pierced with classical anthemion and laurel. Ht 45.7cm/18in.*

The Neoclassical style first appeared in ceramics in the 1760s when the French Sèvres factory introduced vases with a strong Neoclassical influence. Although still painted with Rococo subjects such as flowers, children, or lovers, the shapes were Neoclassical. Of depressed or ovoid urn form, they were symmetrically designed, the basic shape enlivened by a wealth of moulded or applied three-dimensional detail, including acanthus, anthemia, rosettes, laurel garlands, guilloche, ribbons, rings, swagged draperies, and medallions. Sides were fluted, reeded, or gadrooned, and banded with borders of simulated pearls, bosses, or studs, vitruvian scrolls, Greek key pattern, or stiff leaves. Moulded handles with overlapping leaves, or formed as sphinx heads, straps, or even female figures, were applied to the sides. Coloured grounds, particularly a rich overglaze-blue (*bleu nouveau*), added to the air of restrained magnificence.

In 1769 hard-paste porcelain was first made at Sèvres, and the production of large, magisterial pieces became possible. During the 1760s and 1770s imposing biscuit figures were made, not as table decorations, but as miniature sculpture. Throughout the 1770s classical subjects were fashionable, and the art of cameo painting was seen to great advantage in the great Frog service made, 1778–9, for Catherine the Great of Russia, a passionate collector of classical cameos and gems, and even three-dimensional porcelain cameos were applied. Cylindrical coffee cans replaced the traditional cup shape, and in the 1780s a new technique was introduced by Joseph Coteau (1740–1801), which combined "jewelling" in enamels applied over coloured foils, with rich, elaborate gilding.

After the French Revolution, the grandiose manifestation of Neoclassicism – the Empire style – reflected Napoleon's aspirations to achieve the imperial status of classical times. In 1800 A. T. Brongniart (1739–1813) was put in charge of Sèvres. He discontinued the manufacture of soft-paste porcelain. Large vases and services were made as diplomatic gifts and for Napoleon himself. The Austerlitz vase, made in 1806, was copied from a Greek *krater* (a type of jar) and painted in Etruscan style with red

A Display of Historical Themes

1 *Napoleon presented this Sèvres ice-cream pail, from a service made 1810–1812, to Empress Josephine as a divorce present. The Egyptian-style painting is based on Denon's book on Egypt, 1802. Ht 30.3cm/11¼in.*

2 *This urn shaped Paris vase, made c.1790, shows the simplicity of the Neoclassical style at its most formal and restrained. The continuous landscape scene, burnished gilding, and stiff leaves embrace Neoclassicism. Ht 43cm/17in.*

3 The Three Graces Distressing Cupid *is the theme of this c.1810 Paris plate. The matted gilding is tooled with classical border patterns. Matt, burnished, and tooled gilding was often contrasted in Empire style. Ht 23.5cm/9¼in.*

Border Decoration

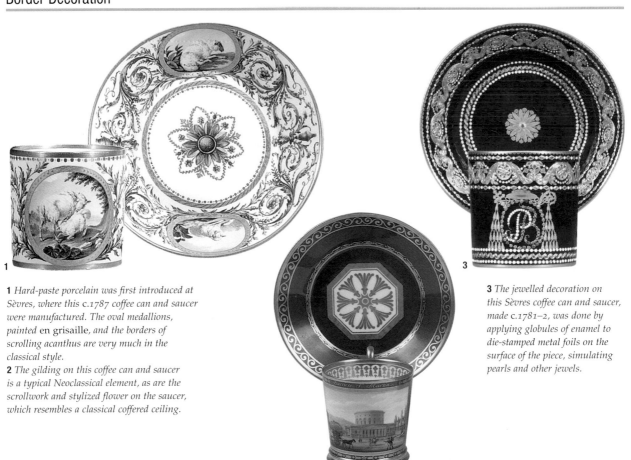

1 *Hard-paste porcelain was first introduced at Sèvres, where this c.1787 coffee can and saucer were manufactured. The oval medallions, painted* en grisaille, *and the borders of scrolling acanthus are very much in the classical style.*
2 *The gilding on this coffee can and saucer is a typical Neoclassical element, as are the scrollwork and stylized flower on the saucer, which resembles a classical coffered ceiling.*

3 *The jewelled decoration on this Sèvres coffee can and saucer, made c.1781–2, was done by applying globules of enamel to die-stamped metal foils on the surface of the piece, simulating pearls and other jewels.*

Vase Shapes Inspired by the Excavations

1 *The portrait of a lady is painted on a dark ground panel, accompanied with a rich, burnished gold ground on this pair of vases made in Paris c.1820. The handles follow a traditional classical shape. Ht 45cm/17¾in.*
2 *This pair of Paris vases, made in the Empire style c.1830, is painted with topographical scenes. The burnished gilding and shaped handles are typical of vases of the period. The square bases were inspired by the excavations at Pompeii and Herculaneum. Ht 39.5cm/15½in.*
3 *The pedestals of these green-ground vases, made at Paris c.1825, are almost as grand as the bodies of the vases themselves. The upright swans' head handles are typical of the Empire style.*
4 *The cameo portraits in profile on this pair of blue-ground vases were a popular subject for the Neoclassical painter. Ht 33cm/13in.*

figures on a black ground, and represented Napoleon, crowned with laurel and driven by Victory in a chariot.

Several porcelain manufacturers set up in Paris at the end of the 18th century. Fine painting *en grisaille* (in imitation of stone sculpture in black, white, and grey) was used for tea and coffee services, and inexpensive wares were painted with scattered cornflower sprays. Some tea wares and vases combined biscuit and glazed porcelain with burnished gilding and innovatively shaped handles.

Meanwhile, in the provinces, stiffly Neoclassical figures were made at Niderviller, and at Creil, founded in 1793, English-style creamwares were printed in black with classical scenes and borders.

During the Seven Years' War (1756–63) Saxony was overrun by Prussian troops, and production at Meissen came almost to a halt. After the war, the French sculptor Victor Acier was appointed to introduce "modern" taste, to compete with Sèvres, which had reigned supreme over porcelain production during the war. Ten years later in 1774, Count Camillo Marcolini was appointed director.

By the 1760s the Neoclassical style, inspired by the excavations at Pompeii and Herculaneum, was becoming fashionable. Acier designed figures and groups of naked cupids at amatory pursuits, with square bases moulded with anthemia and edged with Greek key pattern. Sentimental groups of lovers and children sat on Neoclassical chairs or by classical urns, and their oval bases were moulded with borders of vitruvian scrolls or gadroons, gilt to resemble Louis XVI ormolu mounts.

Throughout Germany shapes of tablewares adapted to the new style, with pinecone, artichoke or, impractically, laurel wreath knops. Urn-shaped vases had rams'-head and mask handles, and architectural gadroon borders were popular on flat wares. By the 1780s cylindrical coffee cans had replaced bowl-shaped cups across Europe. The oval medallion was a popular shape for reserved panels, with tooled borders of flat gilding enclosing monograms, silhouettes, or profile portraits, which gave an illusion of framed miniatures hanging from a bow or floral garland.

Mastering the Medium – The Skill of the Modeller

1

1 *The Neoclassical taste for mythological characters can be seen in this Meissen figure group, c.1765, though it still shows many elements of Rococo.*

2 *Modelled by Michel Victor Acier and Johann Carl Schonheit, this allegorical Meissen group, made c.1774, represents* The Test of Love. *It shows the lovers by a Neoclassical urn on a pedestal, and the gadrooned base has replaced the Rococo rocky mound. Ht 50cm/19¾in.*

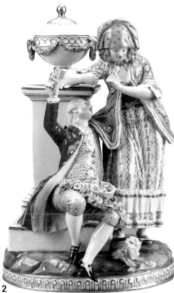

2

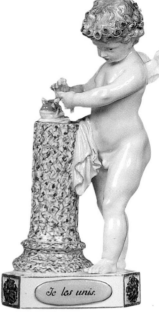

3

3 *This Marcolini Meissen figure of* Cupid, *modelled by Michel Victor Acier c.1775, has a classical column instead of a Rococo tree trunk. The pale colour palette, the rectangular base, and the subject epitomise Neoclassical severity softened by sentiment. Ht 14.7cm/5¾in.*

From Curves to Angles

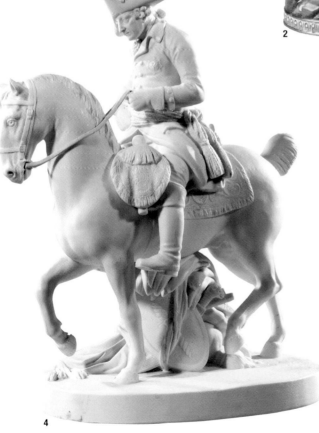

4

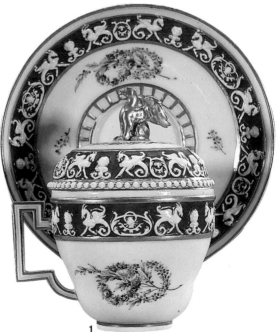

1

4 *This Berlin biscuit group of Frederick the Great, made c.1780, shows him mounted on horseback like a classical emperor. The white unglazed porcelain shows the sculptural quality of the group. Ht 35.5cm/14in.*

1 *The angular handle on this Marcolini Meissen chocolate cup with cover and saucer, made c.1775, no longer has the sinuous curves of the Rococo. The gryphons are classical, as are the entwined garlands.*

The Restrained Decoration of German Porcelain

1 *A Frankenthal coffee can and saucer, made 1775, showing the skill of the artist, who created a trompe l'oeil engraving of a landscape pinned to a wooden board.*

2 *The decoration of this Frankenthal coffee can and saucer, c.1780, is restricted almost exclusively to the central panel of a landscape. Gone is the extravagance of the Rococo style.*

3 *This Frankenthal coffee can and saucer, made 1785, has initials within ribboned medallions and a scattering of flowers, both of which are typical Neoclassical elements.*

Naturalistic Painting

1 *A Vienna oval tray, painted in 1809 with a basket of flowers by Joseph Nigg, demonstrates the tendency to treat the porcelain as a canvas on which to paint. Ht 42cm/16½in.*
2 *This Berlin two-handled Münchner vase, in a typical Neoclassical urn shape, is painted with topographical views of Berlin on a rich reddish ground. Ht 61cm/24in.*

At Frankenthal, a leading German factory, fine, detailed painting of allegorical or mythological subjects after French engravings was seen on *solitaires*, *déjeuners*, and *tête-à-têtes* – tea and coffee services for one or two people on a matching porcelain tray – the last providing an unusually large and flat surface for the porcelain artist.

The Empire style, which dated from around 1800, was by no means confined to France, and its effects were felt all over Europe. The cylindrical coffee can became flared at the rim and was supported on three gilt lion paw feet. Borders of simulated pearls appeared, as did high curving gilt handles in the shape of swans' necks and dragons' heads. Gilding was burnished to a brassy brightness, matted, bronzed, or engraved for decorative effect. The rapid growth of the middle classes provided a market for single, superbly painted cabinet cups, as opposed to the large dinner services ordered by the aristocracy, and by the 1820s and 1830s improved travel links further stimulated this market by providing a need for high-quality souvenirs of holidays and tours to the beauty spots and spas of Europe. Ovoid or bell-shaped tea and coffee wares became fashionable, and milk jugs and coffee pots took the form of classical ewers.

The icy white porcelains of the German Berlin and Austrian Vienna factories proved an ideal background for highly skilled, precise, detailed miniature painting. Now, under the influence of Friedrich Wilhelm III (1770–1840), the Berlin factory produced *Berliner Vedutenporzellan*, exquisite topographical city views of unsurpassed quality. Flowers and portraits were also painted with minute naturalistic detail, against grounds that included a brilliant Prussian blue, black, and buff.

At Vienna, Konrad Sorgel von Sorgenthal was appointed director in 1784, and so committed was he to Neoclassicism that in 1792 his master modeller, Anton Grassi, visited Rome to assimilate the forms of excavated Roman artifacts. Rich plates with coloured grounds and elaborate borders were painted with scenes after Angelica Kauffmann, and spectacular plaques, vases, and trays were painted with flowers by Joseph Nigg (*fl.* 1800–1843).

Richness of Colour and Gilding

1 *The palmettes on this Berlin cabinet cup and saucer, c.1815, made more pronounced by the strong pink ground colour, are a popular Neoclassical motif. The form of the cup, sitting on a pedestal foot and with an upright handle, are typical classical shapes.*
2 *This c.1815 Nymphenburg matt blue-ground cabinet cup and saucer was painted by Christian Adler with a portrait of Crown Prince Ludwig of Bavaria, Austria.*
3 *A c.1815 Berlin gold-ground coffee service, which is tooled and has burnished gilding to give it a brilliant finish. The pedestal feet and erect handles are typical of Neoclassicism.*

Elegance of Style and Simplicity of Shape

1 *A c.1810 Berlin two-handled commemorative vase, with bronzing and gilding, applied with biscuit profile busts of Queen Louise of Russia and her children. The shape of the vase was inspired by the classical urn, and the swags and swan-shape handles are Neoclassical elements. Ht 48.5cm/19¼in.*
2 *Devoid of decoration, with the exception of the single gilt band, this coffee pot has a truly Neoclassical shape – with a pedestal foot, upright handle, elegant spout, and finial knob.*

English Pottery and Porcelain

Moulded and Pierced Neoclassical Decoration

1 *The cover of this Wedgwood (or Leeds Pottery) Queen's ware, or creamware, chestnut basket, made c.1775–85, is pierced to allow the steam from the hot chestnuts to escape. The swags and pendant acanathus leaves display Neoclassical influence.*
2 *A reproduction of an illustration from the Wedgwood creamware pattern book for 1774 shows strong Neoclassical elements such as the pineapple finial, the central urn shape decorated with gadroons and moulded festoons, and the overall symmetry of the shape.*

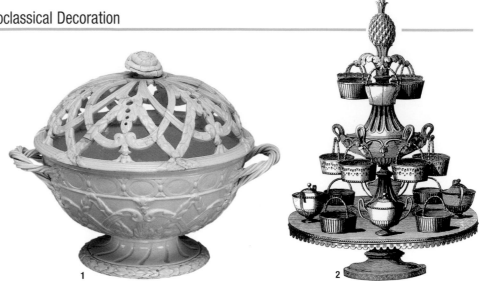

Restrained Neoclassical Decoration

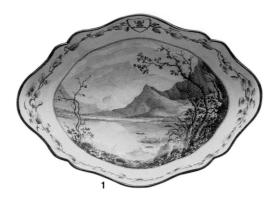

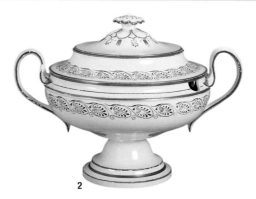

1 *This Wedgwood creamware salad bowl from the Frog service was made for Catherine the Great c.1778–9. The painting en grisaille and gadrooned borders are Neoclassical elements. W. 31.5cm/12⅜in.*

2 *The minimalist elegance of the Neoclassical style can be seen on this c.1790 Wedgwood creamware tureen in a depressed urn shape. The borders of palmettes echo those found on Greek vases. Ht 16.6cm/6½in.*

The ceramic genius of the Neoclassical age was Josiah Wedgwood (1730–95). He refined the Staffordshire cream-coloured earthenware (or creamware) to meet demands of the expanding middle class. In the 1760s, he achieved a pale, thin body by adding Cornish clay and china stone to his Queen's ware. Large services were made, and in the 1790s nautilus shell shapes were introduced. They were sparsely painted with borders of bell-flowers, egg and dart, anthemia, and bands of leaves in Neoclassical style in sepia, green, or blue. Wedgwood also developed pearlware to create a whiter earthenware in 1779. More white clay and flint were added to the body, together with cobalt oxide, which gave the glaze a bluish tinge to create the illusion of whiteness. It was painted in underglaze-blue or coloured enamels, and paved the way for the blue-printed earthenwares of the 19th century.

He next developed a hard, fine-grained black stone-ware, known as "black basaltes." This material had a hardness and lustre that made it ideal for the crisp detailing of applied moulded satyr heads, laurel swags, medallions, and rams' heads on vases. Jasperware, a fine-grained white stoneware capable of taking a mineral oxide stain in shades of blue, green, yellow, lilac, and black, was developed by Wedgwood by 1775. Other Wedgwood "dry bodies," as they were called, included caneware, a buff-coloured stoneware, and rosso antico, inspired by Roman *terra sigillata* (Samian ware).

The Chelsea-Derby factory, formed when William Duesbury of Derby purchased the Chelsea factory in 1770, produced porcelain vases in classical style. Dessert services were also made, painted with festoons and husks, urns, Greek key pattern, and classical subjects *en grisaille*. At the end of the century, the Derby factory made vases in classical ovoid, urn, and ewer shapes. Figures on canted square bases, similar to their contemporary Staffordshire earthenware cousins, also appeared at the same time. Derby tablewares were the height of elegance, with tea services based on contemporary silver shapes. Military, naval, flower, bird, mythological, and landscape scenes were shown against pale yellow, pink, salmon,

New Materials from Wedgwood

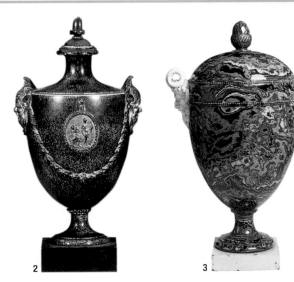

1 *This Wedgwood pearlware bough pot, one of a pair made c.1790–1800, is a typical Neoclassical urn shape. The gadroons and swags are contrasted in white against the dark ground. Ht 36cm/14in.*
2 *Covered with a porphyry glaze, this c.1775–85 Wedgwood vase is made of white terracotta stoneware and applied with gilded reliefs. Ht 30.5cm/12in.*
3 *Made from different coloured marbled clays, and mounted on a marble plinth, this c.1770-75 Wedgwood vase has satyrs' head handles that emulate a classical stone original. Ht 27.2cm/10¾in.*

Restrained Dry Bodies

1 *Wedgwood's Pegasus vase, made of jasperware c.1786, shows the* The Apotheosis of Homer. *The blue colour is often associated with Wedgwood. Ht 46cm/18 in.*
2 *Although this Wedgwood caneware teacup and saucer, made c.1790, shows a hint of chinoiserie, the fluted sides and restrained, cool colours are typically Neoclassical.*
3 *The red and black colours of this rosso antico vase, made c.1785, were inspired by Roman Samian ware. The relief decoration is based on Egyptian designs. Ht 32/cm/12½in.*

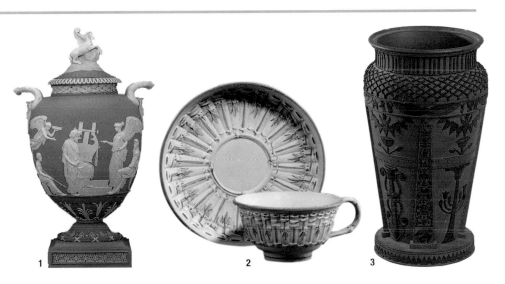

Classically Inspired Figures

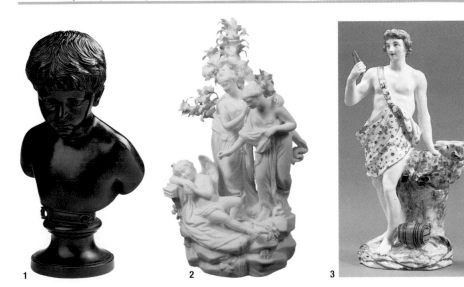

1 *This Wedgwood black basaltes bust of* Mercury, *the messenger of the gods, was made in the late 18th century. Classical figures were a popular subject.*
2 *A c.1775 Derby group, in biscuit, or unglazed white porcelain, shows* The Three Graces Distressing Cupid, *after a painting by Angelica Kauffmann, who worked in the Neoclassical style. The unglazed porcelain gives the illusion of a miniature marble sculpture. Ht 22.9cm/9in.*
3 *The unsophisticated work of some factories can be seen in this c.1775 Champion's Bristol figure of* Autumn, *from a set of the Seasons. Ht 25.5cm/10in.*

Utilitarian Wares

1 *The subdued combination of gilt line borders and bat-printed landscapes en grisaille embellishes the silver-inspired "New Oval" shape of this c.1799 tea service by Spode. W. (teapot, handle to spout) 27cm/10¾in.*

2 *New Hall made this service c.1795–80 with sparsely scattered flower sprigs in the style of contemporary textiles and a cream jug in the shape of an inverted classical helmet – elements typical of the factory.*

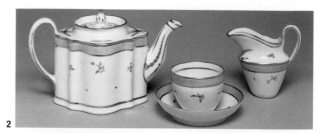

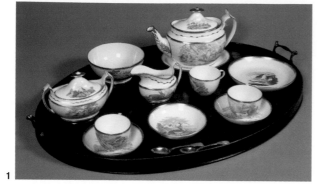

3 *A Flight Worcester plate from the Hope service was made for the Duke of Clarence c.1790–92. The subdued colour scheme emphasizes the Neoclassical style, as does the border of paterae and flutes and the classical figure in the centre. Diam. 24.6cm/9¼in.*

Neoclassical Shapes and Naturalism

1 *The navette form of this sauce tureen, made c.1797–1800 at Derby, was a popular Neoclassical shape, as were the ear-shaped handles. The nautical scene was painted on a bright yellow ground. Tureen w. 23.5cm/9¼in.*

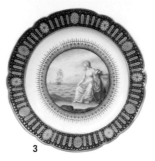

2 *The realistic landscape on this vase shows a taste for naturalistic painting. The vase is on a marbled base, reminiscent of classical vases. Ht 25cm/10in.*

3 *This Worcester jug from the Barr, Flight & Barr factory, made c.1810, shows a realistic painting of shells typical of the period. They are set against a painted background that simulates classical marble. Ht 28.5cm/11¼in.*

and blue grounds, and dessert services had fashionable fruit comports and urn-shaped ice-pails or fruit-coolers.

In 1768 William Cookworthy, a Plymouth chemist, made a formula for hard-paste porcelain. It was imperfect and the Plymouth factory foundered. In 1770 the Bristol factory of Richard Champion purchased the Plymouth formula, and soon the Neoclassical style emerged. Teawares and dessert wares were painted with swags of husks or flowers and medallions painted *en grisaille*, and a number of figures were made. The Bristol hard-paste patent was sold to potters at New Hall in Staffordshire in 1781. They produced tea and coffee wares. The Neoclassical style was interpreted in helmet-shaped cream jugs and urn-shaped coffee pots with simple decoration.

Other factories using a hybrid hard-paste included Worcester, Miles Mason, Coalport, and Davenport. Simple teawares of spirally fluted form were decorated with gilt sprigs, and borders banded in underglaze-blue. A little later wares moved into the full-blown Regency taste, with vases based on classical urn shapes and

painted with topographical views, flowers, and allegorical scenes, along with shells and feathers. They were set against grounds realistically painted to simulate grey or black marble. Burnished gilt handles were shaped and borders of simulated pearls were added by hand. New shapes such as cabinet cups were designed in French Empire style. The Chamberlain's Worcester factory made similar wares of outstanding quality, while the Coalport factory produced vases, and dinner and dessert services.

The greatest development of the period was the Staffordshire potter Josiah Spode's c.1799 invention of bone china. He added bone ash to the standard hard-paste formula, making a strong, highly translucent, white body, which served as an excellent medium for tea and coffee services, as well as flatwares and vases.

The new technique of bat-printing, by which stippled engravings on copper plates were transferred onto porcelain, was especially suited to the Neoclassical style. Subjects included mythological scenes, country houses set in parkland, and scenes of mothers and children.

Mythological and Other Figures

1 *An English pottery blue-and-white meat dish, made c.1820, printed with Greek figure scenes inspired by ancient vases.*

2 *This pair of c.1800 Staffordshire porcelain bough pots was painted with allegorical scenes of classical figures representing* Agriculture and Commerce. *Not only are the lofty subjects typical of classical art, but the D, or lunette, shape is also reflected in contemporary tables, fanlights, and plasterwork. Ht 20cm/7⅞in.*

3 *This Chamberlain's Worcester chocolate cup, cover, and stand, made c.1805, is painted with a Neoclassical scene depicting* Hope Nursing Love. *The high-minded subject is not without a dash of English semtimentality and reflects the style of Bartolozzi engravings after Angelica Kauffmann. Cup ht 12cm/4¾in.*

The Peak of Regency Neoclassicism

1 *This c.1810 Coalport tea service is painted with a typical English armorial, but the highly decorative background of stripes is the epitome of the Regency version of Neoclassicism.*

2 *One of a pair of Mason's ironstone blue-ground large vases and covers, c.1820. Although vases were a Neoclassical form, this one is in chinoiserie style. Ht 54cm/21¼in.*

Other European Pottery and Porcelain

Early Northern European Neoclassical Influences

1

2

3

The Marieberg factory was the only Swedish faience factory to adopt the Neoclassical style, under the regime of Henrik Sten (1769–82), after which the factory was sold to Rörstrand. The famous "terrace vases," modelled as urns surrounded by a curving staircase, were often transfer-printed or painted with classical trophies *en grisaille*, although the design was still Rococo. However, by the 1780s ovoid urns were of classical shape with high ear-shaped handles, moulded with husk garlands and oval medallions hanging from ribbon bows.

The most celebrated of Scandinavia's porcelain achievements was the Flora Danica porcelain service of almost 2,000 pieces, made in 1789 for the Empress Catherine of Russia, and painted with different Danish flowers, copied from engravings by Georg Christian Oeder. In some respects it was still in the Rococo style, but in others it embraced Neoclassicism with its pierced and studded gilt borders and centrepieces of flower-filled baskets standing on rectangular pedestals, each with a border of classical scrollwork *en grisaille*. Moreover, the

delicacy of the detailed botanical specimens threw the rational light of science onto the pure white porcelain, a style already popular at Derby, Vienna, and Berlin.

In Russia, the patronage of the Empress Catherine lent impetus to the imperial factory in St. Petersburg. In the 1760s the factory was producing wares in the Neoclassical style, notably dinner services for the empress and a service for her adviser count Grigory Grivozovich Orlov. This featured rectangular handles and gadrooned gilt borders, with applied swags of green laurel leaves, with the count's monogram enclosed within gilt oval medallions, or flanked by laurel and palm branches. At the private Gardner factory, founded by an Englishman at Verbilki, near Moscow, in 1767, a spectacular series of services was made between 1777 and 1783 for the annual gala dinners of Russia's four supreme awards. These had moulded borders of vine and laurel garlands.

Classically inspired table services dominated Russian production and, under Czar Alexander I (1801–25), the Empire style became paramount, particularly to be seen

Neoclassical Motifs

1 *Gardner made this plate, c.1777–78, as part of a service for the Order of St. George the Dragon Slayer. It shows a Russian interpretation of the Neoclassical style, with the gently waving ribbon of the order entwined with a foliate garland. Diam. 24cm/9½in.*
2 *The portraits in the medallions that make up part of the border and the trophies of arms on this plate are strictly classical in influence. Diam. 24cm/9½in.*

Later Northern European Developments

Figural Inspirations

1 *This Gardner figure group of Moujiks, made c.1860, demonstrates the static poses and plain oval bases that bear some last vestiges of the Neoclassical style. Genre groups were popular in mid-19th-century Russia. Ht 24cm/9½in.*

1 *This Copenhagen plate, made c.1835 with elaborate all-over decoration, shows a late flowering of Neoclassicism. The simulated cameo medallions provide the only classical allusion. Diam. 20cm/8in.*
2 *Painted in the studio of Prince Yusopov of Russia, this c.1825–7 Popov plate has a rose after Redouté. The influence of the French Empire style is seen in the burnished borders and laurel leaves. Diam. 22cm/8½in.*
3 *A portrait of Czar Nicholas I of Russia appears on this c.1810–15 Gardner cup and saucer. Portraits were popular in the Neoclassical era.*

Italian Neoclassicism

2 *This pair of figures of flower sellers from the Italian Doccia family, c.1775, shows none of the drama of earlier Rococo figures, and their pale sprigged clothes are quietly restrained. Ht 14 cm/5½in.*

3 *This Naples plate is from the ercolanese service, made c.1781–2 as a gift from Ferdinando IV to his father, Carlo III of Spain. The centrepiece was surrounded by biscuit representations of the latest archeological finds at Herculaneum, and the central figure is inspired by one of the excavated wall paintings. Diam. 25cm/10in.*

1 *A Le Nove group of Hercules, made c.1780–90, which gives the impression of a classical sculpture in its subject, the columns, its lack of colour, and the Latin inscription "non plus ultra." Ht 26.5cm/10½in.*

in richly gilt and burnished borders with classical motifs, and solid colour bandings.

Perhaps surprisingly, Italian porcelain makers were slow to adopt the Neoclassical style. The Capodimonte factory was founded in 1743 by Carlo III, King of Sicily, just outside Naples, and it produced soft-paste porcelain made with clays from Fuscaldo in Calabria. Early wares were in the Rococo style, and it was not until Carlo III succeeded to the throne of Spain in 1759, and the royal factory was revived in Naples between 1773 and 1806 by Carlo's son, Ferdinando IV, as the Fabbrica Reale Ferdinandea, that the Neoclassical style became *de rigueur*. First based at Portici, and later in the Royal Palace in Naples, the factory produced services for dinner, coffee, and tea. Pieces were painted with classical ruins, landscape scenes, and figures in peasant costume. Some unique jugs were made with trefoil spouts in the form of Greek *oinochoe*, or wine jugs.

One of the most important Naples services was that commissioned by Ferdinando IV as a gift for his father,

Carlo of Spain. It was the first service to be produced by Domenico Venuti when he became director of the factory in 1779. Venuti was the son of an archaeologist, and had been the general superintendent of antiquities for the City of Naples. He was a champion of the Neoclassical style, as seen in the ruins of Pompeii and Herculaneum, and he brought a realism, but also a heroic theatricality, to his designs. The decoration of the service was executed in stippled style by Giacomo Milani, director of the Galleria dei Pittori, and Antonio Cioffi, formerly a painter at the Capodimonte factory. The centrepiece took the form of a biscuit group of Carlo III encouraging his son to continue with the excavations. Classical figures in glazed and biscuit porcelain were made under the auspices of Filippo Taglione, director of the unlikely sounding Academy of the Nude, founded at Venuti's suggestion.

Another major Neoclassical service was made at Naples in 1787 for George III of England. Known as the Etruscan service, it was painted with scenes in red and black, copying early Etruscan vases.

Typical Neoclassical Elements

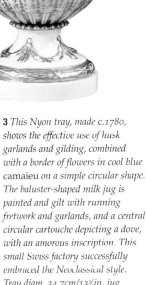

1 *Part of a c.1790 Doccia coffee service. The sugar basin has a depressed urn shape and an upstanding ring as a knop – an example of Neoclassical form not following function. The painting is typical of the Neoclassical love of a monochrome palette.*

2 *This c.1785 Fürstenberg vase shows the angular upright handles typical of the period. Even the finial is of erect rectangular shape. The ovoid vase shape is perfectly balanced and softened by a moulded circular painted medallion hanging from a ribbon bow. Ht 39.5cm/15½in.*

3 *This Nyon tray, made c.1780, shows the effective use of husk garlands and gilding, combined with a border of flowers in cool blue camaieu on a simple circular shape. The baluster-shaped milk jug is painted and gilt with running fretwork and garlands, and a central circular cartouche depicting a dove, with an amorous inscription. This small Swiss factory successfully embraced the Neoclassical style. Tray diam. 34.7cm/13¾in, jug ht 18.5cm/7¼in.*

An Exploration of Form

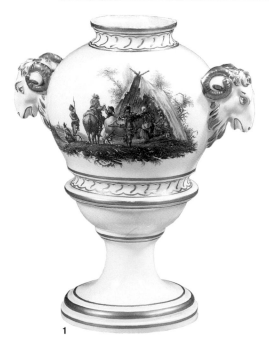

1 *The classical ovoid shape is used for the body of this Dutch vase, made at Loosdrecht c.1782–4. Flamboyant moulded ram's head handles have been applied – these are a recurrent motif in classical architecture and decoration. Ht 17.5cm/7in.*

2 *This bowl, cover, and stand embraces Neoclassicism, with the* en graisalle *decoration depicting antique figures, the eagle-shaped knop, and ear-shaped handles.*

3 *This Neoclassical Buen Retiro wine glass rinser was made in Spain c.1770. It relies on painted decoration, not form, for a Neoclassical effect. Festoons of coloured flowers, suspended by ribbon bows, were a constant theme towards the end of the 18th century. L. 25cm/10in.*

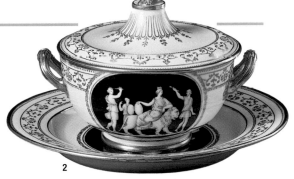

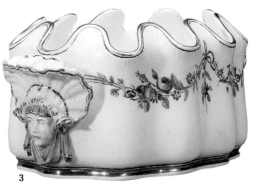

American Ceramics

Foreign Influences and American Ornament

1 With its origins in classical antiquity, it is no surprise that Americans depicted this redware figure of a whippet, by Solomon Bell, c.1831, Winchester, Virginia, in a classical pose. Ht 16cm/6¼in.
2 Hound-handled jugs were first designed in Britain but after Daniel Greatbach visited the US and sold his moulds, variations abounded in many states; this glazed stoneware jug is by David Henderson, Jersey City, New Jersey, c.1830. Ht 16.5cm/6½in.

3 The swags of garlands, paterae, and husks on this late 18th-century jug are all Neoclassical motifs, although the form of the jug itself is more in the Rococo style.

4 An American eagle with a shield takes a prominent place above an American landscape with the American flag proudly displayed above a building on this 19th-century jug in a Neoclassical form.

During the two centuries leading up to the years of the new republic, the appearance and functions of ceramics in the American colonies underwent marked changes. Many early colonial households ate from wooden trenchers or pewter plates, and drinking vessels were made of pewter, leather, horn, or, in exceptional cases, glass or silver. But in the second half of the 18th century, when ceramics became increasingly available, their usage changed. More fine ceramics began to appear in a greater number of households. Nonetheless, the majority of ceramics owned by Americans were still foreign. Exported wares in the late 18th century were similar to those produced for British and continental European use, although the decoration may include American motifs such as armorials and eagles.

Although the American manufacture of ceramics was relatively limited and most objects were imported from Europe, there were a few attempts at production and marketing. There was the odd handful of short-lived pre-revolutionary factories. Their products are rare in comparison to imported goods. The designs of American ceramics made after the Revolution not only used local materials but also catered to the classical taste that captivated so many Americans. Regardless of location or scale, the aim was to match European competition, if not in quantity and economics then in design and fashion.

Following the war of 1812, bitter anti-British sentiment encouraged Americans to favour French design. The porcelain produced during this time and leading to the revival designs of the mid-19th century closely resembled French porcelain of the period. Amphora vases were favourite forms. These vessels were often ornamented with popular local views, and some versions had gilded handles and details, while others had gilt-bronze mounts and handles. American manufacturers ingeniously transformed European classical taste for their own market. Despite the derivative nature of American classical ceramics, competition was fierce with the affordable and desirable English transfer ware designed pointedly for the American market.

5 *Attributed to either Tucker & Hemphill or Joseph Hemphill of Philadelphia, this pair of gilt porcelain vases was made 1833–38. The bodies are in the traditional Neoclassical amphora shape, incorporating American eagles as handles and decorated with American landscapes and anthemia. Ht 56cm/22in.*
6 *Devoid of decoration with the exception of the fantastical handles in the shape of a woman's body with wings – a partial sphinx – this porcelain amphora vase was made in New York in 1816. Ht 33cm/13in.*
7 *This lead-glazed redware dish made by George Hubener of Montgomery County, Pennsylvania, 1786, has stylized birds and tulips, popular motifs among the Pennsylvanian Dutch, a community of German and other northern European immigrants that settled in the state. Diam. 32cm/12½in.*
8 *The decoration on this 1827 lead-glazed redware dish is similar to the one above, but the stylized bird has been transformed into the American eagle incorporating a shield and clutching laurel, a popular American motif. Diam. 35.5cm/14in.*

British Glass

Adamesque

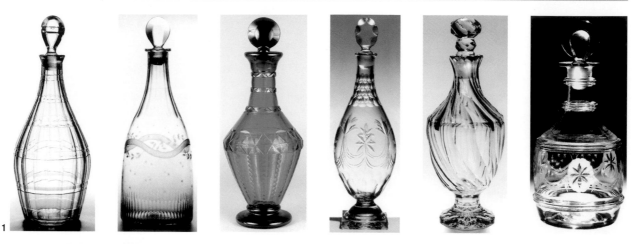

1 *Decanters demonstrating the range of Neoclassical shapes and motifs adopted by British glassmakers, c.1770–80. From left: club, taper, baluster (two are shown here), urn, and "Prussian" shapes applied with a variety of shallow motifs. The club, cut with vertical broad flutes, is associated with a 1775 notice for "curious barrel-shaped decanters cut on an entire new pattern".*

2 *The generously bowled rummer wine glass, balanced on its "lemon-squeezer" pedestal foot, remains the epitome of British early Neoclassicism. This engraved example is c.1775. Ht 15cm/6in.*

3 *A fruit bowl decorated with typical early British Neoclassical cut motifs, including swags, stars, and a bevelled Van Dyck rim, named after the lace collars worn by many of the artist's portrait subjects. W. 26.7cm/10½in.*

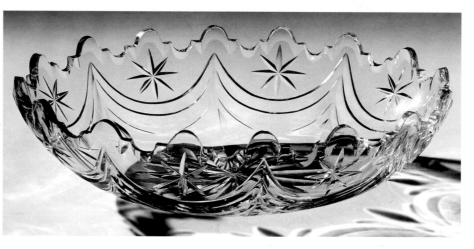

4 *The work of James Giles spanned the Rococo and Neoclassical transition, as seen in this sugarloaf decanter decorated with gilded mosaic urns, c.1770. Ht 28.5cm/11¼in.*

5 *An opaque-white beaker decorated in gold by James Giles with bucrania (ox-skulls) and wheel-like paterae, taken from Giovanni Battista Piranesi's or William Chambers' illustrated works on Roman architecture, c.1765–70.*

6 *A tumbler engraved with paterae, portrait silhouettes, festoons, and borders punctuated with shallow-cut "olives", and the base cut with hollow flutes, known contemporarily as "finger bottoms", c.1780. Ht 14cm/5½in.*
7 *A large, magnificent British Neoclassical chandelier, c.1775–80, conforming to the principles established by Robert Adam in* Works in Architecture *(1773–8). Ht 1.8m/5ft 11in.*

8 *A Neoclassical candelabrum set on a base of a form patented by the merchant-cutter William Parker in 1781. The cobalt blue glass bases with gilding are probably by James Giles and are applied with ormolu rams' heads and paterae. Ht 50cm/19¾in.*
9 *An Adamesque mustard pot mounted on a lemon-squeezer base, c.1775. The body was blown into a mould before the decorative notches were applied. Ht 10cm/4in.*

Neoclassicism has proved to be Britain's favourite and most enduring decorative style. Its themes of empire expressed in geometric sobriety were adopted wholesale and with remarkable speed after its introduction from *c*.1760. Though initially apparent in combinations of engraving and cutting, its ultimate manifestation, in cut mitred motifs during the Regency period (*c*.1790–1830), brought the *façon d'Angleterre* from the backwaters to the forefront of world glassmaking.

The success of Angleterre Neoclassical glassware lay in the lead-based "crystal" perfected by George Ravenscroft in 1676. Possessing greater powers of light refraction and dispersion than European equivalents, lustrous lead or "flint" glass could split the spectrum in sun or flame-light, notably when cut.

British Neoclassicism was influenced by Giambattista Piranesi's engravings of Roman architecture (1743), William Chambers' pattern book *A Treatise on Civil Architecture* (1759), and Baron d'Hancarville's engravings of the Sir William Hamilton collection of classical vases,

Antiquités Etrusques, Grecques et Romaines (1766–67). However, its success is almost entirely attributable to the Scottish architect Robert Adam, who returned to London from his Grand Tour in 1758 to set the capital alight with designs evoking the grandeur of the Roman Empire, later augmented with Greek themes. Adam's dominance over prevailing taste was so pervasive that the form of British Neoclassicism *c*.1760–1790 is known simply as Adam. The wholesale adoption of his themes, as set out in Robert and James Adams' *Works in Architecture* (1773–8), supported James's assertion that Robert "brought about in this country … a kind of revolution in the whole system of this useful and elegant art".

In contrast to Baroque and Rococo, whose expressions on glass were largely superficial, Neoclassicism influenced form as well as ornament. The style held sway over every form of glassware, notably chandeliers, rummers, cruet bottles, and decanters, their decoration growing increasingly exuberant over passing decades until reaching its zenith in the Empire style of the 1820s.

Irish and Anglo-Irish

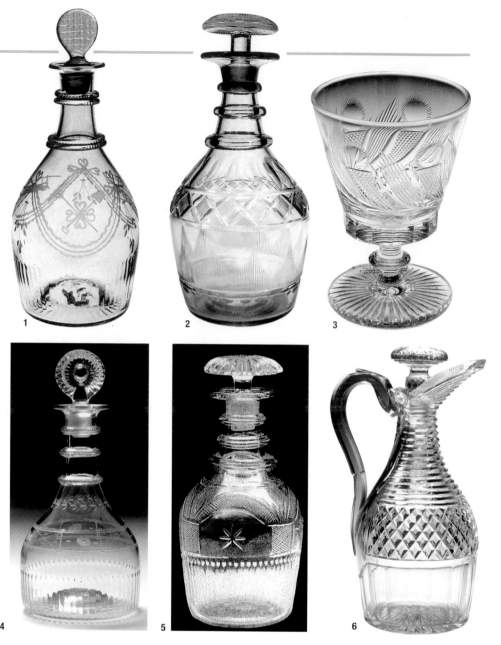

1 *An Irish dip-moulded Prussian-shaped decanter engraved with Neoclassical ribbon festoons and gardening tools. The lower third of such pieces was blown into bucket-shaped moulds of standard sizes which also created their vertically ribbed decoration. Ht 26cm/10¼in.*

2 *Prussian decanter decorated with shallow cutting in the Anglo-Irish Neoclassical style, 1810. Ht 29cm/11½in.*

3 *A Neoclassically shaped bucket-bowled rummer decorated with Anglo-Irish cutting, c.1820. The bowl is cut with hollow circular "printies", slanting comb-like "blazes" and fine diamonds, the foot with a radial star. Ht 12.7cm/5in.*

4 *A broad-based taper decanter with light engraving and a "pinched target" stopper by the Cork Glass Company, c.1800. The crudeness of Irish dip-moulded decanters has led to suggestions that they were blown by workmen recruited from bottle factories. Ht 21.5cm/8½in.*

5 *Typical Waterford Prussian decanter engraved with Neoclassical columns and arches. Ht 24cm/9½in.*

6 *An Irish claret decanter, identifiable by its exaggerated spout, deeply cut with prisms, strawberry diamonds, and flat flutes, c.1820. 28.5cms/11¼in.*

The grant of free trade status to Ireland in 1780 had a profound effect in rejuvenating its dormant glass industry. Previously without a single operational glasshouse, as many as ten new ones were established over the following decades. Irish glassmaking had traditionally mirrored English trends. Further, with mainland works increasingly stifled by the regulations of the weight-related Glass Excise Tax, many of the new Irish businesses were staffed and even owned by migrants from across the Irish Sea. It is therefore unsurprising that their products reflected English fashions.

With the taste for Neoclassicism dominant in Dublin as well as London, the main characteristics of late 18th- and early 19th-century Irish glassware are simple engraving and shallow cutting. However, barring some notable exceptions, most of its shapes and themes are indistinguishable from those made on mainland Britain, giving rise to the generic term Anglo-Irish style glassware.

The common belief that richly cut Regency glassware was an Irish creation is unfounded. The first steam-driven cutting machines, essential to deep-profile cutting, were not installed in Ireland until 1818, almost 30 years after their introduction in England. Whilst Irish glass enjoys high romantic repute, surprisingly little was actually made there: statistics prove that its national output barely matched that of Scotland, and a high proportion of its production was exported to America, the West Indies, and Canada. Further, Irish glass does not bear a particular blue tint as once suggested.

The most distinctive Irish wares are a series of dip-moulded taper and Prussian decanters, some branded with their maker's name on the base, claret decanters with exaggerated spouts, piggin cream bowls, and a series of idiosyncratic bowls, formed as canoes or kettle-drums, some with turn-over rims. The extension of the Excise to Ireland in 1825 and American protectionist tariffs ultimately ruined the Irish industry, though the pattern drawings of Waterford master-cutter Samuel Miller, an Englishman, confirm a continuation of Neoclassical forms into the 1830s.

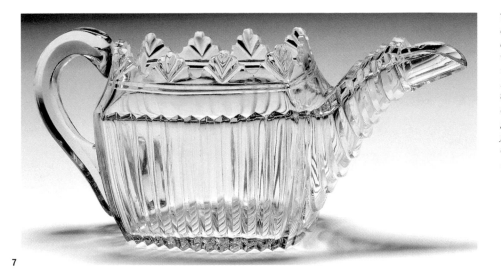

7 *An Irish cream jug with a characteristically long spout, deeply cut with unusual vertical prisms and a Van Dyck rim with fan details, c.1820. Ht 20.6cm/8¼in.*
8 *Piggins, reputedly used as cream or milk bowls, are generally regarded as an Irish form, but this heavy example, deeply cut with hobnails, is English, c.1820. W. 20.5cm/8in.*

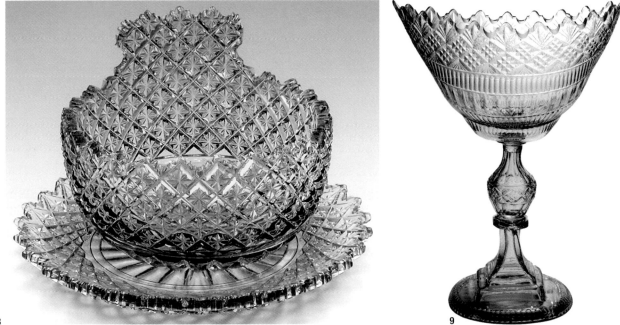

9 *A massive Irish canoe-shaped bowl on detachable stand with Anglo-Irish cut motifs, including a Van Dyck rim, fans, diamonds, and flutes. The terraced foot is moulded and cut. Dublin or Cork, c.1790. Ht 50cm/19¾in.*
10 *A distinctive Irish bowl form, this one known as the kettle-drum shape, decorated with a range of typical Anglo-Irish cut motifs and set on a lemon-squeezer base, c.1825. Ht 21.6cm/8½in.*
11 *Variations on a theme. A montage of cylinder decanter patterns from the ledger of Waterford master-cutter Samuel Miller, c.1825–35.*

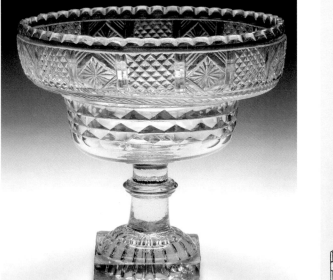

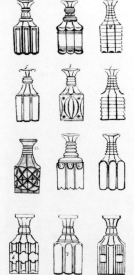

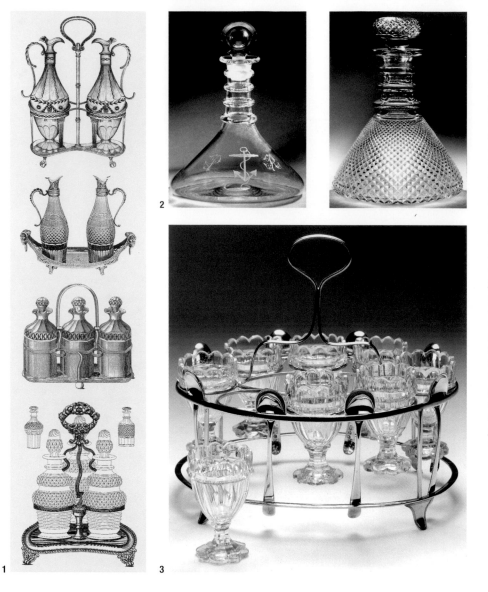

1 *Contemporary designs that illustrate the development of Neoclassically inspired British glass-cutting, c.1770–1820. From top: soy stand with shallow-fluted and engraved bottles, c.1770; boat-shaped cruet stand with rams' head terminals containing fluted and diamond-cut bottles, Wakelin & Taylor, 1776; stand containing decanters with polished faces and deeper diamonds, Walker & Ryland, c.1805–10; stand containing extravagant diamond and prism cut decanters, c.1815–20.*
2 *Two ship's or Rodney decanters demonstrating the stylistic evolution of British glassware, c.1775–1830. Left: plain except for the anchor motif and engraved initials "PR," for* HMS Princess Royal, *launched in 1773. Ht 25.4cm/10in; right: deeply cut with diamonds, c.1815. Ht 24.2cm/9½in.*
3 *Neoclassical design principles were applied to every form of glassware. Here a silver-gilt egg cup frame containing eight cups is cut with adamesque broad-flutes. It is hallmarked for Henry Chawner, 1790. Ht 21cm/8¼in.*

British glass cutting, which had developed an individual path since *c.*1710, achieved the highest standards of excellence and almost universal appeal when expressed in the Neoclassical style during the aesthetic Regency period between *c.*1790 and 1830.

Rejecting Bohème cutting in favour of flat and slightly hollowed motifs, British cutting evolved gradually over several decades. The introduction of steam-driven cutting from 1789 accelerated the trend, with sliced "broad flutes", the defining cut of adamesque glassware, gradually superseded by deeper motifs, typified by diamonds arranged in diverse permutations.

Cut motifs were applied with increasing depth and complexity between 1780 and 1820 as craftsmen became familiar with the technique, and in response to popular demand for richer ornament. The grouping of prisms, fans, pillars, relief, and "strawberry" diamonds became collectively termed mitre-cutting. Engraving maintained a slender foothold during the period, most commonly in the form of borders, armorials, and inscriptions.

The consensus in Regency Neoclassicism was broken from *c.*1800 by a limited taste for the French Empire style (see p.183). More significantly, a schism from *c.*1820 saw some opt for decorative sobriety, whilst others drove the cutters towards a dazzling, jewel-like complexity that again echoed the Empire. The services produced for a group of north-eastern nobles illustrate the division. On one hand, those made for the Duke of Northumberland, *c.*1825, demonstrate the restrained theme, cut with alternating vertical bands of pillars and fine diamonds, and adamesque broad flutes. The contrasting group is a series of increasingly expansive services made by Wear Flint of Sunderland for local nobles, applied with complex mazes of diamonds, pillars, fans, and arches.

By 1830, uniformity regained the ascendancy. The horizontally orientated forms and decoration, typified by stratified decoration and prismatic cutting, that had dominated since *c.*1790, were abandoned in favour of vertical equivalents. Broad-flute cutting and perpendicular vessels came to the fore in the 1830s, anticipating Victorian Gothic.

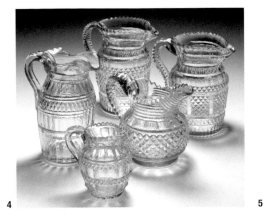

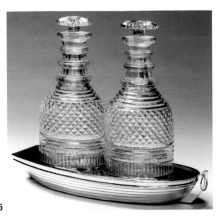

4 *A group of British water ewers cut with broad flutes and bands or fields of diamonds. The earliest at the front, c.1790, the latest, back right, c.1810. Ht (of the tallest) 22.4cm/9¼in.*

5 *A Sheffield plated jolly boat, used for passing decanters around the dining table after the meal. The cylinder decanters are cut with diamonds and prisms, c.1815–20. Ht 26.5cm/10½in.*

6 *An ice bucket, deeply cut with diamonds and prisms, typical of the work achieved by British glass cutters using steam-driven cutting wheels, c.1815–20. Ht 28cm/11¼in.*

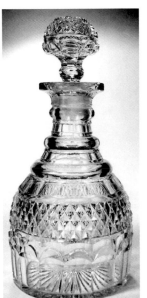

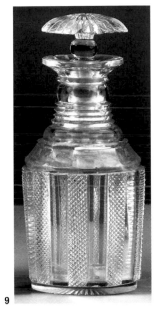

7 *A broad-based taper decanter, c.1810-15, cut with flutes, diamonds, arches, and mitre cuts in relief, demonstrating the cutter's increased confidence and boldness. Ht 36cm/14¼in.*

8 *Archetypal British Neoclassical lidded urn, c.1810, cut all over in large diamonds. Ht 35.2cm/13¾in.*

9 *Decoration fit for a king: a cylinder decanter with an engraved and selectively acid-etched royal cypher, c.1810–16. Ht 18cm/7in.*

10 *A melon-shaped honey-pot finely cut with pillars and strawberry diamonds, and a diamond-cut dish and a second honey-pot with ormolu mounts, all c.1820–5. Ht (of the tallest) 13.7cm/5½in.*

11 *Designs from a price list of the leading late Georgian/early Victorian glassmaker Apsley Pellatt's Falcon Glasshouse, c.1837, illustrating numerous broad-fluted decanters.*

1 *Slice-cut cobalt-blue club decanter with Neoclassical gilt festoons and ribbons. Commonly thought to be French, but probably Bohemian in the Angleterre style for the French market, c.1810. Ht 31cm/12in.*
2 *Baccarat moulé en plein goblet with cut highlights containing a full-height polychrome sulphide portrait of Napoleon Bonaparte. Ht 9.6cm/3¾in.*
3 *One of Baccarat's 28 moulé en plein services. Combinations of deeply profiled moulded diamonds, bamboo staves, swags, leaves, escutcheons, and points, accentuated by selective cutting, appeared on all manner of Baccarat glassware until at least 1844.*

4 *Neoclassical urn-shaped vase in* boulle-de-savon *crystal opaline glass with mercury-gilded ormolu mounts. The glass is probably Baccarat, the mounts and design by Creusot, c.1820. Ht 44.4cm/17½in.*
5 *French amethyst and white opaline tazza mounted on a chased ormolu foot-ring and fitted with a pair of eagles as handles, c.1830. Ht 11cm/4¼in.*

The French glass industry, amongst Europe's oldest, regularly lost many craftsmen to religious persecution and war, leaving its 18th-century products derivative. Bohème dominance in France was supplanted from 1767 with its leading works, including Saint-Louis, Saint-Cloud, and Vonêche, transferring to Neoclassically styled Angleterre lead crystal. France regained its glassmaking identity from 1810 through various innovations manifested in Empire-style Neoclassical wares: sulphide inclusions, *moulé en plein* pressure-moulding, and opalines.

Glassware containing biscuit-porcelain sulphides was pioneered by Sèvres sculptor Barthélemy Desprez, 1796–8. These are inextricably linked with *moulé en plein* glass moulding, invented by Ismaël Robinet, c.1820, and adopted by Baccarat, then Saint-Louis and Val-St Lambert for a wide range of faux rock crystal tableware.

Echoing similar trends in Bohemia, French makers also pioneered opalines over two decades: *blanc laiteux*, from 1823, *bleu turquoise*, 1827, *rose opalin* and *violet*, 1828, and *alabastre*, 1844.

6 *French Empire clock in bleu-lavande glass with ormolu mounts, c.1825. Opaline glass gained its name from its fiery gold colour when viewed in transmitted light. ht 33cm/13in.*
7 *A French blue opaline cup and saucer, the cup with an ormolu handle in the shape of a serpent, c.1825. Ht 13.5cm/5½in.*

Franglais Empire

1 *Design for an Empire-style chandelier incorporating griffins and acanthus from Thomas Hope's pattern book* Household Furniture & Interior Decoration.
2 *Prince of Wales-shaped decanter, part of a service by Perrin, Geddes, for the prince in 1808, one of the most extravagant expressions of British Empire glassware. Ht 24cm/9½in.*

3 *George Cruikshank's view of the Prince of Wales's Carlton House party, 1811, ten days after the event. The suites of voluptuous glassware provided for the 2,000 guests promoted a fashion that endured for over a century.*
4 *An unusual set of silver-gilt mounted British decanters and goblets in the Empire style, cut with diamonds, flutes, and arched protrusions, the decanters set with stoppers shaped as ducal coronets. Maker unknown, c.1815–20. Ht (decanters) 17.2cm/6¾in.*

5 *Stupendous target-stoppered cylinder decanter, richly cut with diamonds, flutes, and prisms, and enamelled with allegorical scenes, with a camel representing Asia and a lion for Africa, perhaps by William Collins, the Strand, London, c.1820–5. Ht 23cm/9in.*
6 *Three-light candelabrum mounted on a black bronze plinth set with a lion and ormolu mounts. Stamped Messenger & Phipson, c.1825–30. Ht 61cm/24in.*
7 *Richly cut candlestick by Apsley Pellatt, c.1825, containing a sulphide bust of the Duke of Wellington. Glass sulphides had been patented by Desprez in Paris in 1818, but were plagiarized by Pellatt from the following year. Ht 18.8cm/7½in.*

The Napoleonic Wars did not prevent the adoption of many of the Percier and Fontaine French Empire themes in Britain. Under the ardent patronage of the francophile Prince of Wales, renowned for his appetite for voluptuous ornament and prodigious spending, their style was propagated by the designer Thomas Hope's pattern book *Household Furniture & Interior Decoration* (1807).

The earliest expressions of Franglais Empire glassware date from *c.*1800, but the best known is the service commissioned for the prince from the Warrington makers Perrin, Geddes, by Liverpool Corporation in 1806. Its deep cutting and flamboyant protrusions were atypical of mainstream contemporary taste but admired by the prince's wealthy coterie.

The leading designers of British Empire glassware were John Blades, Apsley Pellatt, successor to Blades's mantle, and the fine metalworker, Matthew Boulton, whose designs coupled ormolu and bronze with glass cut at his Birmingham works.

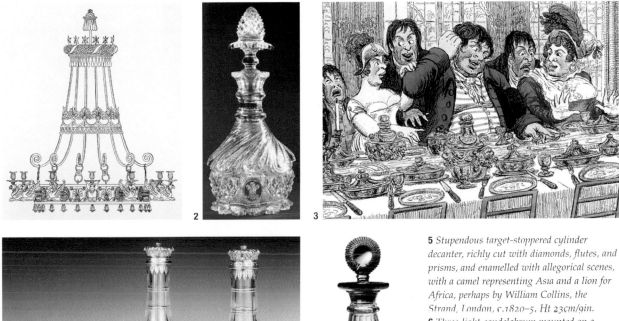

German and Bohemian Glass

Biedermeier Neoclassicism

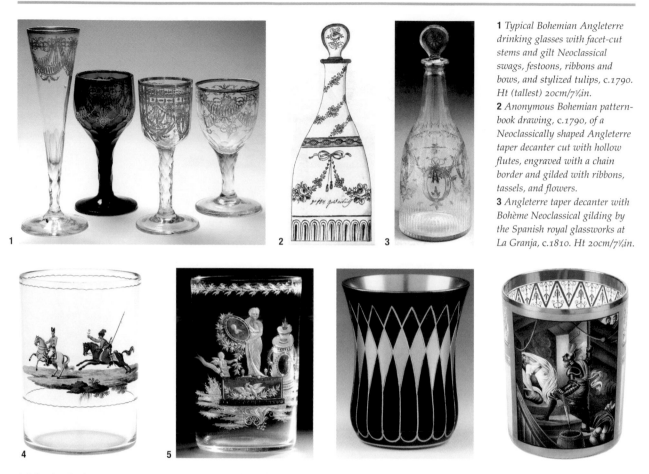

1 *Typical Bohemian Angleterre drinking glasses with facet-cut stems and gilt Neoclassical swags, festoons, ribbons and bows, and stylized tulips, c.1790. Ht (tallest) 20cm/7¾in.*
2 *Anonymous Bohemian pattern-book drawing, c.1790, of a Neoclassically shaped Angleterre taper decanter cut with hollow flutes, engraved with a chain border and gilded with ribbons, tassels, and flowers.*
3 *Angleterre taper decanter with Bohème Neoclassical gilding by the Spanish royal glassworks at La Granja, c.1810. Ht 20cm/7¾in.*

4 *Colourless beaker enamelled with a scene of an Austrian cavalier chasing Napoleon back to France, brandishing a forget-me-not, by Anton Kothgasser, c.1815. The scene is based on an Austrian folk story. Ht 9.5cm/3¾in.*

5 *Central European variations on the Neoclassical theme. From left: beaker engraved with Grecian motifs and festoons by Franz Anton Riedel, c.1810; black Hyalith beaker with gilt geometric decoration by the Buquoy glasshouse, c.1820; an example enamelled with Ivanhoe rescuing a distressed damsel, from the eponymous Walter Scott novel, by Franz Anton Siebel, 1824. Ht (from left to right) 11.5cm/4½in; 10cm/3¾in; 10cm/3¾in.*

The international supremacy of Bohemian glassware, typified by Baroque and Rococo superficial decoration, was usurped by Angleterre Neoclassicism from *c.*1775, and disrupted by the chaos of the Napoleonic Wars. Some makers resorted to copying British forms. However, with political and economic stability restored by 1820, some 170 factories were again operating across Bohemia.

Bohemia, abundant with fine sand, fire clay, wood, and water, had produced glass since the 13th century, drawing on German and indigenous skills. Formerly driven by high-born patronage, its 19th-century output focused on the Hapsburg Empire's wealthy industrial bourgeoisie, mostly living in Vienna. Centuries of experience were combined in Bohemia and Austria to create a dazzling and diverse array of retro and advanced techniques, forms, and colours across the quality scale.

Bohemian makers and decorators at home and abroad were slow to adopt Neoclassicism, with early manifestations simply echoing Angleterre interpretations. Though naturally inclined towards extravagant ornament, the bitterness felt in Napoleon's wake alienated many from the Empire style, leaving a void that was eventually filled by an extraordinary range of variations on the Neoclassical theme. These were generally applied to the sober Biedermeier shapes predominant from *c.*1815 to 1840.

In Austria, Johann Mildner rejuvenated and perfected *Zwischengoldglas*, whilst the Mohns and Anton Kothgasser achieved unsurpassed realism in transparent enamels. To the north, Johann Sigismund Menzel echoed Mildner's shapes and themes, and Count von Buquoy and Friedrich Egermann transformed the colour palette of glass.

Central Europe's most influential contributions were the colours formulated at Buquoy's Gratzen glasshouse, 1803–40, and Egermann at Novy Bor, 1828–40. Buquoy introduced red marbled *Hyalith*, 1803, black *Hyalith*, 1817, and a series of fine decorative techniques, and Egermann created new yellow and red stains and marbled *Lithyalin* tints 1828–40. Bohemian colours and techniques were widely adopted across Europe and helped re-establish the ascendancy of the Bohème style.

6 *Neoclassically inspired goblet by Johann Mildner with a medallion portrait of Emperor Leopold II of Austria; signed and dated 1801. Ht 12.5cm/5in.*

7 *Goblet with fine transparent enamel decoration of a mountain-top Schloss by Gottlob Mohn, the son of the glassblowing family, originally of Dresden, signed and dated 1816. Ht 20cm/8in.*

8 *Beaker with decoration by Anton Kothgasser. This c.1818 example bears a Neoclassical medallion containing symbols of love. Ht 10.5cm/4¼in.*

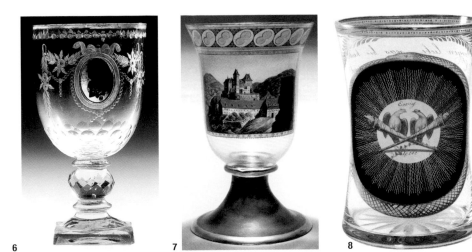

9 *Red* Hyalith *cup and saucer with gilded chinoiserie decoration by Count von Buquoy's glasshouse, c.1820–37. Buquoy also developed a range of other marbled colour effects. Saucer diam. 14.5cm/5¾in.*

10 *Lidded goblet, set on a lemon-squeezer base, containing inserted medallion silhouettes of an elderly couple – and echoing the work of Johann Mildner – by Johann Sigismund Menzel, Warmbrunn, c.1795. Ht 26.5cm/10½in.*

11 *Glassware made by the Harrachov works, Bohemia, and decorated by Friedrich Egermann. Left: the extraordinary Culm Goblet, made in 1835 to commemorate the Russian victory at the Battle of Culm, 1813. Ht 41cm/16¼in; above: monumental three-part Neoclassical urn with Egermann ruby staining. Ht 44.5cm/17½in.*

American Glass

Classical Forms and Decoration

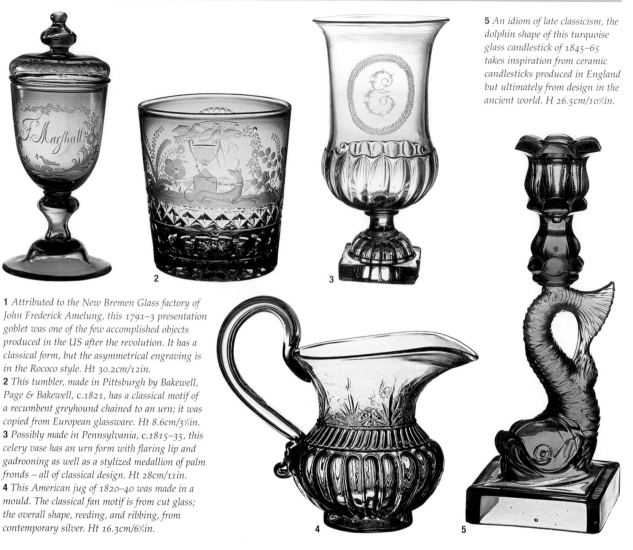

5 *An idiom of late classicism, the dolphin shape of this turquoise glass candlestick of 1845–65 takes inspiration from ceramic candlesticks produced in England but ultimately from design in the ancient world. H 26.5cm/10⅜in.*

1 *Attributed to the New Bremen Glass factory of John Frederick Amelung, this 1791–3 presentation goblet was one of the few accomplished objects produced in the US after the revolution. It has a classical form, but the asymmetrical engraving is in the Rococo style. Ht 30.2cm/12in.*
2 *This tumbler, made in Pittsburgh by Bakewell, Page & Bakewell, c.1821, has a classical motif of a recumbent greyhound chained to an urn; it was copied from European glassware. Ht 8.6cm/3⅜in.*
3 *Possibly made in Pennsylvania, c.1815–35, this celery vase has an urn form with flaring lip and gadrooning as well as a stylized medallion of palm fronds – all of classical design. Ht 28cm/11in.*
4 *This American jug of 1820–40 was made in a mould. The classical fan motif is from cut glass; the overall shape, reeding, and ribbing, from contemporary silver. Ht 16.3cm/6⅜in.*

The number of American glasshouses increased dramatically after the revolution. Even with political independence from Britain, the few manufacturers who were able to make the heavy investments necessary to start a glass-making concern still had to contend with competition from imported goods. Despite the challenges of glass making in the early years of the United States – the need for huge quantities of fuel, the dependence on technical knowledge and substantial finances – glass from this period disseminated classical design to the masses. The glass manufacturers that flourished throughout the United States, from East Coast centres to the Midwest, made available a vast array of utilitarian and fashionable glassware.

Wares were designed in classical forms or with motifs drawn from antiquity and then marketed to the burgeoning population towards the middle of the 19th century. Objects were decorated by engraving, cutting, pressing, enamelling, gilding, or painting to enhance visual appeal. Ornament on late 18th- and early 19th-century glassware often bears Neoclassical elements with symmetrically arranged swags, tassels, eagles, and floral bands. On later Neoclassical wares, from the 1820s until the 1840s, cornucopia, lyres, eagles, and baskets of fruit decorated much moulded glass tableware and bottles. Bold forms such as dolphin-shaped candlesticks appeared, reflecting the same motif in furniture.

The American introduction of machine pressing at the beginning of the 19th century made moulded and pressed glass an affordable alternative to labour-intensive cut glass. The design on some Neoclassical glassware was based on imported ceramics, while other forms were just miniature versions of furniture. Covered box shapes in glass used for various condiments, for example, referred to the ancient sarcophagus on which classical wine coolers were based. Having moved from its position on the sideboard to a less expensive version that could be used on the dining table, Neoclassical designs in glass brought the forms of ancient Greece and Rome to a more diverse audience.

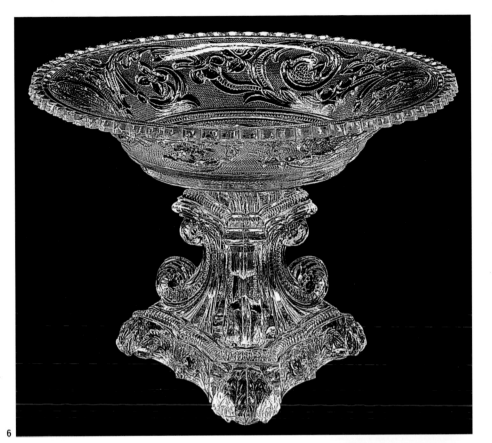

6 While many examples of Empire or late Neoclassical style glassware took inspiration from ceramics and silver, it was Empire furniture that inspired the design of this comport. C-scroll supports on the stem, beaded and ribbed detailing, and the trademark paw feet all exemplify Empire design. Ht 14.4cm/5⅝in.

7 This covered casket with a tray was produced in the Midwest United States, 1830–40. The sarcophagus form was one taken from the classical world and, in this instance, it was designed in miniature for the dining table as a butter tub or container for condiments. Ht 12.7cm/5in.

8 Newly invented in France in 1810, the astral lamp provided light without shadow. American glass manufacturers, especially the New England Glass Co., produced decoratively cut shades to illuminate the new technology. Ht 44.6cm/17½in.

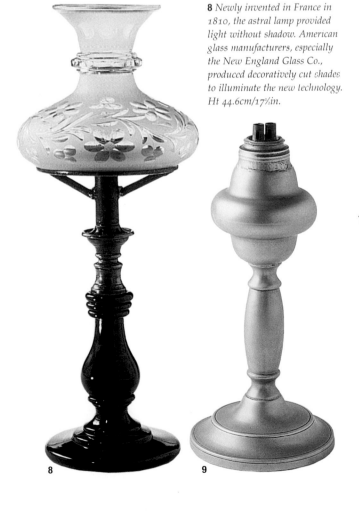

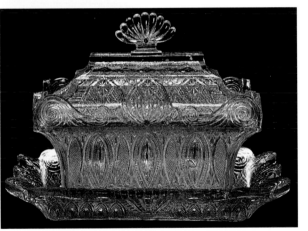

9 This oil lamp has a milky white opaque glass stem in a form similar to a contemporary Neoclassical silver candlestick. Ht 44.5cm/17.5in.

10 One of a pair, this 1828 decanter is by the Pittsburgh glasshouse of R.B. Curling & Sons. The shape derives from Anglo-Irish examples, but the understated decoration is a departure from the heavily cut glass imported during the period. Ht 26.7cm/10½in.

Silver and Metalwork

Transitions in British Silver

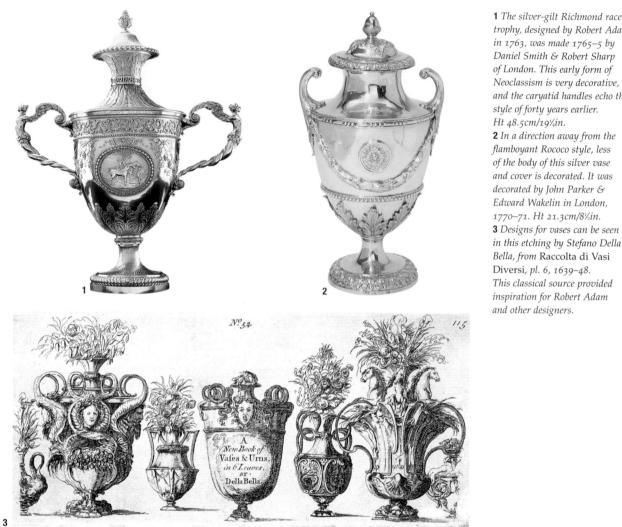

1 *The silver-gilt Richmond race trophy, designed by Robert Adam in 1763, was made 1765–5 by Daniel Smith & Robert Sharp of London. This early form of Neoclassism is very decorative, and the caryatid handles echo the style of forty years earlier. Ht 48.5cm/19¼in.*
2 *In a direction away from the flamboyant Rococo style, less of the body of this silver vase and cover is decorated. It was decorated by John Parker & Edward Wakelin in London, 1770–71. Ht 21.3cm/8½in.*
3 *Designs for vases can be seen in this etching by Stefano Della Bella, from* Raccolta di Vasi Diversi*, pl. 6, 1639–48. This classical source provided inspiration for Robert Adam and other designers.*

The earliest, most influential, and prolific designer of Neoclassical silver in Britain was the Scottish architect Robert Adam (1728–92). He conceived silverware as part of the overall interior design for large houses, and his designs were realized by leading London goldsmiths such as Daniel Smith, Robert Sharp, John Carter, and Thomas Heming. Drawing on the publication of recent archeological excavations in Greece and Rome, from the late 1750s Adam created designs for sideboards with vases, and sets of dinner plate that matched the plasterwork and carved friezes of rinceaux (acanthus scrolls), anthemia, paterae, and husk festoons. This "magazine of ornament" he freely and inventively combined with classical sources derived from largely 17th-century Italian prints, like those of the goldsmith Stefano Della Bella (1610–64). The urn or vase form was particularly popular and was applied to both domestic and presentation silver.

Another source of inspiration came via the French, who created a heavier, more naturalistically based Neoclassicism very distinct from that derived from Italian Renaissance and adamesque designs. The sources came via prints such as Juste-Aurèle Meissonnier's *Livre des Légumes* and French silver, notably that of Robert-Joseph Auguste (1723–1805), which was imported into Britain by francophile English aristocrats. The most prominent designer of this type of English Neoclassical silver was the architect Sir William Chambers (1723–96). His design for a pair of soup tureens for the Duke of Marlborough incorporates an artichoke finial and celery stalk handles derived from Meissonnier, with a high-domed heavily gadrooned cover, features that recur in French-derived Neoclassical silver. At the end of the 18th century the French-inspired severe Greek style influenced English silver, characterized by the use of crisply modelled cast elements of classical or Egyptian derivation balanced with areas of plain silver. Much work by Digby Scott & Benjamin Smith (partnership dissolved 1807) exemplifies this later phase of Neoclassical silver. Its introduction into England has been connected with the purchase by the Royal goldsmiths Rundell, Bridge & Rundell in *c*.1800 of

French-Inspired Classicism

1 *In this design for a soup tureen by John Yenn after Sir William Chambers, c.1767, naturalistic elements can be seen in the celery stalk handles and artichoke finial. Ht 27.2cm/10¾in.*

2 *These sauce tureens by Thomas Heming of London, made 1769–70, display a band of guilloche, partly hidden behind classical rams' heads adorning the more elaborate stands. Unlike Rococo predecessors, these tureens are symmetrical in design. Ht 16cm/6¼in.*

3 *A pair of silver Lyon-faced candlesticks by Boulton & Fothergill, made 1774–5, displaying Neoclassical features such as bound laurel wreathing, swags, and the Greek key motif. Ht 31.7cm/12½in.*

4 *A design for a race cup by J.J. Boileau, made 1800, shows a calyx of broad fleshy leaves and symmetrical, angular upright handles with clearly defined friezes of ornament.*

The Influence of Adam

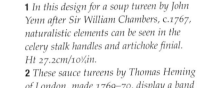

1 *One of a pair of candlesticks by John Carter, 1767, illustrating the use of acanthus leaves around its stem, and guilloche, beading, and reeding near the base. Ht 34.3cm/13½in.*

2 *Designs for Kenwood House, London, by Robert Adam, illustrated in the* Works, *incorporate urn-shaped vessels (on pedestals left and right), knife boxes, plates, vases, and ewers for the buffet in the dining room. Note the symmetry of the design.*

3 *One of a pair of sauce tureens by Matthew Boulton & John Fothergill, Birmingham, 1776–7, with upswept reeded handles, a band of rinceaux, and bellflowers embossed in flutes on lid and bowl. Ht 26.7cm/10½in.*

4 *One of a pair of elegant sauce tureens after a design by Robert Adam, made by John Carter, London, 1774. It shows husk festoons adorning the body, with beading, stiff leaves, and a simple ring-shaped knop. Ht 36.8cm/14½in.*

The Impact of Technology on Design

1 *This machine-processed tea caddy, with bright-cut engraving by Hester Bateman, 1788–9, has a gadrooned dome-shaped cover and reeded body. Ht 12cm/4¾in.*

2 *Louisa Courtauld & George Cowles of London made this silver tea canister in 1773. It was made from flatted sheet silver, scored and folded, and decorated with bright-cut engraving of a Greek key pattern and Chinese figures. It is adorned with a cast prunus blossom finial, and its shape is based on the chests in which tea was imported from China. Ht 8.9cm/3½in.*

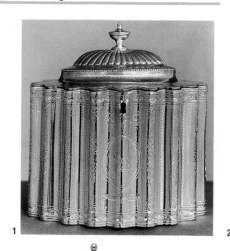

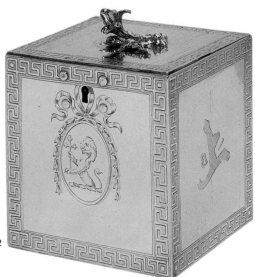

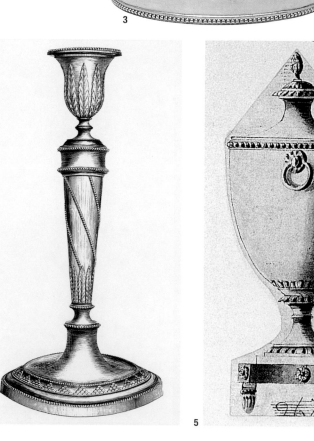

3 *The decoration on the body of this teapot, by Andrew Fogelbert in 1778, is restricted to a medallion and two bands of beading. Ht 12.7cm/5in.*

4 *An illustration of one of many candlesticks in a Sheffield pattern book, c.1780. The design consists of an arrangement from several standard dies which could be combined to form a wide variety of modular variations.*

5 *This tea urn was illustrated in one of Matthew Boulton's pattern books, c.1780. Wadham's patent for the tea urn meant that a heated cylinder could be built into the urn, dispensing with the need for an external heater, thus making for a more elegant, streamlined design.*

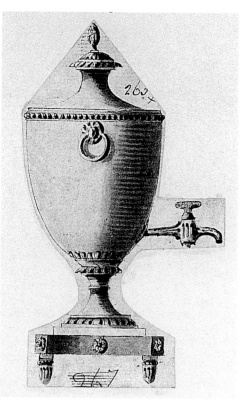

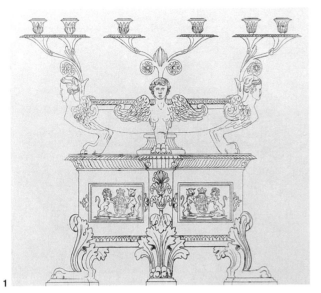

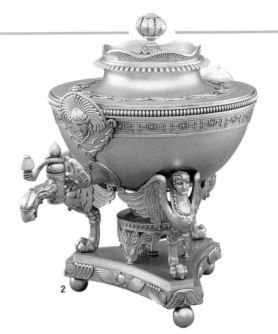

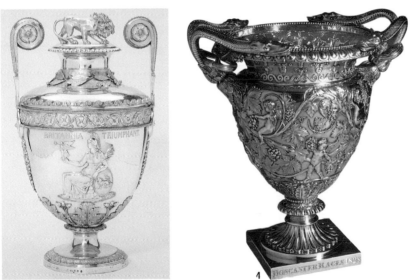

1 *This design for a centrepiece from* Designs for Ornamental Plate *by Charles Heathcote Tatham, 1806, shows a new interest in large, grandiose designs with classical figures.*
2 *Digby Scott & Benjamin Smith of London made this silver-gilt tea urn, 1806. An example of the Egyptian style, it incorporates a massive tripod base of three cast monopodial sphinxes with applied scarabs. Ht 37cm/14½in.*
3 *The Trafalgar vase, designed by John Flaxman, was made by Digby Scott & Benjamin Smith, in London, 1805–6, for Rundell, Bridge & Rundell. The form is based on Attic urns and the decoration incorporates cast and applied reliefs.Ht 43 8cm/17½in.*
4 *Rebeccah Emes & Edward Barnard made the silver-gilt Doncaster race cup in London, 1828. The snake handles and relief decoration of bacchic figures was applied to domestic as well as presentation silver. Ht 39.4cm/15½in.*

a pair of tureens made by the Parisian goldsmith Henri Auguste and designed by Jean Jacques Boileau, who emigrated to England and worked for Rundell and Garrard.

In the mid-18th century new mechanized processes assisted in the manufacture of modular, symmetrical, and light silverwares, exemplified by the silver supplied by the Bateman family. Flatting mills meant that large quantities of thinner gauge metal could be scored, folded, rolled, and soldered to form cubes and cylinders – geometrical shapes integral to Neoclassicism – at a fraction of the cost of hand-raising. Thin sheet could be easily and effectively worked with die stamps made of new extra hard steel. Standard mouldings or beadings could be supplied more cheaply than hand carving, and machine cutting and wire drawing replaced hand fretting for cake baskets and condiment holders. Thinner silver involving less labour meant that light elegant wares proliferated and were available to a larger market than ever before. For the first time provincial silversmiths such as Matthew Boulton (1728–1809) in Birmingham and those in

Sheffield began to compete with London manufacturers in the supply of an ever-increasing range of tea and table-wares. By the 1780s and 1790s English Neoclassical silver became much plainer, often decorated with simple cast medallions, some designed by Tassie, or low figural relief work after Flaxman.

At the end of the 18th century and in the first decades of the 19th century, English Neoclassical silver entered a new phase. Larger in scale, often gilded, and generally more massive, designs were often taken from ceramic or marble antiquities (or engravings of them) that had been excavated in Greece and Rome in the late 18th century and sold to English aristocrats. These, such as the Warwick vase, the Buckingham vase, and the Portland vase, were interpreted in silver by such goldsmiths as Rebeccah Emes & Edward Barnard, and they became icons of design. C.H. Tatham's publication of *Designs for Ornamental Plate* in 1806 promoted a return to archeological correctness and grandeur, and heralded what became known as the Empire style in silver.

NEOCLASSICISM | SILVER AND METALWORK

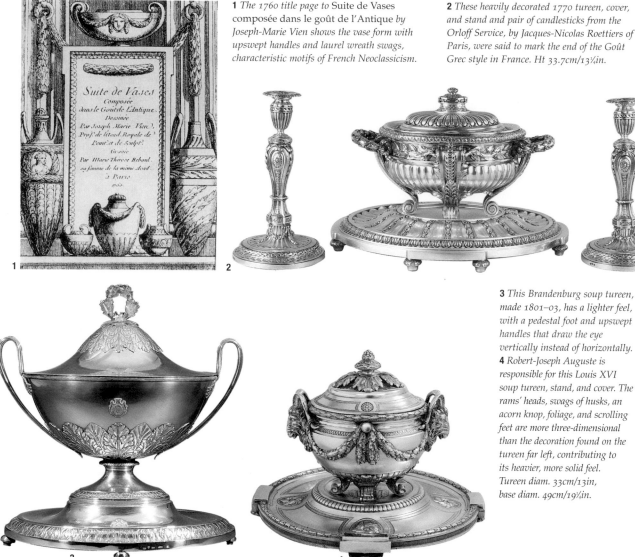

1 *The 1760 title page to* Suite de Vases composée dans le goût de l'Antique *by Joseph-Marie Vien shows the vase form with upswept handles and laurel wreath swags, characteristic motifs of French Neoclassicism.*

2 *These heavily decorated 1770 tureen, cover, and stand and pair of candlesticks from the Orloff Service, by Jacques-Nicolas Roettiers of Paris, were said to mark the end of the Goût Grec style in France. Ht 33.7cm/13¼in.*

3 *This Brandenburg soup tureen, made 1801–03, has a lighter feel, with a pedestal foot and upswept handles that draw the eye vertically instead of horizontally.* **4** *Robert-Joseph Auguste is responsible for this Louis XVI soup tureen, stand, and cover. The rams' heads, swags of husks, an acorn knop, foliage, and scrolling feet are more three-dimensional than the decoration found on the tureen far left, contributing to its heavier, more solid feel. Tureen diam. 33cm/13in, base diam. 49cm/19¼in.*

The French laid the foundations for Neoclassicism. Charles-Nicolas Cochin (1715–90), in his *Supplication aux Orfèvres*, published in 1754, pleaded for a return to "simple rules governed by good sense," and a return to the "old style" – classicism. Symmetry, proportion, and classical architectural motifs such as the acanthus leaf, guilloche pattern, paterae, and laurel swags returned.

It is difficult to judge the early development of Neoclassicism in French silver because plate was melted down to fund the Seven Years' War (1756–63). However, its influence can be seen in the spread of the new style from France to other European countries, most notably Britain, Italy, Russia, and Scandinavia, via prints such as the engraved designs for vases, published in Paris in 1760. Robert-Joseph Auguste (1723–1805) was an influential Parisian goldsmith working in the early Neoclassical style, and from 1756 he produced a series of tureens for the Danish court in the heavy Goût Grec style. One of the last examples of this style was made by Jacques Nicolas Roettiers (b.1736) for the Russian Prince Orloff in 1770.

Surviving drawings and silver from the Valadier workshop in Turin show how quickly other countries adopted French designs.

This heavy, muscular form of the early phase of Neoclassical silver was replaced in the 1770s with lighter, plainer silver, as shown in the work of Robert-Joseph Auguste's son Henri (1759–1816), anticipating the style of the Directoire and Empire. Large areas were left plain, and sometimes matted to contrast with bands of architectural ornament. Greek, Egyptian, and Roman motifs such as eagle heads and sphinxes were published by Charles Percier (1764–1838) and Pierre-François-Léonard Fontaine (1762–1853). They reflected the imperial ambitions of Napoleon and were exemplified in the silver designed for him by Jean Baptiste-Claude Odiot (1763–1850) and that of his rival Martin-Guillaume Biennais (1764–1843), after patterns devised by Jean-Guillaume Moitte. The large-scale and sculptural forms of French silver such as that of Odiot were adopted by other countries, as seen in the Portuguese dinner service.

Stylized, Austere, and Plain Decoration

1, 2 *This 1789–90 ewer and basin by Henri Auguste, Paris, has an elegant Grecian design based on patterns by the sculptor Jean Guillaume Moitte (1746–1810). Austere ornament is confined to bands and focal points, leaving large areas of silver undecorated, with a matt surface.*

3 *A design for a circular soup tureen by Giuseppe Valadier shows a concentration on form. Other than the reeding, decoration is limited to the lions' heads and swags of husks, with the eye concentrating on the simple, yet elegant curves of the body.*

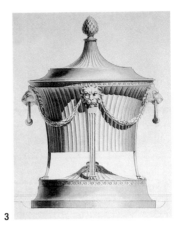

Exotic Empire

1 *In this design for a three-light candelabrum from Percier and Fontaine,* Recueil de décorations intérieures, *Paris, 1812, a triangular-shaped base and horn-shaped branches are apparent.*

2 *This pair of 1814 Austrian chamber candlesticks is based on an Odiot model. Each has a square flat base edged with a band of water leaves, with a square stem-shaped column, which is chased with palmettes in matted frames and supports a classical female head. Ht 21cm/8¼in.*

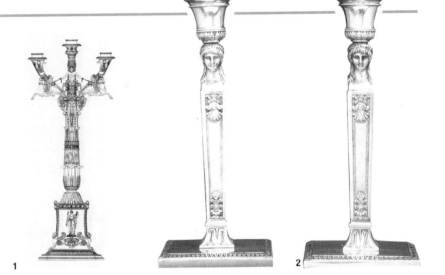

Imperial Ambitions

1 *This 1799–1809 coffee pot by Martin-Guillaume Biennais has a vase-shaped body and tripod base with female masks. The lower part is chased with a band of fluted and matted palm leaves and the shoulder is applied with bands of laurel. Ht 32cm/12½in.*

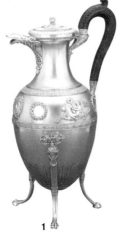

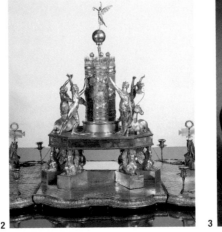

2 *Part of the Portuguese dinner service made for the Duke of Wellington to celebrate the victory at Waterloo, this table centrepiece, designed by Domingos Antonio de Sequeira in 1816, was influenced by the French.*

3 *The portrait of Napoleon's designer Jean-Baptiste Claude Odiot, by Robert Lefèvre, shows the designer with his drawings, along with one of his designs in the background.*

The Simplicity of American Silver

1 *This 1796 presentation punch urn by Paul Revere of Boston is one of four presented to the Boston Public Theatre. It has a simple urn form, flaring circular foot, upswept handles rising from acanthus foliage, and a high domed cover with ball finial. Ht 29.5cm/11⅝in.*

2 *Although this 1795–1800 cream jug by Paul Revere is devoid of decoration, the simple urn form has faceted sides, complemented with a simple upswept strap handle. Ht 16.3cm/6½in.*

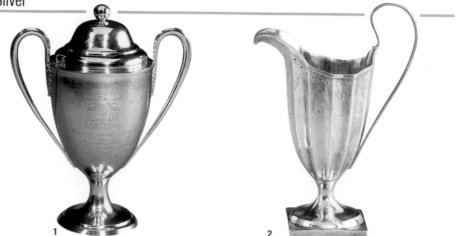

Fluting and Fancy

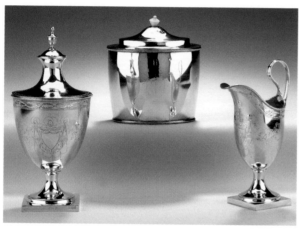

1 *Part of a 1799 tea and coffee service by Joseph Richardson Jr. of Philadelphia. This wedding present is simply decorated with bright-cut engraving and beading. Vase-shaped sugar basin ht 27cm/10¾in.*

2 *This c.1790 teapot by Paul Revere has a fluted oval body and tapered cylindrical spout. The stand is scalloped to match the fluted body. A bright-cut engraved oval cartouche and floral swags adorn the pot. Ht 15.3cm/6in.*

3 *Bright-cut engravings with swags and tassels decorate this c.1790 fluted sugar urn by Paul Revere. Ht 22.8cm/9in.*

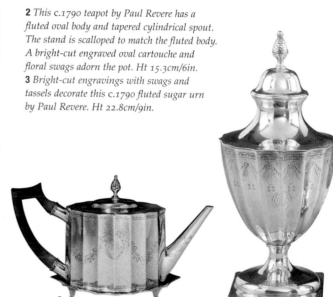

The impact of the American Revolution meant that both the import and home manufacture of silverwares was interrupted between 1775 and 1783. After the Revolution, despite the political situation, Neoclassical forms and decorative motifs continued to derive from British sources via imported silverwares, pattern books, and trade catalogues. No system of assaying and legal marking of silver was established, except in Baltimore in 1814, although there had been several attempts in Philadelphia from 1753.

There are some splendid pieces of American-made presentation silver, but it is the domestic tablewares, particularly those for tea and coffee, which dominated the market. Much Neoclassical silver was made in Philadelphia, a leader in taste and elegance, by such goldsmiths as Joseph Richardson (1711–84) and his son Joseph Richardson Jr. (1752–1831) until the outbreaks of yellow fever in 1793 and 1798. Many, including goldsmiths, fled to Baltimore, which took over as the epicentre of fashion. The cream jug made by the Boston

silversmith Paul Revere (1735–1818) 1795–1800, with its plain faceted body, hexagonal base, and upswept handle reflects the demand for simple, elegant vase shapes adapting antique forms for contemporary use. American silversmiths adorned their silver with bright-cut engraving, popular in England in the 1770s, often in delicate festoons. These light-weight wares made from flatted sheet, and sometimes fluted, echoed London-made silver such as that supplied by the Batemans.

At the turn of the century simpler, plainer wares became more popular, with large expanses of plain polished silver. By the early 19th century forms were becoming more robust and imperial imagery began to appear, such as the eagle head spouts, typical of sculptural castings of this period, on the John McMullin (1765–1843) tea and coffee service of c.1820.

From the beginning of the 19th century the smaller workshops began to face growing competition from larger manufacturing and retailing firms, and forms and decorative motifs became more standardized.

From Simplicity to the Growth of Grandeur

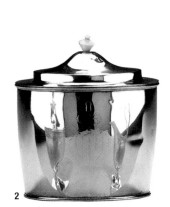

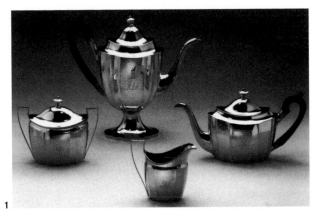

1

1 This three-piece tea service with coffee pot were made by *William Moulton of Massachusetts, 1800–10. Although simply decorated, the forms hint at a more flamboyant style, with angular handles and tapered, S-curved spouts.*

3

2 *The 1790–1810 tea caddy by John McMullin of Philadelphia has a plain oval body, the only decoration being a light beaded rim to base and cover and a simple shield coat of arms. Ht 16.5cm/6½in.*

3 *Joel & John Sayre, probably of New York City, made this three-piece tea service and coffee pot, 1802–18. The fluted oval bodies are based on classical urn forms with high domed covers. Coffee pot ht 33.5cm/13¼in.*

4 *A coffee or tea urn, made by Charles L. Boehme of Baltimore, c.1800. It has a vase-shaped body. It is unadorned, apart from the beaded borders and urn-shaped finial with an eagle on the lid. Ht 37.5cm/14¾in.*

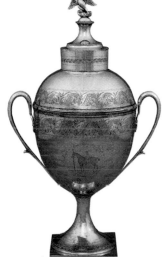

4

The Influence of Empire

1

1 *The Empire style can be seen in this c.1820 four-piece tea and coffee service by John McMullin of Philadelphia. Its imperial motifs include the eagle's head for the spouts of the pots and the bands of chased palmettes. Coffee pot ht 27.3cm/10¾in.*

2 *The globular bowl of this c.1816 punch service by Thomas Fletcher and Sidney Gardiner of Philadelphia bears areas of plain silver but sits on a stand supported by eagles.*

2

Sheffield Plate and the Importance of the Candlestick

1 *One of a pair of c.1775 Sheffield-plate candlesticks inspired by French Neoclassicism. It has a Greek key pattern, rams' heads, and a fluted nozzle. Ht 29.5cm/11½in.*

2 *This candlestick, by Matthew Fenton, c.1780, combines many characteristics of Neoclassicism: an urn-shaped socket, the column pressed with classical figures and swags, echoed in the foot. Ht 29.3cm/11½in.*

3 *A change from the square to triangular form can be seen in this c.1774 candlestick, made by Matthew Boulton of Birmingham after a design by James Wyatt. Ht 29cm/11½in.*

4 *A variety of Neoclassical candlestick designs for Sheffield plate and silver can be seen on this page from Matthew Boulton's c.1780 pattern book, including fluted tapering stems and plain columns, all with high stepped feet, some of which are plain, others decorated.*

5 *This page from R.M. Hirst shows that the Sheffield platers understood the principles governing classical architecture. The candlestick to the left is Doric, the simplest form of column, the one in the middle Ionic, and the one on the right Corinthian, the most decorative form.*

Sheffield plate was invented in 1742 by the Sheffield cutler Thomas Bolsover (1705–88). He discovered that copper fused with silver under heat and pressure, with both metals spreading at a uniform rate. The unique property of Sheffield plate that sets it apart from other plating processes is that the plating takes place before the item is formed. However, it was not until Joseph Hancock (1711–90), another Sheffield cutler, started making candlesticks that manufacture began on a commercial scale. Copper was sandwiched between two silver sheets, hammered, heated, and rolled, and stamped with steel dies to produce a variety of designs. There are few examples of Rococo Sheffield plate, but the symmetry, modular construction, and repetitive architectural decoration characteristic of Neoclassical silver was ideally suited to this process of manufacture. The same dies were used to make both silver and Sheffield plate, the latter only recognizable when the copper showed through the silver after wear. Sheffield plate could be worked in the same way as silver apart, of course, from casting. Discs of silver

were let into Sheffield plate for engraving, and silver rims were added to shield the plate from wear.

At a fifth of the cost of silver, Sheffield plate became very popular. Trade catalogues first appeared in the late 1770s, and those of Matthew Fenton & Co. in Sheffield and Matthew Boulton in Birmingham showed the great variety of designs that were available. Much was exported to Europe, and although the French in particular tried to copy it, nothing matched the quality of Boulton's Sheffield plate. By the 1780s many more forms were available in Sheffield plate, from tureens and covers to tea urns and toast racks. Perhaps the grandest pieces were the combined tea and coffee machines, standing on plinths, which are reminiscent of the simple and striking geometrical architecture of Ledoux. Sheffield plate did not produce any innovation in design, but its popularity helped disseminate silver patterns more widely than ever before. Sheffield plate only became redundant when it was replaced with the even cheaper process of electroplating, introduced by the Elkington Brothers in 1840.

1 The c.1780 inkstand includes a pounce pot in the centre. The simple pierced decoration gives the stand a light, elegant feeling. Ht 19.5cm/7¾in.

2 A sauce boat and stand made in the 1780s; its attenuated form, fluting, plain areas, and upswept handles are typical of Neoclassicism. L. 28.5cm/11¼in.

3 A trade card for William Spooner & Co. c.1860, which illustrates the many forms that Sheffield plate took, including a candle snuffer (top centre) and cruet stand (bottom right).

4 This 1780 monteith displays an unusual wave-shaped rim designed to hold the stems of wine glasses. The ring-shaped handles dangle from lion head mounts. Diam. 25.4cm/10in.

5 In this advertisement for a combination of tea and coffee machines, many Neoclassical elements are apparent, including the gadrooning, the ball feet of the stand and lion paw feet of the urns, the lion mask handles, and the fluted globular bodies.

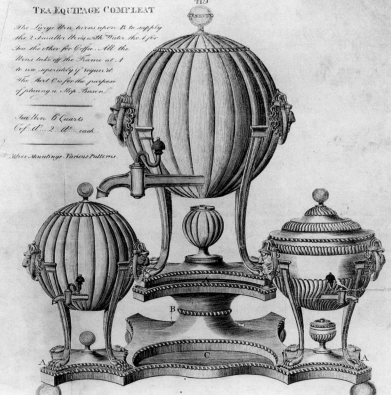

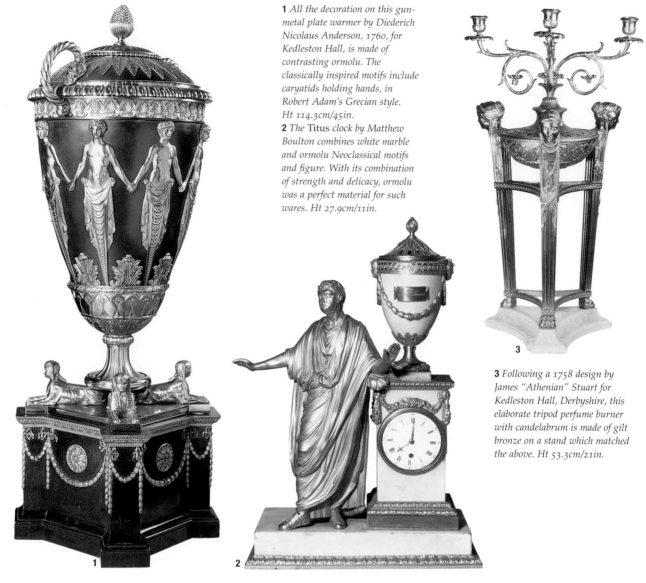

1 *All the decoration on this gun-metal plate warmer by Diederich Nicolaus Anderson, 1760, for Kedleston Hall, is made of contrasting ormolu. The classically inspired motifs include caryatids holding hands, in Robert Adam's Grecian style. Ht 114.3cm/45in.*

2 *The* Titus *clock by Matthew Boulton combines white marble and ormolu Neoclassical motifs and figure. With its combination of strength and delicacy, ormolu was a perfect material for such wares. Ht 27.9cm/11in.*

3 *Following a 1758 design by James "Athenian" Stuart for Kedleston Hall, Derbyshire, this elaborate tripod perfume burner with candelabrum is made of gilt bronze on a stand which matched the above. Ht 53.3cm/21in.*

The word ormolu derives from the French for ground gold, and it was mercury-gilded onto cast bronze, brass, or other metals. Ormolu was a luxury material in its own right, but it was usually used in combination with other expensive materials such as marble and porphyry. The supplement to Diderot's *Encyclopédie* reported that while gold leaf cost 90 livres an ounce, ormolu cost 104 livres an ounce. It became popular in the 18th century when it was used for the manufacture of decorative objects, especially as mounts applied to furniture and ceramics.

As a French-associated product ormolu became highly desirable in Britain, and it was greatly admired by the nobility and gentry. The greatest exponent of ormolu was the Parisian Pierre Gouthière (1732–c.1813), who perfected the technique of matt finishing to contrast with the high burnish. Between 1768 and 1782 it was manufactured by Matthew Boulton (1728–1809) in Birmingham, who often combined it with blue john and marble to create luxurious Neoclassical vases, perfume burners (used to counter the smell of food), candelabra,

and clocks, contrasting the glitter of the ormolu with other precious materials.

Robert Adam, William Chambers, James "Athenian" Stuart, and other architects created designs for ormolu, which were realized by Boulton and Diederich Nicolaus Anderson (d.1767), a highly skilled immigrant from Scandinavia specializing in ormolu work. Adam's 1766 designs for the door knobs and escutcheons for the dining room at Kedleston Hall demonstrate the qualities of fine casting and detailed delicate form for which ormolu was so admired.

The bold shapes, decoration, and contrast typical of the Empire style were brilliantly suited to the use of ormolu, and this can be seen on the patinated copper vase designed by Thomas Hope (1769–1831) and mounted by Alexis Decaix, an émigré from France. In Paris one of the most skilled ormolu workshops at the time was run by Pierre-Philippe Thomire (1751–1843), who had trained with Gouthière, employed over eight hundred men, and was much patronized by Napoleon.

The Popularity of the Tripod Form

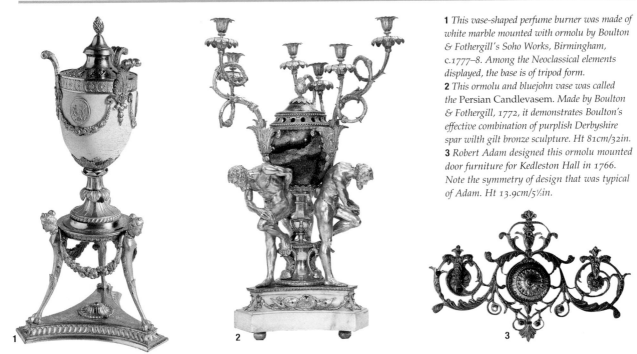

1 *This vase-shaped perfume burner was made of white marble mounted with ormolu by Boulton & Fothergill's Soho Works, Birmingham, c.1777–8. Among the Neoclassical elements displayed, the base is of tripod form.*
2 *This ormolu and bluejohn vase was called the* Persian Candlevasem. *Made by Boulton & Fothergill, 1772, it demonstrates Boulton's effective combination of purplish Derbyshire spar wilth gilt bronze sculpture. Ht 81cm/32in.*
3 *Robert Adam designed this ormolu mounted door furniture for Kedleston Hall in 1766. Note the symmetry of design that was typical of Adam. Ht 13.9cm/5½in.*

Ormolu and the Architects

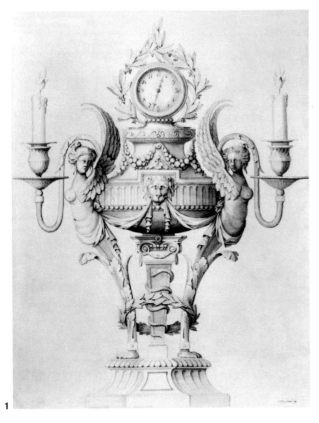

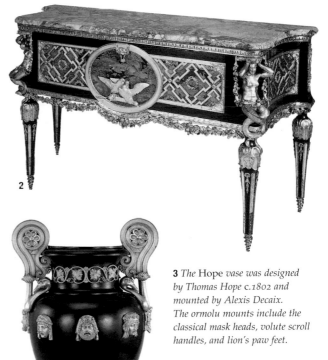

3 *The* Hope *vase was designed by Thomas Hope c.1802 and mounted by Alexis Decaix. The ormolu mounts include the classical mask heads, volute scroll handles, and lion's paw feet.*

1 *This elaborate design for a clock was envisioned by Marchand. The realized version would have incorporated ormolu in many of its decorated areas, such as the wreath of leaves encircling the pedestal base.*
2 *A Louis XVI commode made in the style of Weisweiler, with a marble top and ormolu mounts, including the female figures at the corners and decoration on the legs.L. 1.67m/5ft 6in.*

Pewter and Brass

1 *Imitating popular silver shapes and decoration, this c.1770 English pewter tobacco box is oval in form and decorated with an oval cartouche, bright-cut engraved laurel border, and beaded base. Ht 10.5cm/4in.*

2 *This late 18th-century German tureen is made of pewter. It has typical Neoclassical features, with a plain oval body, upswept wire handles, and a cast urn finial. Ht (with cover) 29.2cm/11¼in.*
3 *James Harrison (1770–97) made this American brass candlestick. It has a simple form, almost devoid of decoration, with a square base. Ht 17.8cm/7in.*

Paktong

1 *Made of paktong, c.1790, this candlestick is of Corinthian column form with a high stepped and gadrooned base. Ht 27cm/10¾in.*

2 *One of a pair of fire grates and fenders attributed to Robert Adam. The design includes serpentine fenders in pierced anthemion pattern supported by fluted columns. The fenders have ball feet. Grate w. 96.5cm/38in.*

The high cost of precious metals meant that cheaper substitutes were desirable. Pewter, an alloy of lead, was cheap and could be polished to a silver-like sheen, while brass gave a gilt-like gleam. Objects made from them copied the form and decoration of silver and gold, and disseminated fashionable design among consumers who could not afford the originals on which they were based.

These base metals were superseded by new, improved alloys invented in the 18th century that were harder than pewter and easier to work than brass. Paktong, an alloy of copper, nickel, and zinc, was imported from China in the 18th century. It was tarnish-resistant and ideal for fire grates – several were designed for Adam interiors – as well as for candlesticks. Developments in smelting produced harder iron and steel. The Carron ironworks in Scotland specialized in the production of cast iron and steel grates cast with fashionable Neoclassical festoons and paterae to match the interiors for which they were destined. In Oxfordshire and Birmingham, steel was cut and polished to make buckles, buttons, and sword hilts.

While Britain led the field in developing new metals, the cut steel factory at Tula in Russia was one of the few to challenge their lead. Staffed by foreign workers, it produced high-quality decorative wares such as candlesticks that combined cut and burnished steel with softer metals such as bronze, brass, and silver, which were chased and gilt. In Paris, steel was combined with gilt-bronze to produce exotic, highly worked furniture. The hardness of the material meant that it could only be worked by highly skilled craftsmen, making it expensive to buy.

At the cheaper end of the market there was a fashion in the later 18th century for painted base metals. At Pontypool in Monmouthshire a process of dipping iron in tin was combined with a new varnish to make Pontypool ware, or tôleware. By the 1770s it had become popular, and followed Neoclassical shapes and decoration.

Seen as exotic novelties, the design of objects made in these new materials always followed fashion. They were admired as much for their innovation as for the material from which they were made.

The New Iron and Steel

1 *Even cast iron could be made to accommodate classical images. This fire grate incorporates oval roundels and swags in light and delicate relief, and the steel fender is cut to make it light and contrast with the cast iron. By Carron Ironworks, c.1790.*
2 *A pair of steel shoe buckles, made in Birmingham c.1780, which imitated more expensive diamond ones, but were fashionable in their own right.*

Gilt-Bronze Decoration

1 *This c.1785-1800 steel candlestick with applied gilt-bronze decoration was made at the Tula factory in Russia. Staffed by foreign workmen, designs derived from the western European fashions they brought with them. Ht 31.8cm/12½in.*
2 *This Louis XVI French table was made of steel and gilt bronze and gilded in three tones. The polished steel was a novelty, being difficult to work with and expensive. The inset* verde antico *top was added at a later date. W. 146cm/57½in.*

Painted Metal

1 *This late 18th-century Dutch cruet stand was made of pewter and painted. It has a stamped gallery of floral festoons and pilasters, and Greek key handles with urn finials.*

2 *A pair of early 19th-century Welsh japanned pewter chestnut urns with dished lids and tall finials. The bodies are painted with rural scenes and adorned with lion mask and ring handles. Ht 31cm12½in.*

Textiles and Wallpaper

Architectural

1 *"Gothick" stucco-work paper, Moffat-Ladd House, Portsmouth, New Hampshire, c.1760. Neoclassical wallpaper patterns derived from many sources, in this case directly from plasterwork, in the so-called Gothic style.*

2 *The trade card of Matthias Darly, painter, engraver, and paper stainer, showing wallpapers in "Modern" (Neoclassical), Gothic, or Chinese tastes, London, c.1760–70.*
3 *Pillar-and-arch paper, stencilled and block-printed, probably Boston, 1787–90, showing the influence of classical architecture. Such papers were particularly popular in America.*

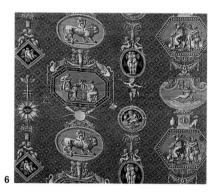

4 *Block-printed "demy" (referring to the limited colour palette), cotton chintz, Bannister Hall, Lancashire, England, c.1805, with Gothic pillars included in the design.*

5 *William Kilburn design for furnishing chintz, Wallington, Surrey, England, c.1792. Here, plasterwork elements provide the organizational structure for a floral stripe.*

6 La Marchande d'amours, *roller-printed cotton, Oberkampf, Jouy, France, 1817. From c.1795–1820, purists found inspiration in original sources such as designs for Neoclassical plasterwork (see 2, bottom group, opposite).*

Many Neoclassical patterns overlap in time with those of the late Rococo, but are distinguished from them by the prevailing characteristic of a light-handed formality and the influence of architecture and plasterwork, a feature that it is particularly noticeable in "scenic" textile designs. The organizational structure becomes simpler, even though the final effect may still appear complex. This is a style based on swags, trellises, stripes, and their related arrangement, grotesques. Despite this, it is also the period when naturalistic renderings of field and garden flowers reached their apex; such free-flowing designs co-existed with those employing both realistic and stylized blooms forced to conform to an over-riding structure.

Several types of architectural ornament appear frequently in Neoclassical textile patterns. Imitations of stucco or plasterwork in wallpaper are a logical extension of the supply of papier-mâché ornaments, which was also part of the wallpaper trade at this time. Plasterwork may provided a framework for floral motifs. From about 1760 to 1810, depictions of columns and arches were also a source of patterns. Towards the end of this period both elements are combined in *trompe l'oeil* floor-to-ceiling wall coverings known as décor or fresco papers, and the same principle can less often be found at work in woven and embroidered wall-hangings. Both Gothic and classical architectural features are sources for all these types of patterns, which remained popular into the 1870s. However, the numerous illustrated accounts of rediscovered ancient sites and artifacts gave classical ornament wider circulation and it is these that dominate during the Napoleonic period.

Illustrations of all subjects were culled for scenic designs. Aside from temples and ruins, operas and plays, wildlife, political events, trophies, and both real and mythological figures are the most typical subjects. Their arrangement falls roughly into three periods. In the 1760s and 1770s patterns are organized around "islands" or

Scenic Islands

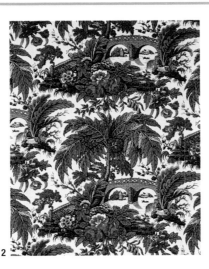

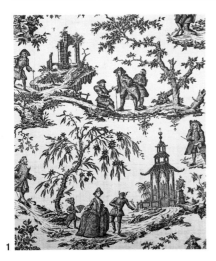

1 Lethe, or Aesop in the Shades, *plate-printed fustian in china blue with scenes from a play by David Garrick and figures from prints by Gabriel Smith and A. Mosley, 1766–74, cotton and linen. The classic scenic patterns, known as* toile de Jouy, *although using a technique of copperplate printing perfected in Ireland by 1752, were often combinations of Rococo informality and Neoclassical scenic elements.*
2 *Block-printed furnishing chintz, Peel & Co., Church Bank, England, 1812. The taste for crowding the scenes on textiles that developed from the 1790s is especially evident in the revival of scenic "island" designs, often chinoiserie in style.*

Framed Scenics

1 *Wallpaper by Appleton Prentiss, Boston, 1791. As the Neoclassical period progressed, arrangements of scenic patterns became more ordered through the introduction of frames, cartouches, or roundels. Such framed patterns might be large or small, and also appeared on weaves and on wallpapers, as here.*

1

2

2 *Detail of a page depicting plaques from Joseph Beunat's* Designs for Architectural Ornaments *(Paris, c.1813). Such original source material illustrating ancient sites was faithfully incorporated by some textile designers.*
3 *Block-printed cotton, Francis & Crook, Covent Garden, London, 1792. The background is full of ornamentation, in keeping with contemporary taste. Such separated framed motifs were ideal for covering chair seats and backs.*

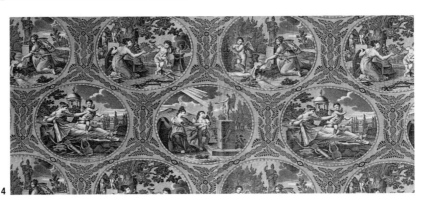

4 L'Allégorie à l'amour Cupidon and Psyche, *roller-printed cotton, Favre, Petitpierre & Cie, Nantes, France, 1815. The trend towards density from the late 18th century led to scenes closely set on busily figured coloured grounds.*

4

NEOCLASSICAL | TEXTILES

1 *Needlepoint lace, Argentan, France, c.1785. The curves of the swags here are Neoclassical in their symmetrical arrangement; compare with the Rococo asymmetry of the swags (in no. 1 opposite).*

1

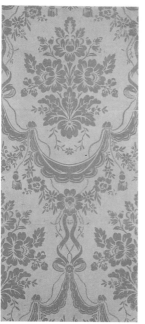

2

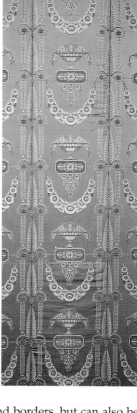

3

4

2 *Caffoy damask-style flocked paper, probably British, c.1750–60. More than any other motif, swags demonstrate the inter-relationship between Rococo and Neoclassical patterns. They introduce a Rococo touch here, rendered as bunting.*

3 *Block-printed cotton counterpane, John Hewson, Philadelphia, 1790–1800. Often deployed as borders in this period, swags under the influence of Neoclassical restraint could be very subtle.*

4 *Silk damask by J.P. Lacostat & Cie for Versailles, 1812–13. The swags on this damask are treated as stylized floral bowers, and have a plasterwork-like solidity entirely compatible with pure Neoclassical designs.*

are also aspects of Rococo designs. During the 1780s and 1790s a more ordered format prevails, with motifs contained within cartouches, ovals, roundels, and the like. Early in the 19th century, the height of printed repeats is often reduced, resulting in designs, whether of the revived island type or plasterwork-inspired, with a cramped appearance.

As a source of pattern details, swags and draperies based on real fabric treatments were the principal alternative to plasterwork structures throughout the period. From the 1760s to 1790s these most often imitate suspended bunting, especially in damasks and damask-style papers. Less overt variations depict floral bowers instead. The very small background patterns often incorporated into printed wallpaper designs – of this type and others – is also in imitation of textiles, replicating the lively surfaces of minutely patterned velvets and laces. As 1800 approaches, the curve of the swag becomes very shallow, only gradually to return to a more generous proportion by about 1810 to 1815. Faux draperies were a

feature of many wallpapers and borders, but can also be found depicted in all types of textiles.

Trellises and their natural accompaniment, sprigs, are perennial pattern types that nevertheless were particularly popular in the Neoclassical period. Their treatment may incorporate a suggestion of ribbons or architectural ornament. However, even when the design appears complex, such as a lattice-work intertwined with vines, the structure is clear. The single sprig or spot patterns that are often positioned within trellises were also widely used as all-over patterns. These were particularly important for cotton textile printers who were gradually mechanizing their production from the 1780s onwards, and became the staple for dress cottons for more than a century thereafter.

Stripes of many types are associated with this period. Often it is their inclusion in a pattern that defines it as being Neoclassical rather than Rococo. The evolution of an asymmetrical vertical pattern into a symmetrical one indicates the same trend; it is not uncommon to find

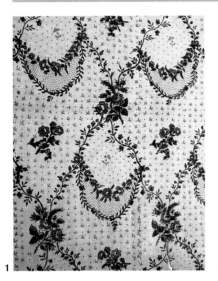

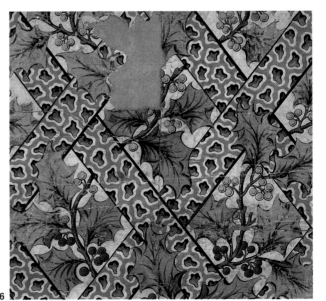

1 *Block-printed linen, France, c.1780, with asymmetrically arranged swags in Rococo style.*
2 *Block-printed cotton velvet, France, 1780–90. The swag was a favourite motif within* trompe l'oeil *designs, themselves particularly fashionable from around 1770 to 1825.*
3 *Block-printed wallpaper borders, probably Boston, 1810–25. After about 1795, swags could be entirely literal, replicating complex arrangements of draperies.*
4 *Block and stencil wallpaper, Whitehall, Cheam, Surrey, c.1740. As the market for textiles and wallpapers increased, trellis and sprig patterns became the mainstay of designers working on small-scale schemes. Small repeating patterns produce less waste when pattern-matching along joined pieces, and are thus more economical, while errors in matching up are also less evident.*

5 *Sample book of roller- and block-printed cottons, Jonathan Peel, Church Bank, Lancashire, 1806–17. Sprigs when used alone were often aligned along crossing diagonal lines.*
6 *Design for block-printed chintz, Bannister Hall, Lancashire, 1806. Trellises typically became more prominent as the Neoclassical period progressed.*

Stripes

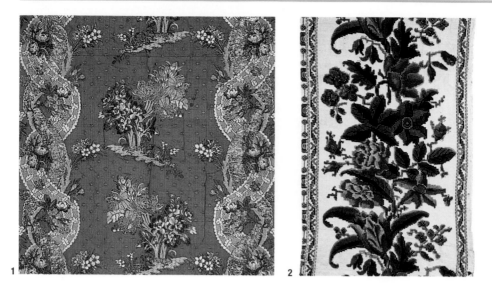

1 *Brocaded silk, France, 1760–70. Stripes both simple and complex were included in many Neoclassical designs. A favourite motif shared with late Rococo patterns was a stripe composed of interlinked meanders.*
2 The One Stripe Needlework Flower Pot Chintz Border, *block-printed by Bannister Hall, Lancashire, for Richard Ovey, London, 1805. From about 1790 to 1815 and beyond, floral stripes abounded. These could be as wide as 35cm/13¾in, as this border demonstrates.*

Intricate Stripes

1 Domino *wallpaper, c.1750, France, block-printed and stencilled on hand-made paper. In this variant on stripes composed of interlinked meanders, the arrangement is more formal and the meanders are contained within additional stripes.*
2 *Block-printed cotton, Lesourd, Angers, France, 1786. This later Neoclassical textile includes contorted meanders that appear "trapped" within a stripe.*

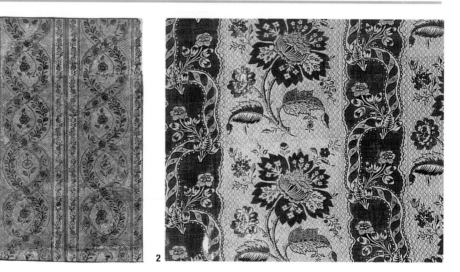

similar pairs of asymmetrical/symmetrical designs from about 1760 until the 1780s. In weaving, stripes are easily added as a background to other motifs, a device that gained in popularity from the late 1750s onwards. However, from the early 1770s the motifs tend to be positioned within the stripes, rather than across them. The stripes themselves also become less varied in width and number and, by about 1780, settle into an arrangement of two roughly equal-sized stripes, one with a more distinct pattern. Double stripes also emerge in printed fabrics and wallpapers, although their relative scale remains varied. Many stripes were designed to be used as side-by-side repeats and, cut away, as borders, a flexibility reinforced visually by the inclusion of a narrow edging stripe.

Related to stripes in their strong vertical emphasis are grotesque patterns. Typically incorporating images of figures or animals, they were inspired by the elongated designs found in Renaissance grottoes. At their most elaborate as wall-coverings, they are related to décor,

with no repeat from top to bottom. A master of this genre was Jean-Démosthène Dugourc (1749–1825), a designer who worked in several European courts and in 1782 published a series of engravings entitled *d'Arabesques* (designs consisting solely of curling flowers and foliage are today known in English as arabesque patterns). The fashion for grotesques existed from the 1780s until the early 1800s, although latterly they appear more typically in large borders, rather than as all-over patterns. Their legacy remains in post-1810 Empire designs with elongated forms.

Towards the end of the 18th century, two factors brought naturalism to the fore. One was the Romantic Movement and its concern with the relationship between people and their natural environment. This favoured the depiction of field and forest flowers and foliage, arranged to suggest random growth. The other was the increasing issue of hand-coloured engraved plates illustrating botanical specimens, many depicted in their habitat or as informal posies. While flower painting had long

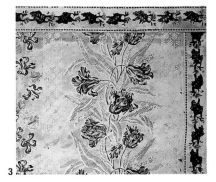

3 *Block-printed paper and border, New England, 1800–15. The outer edges of floral stripes gradually became more fluid and naturalistic during the period, rather than straight or nearly so.*

4 *Design by Jean-Démosthène Dugourc for Aranjuez, Spain, c.1786, which incorporates grotesque patterns around depictions of Italianate scenes. The vertical framework divides the panel into what are essentially large, complex stripes.*

5 *Block-printed paper with Egyptian motifs for the drawing room, Crawley House, Bedfordshire, England, 1806. Topical designs appeared in stripes and were especially fashionable as borders, combined with trellis or sprig patterns.*

Grotesques

2 *Embroidered satin appliquéd with shaded velvet and chenille, attributed to Jean-François Bony, France, 1795–9. Seldom entirely symmetrical, emphasis nevertheless fell on the grotesque pattern's vertical centre line.*

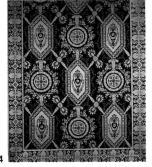

3 *Block-printed chintz, Half Moon and Seven Stars Furniture, printed by Bannister Hall, Lancashire, for Richard Ovey, 1804. Later grotesque designs were indebted to patterns for carved pilasters.*

4 *French silk velvet. This late grotesque pattern was inspired by plasterwork. It was used at the Elysée Palace, Paris, in 1848 and at Fontainebleau, c.1850, and typifies the sustained influence of French Empire designs.*

1 *Silk lampas (compound weave), Lyons, 1790–2. Grotesque patterns were generally consistent with their inspiration, incorporating scrollwork, cameos, cherubs, trophies, and the like.*

Naturalism

1 Design for a printed textile by William Kilburn, c.1790. Naturalism in the Neoclassical period was not simply a matter of realism in the drawing, but also pertained to the structure of a pattern. In all-over patterns, motifs appear to wander over the surface and the repeat is often skilfully disguised.

2 Embroidery and appliqué on tulle and taffeta, France, c.1795–1805. Although seldom intermingled, naturalistic patterns were placed adjacent to structured repeats such as scale motifs.

3 Border from Joseph Beunat's Designs for Architectural Ornaments (Paris, c.1813). Even when designed as borders, a naturalistic arrangement is evident in this plate.

4 Block-printed wallpaper, France, c.1800. Despite their three-dimensional rendering, floral sprays and vines were typically placed against minutely patterned or solid-coloured grounds, thus emphasizing two planes – figure and ground – rather than an overall trompe l'oeil effect.

5 Silk damask, Camille Pernon for Saint-Cloud, 1802–5. Such cloth, with a dominant naturalistic pattern of a single plant form, in this case the oak, often emphasized the scale and proportions of walls, curtains, and furnishings.

informed pattern design, these plates were far more widely available. Some who produced them were also designers, such as the English calico printer William Kilburn (1745–1818). The illustrator best known for his impact on pattern design is Pierre-Joseph Redouté (1759–1840), who supplied plates for various works from 1784 and his own volumes from 1803–24.

An informal quality obtains in the patterns thus influenced, whether arranged as all-overs, borders, or bunches, and some plants and trees were especially favoured: roses, strawberries, thistles, clover, and acorns and oak leaves. The emblematic significance of such motifs was still widely understood at this time, with imagery from oak trees, for example, recognized as denoting permanence and strength.

Even at the height of the fashion for naturalism, stylized floral patterns were created, many influenced by textiles from the Indian subcontinent. However, in keeping with Romantic notions, the result often suggests casually tossed leaves or sprigs. In addition, realistic depictions of plants and flowers were sometimes employed as the internal decoration within leaves and petals. Coral and vermicelli, with their equally lively forms, were also elements of the designer's repertoire. The most lasting of internally decorated shapes is the *boteh* (meaning flower), evolving among Persian and Kashmir shawl weavers by about 1790 into its distinctive cone shape. Scarce and coveted, these shawls by about 1805 to 1810 had initiated European imitations, from which arose the manufacturing speciality of Paisley, in Scotland. As a result, now known as paisley patterns and then also called cashmeres, such exoticized floral forms became an important aspect of European designers' visual vocabulary. In particular, their stylized sprigs (used all over) and borders appear in many repeat patterns. During the Napoleonic Empire, stylized Egyptian-inspired plants also adorned designs but, Kashmiri motifs aside, the lasting legacy of floral patterns to the following decades was realism, which even softened architecturally inspired late-Empire designs.

Nature Rearranged

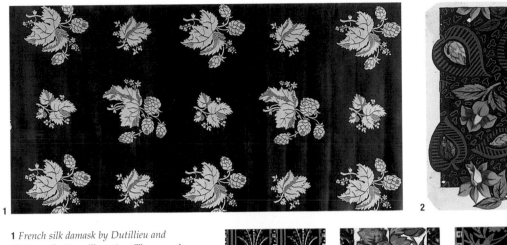

1 *French silk damask by Dutillieu and Théileyre for Versailles, 1811. These evenly distributed posies are nevertheless treated naturalistically.*

2 *J. Foerg (German) design engraved by Henri Haury, 1797, block-printed by Haussmann, Logelbach, Germany. From the vocabulary of Indian textiles came such teardrop boteh forms.*

3 *Block-printed wallpaper borders, c.1780–1810. The proliferation of printed wallpapers and textiles during this period encouraged a wide and inventive range of patterns based on plant life.*

4 *Silk damask, produced in France for the Palazzo del Quirinale, Rome, 1813. Highly stylized plant forms such as papyrus (alluding to Napoleon's Egyptian campaign) were most often reserved for grotesque patterns.*

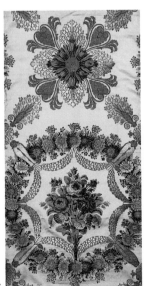

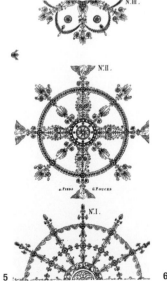

5 *Rosettes from Joseph Beunat's* Designs for Architectural Ornaments *(Paris, c.1813). Here, stylized floral forms appear in plasterwork-like designs. Even so, a light and lively touch prevails.*

6 *Brocaded silk, Bissardon, Cousin & Bony for Versailles, 1812–15. Like the rosettes from Beunat's pattern book, these semi-naturalistic floral forms refer to plasterwork patterns of the time.*

Historic Revivals

c.1820–1900

Design during the 19th century was influenced by eclectic historical styles, the pervasive effects of the Industrial Revolution, and the international exhibitions that showcased design trends. Writing in the *House Decorator's and Painter's Guide* in 1840, H.W. and A. Arrowsmith observed that "the present age is distinguished from all others in having no style which can be properly called its own." Certainly by this point in history, designers in Europe and the United States had an increasingly bewildering variety of styles from which they could draw as they responded to the latest fashions.

Consumers could choose from a variety of objects created in a range of styles, from Gothic Revival to Modern Grecian or from Elizabethan to Rococo Revival. The past was pillaged, through engravings and publications, to provide inspiration for designers busy trying to provide for a public which (according to the 1849 *Journal of Design*) had "a morbid craving for novelty without regard to intrinsic goodness."

For some the choices available were too confusing. In response, works such as J.C. Loudon's *Encyclopaedia of Cottage Farm and Villa Architecture and Furniture* (1833) and the American A.J. Downing's *The Architecture of Country Houses* (1850) were published with information about how the new styles could be used and where they might be appropriate. Downing, for example, felt the Elizabethan taste to be ideal for the houses of collectors, or those who had recently moved to the US from the Old World and wanted to be reminded of the homes they left behind.

Both volumes featured furniture in a bulky classical taste, termed by Loudon "the Grecian or modern style," which he described as "most prevalent." Despite the alternatives, classically inspired design continued to play a part in furnishing tastes throughout the century, providing consumers with, on the one hand, a range of solid unpretentious furniture and on the other with elaborate reworkings of ancient or Neoclassical motifs.

But the trend towards stylistic variety was not new. Eighteenth and early 19th-century design, although dominated by classical sources, had begun to take a greater interest in a more varied cultural past. In England, Gothic motifs had been periodically fashionable during the 18th century, but had been of a light, almost playful nature. By the 19th century, this whimsical version of Gothic was slowly replaced by an increasingly scholarly approach. Publications such as Thomas Rickman's *Attempt to Discriminate the Styles of English Architecture* (1817) and the writings and designs of A.W.N. Pugin gave the style a gravity and moral importance that appealed to high-minded people in Europe and the US. However, for many it was simply admired for its picturesque qualities.

Left: the elaborate floral decoration, the finial, and the form of this silver coffee pot, from a tea and coffee service made by Samuel Kirk & Son in Baltimore, Maryland, c.1850, is in the Neo-Rococo style. The ship and seafront town are popular themes on American wares. Ht 36cm/14¼in.

Opposite: the Great Exhibition of the Works of Industry of All Nations, more commonly known as the Great Exhibition, was held in 1851 at the specially built Crystal Palace in London. It included this Medieval Court, designed by the progressive Gothicist A.W.N. Pugin (1812–52), which displayed ecclesiastical and domestic furnishings by leading makers. Gothic Revival taste in all its guises was one of the most influential design styles in 19th-century Europe and the US.

1 *Created for the Parisian home of Princesse Mathilde in the 1860s, this Renaissance Revival interior is decorated in rich colours and furnished with antique and modern pieces. Lavish upholstery fabrics and antique metalwork and glass combine with armour to give a romantic 15th- to 16th-century flavour to the room.*

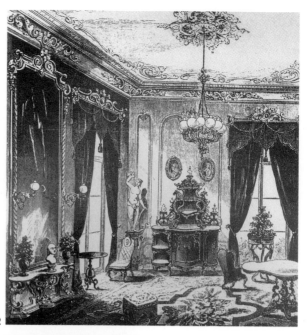

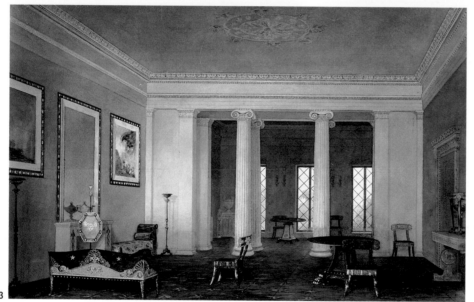

2 *Taken from the* Pictorial Drawing-Room Companion *of 1854 by Gleason, this American interior is dominated by the Neo-Rococo taste. Elaborate scrollwork defines the furniture and mirrors, while the upholstery and carpet are covered with naturalistic floral ornament.*

3 *Classicism, both Greek and Roman, continued to be part of the designer's repertoire in the 1840s. This American interior is the double parlour in the John Cox Stevens house, designed by Alexander Jackson Davis (1803–92), and it demonstrates an uncompromising example of Greek Revival design.*

Some styles were adopted for political reasons. In the 1820s, the aristocratic British fascination with French design of the 1740s and 1750s is often ascribed to a nostalgic interest in the former Bourbon régime and the old order, which was swept away by the French Revolution and supplanted by Napoleon's Empire. By the time it reached a wider audience in the 1830s and 1840s, these connotations were replaced by an appreciation of the luxurious appearance of the Neo-Rococo style and its suitability for use on new and comfortable furnishings such as the spring-upholstered sofa.

Styles also had literary inspiration. In England and France, the Elizabethan or Troubadour styles were partly inspired by popular novels, which identified the period with chivalry and high ideals. People wanted objects that referred to the romance of "olden times."

But craving for novelty played a part, too. Classicism in a variety of guises continued to survive into the 19th

century, especially in Italy. The Industrial Revolution led to the growth of the middle class, and these new rich consumers wanted choice and novelty; designers were happy to supply them. As one commentator remarked of a cotton printer in 1849, "the very instant his hundred patterns were out he began to engrave others." The variety of styles available helped to satisfy this rapidly growing, aspirational market for which ornament was often synonymous with beauty.

Design was also shaped by the new technology. It should be remembered that from the 1830s, objects could be produced more quickly and in some instances more cheaply than ever before. The old-fashioned approach, where an affluent patron would commission an object from a craftsman, was still viable for the very rich but, increasingly, mass production was the order of the day. By the 1840s the wallpaper, textile, and metalworking trades had all achieved a degree of mechanization.

Furniture trades still practised hand working, but this was now augmented by new equipment that allowed the thin cutting of veneers or the roughing out of carving. Developments in materials such as cast iron or papier mâché prompted the design of furnishings that could be reproduced quickly. In response, manufacturers were increasingly seeking designs that would sell in large quantities in order to justify mass production. It was also a period of intense innovation and experiment. New techniques such as the development of the laminating and steam-shaping of woodwork, pioneered by the furniture makers Michael Thonet (1796–1871) and John Henry Belter (1804–63), were to lay the foundations for 20th-century furniture production.

Styles were also increasingly cosmopolitan. Revolutions and wars, coupled with improved transport systems, moved craftsmen and designers around the world and led to a greater exchange of ideas. In addition, the early 19th century saw the beginnings of the concept of international exhibitions as a means of stimulating trade and design. In 1849 international shows were planned in Birmingham and Paris but both failed to attract exhibitors from other countries. However, in 1851 London was the venue for the Crystal Palace exhibition. Intended as a showcase for international manufacture and design, the "Great Exhibition of the Works of Industry of All Nations," or the Great Exhibition as it was popularly known, allowed nations to view the work of competitor nations and to be influenced by new trends. In countries such as Britain, it gave extra impetus to the existing provision of design education, when British manufacture was seen to compare badly with the output of countries such as France. In Europe and the United States, it set a trend for international exhibitions that were to last another 50 years. These included New York in 1853, London in 1862, Paris in 1867, Vienna in 1873, Philadelphia in 1876, and Paris in 1878. It also spawned a

new breed of object: the exhibition piece. Created in the grand manner to show off manufacturing skill and design virtuosity, exhibition pieces often used innovative materials and techniques to achieve eye-catching results; just as often they were highly conservative.

Out of the stylistic diversity of the 1830s and 1840s came a serious approach to revival styles. In 1856 Owen Jones's *Grammar of Ornament* was published, followed by Heinrich Dolmetsch's *Ornamentenschatz* in 1887. Both were seminal works, attempting to instruct designers in the true nature of historic styles and to encourage a more academic use of historical motifs. In manufacturing this was paralleled by the glass and ceramic industries, whose productions were increasingly characterized by the recreation of historic styles, often realized by using historically accurate techniques.

Mass production also caused a reaction. The increasing use of mechanization led designers such as Willam Morris (1834–96) to turn away from industrial design to concentrate on craft production. This in turn was to shape the highly influential Arts and Crafts Movement that emerged in the 1860s.

Historical styles continued to be used and re-invented throughout the century. In the 1870s, the Aesthetic Movement found inspiration in the furniture of the 18th century, which was previously criticized as meagre or sparse. By 1880, furniture in the Chippendale, Hepplewhite, and Sheraton styles was part of the usual stock-in-trade of the commercial furnisher, together with French-style "Louis" pieces and "Renaissance" evocations. For the 19th century consumer, variety was almost a style in itself.

4 *Books such as Richard Bridgens'* Furniture with Candelabra and Interior Decoration *promoted revival styles Published in London in 1838 (2nd edition), the book's illustrations covered many aspects of furniture design in the Elizabethan taste.*

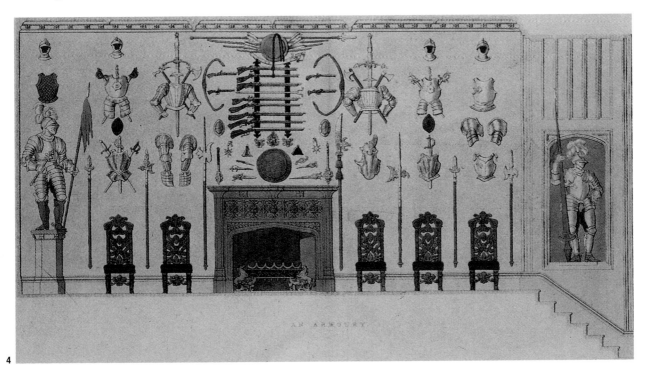

Gothic Revival Furniture

Architectural Influences

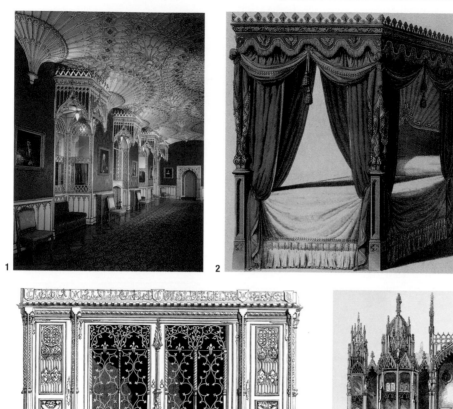

1 *In the 1750s Horace Walpole decorated his house at Strawberry Hill, Middlesex, in the Gothic style. This decorative approach continued to be popular into the 19th century. "The gallery" ceiling tracery is based on that in the Henry VII chapel in Westminster Abbey, London.*
2 *Gothic was one of the many styles used to adorn furniture and decoration in the 1820s. This four-poster bed design was published in 1826. The cresting is decorated with stylized leaves and the posts with carved quatre-foil motifs, all inspired by Medieval architecture.*

3 *Pugin showed this cabinet in his Medieval Court at the Great Exhibition in 1851. Although decorated with carving, the ornamentation is restrained and closely based on historical prototypes.*

4 *Elaborate specimens in the Gothic taste were a feature of the Great Exhibition of 1851. Leistler & Son of Austria submitted this vast oak bookcase, designed to look like a choir stall, as a gift for Queen Victoria.*

The Gothic taste in Britain had its roots in 18th-century design and the influence of connoisseurs such as Horace Walpole (1717–97), whose villa, Strawberry Hill, was decorated and furnished in the Gothic manner. With details derived from Medieval architecture incorporated into modern furniture shapes, it was essentially a superficial style admired for its decorative and romantic qualities, and during the first quarter of the 19th century it retained a certain prestige. Features in fashionable magazines and a growing interest in antiquarian subjects fuelled enthusiasm for the Gothic, and it began to be seen as the British national style. This status was confirmed when the style was chosen for Sir Charles Barry's new Palace of Westminster after the fire of 1834.

Gothic was characterized by the use of architectural features such as crockets, pointed arches, and pinnacles carved from oak or other dark woods. These designs became so fanciful that A.W.N. Pugin (1812–52) was moved to comment that "a man who remains…in a modern Gothic room and escapes without being wounded by some of its minutiae may consider himself extremely fortunate."

In Europe, by the 1840s, the French Gothic Revival taste had taken on a new character through the work of Eugène Viollet-le-Duc (1814–79). Informed by a scholarly understanding of Gothic furniture and architecture, he published a series of highly influential works including the *Dictionnaire du Mobilier Français* (1858–75).

In the United States, the Gothic style was promoted by publications such as Robert Conner's *Cabinet Maker's Assistant* (1842) and the writings of Andrew J. Downing (1815–52). Downing worked with the architect Alexander Jackson Davis (1803–92), who designed Gothic furnishings for new mansions.

The fanciful Gothic was supplanted by an increasingly serious approach led by the British designer A.W.N. Pugin. His designs, which were derived from extant examples of Gothic furniture and the principles of Medieval constructional woodwork, were widely copied throughout Britain and Europe.

Furniture Forms

1 *The dining room at Windsor Castle was equipped with a new suite of chairs in the 1820s. They were designed by the young Pugin, at this time working in a Georgian Gothic mode. Using rosewood veneers highlighted by gilding, the chair backs are based on 15th-century window tracery. This is the type of design that Pugin was later to criticize in his publications. Ht 1m/39½in.*

2 *Designed to be knelt on for prayer, this French* prie-dieu, *c.1840, is carved various Gothic motifs including arcading and carved trefoils. The back panel is painted with the Virgin and Child, after Raphael. Ht 81cm/32in.*

3 *This tracery-backed chair is of a type known in France as à la* cathédrale. *Crockets and pinnacles combine to create a suitably spiky silhouette in this romanticized recreation of the Gothic style.*

4 *Pugin's published furniture designs inspired this Gothic armchair of 1864. Made from carved oak, the chair is elaborately upholstered in tapestry fabric. It reflects Pugin's more serious approach to Gothic after the 1820s. Ht 1.12m/3ft 7½in.*

5 *This mid-Victorian Gothic Revival oak library table relies on construction rather than decoration for its effects. The use of "revealed construction," as Pugin termed it, marks an important new strand in the Gothic Revival, which can also be seen in the chair. Pugin's publications were highly influential in Britain and in Europe and the US. His work laid the foundations for the Arts and Crafts Movement and inspired designers including William Burges (1827–81), B.J. Talbert (1838–81), and Charles Locke Eastlake (1836–1906). Table l. 1.53m/5ft, chair ht 1m/3ft 3in.*

HISTORIC REVIVALS | GOTHIC REVIVAL FURNITURE

215

Elizabethan Revival Furniture

Fanciful Furniture for the Romantics

1 *Turned uprights characterized much Elizabethan Revival furniture. This example, probably designed by Richard Bridgens and made in the workshops of George Bullock, c.1815, was executed in painted oak with gilded detailing and a heraldic crest above the back. Ht 90cm/35½in.*

2 *By the 1840s, the Elizabethan style became more elaborate. Carved and turned decoration on chairs like this one provided the perfect framework for the new Berlin woolwork, seen here on the seat and back. Ht 1.01m/3ft 3½in.*

3 *Chairs of this type were known as Scott or Abbotsford chairs. They were characterized by tall backs and twist-turned uprights. This example was designed for the Scott summer house at Buckingham Palace in 1844.*

4 *Queen Adelaide's bedroom, in Mamhead, Devon, was designed c.1830 by Anthony Salvin (1799–1881). The suite of furniture is made of oak with incised and carved decoration. The turned legs of the couch and the curved stretchers were inspired by later 17th-century furniture design.*

Sir Walter Scott's historical romances and a growing sense of nationalism prompted by the aftermath of the Napoleonic Wars were some of the influences persuading British designers to adopt the Elizabethan style after the 1820s. Lack of detailed historical knowledge meant that makers were unsure about the true nature of Elizabethan design, and they also took motifs from furniture now associated with the 17th century. This rich mix generated fanciful creations of strapwork, arabesques, spiral twists, and elaborate carving. George Fildes, an advocate of the Elizabethan taste, confessed in 1844, "there is no style…that affords a more fatal facility than the Elizabethan for the exercise of bad taste."

Materials such as oak and walnut were seen as most appropriate for Elizabethan-style furniture, but commercial makers were keen to use the latest technology and materials to add novelty. The fashion also prompted a demand for real and restored antique pieces. Historical fragments such as panels and carvings were used as a starting point for new furniture.

The publications available to makers at this time fuelled interest in the Elizabethan style. Henry Shaw's *Specimens of Ancient Furniture*, which illustrated many examples of Elizabethan design, was published in 1836 and re-issued in 1866. Richard Bridgens' *Furniture with Candelabra and Interior Decoration* of 1838 included plates of appropriate designs, many of them illustrating how motifs could be adapted to modern furniture types.

In the US, the Elizabethan taste found new admirers, supported by the writings of Andrew Jackson Downing. Delighting in the "mingled quaintness, beauty and picturesqueness" of the old English house, he described the "curiously carved furniture and fixtures" of such buildings and revelled in their "romance and chivalry." He particularly recommended the style for the decoration of parlours and sitting rooms.

The French equivalent of the Elizabethan Revival, known as Troubadour style, drew mainly on Gothic motifs, but was similarly inspired by notions of chivalry and historical romance.

5 *This 1830s dining room at Charlecote Park is in the Elizabethan taste. The 17th century-style oak chairs are upholstered in red cut velvet.*

6 *This bookcase was presented to the singer Jenny Lind by New York firemen in 1850. Made from fashionable rosewood, it mixes Elizabethan and Renaissance motifs to achieve a new level of eclecticism. Ht 1.01m/3ft 4in.*

7 *Real fragments of 16th- and 17th-century woodwork (including an overmantel and oak floorboards) were creatively combined to make this bookcase. It is a fanciful compilation of sculptural and low-relief carving, with spiral turning and intarsia panels. Ht 2.59m/8ft 5in.*

8 *The Elizabethan style was used on several items shown at the Great Exhibition, London, in 1851. It was often used to decorate new types of object such as this piano by Erard. Carved pilasters, strapwork and gadrooning are combined for maximum impact.*

Renaissance Revival Furniture

A Return to the 16th-Century Renaissance

1 *The Renaissance style was applied to established forms such as the sofa. This design of 1847 includes carved three-dimensional fruit, leaves, and grotesque animal heads.*

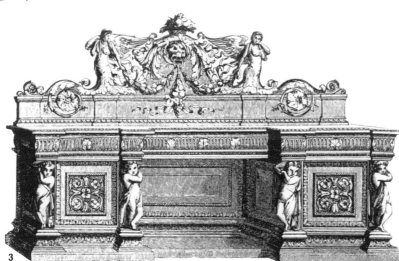

2 *By the time of the Great Exhibition in 1851, American makers were fully adept at the new style. This inlaid rosewood Steinway grand piano of c.1857, possibly by New York makers Herter Brothers or Alexander Roux, shows the importance of carving in achieving the Renaissance effect. L. 2.49m/8ft 1in.*
3 *French makers were quick to adopt a style which they associated with the time of Henri II. This exhibition sideboard of 1851 shows all the key features: figures, strapwork, gadrooning, and elaborate carvings, all held together by a rigidly architectural framework. The sideboard was made from walnut.*

The 1840s saw an increasing interest in the literature, art, and architecture of 16th-century Italy. Newly termed by critics "the Renaissance," it began to provide inspiration for American and European furniture makers. By the time of the Great Exhibition in London in 1851, almost every country had contributed something in this taste. Subsequent international exhibitions promoted it as a universally important style, its motifs popularized by the well-illustrated catalogues of the period.

With its roots in architecture and sculpture, Renaissance Revival furniture was characterized by broken pediments, deeply carved surfaces, applied cartouches, and semi-nude figures. Makers used various materials such as bronze, marble, and ivory, along with walnut, ebony, and mahogany, to achieve lavish results. The royal cradle commissioned by Queen Victoria was a splendid example of this style. Carved from boxwood by W.G. Rogers (1825–73), it resembled an immense chest or *cassone*.

Continental Europe saw the Renaissance Revival style take on national overtones, especially in pre-unification Italy and Germany. Identified with the past glories of the Medici family and the Germanic late Middle Ages, the style was realized in Italian ivory-inlaid ebony furniture and German carved dark wood. In France, the style was known as "Henri II." Pieces were ordered for restoration projects at imperial palaces such as Fontainebleau (1860). Here the furnishings, all on the grandest scale, were supplied by Guillaume Grohé.

In the US, the style was recommended by A.J. Downing in the 1850s. After the Centennial Exposition of 1876 in Philadelphia, the revival took on new strength. As in Europe, its emphasis had changed. Chairs and cabinets were now decorated with rows of small turned balusters. Elaborate ivory inlay or incised and gilded lines appeared on doors and panels. Niches and shelves were used in the design of cabinets and overmantels to house the growing collections of ornaments. This led to the revival later being caricatured by Goodhart Rendal as "the bracket and overmantel style." Versions of the "Free Renaissance" taste continued to be made into the 20th century.

4 *Prince Albert's interest in the Italian taste can be seen in the royal cradle made by W.G. Rogers. Influenced by Renaissance tomb sculpture and wedding chests, it reflects the more serious character of revival furnishings.*
5 *This* armoire à deux corps, *made by J.B. Waring in 1862, has a broken pediment incorporating semi-nude figures and a cartouche in the centre. The lavish, sculpted decoration on the architectural form are typical of the Renaissance style.*

6 *Holland & Sons' combined chimneypiece and bookcase incorporated some niches for ornaments. The shallow carving contrasts with the richness of the relief carving to the pilasters.*
7 *The 1860s and 1870s saw refinements to the Renaissance style. Carving became shallower and more controlled, as seen in the subtle cartouche motifs on this sofa made in New York. L 1.73m/5ft 8in.*

8 *Part of a Renaissance-style bedroom suite, this 1876 bed was made by the Berkey & Gay Furniture Co. in Grand Rapids, Michigan. Ht 2.5m/8ft 2in.*
9 *The Renaissance style was taken up in the 1870s–80s by the Arts and Crafts and Aesthetic Movements. This rosewood cabinet with ivory inlays by Stephen Webb, c.1885–90, is attributed to Collinson & Lock. Ht 1.98m/6ft 6in.*

Rococo Revival Furniture

Old French Style

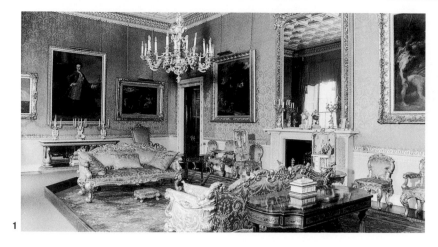

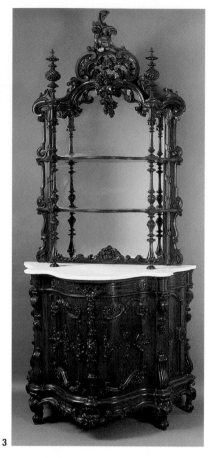

1 *Lewis Wyatt (1777–1853) designed the drawing room at Tatton Park in the 1820s. The chairs and sofas were in the "Louis" revival style, with elaborately curved legs, and C- and S-scrolls with shell motifs and gilding.*

2 *Thomas King's 1840 design in the Old French Style employs scrolling Rococo curves to form the sofa frame. King's designs used gilding to cover a construction of composition and wood to give the showiest effect for the least cost.*

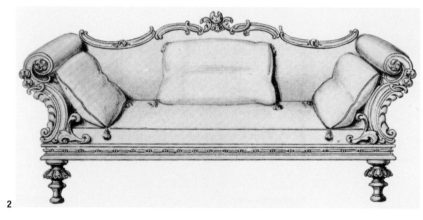

3 *Ornamental cabinets were an important part of the furniture maker's repertoire. This 1850s New York example of carved rosewood incorporates mirror panels and is topped by a fleshy Rococo cartouche.*

Many examples of antique French furniture arrived in England after the French Revolution of 1789. By the 1820s, the style associated with Louis XIV and Louis XV had become popular. The original style, now known as Rococo, was characterized by scrollwork, naturalism, and asymmetry using exotic woods and gilding. Its imitators gave it several names including "Old French" and "Florid Italian." The style was supported by pattern books such as Thomas King's *Modern Style of Cabinet Work Exemplified*, reprinted from the 1840s to the 1870s. As King pointed out, "carving will only be required in the boldest scrolls." The rest of the design was made of composition and covered with paint or gilding for cheap production. However, there were also expensive alternatives such as the lavish recreations of the work of Louis XIV's *ébéniste*, André Charles Boulle (1642–1732), famous for furniture decorated with complex metal marquetry, and high-quality facsimiles of 18th-century French pieces.

By c.1850, furniture shapes were defined by the use of florid C- and S-scrolls. Although not as asymmetrical as 18th-century Rococo, the new "Louis" style embraced gilding, marquetry, painting and naturalism. Another aspect of the style was its comfort. By the 1850s the "Old French" taste had combined with new upholstery techniques to provide furniture that reflected relaxed trends. The Rococo was seen as appropriate for drawing rooms and boudoirs because of its feminine character.

Many critics hated the Rococo, considering it debased, but it remained popular. In the US it was championed by J.H. Belter (1804–63), whose laminated rosewood furniture combined new technology with high-quality carving.

Following the revival in England, interest in Neo-Rococo design grew in France, especially at the start of the Second Empire, when imperial building projects featured furniture and panelling in the scrolling Rococo taste.

The 1860s and 1870s saw a growing interest in the production of accurate copies of 18th-century French furniture, often using the best materials and craftsmanship. By the 1900s, many houses were using a refined and more accurately observed version of the Rococo in furnishings.

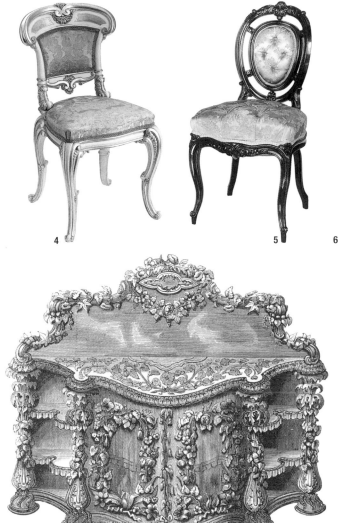

4 *A light "fly" drawing room chair, designed by the architect Philip Hardwick, 1834, and made by W. & C. Wilkinson for Goldsmiths' Hall. The chair is of carved beech with white paint and gilding. Ht 83.5cm/33in.*
5 *The balloon-back chair was one of the successes of the Old French style and could be found in furniture catalogues into the 1900s. This French example, c.1860, is of ebony with an upholstered back and seat. Ht 88cm/34½in.*

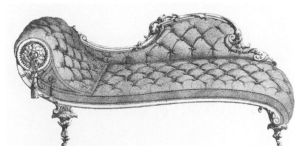

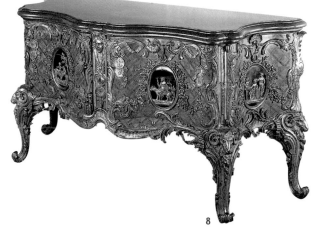

6 *Naturalism and the Rococo style converge in the curvaceous forms of this drawing-room sofa. The introduction of upholstery springs, post-1830, and deep buttoning, allowed furniture to reach new heights of comfort.*

7 *This cabinet by Howard & Son was on display at the Great Exhibition and shows the "Horticultural School" (the disparaging term coined by critic R.N. Wornum in 1851) at its height. A basic Rococo shape is embellished with carved flowers and fruit, while supporting columns sprout inverted acanthus leaves. Mirrors were set into the surfaces to magnify the effect.*
8 *Henri Dasson (1825–96) made this copy of Louis XIV's medal cabinet in 1870. French makers excelled in accurate reproductions of fine antique furniture. This example is of kingwood, tulipwood, and red marble with gilt-bronze mounts. Ht 91cm/36in.*
9 *By the 1890s, a lighter version of the Louis style was used in fashionable drawing rooms. This London interior has gilded Louis-style sofas and chairs alongside painted Rococo screens.*

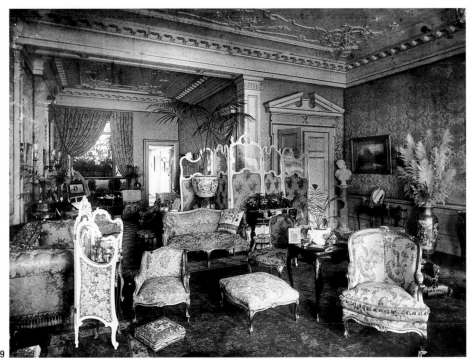

Exhibition Furniture

A Showcase for the Talented

1 *This engraving shows the American section of London's Great Exhibition of 1851. The exhibition provided a showcase for world manufacturers to display their own products and to see the work of other nations.*
2 *Jackson & Graham created this large-scale cabinet for the Paris Exhibition of 1855. Over 40 craftsmen were involved in its manufacture. The ceramic plaques were by Minton's of Stoke-on-Trent, and the cabinet incorporates a newly fashionable plate-glass mirror. Ht 4.3m/14ft.*

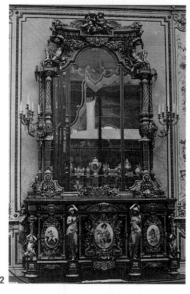

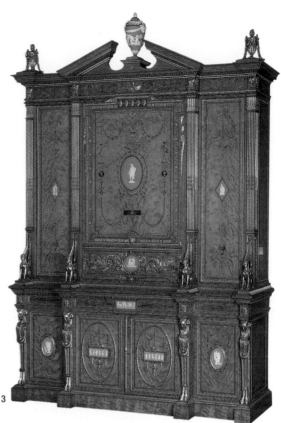

3 *Wright & Mansfield made this cabinet for the Paris Exhibition of 1867. An early example of Adam Revival furniture, the cabinet is made of satinwood with inset panels by Wedgwood and gilded enrichments in carved wood. Ht 3.37m/11ft 1in.*

National exhibitions such as that held in Paris in 1849 were soon to be replaced by grander projects. The Great Exhibition held in London in 1851, like the New York Exhibition of 1853, started a trend for international exhibitions that was to last for over half a century. Popular with the public, the exhibitions gave furniture makers from around the world an opportunity to show off their talents in the fields of design and manufacture. Accompanied by illustrated souvenir publications, they allowed new styles, techniques, and innovations to be seen by the widest possible audience. They were regarded as a shop window to the world.

In response to the exhibitions, makers produced opulent pieces intended to catch the viewer's eye or reinforce the prestige of a company. Exhibition items tended to be on a larger scale than ordinary domestic furniture, and used materials and labour at a level that would not have been cost-effective in normal production.

In every sense extraordinary, exhibition furniture (like couture fashion) offered an opportunity to experiment with new styles and ideas. The London International Exhibition of 1862 gave the world its first glimpse of the work of Morris, Marshall, Faulkner & Co., soon to become the perceived leaders of the Arts and Crafts Movement. The Paris Exhibition of 1867 showed, in the work of London makers Wright & Mansfield, that the 18th-century Neoclassicism of Robert Adam was due for revival.

The exhibitions revealed the progress of manufacture through the variety of new materials and techniques that the 19th century was to discover. They also displayed a certain eccentricity in demonstrating the ways in which furniture could be adapted to solve a number of everyday problems. For example, London's Great Exhibition displayed versatile tables that turned into bedsteads, a padded ottoman (a type of stool) that was also a coal scuttle, and a piano that could be played by four people at the same time. These exhibits, like many of the other design ideas being displayed, reflected the 19th-century passion for novelty and innovation. It was a passion that would ultimately lead to reaction and reform.

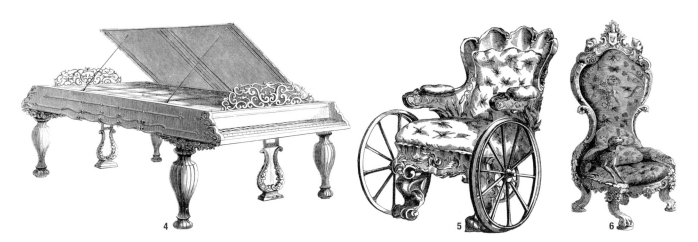

4 Designed by James Pirsson of New York, the Patent Double Grand Piano allowed four people, two at each end, to play at the same time. Inventeness was a significant feature of international exhibition design.

5 Using the form of an upholstered armchair, James Heath's bath chair is lavishly carved and painted in the Rococo taste. The wheels were designed to allow users to propel themselves around a room unaided.

6 This fauteuil, or armchair, was made by A.J. Jones, of Dublin, and displayed in the Great Exhibition of 1851. Intended to illustrate Irish history, ancient warriors adorn the back and the arms are in the form of wolfhounds.

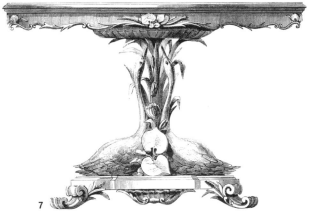

7 Lavish craftsmanship was often a feature of exhibition furniture. This painted and gilded centre table, shown by the royal decorators, George Morant & Sons, at the Great Exhibition of 1851, is supported on a tripod base featuring three swans with a central pillar carved with rushes. Actual table ht 74cm/29in.

8 The main figures of the Crusades are represented on this chess table, which was made by Gradon of Dublin and shown at the Great Exhibition of 1851. The figures, carved in ivory, were supplied by a London craftsman.

9 This state bed was exhibited at the Great Exhibition of 1851 by Faudel & Phillips of London. It includes and elaborate embroidered bedhead and hangings.

10 This light and graceful brass chandelier was designed and exhibited by Cowley & James to create an ethereal feeling in a drawing room.

Techniques and Materials

Carving

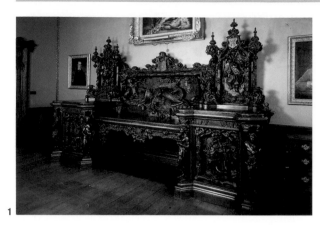

1 *Elaborate carving was a feature of much mid-19th century furniture. This 1853 example by William Cooke of Warwick is decorated with life-size game and trophies of the hunt.*
2 *Wood-carving machines, such as this model of Jordan's patent version, were devised to meet the growing market for carved ornament prompted by the revival styles.*
3 *T.B. Jordan's Patent Carving Machine (see above) was used to create this screen for London's Great Exhibition of 1851. Carving machines were used for repeat patterns and ornament. They roughed out the shapes that would then be finished by hand.*

The 19th century saw innovation in all aspects of the furniture trade. Fresh materials as well as new and revived techniques made it a period of experimentation. Furniture makers worked hard to supply the public's constant demand for design novelty.

Carving underwent a revival in the early 1800s, partly due to the demand for Elizabethan and Gothic furniture. W.G. Rogers of London, Gerrard Robinson of Newcastle, and T.H. Kendal and William Cooke of Warwick were some of the masters of their art. Much of their carving was used to tell stories on the vast sideboards and cabinets that were in vogue the mid-19th century.

The demand for carving led to the development of carving machines. Between 1844 and 1848 no less than five British patents were taken out for this kind of machinery. Harnessing steam power, they were used to rough out the pierced backs of Elizabethan chairs or the outlines of mouldings. Although this reduced the level of skilled labour needed, and thus the cost of the furniture, finishing continued to be done by hand.

The 1830s saw the introduction of new steam-driven machines that could cut veneers more thinly than by hand. Once introduced, they allowed a greater economy in the use of expensive woods. Mounted on softwood, the new veneers gave a luxurious look to even the cheapest furniture. In response, the word "veneering" began to be used as a term synonymous with shoddiness.

A more attractive use of veneer was developed in the 1820s. Called end-grain mosaic or Tunbridge ware (after Tunbridge Wells, Kent, where it was made), objects decorated in this way were especially fashionable from the 1840s to the 1870s. The technique used thousands of minute coloured hardwood sticks, which were assembled in blocks to match an ornamental pattern mapped out on graph paper. The sticks were glued together and thin layers were sawn off to be mounted on work boxes, tea caddies, and other small items to give a colourful, decorative finish.

The American furniture maker John Henry Belter (1804–63) used thin layers of wood, glued together to

Veneers and Papier Mâché

1 *Costly woods could be used more economically when new veneer-cutting machines were used. This 1878 combined work and games table uses walnut and amboyna veneers mounted on a pine carcase. Ht 71cm/28in.*

2 *End-grain mosaic gave a colourful finish to small-scale furnishings such as this Tunbridge ware writing desk. Designs were sometimes taken from contemporary Berlin woolwork patterns. Ht 8.5cm/3¼in.*

3 *Michael Thonet's Great Exhibition entry was a rosewood table using his groundbreaking steam-bending technique. The inlaid table top lifted to reveal a semi-circular storage compartment.*

4 *Papier mâché was an economical means of producing repeat ornament. In the 1840s Charles Bielefeld supplied papier-mâché detail for the canopy of the throne, designed by Pugin, at the House of Lords in London.*

5 *Light furniture, such as whatnots, were ideally suited to papier mâché. This example is painted with views of Gothic ruins and decorated with applied pearl shell tinted with transparent glazes. Ht 1.37m/4ft 6in.*

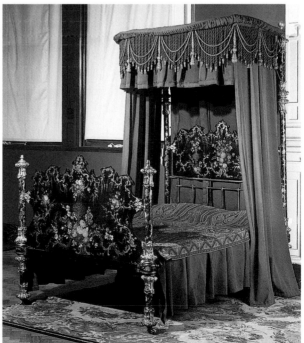

6 *Jennens & Bettridge of Birmingham were one of the largest makers of papier-mâché furniture in England. Their* **Day Dreamer** *chair of 1851 uses painted and lacquered decoration on the moulded paper form.*

7 *Because of its fragile nature, papier mâché was rarely used for large-scale pieces of furniture. This 1850 bedstead uses papier mâché for the foot and headboard. The bed frame is made from painted iron. W. 1.6m/5ft 3in.*

HISTORIC REVIVALS | TECHNIQUES AND MATERIALS

1 *Italian techniques were copied to create this English inlaid marble table top. Produced by Samuel Birley in 1862, the table is decorated with a roundel of Renaissance-inspired ornament encircled by naturalistic flowers.*

2 *Some makers used painted slate to imitate costly marble table tops. Painted in oil and then varnished, this example, c.1845, is decorated with flowers and exotic birds among Rococo foliage.*
Diam. 1.06m/3ft 4in.

3 *This garden seat made by Carron of Stirlingshire in 1846, shows the sophistication of cast-iron design. Gothic and Rococo motifs are combined to form the framework. Cast-iron designs often had long production runs; this model continued to be made into the 1890s. W. 1.63m/5ft 3 ¼in.*

4 *Cast iron was made to imitate a variety of materials. This chair, designed by Charles Green and made by the Masbro Stove Grate Company, copies a wooden prototype, complete with deep-button upholstered seat. It is carefully painted to simulate the real thing.*
Ht 1.27m/4ft 2in.

create a kind of plywood or laminate. Each layer of wood had its grain running in the opposite direction to the one before, giving a material of immense strength. Belter then steamed the wood in moulds, allowing it to take on gracefully curved shapes that were light yet strong. These were then used to create the lavish Rococo Revival furniture that Belter called "Arabasket."

In Austria, Michael Thonet (1796–1871) used a similar steaming technique to bend solid beech or rosewood rods. Bent into fanciful shapes, the rods were combined to make innovative, cheap furniture. Flat-packed for easy transportation, his furniture was sold all over the world.

Materials such as papier mâché found new uses in the 19th century. First developed in the 17th century, it was made either from damp paper layers that were set into moulds and dried in a stove, or from wood pulp which was pressed by machine into moulds. Once dry, the papier mâché panels could be formed into furniture, usually in combination with a wooden or metal frame to give them strength. The surfaces were then painted or could be decorated with pearl shell. Jennens & Bettridge of Birmingham were famous in this field.

More expensive was the inlaid marble furniture that was briefly successful in Britain in the 1840s and 1850s. Centred in the marble- and spar-producing areas of Derbyshire and Devon, the industry produced table tops inset with flowers and stylized patterns emulating Italian *pietre dure*. It was soon imitated more cheaply in painted slate by makers such as E.G. Magnus of London.

Metal furniture was popular throughout the 19th century. Cast iron, often painted to look like stone or wood, was used for hall furniture, garden seats, and beds. Admired for its durability and hygienic qualities, improvements in the technique meant that by the 1850s whole items could be made from a single casting. Iron and brass began to be used for bedsteads in the 1830s and became the norm for the rest of the century. Metal tubing and springs were also features of innovative design, and American and English makers produced strikingly simple rocking chairs in this material in the 1850s.

5 *John Henry Belter and his contemporaries used a mixture of laminated wood and steampressing to achieve sinuous furniture shapes. This love seat, c.1850, has elaborate carved and pierced ornament. W. 2.32m/7ft 6½in.*

6 *The American Chair Company of New York caused a stir at the 1851 Great Exhibition with their progressive* Centripetal Spring Chair. *Cast-iron Rococo ornament and elaborate paintwork conceal a giant spring that allows the chair to recline or tilt.*

7 *Innovative use of metal was a feature of mid-19th century design. This example is by Peter Cooper of Trenton, New Jersey after an English prototype. The simple shape is formed from brass strap painted to simulate tortoiseshell.*

8 *Imitating new fashions in woodcarving, this sideboard is made from gutta-percha, a material derived from wood sap. Gutta-percha was soon abandoned as a new material when it began to disintegrate in use.*

9 *Winfield's of Birmingham made this iron and brass bedstead. The posts use a new metal extrusion system, which allowed ornamental uprights to be drawn out as simply and as inexpensively as plain ones.*

10 *The Viennese firm of A. Kitschelt displayed this Rococo-inspired tubular metal furniture at the Great Exhibition in 1851. They also produced designs in hollow-cast zinc, a material discovered in the 1830s.*

British Ceramics

Foreign Influences and Inspiration from the Past

1 *From 1820 to 1840 the Coalport factory and its contemporaries produced elaborate Rococo Revival pieces based on 18th-century German prototypes. This c.1830 pot-pourri vase displays the factory's skill in flower painting as well as applied floral decorations. Ht 28cm/11in.*

2 *The Rockingham factory made this lidded vase for William IV, c.1830. Gilding, enamelling, and naturalistic ornament were used to create this Rococo-inspired tour-de-force. Ht 98cm/38½in.*

3 *Slip-cast stoneware jugs and teapots were often decorated with fashionable Gothic motifs. Charles Meigh of Hanley made this York Minster jug in 1846. Ht 20cm/8in.*

4 *Pugin designed a range of Gothic-style ceramics for Minton, including tableware and tiles in the encaustic technique. This example is a Minton bread plate, c.1849. Diam. 33cm/13in.*

5 *Popular in the 18th century, red earthenware copies of Etruscan pots underwent a revival in the 1840s and 1850s. At the Great Exhibition of 1851, Thomas Battam recreated an Etruscan tomb to display wares in this style. Ht 36.5cm/14½in.*

Continental European ceramics and historical styles played a major part in shaping British ceramic design. From the 1820s to the 1840s, the Rococo styles of 18th-century German makers such as Meissen inspired the Coalport and Rockingham factories. Heavily modelled with flowers and Rococo scrolls, their pieces were elaborately gilded and enamelled. They set a trend that was soon copied in France.

Gothic design also influenced ceramic production. Stoneware jugs of the 1840s often included details such as arcading or tracery, usually as moulded decoration. The designer A.W.N. Pugin brought historical accuracy to the genre by creating designs for tiles and dinnerware for the Minton factory. Taking inspiration from surviving Medieval decoration, many of the jewel-coloured wares were produced by the encaustic technique. The Worcester factory also produced these wares.

As the century progressed there was an increased interest in the ceramics of the Renaissance period. By the 1850s, Minton was producing *Henri Deux* ware, which copied, in enamel, the inlaid ceramics of Renaissance France. Minton went on to appoint Alfred Stevens (1817–75) to design wares emulating 16th-century tin-glazed earthenware.

Perhaps Minton's most impressive ware was majolica. Developed by the Frenchman Léon Arnoux (1816–1902), this involved colouring relief-modelled decoration with brilliant translucent glazes. Taking the Renaissance ceramics of Bernard Palissy (c.1510–90) as a starting point, the wares soon included contemporary themes such as a giant fountain for the 1862 London International Exhibition. Competing factories such as Wedgwood went on to produce majolica wares into the 1940s.

The 1850s saw a revived interest in 18th-century Sèvres porcelain, with factories such as Coalport imitating its rich colours, original shapes, and enamel decoration.

Historic styles were augmented by new techniques. France introduced *pâte-sur-pâte*, developed at Minton by Marc-Louis Solon (1835–1913); and the Copeland factory produced the white unglazed figures of Parian porcelain.

6 *French Renaissance inlaid pottery was imitated by Minton using heavily outlined painted decoration. Wares were marketed as Henri Deux (now known as Saint-Porchaire). This ewer was shown at the London International Exhibition of 1862. Ht 40cm/15¾in.*

7 *Alfred Stevens (1817–75) was a leading architect and designer who worked in the style of the High Renaissance. He produced various designs for Minton that emulated Italian Renaissance maiolica, including this amphora-shaped vase, made 1864. Ht 42.5cm/16½in.*

8 *The Minton factory termed their rich-glazed wares "majolica." First shown at the Great Exhibition, 1851, the technique was used for many items, like this pair of pedestal-form garden seats, c.1875. Ht 46cm/18in.*
9 *Produced by the Coalport factory c.1850, these vases are based on French Sèvres porcelain. Original Sèvres colours are recreated, together with enamel panels after the 18th-century painter François Boucher.*

10 *French designer Marc-Louis Solon (1835–1913) developed the* pâte-sur-pâte *technique for Minton, seen here in his two-handled vase and cover of 1886. Delicate effects reminiscent of cameos were achieved by painting in translucent layers of slip (liquid clay). The style is suited to classical subjects. Ht 51cm/20in.*
11 *Copeland produced this Parian porcelain figure of Miranda, 1877, one of Shakespeare's characters. Parian is a pure white, unglazed porcelain reminiscent of marble. From the 1840s it was used to make small-scale versions of popular statues. Parian wares reflected an ongoing interest in classical forms and was widely copied. Ht 39cm/15¼in.*

French Ceramics

Revived Styles, New Techniques

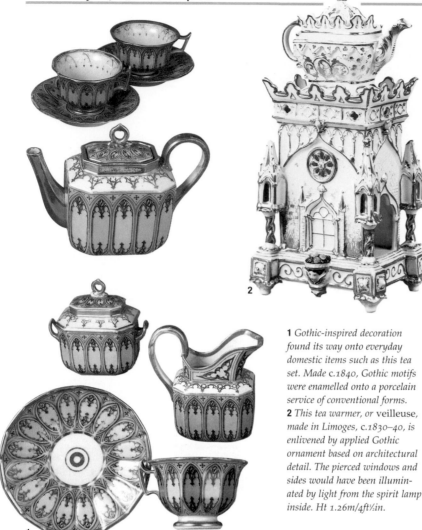

3 *This Sèvres Roman clock of 1845 reflects a growing interest in Renaissance forms combined with Gothic details. Enamelled plaques, historical scenes, and simulated alabaster display the factory's technical skills.*

1 *Gothic-inspired decoration found its way onto everyday domestic items such as this tea set. Made c.1840, Gothic motifs were enamelled onto a porcelain service of conventional forms.*
2 *This tea warmer, or* veilleuse, *made in Limoges, c.1830–40, is enlivened by applied Gothic ornament based on architectural detail. The pierced windows and sides would have been illuminated by light from the spirit lamp inside. Ht 1.26m/4ft⅓in.*

Following the Napoleonic period, French porcelain production was admired for its austere ceramics, which were lavishly enamelled in imitation of fine oil paintings. Themes were taken from Medieval French history or the Renaissance, but the scale was truly Empire.

The 1830s saw a change, as the Rococo Revival taste began to influence ceramic design. Factories such as that of Jacob Petit (1796–1868) went into production, making whimsical ornaments in imitation of 18th-century prototypes. Enamelling, modelled flowers, and gilding were used to create a good-humoured caricature of the style. Petit was soon outclassed by the long-established Sèvres factory, which took on the revived style with a creative seriousness. At the request of the Empress Eugénie, original 18th-century shapes and colours were faithfully recreated, while new designs in the Rococo taste sought to rival or surpass historic originals.

At Sèvres, the mid-19th century was a period of innovation. During the 1850s and 1860s, experimentation at the factory led to the discovery of the *pâte-sur-pâte* technique, later developed at Minton's in Britain. Thin-brushed layers of liquid clay were built up to create diaphanous ornament reminiscent of cameos, and the technique was used to reproduce classical and Renaissance forms. Also fashionable at this time were vases in the Pompeian taste, which reflected the ongoing interest in the classical past and the court taste in decoration.

The Pouyat factory of Limoges produced undecorated wares. Using a refined white porcelain known as *blanc de Pouyat*, their exhibition pieces were sculptural in character and show a 19th-century passion for naturalism that reflects contemporary silver design.

Meticulous revivals of historic styles were an increasing feature of ceramic production from the 1860s. Reworkings of designs by the French Renaissance potter Bernard Palissy were made by, among others, Charles Avisseau and C.J. Landais of Tours, and the Paris factory of Barbizet. Inspired by a heady mixture of historicism and naturalism, these makers produced exotic recreations of his plant- and amphibian-encrusted wares.

5 Pompeian taste was popularized by well-publicized decorative themes such as that for Prince Napoleon's house. Using matt colours on a biscuit porcelain body, Sèvres were able to recreate the style in ceramic form on this Adélaïde vase, designed by Leloy and made 1852.

6 The Sèvres factory developed the pâte-sur-pâte technique in the 1860s. Painted by J. Gély, the vase is a porcelain copy of a 16th-century rock-crystal vessel in the Louvre.

7 These ormolu-mounted vases and covers were made at Sèvres in 1869, using the pâte-sur-pâte technique on a mauve ground.

8 18th-century prototypes were caricatured in porcelain by the Jacob Petit factory, c.1850. This perfume bottle incorporates modelled flowers and pierced porcelain on a base of gilded Rococo scrolls.

4 The Sèvres factory made a number of attempts to imitate 16th-century Limoges enamels. Made in 1841, this vase is decorated with bands of Renaissance ornament taken from historic examples.

9 The Pouyat factory of Limoges produced a pure white ceramic body known as blanc de Pouyat. Designed by the sculptor Paul Comolera in 1855 for the Paris Exhibition, the centrepiece shows the 19th-century interest in nature as ornament. Ht 69cm/27¼in.

10 Interest in Renaissance design led makers to adopt the compositions of the 16th-century Frenchman Bernard Palissy. Executed in earthenware with thick glazes, the high-relief designs on this dish of c.1855 by Landais of Tours combined nationalistic historicism with naturalism. L. 53.5cm/21in.

Other European and American Ceramics

European Wares

1 *Empire styles were still being produced by many companies. The Italian Doccia factory was famous for its enamelled decoration, often copied from Old Master paintings. This example uses a gilded border to frame a miniature reproduction of a Rubens self portrait.*

2 *Made by the Vienna factory in c.1834, this tray shows their continued interest in detailed enamel painting. The border uses etched gilding, inspired by Neoclassicism. L. 29cm/11½in.*

3 *Designed by E.N. Neureuther (1806–82) for the Nymphenburg factory, these porcelain pitchers combine Medieval motifs with naturalistic details such as leaves and figures. They were shown at the Great Exhibition in London in 1851.*

4 *This Rococo porcelain table, made by Meissen in 1853, is decorated with hand-modelled birds and flowers. Revival pieces were popular throughout Europe; Ludwig II of Bavaria had a whole room decorated with Meissen porcelain in the Rococo taste.*

5 *Torelli, a Florentine company, drew on Italian Renaissance designs to create this dish in 1875. The decoration centres on a creative interpretation of 16th-century grotesque motifs.*

American Wares

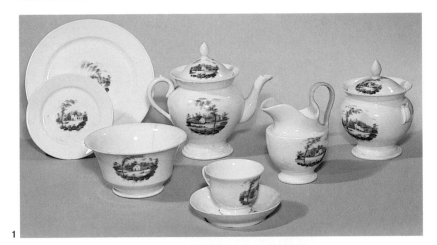

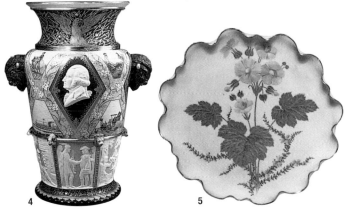

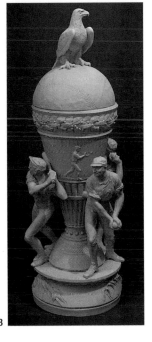

1 *Made as a wedding gift in 1838, this William Ellis Tucker porcelain tea service shows the simplified Neoclassicism favoured by the American market. The white body is enhanced by small-scale classical swags and gilding. Teapot ht 21cm/8¼in.*

2 *Tucker developed hard-paste porcelain production in the US in the 1820s and 1830s. Shapes such as that of this 1828 jug are based on Empire prototypes, often decorated with enamelled flower painting or landscapes.*

3 *Designed by Isaac Broome, the Baseball Vase combines classical motifs such as laurel wreaths, with figures in modern dress. This sophisticated Parian-ware vase was made by Ott & Brewer for the Philadelphia Centennial Exhibition of 1876. Ht 81cm/32in.*

4 *American motifs such as buffalo heads appear on the Union Porcelain Works' Centennial Vase of 1876. Designed by German-born Karl Mueller, the vase also incorporates a relief-moulded frieze showing passages from American history. Ht 56.5cm/24¼in.*

5 *In the 1880s, Ott & Brewer produced glazed Parian wares named after the Irish Belleek factory. This dish is decorated with coloured nature studies. The Parian technique may have been taken to the US by John Harrison, an ex-employee of the English Copeland factory.*

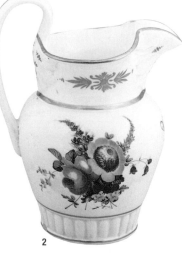

The chaos that followed the Napoleonic Wars left many European factories in a state of disarray. The ensuing years were to see a number of closures, with some companies forced to make industrial goods to survive. Those that did survive clung to old styles and fashions.

Many factories, such as Doccia in Italy, and others in Germany, Austria, and Russia, continued to make Empire-style pieces where rich gilded decoration framed elaborate enamel paintings. By the 1840s, German factories such as Nymphenburg were producing pieces in the Gothic and Renaissance styles imitating 16th- and 17th-century stonewares. However, it was the Rococo Revival that revitalized many companies. At Meissen, original moulds were pillaged for ideas and 18th-century models copied. As well as figures, they produced porcelain furniture such as tables and mirrors, encrusted with fully modelled Rococo flowers and scrolls imitating 16th- and 17th-century stonewares. Other recreations included Renaissance-style dishes in tin-glazed earthenware from the Torelli factory of Florence and lustre wares from Escofet in Spain.

The ceramics industry in the United States was beset by problems. Imported ceramics from Britain were cheap, making competition hard, and the American Civil War interrupted the development of the industry until the 1860s. Throughout this period, imported British ceramics and European craftspeople were influential in shaping design, and historical revivals prevailed. Nevertheless, attempts were made to produce porcelain, notably by William Ellis Tucker, who established a factory in Philadelphia from *c.*1825, while at the lower end of the market, Fentons of Bennington, Vermont, made serviceable earthenwares with rich brown *Rockingham* glazes.

As in Europe, Parian porcelain was fashionable mid-century. From the 1870s, ambitious ceramic wares were being produced by companies such as Ott & Brewer. Established in 1871, they employed professional sculptors to work on prestigious pieces. Together with Smith's Union Porcelain Works, they dazzled the public with objects decorated with American themes at the 1876 Philadelphia Centennial.

British Glass

Cut Glass and New Technology

1 *Gothic forms influenced the cutting of this 1840s decanter made in Stourbridge. Tracery patterns of the 14th century inspired the curving glass cuts, and the diagonal strokes imitate window leading.*
2 *F. & C. Osler created this fountain, a combination of cut and moulded glass, for London's Great Exhibition of 1851. Osler was a leading maker in this field, specializing in large-scale commissions and elaborate light fittings such as gasoliers.*

3, 4 *Richardson's of Stourbridge used elaborate enamelling to decorate these opaline vases, c.1850. Painting techniques were often copied from ceramic styles and occasionally used the same operatives. Plant forms were especially popular at this time. Ht (of both) 30.5cm/12in.*
5 *George Bacchus & Sons of Birmingham made cased glass in the Bohemian taste. This decanter of 1850 uses all-over cutting to give a chequered surface pattern.*

Despite the importance of revival styles, cut glass in the grand manner retained an important hold on 19th-century British taste. Already popular in 1800, the opulence and innovation of cut-glass design led many to see it as Britain's most important contribution to the world glass scene. There were occasional falls from favour – as in the 1860s, when lighter styles were preferred – but cut glass reinvented itself to reach new levels of elaboration in the 1880s. Although described by the critic John Ruskin (1819–1900) as "barbarous," British-designed cut glass was an admired element of the international exhibitions. For example, the centrepiece of London's Great Exhibition of 1851 was a 20-foot high cut-glass fountain by F. & C. Osler of Birmingham.

Designers also adopted techniques such as engraving, enamelling, and transfer printing to create revival designs. Thin engraved or etched ornament was used to apply a classical touch to water jugs and decanters. Enamelling and transfer work turned milky opaline vessels into Grecian urns or Rococo fantasies.

When the tax on glass manufacture was repealed in 1845, the Irish glass industry (which had been exempt from the tax) floundered, and the English manufacturers found a new freedom to experiment. Increasing numbers of companies were making home-produced imitations of Bohemian overlay and flashed glass, whose rich colours and novel techniques became highly popular.

The 1860s saw an increasing search to re-create historic styles in an authentic manner. In later decades, manufacturers such as Webb of Stourbridge made cameo glass in the Roman style, using it on Renaissance and classical designs. At the same time, developments revealed that glass, cut, engraved, and polished, could re-create the beauty of Renaissance and oriental rock crystal.

Industrial glass production saw advances too. In the wake of American developments, Britain was producing pressed glass from the 1830s, at first in the Midlands and later in the north east. Designers imitated cut glass or created new lace-like patterns to conceal the unsightly lines left by the moulds.

6

7

9

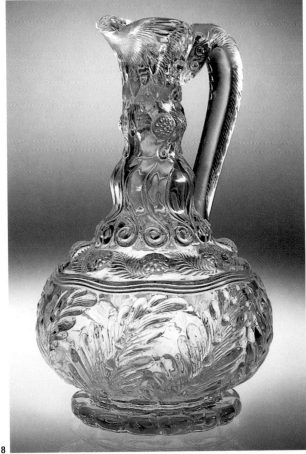

8

6 *Reacting against the taste for cut glass, the designer Henry Cole (1808–82) chose enamelled decoration to complete this water carafe. The ornament is based on reeds and water flowers, an appropriate design that suits the vessel's use.*

7 *The 1880s revival in cut glass led to objects being decorated in the brilliant-cut style. Made by Stevens & Williams of Stourbridge in c.1880, this sweetmeat dish uses a variety of cutting styles to achieve a diamond-like glitter.*

8 *Rock-crystal engraved wares were decorated in a variety of styles, including fashionable Renaissance ornament. The Bohemian immigrant William Fritsche (c.1853–1924) carved this ewer of c.1880 for Thomas Webb & Sons of Stourbridge. Ht 25cm/10in.*

9 *Britain was quick to adopt pressed glass technology. By the 1880s, factories in the north east were producing ornamental and functional pieces in a range of colours and styles, such as this press-moulded butter dish, c.1885, made by George Davidson & Co., in Gateshead. Ht 11cm/4¼in.*

Other European and American Glass

European Innovations

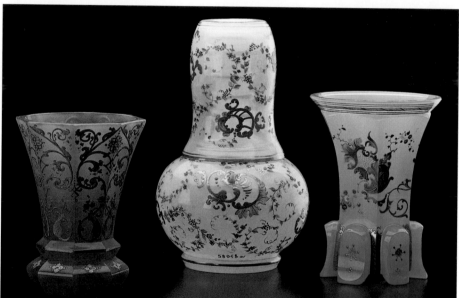

1 *Friedrich Egermann developed a means, known as lithyalin, of mixing opaque glass in different colours to imitate precious stones such as agate. Items such as this c.1830–40 covered jar were decorated with broad facet cuts to show off the grain.*

2 *The German glassmaker Franz Paul Zach produced elaborately engraved pieces in the Bohemian style. This goblet of 1855 is decorated with a classical frieze cut through a layer of blue glass.*

Bohemian glassmakers exerted a major influence in Europe during the first half of the 19th century. Famous for their overlay, or cased glass, with its brilliant colours, detailed wheel-engraving, and enamelling, their Renaissance- and Baroque-inspired wares were widely imitated by French and German glassmakers. Designers such as Franz Paul Zach (1818–81), for example, continued the tradition into the 1850s, adapting it to suit the revived classical taste.

Bohemia was also an important centre for technical innovation, particularly in the field of coloured glass. Friedrich Egermann (1777–1864) invented a rich red colour stain in 1832 and in around 1830 he developed lithyalin, an astonishing opaque glass that imitated the appearance of semi-precious stones.

France soon became an increasingly important centre for new design. At the Baccarat factory new productions such as opaline glass, with its clear, fresh colour palate, was fully exploited and used as a basis for grand classical ornament. More light hearted was the development at

3 *Semi translucent opaline glass was made by many European manufacturers. These Bohemian examples, 1830–40, show the range of colours available.*

4 *Gothic decoration such as trefoils can be seen on this ruby overlay vase and cover, made in Bohemia c.1850, an example of the quality of detail that can be found on Bohemian glassware. Ht 64cm/25in.*

5 *The shape of this milky white opaline glass ewer, made in France, is derived from a classical form, while the naturalistic elements such as the snake entwining around the handle and the shell-like edging around the body are inspired by the Rococo.*

1 *The ground colours of this collection of 19th-century pressed glass include yellow and a reddish pink known in the United States as cranberry.*

2 *The finial of this comport in the* Westward Ho! *pattern, made by James Gillinder & Sons, is a figure of a native American. The theme is continued with deer circumventing the body. Ht 29cm/11½in.*

3 *This decanter by the Dorflinger Glass Co., White Mills, Pennsylvania, has a simple form, with engraved decoration of foliage. Ht 29cm/11½in, diam. (at base) 7.5cm/3in.*

4 *Produced in 1876 by the Dorflinger Glass Co., this heavy cut decanter exemplifies the cut-glass revival of the late-19th century. Deeper cuts exaggerate the decorated surface. Decanter ht 41.5cm/16¼in.*

this factory and at St Louis and Clichy of *millefiori* paperweights. *Millefiori* was an old glass-making technique revived for new uses (see p. 240).

Serious historical revival was to take centre stage in 1860s Italy. Here, the Venice & Murano Glass Company (originally founded by Antonio Salviati *c*.1859 and known as Salviati & Co.) revived 16th- and 17th-century Venetian glass designs. Made with coloured and *latticino* glass, their creative evocations of historic glass found a ready market in a period of historical revivals.

Across the Atlantic, American glass design was influenced by the whole spectrum of European production. Bohemian glass was imported, appreciated, and imitated by manufacturers such as the New England Glass Co. Cut glass in the English taste was universally admired and made, taking on grander proportions in the United States during the 1880s than anywhere else.

In the early part of the 19th century, historical styles were less important in the United States because they could not be satisfactorily produced using the cut-glass technique. However, in the 1820s, advances in the field of pressed-glass manufacture brought a new medium to the

fore. At first this early method of mass production was used to imitate the grand manner of the glass-cutters' art, but it was not long before inventive mould makers applied the whole repertoire of Neo-Gothic and Neo-Rococo ornament to create inventive pressed shapes. These styles were soon accompanied by uniquely American motifs such as the eagle and the flag.

By the 1840s, American advances had influenced world production. Exports were so successful that Bohemian glassmakers became increasingly concerned that they would be eclipsed by this newcomer to the field.

The 1870s saw the development of a decorated glass type that is usually known as Mary Gregory, after a glass decorator who is said to have worked at the Boston & Sandwich Glass Co. Although the history and attribution of the ware is uncertain, the style (which involved the enamelling of Aesthetic Movement figures and landscape details on a coloured glass ground) is unmistakable. The technique was used to imitate more costly cameo glass and was exported across the world. The wares included decorative vases, jugs, and souvenir and commemorative pieces.

Glass Techniques and Materials

Glass-Cutting and Etching Techniques

1 British cut glass was imitated worldwide. This view of the showroom of the Birmingham-based company F. & C. Osler illustrates the range of wares available from the firm, c.1860. The stock included chandeliers and elaborate cut-glass lustres.
2 Baccarat produced this design for a glass armchair, probably for an Indian prince, around 1888. Glass furniture, often inspired by Renaissance Revival shapes, was made from cut- and pressed-glass components.

Glass made in the 19th century was largely defined by method rather than style. For example, techniques such as cut glass could rarely take on the fluid shapes of Neo-Rococo design. Instead, cut-glass designers developed their own repertoire of motifs independent of historical styles. However, for those wishing to re-create revival tastes, surface-decoration techniques such as engraving and enamelling were increasingly available.

In the second half of the century, manufacturers focused on reviving a range of glassmaking practices from the past. These techniques (which included cameo- and rock-crystal-style glass) allowed designers to respond to the need for more accurate re-creations of historic design.

Cut glass was created by marking the vessel, roughing out the decoration on a V-shaped wheel, then refining these coarse cuts on a copper wheel or sandstone. Wheel polishing or immersion in a hydrofluoric acid bath finished the piece. Cut patterns included fans, flutes, blazes, and diamonds. Following the Philadelphia Centennial Exhibition of 1876, cut glass was given new

vitality by the introduction of elaborate pinwheel and geometric patterning. It was also popular in Europe.

Pressing developed as an inexpensive way of imitating cut glass. In American factories, two operatives were involved in making each item. One inserted molten glass into the metal mould. The other then activated a plunger to press the glass into the mould. After the 1860s, steam mechanization was introduced. Press moulding was important to glass industries worldwide; designers used it to experiment with decoration and form.

The 19th century saw the revival of a number of historic glass-making techniques. Opaline glass, a semi-translucent glass first developed in 17th-century Murano, Italy, was achieved by adding calcined bone ash to the glass mix. Baccarat revived opaline in France in the 1820s, and created colour by adding metal oxides. Colours ranged from pastel shades to deep blue or coral. Individual pieces were often gilded or enamelled in imitation of porcelain or antique Greek pottery. Classical forms were used for undecorated wares.

3 *Regency glassmakers established a repertoire of patterns achievable by wheel cutting. Used in a variety of combinations, they were influential throughout the 19th century. This example is a cut-glass water jug, c.1820. Ht 20cm/8in.*

4 *Oriental bowls were a source of inspiration for some of the new rock-crystal wares of the 1870s. Designed by John Northwood, this example of 1884 shows the undulating surface achieved by engraving, then polishing. Ht 12.5cm/5in.*

3

4

5

6

5 *The process of cutting the decoration on a cameo glass vase is shown in this unfinished example, possibly from John Northwood's workshop, c.1875. Dark areas represent patches of the removed upper layer. Acid was sometimes used to accelerate the removal process.*

6 *J.T. Fereday used Renaissance motifs on this cameo glass vase of 1884. Contrasting colours of amber and white were achieved by layering, then cutting the glass. Ht 18.5cm/7¼in.*

7 *Stevens & Williams of Stourbridge used acid etching to create their* Death of Socrates *vase, c.1865. Classical subjects were fashionable in the mid-19th century and glassmakers were inspired by Greek vases. Ht 30cm/12in.*

8 *Machines were used to speed up etched-glass decoration; they were especially useful in creating the looped and scroll patterns seen on this goblet, in vogue in the 1860s.*

9 *The renewed fashion for copper-wheel engraving was introduced by Bohemian craftsmen. Elaborate scenes were copied from Old Master paintings; on this vase and cover made by August Bohm in 1840, the scene is based on the Lebrun painting of Alexander defeating the Persians, which is in the Louvre.*

7

8

9

239

Decorative Materials and Techniques

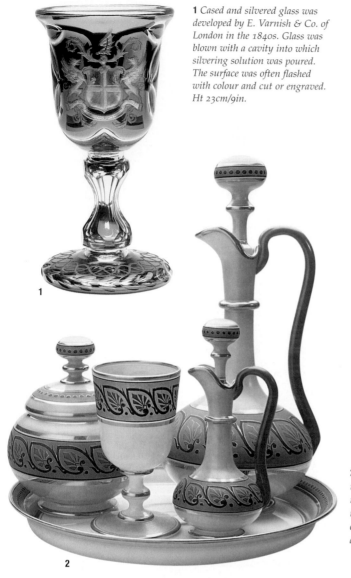

1 *Cased and silvered glass was developed by E. Varnish & Co. of London in the 1840s. Glass was blown with a cavity into which silvering solution was poured. The surface was often flashed with colour and cut or engraved. Ht 23cm/9in.*

2 *Baccarat used opaline glass in pastel shades. Admired for its porcelain-like finish, wares of the 1860s, such as this set, were often decorated with Greek motifs and had classical forms.*

3, 4 *Bohemian-inspired glassware used a variety of techniques including flashing, staining, engraving, and enamelling. Brilliant colours and elaborate detail made them popular from the 1840s to the 1860s.*

Acid etching was used when glass was too thin to be engraved on a wheel. The technique involved covering the glass to be decorated in wax, an acid-resistant substance. The pattern was then cut into the wax surface and the vessel dipped into acid, which bit into the unprotected areas. By the 1850s, English makers began to patent stencils that could be used to paint the resist patterns. In the 1870s, John Northwood invented a machine that applied templates for making geometric patterns.

Millefiori (a thousand flowers) involved embedding slices of coloured cane in clear glass. Practised in 16th-century Venice and in the 1840s by French factories such as Baccarat, *millefiori* was applied to paperweights and, at Stourbridge, to glasses, perfume bottles, and jugs.

Interest in Venetian wares led to the re-introduction of crackle glass (known in the US as overshot glass). This involved plunging the hot blown glass into a bath of cold water. The crazed glass, when reheated, retained a finish like cracked ice. Exhibited by the London firm Apsley Pellatt in the 1850s, it was called Anglo-Venetian glass.

Bohemian glass was imitated across Europe and the United States. One type, known as flashed glass, was achieved by dipping a clear glass vessel into molten glass of a different colour. This outer layer was then cut to reveal the contrasting layer beneath.

The 1870s saw the revival of cameo glass. Used by the ancient Romans, the technique was familiar to Victorians through the discovery of the Portland Vase in Rome in the 16th century. The approach used cup-casting, in which an outer case of coloured glass is blown and placed in a mould, before a new contrasting layer of coloured glass is blown inside. The two layers are then heated until they fuse. Thicker than flashed glass, the outer glass skin was carved with relief decoration, exposing the lower layer.

Engraving and polishing were combined to simulate the Medieval and oriental techniques of rock-crystal carving. Developed in the 1870s, its water-like finish was used for marine subjects as well as for direct imitations of classical, Renaissance, and Japanese art. Press-moulded shapes were later used to speed up the process.

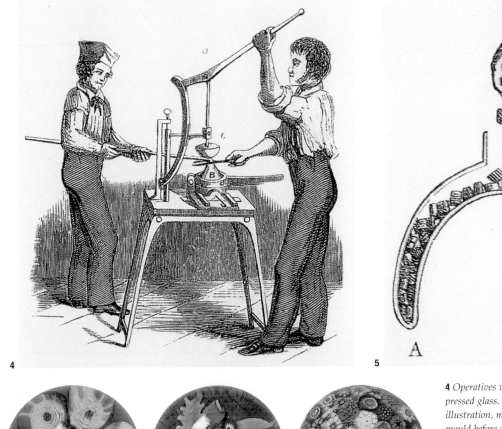

4 *Operatives worked in pairs to make pressed glass. In this contemporary illustration, molten glass is lowered into a mould before a plunger presses it into shape.*
5 *The metal-shaping device shown here was used to set small sections of coloured glass cane into clear glass. Sections of coloured glass were arranged in a pattern, then stretched to form canes, which were used to produce* millefiori *paperweights.*

6 *Cane glass was used to provide complex* millefiori *decoration for paperweights and other objects from the 1840s. These examples reflect the 19th-century interest in novelty and pattern. Diam. 9cm/3½in.*
7 *Sharp mould lines often disfigured pressed wares. Mould makers worked hard to design over-all decoration to conceal any imperfections. This jug and goblet are examples of their art. Goblet ht 14.5cm/5¼in.*
8 *The French company Baccarat combined press moulding with etching to produce high-quality objects for the wealthy, such as this ice bucket of 1876, which is decorated with Roman scenes.*

Silver and Metalwork

Inspiration from the Older Styles

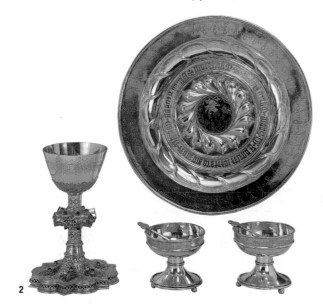

1 *Copied from an English stoneware jug, this New York-made pitcher of c.1845 is by Zalmon Bostwick (working 1845–52). As in the ceramic original, the sides of the vessel are decorated with ornament based on Gothic architecture. Ht 27.5cm/10¾in.*

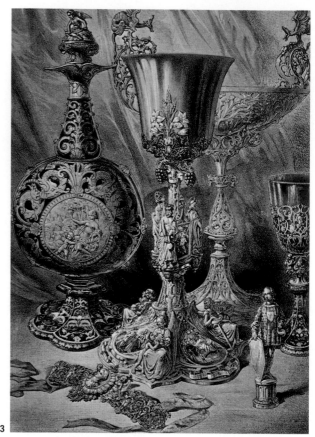

2 *John Hardman of Birmingham made many of Pugin's metalwork designs in the 1840s. Here, embossed and engraved decoration is set off by enamelling, gilding, and semi-precious stones. Chalice ht 26cm/10¼in.*
3 *The French firm of Froment-Meurice produced these Renaissance-inspired wares for the Great Exhibition. The cup is in gold and silver and incorporates religious scenes in enamel.*

European silversmiths were quick to respond to the many shifts in taste that characterized the 19th century. Within the first half of the century, Rococo-, Gothic-, classical-, and Renaissance-inspired pieces were available to a broadening market. International exhibitions showcased prestigious centrepieces as taste moved towards ever more accurate recreations of historic styles.

Promoted by the court of the Prince Regent, Rococo style was an important part of the English silversmiths' repertoire by the 1820s. Fuelled by books such as *Knight's Vases and Ornaments* (c.1833), makers produced a variety of Rococo-inspired items. Some were direct copies from engravings of 18th-century designers such as Juste-Aurèle Meissonnier. The end results were naturalistic, metamorphosing plant or shell forms into tableware, or fanciful, covering everyday items with a mass of C- and S-scrolls. In the US, the taste was absorbed from pattern books and trade catalogues. Critics disliked the style because they felt that even an untrained artisan could produce something from the wide repertoire of motifs.

Neo-Gothic had its roots in early 19th-century taste. By the 1840s, exponents fell into two schools: those who took architectural details and incorporated them into everyday forms, and those with an archeological approach. A.W.N. Pugin was in the latter category. Working with John Hardman, the Birmingham metalworker, he designed items that followed Medieval precepts.

By 1850, the Renaissance style was the international favourite. Continental designers such as J.B.J. Klagmann (1810–67) and craftsmen including Antoine Vechte (1799–1868) were leading exponents. There was increased interest in embossed decoration and in niello work, an inlay technique perfected in the Renaissance period.

New technologies affected silversmithing. Steam-powered machinery could now turn out vessels ready formed, and mass production was on the horizon. During the 1830s and 1840s, Elkington's in Birmingham patented electroplating, using low-voltage current to silver-plate objects of a lower value metal. It superseded Sheffield plate as a way of making silvered wares economically.

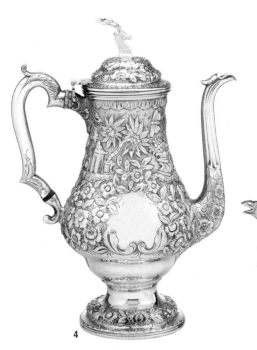

4

5

6

4 *Made by Samuel Kirk, this coffee pot, c.1840, combines Neo-Rococo and naturalistic ornament to opulent effect. American makers were quick to respond to the European taste for the "Old French" style. Ht 33.5cm/13¼in.*

5 *Edward Farrell produced this Rococo Revival teapot in 1833. Shell feet and the scrolling handle and spout are taken from 18th-century prototypes. The engraved decorations are copied from 17th-century Dutch genre scenes.*

6 *Motifs taken from Greek vase painting were used to decorate classically inspired silver vessels. This example by W. Sissons, 1871, uses engraving to realize the design.*

7

8

9

7 *Elkington & Co commissioned the* Milton Shield *in 1866. Made from gold, iron, and embossed silver, the original was easily copied by electroforming, a variant of the electroplating process developed by Elkington. W. 67.5cm/26⅝in.*

8 *Antoine Vechte made the* Jupiter *or* Titan *vase in 1847. Using hand embossing, Vechte was able to create relief decoration of amazing depth. His designs reflect a growing interest in Renaissance craftsmanship. Ht 75.5cm/29½in.*

9 *Johann Karl Bossard (b.1846) exhibited a range of wares that imitated 16th-century designs. This ewer of c.1880 uses engraved rock crystal and enamelled silver faithfully to recreate Renaissance style. Ht 23cm/9in.*

Textiles

Carpet Trends

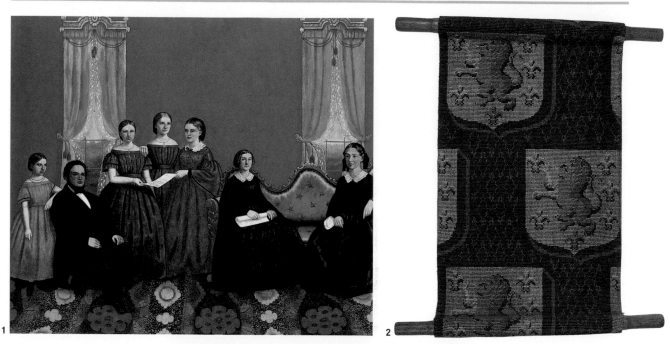

1 *American portraits of the 1840s and 1850s often make a feature of the family carpet. The Smith family group, painted by Erastus Field c.1860, is standing on a medallion-pattern carpet designed to fit the room.*
2 *The library of Carlton Towers, Yorkshire, ancestral home of the Beaumont family, was refurbished in 1844. The new Brussels carpet was specially woven for the room with a repeat pattern of heraldic shields.*

3 *Carpet designs were often carried out initially in watercolour on squared paper. Whitwell & Co. of Kendal made this example in 1844. Rococo designs were a staple part of the carpet maker's repertoire.*
4 *This watercolour of the Royal dressing room at Osborne House in 1851 shows the effects achievable with Rococo-inspired carpets. Carpets were specially woven to match decorative themes in grand houses.*

Fitted or "planned" carpets were an essential part of the 19th-century interior, until they were supplanted by a revived interest in oriental rugs in the 1870s and 1880s. The desire for integrated decorative themes led designers to produce carpet patterns reflecting the eclectic tastes of the time. Gothic, classical, and, increasingly, Rococo themes were realized in carpets throughout the century.

By 1850, customers had endless patterns and styles to choose from. Gothic motifs were particularly popular in the 1830s and 1840s, using architectural detailing as a source of inspiration. Elizabethan Revival tastes led to the production of carpets that took up heraldic or other suitable symbols. Scrolling Neo-Rococo patterns were in favour at all levels of society.

New technology brought carpets to a wider audience. In 1851, at the Great Exhibition, Erastus Bigelow (1814–79) exhibited his new power loom, capable of weaving a Brussels carpet. With patent rights soon sold to European makers, the yardage of revival-inspired carpets began to flow uncontrollably, responding to ever shifting tastes.

The Increasing Popularity of Needlework

1 *Needlework borders were often used to enliven plain cloth carpets. This English example of c.1840 uses thick wool in cross stitch on a coarse double-thread canvas ground to depict a trail of full-blown roses.*
2 *Raised woolwork, or plush stitch, was used to create a three-dimensional effect, as in this example, c.1850, which also includes beads. Looped pile was trimmed with scissors to create the curve of rose petals and foliage.*

5 *This Berlin woolwork panel of c.1850 may have been in the Great Exhibition of 1851. The naturalistic ornament is in the Neo-Rococo taste.*

3 *Framed by a Puginesque firescreen, this needlework panel depicts Walter Scott in an Elizabethan interior at Abbotsford. Old English and Gothic subjects were fashionable themes in 1830s and 1840s needlework.*

4 *Woolwork patterns were first produced in Berlin by Philipson, a print seller, c.1804. Coloured by hand, these charts were expensive to produce but, by the 1830s, were available in Europe, Britain, and the US.*

The rise of Berlin woolwork in the 1830s and 1840s introduced to Europe and the United States a needlework style that was soon practised everywhere and lasted well into the 1880s. The technique used a simple tent stitch in wools (at first supplied from Berlin), worked on a canvas ground. It was simple to do, quick to progress, and, augmented by printed design cards, allowed almost anyone to produce an elaborate piece of embroidery.

Woolwork was used to decorate a range of objects including chair upholstery, firescreens, and even settees. By the 1850s, glass or steel beads were incorporated into designs. Also in the 1850s came the introduction of new chemical dyes in brilliant colours such as magenta and mauve. These were preferred to the less lurid vegetable-dyed wools. Designs could be ambitious, duplicating in wool such celebrated paintings as Edwin Landseer's *Monarch of the Glen*, or portraits of famous people such as George Washington. Echoing the Gothic and Elizabethan revivals, many designs illustrated moody ruins or scenes after Walter Scott's novels.

Upholstery

Furniture, Drapery, and Patterns

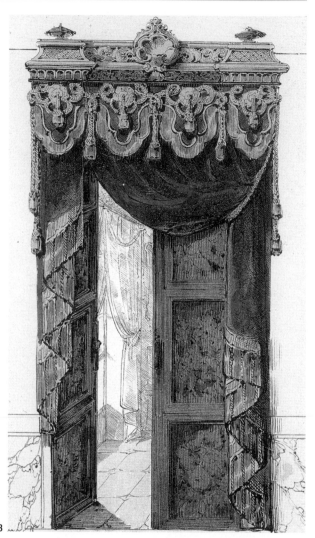

1 *Revival styles in furniture were matched by a demand for appropriate fabric designs. These Louis Revival armchairs of 1855, exhibited by the French upholsterer Langlois, are covered in Rococo-inspired cut velvet and silk damask.*

2 *Gothic motifs were used on numerous early 19th-century chintz designs. This 1840 example uses architectural patterns framed by heraldic ornament.*

3 *French curtain designs were universally admired. This 1839 design for a portière, or door curtain, was described as Louis Quinze in style. It uses elaborate fringed and applied trimmings to achieve a sumptuous effect.*

The importance of the 18th-century decorative theme allowed the upholsterer to continue to exert a major influence on interior decoration into the 1860s. During the 1830s and 1840s, advances in upholstery technique led to the widespread use of springing for seat furniture. Superlatively comfortable, such couches and chairs exuded a rounded, overstuffed appearance. One particular type of low armchair was known as a *crapaud* (toad) from its bulging look.

Upholstery fabrics included Italian cut velvets, woven silks, and hand embroidery. Precious fabrics were usually protected with durable case covers of glazed cotton or, after the 1860s, *cretonne* (a heavy unglazed cotton). Curtains went through a period of elaboration with lambrequins (an ornamental pelmet) used to finish off window arrangements. Trimmed with rich fringes and braids, French curtain concepts were admired in Britain and the United States. Published curtain designs were widely circulated, providing a useful source of information. In meeting the upholsterer's needs, textile designers were aided by improvements in textile-making machinery. Pattern looms, invented by Lyons-born Joseph-Marie Jacquard in 1802, were used in the industry by the 1830s. Roller printing, often augmented by hand colouring (or "painting"), had been available in Britain since 1815.

Designs ranged from a continuation of 18th-century fabric patterns (especially in the silk-weaving centre of Lyons) to new responses to revival tastes. Gothic, Neo-Rococo, and Renaissance motifs were all realized in printed chintz, *cretonne*, or in the woven silks and cut velvets of the period.

Gothic taste was refined by the productions of A.W.N. Pugin, who used examples of Renaissance and Medieval fabrics and wall paintings as inspiration for his woven and printed textile designs.

The 19th century was dominated by a passion for realistic floral ornament. Often criticized by design theorists, flower prints from the 1840s to the 1880s showed great virtuosity and invention in transforming natural forms into two-dimensional design.

4 *Woven in wool damask c.1847, this design is by Pugin. The pattern was inspired by Medieval needlework and the fabric was intended for use as curtains.*
5 *Pugin produced several designs for woven silk. This brocatelle was made in London's Spitalfields for the decorator J.G. Crace and shows the influence of Italian Renaissance silk patterns.*

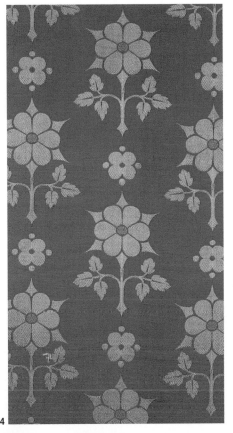

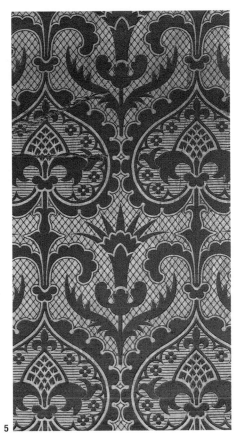

6 *Produced by Matheun et Bouvard in Lyons in 1868, this Renaissance-style cut velvet fabric was inspired by 16th-century printed ornament.*
7 *By the 1880s, French designers had reached the peak of naturalistic flower-inspired design. Produced in Alsace, this fabric design is decorated with sprinklings of garden flowers.*
8 *Floral decoration was a feature of printed fabrics from the 18th century, but took on an increased importance from the 1830s as designs became ever more naturalistic. This example was produced in England in 1851.*

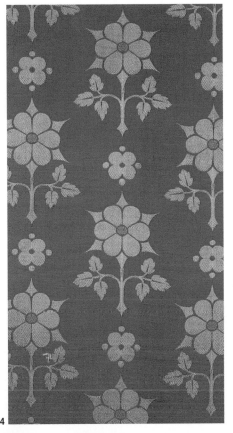

Wallpaper

Naturalistic Scenes and Gothic Decoration

1 *Scenic wallpapers were an important part of the French wallpaper scene. They were exported to the US, where they were used in halls, passages, and drawing rooms. Produced in 1861 by Desfossé et Karth, the* Décor Eden *was printed by hand using 3,642 wooden blocks. By 1870, such decoration had fallen from favour.*

2 *The designer A.W.N. Pugin hated superficial Gothic ornament and its use of architectural forms. However, such patterns as this Gothic example, c.1840–50, remained popular throughout the 1840s.*

3 *Pugin produced this* Fleur-de-lis *design for the Houses of Parliament in 1847. The stylized plant forms and textile-like design are in marked contrast to more popular approaches to the style (see 2).*

4 *In c.1870, the designer Owen Jones produced his own Gothic-inspired paper. Here, stylized plant and leaf forms sit in a formal diaper pattern.*

Those wanting to buy wallpaper in the 19th century had a bewildering range of patterns to choose from. Hand-blocked imports from France and machine-made papers from England all took up the fashionable styles of the day or illustrated the grand manner through their lavish scenic papers.

Developed in the early 1800s, scenic wallpapers were intended as complete room decorations. Known as *paysages décors*, they were block printed and required thousands of individual blocks to complete a pattern. Papers of the 1830s showed an interest in natural over mythological subjects. By the 1860s, affluent buyers could recreate the Garden of Eden in their hall or drawing room.

European makers avidly produced historical revival styles. Gothic decoration took the form of what Pugin described as the "wretched character of a pointed building," that is, Gothic architectural detail. French versions of the taste varied the repertoire by offering scenic views of romantic ruins. Pugin was quick to supply improved versions of the Gothic taste, as was the

designer Owen Jones (1809–74). Based on stylized plant forms, diaper patterns, or Medieval textiles, these papers marked shifts in taste from the 1840s to the 1870s.

The Rococo style was easily adapted to wallpaper design, uniting C- and S-scrolls with brilliantly coloured flowers or fruit. Some designers turned to the paintings of Antoine Watteau (1684–1721) to enliven the scrollwork with figures in fanciful 18th-century costume. Renaissance ornament was adapted to the same formula, with strapwork encapsulating printed landscape views or naturalistic bowls of flowers.

Throughout the period, French designers produced a dizzying range of naturalistic papers that imitated swags of lace, buttoned upholstery, or giant bouquets of flowers. Satisfying the public demand for novelty, papers were soon recording moments in history. Buyers in the 1850s and 1860s could purchase wallpapers depicting the opening of the Crystal Palace or the launch of a roller-skating rink. Designs proliferated as inexpensive wallpapers fed a hungry market.

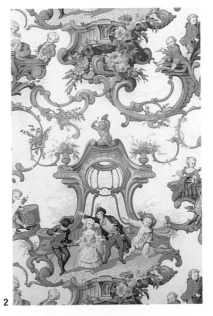

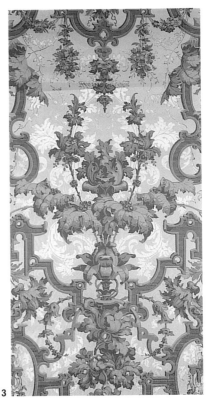

1 *Naturalistic representations of flowers were a regular feature of wallpaper design after the 1830s. This Louis-style floral stripe English example dates from 1860. The artist and design reformer Richard Redgrave (1804–88) characterized such papers as "florid and gaudy."*

2 *Attributed to the French designer Hippolyte Henri, this Louis-style paper of 1840–45 depicts children in fancy dress.*

3 *Renaissance strapwork is used as a decorative framework on this elaborate paper designed by Zipelius and made by Zuber in 1843. The decoration was enhanced by silver dust.*

4 *The 1860s saw a vogue in France for black-ground papers and furnishing fabrics. This example sets naturalistic roses against a backdrop of lines and grids.*

5 *This Lyons striped wallpaper border was produced in England by William Woollams, 1837–52. It follows the French fashion for papers that gave a trompe-l'oeil rendition of fabrics such as lace or silk.*

6 *Manufactured by Heywood, Higginbottom, & Smith around 1853, this wallpaper depicts views of the Crystal Palace. Papers in the 1850s and 1860s increasingly recorded local or national events.*

HISTORIC REVIVALS | **WALLPAPER**

The Aesthetic Movement
1870–90

A British and American phenomenon of the 1870s and 1880s, the Aesthetic Movement was a cult of beauty which sought to elevate the status of all objects to works of art. Designers re-interpreted and combined sources, including historical periods and cultures, and exploited industrial processes, both new and established, to create an entirely new style. The Movement began in Britain, where in the 1850s and 1860s the designers Owen Jones (1809–74) and Christopher Dresser (1834–1904) codified the theories which were to lie behind much Aesthetic design.

Central to their philosophy was the idea that nature, together with the best designs of different eras and cultures (increasingly accessible through public collections and exhibitions, and studied in design schools), should serve as models to be appropriated and adapted by the modern designer for contemporary use. Jones's *The Grammar of Ornament* (1856) illustrated various design sources, including Greek, Egyptian, Islamic, and Chinese; and Dresser, a botanist fascinated by plant structure, developed a form of conventionalized plant-based ornament expressive of dynamic growth. Both believed that design should be appropriate to function, expressed dramatically in Dresser's starkly geometric electroplated silver tableware; and also in fitness of purpose – for example, that the decoration of flat surfaces, such as textiles and wallpapers, should reject the illusion of depth in favour of two-dimensional patterning.

Japanese design profoundly influenced Aesthetic Movement designers (Dresser himself visited Japan in 1876–7). Japan had only recently opened up to the West, and Japanese artifacts, including blue-and-white ceramics, *cloisonnés*, ivories, bronzes, lacquers, and textiles, were shown at international exhibitions in London (1862), Paris (1867), and Philadelphia (1876), and were available from retailers such as Liberty & Co. in London (est. 1875). Manufacturers and craftsmen were drawn to the high quality of workmanship, and designers to Japanese geometry and abstraction, novel to Western eyes. Western design tradition was challenged by devices such as the apparently arbitrary cropping of shapes and asymmetry, with the result that, as Clarence Cook declared in his book *What Shall We Do With Our Walls?* (New York, 1880), even "the classic laws of symmetry and unity are no longer to be considered the absolute rulers of the field of decorative art." Japanese and Chinese forms were Westernized, as seen in the Japanese architectural elements adapted by E.W. Godwin (1833–86) to create his Anglo-Japanese furniture. Oriental shapes were adapted for use in ceramics, as were straight-sided vessels or shapes

Left: the shape of this faience vase, c.1873, by the Paris ceramicist Joseph-Théodore Deck, is derived from a Chinese bronze model, while the applied naturalistic foliage forming the handles and surface decoration betrays Japanese influences. Ht 48.5cm/19in.

Opposite: My Lady's Chamber by the British artist Walter Crane appeared as the frontispiece to the American Clarence Cook's popular house-decorating manual, The House Beautiful (1878). The inclusion of so many Aesthetic themes in the wood engraving – the lady's Aesthetic dress, blue-and-white oriental porcelain and Japanese fans on the mantelpiece, lightweight ebonized furniture, the flat patterning of the papered walls, glazed cabinets (just seen) showing off ceramics, and the revivalist 18th-century tea service on the table – make this a virtual icon of the Aesthetic Movement.

1 In the Morning – Three Young Ladies in an Aesthetic Interior, *1877, a watercolour by Gustavus Arthur Bouvier. Like Walter Crane's illustration (p.251), this is an image full of Aesthetic motifs: blue-and-white porcelain, a Japanese folding screen, and embroidered peacocks on the table cover.*

2 *This geometric electroplated silver and ebony tea pot by Christopher Dresser was made by James Dixon & Sons, c.1879. Ht 17cm/6¾in.*
3 *Bruce Talbert's fine ebonized, carved, gilt, and burr wood cabinet for Marsh & Jones of Leeds, late 1860s, incorporates embossed Japanese paper and lacquer panels. Ht 2.30m/7ft 6in.*

derived from Chinese metalwork. Conversely, Western forms were orientalized, usually by the addition of Japanese motifs. Silver and plated wares were particularly strongly influenced by oriental motifs, led by Tiffany & Co. in New York. The influence of Japan was felt in Europe, particularly France, where *Japonisme* flourished in ceramics, glass, and metalwork. The *horror vacui* (fear of emptiness) characterizing most later 19th-century design was occasionally tempered by blank areas of space opposite an asymmetrically arranged motif, although taste often favoured objects embellished with a profusion of designs associated with the Orient. These included animals (frogs, bats), birds (cranes, storks), insects (butterflies, dragonflies), plants (bamboo, pine branches, cherry blossom, chrysan-themums), objects (fans and circular family crests known as *mons*), and wave patterns. Other motifs were lilies, bulrushes, artists' palettes, easels, peacocks and peacock feathers, and sunflowers, which came to epitomize the movement.

The Aesthetic Movement reached a wide audience at the international exhibitions held between 1871 and 1878 in London, Vienna, Philadelphia, and Paris, and at the showrooms of furnishers such as Morris & Co. in London and Cottier & Co. in New York. The movement was popularized by a series of house-decorating manuals aimed at the public, such as *Hints on Household Taste* (London 1868; Boston 1872) by the British writer Charles Locke Eastlake (1836–1906), which encouraged consumers to discriminate when furnishing an artistic interior while taking into account their individual means. Eastlake helped to popularize the reforming design principles of A.W.N. Pugin, Street, Shaw, and Seddon (see p.254) by advocating truth to materials and honest construction. Bruce Talbert (1838–81), in his *Gothic Forms Applied to Furniture* (Birmingham 1867; Boston 1873), provided the furniture trade with designs inspired by 17th-century Jacobean furniture, utilizing straight wood and revealed construction, and emphasizing surface decoration of inlays, low-relief, or incised carving which were taken up by the trade in both Britain and the United States. This Art or, as it became known in the US, Eastlake furniture, was often ebonized and included cabinets with a profusion of shelves to display Art objects. In the 1870s, Gothic and Jacobean designs were gradually supplanted by the English Queen Anne style and its American

equivalent, known as the Colonial Revival, which predominantly drew inspiration from English 18th-century prototypes.

An unprecedented urban expansion, together with an increase in mechanized manufacture at all levels, created a strong demand as well as capacity for Art objects of all types. Even manufacturers not traditionally associated with advanced design employed freelance designers, or opened Art departments for the production of artistic furniture, ceramics, and metalwork, to mention a few. New or revived manufacturing techniques encompassed every sphere of production, and included an interest in artistic glazes in ceramic manufacture and the emulation of the oriental technique of *cloisonné* by metal manufacturers. New materials came into vogue: cast iron and rattan were increasingly used for furniture, and media such as stained glass and ceramic tiles were incorporated into domestic settings on a scale never seen before or since.

In his influential manual *The House Beautiful* (1878), the American Clarence Cook (1828–1900) stressed the importance of selecting from different periods and harmoniously combining disparate elements to create a coherent, beautiful whole. The remarkable stylistic unity which resulted was partly because many of the key designers produced work for the whole gamut of decorative arts such as Walter Crane (1845–1915), who designed furniture, ceramics, glass, metalwork, textiles, wallpapers, and book illustrations. Ceramic and metalwork design showed a typically eclectic approach and often blended different themes, so that a vase with a Persian shape may have had decoration of Japanese,

Renaissance, or Egyptian origin – or all three. Unity was nevertheless also achieved because the appreciation of the sensory qualities of materials encouraged a new freedom in the mixing of media, resulting in painted panels, stamped leatherwork, ceramic tiles, and *cloisonné* panels being incorporated into furniture and clock cases, for example. Textiles and wallpapers benefited from the emphasis on flat patterning and the use of a variety of sources. They were produced in subtle secondary or tertiary colours, particularly green and gold, which aimed at a subdued and rich effect. The flat, flowing, and curvilinear naturalism of some wallpaper and textile designs were precursors to the French Art Nouveau, while a reaction against the rich density of Aesthetic interiors contributed to the reactionary simplicity and minimalism of much early Modernist design.

During the Aesthetic movement the laws of the market economy affected the production and promulgation of designs. Firms such as Morris & Co. built up archives of stained-glass cartoons which could be adapted to new commissions. Paintings by artists with Aesthetic leanings such as Albert Moore (1841–93) were copied from engravings and appeared on ceramics, stained glass, and other media in Britain and America, often without acknowledgment or permission. In an attempt to prevent copying of the designs for which they had paid, manufacturers often registered their designs at the Patent Office, indicated by a diamond-shaped registration mark on their goods. The cult of the industrial designer was bolstered by Christopher Dresser, whose name or facsimile signature appeared on a number of the pieces of metalwork and ceramics he designed.

4 *French and Japanese forms combine in this luxurious cabinet made by Herter Brothers in New York, c.1875. Constructed of ebonized and gilt cherry it incorporates marquetry of various woods and decorative paper. Ht 1.52m/5ft.*

5 *As its name suggests, this Nagasaki woven silk damask designed by Bruce Talbert for Warner, Sillett & Ramm of Braintree, Essex, c.1874, owes to Japanese design the seemingly random overlapping of leaves and flowers.*

Reformed Gothic Furniture

Muscular Gothic Forms

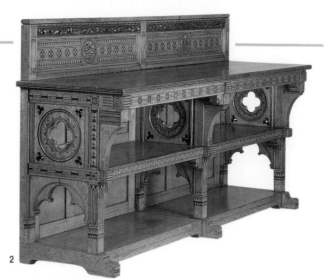

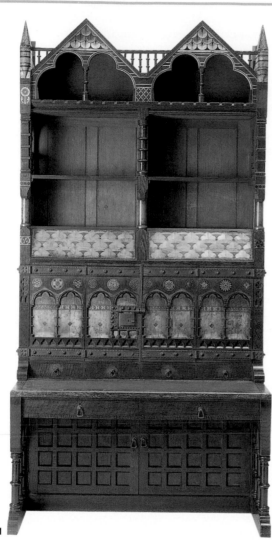

1 *Painted and inlaid oak bookcase designed by Richard Norman Shaw and made by James Forsyth in 1861. It was shown at the London International Exhibition in 1862. Ht 2.80m/9ft 2½in.*
2 *Buffet based on a design in Bruce J. Talbert's* Gothic Forms *(1867), described as a "side table." Made of oak inlaid with ebony, walnut, boxwood and other woods by Holland & Sons in London. Ht 2.14m/7ft.*
3 *An early example of Reformed Gothic furniture, this oak side chair with bold geometric inlaid back was designed by the architect William White for the rectory at St Columb Major, Cornwall, c.1850. Ht 91.4cm/36in.*

A rt Furniture of the 1870s developed from the Reformed Gothic of the 1850s and 1860s, a style advanced by a number of innovative architect-designers in England who "Reformed" or re-interpreted the Gothic style. The seeds were sown in the 1840s by A.W.N. Pugin (1812–52), whose simplest furniture designs show an understanding of the underlying principles of Gothic form and construction, ideas which were encouraged in the publications of the French architect Eugene Viollet-le-Duc (1814-79). In England the Ecclesiological Society advocated a return to early Anglican church ritual, leading architects including George Edmund Street (1824–81), William Butterfield (1814–1900), and William White (1825-1900) towards the massive forms of 13th- and 14th- century Gothic in their ecclesiastical and secular furniture. Often large in scale – it is sometimes called Muscular Gothic – this furniture featured revealed construction, architectural elements such as sturdy stump columns and chamfering, inlaid geometric decoration, and prominent hardware. At the London International

Exhibition (1862), furniture designed or decorated by Richard Norman Shaw (1831–1912), William Burges (1827–81), John Pollard Seddon (1827-1906), Philip Webb (1831–1915), and William Morris (1834–96) showed the revived interest in medieval painted furniture.

By the late 1860s the Reformed Gothic style had laid the foundations for the Art Furniture of the 1870s. Two seminal publications, published and circulated widely in Britain and the United States, set the tone. Charles Locke Eastlake's *Hints on Household Taste* (1868) was aimed at a wide audience and addressed the importance of practicality in the design, construction, and decoration of furniture in the context of an artistic interior. Even more influential were the illustrations provided by Bruce James Talbert in his *Gothic Forms Applied to Furniture* (1867), which successfully drew on 17th-century English vernacular prototypes to reduce the massiveness of Reformed Gothic to a more domestic – and commercially successful – scale. Both publications paved the way for the popularity of Art Furniture.

Reformed Gothic Shapes and Motifs

1

2

3

1 *Carved and gilded walnut corner what-not designed by John Pollard Seddon in 1860 and probably made in London by his family's cabinetmaking firm. Ht 1.71m/5ft 6in.*

2 *An outstanding example of Reformed Gothic design, this bed was designed by Charles Bevan c.1866. It was probably made by the Leeds firm of Marsh & Jones, and built of sycamore inlaid with amboyna, purplewood, ebony, mahogany, and various other woods. Ht 1.92m/6ft 3in.*

4

3 *The hooded canopy of this ebonized, painted, and part-gilded corner cabinet, one of a pair designed by Talbert, c.1870, lends it a strong Gothic flavour. The bevelled mirrors backing the upper shelved section were a common feature. Ht 2m/6ft 6in.*

4 *Walnut armchair designed by John Pollard Seddon, painted with the story of Pyramus and Thisbe, and exhibited in the Mediaeval Court of the London International Exhibition in 1862. Ht 1.04m/3ft 5in.*

5 *This desk was designed by Frank Furness and made of American black walnut by Daniel Pabst in Philadelphia c.1875. It displays the daring, playful, and highly imaginative treatment of forms characteristic of the architect's work. Ht 1.8m/5ft 11in.*

6 *The ante-room to the drawing room entrance at The Grove, Harborne, near Birmingham, remodelled by the architect John Henry Chamberlain, 1877-8, is of inlaid, painted, and gilded sycamore and oak.*

5

6

British Furniture

The House Beautiful

1 *Robert W. Edis's own highly artistic home served as the model for "A Drawing Room Corner," the frontispiece to his* Decoration and Furniture of Town Houses *(London 1881).*

3 *Jeckyll provided an intricate series of shelves to display blue-and-white porcelain for the Peacock Room in the London home of the shipping magnate Frederick Leyland (now in the Freer Gallery of Art, Washington).*

2 *Thomas Jeckyll's inlaid oak table, designed in the mid-1860s for a client in Yorkshire, is a skillful fusion of Eastern and Elizabethan forms, and was probably made by Jackson & Graham in London. Ht 73cm/28¾in.*

In the 1870s a fashion developed for ebonized and painted furniture, stemming partly from the much-exhibited versions of a cabinet designed *c.*1871 by Thomas Edward Collcutt (1840–1924; see p.257). This cabinet boasted a Talbert-derived architectural framework with Gothic details, such as the canopy over the upper structure. The cupboard doors were inset with painted figurative panels and complemented by profuse shelves, one backed with a bevelled mirror to reflect the Art objects placed on it. There was none of the heavy carving that Talbert and Eastlake rejected, and much of the decorative effect was derived instead from mouldings.

These features were to be found on much Aesthetic cabinet furniture over the next fifteen years, when other items suitable for showing off objects, such as overmantels incorporating numerous shelves, and hanging cabinets also became popular.

Furniture designed during the 1870s also reflected the wide variety of influences to which designers were exposed. The marquetry devised by Owen Jones adapted

elements from an eclectic range of sources including Moorish and classical prototypes. A knowledge of ancient Egyptian prototypes was demonstrated by the painter William Holman Hunt (1827–1910), who in 1857 designed a *Thebes* stool (named after the site of Egyptian excavations); similar designs were produced by Ford Madox Brown (1821–93) for Morris & Co. and were patented by Liberty & Co. in 1883.

An interest in Japanese art prompted W.E. Nesfield (1835–88) to design a folding screen with Japanese motifs in the late 1860s. Thomas Jeckyll, who incorporated Japanese motifs in his Jacobean oak furniture, exploited both Japanese and Hispano-Moresque themes in the attenuation and complexity of the built-in shelves he designed for the Peacock Room, named after James McNeill Whistler's (1834–1903) japanesque painted scheme. This led to Godwin pioneering a type of furniture influenced by oriental sources, published by the London cabinetmaker William Watt in *Art Furniture* (1877). Godwin's Anglo-Japanese style adapted decorative and

Unity Through Eclecticism

1

2

3

2 *This ebonized wood screen by W.E. Nesfield is decorated with textile-derived gilt fretwork and incorporates Japanese painted paper panels of birds on branches. Made by the cabinetmaker James Forsyth in 1867. Ht 2.08m/6ft 10in.*

3 *A model of William C. Codman's ebonized, painted, incised, and gilt hanging cabinet was shown by the London firm of Cox & Sons at the London International Exhibition of 1874. Ht 1.24m/4ft 1in.*

1 *This design by Thomas Edward Collcutt, made by Collinson & Lock, was shown at international exhibitions in London (1871), Vienna (1873) and Philadelphia (1876), and helped to popularize ebonized and painted furniture. Ht 2.40m/7ft 9½in.*

4 *The design of this ebonized and painted beech side chair is attributed to John Moyr Smith. Made by Cox & Sons of London, c.1871, it shows Greek as well as Gothic influences in the austerity of its structure. Ht 83.8cm/33in.*

4

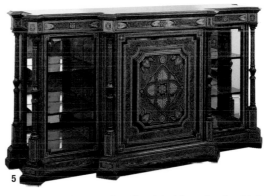

5

5 *The sophisticated design and quality of the inlays adorning this breakfront vitrine, c.1870, suggest the names of Owen Jones and Jackson & Graham as designer and manufacturer respectively. It was retailed by Hewetson & Milner of Tottenham Court Road, London. W. 2m/6ft 6in.*

Later Aesthetic Furniture

1 *The Queen Anne walnut wall clock, by Thomas Harris for Howell & James & Co., was also designed to serve as a hanging étagère. An example was shown at the 1878 Paris Exposition Universelle. Ht 99cm/39in.*

2 *This music cabinet by Stephen Webb for Collinson & Lock of London, c.1890, is made of ivory-inlaid rosewood. Its restrained, elegant proportions recall the 18th-century furniture by then so fashionable. Ht 1.45m/4ft 9in.*

3 *The taut, sinuous form of this inlaid rosewood occasional table leads from Godwin to the Art Nouveau movement. Made by Lamb of Manchester, c.1886, the design is attributed to Charles Edward Horton. Ht 66cm/26in.*

1

2

3

Japanese and Ancient Influences

1 *Designed by E.W. Godwin and made by representatives of William Watt in London, c.1885, the design of this "cheap chair" was based on those of Greek thrones and stools, which Godwin may have seen at the British Museum. Ht 1.03m/3ft 4½in.*

2 *Godwin designed his much-imitated coffee table around 1867. The manufacture of this example is attributed to William Watt, for whom he supplied designs; countless other manufacturers made copies of varying refinement. Ht 69.5cm/27¼in.*

3 *The satinwood and painted* Four Seasons *cabinet, designed by Godwin, c.1877. Possibly painted by Godwin's wife, the seasons were a popular motif for ceramic tiles (see p.263) and stained glass as well as painted furniture panels during the Aesthetic Movement. The bell-shaped lattice of the lower doors and the structure of top rails are derived from Japanese architecture, via the prints of Hokusai. Ht 1.77m/5ft 10in.*

4 *The* Butterfly *cabinet was designed by Godwin and painted with oil-based decorations by James McNeill Whistler. Made by William Watt in London, the lower central section originally incorporated a fireplace and the whole formed the centrepiece of Watt's stand at the 1878 Paris Exposition Universelle. Ht 3m/9ft 10in.*

constructional devices gleaned from Japanese prints illustrating domestic fitments and woodwork to create a series of highly rectilinear deal buffets. They were ebonized to resemble oriental lacquered furniture and were constructed from symmetrical arrangements of straight horizontal and vertical lines, achieving their effect, as he put it, "by the grouping of solid and void and by more or less broken outline." In these, and in his other Anglo-Japanese designs, surface decoration was minimal and confined to panels of embossed leather paper and geometric, incised gold lines.

By the mid-1870s the Queen Anne style, an inaccurate title referring to architecture inspired by 18th-century English design as well as other sources, had begun to influence furniture. Neo-Georgian pediments and complex glazed fronts appeared on display cabinets by designers such as Thomas E. Collcutt.

The revival of interest in 17th-century ornament, sometimes known as the Wrenaissance after the architect Sir Christopher Wren, led firms such as Collinson & Lock to produce delicately scaled ivory-inlaid rosewood cabinets. Godwin designed polished mahogany and walnut furniture with attenuated, curving lines and slender, tapering legs, lending objects an increasingly lightweight appearance. Meanwhile, the work of commercial firms, such as James Lamb of Manchester, produced furniture reflecting the latest fashions.

From the 1860s, furniture detailing became even finer and the complexity of cabinets increased, with more and more elaborate panels appearing in the work of H.W. Batley and Thomas Harris. Commercial firms such as James Lamb of Manchester blended the fashionable designs into their work. From the 1860s, the birth of the Adam Revival style, named after the 18th-century architect-designer, led many manufacturers to re-interpret or re-introduce forms of that period, often veneered with satinwood. The style gathered momentum in the 1870s and remained popular until beyond the turn of the 19th century.

Godwin and Dresser

1 *Detail of plate 6 from* Art Furniture *(1877). Designed by Godwin and manufactured by William Watt, the buffet was offered for sale ebonized or in oak.*

2 *A design icon of the Aesthetic Movement, this version of Godwin's Anglo-Japanese sideboard was made in London by William Watt & Co., c.1867–70. It is made of ebonized mahogany with silver-plated fittings and embossed Japanese leather paper inserts. W. 2.56m/8ft 4in.*

3 *The design of this upholstered mahogany easy chair, probably manufactured by Collinson & Lock in London, c.1872–5, is attributed to Godwin. Ht 81cm/32in.*

4 *Godwin designed this ebonized easel with stamped and gilded leather panels, c.1870; he recommended "light, easily movable easels of different choice woods to hold choice drawings" in the drawing room. It was probably made by William Watt & Co. Ht 1.67m/5ft 6in.*

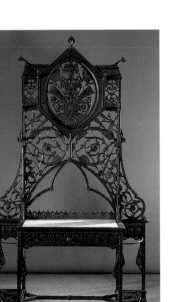

5 *Structural simplicity distinguishes Christopher Dresser's ebonized dining chair, designed c.1883 for the Art Furniture Alliance, which he founded in 1880. It was made by Chubb & Co. for retail in the Alliance's shop in New Bond Street, London. Ht 88.5cm/35in.*

6 *One of a number of cast-iron designs by Dresser manufactured by the Coalbrookdale ironworks in Shropshire. The stylized foliage and Gothic architectural details of this hall-stand are all typical of his much-imitated style. It is stamped with a patent registration mark for 1869 in an attempt to prevent pirating of the design. Ht 2.31m/7ft 7in.*

American Furniture

The Eastlake Style

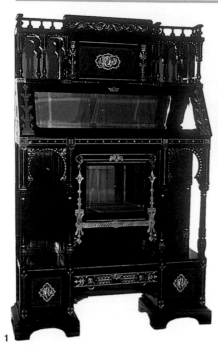

3 *The bold architectural furniture made by Daniel Pabst, such as this walnut cabinet with nickel-plated hardware, c.1880, shows the influence on American design of Bruce Talbert and Christopher Dresser. Ht 1.8m/5ft 11in.*

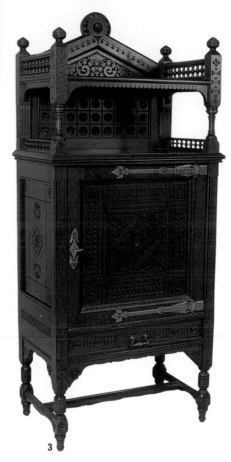

1 *An ebonized cherrywood Eastlake cabinet made by the New York cabinetmakers and furnishers Kimbel & Cabus, c.1880. Moorish influences, which abound in the horseshoe arches and the hand-painted Arabic-inscribed French tiles, are combined with prominent Gothic strap-hinges. Ht 2m/6ft 6in.*
2 *Painted panels such as this, from an ebonized cherrywood cabinet made by Kimbel & Cabus in New York, c.1876, were influenced by the popularity of painted Art Furniture in Britain.*

In the United States, the British design reforms of Talbert and Dresser were expressed in the designs of Frank Furness executed by Daniel Pabst in Philadelphia. Eastlake furniture, the American version of Art furniture, with its rectilinear forms, panelled construction, turned uprights, and spindled galleries, continued in popularity throughout the 1870s and 1880s. Renaissance decorative elements were also popular in the US, employed by firms such as John Jelliff (1813–90) in Newark, New Jersey. More innovative was the furniture produced by George Hunzinger (1835–98) in Brooklyn, New York, which played on the ingenious massing of complex turned elements. Materials popular in the US included bamboo furniture and imitation bamboo made from bird's-eye maple. The technique of woodcarving, less prevalent in British furniture, was employed in the naturalistic motifs adopted by the woodcarving school that flourished in Cincinnati, Ohio.

Opulent materials and skilled craftsmanship were also characteristic of much American Aesthetic furniture.

Herter Brothers of New York adopted a restrained stylistic vocabulary that drew on European – particularly British and French Empire – sources, often executed in ebonized cherry or gilded maple, with flat panels of intricate, sometimes asymmetrical, floral marquetry. The Anglo-Japanese style popularized by Godwin flourished in the work of A. & H. Lejambre, which manufactured tables with asymmetrical shelves and mahogany tops inlaid with mother-of-pearl and metal inlays. Other fashionable styles such as the Celtic and Moorish revivals inspired the furnishing of the interior of the Seventh Regiment Armory in New York (1879–80) by the Associated Artists formed by Louis Comfort Tiffany (1848–1933).

The Moorish craze of the 1880s and 1890s was popularized in Britain by Liberty & Co., and in the US by Tiffany & Co. After the 1876 Philadelphia Centennial Exposition, the counterpart of the English Queen Anne movement was echoed in the US by the Colonial Revival, inspired by its colonial heritage, which encouraged the re-introduction of 18th-century forms.

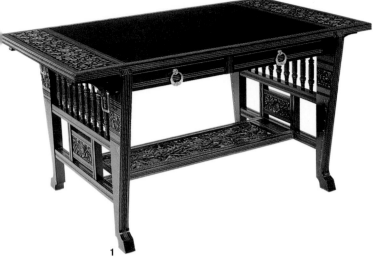

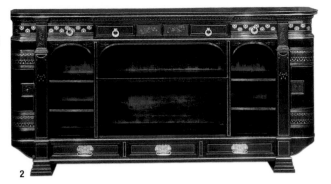

1 *A centre table by Herter Brothers, c.1878–80, in which the sophisticated design, its stylized equine legs terminating with hoofed feet, is realized in superbly executed marquetry and low-relief carving. W. 1.42m/4ft 8in.*
2 *Although its doors are long gone, the strong design of this Herter Brothers cabinet is undiminished. The carcase is veneered with ebony and inset with Japanese lacquer, copper panels, and brass inlay. W. 2.4m/7ft 11in.*

3 *The influence of Godwin's Anglo-Japanese furniture (see p.258–9) is evident in this copper, mother-of-pearl, and brass inlaid mahogany tea table made by A. & H. Lejambre of Philadelphia, c.1880. The inlay on the top depicts a dragonfly in flight and a web-bound spider. Ht 68.5cm/27in.*
4 *The case of this wall clock demonstrates the robust, naturalistic carving produced in Cincinnati. The part-ebonized walnut case was made in the circle of Benn Pitman, c.1883; the dial is of partially silvered brass. Ht 62cm/24½in.*

5 *A Queen Anne hanging cabinet of American walnut, c.1880. It relies for its decorative effect on the incised strap-hinges, fretted gallery, and subtly reeded mouldings. Ht 1.14m/3ft 9in.*

6 *Frog-devouring herons provide the theme for an oak dining table designed by Frank Furness and probably manufactured by Pabst in Philadelphia, c.1875, as part of a dining-room scheme. Diam. 1.67m/5ft 6in.*

European Ceramics

Britain

1 *This pierced and gilded japanesque porcelain night-light, made by the Royal Worcester Porcelain Co. in 1873, imitates a section of curved bamboo on a Chinese-inspired stand. Ht 25.5cm/10in.*
2 Japonisme *abounds in the angular handle and in the stylized and seemingly arbitrary cropping of the transfer-printed and hand-coloured foliage on this flask made by Pinder Bourne in Burslem, Staffordshire, 1881. Ht 24cm/9½in.*

3 *The fanciful zoomorphic quality of which Christopher Dresser was capable is apparent in the gold figure handles of this vase, with painted floral patterns in imitation of* cloisonné; *made by the Old Hall Earthenware Co., c.1880. Ht 35.5cm/14in.*
4 *A fine example of Minton's much-admired imitation* cloisonné *decoration, this jardinière was made in Stoke-on-Trent in 1888 for the London retailers Thomas Goode & Co. Ht 32cm/12½in.*
5 *Persian influence inspired the form of this painted earthenware pilgrim bottle (or moon flask), Italian Renaissance maiolica the palette, and medieval art the subject matter. Designed by Henry Stacy Marks, originally for Minton's Art Pottery Studio, and made by Minton & Co. in Stoke-on-Trent, 1877. Ht 35.5cm/14in.*

The most pervasive influence on Aesthetic ceramics was *japonisme*. The firm of the French ceramicist Joseph-Théodore Deck employed designers such as Félix Bracquemond (1833–1914), whose work used motifs taken from Japanese prints, placed at seemingly random intervals. Bracquemond's concept was copied in Britain, where any elements remotely oriental were often profusely (even indiscriminately) applied to ceramics to create the rich effects demanded by the market. These motifs were applied to forms from the European, Islamic, or Chinese repertoires, sometimes in sharp angular planes drawn from Japanese ceramics and metalwork. Oriental elements such as bamboo-shaped handles were often incorporated; oriental metalwork also inspired surface decoration, such as the *cloisonné* effect emulated by Minton & Co.'s much-admired enamelled and gilded porcelain.

In the 1870s and 1880s Minton developed the French technique of *pâte-sur-pâte*, used to embellish ornamental pieces with predominantly Neoclassical themes fused with *japonisme*. Minton and Wedgwood also employed freelance commercial designers such as Christopher Dresser for their industrial production, and created special Art pottery departments. Doulton's Lambeth Faience Co. produced delicately incised salt-glazed stoneware based on earlier European prototypes and Minton's Art Pottery Studio made hand-painted figurative panels with subjects from contemporary painting in a flat japanesque style. Designs by other artists such as Albert Moore, Walter Crane, and John Moyr Smith were widely disseminated through transfer-printed tableware and tiles.

Tastes varied greatly. Majolica was produced in a variety of naturalistic forms in bright colours, in contrast to the austere Dresser-inspired geometry of Watcombe's unglazed terracotta wares. Dresser's other contribution was at Linthorpe, where he and Henry Tooth developed art pottery with coloured, often running glazes dripping down forms drawn from a variety of near and far-eastern forms, prefiguring the studio pottery of the Arts and Crafts Movement.

Tiles and Plaques

1 *The* Tambourine Player, *from a series of eight classically inspired figures with musical instruments, designed by John Moyr Smith and produced by Minton China Works, c.1876. Available in different colourways, designs such as this were adapted by other manufacturers for different media, and the tiles themselves were used to decorate chairs, stoves, and wash-stands, etc. Ht 20.5cm/8in.*

2 *Guinevere wears a loose Hellenistic gown in this painted earthenware hearth, probably designed by Daniel Cottier and made by Cottier & Co. in London. The tiles above are from Moyr Smith's* Fairy Tale *series designed for Minton, 1873–4, and the fireplace installed in Glenview Mansion, Yonkers, New York, built c.1876–7.*

3 *Kate Greenaway, famous for her children's book illustrations, probably designed* Summer, *a transfer-printed and hand-coloured earthenware tile made by T. & R. Boote in Birmingham, 1883. Ht 15.5cm/6in.*

4 *Signed by William Stephen Coleman (1829–1904), this earthenware plaque was made in 1872 at the short-lived Minton's Art Pottery Studio in London of which he was the Art Director. It features a classically inspired reclining nude rendered in a flat Japanesque treatment within a vaguely Eastern setting. Ht 30.5cm/12in.*

French Influences

1 *In porcelain services such as the* Service Rousseau *and the* Service Parisien *(illustrated here), some of the earliest expressions of French Japonisme were made. Designed by Félix Bracquemond and manufactured by Haviland in Limoges, 1876. Diam 25.5cm/10in.*

2 *The pâte-sur-pâte technique involved the application of successive thin layers of slip (liquid clay), a slow and costly process, here applied to a quirky experimental pot made by Moore Brothers at Longton, c.1875. Ht 12.5cm/5in.*

American Ceramics

The Pursuit of Beauty

1 *Avalon Faience eagle-spout pitcher made by the Chesapeake Pottery, Baltimore, Maryland, c.1882. The form of the spout is echoed in the eagle head which forms the upper part of the handle. Ht 10cm/4in.*

2 *Lamp base with an arrangement of overlapping motifs inspired by Japanese design (compare with 4 opposite) decorated by Matthew A. Daly at the Matt Morgan Art Pottery, Cincinnati, Ohio, c.1882–3. Ht 19cm/7½in.*
3 *Hungarian Faience ewer made by the Cincinnati Art Pottery Co., c.1880. Cincinnati's importance as a centre of art pottery production can be traced in part to the efforts of Benn Pitman, an Englishman who in 1873 began wood-carving classes (see p.261) followed by china painting classes in 1874; both enterprises enjoyed the strong support of local women. Ht 26.5cm/10½in.*
4 *Buff vase decorated with bees and sweet-peas by Jane Porter Dodd of the Cincinnati Pottery Club, 1881. The club was founded in 1879 by twelve women who had studied under Benn Pitman, and whose work drew inspiration from nature as well as Japanese prints. Ht 14cm/5½in.*

The years 1875 to 1885 witnessed the development of the manufacture of art pottery and tiles in the United States, following the British precedent. Karl L.H. Müller (1820–87), working for Union Porcelain Works, Brooklyn, New York, sought to develop an American style in ceramics distinct from European models, resulting in an eclectic range of symbols, usually from literature or everyday American life and applied to conventional forms. Manufacturers such as Ott & Brewer developed a type of eggshell porcelain applied with Japanese motifs chased in shades of silver and gold, and the Faience Manufacturing Co., Brooklyn, New York, produced exotic forms with Anglo-Japanese decoration.

The development of artistic glazes was exemplified by the Chelsea Keramic Art Works, Massachusetts, whose designers and craftsmen were inspired by oriental ceramicists to create glazes, including a soft celadon green, and a dry glaze produced by firing a high glaze at a low heat, which resulted in a matte grey-brown resembling polished bronze, and applied over a low-relief honeycomb surface resembling hand-hammered metal. The Rookwood Pottery Co. in Cincinnati developed a sophisticated series of glazes painted with underglaze decoration of whimsical animals inspired by Japanese *manga* (Japanese comic books) and the J. & J.G. Low Art Tile Works, Chelsea, Massachusetts, produced thickly glazed tiles with relief decoration, which were sometimes incorporated into objects such as clock cases (see p.269).

Hand decoration was also highly valued. Tile clubs, such as that founded in New York in 1877 under the patronage of the painter Winslow Homer (1836–1910), encouraged the fashion, popular in Britain, for painting on ceramics. Also in New York (after training in England) John Bennett (1840–1907) painted ceramics with flat, linear, stylized flowers executed in a strong palette of vitreous enamels inspired by Persian ceramics and the work of William Morris. Relief decoration was also practised by artists such as Agnes Pitman (1850–1946; daughter of Benn) in Cincinnati and Isaac Elwood Scott (1845–1920) at the Chelsea Keramic Works.

1 *An earthenware plaque painted by John Bennett in New York, 1878. Butterflies and bees encircle blossom in one of Bennett's more japanesque designs, against a crackled-ice background derived from oriental ceramics. The sensitive arrangement of motifs and sophisticated palette are hallmarks of Bennett's work. Diam. 36cm/14¼in.*

2 *The* Pastoral *vase, with its classical iconography, was designed and modelled by Isaac Broome in 1876 and made of cast terracotta-coloured porcelain by Ott & Brewer, Trenton, New Jersey. Ht 45cm/17⅞in.*

3 *Oriental beaten metalwork is recalled in the honeycombed surface of this lead-glazed earthenware vase made at Chelsea Keramic Art Works, Chelsea, Massachusetts, c.1879–83. Ht 19.5cm/7¾in.*

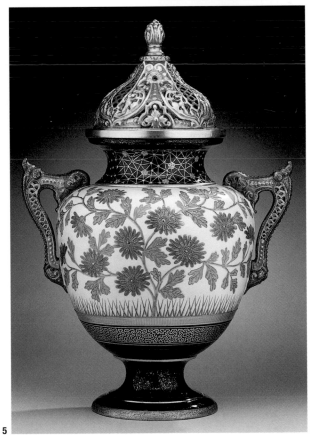

4 *Typical of* japonisme *are the wilful asymmetry and complex illusionistic overlapping of forms on this glazed earthenware tile; design attributed to Arthur Osbourne, made by the J. & J.G. Low Art Tile Works, Chelsea, Massachusetts, 1881–4. Ht 15cm/6in.*

5 *A feat of gilding and painting, this earthenware covered vase was decorated under the supervision of Edward Lycett at the Faience Manufacturing Company, Greenpoint, Brooklyn, New York c.1884–90. Ht 40cm/15¾in.*

Glass

Britain, France, and the United States

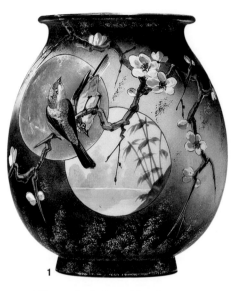

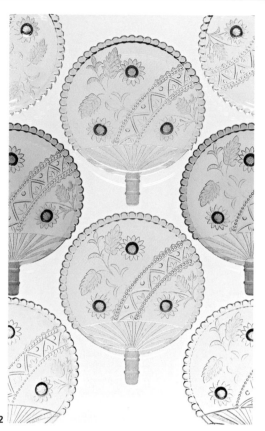

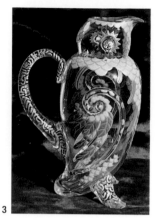

1 *The powdered gilt speckling the graduated grey ground of this oviform glass vase, produced by Baccarat in Lille, c.1880, emulates the effect often found on Japanese lacquer. Ht 19.5cm/7¾in.*

2 *Popular Aesthetic designs, such as these press-moulded glass cake plates shaped like Japanese fans, continued to be produced until the end of the 19th century.*

3 *Enamelled and blown-glass jug in the form of a cockerel, made by Thomas Webb & Sons, near Stourbridge, c.1879. Ht 19cm/7½in.*

4 *A superb example of Aesthetic design, Frederick Ashwin's painted- and leaded-glass panel depicts the* Dawning of the Last Day; *formerly the north transept window of the church of St Barnabas, Hengoed, Shropshire, dating from 1871.*

5 *Probably designed by Daniel Cottier and made by Cottier & Co., London, c.1875, the painted- and leaded-glass* Harvest Girl *is in a frame of golden quarries produced by silver stain (sodium nitrate). Ht 66.5cm/26¼in.*

6 *Edward Burne-Jones designed the figures and Philip Webb the quarries for this Morris & Co. window, for a Refreshment Room in the South Kensington Museum (now the Victoria & Albert Museum), London, 1867–9.*

2 *Made for Liberty & Co. of London by James Couper & Sons of Glasgow, this "Clutha" amorphic green vase with an opaque swirl was designed by Christopher Dresser and produced c.1880–96. The mottled or bubbled glass was inspired by excavated Roman glass. Ht 24.5cm/9¾in.*

3 *An illustration from Charles Booth's* Modern Surface Ornament *(New York 1877). Booth was born in Liverpool and active in New York from around 1875–80. His work shows the extent to which Aesthetic design, particularly the work of Christopher Dresser, had permeated American design circles by the mid-1870s.*

1 *Dating from around 1870, Christopher Dresser's* Frost *design for a stained-glass window was inspired by sketches he had made of frost on his window some 14 years earlier. He recommended the pattern to decorate glass in subsequent publications, demonstrating his skill in adapting natural forms to appropriate uses.*

The 1870s and 1880s witnessed an explosion in stained glass production for domestic and public settings, partly an offshoot of extensive church glazing schemes. Figurative panels designed by leading British artists, notably Edward Burne-Jones (1833–98) for Morris & Co., translated into glass the Aesthetic fine art motifs of languid maidens in allegorical guises, executed in golden yellows and earthy browns with flashes of turquoise and ruby red. Flat background patterns composed of quarries (small, geometric panes) with conventionalized leaves and flowers or patterns, stressed the two-dimensional nature of the panels, while admitting light to richly decorated interiors. Hand-painted or transfer-painted panels, usually of flowers and birds, proliferated in the doors and hallways of urban dwellings where the new technique of sandblasting was used to create a series of matte, or frosted, forms against a clear background.

Christopher Dresser's geometric stained-glass designs illustrate his belief that a window should "never appear as a picture with parts treated in light and shade." In the United States, Charles Booth (1844–93), interpreted Dresser's geometricized plant forms with windows executed in a predominantly aquamarine, amethyst, pink, and pale yellow palette. In 1879, John La Farge developed opalescent glass and pioneered plating (layering sheets of glass) to create combinations of texture and colour, also exploited by Louis Comfort Tiffany, allowing subtlety that was unprecedented in shading, tone, and density.

Aesthetic motifs, from naturalistic flowers, vines, and ferns to japanesque devices, were painted, gilded, engraved, or enamelled onto opaque and clear glass hollow-wares. Clear or coloured pressed table-glass was popular. A number of technical developments were made in the US. In 1878 Frederick S. Shirley patented lava glass (lava ash created the black body colour), embedded with chips of coloured glass and enamels and blown into simple shapes inspired by recent European excavations of Roman glass. Other techniques resulted in the subtle gradation of colours, such as Amberina glass, and the Chinese-inspired Peachblow glass.

Metalwork

Naturalism

1 *Cast-iron fire surround designed in 1878 by Thomas Jeckyll for the Norwich foundry of Barnard, Bishop & Barnards. The influence of Japanese design abounds in the treatment of the birds perched in the spandrels and the* mons *around the arched grate. Ht 96.5cm/38in.*
2 The Botanic, *a copper-plated brass coal scuttle and shovel with a tin liner on a wrought-iron stand was manufactured by Benham & Froud in London, c.1892. Ht 58.5cm/23in.*

Geometry

1 *The striking geometry of this silver teapot, designed by Christopher Dresser and made by Hukin & Heath in Birmingham in 1879, is relieved by the enamelled cabochons studding the flattened shoulders, while the enamelled and gilt bone disk of Japanese origin set into the lid signifies the designer's debt to Japanese art. Other English firms such as Elkington & Co., which developed the silver electroplating technique, and James Dixon & Sons, (see p.252) allowed Dresser to design even more strikingly angular and severe proto-modern designs for tea services and claret jugs, which took the contemporary interest in geometry to extremes. Ht 10.5cm/4¼in.*

Aesthetic metalwork was extremely inventive and strongly influenced by Japanese and other Near and Far Eastern designs and techniques. Japanese motifs featured heavily in the design of Thomas Jeckyll's cast-iron pavilion which was "decorated in gold and orange, to the designs of…Whistler," and shown at the international exhibitions in Philadelphia (1876) and Paris (1878). The design for the balustrade, which consisted of stylized sunflowers, icons of the Aesthetic Movement, was adapted for use as cast-iron or gilt bronze andirons. Jeckyll also designed a series of Anglo-Japanese fireplace surrounds consisting of low-relief *mons*, often overlapping and asymmetrically arranged on diaper-pattern grounds. In France, interest in Chinese and Japanese art during this period was reflected in the designs manufactured by firms such as Christofle & Cie. in Paris.

In the United States, Japanese as well as Moorish influences were developed in the designs of Edward Chandler Moore (1827–91) designing for Tiffany & Co.

from the 1870s. Tiffany's japanesque silver typically combined organic forms, often with attenuated spouts and handles, and hand-hammered surfaces. The surface of the metal was embellished with Japanese-inspired motifs, which were chased and engraved or inlaid with copper and other base metals (known as *niello* work), a practice outlawed in Britain. Much commercial British and American Aesthetic silver consisted of straight-sided or very simply curved vessels decorated with engraved designs of Anglo-Japanese natural plant and bird forms.

Techniques inspired by the Near and Far East, such as *cloisonné* enamelling and decoration imitating Japanese *komai* work, were developed in Britain by Elkington & Co.. Cast iron was also increasingly used for furniture, and brass was among the metals used for items such as clock cases and light fittings, particularly in the US, where Dresser-inspired stylized botanical ornament was incorporated on cast-brass plant stands with winged feet and angular decoration.

American Designs

1 *Covered bowl made of cast bronze and chased with daisy heads entangled in spiders' webs, by M. Louise McLaughlin of Cincinnati in 1884. Ht 13.5cm/5¼in.*

2 *Bronze mantel clock case incorporating glazed earthenware tiles by the J. & J.G. Low Art Tile Works, Chelsea, Massachusetts. The works are attributed to the New Haven Clock Company, New Haven, Connecticut, 1884–90. Ht 30.5cm/12in.*

3 *One of the most bizarre creations of the Aesthetic Movement in any medium, this polished cast-brass plant stand inset with Longwy tiles, was probably made in Meriden, Connecticut, and retailed by the Meriden Flint Glass Co. around 1880. Ht 85.5cm/33¾in.*

4 *Japanesque water pitcher designed by Edward C. Moore, with silver irises, carp, and dragonfly inlaid in bronze. Made by Tiffany & Co. in New York about 1877. Ht 20cm/8in*

France and England

3 *Probably designed by Emile Reiber, this part-gilt bronze bowl was made by Christofle & Cie., Paris, c.1870. The form is based on a 17th-century Chinese censer; the bamboo decoration on Chinese metalwork. Ht 13cm/5in.*

1 *One of a pair of* cloisonné *enamel and electrogilded bronze vases; the design is attributed to Albert Williams, the manufacture to Elkington & Co. of Birmingham, c.1875. Ht 35.5cm/14in.*

2 *This Chinese* cloisonné *vase was imported to Paris, where it was assembled into a lamp, complete with silver and gilt glass globe, by Susse Frères, c.1880. Ht (inc. chimney) 72.5cm/28½in.*

4 *Brass, pewter, and various woods are inlaid on an ivory-ground jardinière manufactured by F. Duvinage in Paris, c.1870. The ormolu mounts are of Chinese inspiration. W 31cm/12¼in.*

Textiles and Wallpaper

Textile designs of the 1870s

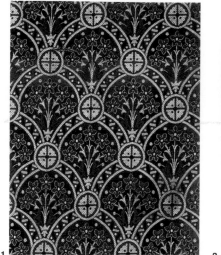

1 *Conventionalized sprays of flowers and centred diapers, the shapes of which are derived from Islamic tile-work, add a lively dash to this woven wool-and-silk textile designed by Christopher Dresser and made by James W. & C. Ward of Halifax in 1871.*
2 *The design of the peacock in this crewel-work panel is attributed to Philip Webb, the scrolling vine background to William Morris. It was made by Morris & Co. in London around 1880. 76 x 1.01cm/30 x 3ft 3in.*

3 *Typical of his dense yet lively and fluid flat patterns, Bruce Talbert's Fruits and Foliage was designed c.1875 and woven in silk by Warner & Ramm, London. 56.5 x 46cm/22¼ x 18in.*
4 *Detail of a silk and wool jacquard-woven portière with passementerie decoration, probably designed by Talbert and made by J. & J.S. Templeton & Co. in Glasgow, c.1870. Designed to be hung on a wall or as a curtain across the back of a door, it reflects the fashion for dividing walls into horizontal bands. 3.5 x 1.75m/11ft 6in x 5ft 9in.*

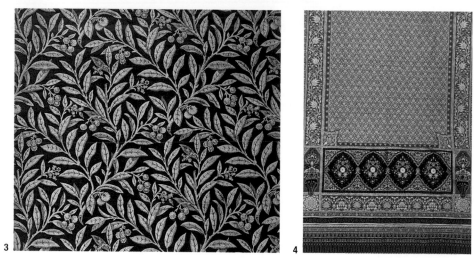

Textiles played an important part in Aesthetic interior schemes, from carpets and curtains to upholstery, as well as in dress. By the 1870s the influence of Owen Jones, who published designs based on Etruscan, Greek, Moorish, and other sources, in addition to designing textiles for commercial production, was being felt in Britain and the United States. Christopher Dresser also designed textiles indebted to Jones, which followed his principles of using conventionalized motifs from nature. The stress on suitability of ornament steered designers away from three-dimensional illusionism towards linearity and flat patterns based on what Jones termed "geometrical construction."

Given this emphasis on flatness, sophisticated methods of disposing surface pattern were gleaned from Japanese art, which particularly captured the imagination of designers such as E.W. Godwin and Bruce Talbert. Some of Godwin's patterns utilized repeated circular motifs derived from Japanese wood-blocks, whereas Talbert adapted Japanese and Indian sources in his textile designs, which included a number for *portières*. Like Morris's designs, Talbert's floral motifs owe their liveliness to his careful studies of nature. The fluid lines of some of Walter Crane and Lewis F. Day's textile and wallpaper designs prefigured the Art Nouveau movement which followed.

In contrast to the approach prevalent in textile production in the 1850s, Japanese influence also helped to simplify the colours used in textiles. Many of the textiles produced under the direction of William Morris (1834–1904) were made using vegetable dyes in colours inspired by Indian textiles, in part a reaction to the strident colours produced by chemical dyes in the preceding decades, and his firm's printed textiles revived the lost art of indigo dyeing. Encouraged by designers such as Morris as well as E.W. Godwin and James McNeill Whistler, subdued secondary and tertiary (dubbed "greenery-yallery") colours came to characterize the Aesthetic interior.

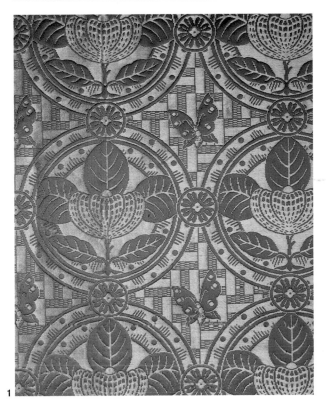

1 *Jacquard-woven silk* Butterfly *brocade designed by E.W. Godwin and made by Warner, Sillett & Ramm, London, c.1874. It was probably commissioned by Collinson & Lock. 51 x 55cm/20 x 21¾in.*
3 *In his* Batt *woven silk designed c.1880 for Daniel Walters & Sons, George Haité has used overlapping flowers, rectangles, and squares emblazoned with auspicious Chinese bats.*

2 *Detail of the* Large Syringa *silk damask designed by Godwin, 1875, and made by Warner & Ramm in London. Godwin owned a Japanese book of* mons *that inspired the design. 3.30 x 1.70m/10ft 10in x 5ft 7in.*
4 *Continental Art Nouveau is prefigured in this detail of a printed* Tussah *silk depicting allegorical figures, designed by Léon Victor Solon, c.1893. 2.86 x 1.69m/9ft 5in x 5ft 7in.*

THE AESTHETIC MOVEMENT | TEXTILES AND WALLPAPER

1 *Frieze, filling, and dado designed by Bruce Talbert and made by the London firm of Jeffrey & Co. in 1877. A number of the wallpaper schemes he devised contrast a flowing filling design with a more geometric dado pattern.*

2 *A rhythmic pattern of bees and blossom decorates this detail of a wallpaper scheme devised by Candace Wheeler for her winning entry to an international wallpaper design competition in 1881; the silver honeycombs of the filling contained golden cells.*

3 Apple Blossom *wallpaper designed by Lewis F. Day and hand printed by Jeffrey & Co. for M.B. Simpson & Sons in 1878. Day's convincing illusion of randomly scattered blossom conceals a tightly organized design.*

Wallpaper came into its own as a medium for creative design during the Aesthetic Movement. An unprecedented interest in the most suitable methods of decorating walls led to a number of prolific and versatile commercial designers being commissioned by manufacturers to produce patterns. The walls of the Aesthetic interior were usually divided into three sections, comprising a frieze, filling, and dado. As with textiles, subdued tertiary colours predominated, and papers were produced in different colourways to assist matching, with designers employed to produce entire complimentary sets.

Natural motifs predominated in wallpaper design at this period. William Morris designed wallpapers (as well as textiles) depicting scrolling and flowing organic motifs filtered through the art of the Medieval and Indian textiles which he admired, while designers such as Lewis F. Day, Dresser and Godwin drew heavily on Japanese art for innovation in their designs. British wallpapers enjoyed popularity in the United States, particularly those produced by Morris & Co. and the designs of Walter Crane, who brought his superb control of linear motifs to the medium. In the US, Candace Wheeler (1827–1923) produced patterns combining naturalist plant forms with geometric Japanese-inspired patterns. Wheeler based her designs on American flora and fauna, and superimposed carp on formalized spirals of rippling water in her textiles and, notably, swarming bees and blossom against a honeycomb lattice in the fill of a wallpaper design.

Machine-printing was widely used by this stage, and technical advances allowed firms such as Warren, Fuller & Co. of New York to apply bronze powders in a liquid state, producing multi-coloured papers highlighted with gold, silver, and bronze tints, which created a shimmering effect of illusory depth. Lincrusta-Walton, a composition material evocative of 17th-century embossed leather wall coverings and often gilded, satisfied a demand for high-relief wallpaper.

2 *The* Bamboo *wallpaper designed by E.W. Godwin in 1872 demonstrates a free and bold use of Japanese motifs which was reproduced in bold, flat colours inspired by Japanese woodblock prints, or ukiyoe. 54 x 54cm/21¼ x 21¼in.*

1 *Christopher Dresser's designs for wallpaper and frieze combine flat abstracted plant forms with, in the filling, Celtic interlacing. The harmonious colour scheme was calculated not to overpower interiors.*
3 *The rhythmic qualities of line are unleashed in Walter Crane's watercolour and gouache* Swan *dado designed in 1877 to accompany his* Iris and Kingfisher *filling. 53.3 x 53.3cm/21 x 21 in.*

Friezes

1 *An interesting comparison with Candace Wheeler's design (opposite), Bruce Talbert's frieze was part of a scheme designed for Jeffrey & Co. in 1877. A scrolling cloud motif derived from oriental art provides a subtle but lively background to the design.*

2 *Shortly after his return from Japan Christopher Dresser designed this Anglo-Japanese wallpaper frieze which was manufactured by William Cooke & Co. in 1878.*

Arts and Crafts

c.1880–1920

The Arts and Crafts Movement began as an English decorative arts movement in the second half of the 19th century. It was a rebellion against the Victorian fashion for inventive sham and over-elaborate design and it made a concerted attempt to break down established barriers between artists, designers, and craftpeople. As well as a style, it was a movement of ideas about work, art, and society, developed by eminent writers, architects, and artists from Thomas Carlyle (1795–1881), A.W.N Pugin (1812–52), and John Ruskin (1819–1900) to William Morris (1834–96) – the father figure of the movement.

In 1861 Morris and his friends set up Morris, Marshall, Faulkner & Co. to design and produce domestic decorative arts together with ecclesiastic stained glass. The architect Philip Webb (1831–1915), the Pre-Raphaelite artists Ford Madox Brown (1821–93), Edward Burne-Jones (1833–98), and Dante Gabriel Rossetti (1828–82), as well as Morris himself, all designed for the firm. From the 1870s, trading as Morris & Co., the company was associated with a number of younger designers including the metalworker, W.A.S. Benson (1854–1924). William De Morgan (1839–1917) designed tiles for both Morris & Co. and the Century Guild founded in 1882 by A.H. Mackmurdo (1851–1942) along similar lines. Although its output was limited, Century Guild furniture, wallpaper, and textiles influenced C.F.A. Voysey (1857–1941) and other British Arts and Crafts designers as well as avant-garde figures such as Henri van der Velde (1863–1957) who were more closely connected with Art Nouveau.

Morris's writings, lectures, and the force of his personality had as much impact on the next generation as his practical example. In 1884, architects, designers, artists, and manufacturers set up the Art Workers' Guild, which was the first of several new cross-disciplinary organizations that attempted to create a fresh approach to the design and making process. The associated group, the Arts and Crafts Exhibition Society, was named by the bookbinder, T.J. Cobden-Sanderson (1840–1922) in 1887, and his phrase, "Arts and Crafts," became the generic title of the movement.

The Arts and Crafts Movement was based on simple forms, an almost sensuous delight in materials, and the use of nature as the source of pattern. The generation born in the 1850s and 1860s were at the forefront of the movement. They were passionate about the decorative arts and the processes of making. Their work could be highly decorated but was often extremely plain, taking inspiration from vernacular traditions. The roughness and simplicity of some work could be crude but the richness of many interior schemes and individual designs

Left: C.F.A. Voysey, Britain, design for a clock case painted in oils, 1895. Voysey incorporated mottoes into his work, and invested motifs such as the tree and dove with symbolic meanings. These elements became part of the design vocabulary of the Arts and Crafts Movement. Ht 78.5cm/31in, w.56cm/22in.

Opposite: the refreshing simplicity and scale of much Arts and Crafts work made it particularly appropriate for the domestic interior. Woven and printed textiles by Morris & Co. are shown here with pottery by the Martin Brothers and William De Morgan, and a silver-plated candlestick by W.A.S. Benson.

1 *Ernest Barnsley, the library at Rodmarton Manor, Gloucestershire, 1909–26. Local oak and stone provide the unifying factor between the landscape, the house, and the furniture, creating a spartan yet restful atmosphere. The garden beyond was treated as a series of outdoor rooms with formality near the house giving way to more natural planting.*
2 *A.T.J. Cobden-Sanderson,* Ecce Mundus: Industrial Ideals and the Book Beautiful, *1904, printed by the Doves Press and bound by the author. Cobden-Sanderson developed craft skills as a bookbinder, using natural forms and geometric patterns. His intellectual and literary skills found expression in the Doves Press, which he founded with Emery Walker in 1902.*

was visually stunning. Ordinary domestic items for the middle-class home – kitchen dressers, kettles, and curtains – were considered worthy of serious artistic endeavour. Amateur work, often by women, was encouraged while the female role as consumer and decorator within the home was increasingly valued.

The Arts and Crafts Movement was a rebellion of both substance and style. Its power came from the conviction that art and craft could change and improve people's lives. Some of those involved with the movement were socialists and many more had a radical approach to art, work, and society. The written word and therefore the associated book crafts played an important role in establishing and popularizing the movement. With the printer, Emery Walker (1851–1933), Morris set up the Kelmscott Press in 1890; others in Britain, Germany, and the United States followed suit. The crafts of bookbinding, lettering, and typography were developed and, through the work of Edward Johnston (1872–1944) in particular, these impacted on design throughout the first half of the 20th century.

Arts and Crafts designers were concerned with methods of production, partly as a reaction against the shoddy nature of much Victorian mass-production and also to provide creative and satisfying employment. Some designers such as Voysey and M.H. Baillie Scott (1865–1945) entrusted their designs to a few reputable manufacturers. Machine production and technology were embraced where they performed a useful role, for example in the precisely engineered metalwork of W.A.S. Benson; however, hand craftsmanship was particularly valued both for aesthetic considerations and because it could provide satisfying work for craftsmen. Craft guilds or workshops emulating Ruskin's Guild of St George were set up. C.R. Ashbee's Guild of Handicraft (1888–1908) and the Haslemere Peasant Industries (1896–c.1931) in Britain and, in the US, the Byrdcliffe Colony (1902–15) are typical of the range of workshops which provided training and employment.

The Arts and Crafts Movement believed in learning from tradition. Historic and foreign styles were studied, absorbed, and used in the evolution of new designs. Designers such as De Morgan and C.R. Ashbee (1863–1942) revived long-forgotten techniques such as lustre glazing and lost wax casting by a process of both research and trial and error. The architect and designer,

Ernest Gimson (1864–1919) described the Arts and Crafts approach, writing "I never feel myself apart from my own times by harking back to the past, to be complete we must live in all the tenses, past, future as well as present." Following Morris's example, the medieval period with its rich narrative tradition was an important source of inspiration. Designers also echoed the Aesthetic Movement's admiration for Japanese art as well as looking to Renaissance Europe, India, and the Middle East for their creative vision.

In a similar manner to Islamic art, much Arts and Crafts decoration was based on plant forms. Both Morris and John Sedding (1838–91), whose architectural office provided a training ground for many leading designers including Gimson and Henry Wilson (1864–1934), emphasized the importance of drawing from nature for its uplifting qualities and to avoid staleness. The natural rhythms and patterns of plants and flowers were the reflection of a purity of approach. The Arts and Crafts designers reacted violently against the distortion of natural forms adopted by Art Nouveau in continental Europe. Symbolism, however, played an important role in both movements. Motifs such as the heart or the sailing ship which represented the journey of life into the unknown reappear with regularity throughout the work of the Arts and Crafts community.

The British Arts and Crafts Movement found willing converts in North America from 1890 onwards. Following rapid industrial expansion in the post-Civil War period, a centralized, urban, and industrial society had emerged in large parts of the United States. Between 1860 and 1900 the number of office workers had tripled and for many individuals the Arts and Crafts Movement provided an alternative to urbanized dwelling and the resulting loss of autonomy. The main areas of craft activity included the eastern seaboard from Boston southwards to Philadelphia, the central region around Chicago, and southern California. Individual designer-makers set up studios alongside craft colonies and large semi-industrial workshops.

Arts and Crafts influence in Britain, the United States, and continental Europe encouraged the use of design to improve industrial manufacture. In many cases rural crafts and folk art were also revitalized. The reappraisal of native folk traditions as part of a search for national identity linked the Arts and Crafts Movement to popular nationalist movements particularly in Norway, Finland, Ireland, and Hungary.

The Arts and Crafts Movement has made a powerful and pervasive contribution to international design. Art schools and technical colleges such as the Central School of Arts and Crafts in London played a significant role in fostering the movement. In turn the Arts and Crafts approach influenced the teaching of art, craft, and design in Britain, the United States, and, to a lesser extent, in Germany through to the 1950s. Its influence on design runs from Art Nouveau through to the Bauhaus, the Modern Movement, and contemporary craft practice, while many furniture makers working today still see their roots in the work of designers such as Baillie Scott, Gimson, and Voysey.

4 William Morris, sketches, 1893. His doodles of plants and flowers on a socialist leaflet about the plight of the miners indicate the dynamic relationship between the Arts and Crafts, work, and society.

3 *Compton Pottery, planter, c.1910. Inspired by the Home Arts and Industries Association, Mary Seton Watts (1849–1938) set up craft classes for local people in the village of Compton, near Guildford, Surrey. The school sold its garden ornaments in grey and red terracotta, decorated with Celtic motifs, through Liberty's in London. W. 51cm/20in.*

British Furniture

Celebrating Woodworking Crafts

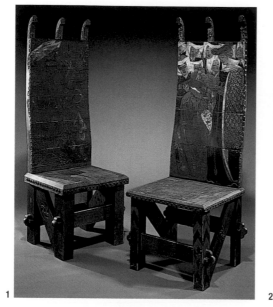

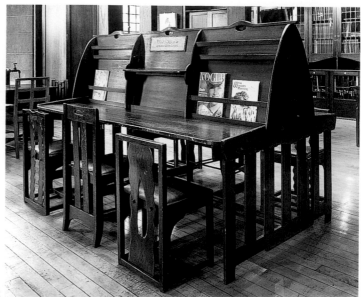

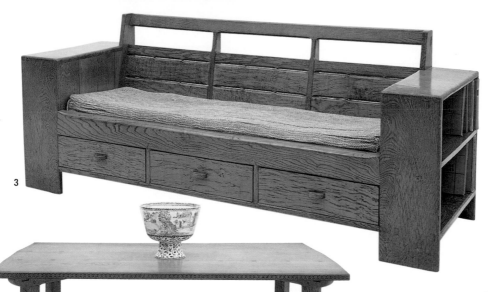

1 *William Morris and Dante Gabriel Rossetti, chairs, 1856–7. The design, inspired by Medieval manuscripts, features structural details such as pinned joints and tall chamfered uprights. Ht 1.4m/4ft 7½in.*

2 *Charles Rennie Mackintosh, desk and chairs for the library, Glasgow School of Art, 1910. The stained cypress supports of this desk each have a different design relating to the library's architectural features. Desk ht 1.36m/4ft 5in.*

3 *Eric Sharpe, oak settee, c.1929. Arts and Crafts designers had a tradition of incorporating exposed constructional features in their furniture designs. L. 1.75m/5ft 9in.*

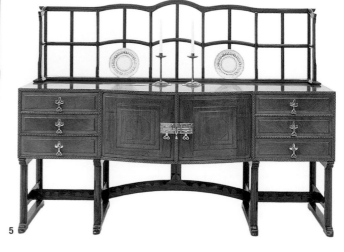

4 *Sidney Barnsley, oak dining table, 1923–4. The Barnsleys adapted traditional woodworking techniques to add a distinctive edge to their designs. The chamfered underframing derives from the hayrake. Bowl by Alfred Powell (see p.287). Table w. 1.95m/6ft 5in.*

5 *Ernest Gimson, sideboard and plate stand, 1915. Arts and Crafts designers used walnut for its fine grain and links with classic English 17th- and 18th-century design. Here it is strikingly combined with macassar ebony. Ht 1.54m/5ft, w. 2.05m/6ft 8¼in.*

3 Louise Powell and Peter Waals, detail of the Woodpecker cabinet, 1920s. The drawer fronts of this piece were veneered in satinwood, providing a dappled background for Louise Powell's oil painted design.

1 *Peter Waals, detail of a chest of drawers, c.1920. The chamfered detailing to the drawer fronts and the lines of gouged decoration reflect the light and add vigour and movement to this unpolished oak piece.*

2 *Arthur Romney Green (1872–1945), detail of a chest of drawers, 1920s. Normally out of sight, these beautifully cut dovetails enhance the design, like the contrasting oak body and the figured macassar ebony drawer front.*

4 *George Walton, Brussels chair, c.1899. Walton added the ubiquitous heart-shaped cutout motif to an elegant form inspired by 18th-century designs. Ht 1.04m/3ft 5in.*
5 *C.F.A. Voysey, Kelmscott Chaucer cabinet, 1896. The rectilinear design combined with the distinctive capped vertical lines is enhanced by the restrained brass and suede decoration. Ht 1.33m/4ft 4in.*
6 *W.A.S. Benson and G. Heywood Sumner, cabinet for Liberty, London, 1905. This mahogany cabinet combines strong horizontal and vertical lines with elegant proportions. Ht 1.67m/5ft 6in.*

The phrase "good citizen's furniture" coined by William Morris in 1882 expressed the intensely moral character of the Arts and Crafts Movement. It emphasized the central role of simple domestic pleasures and the populist audience at which the movement was targeted: the middle classes rather than an artistic élite.

The Arts and Crafts Movement was based around the home. The Gothic style adopted by High Victorian architects such as William Burges (1827–81) and by Philip Webb in the 1860s and 1870s was not particularly appropriate for a domestic scale. A new approach was developed based on simple lines, exposed construction, and rural carpentry traditions. Revealed joints such as beautifully-cut cogged dovetails enhanced the decorative quality of the wood and fitted in with Morris's ideas about honesty. His comment that furniture ". . . should be made of timber rather than walking-sticks" was taken as support for framed-and-panelled construction in solid wood. Large tables with stretchers chamfered to the design of the traditional farm hay rake were both decorative and practical. The striking grain effects of planks of quartered oak or figured walnut panels meant that, for Arts and Crafts designer-makers, additional decoration was often superfluous or was restricted to carpentry techniques such as chip-carving and gouging which could create a rich effect on the surface.

The strong vertical and horizontal lines of much Arts and Crafts furniture reflected the emphasis on simplicity and fitness for purpose in the architecture of the period. The most influential designers – C.R. Ashbee, Ernest Gimson, and C.F.A. Voysey – were architects, and furniture was an important part of their interiors. They shared the interest of the Aesthetic Movement designer E.W. Godwin (1835–86) and Ford Madox Brown in Japanese art, using geometric effects such as lattice work sometimes softened by chamfering. Even Charles Rennie Mackintosh (1868–1928), whose work grew out of the Arts and Crafts Movement even though it is more often characterized as Art Nouveau, produced designs in the same idiom. Features of old work, particularly the chests and cabinets

Design Classics

2 *Ambrose Heal, part of a dining suite, 1938. A late example illustrating the enduring appeal of the Arts and Crafts approach to furniture. Heal successfully promoted straightforward designs to a middle-class market. Ht 91.5cm/36in.*

1 *Charles Rennie Mackintosh, card table, 1898–9. A functional yet powerful design based on vernacular traditions of woodworking. The pierced and carved motifs are derived from natural forms. Ht 61cm/24in.*

Influences

1 *Sidney Barnsley, stationery box, c.1905. The crisp geometric inlay in mother of pearl on this oak box was inspired by Byzantine architecture and decoration. L. 29cm/11½in.*
2 *Reginald Blomfield for Kenton & Co., cabinet on a stand, 1891. The decorative geometry of the front and the tension between the rectilinear design of the cabinet and the precisely turned front legs of the stand create a strong impact. Blomfield drew inspiration from 18th-century inlaid furniture. Ht 1.43m/4ft 8½in.*

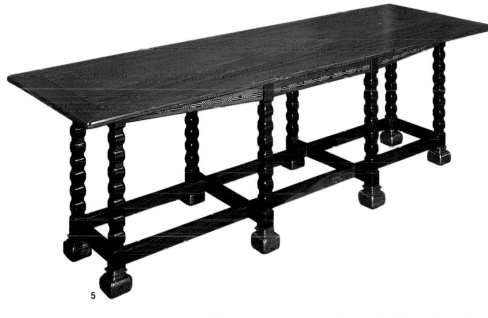

3 *Charles Spooner, cabinet on a stand, c.1910. A teacher at the London Central School of Arts and Crafts, Spooner emphasized the close relationship between design and craft. Ht 1.27m/61¼in.*
4 *Ambrose Heal, Newlyn bedroom furniture, c.1898. The woodcut by the architect C.B.H. Quennell helped to market this range of plain oak bedroom furniture by setting it in its Arts and Crafts context.*
5 *W.R. Lethaby, hall table, c.1892. The scale and proportions of this mahogany table are based on medieval prototypes. Despite its elegance and restraint – the inlaid dots round the edge of the top were a feature of Lethaby's designs – it makes a powerful visual impact. L. 2.44m/8ft.*

of the 17th and 18th centuries, were also absorbed and distilled into new rectilinear forms. The radical approach of these architect-designers influenced the Wiener Werkstätte (1903–14) and the work of the Americans, Charles P. Limbert Co. (1902–44) and Greene & Greene, as well as the furniture of Gordon Russell (1898–1980) who worked at Broadway, Worcestershire, in the 1920s and '30s.

Although simplicity was the dominant feature of the Arts and Crafts Movement, it was an adaptable style. Walter Crane (1845–1915) wrote in 1913 about "the simplicity and splendour of the Morrisian method" while Morris justified "the blossoms of the art of furniture as much as for beauty's sake as for use." Ecclesiastical commissions were an obvious area where designers could give free expression to their love of pattern and rich materials. But in addition, Morris and his friends had painted pieces of domestic furniture for their own use in the 1860s, while the simple four-square chests and cabinets produced by designers such as Baillie Scott, Gimson, and Peter Waals (1870–1937) were particularly suitable for

painted decoration, veneers, or decorative inlays. As well as using patterns inspired by nature, designers also looked to India, the Middle East, and Byzantium for decorative inspiration. In the furniture trade, small details such as inlaid floral motifs and heart-shaped cut-outs created an immediate impression of Arts and Crafts style.

Certain types of furniture were regularly used in Arts and Crafts interiors. Medieval pieces such as settles, dressers, long tables, and benches were still found in country inns and houses. Such pieces were associated with communal living and their simple lines formed the inspiration for new designs. Settles and dressers by Voysey and Baillie Scott were sometimes built in to eliminate awkward corners and simplify cleaning. Dressers with plate racks were designed by Gimson and Sidney Barnsley (1865–1926) and were also produced very successfully for a mass market by Ambrose Heal (1872–1959).

The importance of music and communal entertainment to the Arts and Crafts Movement encouraged designers such as Burne-Jones to produce decorated pianos. A range

1 *Ernest Gimson, dresser in oak stained black, c.1902–5. Like the settle, the dresser was an archetypal piece of Arts and Crafts furniture. Features such as the latch handles and the chip-carved decoration derive from the vernacular tradition. Ht 1.68m/5ft 6½in.*
2 *Charles Rennie Mackintosh, ladder-back chair for Windyhill, Kilmalcolm, 1901. As well as his more individual rectilinear pieces, Mackintosh produced a number of designs influenced by traditional country chairs. Ht 1.03/3ft 5in.*

of innovative designs were developed by Baillie Scott and Ashbee with the firm of John Broadwood & Sons.

Morris & Co.'s success with the adaptation of a light, adaptable Sussex chair was emulated by many Arts and Crafts designers. Simple rush-seated chairs were designed by Ashbee and the Scottish architect George Walton (1867–1933) among many others. Gimson, working in conjuction with Edward Gardiner (*d*.1958), was the most prolific, producing numerous designs for ladder-back chairs.

After 1900, cane chairs became a popular choice for commercial and domestic settings. Harry Peach (1874–1936) introduced a new range at the Dryad Workshops in Leicester designed by Benjamin Fletcher (1868–1951) to compete with imports from continental Europe.

The 1890s saw painters in central Europe joining forces against the art establishment and developing two distinct approaches to the Arts and Crafts Movement. One of these was based on individuality. The Belgian artist, Van der Velde, was influenced by Morris's and Crane's theories about the unity of the arts. At Mathildenhöhe near

Darmstadt, Ernest Ludwig, the duke of Hesse had commissioned work from the British designers, Baillie Scott and Ashbee. In 1899 he assembled an artists' colony. Young designers such Peter Behrens (1868–1940) and Joseph Maria Olbrich (1867–1908) produced simple furniture based on British forms which was characterized by their painterly sense of decoration. As well, in places as disparate as Russia, Hungary, and Ireland, craft centres were set up in country areas by philanthropic landowners. They brought local craftspeople into contact with artist-designers to enhance the rural economy. Basic skills such as woodcarving were taught and furniture was produced in tune with the Arts and Crafts spirit, based on traditional craft forms. Intricately carved and painted pieces were decorated with symbols of folk and religious imagery.

The second approach was a contrasting one. Workshops such as the German Vereinigte Werkstätten championed design for machine production. Richard Riemerschmid (1868–1957) produced elegant furniture using veneers and laminates which were suitable for batch production.

European Furniture

Functionalism and Decoration

1 *Otto Prutscher, mantel clock, c.1908. Prutscher was influenced by the work of the Glasgow School. The distinctive rectilinear form is enhanced by the geometric inlays in wood and mother of pearl. Ht 36.5cm/14⅜in.*

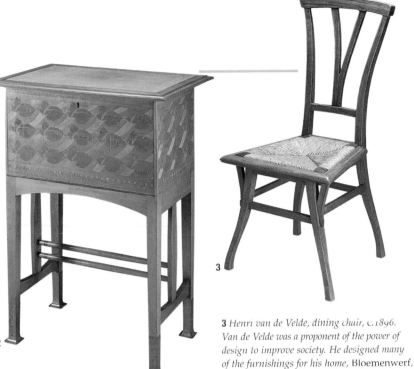

3 *Henri van de Velde, dining chair, c.1896. Van de Velde was a proponent of the power of design to improve society. He designed many of the furnishings for his home, Bloemenwerf, including this chair. Ht 94cm/37in.*

2 *Leopold Bauer, cabinet for a postcard collector, c.1901.The form and inlaid decoration of this German cabinet show the influence of English Arts and Crafts designers such as Ashbee, Gimson, and Voysey. Ht 90cm/35½in.*
4 *Peter Behrens, dresser for the Deutsche Werkbund, c.1907. This association of workshops, designers, and architects tried to influence mass-production through the example of such well-designed pieces. Ht 1.9m/6ft 2in.*

5 *Richard Riemerschmid, oak linen chest, 1902. This piece relates to Arts and Crafts designs, but the intricacy of the metal hinges is pure Art Nouveau. Their abstract yet naturalistic pattern derives from popular botanical drawings. Ht 2.11m/6ft 11in.*
6 *Carl Larsson, The Artist's Studio, 1899. This watercolour of Larsson's cottage in northern Sweden depicts furniture and textiles created by Larsson and his artist wife Karin.*

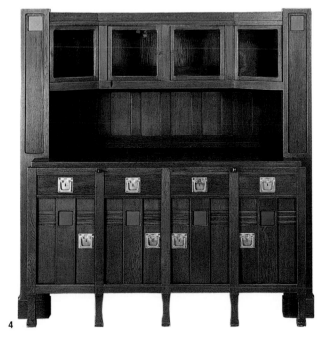

American Furniture

Arts and Crafts for the Wider Market

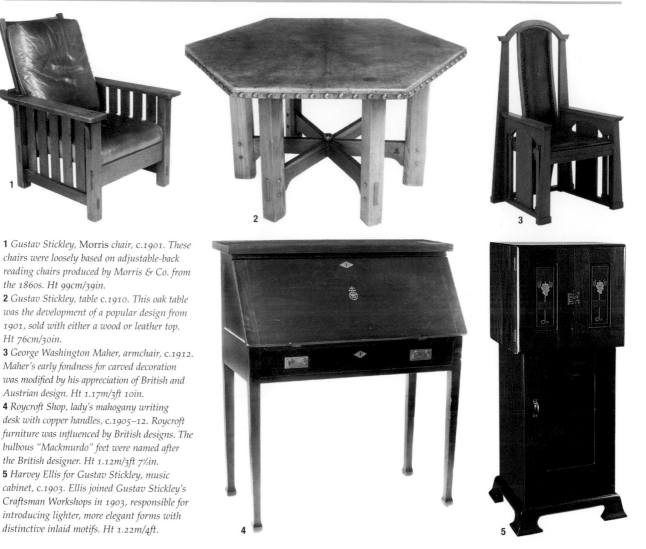

1 *Gustav Stickley, Morris chair, c.1901. These chairs were loosely based on adjustable-back reading chairs produced by Morris & Co. from the 1860s. Ht 99cm/39in.*

2 *Gustav Stickley, table c.1910. This oak table was the development of a popular design from 1901, sold with either a wood or leather top. Ht 76cm/30in.*

3 *George Washington Maher, armchair, c.1912. Maher's early fondness for carved decoration was modified by his appreciation of British and Austrian design. Ht 1.17m/3ft 10in.*

4 *Roycroft Shop, lady's mahogany writing desk with copper handles, c.1905–12. Roycroft furniture was influenced by British designs. The bulbous "Mackmurdo" feet were named after the British designer. Ht 1.12m/3ft 7½in.*

5 *Harvey Ellis for Gustav Stickley, music cabinet, c.1903. Ellis joined Gustav Stickley's Craftsman Workshops in 1903, responsible for introducing lighter, more elegant forms with distinctive inlaid motifs. Ht 1.22m/4ft.*

Inspired by British examples, the United States wholeheartedly embraced the Arts and Crafts Movement. British journals such as *The Studio* and *The Cabinet Maker and Art Furnisher* introduced the work of Morris, Mackmurdo, Baillie Scott, Voysey, and Ashbee to American audiences. Craft communities were set up to promote craftwork. In 1901 the architect William Price (1861–1916) set up workshops in a disused textile mill in Rose Valley near Philadelphia. Ralph R. Whitehead (1854–1929), who had met Morris at Oxford, established the Byrdcliffe Colony at Woodstock in 1902, and the Roycroft Community at East Aurora near Buffalo was set up to market the Arts and Crafts philosophy as a business.

Gustav Stickley (1858–1942) combined elements of Arts and Crafts design with American vernacular traditions to create the popular "Craftsman" or "Mission" style. His factory in Syracuse produced solid wood furniture in quarter-sawn oak fumed to emphasize the grain. Strong vertical lines and visible constructional devices characterized the designs. A short-lived but important contribution was made by the architect Harvey Ellis (1852–1904), whose well-proportioned designs often included the use of inlaid floral motifs. In 1901 Stickley established *The Craftsman*, an influential magazine which promoted Arts and Crafts nationally, providing drawings for furniture as well as articles about design and social change. A consumer culture fuelled by such magazines ensured that good design reached a mass audience.

Frank Lloyd Wright (1867–1959) worked in Chicago, where he became the central figure in the Prairie School, and in California. His furniture echoed the strong horizontal lines, traditional materials, and vernacular style of his architectural work. Most was machine-made to achieve the desired clean-cut effect. In contrast Charles Sumner Greene (1868–1957), working with his brother Henry, was enthusiastic about handwork and employed skilled craftsmen to create pieces with curved lines and pierced shapes. Both Wright and the Greenes produced beautifully proportioned furniture and interiors that combined elements of Japanese and Arts and Crafts design.

6 *Charles P. Limbert Co., oak table, c.1905. Limbert popularized British and European designs. The rectangular cut-outs on the cross-supports echo the geometric designs of Baillie Scott and Mackintosh. Ht 46cm/18in.*
7 *Dard Hunter, Reception Room of the Roycroft Inn, c.1910. Japanese prints inspired Hunter's stylized use of black outlines, flat colour, and an angled viewpoint.*

Architects and Interiors

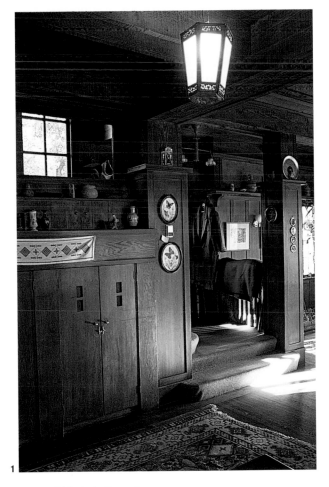

2 *Frank Lloyd Wright, high-backed oak chair for the Hillside House School, Wisconsin, c.1903. Wright was inspired by the simple forms of Japanese art. The design echoes the strong vertical lines and planes of his architectural work. Ht 99.5cm/39¼in.*
3 *Charles and Henry Greene, the dining room, Gamble House, Pasadena, California, 1908–9. The Greenes combined the Arts and Crafts approach with elements from Japanese architecture. The wood panelling and furniture create a cocoon of warm repose.*

1 *Bernard Maybeck, Greyoaks, front entry and stairway, 1906. Local redwood timber left complete with the marks of the saw dominates the interior of this Californian country house built by Maybeck for the timber magnate, J.H. Hopps.*

Ceramics

Painted Decoration

1 William De Morgan, rice dish decorated by Charles Passenger, c.1900. Islamic motifs and the "Persian" colour palette were a major influence on De Morgan's work. Diam. 44.5cm/17½in.

2 Alfred Powell, lidded pot for Wedgwood, 1920s. The Powells painted directly on to the porous, unglazed earthenware body, a technique that necessitated rapid unhesitating brushwork. Ht 10cm/4in.

3 Louise Powell, ewer for Wedgwood, c.1920. Louise Powell found inspiration for both abstract and floral patterns in Islamic pottery and English 16th-century embroidery. Ht 30cm/11¾in.

4 Roycroft cup and saucer, Buffalo Pottery Company, c.1910. This features the mark of the Roycroft colony derived by Elbert Hubbard from a Venetian 15th-century printer's motif. Ht 5cm/2⅛in.

5 Hans Christiansen, design for a covered vase 1901. Christiansen was one of the painters at the artists' colony at Darmstadt who turned his skills to domestic design. The clear colours and flowing naturalistic patterns of the English Arts and Crafts Movement are reflected in his work.

6 Clifton Pottery, Indian jug, c.1910. One of numerous small-scale art potteries set up in the United States, the Clifton Pottery used native American pottery from Arizona as inspiration for the painted decoration on its "Indian" wares.

Modelled Work

1 Martin Brothers, vase, 1885–1900. Only a minority of Arts and Crafts potters appreciated the plasticity of clay. This vase, with modelled and incised nodules applied to the body, reflects the Martin Brothers' individual approach and interest in organic forms. Ht 26cm/10½in, diam. 17cm/7in.

2 *Ruskin Pottery wares, 1925–6. A number of art potteries, including the Ruskin Pottery in Smethwick, England, specialized in high-temperature glaze effects which were inspired by Chinese monochrome and* sang-de-boeuf *pottery. Ht 25.5cm/10in.*

ARTS AND CRAFTS | CERAMICS

1 *Eugene Lion, France, two earthenware vases, c.1890. Lion was among a number of artists at Saint-Amand near Dijon who developed a style of drip-glazed decoration inspired by Japanese pottery. Ht 30cm/11¾in and 51.5cm/20¼in.*

3 *Shoji Hamada, stoneware vase with a* temmoku *glaze, 1923. Hamada, who worked with Bernard Leach in 1920 at St Ives in Cornwall, established a craft colony in Mashiko, later Japan, based on his English experiences. Ht 16cm/6¼in.*

Large manufacturers had almost complete control over the production of ceramics because of the complexity and cost involved. Competition encouraged established firms in Britain to use artistic designs for industrial production, sometimes setting up small studio workshops such as that at Doultons in Lambeth, or specific art pottery ranges such as Pilkington's Royal Lancastrian.

The Martin brothers, who had worked at Doultons, set up one of the few small-scale potteries in 1873. They worked in stoneware, producing vessels and figures with modelled, incised, and relief decoration. The designs by Robert Wallace Martin (1843–1924) were based on plant and animal forms, or abstract geomorphic decoration. Individual designs were also produced by Edmund Elton (1846–1920) in Somerset, George E. Ohr (1857–1918) in Biloxi, Mississippi, and by the leading American potter, Adelaide Alsop Robineau (1865–1929), who produced porcelain with laborious incised and relief decoration.

De Morgan began decorating tiles and pottery in 1872. He experimented with glazes, particularly the lustre effects of 16th-century Hispano-Moorish pottery, and his bright colours and flowing naturalistic designs were widely emulated. In 1903 Alfred Powell (1865–1960) and his wife Louise (1882–1956) began a long association with Josiah Wedgwood & Sons in Stoke-on-Trent, England. Their designs ranged from abstract repeating patterns based on plant forms to detailed buildings and landscapes. From 1906 they created a range of simple designs for the new hand-painting studio at Wedgwood. The small-scale repeating patterns were adopted at Darmstadt and by many craft potteries in the United States.

European and American potters also experimented with surface decoration, looking to oriental examples for inspiration. In France, potters such as Eugène Lion developed dramatic glaze effects for their simply shaped pots, a style adopted by Bernard Moore and the Ruskin Pottery in Staffordshire, England. The development of smaller kilns in the early 20th century helped to create the unity of approach to the form and decoration of ceramics which led to the studio pottery movement in the 1920s.

Glass

Drinking Glasses

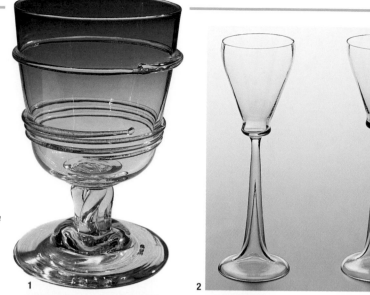

1 *Philip Webb for James Powell & Sons, claret glass, c.1860. With its trail of applied decoration inspired by Venetian designs, this glass has a tactile quality which relates to Webb's admiration for the hot-worked glass technique.*
2 *Richard Riemerschmid, wine glasses from the Menzel service, c.1903. Riemerschmid's simple, elegant, sculptural designs effectively exploit the translucency of the material.*

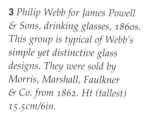

3 *Philip Webb for James Powell & Sons, drinking glasses, 1860s. This group is typical of Webb's simple yet distinctive glass designs. They were sold by Morris, Marshall, Faulkner & Co. from 1862. Ht (tallest) 15.5cm/6in.*

The demands of 19th-century entertaining and, in Britain, the removal of excise tax on glass in the 1840s led to the production of large amounts of domestic glassware. It was based on heavily cut lead glass, a technique that John Ruskin vehemently criticized since it was both at odds with the fluidity of molten glass and a wasteful process in conjunction with such a breakable material. He admired 16th- and 17th-century Venetian glasses, examples of which were widely exhibited for the first time in the 1850s. Their curved forms and light, fantastical decoration were widely copied.

Venetian and northern European examples inspired a number of deceptively simple designs by Philip Webb for Morris, Marshall, Faulkner & Co. in the 1860s. These solid, plain glasses were produced by the firm of James Powell & Sons who also made stained glass for the company at their factory in Whitefriars, London. The firm became synonymous with modern artistic glass from the 1870s under the direction of its designer-manager, Harry Powell (1864–1927), who developed a style inspired by

the proportions, clarity, and elegance of Venetian glass. He also experimented with different uses of coloured glass and developed a streaky white opalescent material.

Powell used drawings from nature as the basis for his engraved designs. Despite the rejection of cut glass by Ruskin and the Arts and Crafts Movement, he gradually introduced some shallow-cut glasswares inspired by Roman pieces. This softer, more painterly approach to cut glass continued into the 20th century in the work of designers such as Clyne Farquarson (*fl.*1930s), Keith Murray (1892–1981), and Gordon Russell.

Powell's personal contacts through the Art Workers' Guild and the technical excellence of the firm encouraged designers such as Ashbee and Benson to incorporate pieces of Whitefriars glass in their designs. The work of James Powell & Sons was exhibited widely and the firm was a major force in glass design through to the 1960s. Its simple designs based on the qualities of the raw material influenced designers including Riemerschmid and Behrens and Scandinavian manufacturers such as Orrefors.

Form and Decoration

1 *Philip Webb, designs for table glass, 1860s. Webb studied Venetian and northern European drinking glasses and produced simple shapes which relied on their form and proportions for impact, rather than on decoration.*

2 *G.M. Heywood Sumner for James Powell & Sons, covered cup, 1898. The engraved and gilt plant forms on the bowl soften the cut flint glass form. As well as Heywood Sumner, T.E. Jackson and George Walton produced tableware designs for the London firm. Ht 32.5cm/12¾in.*

3 *Otto Prutscher, champagne glass, c.1907. This Austrian vessel is of mould-blown glass with a coloured overlay and a cut design. The square shapes characteristic of the Viennese Secession have been cut so that the stem has the appearance of a delicate chain. Ht 21cm/8¼in.*

4 *Gordon Russell, designs for glass cutting, 1927. Russell designed domestic glassware for a number of British manufacturers in the 1920s. Vessels decorated with these experimental designs for cut glass were produced by James Powell & Sons.*

1

2

3

4

VARIOUS DESIGNS FOR GLASS CUTTING

585

Decorative Wares

1

2

1 *Omar Ramsden, green glass vase with silver mounts, c.1914. The design of this British vase was based on a piece in a painting by the 16th-century German artist Hans Holbein. The techniques of blown glass and hammered silver were ideally suited to its sensual curves. Ht 44cm/17¼in.*

2 *James Powell & Sons and W.A.S. Benson, glass vase in a bronze stand, 1903. The Powells and Benson were involved with experimental work; Harry Powell's experiments with metal inclusions in coloured glass, as used in this vase, were indicative of their approach. Benson designed the stand. Ht 36cm/14¼in.*

Silver and Metalwork

Techniques and Decoration

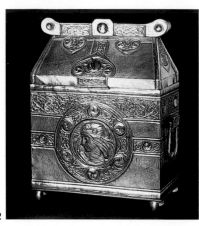

3 *Shreve & Co., kettle on a stand, c.1910.*
American metalworkers were inspired by the
hammered silverwork of Ashbee and the British
Arts and Crafts Movement. Ht 25.5cm/10in.

1 *John Pearson, copper plates,*
c.1892. Pearson's designs
featuring grotesque birds, fish, and
foliage hammered in relief, inspired
the development of the Newlyn art
metal industry in Cornwall which
continued in production until
1939. Diam (largest) 59cm/23¼in.

2 *Mary Houston, casket, 1902.*
Houston, based in London and
Dublin, used the repoussé
technique to decorate this silver-
plated copper casket. Resembling a
Celtic shrine, it has intricate bands
of ornament and an idealized
female head. Ht 24cm/9½in.

4 *C.R. Ashbee, designs for boxes*
and panels, 1906. Ashbee's plain
boxes and dishes were often
decorated with sparkling and
colourful enamel plaques of
flowers, animals, landscapes,
and narrative scenes.

5 *C.F.A. Voysey, copper pen tray,*
coated brass handle, and inkwell,
1895–1903. The metalwork of the
English architect and designer
Voysey were characteristically
simple and complemented his
furniture and interiors.

The earliest Arts and Crafts metal pieces from the 1880s were made in brass and copper. John Pearson (*fl.*1880s–1908) and John Williams (*d.*1951) were both early members of Ashbee's Guild of Handicraft in London. They produced large dishes decorated with hammered repoussé and chased decoration featuring birds, fish, and ships. It was a style of work that became a regular feature of Arts and Crafts exhibitions because of its visual impact and because the techniques involved were relatively simple, making it ideally suited to amateur work.

In the 1890s Ashbee and his guild experimented with the techniques of Italian Renaissance metalwork. "Lost wax" casting, which translated modelled work in wax into silver, was used to make the stems and feet of cups as well as jewellery. As Ashbee gained confidence as a designer in silver he developed the most influential Guild of Handicraft pieces. From about 1896, he produced quantities of cups, bowls, and dishes raised from hammered silver sheet metal with looped wirework handles. The silver wires were used singly, in pairs, or as

a twisted group and demanded attention as they swooped in an elegant curve. The otherwise austere vessels were made by hand, and Ashbee liked to leave the surface lightly indented from the small round-headed planishing hammer which had shaped them. This mark of the craftsman's hand is found on much Arts and Crafts metalwork although some, including Liberty's *Cymric* silver and *Tudric* pewter ranges, were made by machine with the hammer marks added as part of the finishing process.

In contrast, many of Voysey's and Benson's designs were for items such as handles, hooks, and components for light fittings, intended for batch production. They were either cast from prototypes or turned or spun on lathes and left with a smooth and polished finish indicative of their machine origin.

Voysey, Benson, and Ashbee influenced countless metalwork designers. The effective use of simple geometric forms and flowing lines can be seen at an international level in the silverwork designed by Oliver Baker (1856–1939) for Liberty's, by Josef Hoffman

Naturalistic Decoration

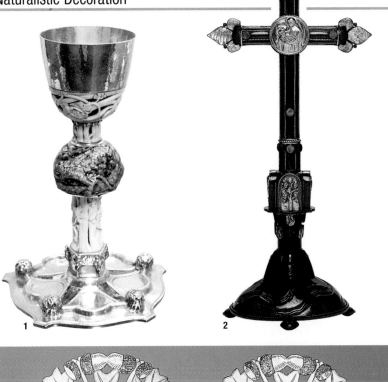

1 *Henry Wilson, chalice for St Bartholomew's Church, Brighton, England c.1898. The techniques and use of silver and silver gilt with carved ivory and enamel suggest the splendour of the finest Renaissance work. Ht 46cm/18in.*

2 *John Paul Cooper, altar cross, 1907. Cooper's work achieved a rich surface texture by combining materials, in this case patinated copper, silver, and mother of pearl. Ht 58.5cm/23in.*

3 *C.R. Ashbee, Guild of Handicraft silverwork, c.1905. Ashbee used intense areas of decoration for his simple, elegant forms. The cylindrical stem of the cup and cover is chased and pierced with a foxglove design, and a pattern of leaves has been chased round its bowl. Cup ht 37cm/14½in, ladle l. 38.5cm/15in.*

4 *Ernest Gimson, pair of brass candle sconces c.1905. Gimson set up a smithy in the English Cotswolds employing blacksmiths to produce metal fittings such as these. Ht 25cm/10in.*

5 *Gordon Russell, brass candle sconce, c.1922. The acorn and oak leaf motif was popular because of its identification with the English countryside. Ht 30.2cm/12in, w. 25cm/10in.*

Blacksmiths' Work

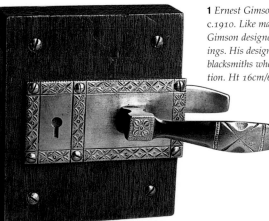

1 *Ernest Gimson, door handle and lockplate, c.1910. Like many Arts and Crafts architects, Gimson designed metal hardware for his buildings. His designs were made by his blacksmiths who also made the stamped decoration. Ht 16cm/6¼in.*

1 *C.R. Ashbee, butter knife for the Guild of Handicraft, 1900. Ashbee used commercially produced silver wires and balls in conjunction with his handmade designs. The twisted handle combined function and ornament. L. 14cm/5½in.*

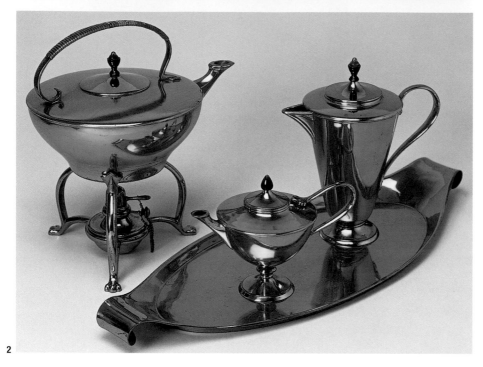

2 *W.A.S. Benson, tea wares, 1894. Benson's designs were machine- spun and cast, often in copper and brass. His workshop, set up in 1880, developed into a well-equipped factory producing domestic wares and light fittings. Kettle ht 28.5cm/11¼in.*

3 *C.R. Ashbee, decanter for the Guild of Handicraft, 1904. This is one of Ashbee's classic designs. A cage of silver wirework encircles the glass body, forms the bold curve of the handle, and provides an elegant support for the finial. Ht 19cm/7½in.*

(1870–1956) for the Austrian Wiener Werkstätte, and by the painter Johan Rohde (1856–1935) for Georg Jensen (1866–1935) in Denmark. Designs by Archibald Knox (1864–1933) which combined spare, elegant shapes with intertwined Celtic patterns were extremely popular.

Late Medieval forms such as decorative caskets and chalices inspired Arts and Crafts designers such as Alexander Fisher (1864–1936) and Henry Wilson (1864–1934), who began working in metal in 1890. Smoothly rounded semi-precious stones and brilliantly painted enamel plaques provided a rich inlaid surface finish to such pieces. An architect and sculptor, Wilson's metalwork is rich in imagery and architectonic forms. He drew from nature and encouraged others to do the same. The naturalistic effect of many Arts and Crafts pieces was enhanced by the bold combination of materials such as amber, coral, bone, ivory, and mother-of-pearl with silver and other metals. Birds, animals, flowers, plants, and trees are found in the simplest metalwork designs such as Gimson's sconces or Voysey's handles as well as in

elaborate pieces such as cups and crosses. The ubiquitous heart motif recurs regularly in pierced or raised forms.

Ashbee's mature style in silver, which developed from about 1906, has a rich and imposing character also found in some of the finest Arts and Crafts silverwork by Wilson and his close associates, John Paul Cooper (1860–1933) and Edward Spencer (1872–1938). Bands of silver mouldings or ropework were used to divide designs into distinct horizontal sections dictated by the construction. Cooper found a ready market for his shagreen-covered boxes with decorative silver mouldings.

Gimson's metalwork designs from 1902 combined simplicity with precision. Handles, fire tongs, and other tools in iron or polished steel were designed to do their job perfectly and are an ergonomic pleasure to handle. Their clean lines were enhanced by a scattering of small chased patterns such as half-moons or dots made by different punches. Gimson established a standard of metalworking which was continued in the Cotswolds by Gordon Russell during the 1920s and 1930s.

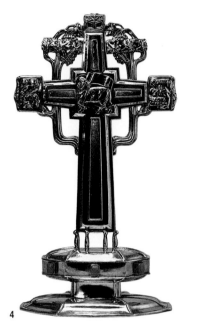

4 *Alexander Fisher, altar cross in silver, amber, and enamel, 1903. The spare geometric cross contrasts with the encircling tree design in chased silver. Ht 40cm/15¾in.*

5 *Archibald Knox, Cymric pitcher for Liberty, 1901. Knox is best known for his use of Celtic ornament inspired by the traditions of his birthplace, the Isle of Man. The controlled curves of his designs were inspirational throughout the 20th century. Ht 38cm/15in.*

6 *Oliver Baker, silver and enamel bowl for Liberty, c.1899. Baker's designs show his interest in Celtic and historic styles. Ht 13.5cm/5¼in.*
7 *Joseph Maria Olbrich, silver box, c.1906. The Austrian-born architect was a member of the artists' colony at Darmstadt. He designed furniture and metalwork and developed a geometric style which relates both to the Arts and Crafts and to the Art Nouveau movements. Ht 18.5cm/7¼in.*

8 *Albin Müller, candlestick in bronzed brass and copper, c.1906. The curved upward sweep of Muller's design is enhanced by the opalescent glass cabochon stones set in the base. Ht 27cm/10¾in.*
9 *Albin Müller, pewter decanter and cups, c.1906. Inspired by the work of Christopher Dresser, Ashbee, and van de Velde, Müller and other German designers produced designs such as this which combine geometric forms and curvilinear shapes. Ht 34.5cm/13½in.*

Textiles and Wallpaper

Embroidery

1 *Alexander Fisher, Rose Tree 1904. Arts and Crafts embroideries, such as this English example, were often worked on silk damask which gave a patterned ground for the design. L. 3.12m/10ft 3in, w. 1.37m/4ft 6in.*

2 *Louise Powell, The Whitebeam Tree hanging, c.1920, embroidery on hand-woven indigo-dyed silk. A tree with squirrels, birds, and fern heads at the base, provided the framework for this embroidery. L. 2.01m/6ft 7in.*
3 *Godfrey Blount, appliqué panel, 1896–7, hand-woven linen. Blount's embroideries provided a flat graphic finish and were adopted as an alternative to stencilled decoration.*
4 *Gustav Stickley, China Tree table runner, c.1910. Stickley, who wanted "a robust sort of beauty" for his interiors, chose unbleached linen embroidered in neutral tones for textiles. L 2.21m/7ft 3in, w. 35.5cm/14in.*

William Morris designed a number of embroideries in the 1860s whose painterly approach contrasted with the prevailing fashion for the precise cross-stitched patterns on canvas popularly known as Berlin woolwork. He was inspired by late Medieval examples to revive the use of crewel work on woollen cloth, a technique that could quickly but effectively cover a large area.

In the 1870s Morris began using plant dyes, especially madder (red) and indigo (blue), in experiments with Thomas Wardle at his dye works at Leek, Staffordshire. Their softer tones were more sympathetic to a painterly approach than the newly popular bright chemical dyes. His daughter May Morris (1862–1938) singled out blue as the most sympathetic colour for embroidery, saying "choose those shades that have the pure, slightly grey, tone of indigo dye." In Deerfield, Massachusetts, the Society of Blue and White Needlework concentrated on that limited colour scheme with a sparing use of other natural dyes. This subtle use of colour characterizes much Arts and Crafts work through to the 1920s. Linen and jute cloths were chosen for embroidery for the strength of their texture; double-woven silk and linen mixtures and damasks were also popular for the same reason.

Morris added texture to some block-printed wallpapers by incorporating background lines or dots in the designs. Exotic handmade papers such as Japanese grass paper were chosen by designers and manufacturers as the basis for stencilled designs for their textural quality.

Flat patterns, whether for printed textiles or wallpapers, required an underlying structure. In his *Trellis* wallpaper of 1864, Morris used latticework to create a basic structure. The use of scrolling acanthus leaves, flowering stems, and other devices to provide underlying construction became more subtle and effective in his later designs. C.F.A. Voysey excelled as a designer of repeating patterns and his wallpapers were lauded by van der Velde in 1893 in an article in the Belgian magazine *Emulation*. He and other Arts and Crafts designers were particularly adept at creating coherent designs for border patterns on rugs, carpets, and

Carpets and Border Patterns

1

2

3

1 *William Morris, hand-knotted Hammersmith carpet c.1890. This large rug, worked in the distinctive Morris colours of indigo blue and madder red, relies on its intricate border of geometric and naturalistic patterns for its decorative effect. L. 1.52m/5ft, w. 1.18m/3ft 10½in.*
2 *Ernest Gimson, embroidered cloth, c.1900. Gimson based many designs on his drawings of plants and flowers. Ht 54.5cm/21½in.*
3 *Jessie Newbery, appliqué cushion cover, c.1900. Newbery's designs were often satin-stitched in silk on heavy linen. The strong outlines have a similar effect to the leading in stained glass. Ht 56cm/22in.*

Flowing Designs and Imagery

1

2

3

1 *George Walton, silk and linen tapestry, c.1895. The flowing lines relate to early chintzes by Morris, such as* Medway.
2 *William Morris,* Flower pot *embroidered cushion cover, c.1878–80. Small domestic pieces such as this, which was based on 17th-century Italian panels, made Morris's work available to a larger market.W. 52cm/20½in.*
3 *J.H. Dearle and May Morris, screen with embroidered panels, c.1885. The geometric simplicity of the screen frames the panels. Ht 1.77m/5ft 10in.*

1 *William Morris, Trellis wallpaper, c.1864. In this early example of Morris's pattern design, the trellis provides a grid structure for the meandering briar rose and birds.*
2 *Phyllis Barron and Dorothy Larcher, pointed pip hand-block printed linen, c.1930. Barron and Larcher revived the craft of hand-block printing on fabric using experimental techniques and producing influential designs.*
3 *M.H. Baillie Scott, block-printed cotton, c.1905. Baillie Scott used the flowers and plants of the English garden as the basis of many designs. This textile has an artless feel belying its strong underlying structure.*

domestic textiles. Care and inventiveness ensured that the border design flowed smoothly round right-angles.

The use of naturalistic imagery in Arts and Crafts embroidery and textiles is closely related to the growing interest in garden design in the 1880s. Morris described the role of nature in textile design as the depiction of "the outward face of the earth." He used traditional English flowers and plants such as marigolds, honeysuckle, and willow boughs in his designs at a time when writers on garden design were criticizing the fashion for imported species such as fuchsias and were in favour of wild or native flowers. In the United States native plants such as the pinecone and the leaf of the maidenhair tree, were used as motifs in embroideries and wallpapers.

Many folk crafts and village industries involved textiles. Traditional rag rugs as well as American Indian and Mexican designs became a feature of Arts and Crafts homes in the United States, and in Britain and America, Arts and Crafts embroideries were produced in kit form, and magazines published designs for copying.

The image of the tree of life, a growing tree, was popular throughout Arts and Crafts design, but it was particularly suited to two-dimensional representation in wallpapers and textiles. It could be an elaborate picture incorporating birds and animals or simplified to an eye-catching graphic motif.

Birds, animals, and human figures feature in the designs of Voysey and of Henry Horne (1864–1916). Walter Crane produced popular designs for wallpapers and domestic textiles which incorporated the classical figures synonymous with much of his work (see p.263). The growing interest in the environment of childhood inspired designs by Voysey, Arthur Silver (1853–96), and others, with a strong narrative element for the nursery.

Block-printed and stencilled linen fabrics by the Omega Workshop in about 1913 heralded a revival in hand-block printing in the 20th century. The most influential exponents were Phyllis Barron (1890–1960) and Dorothy Larcher (1884–1952) who worked during the 1920s and 1930s.

1 *C.F.A. Voysey,* The House that Jack Built *wallpaper design, 1929. This was one of Voysey's most popular nursery wallpapers. From about 1910 he developed a strong narrative element in his two-dimensional designs incorporating images such as the fruit tree which had featured in earlier work.*

2 Robin Hood *frieze, c.1893, Probably designed by Harry Napper for Silver Studio and supplied to the manufacturer Charles Knowles. This machine-printed wallpaper frieze has a stylized pattern reflecting the fashion for oriental designs.*

3 *Silver Studio, wallpaper design, 1905. The uncluttered flat patterns and light, bright colours of this wallpaper reflect the fashion for stencilled designs in the early 20th century.*

4 *Dun Emer Guild, tapestry, c.1904. The Guild trained women within an Irish craft tradition. The sailing ship was a popular Arts and Crafts motif. Ht 80cm/31½, w. 67.5/26½in.*

Art Nouveau

1890–1914

Art Nouveau emerged in the early 1890s and spread quickly across Europe and the United States. It reached a climax at the Paris Exposition Universelle of 1900 before falling into decline in the early years of the new century and collapsing with the outbreak of World War I. The style emerged from the activity of a collection of movements, manufacturers, public institutions, publishing houses, individual artists, entrepreneurs, and patrons. It encompassed architecture, the decorative arts, graphic design, painting, and sculpture and is characterized by various stylistic features which vary according to region.

Most archetypally, Art Nouveau is associated with the sinuous, asymmetric curving line, but the style can also be identified through the use or organic or natural forms or applied decoration; geometric, abstract, or linear form and patterns; the use of specific historical sources; and Symbolism.

Art Nouveau can be most usefully seen as the search for a modern national style, in a period characterized by increasing nationalistic concerns. Fundamentally, it uses modernized decoration as a key approach to style. This movement is known by a variety of names in different countries, including Modern Style, *Le Style Guimard*, *Le Style Metro*, *Style 1900*, *Jugendstil*, *Stile Floreale*, *Stile Liberty*, *Sezessionstil*, *Modernisme Nieuwe Kunst*, and Tiffany Style. However, the term most commonly recognized is Art Nouveau, after the gallery, *L'Art Nouveau*, a shop and workshops established by Siegfried Bing (1838–1905) in Paris in December 1895.

The first works appeared in 1893 with the Tassel House in Brussels by Victor Horta (1861–1947), the first full architectural statement in the Art Nouveau style, and a design for Oscar Wilde's play *Salomé* by Aubrey Beardsley (1872–98). Both demonstrate a parallel investigation into the importance of curvilinear line.

The rise of Art Nouveau was a complex phenomenon which combined a large variety of factors in the different countries and cities in which it evolved. A desire to break with the design styles of the past and to create a unified modern art that was available to all was a governing concern in most countries. Many designers were committed to the regeneration of craft practice and developed utopian models, in part derived from Arts and Crafts philosophy. Others embraced machine production, and realized mass availability of high-quality products that responded to the demands for consumer goods of a new and prosperous middle class.

Devising a new idiom of design suitable for the functions of the machine became the goal of many in the field. This clearly set Art Nouveau apart from its Arts and Crafts forebear.

Left: this Rococo figure group of Venus and Adonis was in made in the mid-18th century in Vincennes, France. The curves, asymmetry, and sensuality of the Rococo were a source of inspiration for Art Nouveau designers, particularly in France. Ht 30cm/11¾in.

Opposite: the Belgian architect Victor Horta designed the Tassel House in Brussels in 1893. It is one of the most important and complete examples of Art Nouveau architecture. The sinuous, organic forms of the decoration are characteristic of the style.

1 *The entrance of Siegfried Bing's gallery,* L'Art Nouveau, *in Paris, is adorned with sunflowers, denoting the importance of nature in the Art Nouveau style.*

2 *Aubrey Beardsley's illustration "J'ai baisé ta bouche Iokanaan" for Oscar Wilde's* Salome *is one of the earliest works in the Art Nouveau style. Its delicate use of curvilinear line and symbolism is typical of Beardsley's work.*

The inspiration for the new style came from various sources and most Art Nouveau objects are highly eclectic. The urge to create modern national design meant that the use of specific historical sources was given particular meaning within the national context. For instance, in France the use of the asymmetric and curvilinear forms and sensual imagery of the Rococo style simultaneously associated Art Nouveau with a period of great craft skill and decadent extravagance. In many countries folk art and culture were thought to embody pure and honest values which could provide the basis for a modern style. The English Arts and Crafts Movement had already led the way in a reappraisal of folk culture, while the Morrisian commitment to a non-hierarchical unity of the arts and the total artistic interior or *Gesamtkunstwerk* became governing precepts of Art Nouveau. The influence of English design, however, went beyond John Ruskin and William Morris's concern to reconcile art and society. The "decadents" of the Aesthetic Movement with their ethos of "art for art's sake" also exerted considerable influence and this, combined with French Symbolism, provided a deeply anti-materialist and metaphysical element within the style. As Octave Uzanne wrote in *The Studio* in 1897, "what the new art sought to depict was the eternal misery of the body fretted by the soul."

Another important source was non-western art, particularly the arts of Japan, North Africa, and the Middle East. The arts of these regions represented a fresh aesthetic vision which could revitalize moribund Western traditions. Japanese woodblock prints were particularly influential, and their use of flat areas of colour with strong defining outlines, bold and evocative lines, asymmetry, lack of spatial recession, and simplification of forms became a defining feature of the new style. The geometry and simplicity of Japanese architectural forms and design were also extremely influential for the development of the style in Glasgow and Vienna.

Colonial enterprise also advanced the development of the style. In Belgium the need to promote the use of products from the Belgian Congo brought about a revival in the use of ivory in the decorative arts, while exotic woods from various colonies became a feature of much Art Nouveau. Indonesian arts and techniques were particularly important for the development of Art Nouveau in Holland.

Without doubt the single most important source of forms and motifs was nature. Nature was used in Art Nouveau in varying ways and for different purposes. One strategy was conventionalization. Plant and flower forms were stylized and often made into patterns to be applied to all forms of art. Conventionalization was the dominant aesthetic strategy in Art Nouveau, as it had been in Arts and Crafts design, and represented a rationalist approach to design.

Nature was also used directly and often realistically to create the form or imagery of an object. Realistic animals, insects, and reptiles were applied directly to works without conventionalization and often had particular symbolic meaning. Perhaps the most important strategy for the use of nature was the evolutionary model. Following the theories of Darwin, many designers thought of nature as representing a progressive model for design. The forces of growth were explored and represented symbolically. The highly organic curvilinear line became an expression of this use of nature. The work of the German biologist and evolutionary theorist Ernst Haeckel became particularly important for the adoption of this approach.

Combined with this approach to nature was the frequent use of metamorphosis. Many Art Nouveau objects appear to represent metamorphosis and fuse the human form with the natural world. Through evolutionary theory man was seen to be part of the natural world. The predominance of the metamorphosing female form, often in flux, can be seen to be part of this strategy.

Art Nouveau was disseminated quickly across Europe and the United States through a number of mechanisms. Periodicals were important and the dramatic increase in the number of new journals during the time had a direct impact on the spread of the style. Some of the most important journals devoted to the decorative arts were *The Studio*, *L'Art Moderne*, *Art et Décoration*, *L'Art Décoratif*, *Pan*, *Jugend*, *Dekorative Kunst*, and *Ver Sacrum*.

The establishment of shops such as Liberty's, in London, and La Maison Moderne and Galerie L'Art Nouveau, in Paris, actively promoted the Art Nouveau style. Louis Comfort Tiffany sold his creations through Bing, in Paris, while the Nancy-based designers of Emile Gallé and Louis Majorelle established shops in many city centres, including London.

The role of international exhibitions enabled vast audiences to be introduced to Art Nouveau. For example, the 1900 Exhibition Universelle in Paris was visited by more than 51 million people. Other world fairs with substantial displays of Art Nouveau took place in Chicago (1893), Turin (1902), St Louis (1904), and Milan (1906). National exhibition societies, groups, and salons evolved and did much to promote the style.

Museums also played a role when they began to collect and exhibit Art Nouveau. Important collections were amassed in Hamburg, Budapest, Copenhagen, Trondheim, Oslo, Paris, and London. These collections brought Art Nouveau to the attention of the general public and enabled designers to study at first hand developments by designers in other countries.

3 *Eugène Grasset's volume,* Plants and their Applications to Ornament *of 1897, demonstrated how plants and flowers could be conventionalized and used in decoration.*
4 *The strong, linear design and articulation of space seen in Japanese wood block prints, such as this example by Utagawa Kunisada of c.1847, were extremely influential for the development of Art Nouveau.*
5 *Ernest Haeckel's* Kunstform der Natur *of 1898, which showed the structure of plants and sea life in detail, became an important source of forms for Art Nouveau designers, particularly in Germany.*

French Furniture

Nancy

1 *This fire screen of 1900 by Emile Gallé is made of ash and decorated with marquetry of various woods. The sinuous, asymmetric decoration is clearly indebted to Japanese art. Ht 1.09m/3ft 6¼in.*

2 *Emile Gallé produced this cabinet in 1896. It is profusely decorated with animal and flower motifs in applied carving and marquetry. Bats with outstretched wings form the support of the cabinet.*
3 *Emile Gallé's masterwork in furniture, the* Aube et Crépuscule *bed was made in 1904. A giant moth inlay with mother-of-pearl forms the main decorate element of the head and foot boards. The moth is depicted active in the dark, and at rest in the light, symbolizing the cycle of night and day. Ht 60cm/23½in.*

Nancy, an important city historically for the decorative arts, became a key centre for Art Nouveau furniture production. The establishment of the *Alliance Provinciale des Industries d'Art* (later called the *Ecole de Nancy*) in 1901, gave a coherent identity to the designers and companies responsible for the renaissance seen in the decorative arts towards the end of the century. The companies of Emile Gallé (1846–1904) and Louis Majorelle (1859–1926) were pre-eminent in furniture production. Both designers used nature as a basis for design while using traditional forms and techniques. Like many Art Nouveau designers, Gallé advocated the idea that beauty was to be found in the sympathetic application of the principles of natural growth. His stated aim was to "synthesize the logic and essence of life." Flowers and insects, particularly the dragonfly, became staple motifs both structural and applied. Gallé's and Majorelle's furniture was strongly influenced by French 18th-century forms. The use of sophisticated veneers, marquetry, and ormolu mounts is a feature of their work. These techniques were, however,

modernized. An innovation peculiar to Gallé was the use of inlays carved in relief; his marquetry often used a huge range of woods and represented new subject matter such as landscapes and lines from poetry. Majorelle devised elaborate decorative forms for his ormolu mounts, usually plants and flowers native to Lorraine. He combined these with exotic woods, and his work is typified by the use of rich materials. Victor Prouvé (1858–1943) and Louis Hestaux helped provide designs for marquetry for both Gallé and Majorelle.

The Gallé workshops did use motor-driven tools for constructional parts, but finishing and detailing were achieved by hand. Majorelle produced furniture on a greater scale, producing multiple versions of a piece through mechanization. Suites of furniture were produced with almost assembly-line precision. Eugène Vallin (1856–1922) and Emile André (1871–1933) benefited from increased attention to Nancy. Trained as architects their furniture, made of plain woods, was influenced by the organic, abstracted line of Belgian Art Nouveau.

4 Ormolou mounts in the form of orchids adorn this writing desk by Louis Majorelle of c.1903. Bronze mounts representing plants or flowers are typical of his work. Ht 95cm/37½in.

5 The lower part of this Majorelle cabinet of 1899 depicts the common Lorraine plant, the Ombelle (giant hogweed). The decorative panel at the top, depicting an eagle defending her young from a snake, may well symbolize the fight of French Lorraine against the German annexation of the territory. Ht 1.69m/5ft 7in.

6 The sensuous curves and flowing lines of this chair are typical of the work of Louis Majorelle. This chair was exhibited in the Paris exhibition of 1900 and subsequently bought as a representative example of Art Nouveau by the Victoria and Albert Museum. Ht 1.22m/4ft.

7 Better known as a glass maker, Jacques Gruber (1870–1936) also designed this three panel screen with stained-glass panels. Ht 1.7m/67in.

8 Eugène Vallin produced exclusive pieces of commissioned furniture for wealthy patrons. This table typifies Vallin's architectural approach to the structure of furniture.

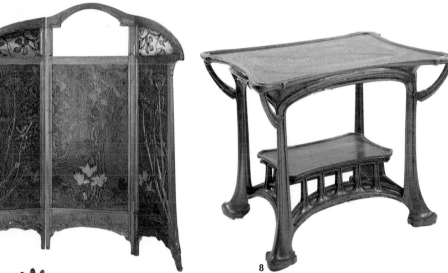

9 The intricate, carved decoration of this cabinet designed by Louis Hestaux reveals a fascination with Symbolism that was explored by many Art Nouveau designers.

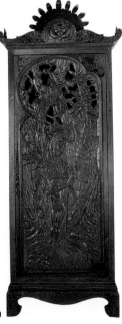

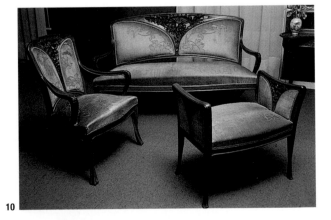

10 Camille Gauthier worked with Louis Majorelle from 1894 to 1900. In 1901 he established his own company. This suite of 1903 reveals his clear debt to the style of Majorelle. Chair ht 94cm/37in.

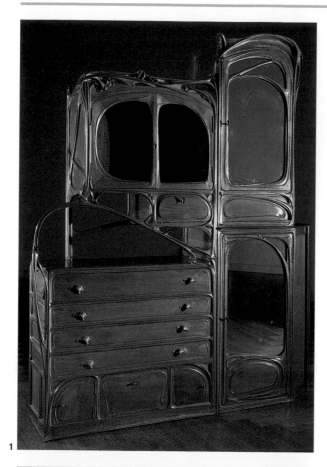

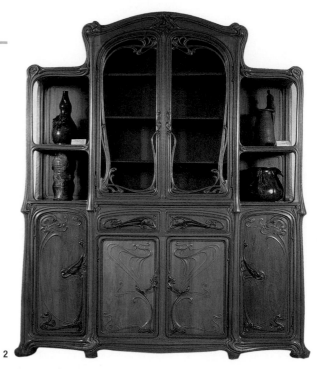

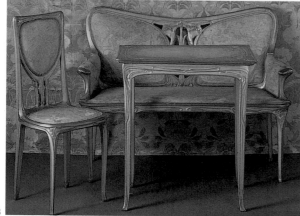

1 *This monumental sideboard was designed for a dining room in the Castel Béranger, one of Guimard's most important buildings. It was conceived as part of an overall design for the dining room. Ht 2.97m/9ft 7½in.*
2 *Siegfried Bing commissioned Eugène Gaillard to create a dining room for his Pavillon L'Art Nouveau at the Paris exhibition of 1900. This buffet, with elegant, restrained curves, formed the centrepiece of the display. Ht 2.63m/8ft 8in.*
3 *This suite of gilded furniture, by Georges De Feure, won a gold medal at the Paris exhibition. Deeply indebted to Rococo forms, it was seen to represent the height of modern French design. Chair ht 94.5cm/37¼in.*

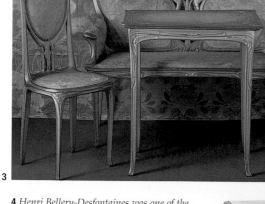

4 *Henri Bellery-Desfontaines was one of the leading figures of French Art Nouveau. His style was influenced by the forms of Gothic art and the writings of Viollet-le-duc. The floral decoration of the table does not disguise its structure. Ht 90cm/35½in.*
5 *The debt to historical French models in clear in this writing desk by the French company Maison Bagues of c.1900.*

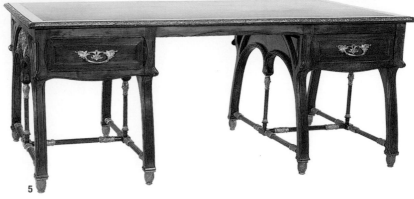

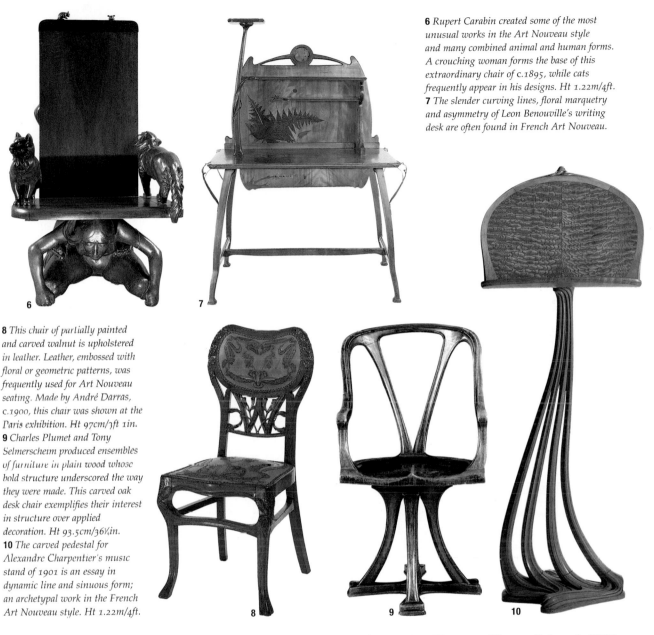

6 *Rupert Carabin created some of the most unusual works in the Art Nouveau style and many combined animal and human forms. A crouching woman forms the base of this extraordinary chair of c.1895, while cats frequently appear in his designs. Ht 1.22m/4ft.*

7 *The slender curving lines, floral marquetry and asymmetry of Leon Benouville's writing desk are often found in French Art Nouveau.*

8 *This chair of partially painted and carved walnut is upholstered in leather. Leather, embossed with floral or geometric patterns, was frequently used for Art Nouveau seating. Made by André Darras, c.1900, this chair was shown at the Paris exhibition. Ht 97cm/3ft 1in.*

9 *Charles Plumet and Tony Selmersheim produced ensembles of furniture in plain wood whose bold structure underscored the way they were made. This carved oak desk chair exemplifies their interest in structure over applied decoration. Ht 93.5cm/36¼in.*

10 *The carved pedestal for Alexandre Charpentier's music stand of 1901 is an essay in dynamic line and sinuous form; an archetypal work in the French Art Nouveau style. Ht 1.22m/4ft.*

While still rooted in a commitment to the new, greater attention was paid by many Paris-based designers to the renewal of the French craft tradition. The Rococo-inspired furniture and interior ensembles produced by Siegfried Bing to designs by Georges De Feure (1868–1943), Eugène Gaillard (1862–1933), and Edouard Colonna (1862–1948) were intended to revitalize the French luxury craft industry. Bing promoted the idea of the small artisan workshop where few pieces were produced in series. His selected designs are typified by a fusion of taut, organic naturalism with Rococo forms, exemplified in Georges De Feure's sitting room furniture for the Pavillon Bing, a gold-medal winner at the Paris Exhibition of 1900.

Members of the Paris group *Les Six*, Charles Plumet (1861–1928), Tony Selmersheim (1840–1916), and Alexandre Charpentier (1856–1909) produced furniture that used plain woods with undecorated surfaces. Their pieces emphasized structure and line which underscored the assembly of the furniture. As *ensembliers*, Selmersheim and Plumet were interested in the overall unity of works within the interior. However, Hector Guimard (1867–1942) was the designer to best express the unity of the Art Nouveau interior design in Paris. Trained as an architect, his furniture designs are an integral part of his interiors and employ a highly personal sense of architectural functionalism. For Guimard, decoration comprises an essential part of the form and is never merely applied. The intense organism of his art demonstrates his commitment to the strategy of nature providing a progressive model for design. Guimard was influential and many designers adopted his style.

Rupert Carabin (1862–1932) came to furniture design from sculpture. His carved pieces break down the barriers between the fine and decorative arts, a key aim of Art Nouveau design. Working in many materials, his furniture often incorporates metal fittings or details. The nude female figure predominates and is often accompanied by animals with various symbolic meanings. Carabin's often erotic and highly mysterious pieces provide a link between Art Nouveau and Symbolism.

Belgian and Dutch Furniture

Belgian Art Nouveau

1 *Victor Horta's house in Brussels of c.1898–1900 is an important example of the total artistic interior or Gesamtkunstwerk. Horta's furniture followed the same principles as his architecture. Both explored the use of complex, organic line.*

2 *Henry Van de Velde's was one of the first proponents of Art Nouveau. The bold, curvilinear form of this desk of 1898–9, one of several made to this design, became a hallmark of his style. Desk ht 1.28m/4ft 2in.*

3 *This oak armchair by Van de Velde of c.1897 has simple, curving lines and generous proportions. Ht 86.3cm/34in.*

4 *The attenuated forms of Horta's furniture designs signalled his rejection of the simplicity of the Arts and Crafts Movement and his debt to Rococo models. Ht 95cm/37¼in.*

5 *The use of a gently curving arch in this bed by Gustave Serrurier-Bovy is typical of his furniture and architecture. It is decorated with curvilinear metal mounts, a common Art Nouveau feature. L. 2.11m/6ft 11in.*

6 *This 1895 suite for* Chambre d'Artisan *by Serrurier-Bovy reveals his interest in the principles of the Arts and Crafts Movement. Chair ht 93cm/36¾in.*

7 *Paul Hankar designed this folding chair and stool. A concentration on line and form is apparent in the chair, while the legs of the stool follow a modern interpretation of the cabriole leg. Chair ht 1.14m/3ft 9in.*

Dutch Art Nouveau

1 *The decorative inlay of tropical woods on this music stand of 1903, by Carel Adolphe Lion Cachet, depicts stylized peacocks. The decoration is inspired by Indonesian art. Ht 1.4m/4ft 7in.*

2 *H.P. Berlage was one of the most rationalist designers of the Dutch Nieuwe Kunst. The restrained decoration and solid forms of this large sideboard of 1898 are typical of his style. Ht 2.6m/8ft 4in.*

3 *The curvilinear forms of the back of this oak settee, made in 1898 by Jan Thorn-Prikker, exemplify the more organic strain of Art Nouveau. Ht 1.24m/4ft, l. 1.08m/3ft 6in.*

1

3

4 *Theodor Nieuwenhuiis was one of many Dutch artists who looked to Eastern forms, particularly Indonesian, for inspiration. The decorative panels in the back of these otherwise very simple oak chairs, c.1899, are influenced by Indonesian batik patterns. Ht 97cm/38¼in.*

4

Belgium became an important centre for the reception of English Arts and Crafts ideas, and it was the first country to arrive at a fully fledged mastery of the Art Nouveau style. The key Arts and Crafts idea of the *Gesamtkunstwerk* was clearly expressed in the works of Henry van de Velde (1863–1957), Victor Horta (1861–1947), and Gustave Serrurier-Bovy (1858–1910). These designers applied to their furniture the principle of the unifying importance of line. Van de Velde, following Arts and Crafts forebears such as Walter Crane, described line as being "a force which is active like all elemental forces," and Belgian Art Nouveau design is typified by the use of curvilinear, abstract line. In Horta's interiors all elements, including furniture, are subordinated to the dominant and unifying use of organic line. Van de Velde's furniture developed the idea of ornament evolving from structure, and his work carried the organic away from an imitation of nature towards the abstract. Most Belgian furniture is executed in plain woods but both van de Velde and Serrurier-Bovy occasionally incorporated

metal fittings. The decorative quality of their work is inherent in their use of energetic line rather than through application of ornamentation. Serrurier-Bovy developed a particular use of the arch, which gave his furniture a structural tension, belying his training as an architect.

In the Netherlands a number of architects turned their attention to designing interiors in the 1890s, and they gave *Nieuwe Kunst*, the Dutch variant of the style, its distinctiveness. Various approaches emerged. H.P. Berlage (1856–1954) represented a rationalist strain. Again, inspired by Arts and Craft principles, he developed functional furniture where construction and craftsmanship of the item are clear features.

Lion Cachet (1866–1945), Theodor Nieuwenhuiis (1866–1951), and Gerrit Willem Dijsselhoff (1866–1924) represented another strain of Dutch Art Nouveau that combined decoration with construction. These artists all worked for Van Wisselingh & Co. Using exotic woods, materials, and patterns from eastern sources (particularly Indonesia), the renewal of decoration was a primary goal.

ART NOUVEAU | BELGIAN AND DUTCH FURNITURE

307

German, Scottish, and Austrian Furniture

Jugendstil

1 *Bernhard Pankok produced some of the most extraordinary Art Nouveau furniture, and this vitrine of 1899, with its insect-like legs, is one of the greatest examples in the style. Pankok frequently used decoration suggestive of animal or plant forms. Ht 2m/6ft 6in.*

2 *This dining room sideboard and chair of 1902 are typical of the restrained, rationalist design of Peter Behrens. Metal fittings were frequently used to supply the decorative embellishment for simple pieces. Ht 1.9m/6ft 2¼in.*

4 *This simple music room chair was by Richard Riemerschmid, c.1900, a leading German designer. Its bold curving lines and simple construction reveal Riemerschmid's interest in serial production. Ht 74cm/29¼in.*

5 *Hermann Obrist's belief that nature could provide a model for style governed his design. The metal fittings may have been influenced by the botanist Ernst Haeckel. L. 1.32m/4ft 3¾in.*

3 *August Endell (1871–1925), like Pankok, was fascinated with natural forms. The carved decoration and pale colour of this armchair of 1899 is suggestive of knarled wood or bone. Ht 86.5cm/34in.*

The artists of the German Jugendstil (Youth Style) schools were divided between rational and expressive styles. As the critic Leopold Gmelin, editor of *Kunst und Handwerk*, stated in 1897, "Two principles characterize the modern direction of applied art: first… simplicity of construction; secondly, the association with the plant and animal world…. Hand in hand with simplicity of construction goes a preference for modest materials." Designers committed to the first principle sought to develop furniture that could be machine produced. The Munich-based United Workshops for Art in Handicraft (*Vereinigte Werkstätten für Kunst im Handwerk*) developed a simplified, pared-down aesthetic for furniture and interiors, in part inspired by Arts and Crafts, that could be serially produced. Richard Riemerschmid's furniture reflected this concern with practicality, honesty, and truth to materials. His *Maschinenmöbel* heralded production methods in the new century.

The furniture of those artists influenced by Hermann Obrist (1862–1927) represented the expressive second principle. Obrist's philosophical preoccupation with nature as an evolutionary model for design resulted in the organic thread of Jugendstil. Abstract natural forms are the determining feature of this strain of the style and are seen in the furniture of Endell, Obrist, and Bernhard Pankok (1872–1943).

The leading Viennese designers trained as architects under Otto Wagner (1841–1918) and, like the Scottish Charles Rennie Mackintosh (1868–1928), developed an architectural approach to furniture design. A similar taut geometry can be seen in the work of Josef Maria Olbrich (1867–1908), Koloman Moser (1868–1919), and Josef Hoffmann (1870–1956). Mackintosh's display at the eighth Vienna Secession exhibition, 1900, introduced the Viennese to the structural rationale and linear geometry of Glasgow furniture and led to a more rigid style seen in the furniture of Hoffmann and the Wiener Werkstätte. However, Secession furniture continued to explore historical models for new style. Biedermeier exerted a considerable influence on forms and decoration.

The Glasgow School

1 *Charles Rennie Mackintosh developed a unique style, frequently with geometric forms and elongated lines, with a profound impact. This chair, 1897–1900, with its elongated back and deceptively simple structure is iconic. Ht 1.36m/4ft 5in.*

2 *Mackintosh worked with his wife, Margaret McDonald. This cabinet is decorated with motifs that became archetypal of the Glasgow School: abstracted egg forms, stylized roses, and attenuated female figures. Ht 1.54m/5ft.*

2 *This lady's writing desk and armchair was designed by Kolomon Moser in 1903. The armchair slides almost invisibly into the desk. This piece also draws from Biedermeier with its satinwood and brass inlay. Ht 67cm/26½in.*

The Viennese Designers

1 *Designed by Joseph Maria Olbrich in 1905, this secrétaire is adapted from a Biedemeier model. Its form and decorative motifs have been simplified and appear strikingly modern. Ht 1.92cm/6ft 3in.*

3 *Traditional and contemporary elements exist in this three-panel screen by Josef Hoffman, 1899–1900. The lyre forms at the top are derived from antiquity; the tooled gold decoration in the leather panels is modern. Panel ht 1.55m/5ft.*

Italian and Spanish Furniture

Stile Floreale

1

2

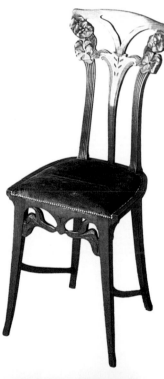

3

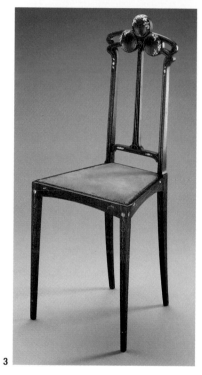

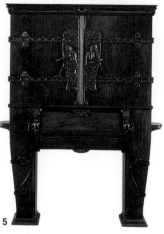

5

6

1 *Designed in Venice, this dining room suite of c.1900 is typical of the extremely decorative Italian Stile Floreale. The ornate floral forms and use of the female nude as a sculptural motif characterize much Art Nouveau in Italy.*
2 *The extraordinary Snail chair was designed by Carlo Bugatti for the Exposizione Internazionale at Turin in 1902. A wood frame is covered with delicate, painted parchment and copper. Ht 89cm/33½in.*

3 *Carlo Zen made this fruitwood side chair in c.1900. It is inlaid with mother-of-pearl and metal, and the back of the chair bears attenuated floral motifs. Ht 93.7cm/36⅞in.*
4 *The carved back of Giacomo Cometti's side chair, for the Exposizione Internazionale at Turin in 1902, also suggests the form of an abstracted plant or flower.*
5 *Ernesto Basile's training as an architect is clear in in the solid structure of this mahogany secrétaire, shown at the Venice Biennale, 1903. The massive proportions are softened with figural decoration in the bronze fittings.*
6 *Influenced by Japanese art, some Italian designers used Japanese motifs in their designs. This mahogany cabinet of c.1902 by Carlo Zen is inlaid with mother-of-pearl and brass.*

1 *This powerfully asymmetric dressing table was designed by Antoni Gaudí. Its eclectic form borrows from many sources. Plant and animal forms can be identified as well elements taken from the Gothic and Baroque.*
2 *This vitrine was designed by Alejo Clapes Puig and Gaudí. Gaudí's use of highly organic forms influenced many of his contemporaries and can be seen in the sinuous and dynamic sculptural forms of this work.*

3 *Gaspar Homar (1870–1953) also designed works influenced by Gaudí, but this wall panelling and settee of 1904 represents a more restrained approach. The marquetry panels were designed by Joseph Pey i Farriol. Ht 2.68m/8ft 9in.*

Two distinct stylistic strains emerged within Italian Art Nouveau furniture design. On the one hand an extremely floral sculptural style was developed by such designers as Vittorio Valabrega (1861–1952) and Agostino Lauro (1861–1924), while some designers were inspired by the exotic forms and techniques emerging from North African and Middle Eastern art. Carlo Bugatti (1856–1940), Eugenio Quarti, and Carlo Zen (1851–1918) are prominent designers who experimented with exotic materials and eastern forms in their designs. The furniture of both groups is often determined by rich ornamentation and great technical skill.

The Valabrega company produced pieces in multiples by machine, and were one of the few Italian companies that could reach a larger market. Their furniture design was often highly sculptural, with decorative floral motifs. By contrast the work of Ernesto Basile (1857–1932) and Giacomo Cometti (1863–1938) represented a more restrained, Art and Crafts-inspired aesthetic. Simpler linear forms were applied to both hand crafted, in the

case of Cometti, and machine-produced works. The most original furniture designer in Italy was Carlo Bugatti. However, his work was often considered bizarre at the time. Its exotic appearance was enhanced by the use of the characteristic keyhole arch, a determining feature of his furniture, and the use of vellum, silk tassels, and inlaid abstract decoration in pewter, bone, and ivory.

The Spanish response to Art Nouveau interior design centred on developments in Barcelona, and particularly on the work of Antoni Gaudí (1852–1926). His unique, highly organic style had a profound influence on the design style of his contemporaries. His avowedly Catalan form of Art Nouveau, Modernismo, depended upon the use of nature as both a basis for structure and ornamentation. In line with many of his European counterparts and under the influence of the French theorist Viollet-le-Duc, Gaudí developed a structural rationalism based on nature. His designs for furniture rigorously develop organic form into a structural whole. Nature is not applied as decoration but determines the form in his work.

American, Hungarian, and Nordic Furniture

America

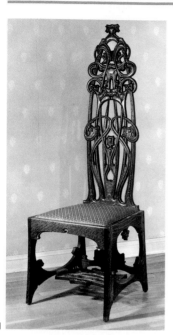

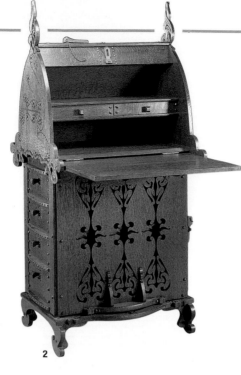

1 *The tall back of this chair, designed in 1898 by the Buffalo-based Charles Rohlfs, is inspired by the interlocking motifs of Celtic art. Ht 1.4m/4ft 7in.*
2 *Rohlfs' hall desk, executed in American white oak between 1898–1901, reveals a debt to the Gothic, but the sinuous forms of the finials and cut-out decoration are clearly reveal the influence of European Art Nouveau. Ht 1.42m/4ft 8in.*

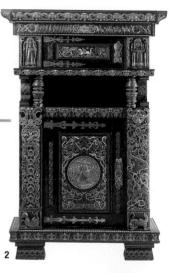

The Dragon Style

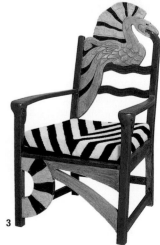

1 *The table, chairs, and buffet from the Holmenkollen Tourist Hotel in Norway by J.A.G. Ackel, were simply designed with elegant attenuated curvilinear shapes, as seen in the legs and back of the chair.*

2 *This extraordinary cabinet designed by Lars Kinsarvik (1846–1925) is decorated with Viking and Celtic motifs. Many Norwegian designers used Viking imagery in the search for a modern, national style. Ht 1.89m/6ft 1½in.*

3 *Gerhard Munthe (1849-1929) designed this dragon chair in 1898 for the Holmenkollen Hotel in Norway. The interiors explored Viking imagery and motifs. This chair combines a stylized dragon form with bold, modern colouring. Ht 1.1m/3ft 7in.*

4 *Devoid of decoration, Carl Westman relied on the subtle curves and simple lines of this chair to make a design statement. Ht 1.01m/3ft 4in.*
5 *The* Koti *chair was designed by Eliel Saarinen for the Paris exhibition of 1900. The shape and decoration of the chair are adapted from traditional Finnish folk forms. Ht 1.32m/4ft 4in.*
6 *Akseli Gallen-Kallela was Finland's leading Symbolist painter. He occasionally designed furniture and the* Tree of Knowledge *cabinet of 1897–8 was designed for his home. Its carved decorative panels depicts Eve handing the apple to Adam. Ht 1.29m/4ft 3in.*

Hungarian Folklore and Art Nouveau

2 *In Hungary many designers adopted the international Art Nouveau style of sinuous decorative forms. Several designers developed a distinctly Hungarian response. Ödön Faragó combined motifs drawn from Hungarian folk art, international Art Nouveau, and Eastern architecture. Cabinet ht 2.4m/7ft 10in.*

1 *This plain forms of this oak and ebony sideboard, 1900, by Pál Horti (1865–1907), are decorated with delicate brass fittings. After 1904, Horti was active in the United States, known as Paul Horti. Ht 1.86m/6ft 1in.*

The Arts and Crafts Movement provided a powerful precedent for an aggressive commitment to simplicity inspired by folk culture. Much Art Nouveau design in the United States, the Nordic, and Central European countries was mediated by an Arts and Crafts aesthetic or was inspired directly by national folk cultures.

The predominant influence on furniture in the United States was the Arts and Crafts Movement, and few companies acknowledged the modernizing tendencies of Art Nouveau. The idiosyncratic Buffalo-based designer Charles Rohlfs (1853–1936) was one of few to incorporate some more sinuous forms and nature-inspired ornament of Art Nouveau into his solid Arts and Crafts pieces.

In most countries the search for a modern national style led designers to explore their own traditions, and nowhere was this more clearly demonstrated than in the Nordic and central European countries. In Norway the rediscovery of the complex ornament of Viking ship art provided the basis for a new decorative language. The affinity of the abstract animal and plant forms and interlocking sinuous ornament of Viking and Celtic art with Art Nouveau appealed to the new generation of designers. It was easily assimilated, adapted, and modernized for all areas of the decorative arts. In Finland Akseli Gallen-Kallela (1865–1913) and Eliel Saarinen (1873–1950) explored ancient Karelian myths and legends to provide inspiration. Their furniture used vernacular or folk-inspired patterns and sturdy forms or carving with Symbolist subject matter.

Hungarian Art Nouveau furniture design combined eastern ornament with the vernacular. Designers usually favoured natural motifs such as the flora and fauna of the Hungarian peasant countryside or patterns derived from folk textiles. The furniture of Ödön Faragó (1869–1935), which is typical of much Hungarian Art Nouveau, mixed eastern ornamental forms and folk patterns with symbols of Hungarian national identity such as the stylized tulip. However, much eastern European Art Nouveau furniture demonstrates a fusion of folk forms with the sinuous flowing line of the international Art Nouveau style.

Ceramics

French Designers

1 *Ernst Chaplet was one of the first to emulate the red flambé glazes on Chinese porcelain. This vase shows Chaplet's experiments with high-temperature glazes. Ht 36cm/14¼in.*

2 *These examples of stoneware by Pierre-Adrian Dalpayrat (right), Auguste Delaherche (centre), and Georges Hoentschel (left) were influenced by Chaplet. They demonstrate an interest in both experimental glazes and organic forms. Ht (of tallest) 66.5cm/25½in.*

3 *This biscuit ware figure is part of the* Jeu de l'écharpe *table setting by Léonard Agathon, made by Sèvres, and exhibited in the Paris exhibition of 1900. Ht 60cm/23¼in.*

4 *This porcelain coffee service of c.1900, by Maurice Dufrène, was sold through La Maison Moderne. It is an example of the commercial application of Art Nouveau.*

1 2

3 4

Towards the end of the 19th century the French art ceramics industry experimented with high temperature glazes to achieve the deep red known as flambé and subtle crystalline effects. Ernst Chaplet (1835–1909) was the most influential designer to experiment with these glazes. New effects were combined with organic forms while artists such as Auguste Delaherche (1857–1940) and Pierre-Adrian Dalpayrat (1844–1910) reassessed vernacular stoneware as an artistic medium. Delaherche developed difficult glazes, which he applied to stoneware bodies, while Alexandre Bigot (1862–1927) specialized in firing large-scale stoneware for both the exterior and interior of buildings. The leading exponent of the popular technique of lustre glazes was Clément Massier (1845–1917). Sèvres, the national manufacturer, produced a vast range of works in the Art Nouveau style, from huge architectural vases by Hector Guimard to delicate porcelain tea services with applied insect motifs by Léon Kann. Many commercial factories produced ceramics in the new style and they were widely available.

There was also a revival of interest in stoneware in Germany where Höhr Grenzhausen employed a new generation of designers to update traditional forms. Richard Riemerschmid and Peter Behrens gave beer jugs and mugs radical new decorative styles, adding colour and linear patterns to traditional forms.

The German porcelain companies of Nymphenburg, Meissen, and Villeroy & Boch made Art Nouveau wares. Nymphenburg employed Hermann Gradl (1869–1934) to produce a naturalistic fish service while Meissen commissioned Behrens, Riemerschmid, and Henry van de Velde to produce table services with abstract pattern and swirling linear ornament. The finest porcelain manufacturer in The Hague was Rozenburg. J.J. Kok (1861–1919) developed an eggshell porcelain unmatched for the thinness of the body and its delicate shapes. Rozenburg incorporated Indonesian motifs into their designs, as did other Dutch designers such as Theodor Christiaan Colenbrander (1841–1930). Lustred glazes using metallic oxides were first revived in Italy, and fine

1

2

3

1 *Attributed Alf Wallander, the artistic director of the Swedish factory Rörstrand, this porcelain vase of 1900 is finely modelled and takes the form of a flower. Many Rörstrand pieces were inspired by animal or plant forms.*

2 *These pieces from the* Blue Anemones *porcelain dinner service, designed by the Norwegian Gerhard Munthe (1892–3) for Porsgrund, incorporate the decorative motifs of swirling lines and stylized flowers. Plate diam. 24cm/9¼in.*

3 *The Bing and Grøndahl Factory specialized in exquisite modelling in porcelain. The pierced body of this vase and flower decoration are typical of Bing and Grøndahl pieces from the turn of the century. Ht 43cm/17in.*

4 *The Dane Thorvald Bindesbøll painted and incised decoration on this large-scale earthenware vase of 1893. He developed a distinct and extremely painterly approach. Ht 57.5cm/22¾in.*

5 *Following the lead of Sèvres, Valdemar Engelhardt (1860–1916) at the Royal Copenhagen Factory, developed crystalline glazes in bright colours. Ht 17cm/6½in.*

6 *The Arabia Factory in Finland launched a new earthenware range entitled Fennia in 1902. It was characterized by striking geometric patterns and distinctive modern shapes. Ht 25cm/10in.*

4

5

6

examples were made by Chini. The Zsolnay Factory in Budapest was the leading company to make lustreware ceramics from 1900.

Denmark and Sweden specialized in modelled porcelain employing motifs from nature. Rörstrand, Bing & Grøndahl, Royal Copenhagen, and Gustavsberg produced porcelain wares typified by subtle, pale colours and sculptural forms with flora and fauna. Designers, often trained in different disciplines, modernized the wares of these companies. Alf Wallander (1862–1914), artistic director of Rörstrand from 1895, used swirling lines, natural forms, and Japanese motifs, while the Norwegian porcelain manufacturer Porsgrund employed Gerhard Munthe to create designs for services such as a stylized blue anemone. The Arabia factory in Finland introduced a range of earthenware which, in contrast to other Nordic factories, used bright colours and geometric patterns. Thorvald Bindesbøll's (1846–1908) painted and incised earthenwares disregarded tradition, and were influenced by Gauguin, revealing a strong painterly approach.

American companies such as Grueby Faience, Teco, and Rookwood successfully experimented with new decorative forms, patterns, and glazes. Grueby and Teco developed unique matt and semi-matt glazes while the Rookwood Pottery's speciality was painting in coloured slip on unfired clay. An atomizer was used to give a smooth and glossy surface to the work and successful new glaze lines were developed, including the Sea Green, Iris, and Vellum glazes. Painters such as Harriet E. Wilcox and K. Shirayamadani painted designs directly onto the vessels. Artus Van Briggle (1869–1904), who trained in Paris and had worked for Rookwood, developed organic and sculptural vessel forms that suggested metamorphosis of the female form. The American Adelaide Alsop Robineau was unique among ceramic makers in Europe and the United States. She carved porcelain and constructed the intricate forms and decoration of her works.

Few British ceramics manufacturers made pieces in the new style, but Doulton created a range called Succession ware with stylized linear motifs on geometric bodies.

ART NOUVEAU | CERAMICS

Other European Wares

1 *These salt-glazed, stoneware tankards and jug of c.1902 are by Richard Riemerschmid and Peter Behrens respectively. These designers modernized traditional German salt-glaze wares by introducing new colours and modern decorative motifs. Ht (of tallest) 32cm/12½in.*

2 *For the Nymphenburg Factory, Herman Gradl designed a fish dinner service in 1899. Each piece took a curvilinear form but depicted a fish naturalistically. Plate w. 62cm/24½in.*

3 *Some of the finest Art Nouveau porcelain was produced at the Rozenburg factory in the Hague. Their "Eggshell" porcelain was extremely thin and often took flamboyant forms. Ht (of tallest) 31.5cm/12½in.*

4 *In Italy, Galileo Chini took inspiration from traditional maiolica ware. This plate of c.1898 adopts the colours of maiolica but its pattern is typical of the flowing lines of Art Nouveau. Diam. 17cm/7in.*

5 *This group of earthenware vases was made c.1899 at the Zsolnay factory in Hungary, a company that became a leader in the field of lustrewares.*

6 *This candlestick is an example of* Succession Ware *produced by Doulton & Co. in Britain. The linear, stylized decoration is clearly indebted to the Viennese style. Ht 30cm/11¾in.*

1 *The Boston firm Grueby Faience emulated the matt and semi-matt glazes developed by European ceramists. This stoneware vase of 1898–1900 is glazed in the famous "Grueby Green". Ht 33.5cm/13¼in.*

2 *Amongst the American producers, Artus van Briggle developed the most sculptural approach. The body of his* Lorelei *vase, made by the Rookwood pottery, metamorphosizes into that of a woman. Ht 28cm/11in.*

3 *Matt glazes were also used in the production of the American Terra Cotta & Ceramic Company (Teco). Fritz Albert designed highly organic vases for Teco. Ht (of tallest) 24cm/9½in.*

4 *Kataro Shirayamadani introduced a Japanese painting tradition at Rookwood. He hand-painted decoration direct to the body, making each vase unique. This vase dates from 1928. Ht 40cm/16in.*

5 *The Fulper Pottery Company produced extraordinary lamps that combined glass and ceramic in organic forms. This* Mushroom Lamp *of c.1910 has a verte antique glaze. Ht 45.5cm/17½in*

6 *Adelaide Alsop Robineau (1865–1929) created this crab vase in 1908. This work in porcelain was a feat of carefully carved decoration. Ht 19cm/7½in.*

Glass

French and Belgian Glass

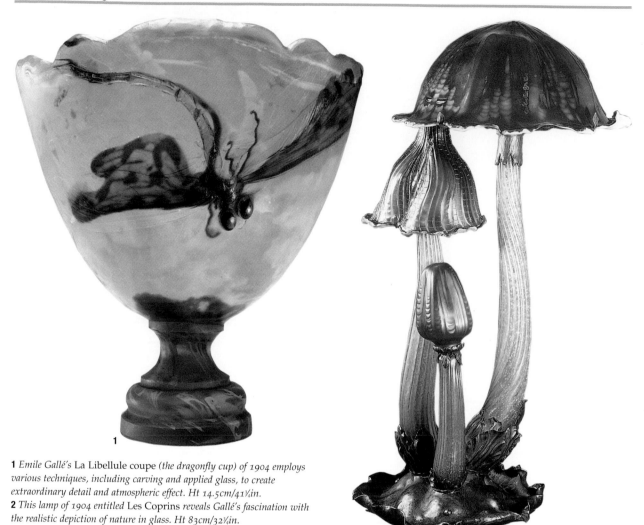

1 *Emile Gallé's* La Libellule coupe *(the dragonfly cup) of 1904 employs various techniques, including carving and applied glass, to create extraordinary detail and atmospheric effect. Ht 14.5cm/4¾in.*
2 *This lamp of 1904 entitled* Les Coprins *reveals Gallé's fascination with the realistic depiction of nature in glass. Ht 83cm/32¾in.*

The late 19th century saw immense experimentation in glassmaking in France. Historic techniques were researched, while new ones such as pâte-de-verre were invented. The French industry went from one-off hand-made objects to cast art glass on a vast scale. Nancy was a thriving centre of production with both the Gallé and Daum Frères factories located there. The pre-eminent Art Nouveau glass producer was Emile Gallé. He provided the designs but never made and rarely decorated the works, many of which incorporated Symbolist prose or poetry. His masterworks are essays in the exploration of natural forms and imagery, and he used various techniques to achieve subtle and dense effects, including carving, casing, acid etching, wheel cutting, and applying glass. Many of his pieces were made by serial production using the commercial technique of acid etching.

Auguste (1853–1909) and Antonin Daum (1864–1930) moved into art glass in the 1890s and employed artists such as Ernest Bussière, Henri Bergé, and Amalric Walter to produce designs for glass. Daum also experimented

with new techniques such as cameo or *intercalaire* (inlays), where differently coloured glass is pressed into the body of the work. Alsace-Lorraine was also the centre for other glass manufacturers such as the Gruber and Muller Frères companies, which produced glass for electric lighting, stained glass, and decorative vessels.

The influence of Gallé was felt across Europe but particularly by the Belgian Val St Lambert Glasshouse, perhaps the most commercially successful at the end of the century. It produced vases with floral decoration and natural forms. One of its most important designers was the Belgian Philippe Wolfers (1858–1929) who, between 1893 and 1903, produced exceptional Symbolist pieces that often incorporated fine metal mounts.

Bohemia, with its distinct tradition of glassmaking, was quick to adopt the new style. The glassworks of J. & J. Lobmeyr and Loetz-Witwe in Klostermühle employed some of the leading Art Nouveau designers and, influenced by developments abroad, developed new forms and techniques such as painting with platinum and

3

4

5

6

6 *Albert-Louis Dammouse (1846–1926), was one of several French artists who created works using the new technique of pâte-de-verre or casting ground glass paste. Subtle, luminous effects and intense colours were achieved through this technique and are exemplified in this bowl of c.1898.*
7 *Jacques Gruber was one of the leading designers of stained glass in France. This window of c.1906 made for a house in Nancy depicts gourds and waterlilies, two common motifs in Art Nouveau.*
8 *Daum Frères emulated Gallé's art glass and produced works that were also technically highly skilled. This cup of 1905 is decorated with a moth and spider web and uses acid-etching, wheel engraving, and applied glass. Ht 16.5cm/6½in.*

3 *This masterwork by Gallé of c.1904 demonstrates his ability to create complex, symbolist works that carefully crafted colour, patination, and surface treatment. Ht 33cm/13in.*
4 *Daum Frères collaborated with Majorelle to produce the realistic metal base for the* Figuier de Barbarie *lamp of 1903. Daum and Majorelle frequently worked together on designs for lamps. Ht 75cm/29½in.*
5 *Cameo glass was one of the most popular techniques in Art Nouveau glass ware, and Muller Frères became a leading company in the production of commercial cameo glass. This lamp, decorated with roses, is typical of much Art Nouveau cameo glass.*

7

8

ART NOUVEAU | GLASS

319

1 *The extremely delicate bodies, curling tendrils, leaves, and stalks of these flower form glasses of 1905–6, by Karl Koepping (1848–1914), were achieved using the lampworking technique. Few undamaged examples survive from the period. Ht (tallest) 32cm/12½in.*

2 *The best known Bohemian glassworks, Loetz, produced lustred or irridescent glass following the success of the American company Tiffany. This is a rare three-handled lustred vase by Loetz. Ht 20.3cm/8in.*

3 *Typical of Josef Hoffman and the Seccession style, this Bronzit vase of 1914 is restrained in both form and decoration. Geometrical designs are painted in black on frosted glass. Ht 14cm/5½in.*

4 *This pair of wine glasses with elongated stems and geometric decoration were designed by the Austrian designer Otto Prutscher in c.1907. Glass (left) ht 16cm/6¼in.*

5 *This plique-à-jour cup of 1900 by the Norwegian designer Thorolf Prytz is a masterwork in the medium. The bowl of the cup is decorated with a conventionalized snowdrops pattern while snowdrops curl around the stem. Ht 22cm/8¾in.*

lustring. Loetz, famous for its iridescent glass, produced the successful *Phänomen* range in 1897.

The height of restrained, geometric Seccession glass design was produced by Hoffmann for Lobmeyr. His *Bronzit* range of 1914, with its geometrical designs painted in black on frosted glass, investigated linear form and decoration. Otto Prutscher produced elegant works for the Viennese company of E. Bakalowits & Söhne. The German designer Karl Koepping (1848–1914) developed unique lampwork flower-form vessels. His intricate designs became famous as examples of the new style.

Although produced by a number of designers, including Feuillâtre in Paris, the Norwegians were the masters of plique-à-jour. The technique of enclosing glass within a fragile metal frame was practised by Gustav Gaudernack (1865–1914) for the silver company David Andersen, and Thorolf Prytz (1858–1938) who produced designs for Jacob Tostrup in Oslo. Conventional flower decoration was used for vessels, and Viking boat ornaments were also made.

Louis Comfort Tiffany (1848–1933), was the most famous American Art Nouveau glassmaker. His works in Corona, New York, made stained glass windows, lamps, mosaics, and blown vessels. Tiffany experimented with forms and surfaces. In an attempt to recreate the nacreous surface of ancient glass he experimented with metallic effects, perfecting an iridescent technique called *Favrile* in 1894. Frederick Carder (1863–1963), one of Tiffany's only USA rivals, was an Englishman who moved to Corning, New York, in 1903, and established the Steuben Glassworks. Steuben also specialized in brightly coloured iridescent surfaces. Stained glass production changed in the hands of Tiffany. John La Farge and Tiffany, disappointed with the quality of American stained glass, aimed to revive the technique as an art form. Tiffany used metallic oxides while experimenting with the sculptural properties of glass. By building up layers he created rich effects within the glass, of folds, wrinkles, or ripples. Both La Farge and Tiffany made images of landscapes, some with figures or animals.

America

1 *Louis Comfort Tiffany's swan-neck vase of 1896 was inspired by the sinuous forms of Persian perfume bottles. The lustred surface of this vase was created using Tiffany's unique development of Favrile glass. Ht 40.5cm/16in.*

2 *One of Tiffany's masterworks, this punch bowl with three ladles was made for the Paris exhibition of 1900. It is made of Favrile glass gilded in silver. Ht 36cm/14⅓in.*

3 *Tiffany was one of the most experimental glass designers and developed many different effects. One of the most unique was his Lava glass. This vase was designed in c.1906 . Ht 15cm/6in.*

4 *This leaded-glass screen depicts grapes, gourds, and clematis in an asymmetrical design inspired by Japanese art. It was called a masterwork when it was exhibited at the Paris exhibition of 1900. Ht 1.79m/5ft 11in.*

5 *Tiffany is best known for his lamps, and many of his designs used motifs drawn from nature. He, like many designers, frequently returned to the the dragonfly theme, appearing here as the border of the shade. Ht 71cm/28in.*

6 *Frederick Carder established the Steuben glassworks, Tiffany's main competitor in the USA. This floral vase uses acid-etching to create subtle surface effects. Ht 17.5cm/7in.*

7 *John La Farge hoped to revive stained glass as an art form and, like many French designers, he saw nature as appropriate subject matter. This window depicts peonies in a landscape. Ht 1.42m/4ft 8in.*

Silver and Metalwork

French Wares

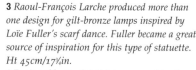

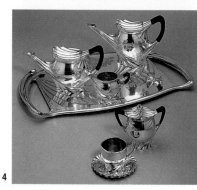

3 *Raoul-François Larche produced more than one design for gilt-bronze lamps inspired by Loïe Fuller's scarf dance. Fuller became a great source of inspiration for this type of statuette. Ht 45cm/17¾in.*

4 *Designed by Paul Follot in c.1904, this silver tea service demonstrates the sinuous, fluid forms that could be achieved in metal. Tray l. 62cm/24½in.*

1 *Hector Guimard produced three entrances for the Paris Metro, c.1900. In this design for covered steps, a glass canopy is supported on a cast-iron structure.*

2 *Decorated with* monnaie-du-pape, *or honesty, these wrought iron and bronze gates by Louis Majorelle were designed in 1906. Ht 1.26m/4ft 1½in.*

5 *These electroplated silver cast-copper fittings were designed by Georges De Feure for the Paris exhibition of 1900 and sold by Siegfried Bing.*

6 *The* Dragonfly Woman *corsage ornament of 1897–8 is René Lalique's masterwork in jewellery. Made of gold, enamel, chrysoprase, moonstones, and diamonds, Lalique used many techniques for the piece. L. 26.5cm/10½in.*

Hector Guimard's famous cast-metal designs for the Paris Metro station are an important example of a standardized modular system in Art Nouveau. Designed for mass production, the Metro design was both functional and sustainable and is still in use. Perhaps the most important exponent of architectural metalwork, Guimard also produced designs for fixtures and fittings, including vases, jardinières, and balcony pieces, all in his highly organic linear style.

The Parisian firms of Fouquet and Lalique produced jewellery in the new style. Enamelling, including *plique-à-jour*, and semiprecious stones replaced traditional tech niques and gemstones, while nature became the predominant subject. Many pieces reflect a preoccupation with Symbolist subjects. Another important area of Art Nouveau metalwork production was the small-scale figurative sculpture, which often doubled as a functional object such as a lamp or inkwell. A vast quantity of figures were produced by designers such as Louis Chalon (1866–1916), Maurice Bouval (1863–1916), and Raoul

Larche (1860–1912). Larche became particularly famous for his swirling, sinuous Loïe Fuller lamps, cast in bronze.

In Nancy, outside Paris, the Majorelle factory produced lamps and fittings. The best designs combined elaborate metal bases in the form of plant stems, and structures with subtle glass shades (made by Daum Frères) in the form of buds or flowers.

Influenced by the rationalist principles of Viollet-le-Duc regarding the exposure of iron structures within the interior, the Belgian Victor Horta's use of metalwork, and particularly cast iron in architecture, set a precedent for Art Nouveau designers. His use of iron as both a structural component and as a decorative element in both the interior and on the exterior of buildings became a defining feature of the style, while his exploitation of the sinuous line in metal is characteristic of much Belgian Art Nouveau metalwork. Many designers explored organic line in metal including Henry van de Velde and Fernand Dubois (1861–1939). The interest of both designers was in combining line with sculptural form.

1 *Victor Horta used wrought iron throughout his interiors. The stairwell of his house in Brussels, designed between 1898 and 1900, demonstrates his use of curvilinear wrought iron as part of the overall decorative scheme.*

2

3

4

2 *Fernand Dubois designed this candelabra c.1899. Made of electroplated bronze, the branches tangle and intertwine to create an organic, asymmetric composition. Ht 53cm/21in.*
3 *This six-branch candelbrum made of electroplated bronze, 1898–9, is a masterwork in the curvilinear, abstract style developed by Henry Van de Velde. Its linear forms suggest dynamic movement. Ht 36cm/14¼in.*
4 *The partnership of Frans Hoosemand and Egide Rombeaux produced exquisite sculptures in silver and ivory. In this candelabrum of c.1899, the delicate female figure is held in a sensual embrace by the searching plant tendrils. Ht 36cm/14¼in*

Belgium saw a Renaissance in the tradition of silversmithing combined with ivory carving, as products from the Belgian Congo were officially promoted in the luxury trades. The most dramatic use of ivory and metal was seen in the work Philippe Wolfers. Trained in every aspect of goldsmithing – modelling casting, chasing, burnishing, and stone setting – Wolfers created often disturbing Symbolist pieces that combine human, animal, and plant forms. Dutch metalwork was influenced by developments in Belgium and the work of one of the leading Dutch designers, Jan Verheul, is clearly indebted to Horta's curvilinear metalwork.

In German art metalwork, abstract natural ornament, derived from the ideas of Hermann Obrist, can be seen in the work of the leading designers Friedrich Adler, Ludwig Vierthaler, Gertraud von Schellenbühel, Ernst Riegel, and Hans Edouard Von Berlepsch-Valendas. By contrast a rich German metalworking industry meant that many factories mass-produced designs in the new style that often used floral or figural motifs. J.P. Kayser &

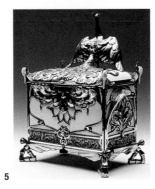

5

6

5 *Philippe Wolfers' jewellery box of 1905 is a superb example of the use of mixed media. Silver, enamel, ivory, opals, and pearls are combined to create a symbolist masterwork. Ht 42cm/16½in.*

6 *Jan Verheul's hanging light fixture for an office employs the sinuous, curvilinear forms of Belgian Art Nouveau.*

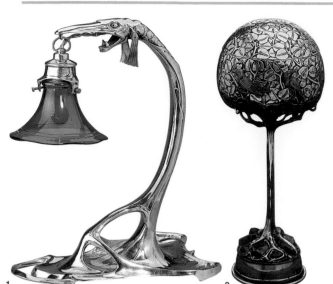

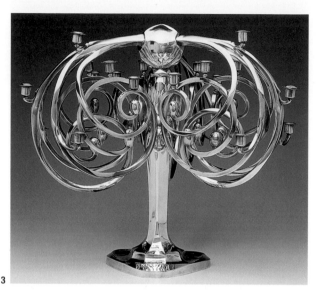

1 *Metamorphic imagery was common in Art Nouveau metalwork. The stem of this desk lamp by Friedrich Alder emerges from the organic form of the base and transforms into the head of a pike. Ht 33.5cm/13in.*

2 *This goblet designed in 1903 by Ernst Riegel takes the form of a tree decorated with crowned ravens. Made of silver, gilded silver, and opals its form recalls that of late Gothic "apple goblets." Ht 24cm/9¼in.*

3 *The dense, curving forms of Gertraud von Schnellenbühel's unique twenty four-light candelabrum of 1910 is clearly influenced by the ideas of Hermann Obrist. It is made of silver-plated brass. Ht 48.5cm/19¼in.*

4 *This tea and coffee service, designed by Josef Maria Olbrich, c.1904, is made of pewter. With its restrained decoration and geometric forms, it is typical not only of Olbrich's work in pewter but of the Seccession style. Coffee pot ht 19.5cm/7¾in.*

5 *Josef Hoffmann developed a powerfully, simplified aesthetic based on geometric form. It became know locally as Quadratstil (square style). This tea service of 1903, in silver, coral, wood, and leather, with its hand-hammered surface, reveals the formal purity of his style. Teapot ht 11cm/4¼in.*

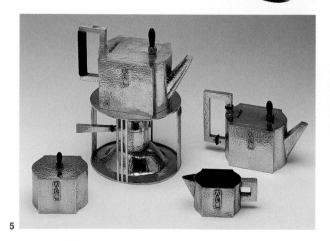

6 *Württembergische Metallwarenfabrik was one of the largest companies to mass produce Art Nouveau-style metal wares. The stem of this silver-plated flower and fruit stand takes the form of a woman. Ht 47.5cm/18¾in.*

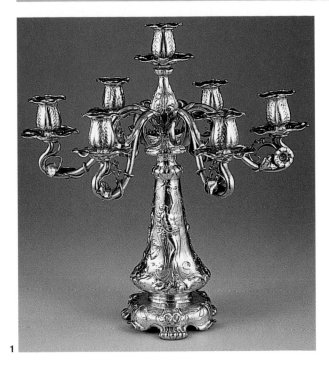

2 *The English designer Kate Harris produced several silver cups for Hutton & Sons in the Art Nouveau style. Although the base of this candle lamp of 1900 is clearly Arts and Crafts in inspiration, the stem adopts the tense curvilinear forms of Art Nouveau. Ht 38.5cm/15in.*
3 *This silver cigarette box of 1903–4 by Archibald Knox is decorated with motifs draw on both Celtic art and the organic sinuous line of Art Nouveau. Ht 11cm/4¼in.*
4 *In Chicago, Louis Sullivan also introduced Celtic imagery. This teller wicket of 1907–8 by George Grant Elmslie uses organic and Celtic forms. Ht 1.04m/3ft 5in.*
5 *Works in beaten metal were often produced by the women designers of the Glasgow School. This panel of 1898 is by Margaret Macdonald. Ht 76.5cm/30cm.*

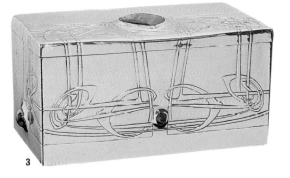

1 *The conventional shape of this candelabrum of c.1900, by the Gorham Manufacturing Co, the largest silver manufacturer in the USA, is masked by the bulging forms and sinuous decoration. Ht 49.5cm./19½in.*

Sohn in Krefeld was the most successful industrial producer of pewter objects. Floral elements combined with linear forms gave pieces a popular appeal. Walter Scherf & Co. of Nuremberg employed Adler to produce designs for the *Osiris* series while WMF, one of the largest electroplate and art metal ware companies, produced vast catalogues of wares for the home including figures, plaques, lamps, and reliefs.

In Austria, the Wiener Werkstätte founded in 1903 explored handcraft traditions and ideas. The silver objects produced by the workshops, which were some of the finest achievements of the enterprise, combined rich materials, geometric forms, and unusual surface treatments. Many pieces have surfaces that were hammered or punched, revealing a clear influence from the English Arts and Crafts philosophy.

Most British silversmiths were unaffected by Art Nouveau, but two leading figures, Charles R. Ashbee and Archibald Knox, did produce designs inspired by the style. Knox produced a range of silver and pewter for Liberty & Co. that exploited Celtic linear forms. His *Cymric* ware of 1899 and *Tudric* ware of 1900 became internationally recognized by Art Nouveau designers and patrons. In Scotland the Glasgow School produced works in various metals, including silver and beaten and embossed lead and brass, that incorporated the typical attenuated Symbolist decoration of the Glasgow style.

American Art Nouveau metalwork was dominated by two New York based companies, Tiffany & Co. and the Gorham Manufacturing Co. These companies utilized typical Art Nouveau forms and imagery in their products, including the female nude figure, stylized flowers and plants, and swirling molten metal forms. The Tiffany enamel workshops produced some of the very finest and most original enamel work of the period. The leading exponent of architectural decorative metalwork in the United States was Louis Sullivan (1856–1924). Much of the complex abstracted organic decoration and celtic-inspired forms reveal his interest in European models.

Textiles and Wallpaper

France

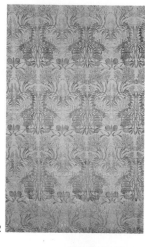

1 *Eugène Gaillard used the curving ogee form, derived from the textiles of the Islamic Orient, to create an elegant repeating floral pattern in this printed velveteen of c.1900.*
2 *Many of Georges De Feure's designs for silk wall-coverings were inspired by the floral repeat patterns of 18th-century France.*
3 *Like many of the Nabis painters, Paul Ranson produced designs for decorative art works. This textile design was exhibited in the Bing pavilion at the Paris exhibition of 1900. Its bold colours and compositions are typical of Nabis design.*
4 *Félix Aubert produced some of the most elegant designs for Art Nouveau textiles. This design of irises in water is derived from Japanese art.*

5 *This design for a wallpaper and border of 1902–3 by the Czech artist Alphonse Mucha demonstrates how flower motifs could be conventionalized for use in design. The use of strong line and delicate colour are typical of Mucha's style.*
6 *La Fête du Printemps was designed as a tapestry by Eugène Grasset in 1900, with the popular Art Nouveau subject of dancing female figures.*

Textiles, whether repeating pattern silks or tapestry "pictures," were vital to the *Gesamtkunstwerk*, or artistic interior. France was the leading producer of textiles, and the important historic centres of the textile weaving industry in Mulhouse, Lille, and Lyons soon adopted the new style. French textile design is typified by the sinuous repeating flower patterns that echo French 18th-century silk patterns. Many leading Art Nouveau artists designed textiles including Edouard Colonna, Eugène Gaillard, and Georges De Feure, who made designs for printed textiles and embroidery for walls and upholstery. Their designs include some of the most sophisticated curvilinear patterns in Art Nouveau. Graphic designers such as Alphonse Mucha and Eugène Grasset also designed textiles and wallpapers. Graphic images were often simply transposed to printed or woven textiles. Grasset designed mass-produced picture panels, sold in department stores, to provide a form of inexpensive tapestry for the home.

Some of the most progressive patterns for textiles and wallpapers were produced in Germany, Austria, and Belgium. Abstract natural or geometric patterns are typical of the designs of Henry van de Velde, Josef Hoffmann, Kolomon Moser, and Richard Riemerschmid. They developed commercial designs for textiles, papers, and carpets which were produced often in more than one colourway and material. Several designers became interested in textile design as a unique form of art. Van de Velde's Symbolist *Angel's Watch*, influenced by Gauguin and the Nabis, was exhibited at La Libre Esthétique salon in Brussels, where it was heralded as a masterwork of the new style. The embroideries of the German Hermann Obrist show an intense commitment to nature and the energy conveyed in his *Whiplash* plant motif has become a defining feature of the style.

In the Netherlands, batik (an Indonesian wax-resistance technique) became popular in textile design. The Hague workshop employed up to 30 women to produce batik. Chris Lebeau's (1878–1945) designs were complex, combining traditional Indonesian patterns with his own imagery of abstract plant and zoomorphic forms.

Belgium, Austria, Germany, and the Netherlands

1 *Under the influence of Gauguin, Van de Velde developed the use of bright colour and flat pattern in this appliqué textile, Angel's Watch. Made in 1892–3 it marks a shift in Van de Velde's work towards a more organic and linear style.*

2 *Hermann Obrist's seminal Whiplash embroidery of c.1895 is an icon of the Art Nouveau style. Many designers attempted to emulate the tense energy achieved through the use of curvilinear line.*

3 *In Austria, Kolomon Moser created abstract patterns derived from plant motifs in his book of patterns,* Die Quelle *(1901). W. 1.15m/3ft 9½in.*

4 *Richard Riemerschmid frequently created patterns that were adapted from plant and flower forms. This textile of 1905 uses a curving stem to create a repeat.*

1

2

3

5 *In the search for a modern style, batik became a popular technique in Holland. This three-panel screen by Chris Lebeau of c.1904 is one of more than a dozen screens produced by the artist using batik. Ht 1.3m/4ft 3in.*

4

5

ART NOUVEAU | TEXTILES AND WALLPAPER

1 *Frida Hansen revived the art of tapestry weaving in Norway. In her* Milky Way *tapestry of 1892, the stars are personified as ethereal maidens.*

2 *The Hungarian Nabis painter, Joszef Rippl-Ronai, created this tapestry,* Lady in a Red Dress, *in 1898. The use of strong outline and bright colour is derived from Japanese art and typical of Art Nouveau graphics.*

3 *Akseli Gallen Kallela's,* Flame *rug was exhibited in the Finnish Pavilion at the Paris exhibition of 1900. It was woven using the ancient* ryijy *technique and its simple geometric forms were adapted from traditional Finnish folk patterns.*

4 *Otto Eckmann's* Five Swans *tapestry was made at the tapestry weaving workshops at Scherrebek which were founded in 1896 to continue the tradition of weaving. This tapestry was one of the most popular designs made at Scherrebek.*

5 *János Vaszary's* Shepherd *tapestry of 1899 combines elements of Hungarian folk art with modern Art Nouveau forms. Traditional patterns are used for the shepherd's jacket and borders while the background is simplified and stylized.*

Innovative designs emerged from the new tapestry workshops in the Nordic countries and central Europe. Tapestry weaving was highly esteemed and underwent a renaissance with such designers as the Norwegians Frida Hansen (1855–1951) and Gerhard Munthe and Hungarian János Vaszary (1867–1939). They devised narrative patterns based on national history, folk myth, and legend to produce modern national designs. Hansen, in the tapestries woven by the Norwegian Tapestry Society at Kristiania, adopted ancient Nordic techniques closer to *Kilim* making than conventional tapestry technique. Similar workshops were established in Finland, Denmark, and Hungary and used indigenous patterns and techniques in tapestry, carpet, embroidery, and lace. Scherrebeck, in Denmark, a successful textile centre, employed designers from other countries to produce large quantities of works. Over 100 versions of Otto Eckmann's *Five Swans* tapestry were produced. Hungarian textile design also saw the modernizing of other traditional techniques. Hallas lace

combined the sinuous forms, new colours, and floral subject matter of Art Nouveau with traditional lace-making techniques.

By 1890 Britain was a leading producer of artistic textiles and wallpapers. A number of British manufacturers produced Art Nouveau designs for export while British designers were employed by both British and foreign manufacturers. Although many companies made designs inspired by Arts and Crafts flat pattern design, companies such as the Silver Studio and F. Steiner & Co. produced a range of exuberant Art Nouveau designs that used attenuated, stylized plant forms.

Scotland saw a revival of interest in craft textile design and techniques. Many, predominantly women, designers associated with the Glasgow School of Art studied techniques and patterns of British and European folk embroidery and developed a unique form of appliqué embroidery that incorporated materials such as glass beads and paper. Common motifs used include the Glasgow rose, the egg, and geometric forms.

1 *This printed cotton textile designed by Harry Napper, c.1900, and printed by G.P. Baker Ltd, adapts the traditional thistle motif to the swirling forms of Art Nouveau.*

2 *F. Steiner & Co produced stylized, floral patterns for export. This printed cotton sateen was produced in 1906.*

3 *Stylized tulips with curving stems and leaves form the pattern in this 1903 design for a wallpaper by Lindsay Butterfield. The subtle palette is composed in shades of green and yellow.*

4 *Jessie Newbery studied both British and European folk embroidery. This collar and belt of c.1900 demonstrate her experimental style that combined appliqué with simple stitching. Belt l. 75cm/29½in.*

5 *Margaret Macdonald produced textiles for interiors by her husband, C.R. Mackintosh. These embroidered panels, 1902, include Glasgow School motifs including attenuated figures, eggs and circles. Ht 1.82m/5ft 11¾in.*

Early Modernism

1900–30

Contemporary with Art Nouveau in France and Belgium and *Jugendstil* (Youth Style), its counterpart in Germany, were the often remarkably modern-looking creations emanating from the design studios and factories associated with the Wiener Werkstätte (Vienna Workshops). This association of artist-craftsmen, modelled on C.R. Ashbee's Guild of Handicraft in Britain, was founded in 1903 by the business-patron Fritz Wärndorfer, architect-designer Josef Hoffmann (1870–1956) and artist-designer Koloman (Kolo) Moser (1868–1918). It owed a considerable debt to the principles of the Arts and Crafts Movement.

The designs of the Wiener Werkstätte are often considered the Austrian manifestation of Art Nouveau, just as the output of the Glasgow School is often called Scottish Art Nouveau, but for the purposes of this book, early 20th-century Viennese design is being considered in addition to the output of Paris, Glasgow, Munich, Barcelona, Turin, and other leading centres of multi-faceted Art Nouveau, which were covered in the previous chapter.

In Austria itself, contemporary design was referred to as *Sezessionstil*. The name derives from that of the Wiener Sezession (Vienna Secession) architects, designers, and artists, including Hoffmann, Moser, painter Gustav Klimt (1862–1918), and architect-designer Josef Maria Olbrich (1867–1908), who in 1897 broke away from the Vienna Academy, the city's conservative, quasi-official society of artists. The Secessionists, who published the influential periodical *Ver Sacrum* (Sacred Spring), aimed to connect themselves, and their city, with similarly progressive artists outside their environs and country, whose art they displayed alongside their own in the magnificent Secession building (1898), a square white Olbrich-designed structure topped by a gilded openwork dome of leaves and tendrils. The resultant efflorescence of the new, often highly innovative, design and decorative arts in the Austrian capital, informed in part by Charles Rennie Mackintosh and the Glasgow School (see previous chapter), proved every bit as influential as, and certainly more long-lasting and timeless than, French and Belgian Art Nouveau.

The goal of the aesthetically (though not necessarily socially) progressive group connected to the Wiener Werkstätte, which existed until 1932, was to apply principles of tasteful design and sound craftsmanship to an extensive range of objects, from furniture and metalwork to textiles and ceramics. Hoffmann, Moser, Olbrich, and other Secession and Werkstätte figures, among them architect-designer-teacher Otto Wagner (1841–1918), and Dagobert Peche (1887–1923) and Eduard Josef Wimmer (1882–1961), both of whom were

Left: Josef Hoffmann's silver-coloured-metal menu holder and Otto Beran's lithographed menu card for the Wiener Werkstätte, c.1906, were originally designed for a 1906 exhibition, Der gedeckte Tisch (the laid table). The card includes the decorative elements found on many Viennese designs of the period, from glassware and china to furniture and posters. Card ht 14cm/5½in; holder ht 3.5cm/1¼in.

Opposite: the Palais Stoclet, Brussels (1905–11), designed by Josef Hoffmann, was a private house furnished completely by the Wiener Werkstätte. Its simple, though subtly decorated, rectilinear black-and-white exterior belied much of the interior design of the residence, which includes decorated furniture by Hoffmann and Koloman Moser, murals by Gustav Klimt, and both utilitarian and decorative objects by the premier early Modernist designers and manufacturers of early 20th-century Vienna.

1 *Vienna-born Winold Reiss, who later settled in New York City, created the gouache-on-board design of a stylized blossom for wallpaper or textile, c.1928, that looked back to organic Viennese design from earlier in the century. Ht 1.01m/3ft 4in.*

2 *Austrians Michael Powolny and Bertold Löffler designed the hand-painted faience violet vase, made by their Wiener Keramik, c.1906. The grid-like design is typical of early Viennese Modernism; similar geometric designs can be found on metalwork, furniture, and textiles. Ht 14.3cm/5⅝in.*

3 *From the early 20th century, examples of Czech design showed influences of the geometric patterns of turn-of-the-century Vienna. Pavel Janák's covered box, 1911, of earthenware with ivory-coloured glaze and jagged black decoration, is also a fine example of Czech Cubism. Ht 12cm/4¾in.*

4 *Arts and Crafts decoration adorns this painted and gilded wood covered jar, c.1906, by Lucia Mathews of San Francisco's Furniture Shop. Modern stylized floral forms also appear. Ht 31.7cm/12½in.*

later artistic directors of the Werkstätte, held their own exhibitions, received important commissions both at home and abroad, taught at the prestigious Kunstgewerbeschule (School of Applied Art) and, most of all, had their influence felt not only across the Continent and the Atlantic but across the decades, well past the demise of the Art Nouveau of France and other countries. All these talented individuals looked with fresh eyes at furniture, ceramics, glassware, metalwork, and other objects, espousing a clean new design vocabulary. From their highly creative designing minds came objects of beauty as well as comfort, utility, and decoration, characterized by qualities such as rectilinearity, geometry, strong patterns, and bright colours. New materials were employed as well, such as bentwood and alpaca, a silver-plated alloy.

The Wiener Werkstätte came to be one of the most progressive forces in art and design of the time, showing its wares at international exhibitions and opening additional branches in Marienbad (Czech Republic) and Zürich (both 1917), New York City (c.1922), Velden in Austria (1922), and Berlin (1929). A century later, much of the Wiener Werkstätte's output still appears decidedly

Modernist, not unlike the even earlier silver and base and composite metal teapots, toast racks, and other utilitarian pieces by Christopher Dresser (1834–1904), the polymathic British designer of the Victorian era.

The creation most closely connected with the Wiener Werkstätte, and arguably its most famous and best-preserved legacy, was a lavish private residence that was located not in Vienna but in Brussels, where Adolphe Stoclet, a wealthy banker, and his Parisian-born wife, Suzanne, commissioned Josef Hoffmann to design for them a modern villa, known today as the Palais Stoclet or Villa Stoclet (1905–11). This rectilinear, subtly decorated structure (still extant but not open to the public) was in turn furnished and decorated by Hoffmann, Moser, Klimt, and other talented Viennese artists and designers of the day. A project marked by both simplicity and luxury, the Palais Stoclet is an icon of refined early Modernism that featured the cool, squared-off furniture and furnishings of Hoffmann and Moser, as well as sparkling gilded and painted murals in the dining room executed by Klimt. Indeed, the Palais Stoclet boasts not only the sole surviving authentic Secession interior, but also one of the most important early-Modernist interiors

in Europe, as fresh and modern today as it was when it was designed and furnished nearly a century ago.

In other countries, similar Arts and Crafts-inspired associations, schools, workshops, and loosely linked groups of artists and designers arose around the turn of the century, creating, among other things, Modernist furniture and objects that were sometimes akin to the output of the Wiener Werkstätte, sometimes distinctly independent of any other movement or style.

In Germany there were the Vereinigte Werkstätten für Kunst und Handwerk (United Workshops for Art and Crafts), established in 1897, and the Dresdner Werkstätten für Handwerkskunst (Dresden Crafts Workshops), founded in 1898. Similarly, there was the artists' colony at Mathildenhöhe, near Darmstadt, set up by Grand Duke Ernst Ludwig of Hesse in 1899 to bring together all the arts following both design and social criteria; among its invited members and teachers were the German architect and designer Peter Behrens, the Belgian Henry Van de Velde, and the Austrian Olbrich. In 1907 the Deutscher Werkbund, yet another Teutonic union of art, design, and industry, was founded with the aid of the Wiener Werkstätte.

A little later in Britain, the Omega Workshops (1913–19), which were associated with the Bloomsbury school of artists, were set up in London by the art critic and painter Roger Fry (1866–1934). The workshops produced textiles, rugs, furniture, pottery, and other objects in a painterly decorative style whose motifs, palette, and style were somewhat akin to Impressionism but marked by an exuberance all their own (and decidedly non-British in character). And though Omega

workmanship was not always first rate, their decorative pieces proved to have a lasting appeal, in part because of the eminence of those, such as Fry, Duncan Grant, and Vanessa Bell, who designed and decorated them.

In Czechoslovakia, architects and designers connected with a short-lived (c.1910–25) movement that took as its inspiration both Secession objects and Cubist paintings and sculptures created highly original, daringly decorative furniture and other objects known today as Czech Cubism. Multi-angled, zigzag-formed chairs and sofas, as well as ceramic tea sets, vases, and others vessels, were among the arresting pieces created by Vlastislav Hofman, Jaroslav Horejc, Pavel Janák, and others.

As well, a number of architects, designers, and painters in the United States were creating objects that can be considered outstanding examples of early Modernism. Among them were, in California, Arthur F. Mathews and his wife, Lucia K. Mathews, and the brothers Charles Sumner Greene and Henry Mather Greene; in New York, Joseph Urban, who for a time headed the Wiener Werkstätte's New York branch, and Winold Reiss; and arguably one of the greatest architect-designers of his (and many would say any) era, Frank Lloyd Wright.

6 British-born Eleanor Mabel Sarton, who lived in Belgium c.1911–15, designed this writing cabinet for the Brussels firm L'Art Décoratif in 1913, when it was exhibited in Ghent. Of various woods, mother-of-pearl, ivory, and silk, the showpiece combines a simple rectilinear form with bold inlaid floral decoration, thus blending geometric elements of contemporary Vienna with decorative motifs of early Art Deco Paris. W. 1.35m/4ft 5¼in.

5 This small wood box of 1914 was painted by Wyndham Lewis soon after he left the Omega Workshops and set up the Rebel Art Centre. Its sleek geometric design complements the box's cube shape and is akin to Modernist continental designs rather than the idiosyncratic figurative and floral motifs typical of Omega. Ht 8.9cm/3½in.

Austrian Furniture

Square and Rectilinear Designs

4 *Wagner's straight-edged glazed walnut cabinet of 1898–9, part of a suite of furniture in his Vienna dining room, has rich but sparse embellishment: domino-like circles of mother-of-pearl, echoing the rings around the drawer pulls. Ht 1.99m/6ft 6in.*

1 *Several versions of Otto Wagner's classic Viennese bentwood and metal armchair exist, derived from a prototype designed by Gustav Siegel and made by J. & J. Kohn, c.1900. This 1902 model by Wagner, of beechwood, aluminium, and metal, is probably the best known. Ht 78cm/30¾in.*
2 *Designed by Wagner, this ebonized beechwood and aluminium stool, c.1904, has a simple cube form, devoid of all ornament but for the metal bolts on the legs. Ht 47cm/18½in.*
3 *The ubiquitous chequerboard of early modern Viennese design appears on the five compartments of this metal and wood plant stand, c.1903–4, attributed to Koloman Moser. Ht 85cm/33½in.*

The furniture designed by Josef Hoffmann, Koloman Moser, Josef Maria Olbrich, and Otto Wagner in Vienna is best known today, be it the mass-produced works of the prolific Hoffmann or the unique veneered case pieces of Moser.

Although perhaps better known for his metalwork designs, Moser produced some of the most exquisitely decorated and crafted furniture of the Werkstätte. He was adept at designing practical geometric pieces, but when he applied his painterly eye and skills to inlaid and otherwise decorated furniture, the results were outstanding. Most of these creations had traditional, rectilinear forms, which acted as a neutral backdrop on which to append mother-of-pearl, pewter, or exotic wood inlay or marquetry. His dining-room chair of 1904 of rosewood, maple, and mother-of-pearl features the chequerboard design, a Werkstätte signature motif, at the top and bottom of the back; its focal point is a dove bearing an olive branch on the back. Moser stopped designing for the Werkstätte by 1907, when he devoted more time to painting.

The extensive array of largely production items by Hoffmann is arguably the Wiener Werkstätte furniture best known today. Among the most attractive are the dark-stained, laminated, ebonized, or white-painted beechwood pieces, most with bentwood elements. His designs were largely made by Jacob & Josef Kohn's Vienna factory as well as Gebrüder Thonet. Hoffmann's simple bent beechwood chair of 1904–6, designed for the dining room of the Purkersdorf Sanatorium, was produced by J. & J. Kohn. Probably his best-known seat furniture is the *Fledermaus* chair, designed for the Werkstätte's theatre-bar, the Kabarett Fledermaus.

Viennese furniture was also designed by Olbrich, Wagner, Otto Prutscher, Gustav Siegel, and Adolf Loos. Bentwood pieces are the most common (the process having been invented by Thonet in the late 1850s); veneered, highly decorated ones are the most unusual. Wagner's ebonized wood and aluminium stool, c.1904, was designed by Thonet for Vienna's Österreichische Postsparkasse (post office).

Bentwood Chairs

1 *Josef Hoffmann's bentwood chair, c.1904, was designed for the Purkersdorf Sanatorium. It is a simple design, with 15 rows of paired circles on its pierced back splat and 8 wooden spheres below its seat. Ht 98.7cm/3ft 2¾in.*

2 *The bentwood* Fledermaus *chair by Hoffmann, c.1906. This is a rare extant example with traces of its original black-and-white paint; the back panel and seat are upholstered in red leather. Ht 72.3cm/28½in.*

3 *Hoffmann's* Sitzmachine, *1908, was an update of the classic, adjustable-seat William Morris chair, and is at once rectilinear and curvilinear, with round and square decorative elements cut out and added. Ht 56cm/22in.*

Opulent Veneered Pieces

1 *The rectilinear form of Koloman Moser's armchair, 1904, is in stark contrast to its opulent decoration: rosewood and maple veneer and mother-of-pearl inlay. Ht 94.9cm/3ft 1¼in.*
2 *Moser's* Enchanted Princesses *cabinet, c.1900, shows Japanese and Symbolist influences. When open, the corner piece reveals two marquetry "princesses" on the door backs, amid circles of alpaca metal. Ht 1.71m/5ft 7½in.*
3, 4 *Moser's lady's writing desk with armchair of 1903, made by Caspar Hrazdil. The pieces are made of exotic Thuja wood inlaid with satinwood and engraved and inked brass. The figurative element – eight women holding hoops – is a distinctive Moser touch. Desk ht 1.44m/4ft 7¾in; chair ht 67cm/26½in.*

British Furniture

Artists' Furniture from the Omega Workshops

1

2

3

4

5

1 *Duncan Grant's oil-on-wood* Lilypond *screen, 1913, features a popular Omega Workshops design. Grant saw the screen as a true meeting of art and design, of fine and applied art. Each panel ht 1.75m/5ft 8¾in.*
2 *Expertly crafted in marquetry of various woods, its decoration that of two stylized giraffes, this cupboard was designed by Roger Fry and made by Joseph Kallenborn for the Omega Workshops, 1915–16. Ht 2.13m/7ft.*
3 *This dressing table made by Kallenborn, c.1919, with its sumptuous veneer of walnut, sycamore, and ebony on holly, is at once a nod to fine Cotswolds craftsmanship and French Art Deco veneered furniture. W. 1.5m/4ft 11in.*

4 *A naked and winged musician strums a stringed instrument on a log box painted by Duncan Grant, c.1916, at Charleston. W. 34cm/13⅓in.*
5 *The inner lid of virginals in effect acting as his canvas, Roger Fry painted a naked woman on this Omega Workshops instrument, her shape distorted to fit the odd angles of the lid. Open keyboard ht 1.04m/3ft 5¼in.*

Furniture created by the Omega Workshops ran the gamut from upholstered chairs and sofas covered with Omega-designed fabrics to marquetry case pieces and hand-painted screens. Vanessa Bell was the likely painter of a tile fireplace surround at Monks House, the home of her sister, Virginia Woolf. Exuberant floral and fruit displays were also painted throughout Charleston, the Sussex farmhouse that in 1916 became the residence of Duncan Grant and Vanessa Bell, and the country retreat of the Bloomsbury set. There, still lifes or simply large blossoms appeared on, among other objects, doors, window surrounds, a gramophone cabinet, a small three-fold screen, and a kitchen cupboard. A screen, *Lilypond*, was painted by Grant in 1913.

At the same time that the Omega Workshops were creating colourful pieces of furniture, the Cotswolds master furniture maker, Ernest Gimson (1863–1919), and other Arts and Crafts designers were hand-fashioning outstanding objects in a simple and often geometric style which prefigured Modernism.

Craftsmen's Artistry

1 *Elegant and painstakingly crafted, Ernest Gimson's cabinet, c.1902, is veneered in walnut with gesso gilt panels and an ebony stand. Note the diamond-shaped pattern around the two upper panels, the circular motifs around the lower two. W. 63.2cm/25in.*
2 *Gimson's small cabinet, c.1907, features an unusual marquetry design – the pattern resembles a sea of open books – in holly, ebony, and walnut. Ht 36.5cm/14in.*

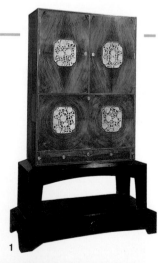

1

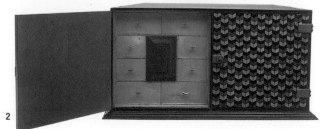

2

American Furniture

Solid Midwest Ingenuity

1 *With its intriguingly low and angled backboard, Frank Lloyd Wright's leather-upholstered oak side chair, 1902–3, was for the Francis W. Little House in Illinois. Though made of the same materials as contemporary Mission oak seat furniture, it has been subverted into something other than a straightforward side chair. Ht 76cm/30in.*

2 *Wright's boxy walnut armchair and ottoman, 1937, were designed for his residential commission, Fallingwater, in Pennsylvania, 1935. The chair is marked by the same superb craftsmanship and a unity of approach in terms of its design and that of the structure for which it was created as the example to its left.*

1 2

Decorative California Pieces

1 *Charles Sumner Greene and Henry Mather Greene created this table, c.1909, of Honduras mahogany, ebony, and silver. Note the graphic wavy line, inlaid in silver on the drawer and cut out on the lower shelf. W. 1.37m/4ft 4in.*
2 *Lucia Mathews's hexagonal carved and painted wood box, c.1910, features floral elements that lie between Arts and Crafts, Jugendstil, and Art Deco. Ht 29cm/11½in.*

1 2

Early Modernism in America had several exponents whose furniture and other wooden objects were indebted not only to the Wiener Werkstätte and the Arts and Crafts Movement but also to Asian, specifically Japanese, design.

Joseph Urban (1873–1933) was a Vienna native who settled in America in 1911 and in the early 1920s was President of the New York outlet of the Wiener Werkstätte. Urban created showy, luxurious furniture that was often lacquered and highlighted with mother-of-pearl. Winold Reiss (1886–1953), a German-born artist, also designed interiors and furniture in turn-of-the-century New York.

Using a design vocabulary more related to British Arts and Crafts were Lucia Mathews (1870–1955) and Arthur Mathews (1860–1945). Lucia's hexagonal wood box, c.1910, is decorated with stylized blossoms. In the 1900s, Frank Lloyd Wright (1867–1959) was designing furniture that was neither Arts and Crafts nor Modernist but could fit in well with Viennese designs of the same period. An example is his oak side chair, 1902–3.

Charles Sumner Greene (1868–1957) and Henry Mather Greene (1870–1954), architect-designer brothers, are considered Arts and Crafts exponents, but their mahogany table, c.1909, has a Japanese look that also looks forward to the streamlined Modernism of two decades later.

German and Continental Furniture

Simple, Practical Designs

1 *Richard Riemerschmid designed this simple, substantial oak and leather desk, c.1903, probably made by the Dresdner Werkstätten für Handwerkskunst. W. 1.99m/6ft 6¼in.*

2 *This pair of oak and leather chairs is after a design by Riemerschmid, c.1900. With their decorative yet structural diagonal side struts, the chairs are a fine, curvilinear example of* Jugendstil. *Ht 78cm/30¾in.*

3 *This beech and pearwood armchair by Riemerschmid, made by the Dresdner Werkstätten für Handwerkskunst, 1902, bears traces of* Jugendstil *in its subtly curving back, arms, and cut-out and chamfered legs. Otherwise it is a solid piece leaning towards later Modernism. Ht 82cm/32¼in.*
4 *The sweeping diagonals of Bruno Paul's maple and leather armchair, 1901, made by the Vereinigten Werkstätten für Kunst im Handwerk, Munich, make a strong design statement yet provide the sitter with an elegantly enveloping seat. Ht 87.5cm/34½in.*

At the time Hoffmann, Moser, and others, were producing their furniture designs in Vienna, designers elsewhere in central Europe, many of whom were associated with the already mentioned workshops, were creating early Modernist furniture, generally not of the elaborate, opulent Viennese type but more straightforward wood-carved and machine-manufactured varieties, often with subtle decorative fillips.

In Germany, for example, Richard Riemerschmid (1868–1957) designed *Maschinenmöbel* (machine-made, hand-finished furniture) for the Dresdner Werkstätten, such as his beech and pearwood armchair of 1902. The *Typenmöbel* (standard furniture) of Bruno Paul (1874–1968) was offered by Munich's Vereinigten Werkstätten für Kunst im Handwerk. A handsome oak dining table with four side chairs of *c*.1910, for instance, was relatively straightforward, rectilinear, and unadorned, but for the backs of the chairs, which comprised a simple rectangular splat with a diamond-shaped mid-section. Two other Modernist furniture designers working in Germany were

Hamburg-born Peter Behrens (1868–1940), who had helped to establish the Munich Vereinigte Werkstätten für Kunst im Handwerk in 1897, and the Belgian Henry van de Velde (1863–1957), who introduced Art Nouveau to Dresden in the same year. Behrens's white-painted wood side chair, 1903, with two elongated arch cut-outs in its subtly curved back, relates somewhat to van de Velde's 1902–3 bedside cabinet, of white-painted pine and brass, which has trefoil cut-outs on the side.

Although better known for his whiplash-curved pieces, the Belgian Gustave Serrurier-Bovy (1858–1910) also created some starkly rectilinear furniture that related to Viennese design. His boxy armchair, *c*.1900, is remarkable for its strong, vertical, almost cage-like elements.

Among the most dramatic early Modernist furniture coming out of Central Europe was that created by exponents of Czech Cubism. With its unique zigzag-shaped elements, Pavel Janák's chair of brown-stained oak, 1911–12, resembles Art Deco creations of the 1920s, or Memphis furniture of half a century into the future.

5 *This oak dining table with four side chairs, c.1910, designed by Bruno Paul and made by the Vereinigte Werkstätten für Kunst im Handwerk, Berlin, is starkly rectilinear, but for the diamond-shaped central back splat on the chairs. Its simplicity and straight lines contrast strongly with the curves of Paul's armchair (4 on the previous page). Table diam. 1.2m/3ft 11¼in.*

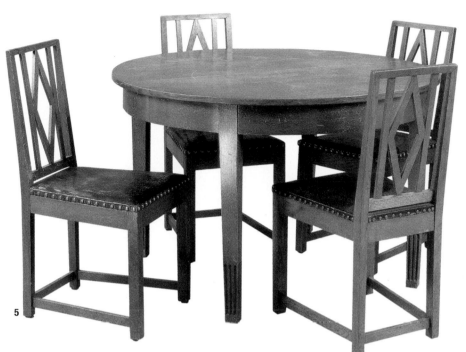

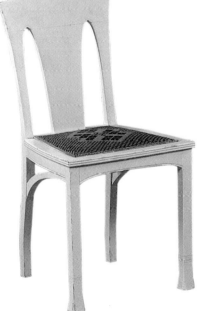

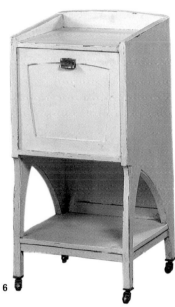

6 *These two pieces of white-painted, elegantly curvilinear Jugendstil furniture could almost be part of a single commission, but in fact each is by a different designer. The chair, 1903, by Peter Behrens, is from the Hamburg house of the poet Richard Dehmel, and the bedside cabinet, 1902–3, by Henry van de Velde, a Belgian architect-designer who worked extensively in Germany, is from the Weimar apartment of writer Max von Münchhausen, a writer at the Bauhaus Archiv. Chair ht 90cm/37½in; cabinet ht 83.2cm/32¾in.*

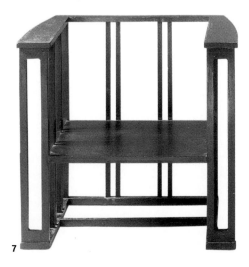

7 *Belgian designer Gustave Serrurier-Bovy is best known for his curvilinear Art Nouveau furniture, but he also created starkly rectilinear forms, in part inspired by Arts and Crafts examples. This painted wood chair, c.1900, is a modern geometric essay, with only the subtlest of curves at the top of its arms. Ht 73.7cm/29in.*

8 *Czech Cubist designers saw furniture as an art form. In this brown-stained oak side chair, 1911–12, Pavel Janák took as his base the triangle, which determines virtually its entire shape. Ht 95cm/37in.*

Ceramics

Figurative and Painterly Pieces

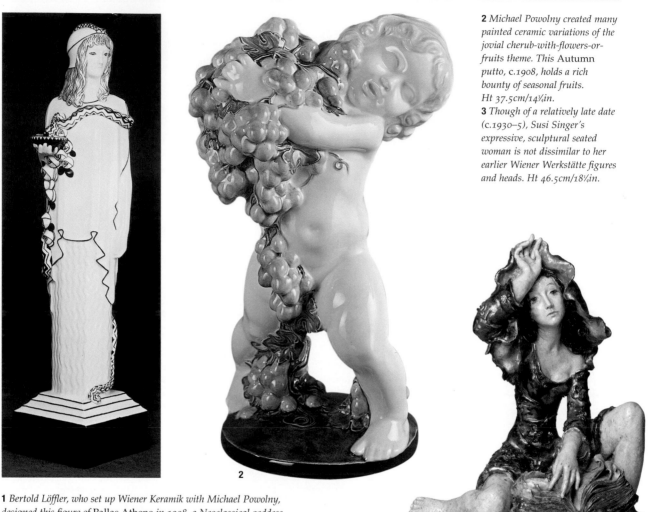

1 *Bertold Löffler, who set up Wiener Keramik with Michael Powolny, designed this figure of* Pallas Athene *in 1908, a Neoclassical goddess with black-painted touches. Ht 33.6cm/13¼in.*

2 *Michael Powolny created many painted ceramic variations of the jovial cherub-with-flowers-or-fruits theme. This Autumn putto, c.1908, holds a rich bounty of seasonal fruits. Ht 37.5cm/14¾in.*

3 *Though of a relatively late date (c.1930–5), Susi Singer's expressive, sculptural seated woman is not dissimilar to her earlier Wiener Werkstätte figures and heads. Ht 46.5cm/18¼in.*

As in other media, turn-of-the-century Viennese ceramics often displayed the distinctive stylized design vocabulary formulated by leading lights such as Hoffmann and Moser. The Wiener Werkstätte produced numerous ceramic vessels, some by Moser, a few by Hoffmann, but a number of others by female designers, including Jutta Sika, who had taken Moser's ceramics class at the Kunstgewerbeschule (the designs from his students even took on the name *Schule Moser*). The Josef Böck firm of Vienna executed several Schule Moser designs, notably Sika's renowned *c.*1901–2 red-enamelled tea service, with circular motifs. Susi Singer was one of several designers from the Wiener Werkstätte to produce distinctive hand-painted ceramic figures and objects, many of which, true representatives of Studio Pottery, were marked by their wit and spontaneity. The Wiener Keramik, co-founded in 1905 by two Kunstgewerbeschule teachers, Michael Powolny (1874–1945) and Bertold Löffler (1874–1960), produced distinctive figural pieces, such as Löffler's *Pallas Athene*, 1908.

In Germany, various ceramics factories produced Wiener Werkstätte-style wares, including Meissen and the Reinhold Merkelbach factory in Grenzhausen. Merkelbach's spherical vase, *c.*1905, to a design by Hans Eduard von Berlepsch-Valendas, features strong *Jugendstil* motifs: waves, dots, triangles, and a chequerboard pattern. Similarly, Königlich-Bayerische Porzellan-Manufaktur in Nymphenburg produced Adelbert Niemeyer's cylindrical vase with chequerboard motifs.

Adherents of the Czech Cubist movement produced numerous glazed ceramics that strongly relate to Viennese pieces. These were largely made by members of the Artel Cooperative, who included Pavel Janák.

The Omega Workshops produced ceramics that were either plainly glazed, utilitarian wares, or exuberant showpieces with painted overglaze decoration. Among the latter are two vases, 1914, that feature stylized figures and abstract geometric designs. On the other hand Roger Fry's domestic tableware, was mostly of plain white tin-glazed earthenware.

Geometric Designs

1 With its striking black-and-white geometric design, Bertold Löffler and Michael Powolny's hand-painted faience pedestal bowl, c.1906, is quintessential Vienna Secession design, timeless and elegant. Ht 21.6cm/8½in.
2 Adelbert Niemeyer's painted and gilt porcelain vase, 1905, made by Königlich-Bayerische Porzellan-Manufaktur, Nymphenburg, features chequered elements on its feet and under its rim, which are balanced by stylized blossoms. Ht 27.5cm/10¾in.
3 Hans Eduard von Berlepsch-Valendas's vase, c.1905, has echoes of the Wiener Werkstätte. Ht 14.9cm/5¾in.

4 Jutta Sika's red-enamelled porcelain tea service, made by Josef Böck, c.1901–2, is thought of as the high point of the purist early phase of modern Viennese ceramics design. Teapot ht 19.6cm/7¾in.

5 Czech Cubist Pavel Janák designed this white-glazed, black-painted earthenware coffee set in 1911. The pieces have unusual bead like handles. Coffee pot with lid ht 22cm/8½in

6 Energetically painted designs have transformed these two Omega Workshop ceramic vases with traditional forms into vivid three-dimensional canvases. The earthenware example at left, its painter unknown, is from 1914, while the porcelain vessel at right, painted with stylized figures, possibly by Roger Fry, dates from 1912–19.

7 In c.1913–14 Fry, for the Omega Workshops, designed and made, at the Carter & Co. pottery in Dorset, a tableware set, including this cup and saucer. The earthenware pieces have a thick, white tin glaze, and all imperfect marks are intentional. The cup's angular handle and simple shape presage British Art Deco china of the 1920s and 1930s. Ht 7cm/2¾in.

Glass

Painted and Decorated Vessels

1 *Dagobert Peche's vase, 1918, is of blown coloured glass and overlaid coloured glass cut with a stylized-leaf design. Made by Joh. Oertel & Co., Novy Bor, Czech Republic, it was retailed by the Wiener Werkstätte. Ht 23cm/9in.*
2 *The chequerboard pattern acts as a border on this wine glass, 1911, decorated by Ludwig Jungnickel. Sold by J. & L. Lobmeyr of Vienna, the mould-blown clear glass has been frosted and decorated with bronzite. Ht 18.7cm/7in.*
3 *Josef Hoffmann's striking architectonic vase, 1914, made by Loetz-Witwe, is of blown opalescent glass overlaid with clear and coloured glass, and acid-etched. Ht 17cm/6¾in.*

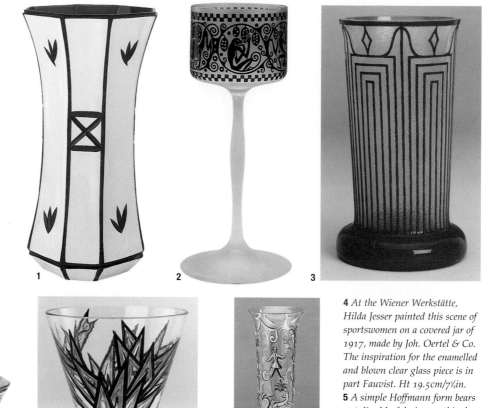

4 *At the Wiener Werkstätte, Hilda Jesser painted this scene of sportswomen on a covered jar of 1917, made by Joh. Oertel & Co. The inspiration for the enamelled and blown clear glass piece is in part Fauvist. Ht 19.5cm/7¾in.*
5 *A simple Hoffmann form bears a stylized leaf design on this clear glass and enamel vase by Peche, c.1917. Ht 15.3cm/6in.*
6 *Mathilde Flögl painted the floral and figurative designs on this mould-blown and enamelled clear glass goblet, c.1920, made at the Wiener Werkstätte. Ht 40cm/15¾in.*

Turn-of-the-century glassware produced in Austria comprised plain, undecorated utilitarian products as well as exuberantly decorated goblets, vases, and the like. Vienna was a major centre in the medium, with the Wiener Werkstätte designing a wide variety of wares, most of which were produced by large factories such as Loetz-Witwe, E. Bakalowits & Söhne, Meyr's Neffe, Ludwig Moser & Söhne, and J. & L. Lobmeyr.

As with Wiener Werkstätte metalwork and furniture, so the glassware marketed under its name was created by its principal designers Hoffmann, Moser, and Otto Prutscher, as well by a number of women (mostly from the 1910s), among them Mathilde Flögl, Hilda Jesser, Jutta Sika, and Vally Wieselthier. Geometric and stylized leaf ornamentation abounded on some but not all Werkstätte pieces, and there were even some unusual examples incorporating figurative designs, such as a wine glass decorated by Ludwig Jungnickel Hoffmann in 1911 and made by Lobmeyr. Their cylindrical bowls sport a chequerboard pattern that borders a frieze of stylized

monkeys within tendril-like medallions sprouting fruit and scrolls; the beasts' tails are similar scrolls. This type of Hoffmann-originated decoration in matt black or dark grey on clear or frosted matt glass is known as broncit ware or *bronzitdecor* (after the metal bronzite), and Lobmeyr, which employed Hoffmann as artistic director from 1910, introduced it that year.

Otto Prutscher employed coloured elements in much of his glassware, which was mostly produced by Meyr's Neffe. He was also known for his handsome goblets, some seeming to balance precariously on inordinately tall stems that were vertical chequerboards of green, pink, blue, and other hues. Koloman Moser was the first Wiener Werkstätte-associated designer to begin creating forms and designs for glassware, some as early as 1898. Most of his pieces were made by Bakalowitz & Söhne in Vienna. Michael Powolny, the potter and teacher, designed glass for both Loetz-Witwe and Lobmeyr. His most distinctive creations were vases and other items in solid colours.

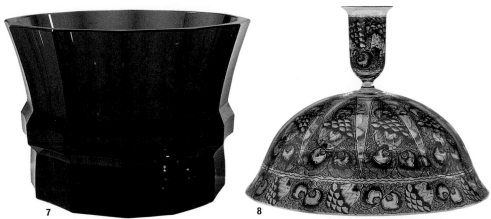

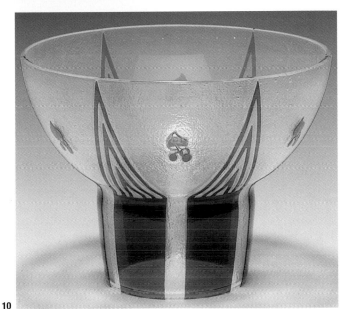

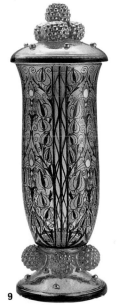

7 *Variations of Josef Hoffmann's sturdy, thick-walled bowl of c.1915, this of violet cut glass, were made by various Bohemian glass factories for the Wiener Werkstätte. Ht 12.2cm/4¾in.*

8 *Karl Massanetz's dense enamelled and gilt decoration on this clear glass candleholder by Oskar Strnad of Vienna, c.1914, harks back to the Schwarzlot technique, but the stylized floral forms relate to Viennese Modernism. Ht 14.1cm/5½in.*

9 *This colourless glass covered vase, c.1914, enamelled in black as well as gilded, is made by Loetz-Witwe. Both its form and decoration are influenced by the Wiener Werkstätte, much of whose glassware was made by Loetz-Witwe in Klostermühle (near Vienna) and then returned to Vienna for decoration. Ht 31cm/12¼in.*

10 *Hoffmann's glass centrepiece, made by Loetz-Witwe before 1914, is of enamelled and cased glass. It features both stylized leaf designs and trios of triangles, effectively combining the geometric and decorative elements of Viennese Modernist design. Ht 15.8cm/6¼in.*

11 *Decorated by Hoffmann or Dagobert Peche and made by Joh. Oertel & Co., this multi coloured glass tumbler, designed before 1915, with its subtle vertical zigzag designs, makes a bold modern statement. Ht 10cm/4in.*

12 *Peche's simple yet dramatic jar with cover, c.1916–17, was made by Loetz-Witwe. Of blown coloured glass and overlaid coloured and clear glass, the piece features an array of tiny black-enamelled designs and, at the foot, vertical lines of white dots. Ht 15.4cm/6in.*

EARLY MODERNISM | GLASS

Silver and Metalwork

Organic and Figurative Motifs

1 *Koloman Moser's architectonic box, 1906, of silver, enamelled and embossed with semi-precious stones, was made for the Wiener Werkstätte by Adolf Erbrich and Karl Ponocny. Like some of Moser's one-off furniture pieces, it is elaborately decorated with organic elements and stylized Neoclassical figures. Ht 24cm/9½in.*

2 *The Viennese architect Josef Maria Olbrich designed numerous buildings at the artists' colony set up in Darmstadt, Germany, 1899. Many German designers were influenced by the metalwork he also created there, as in this silvered-pewter candelabrum, c.1901, made by Eduard Hueck of Lüdenscheid. Ht 36.4cm/14in.*

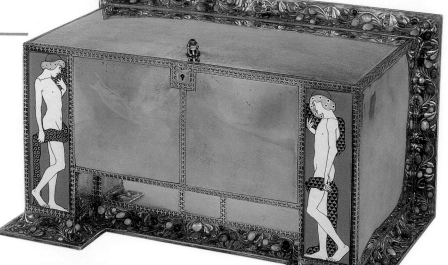

3 *A relatively late Wiener Werkstätte design, Eduard Josef Wimmer's brass jardinière, c.1915, is impressed with an organic design – but one more like a stylized, even primitive, landscape than an overall pattern of blossoms and leaves – while the ubiquitous Viennese grid pattern appears on its legs and oval lower band. Ht 88.9cm/35in.*

4 *Of gilded silver with a lapis lazuli finial on its lid, Carl Otto Czeschka's chalice-like covered goblet, 1909, has an elaborate openwork design on its bowl, in an organic pattern that is typically Vienna Secession. Ht 25.5cm/10in.*

The metalwork designed and produced by members of the Wiener Werkstätte in the early years of the 20th century is among the most distinctive, attractive, and decidedly modern creations of the time. Far removed from the Gallic manifestations of the new style were the largely rectilinear vessels, boxes, and flatware designed by Hoffmann, Moser, Olbrich, Peche, Carl Otto Czeschka (1878–1960), and others.

The silver, silver-gilt, alpaca (silver-plated alloy), brass, enamelled wares, and other decorative metal pieces designed and produced by members of the Wiener Werkstätte included a wealth of objects from flatware to plant-stands, their designs diverse and, for the most part, distinctive. The most easily identifiable designs by the Viennese workshops were those pierced metal objects, mostly designed by Hoffmann and, to a lesser extent, Moser, which were markedly rectilinear, being made up of pieces of metal comprising small open squares, as in a chequerboard. Called *gitterwerk* (latticework), these

signature Werkstätte objects first began to be offered at their various shops in 1904–5. They could take numerous forms and were made of either silver, alpaca, or sheet metal (this usually painted white), perforated with the regular square or grid pattern; occasionally other designs were incised, such as circles. They included handled vases and baskets, round-topped plant tables of white-painted sheet iron, and hexagonal or quatrefoil jardinières.

The Werkstätte's metal output included a wide variety of flatware, with Hoffmann again providing the most, and the best-known, designs. His so-called *flaches Model* (flat model), originally produced in 1903 for patrons Fritz and Lilly Wärndorfer (p.347), was made up of a variety of arrestingly simple sterling silver pieces.

The wide range of other Werkstätte metal objects ran the gamut from simple, undecorated forms that lent themselves to mass production to elaborately embellished one-off articles. Hammered, pierced, embossed, and chased metal pieces were made, as well as examples

5 *Carl Otto Czeschka probably designed this hammered and repoussé brass lamp for the Wiener Werkstätte, c.1920. A stylized bird stands out among the usual foliate motifs on the shade. Ht 64.1cm/25¼in.*

6 *Of silver-coloured metal and cut glass, this table decoration was designed by Hans Bolek, 1909–10. Its upper section's leaf design shows the influence of Wiener Werkstätte, as does its fluted lower section. Ht 15.7cm/6¼in.*

7 *Though a lowly glue pot, the silver-coloured metal container with black-enamel-decorated lid, attributed to Koloman Moser, is an object of great style, as is Moser's rare silver-coloured metal coffee spoon, c.1905. Made by the Wiener Werkstätte, it has a lapis lazuli cabochon on its handle. Box ht 6.5cm/2½in; spoon l. 9.5cm/3¾in.*

8 *Bruno Paul's brass candelabrum, 1901, made by K.M. Seifert, can be seen as boldly abstract, but it is in fact a stylized tree-like form. Ht 40.3cm/16in.*

9 *Peter Behrens created these eight pieces of silver-coloured metal flatware for Martin Josef Rückert of Mainz in 1902. The top four pieces are partially gilt. The triangle-shaped handles of all but the knife are richly decorated with a geometric design.*

10 *Ebonized wood, woven cane, and textured brass comprise Behrens's electric kettle, for AEG, Nuremberg, 1909. Though in essence an object by an industrial designer, this early appliance is still stylish, with its hammered panels and row of horizontal beading. Ht 22.7cm/9in.*

1 *Bellflowers, vertical ribbons, upper lip, and base are decorated with tiny beading on this elegant silver vase (with tin liner), 1911. Designed by Josef Hoffmann, it was made by Alfred Mayer at the Wiener Werkstätte. The stylized blossoms and leaves are typical organic decoration of the Vienna workshops. Ht 15.5cm/6in.*

2 *An especially dense overall stylized leaf design, unmistakably Wiener Werkstätte, comprises an opulent silver cigarette holder by Hoffmann from c.1905. Ht 10cm/3¾in.*

3 *Veering from the geometric, symmetrical designs of Wiener Werkstätte founders Koloman Moser and Hoffmann, Dagobert Peche, who joined the workshops in 1915, created more ornate, sculptural objects. Some were even Neo-Baroque in spirit, like this fantasy bird box in silver and coral, 1920. Ht 21.7cm/8½in.*

4 *The organic elements of Hoffmann's silver tea and coffee set with tray are bold, even verging on the Baroque. Teapot, coffee pot, creamer, and covered sugar bowl are shaped as stylized melons. This design for the Wiener Werkstätte is quite late, c.1924, and far removed from Hoffmann's earlier, more elegant wares. Ht 19.7cm/7¾in.*

dotted with semi-precious stones and enamelling. One of the most luxurious Wiener Werkstätte metal designs was Moser's silver box of 1906 featuring an enamelled male nude on each side, embossed with semi-precious stones.

There were others working in Austria at this time who produced important silver and metalwork. An outstanding table decoration, 1909–10 (p.345), comprising a wide fluted stem on which sits a bowl with leaf designs among scrolls, was designed by Hans Bolek and made by Eduard Friedmann of Vienna.

At the Wiener Werkstätte, Hoffmann continued to design metalwork in the 1920s and 1930s, his forms often not dissimilar to earlier designs, but nonetheless novel and up to date. His brass bowl, c.1920, is a ribbed, half-melon-shaped cup on a trumpet-form foot, with two whimsical handles. Added elements, both abstract and organic, became more prominent on Art Deco-period Werkstätte metalwork, in part due to the influence of Dagobert Peche, who joined in 1915, and whose work was more ornate than that produced there earlier.

In Germany, Munich's designers created outstanding pieces in silver and other metals. An important Munich designer was Bruno Paul, whose 1901 design for a brass candelabrum was ingenious as well as handsome: its dozen limbs were capable of swivelling around the stem, thus allowing the owner to create different configurations.

German and other designers residing for varying amounts of time at Darmstadt's Mathildenhöhe artists' colony created outstanding objects in precious and other metals, among them the multi-talented Peter Behrens, Josef Maria Olbrich, and Albin Müller. Behrens (1868–1940) created objects with a *Jugendstil* feel during his time in Darmstadt, where he lived from 1899 to 1903, but thereafter he became known for his highly functional but stylish designs, such as his textured brass electric kettle for AEG of 1909. Olbrich designed notable metal objects, many of which were mass-produced. Among these was a silvered-pewter candelabrum, c.1901 (see p.344), with characteristic Viennese linear motifs, made by Eduard Hueck of Lüdenscheid.

5

6 *Trio of Hoffmann baskets, c.1905, of silver-coloured metal for the Wiener Werkstätte. Their overall rigid grid pattern, sometimes called gitterwerk (latticework), is softened by the loop handles. Ht 25.5cm/10in.*

6

5 *Hoffmann's brass bowl, c.1920, is an example of his later design for the Wiener Werkstätte, which was affected by the Baroque energy of Dagobert Peche. Ht 19cm/7½in.*

7

7 *Hammered surfaces and fan fluting distinguish these two silver vessels (part of a table garniture) by Hoffmann. Designed c.1910 and made by the Wiener Werkstätte, the vases are rectilinear, but not as rigorously so as Hoffmann's earlier pieces. Ht 21.6cm/8½in.*

8 *The footed dish with cover by Hoffmann of 1902 predates his founding of the Wiener Werkstatte. Of silver with a cabochon turquoise on the lid, the dish contains elements that are found on later Hoffmann pieces: hammered metal, decorative beading, and leaf-like forms. Ht 16.2cm/6¼in.*

9 *Beading is also seen on the spoons, forks, and knives of Hoffmann's 1904 silverware. The set is revolutionary for its simple, flattened forms. Large fork l. 19.2cm/7in.*

8

EARLY MODERNISM | SILVER AND METALWORK

9

10

10 *With its curved fluting and jaunty, auriculate handles, Peche's silver centrepiece bowl, c.1920, exemplifies the Wiener Werkstätte's inclination toward the Baroque in its later stages. W. 28cm/11in.*

Textiles

Geometric and Organic Designs

1 *A jagged energy distinguishes Carl Krenek's block-printed dress fabric* Blitz *(lightning), 1910–11, made by the Wiener Werkstätte.*
2 *A design for Josef Hoffmann's silk-screened silk fabric* Kohleule *(night owl), 1910–15, by the Werkstätte, magnifies the repeated motif of bell-shaped blossoms amid scrolling tendrils, one that he used in many variations in different media.*

3 *Hoffmann's* Vineta *fabric design, 1904, made by Johann Backhausen & Söhne, Vienna, is a geometric pattern of vertical lines and triangles that could be seen as stylized trees.*
4 *A block print and inset fabric sample of Hoffmann's vivid* Kiebitz *design, 1910–15, decorated with typical Werkstätte stylized leaves and geometric forms, all contributing to a dense, highly decorative grid pattern.*

Among the rugs, carpets, and textiles being produced from the turn of the century and into the 1920s was a wide range of Wiener Werkstätte designs, though in Germany, also, some attractive examples were produced, some influenced by the Wiener Werkstätte. In Britain, the Omega Workshops produced floor coverings and fabrics decorated with the lively floral and abstract motifs that marked their painted furniture and other wares.

Over the years some 18,000 designs were produced by the Wiener Werkstätte's textile department. That division was set up *c.*1909–10, although the Johann Backhausen & Söhne firm were making fabrics and carpets for the Workshops from 1898, and the Workshops began printing their own fabrics in 1905. Although luminaries such as Moser and Hoffmann were responsible for many of the textile patterns, many others were employed who could create handsome, decorative repeat patterns, among them Bertold Löffler, Carl Otto Czeschka, Dagobert Peche, and Mathilde Flögl. Besides carpets, upholstery, and clothing, Werkstätte textiles were used for napkins,

cushions, and lampshades. Some patterns were naturalistic floral and faunal designs, while others were more characteristic geometric patterns, such as Hoffmann's *Vineta* design, of triangles and vertical lines.

In Germany, many of the same designers associated with furniture and other objects also designed textiles in the early 20th century. Richard Riemerschmid created a modern adaptation of a Persian carpet featuring stylized twigs in 1903 for the Thieme residence in Munich.

Besides furnishing fabrics, the Omega Workshops produced carpets, embroidered pieces, and even painted silk lampshades. Their fabrics are considered to have revolutionized British textile design in the use of vivid, often abstract or geometric designs, which were influenced by contemporary painting. *Amenophis*, a printed linen fabric of 1913 probably designed by Roger Fry, featured a rich design of trapezoids and other abstract (yet vaguely organic) shapes. Omega produced textiles through the 1930s, and contributed greatly to the look and aesthetic of the Bloomsbury set.

5

6

7

8

5 Miramar, *a Josef Hoffmann design for the Wiener Werkstätte, 1910–15, combines diamond and zigzag shapes in a complex overall horizontal pattern.*

6 *A sample book of Wiener Werkstätte fabrics is open at Koloman Moser's design for its* Baummarder *(pine marten) printed silk textile, which was also available in blue. The design is from c.1903–7, though the workshops did not establish a textile department until c.1909–10. In all, Moser created some 300 patterns for the department.*

7 *This Hoffmann fabric sample, its geometric design comprising horizontal and vertical diamonds within rectangles, dates from 1909.*

9

10

11

8 *Hoffmann created dozens of watercolour designs for textiles, such as* Serpentin, *1910–15. Note the signature heart-shaped leaf, the only organic design element amid a sea of triangles, squares, and rectangles.*

9 *A richly patterned cotton damask tablecloth was designed by Peter Behrens and made by S. Fränkel, Neustadt/Schlesien, Germany. The linens, c.1904, were used at the artists' colony at Darmstadt, for which Behrens created numerous objects. Ht 1.28m/4ft 5¼in.*

10 *Richard Riemerschmid's wool carpet, 1903, sat in the dining room of the Thieme house in Munich, for which Riemerschmid also created furniture. The strong central motif and edges of stylized twigs and blossoms interpret traditional Persian rugs. Ht 3m/9ft 10in.*

11 *The Omega Workshops' printed linen furnishing fabric* Amenophis, *1913, was probably created by Roger Fry. Made by Maromme Printworks in Rouen, the design is sophisticated yet spontaneous.*

Art Deco

1910–39

The Art Deco style had its origins in Paris in the years before the onset of the First World War, only a little more than a decade after the 1900 Exposition Universelle. This exhibition marked the apex, as well as the beginning of the end, of Art Nouveau, the movement that took in the design styles of the Jugendstil and the Vienna Secession, whose motifs and shapes often relate more to those of Art Deco than the contemporary curvilinear, nature-inspired objects produced in Paris and Nancy.

Art Deco did not immediately replace Art Nouveau, nor was it a direct and virulent reaction against it. The movements even had some technical aspects in common, especially in their French manifestations, probably owing to the country's rich design heritage: the finest materials, lavish decoration, and impeccable craftsmanship. Also, there were many individuals and firms comfortably creating fine pieces in both periods and styles, among them Sèvres, Daum, and Lalique.

Although earlier Aesthetic Movement and Art Nouveau designers created harmonious interiors as well as their furniture and other components, it was the Art Deco era that witnessed the rise of the *ensemblier*, the multi-talented designer responsible for the total design, or ensemble, of a room, including its window, floor, and wall coverings, furniture, lighting fixtures, and other accessories. The foremost maker of these strong unified design statements was the Parisian Jacques-Emile Ruhlmann, while others possessing such notable talents, largely working in the French capital, were Robert Mallet-Stevens, the Irish-born Eileen Gray, and, of the firm La Compagnie des Arts Français, Louis Süe and André Mare (often called, simply, Süe et Mare).

Although there are debates and disagreements on the definition and chronology of Art Deco, there is general acceptance in regard to the single most significant event in its history: the 1925 Paris Exposition des Arts Décoratifs et Industriels Modernes. Not only was the style's name adopted, much later, from a shortened version of the fair's title, but its greatest names – French and other nationalities – took part, showing their finest modern wares and thus influencing each other as well as designers and manufacturers in other countries, including America and Germany (neither of which exhibited at the fair). Various arbitrary end points to Art Deco have been suggested, including the start of the Second World War; the maiden voyage of the *SS Normandie*, France's opulent "floating palace;" and the 1939–40 World's Fair in New York. It is agreed, however, that by the end of the 1930s Art Deco had run its rich, varied course.

Left: the ivory-detailed, dyed sharkskin-sheathed, sunburst design ebony side chair by Clément Rousseau, c.1925, is luxurious French Art Deco at its finest. The form and materials are traditional, but combining them with the distinctive decorative motif is pure moderne. Ht 90cm/35½ in

Opposite: the refurbishment of Claridge's Hotel in London, 1929–30, overseen by Oswald P. Milne, was executed in a tasteful Art Deco manner. The dome-topped vestibule was painted yellow, its geometric carpet was by Marion Dorn, and above its lacquered black doors were floral roundels by Mary S. Lea.

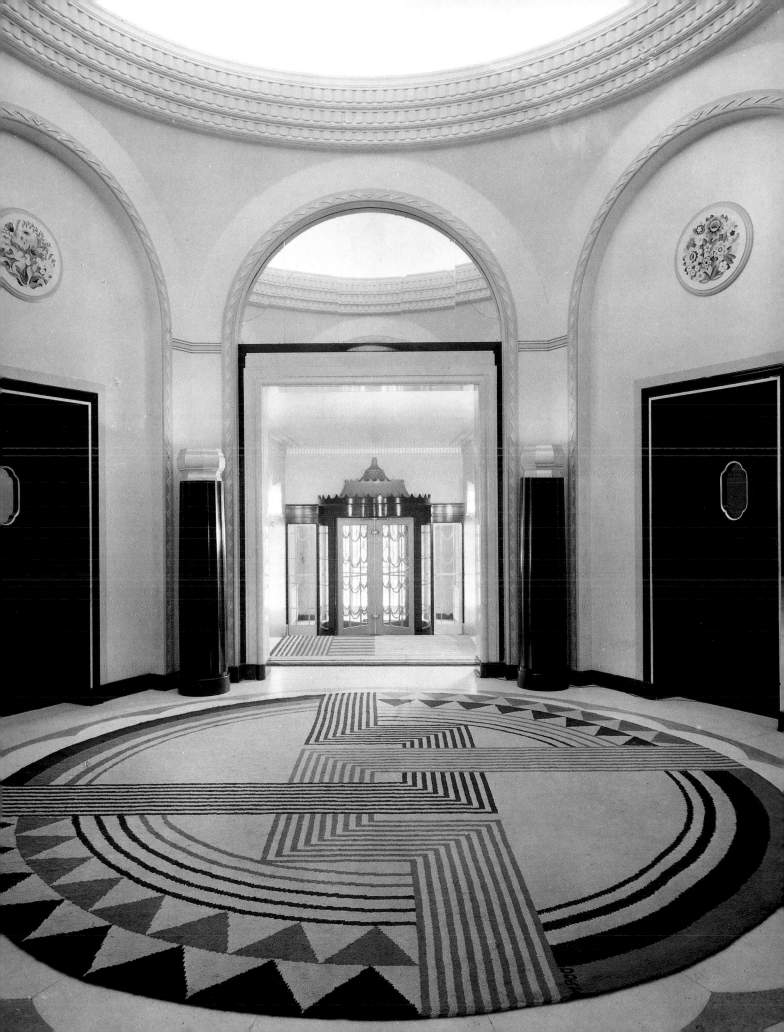

1 *Guerlain's bottle and box for its scent* L'Heure Bleue *were made by Baccarat after the 1925 Paris Exhibition. The stylized fountain decoration was adapted from Edgar Brandt's L'Oasis screen. Ht 5.5cm/2¼in.*

2 *In the early 1930s the designer Waylande Gregory created* Radio *in glazed porcelain. From her stylized, windswept hair, to the zigzag bolt she bears, this sleek allegorical figure is an outstanding American Art Deco piece. Ht (approx.) 68.5cm/27in.*

3 *Robert Bonfils's striking colour lithograph poster for the 1925 Paris Exhibition features Art Deco stylized flora and fauna and a stark sans-serif typeface. The figure's Neoclassical garb is not uncommon in the Art Deco period. Ht 56cm/23½in.*

As for the sources and main characteristics of this diverse and relatively long-lasting style, there were many, and they differed from country to country, as with Art Nouveau, depending on vernacular designs and traditions. One important influence was avant-garde painting – including Constructivism, Cubism, Fauvism, and Futurism – which provided a rich repertoire of abstract and simplified shapes and colour combinations from which designers could draw inspiration.

Aspects of exotic foreign regions, cultures, and traditions – including techniques, forms, and subject matter – were absorbed by numerous Art Deco designers. Sources were as eclectic as ancient Mesopotamia and the Maya, notably these cultures' ziggurat-shaped pyramids, reflected in large-scale 1920s and 1930s skyscrapers as well as in furniture and other objects with stepped motifs; sub-Saharan Africa, whose tribal furniture influenced several French designers, just as its sculpture proved inspirational to Picasso, Modigliani, and other Parisian artists at the time (the Neuilly studio of fashion designer Jacques Doucet included much African-inspiredfine and decorative art by numerous French Modernists); pharaonic Egypt, with the discovery in 1922 of

Tutankhamun's tomb a catalyst in this regard; classical Greece and Rome; China and Japan; and Russia, especially the Ballets Russes dance company, with the bold designs and vivid colours of its sets and costumes.

From the mid-1920s another source of inspiration to designers, especially in America, was machine and industrial forms. This resulted not only in the adoption of repeating and overlapping geometric patterns, but also in bold, colourful rectilinear images incorporating circles, half-circles, squares, chevrons, lightning bolts (often symbols of electricity), and the ubiquitous zigzag design. Somewhat related was the science of aerodynamics, which further inspired designers and architects to create kinetic, parabolic, and winged shapes (huge examples of the latter crown New York's Empire State Building, 1931).

A characteristic motif appearing in the Art Deco period was the stylized sunburst (or rising sun or sunray) pattern; it was thought to have been especially popular in Britain because of that country's lack of sunshine, but its basic geometric design was related to other Art Deco patterns. Also popular, especially in France, was the stylized fountain with cascading water, a variation on a classical theme. There was also a rich repertoire of floral

and figurative shapes, but unlike those appearing on Art Nouveau objects, these were markedly different in terms of their stylization. Blossoms and bouquets were simplified and far removed from nature's originals. The insects, aquatic animals, and peacocks that were typical motifs in Art Nouveau for the most part gave way to sleek, elegant, speedy animals such as gazelles, does (in French, *biches*), greyhounds, and Borzoi and Afghan hounds (a significant exception to this is Lalique's Art Deco glass, which, like his Art Nouveau jewellery, is rich in avian, piscine, and entomological motifs). The snake, interestingly, appeared in both periods, its innate curvilinear form an obvious reason for its earlier use, and its richly textured skin and exoticism appealing to Art Deco designers (some of whom used actual snakeskin in their furniture).

Women were no longer the languorous, long-haired, voluptuous models represented on a multitude of Art Nouveau vessels – though this type had not disappeared entirely – but rather they became androgynous, sleek, self-assured, and either shamelessly nude or fashionably dressed and coiffed, descriptions that could in part be applied to the flappers of the roaring 1920s. Neoclassical figures also appeared on furniture, ceramics, metalwork, and other objects, as they did in monumental Art Deco sculptures, such as those by Paul Manship, and bas-reliefs embellishing Art Deco buildings, notably the façades of Rockefeller Center and other Manhattan skyscrapers. But these figures were usually stylized in a manner – far removed from classical Greek or even 18th-century Neoclassical figures – that was often referred to as *moderne*, a term used in the 1920s and 1930s (and later), in France and elsewhere, to describe much of this contemporary design.

Concurrent with decorative Art Deco in the 1920s, there was a strong Modernist strain of design, continuing through the 1930s and even beyond, and influencing mid-century modern Scandinavian and other designs, especially furniture. Its antecedents were the no-nonsense, functionalist designs of the likes of Christopher Dresser in Britain, Peter Behrens in Germany, and Frank Lloyd Wright in the United States. This sleek, functional style was exemplified in Europe by the furniture and designs of Le Corbusier, Eileen Gray, and Robert Mallet-Stevens in France; Ludwig Mies van der Rohe, Marcel Breuer, Alvar Aalto, Wilhelm Wagenfeld, Marianne Brandt, and various Bauhaus figures in Germany; Alvar Aalto in Finland; and in the United States by the works of designers such as Gilbert Rohde, Norman Bel Geddes, Donald Deskey, Raymond Loewy, and Warren McArthur, all of whom created designs for industry. Many of these people's creations, especially their furniture, are now design oxymorons of a sort: period pieces that are also timeless classics.

4 *The Paris bedroom of couturier Jeanne Lanvin, designed in 1920–2 by Armand-Albert Rateau, includes opulent, exotic touches, such as walls sheathed in "Lanvin blue" silk. Rateau was inspired by the ancient world, to which he added his own modernized flora and fauna as well as personalized touches, such as blossoms of marguerite, the name of Lanvin's daughter.*

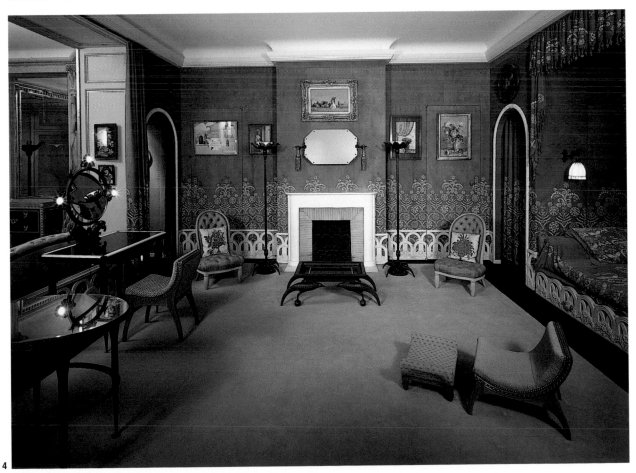

4

French Furniture

Classical Ebénistes and Cabinetmakers

1 *Its form, materials, and technique inspired by great 18th-century French masterpieces, Jacques-Emile Ruhlmann's corner cabinet, 1916, is an icon of Parisian Art Deco. Of lacquered rosewood inlaid with ivory and rare woods, the cabinet features an urn overflowing with stylized flowers. Ht 1.28m/4ft 2½in.*
2 *Desk by Ruhlmann, c.1925–7, a masterwork of Macassar ebony, snakeskin, ivory, and silvered bronze. L. 1.34m/4ft 5in.*
3 *This carved-mahogany writing table and chair, c.1925, is by Süe et Mare. The scallop and scroll designs occur on many French Art Deco pieces. Table l. 1.49m/4ft 10¾in; chair ht 75cm/29½in.*

J acques-Emile Ruhlmann (1879–1933) was the premier furniture-maker and ensemblier in 1920s France. Some of his earliest furniture designs, 1914–18, were already in the Art Deco style for which he was to become renowned. Classical, elegant, and superbly hand-crafted, his furniture from this time made use of exotic wood veneers, such as Macassar ebony, amaranth, and violetwood, and often included inlaid decoration in opulent materials like ivory, snakeskin, and sharkskin. Cabinets, dressing tables, and matching chairs alike mostly stood on slender veneered legs, some shaped like fluted torpedoes. Figurative ornament in ivory, metal, or wood featured on some of the showier pieces, though most were decorated more subtly with ivory dots, scrolls, lozenges, tiny squares, or rectangles. From c.1925, his furniture had a more Modernist, functional look: less inlay, more visible metal, less rounded shapes.

La Compagnie des Arts Français of Paris, founded in 1919 by Louis Süe (1875–1968) and André Mare (1885–1932), known as Süe et Mare, made both veneered and carved case and seat furniture. Unlike Ruhlmann's delicate, understated pieces, however, their output included exaggerated, even overblown forms. Their inspiration was often classic 18th-century shapes, but the interpretation was far from subtle, especially in terms of the huge, wing-like mounts that capped some desks, pianos, and other pieces. Chairs and tables included carved volutes, swags, tassels, and floral clusters, all common Art Deco motifs, while case pieces featured inlays of simple floral or far more elaborate designs.

Other prominent designers of veneered furniture were Jules Leleu (1883–1961), who specialized in the use of light, warm colours, with the subtlest of marquetry and inlay decorations; Léon Jallot (1874–1967) and his son Maurice, whose beautifully crafted, often lacquered and inlaid creations were later followed by more rectilinear Modernist pieces; and René Joubert and Philippe Petit, founders of the furniture and interior design firm Décoration Intérieure Moderne (D.I.M.), which produced small editions of exquisitely made furniture of classical

Sharskin

1 *Clément Rousseau's pair of upholstered side chairs, c.1925, of rosewood, galuchat (sharkskin), and mother-of-pearl, makes use of the dyed organic material popular among many French Art Deco designers. Note the sunburst designs in sharkskin under the seats. Ht 92.5cm/36¼in.*
2 *Dating from c.1912, Paul Iribe's petite commode, of mahogany, ebony, sharkskin, and marble, is an early example of French Art Deco. Based on an 18th-century French form, it was made for the couturier Jacques Doucet. Ht 91cm/36in.*

3 *The Paris design firm Dominique produced this sharkskin and palisander (kingwood) drop-front secrétaire, c.1928. Its form is strictly rectilinear, its only decoration the pattern of the sharkskin. Ht 1.5m/4ft 11in.*
4 *André Groult's sharkskin-sheathed beech and mahogany chiffonier with ivory details, 1925, was made for the 1925 Paris Exhibition, where it was part of a lady's bedroom in the French Embassy's pavilion. The piece was meant to evoke the female form: Groult said he wanted to create an object that was "curvaceous to the point of indecency." Ht 1.5m/4ft 11in.*

Lacquer

1 *Although its shape is simple, Jean Dunand's table, c.1924, features boldly geometric decoration. The blacks and reds are lacquered in the Japanese style, while the white is painstakingly applied crushed eggshell (coquille d'oeuf). Ht 70cm/27½in.*
2 *Both Dunand and Eileen Gray studied the technique of lacquering with the master Sugawara. Gray's five-part screen in brown/black lacquer with gilding, has a geometric design and dates from c.1922–5. Ht 1.4m/4ft 7in.*

Stylized Floral Carving

1 *Léon Jallot's carved and veneered Macassar* coffre *(ebony chest), c.1927, has a simple rectilinear form, but its carved panel, with a bird amid stylized blossoms and fronds, is strongly Art Deco. L. 1m/3ft 3¼in.*

2 *Stylized flowers and leaves run down a carved vertical side panel of Paul Follot's rounded display cabinet of dark wood and ivory, c.1925, commissioned for Au Bon Marché's Pomone atelier. The piece was on display at the 1925 Paris Exhibition.*

Stylized Floral Leatherwork

1 *Tooled and dyed leather panels decorated with typical Art Deco blossoms make up the sides and back of this elegant armchair, c.1925, by Clément Mère. The chair also includes ivory accents and Macassar ebony carved with stylized flowers. Ht 72.5cm/28½in.*

2 *Mère again employed* repoussé *leather and a design of stylized flora on this jewellery cabinet, c.1925, also made of Macassar ebony, ivory, and, at the top, grey marble. Ht 1.41m/4ft 7½in.*

form. Clément Mère (born 1870) became known for carved and veneered pieces covered with large areas of tooled repoussé or lacquered leather.

Two designers were noted for their extensive use of exotic *galuchat* (sharkskin), often dyed in pastel shades. André Groult (1884–1967) and Clément Rousseau (1872–1950) employed it to sheathe the surfaces of their tables, chairs, and cabinets, attached as solid colour blocks or in decorative patterns. Sharkskin-dominated pieces, as well as veneered and carved furniture, were made by the Paris decorating firm Dominique, founded by André Domin (1883–1962) and Marcel Genevrière.

Though small in number, the carved stools, chairs, and other furniture by Paul Iribe (1883–1935) were significant Art Deco pieces. In 1912 both Iribe and Pierre Legrain (1889–1929) worked on the apartment of couturier Jacques Doucet. Carved and sometimes gilt-wood furniture was also made by Paul Follot (1877–1941).

Lacquered furniture was created in large quantities in France. A prolific designer of *dinanderie* (see p.368), Jean

Dunand (1887–1942) also created lacquered chairs, tables, panels, and screens, sometimes embellished with crushed eggshell. Moving to Paris in 1902, Eileen Gray (1878–1976) was apprenticed to the lacquerer Sugawara and by 1913 was showing lacquered furniture, some with silver leaf or inlay elements. By 1925 she had begun to design her better-known Modernist pieces, with tubular-steel, glass, and aluminium elements.

Other notable furniture makers included Jean-Michel Frank (1895–1941), creator of rectilinear furniture veneered with straw and other organic materials such as vellum, parchment, and sharkskin, in geometric patterns; Pierre Chareau (1883–1950), whose practical pieces often combined wood and metal elements; and Robert Mallet-Stevens (1886-1945), a resolute Modernist working in tubular steel and canvas, as well as exotic carved and veneered wood and leather. Taking his inspiration from ancient Greece and Rome and the Far East, Armand Albert Rateau (1882–1938) created Neoclassical tables, chairs, and even chaise-longues, of patinated bronze.

African and Ancient Inspiration

1 *Just as Cubist artists in Paris were influenced by African art, tribal furniture inspired French Art Deco designers. Although adapted from an African chieftain's throne, Pierre Legrain's wooden stool, c.1920–5, is obviously* moderne *in terms of its carving. L. 73.5cm/29in.*

2 *Armand Albert Rateau paid homage to ancient classical prototypes. This bronze chair, c.1919–20, relates to the ancient* curule *(folding seat), with its frontal crossed legs. Ht 92.5cm/36½in.*

Exotic Sofas and Settees

2 *Eileen Gray's lacquered wood and silver-leaf* Pirogue *or* Canoe *sofa, c.1919–20, was originally made for the couturier Suzanne Talbot. It was in part inspired by the Ballets Russes production of* Schéhérazade. *L. 2.7m/8ft 10½in.*

3 *With its giant scroll sides and smoothly arched back, Pierre Chareau's three-seater sofa, along with two armchairs, furnished a salon in the 1925 Paris World's Fair. L. 2.18m/7ft 1¼in.*

1 *Pierre Chareau designed this exotic palisander wood and ivory daybed, c.1923, for the "Salon de Coromandel" of a Paris client. The silk velvet apricot-hued upholstery matched the colours of the room's Chinese lacquered panels. L. 1.83m/6ft.*

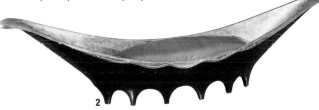

Unusual Materials

1 *Couturier Paul Poiret designed this lacquered gold- and silver-leaf dressing table, c.1929, for a house of "modernistic" furniture in Long Beach, N.Y. The scroll is part of the vanity's form. L. 1.73m/5ft 8in.*

2 *The exotic-looking material sheathing this double-door cupboard by Jean-Michel Frank, c.1928, is in fact simple straw marquetry, a technique popular in 18th-century and Art-Deco France, in a handsome repeating fan-shaped motif.*

3 *Eileen Gray's part Futurist fantasy, part tribal African floor lamp, 1923, of lacquered wood and painted parchment, was exhibited as part of a bedroom-boudoir, called the Monte Carlo room, at the 14th Salon des Artistes-Décorateurs. Ht 1.85m/6ft 1in.*

British Furniture

Modernist and Traditionalist

1 *Edward Maufe's desk, 1924–5, made by W. Rowcliffe, of mahogany, camphor, and ebony gessoed and gilded with white gold, was created for the 1925 Paris Exhibition. Its shining exterior and tasselled decoration paralleled French Art Deco pieces on view there. L. 1.34m/4ft 5in.*

2 *The stepped form of Betty Joel's Australian oak dressing table, 1931, relates more to American Art Deco forms, but the ivory handles are a luxurious French-style touch. It is by G. Ashley and W.R. Irwin, Token Works, Portsmouth. Ht 1.67m/5ft 6in.*

3 *Maurice Adams's sleek cocktail cabinet, 1934, bespeaks Jazz-Age America. An elegant, well-crafted piece of British furniture, it is made of ebonized mahogany with rustless metal casing and mounts. Ht 1.68m/5ft 6in.*

4 *Joel's inviting, satin-sheathed chaise longue, c.1930, is atypically British in its shape and ostentatious nature, but its comfort factor is as high as that of a plush, country-house chair.*

5 *Made by James Clark Ltd of London, this peach glass-sheathed wooden table, 1930s, is a good example of British Art Deco. Blue glass, too, was popular in Britain and America during this period. Diam. 62cm/24½in.*

*M*oderne pieces were produced by Betty Joel (1896–1984), whose London showroom sold her furniture and rugs. Gently curved forms and wood grains as decorative motifs are among the salient characteristics of her output – as they are of much of Ambrose Heal's work. Her pieces lean to the large but not showy. More Baroque in feel were the creations of Syrie Maugham, known for her white furniture and interiors.

Ornate pieces were designed by the Russian-born architect Serge Chermayeff (1900–97), who worked in Britain before moving to the USA in 1933. Lavish furniture was also created by the architect Edward Maufe (1883–1974), notably his 1924–5 mahogany, camphor, and ebony desk.

The PEL company offered chromium-plated tubular-steel furniture in the modern-classic mode, while Finmar distributed Alvar Aalto's laminated-wood and plywood furniture throughout Britain, and the Isokon company (1932–9) produced mostly plywood designs by Marcel Breuer and Walter Gropius.

American Furniture

Modernist and Machine-Age

2

3

4

3 *Eliel Saarinen's elegant fir or maple dining-room side chair with black and ochre paint was designed in 1929 and upholstered by Loja Saarinen, c.1930. Ht 95cm/3ft 1in.*
4 *With its strong geometric design and glittering surface, Donald Deskey's screen, c.1929, of oil paint and metal leaf on canvas and wood, relates to lacquered pieces by Eileen Gray and Jean Dunand. Ht 1.97m/6ft 5in.*
5 *Made for New York retailer Lord & Taylor after a design by Léon Jallot, this lacquered wood, glass, and metal dressing table and bench, c.1929, looks to France and Japan for its decoration, but the vanity's angular shape is reminiscent of Czech Cubist furniture (p.339). Table ht 79.5cm/31¼in; bench l. 55cm/21½in.*

1 *Paul Frankl's* Skyscraper *bookcase, c.1928, features black and red lacquer on California redwood. The skyscraper was arguably the foremost symbol of American Art Deco. Ht 2.41m/7ft 11in.*
2 *T.H. Robsjohn-Gibbings was inspired by classical art and architecture. The* Lotus *console table, c.1936, is of pearwood stained red and deep grey-green. L. 1.35m/4ft 5in.*

The furniture of Donald Deskey (1894–1989) was elegantly Modernist, rectilinear but often with curved or streamlined sections, some pieces decorated with geometric motifs, and often touched with coloured lacquer or shiny Vitrolite or Bakelite.

Many Modernist American designers embraced the materials, techniques, and spirit of the nascent Machine Age, such as Warren McArthur, Gilbert Rohde, and Walter Dorwin Teague. A handful of American furniture-makers, however, worked in a manner that could be viewed as a homage to Gallic traditions. These luxuriant, sometimes one-off pieces featured classical shapes, fine veneering, impeccable workmanship, and motifs echoing Parisian design. Paul Frankl (1887–1958) was best known for his skyscraper-inspired bookcases and desks, some with lacquer trim. The carved-wood furniture by T.H. Robsjohn-Gibbings (1905–76) was inspired by and decorated with classical motifs. Eliel Saarinen (1873–1951) designed elegant but practical furniture, such as his 1929–30 fir side chairs.

5

British and American Ceramics

Figurative and Floral

1

2

3

4

1 Called Age of Jazz, *a series of delightful cut-out and painted dancing and musical figures was designed by Clarice Cliff in 1930. The set of five was intended to be used "as a centrepiece while listening to a dance-band on the wireless."*

2 *The British pottery Carter, Stabler & Adams in Poole produced matte-glazed Art Deco earthenware with distinctive hand-painted motifs – stylized floral, faunal, or geometric – on cream grounds. Both floral and geometric elements appear on this vase. Ht 18cm/7in.*

3 *Designed and painted by Susie Cooper at Gray's Pottery, Hanley, this earthenware ginger jar of c.1926 (it is missing its lid) features strong Art Deco elements. Depicted on each of its three panels is a single animal – an ibex, a deer, and a ram – caught in flight. Ht 33cm/13in.*

4 *This platter by Rockwell Kent is from a 1939 set of china made by Vernon Kilns and called* Salamina *(after Kent's book of the same name). The female figure and mountain landscape exhibit a monumentality and geometric stylization typical of Kent's work. Diam. 32cm/12½in.*

A name synonymous with British Art Deco is Clarice Cliff (1899–1972). Her bright geometric *Bizarre* wares, 1928–37, were followed by *Fantasque, Biarritz,* and other ranges. Cliff's huge output included a wide range of earthenware vessels, generally hand-painted in a vivid palette of yellows, oranges, reds, blues, and other hues. Designs included asymmetrical geometric patterns and stylized flora and fauna (*Crocus* was one of the best loved). She also produced unusually shaped pieces such as tea cups with solid triangular handles. Figurative pieces included the 1930 *Age of Jazz* series, brightly painted cut-outs of jazz musicians and dancers.

For over 50 years, Susie Cooper (1902–95) designed and produced tableware, vessels, and other decorative pieces. Her output is marked by a stylish elegance and functionalism; delicate pastel florals and subtle banded designs were popular patterns. Among the many factories to produce Art Deco ceramics were relatively new firms such as Wiltshaw & Robinson, with *Carlton Ware,* and the Poole pottery of Carter, Stabler & Adams.

Many American firms produced pottery in the Art Deco period. Most successful was the 1928 *Futura* line by the Roseville Pottery of Zanesville, Ohio, which included angled matte-glazed vases, bowls, and wall pockets, often glazed with striking colour combinations. Among the most innovative was the output of the Cowan Pottery Studio near Cleveland, Ohio, which from the mid-1920s until 1931 produced brightly glazed decorative pieces. Best known were their limited-edition pieces designed by artists or sculptors, including Viktor Schreckengost (b.1906), whose *Jazz Bowl* was notable for its distinctive glaze. Three dinnerware lines were designed by Rockwell Kent and manufactured by Vernon Kilns in Los Angeles from 1939, all transfer-printed with illustrations by Kent, such as *Salamina,* which depicted the rocky Greenland landscape and handsome Inuit women.

An interesting collaboration between the Noritake company in Japan and Frank Lloyd Wright led to the production of a set of inexpensive porcelain tablewares, 1916, for the architect's Imperial Hotel in Tokyo.

Geometric Designs

1 *Clarice Cliff's rare* Fantasque Conical Early Morning Set *in* Diamonds,1929; *not only was the motif geometric, but so were the revolutionary handles. Teapot ht 12cm/4¾in.*
2 *Roseville Pottery's* Futura *line, 1928, included vases and bowls with zigzag, triangular, globular, and other geometric motifs. The cubic shapes of two of these* Futura *vases lend themselves to the Art Deco motifs. Ht (left to right): 18cm/7in; 30.5cm/12in; 20.5cm/8in.*
3 *Manhattan's sights and sounds inspired Viktor Schreckengost to create the iconic Cowan Pottery punch bowl known as the* Jazz Bowl, *1930, available in black and varying shades of blue and green. Musical instruments and notes, cocktail glasses, skyscrapers, stars, and circles dance on the carved-earthenware, sgraffito-decorated surface. Diam. 35cm/13¾in.*

4 *This Carlton Ware* Jazz *vase is decorated with a lightning bolt, sunburst, and gilt beam. Carlton Ware was the trade name used by Wiltshaw & Robinson of Stoke-on-Trent for its decorative art items. Ht 24.5cm/9½in.*
5 *For his Imperial Hotel, Tokyo (1916–22; later demolished), Frank Lloyd Wright designed this six-piece set of glazed porcelain china, 1916, its motif multi-coloured, off-centred, overlapping circles. Dinner plate diam. 26.9cm/10½in.*

French and European Ceramics

Neoclassical and Modern Figures

1 *Mythological subjects and abstract, geometric designs typify the work of painter-potter René Buthaud, whose glazed earthenware vase* Europa and the Bull *dates from c.1925. Ht 40.5cm/16in.*

2 *For this earthenware vase, c.1925, with a frieze of maidens, suitors, and satyrs, Jean Mayodon employed metallic oxides and gilding. Ht 44.5cm/17½in.*

3 *From the Swedish pottery Gustavsberg's distinctive line of decorative stoneware known as* Argenta, *this green-glazed vase, designed by Wilhelm Kåge, c.1930–40, depicts a Neoclassical musician in inlaid silver. Ht 20cm/8in.*

4 *This terracotta wall mask,* Tragedy, *c.1922, was made by the Goldscheider Factory, which originated in Vienna in 1885. The allegorical theme is ancient, but the female head is chic and* moderne. *Ht 35.5cm/14in.*

5 *Ceramicist Vally Wieselthier created this striking, modish* Head of a Girl with Flower. *From 1928, the figure, of red clay pottery with coloured glazing, was produced by the Wiener Werkstätte. Ht 25cm/10in.*

6 *In the 1920s, Gio Ponti designed this hand-painted porcelain covered box, called* Omaggio agli Snob, *for the Doccia pottery Richard-Ginori, where he was art director from 1923 to 1930. Ht 29cm/11½in.*

Some of the most classical French Art Deco ceramics were one-off art-pottery items. Emile Decoeur, Auguste Delaherche, and Henri Simmen were renowned for their glazed vessels. The stoneware vessels of Emile Lenoble (1876–1939) often featured incised, painted, or low-relief decorations of scrolls and geometric motifs, as well as stylized blossoms.

The premier French ceramic artist was arguably René Buthaud (1886–1987). This trained painter began to work with ceramics around 1919. His preferred medium was stoneware, crackled glaze a favoured decorative technique. The men and women Buthaud depicted were largely in the Neoclassical-*moderne* vein.

The Sèvres manufactory employed well-known artists and designers, including Jacques-Emile Ruhlmann and Raoul and Jean Dufy, to provide them with forms, models, and motifs. Some of the most charming wares of the Haviland factory in Limoges were bird- and animal-shaped tea and coffee sets, boxes, and decanters by the sculptor Edouard-Marcel Sandoz (1881–1971).

Elsewhere in Continental Europe, the most notable Belgian maker of Art Deco ceramics was Boch Frères Keramis. Its output included wares in a colourful palette of *cloisonné*-type enamel glazes. Chief designer Charles Catteau created vases with floral, geometric, and bold animal designs. In Austria, the Wiener Werkstätte continued to make ceramics before closing in 1932, including pieces by, among others, Gudrun Baudisch and Vally Wieselthier (1895–1945). Many of these harbingers of later studio pottery were marked by a spontaneity of design and form. The Viennese firm Goldscheider made glazed earthenware and porcelain figures, busts, and masks.

Italian architect-designer Gio Ponti (1891–1979) provided moderne and Neoclassical-moderne designs as well as traditional forms to the Richard-Ginori factory, 1923–30. Arguably the best-known Scandinavian designer was Wilhelm Kåge, art director of the Swedish firm Gustavsberg 1917–49. His *Argenta* line (1929–52) of glazed earthenware features muscular nudes and geometric and marine motifs.

Stylized Fauna

1

2

1 *Serpents appealed to both Art Nouveau and Art Deco designers. Here, a turquoise-glazed snake coils around Edouard-Marcel Sandoz's vase, c.1925, its head rising above the vessel's fluted mouth. Ht 42.5cm/16¾in.*

2 *The Keramis vase by Boch Frères, c.1925, was designed by Charles Catteau, Boch's innovative artistic director from 1907. The monumental stoneware vessel has a simple form, but it is intricately incised and polychromed with a band of highly stylized cranes between geometric borders. The jewel-like end result resembles* cloisonné *enamel. Ht 90cm/35½in.*

Stylized Flora

1 *Emile Lenoble's turned stoneware vase, its simple, stylized floral design overlaid in slip, dates from 1925. Ht 29.5cm/11½in.*

2 *Stylized flowers also decorate Henri Rapin's 1926 hard-paste porcelain vase, but the delicacy of their material gives them a totally different effect from that of the simple blossoms on Lenoble's vase. Both, however, are unmistakably Art Deco. Ht 22cm/8½in.*

1

2

Abstract Designs

1

2

1 *The abstract painted decoration on the glazed earthenware body of Robert Lallemant's vase, c.1925–30, echoes the vessel's angled form, and both make reference to Cubism. Most of the designer's ceramic pieces featured ivory-glazed grounds and were reproduced in large quantities. Ht 21.6cm/8½in.*

2 *Painted with abstract shapes in the manner and palette of the Dutch art movement De Stijl, the Bodenvase (tall floor vase), 1930, is by the German Gustav Heinkel and was made by the Staatliche Majolika-Manufaktur in Karlsruhe. Ht 68.5cm/27in.*

French Glass

Classical and Modern Figures

3 *Lalique's late 1920s Victoire car mascot is modelled as an androgynous female head with streamlined, wind-blown hair. It was marketed in the United States as Seminole and in Britain as Spirit of the Wind. Ht 21cm/8¼in.*
4 *A lyrical female adorns Lalique's three-footed opalescent charger, Trépied Sirène, c.1925. Marine motifs abound in Lalique's oeuvre, and here trails of bubbles appear amongst the internal decoration. Diam. 36cm/14½in.*

1 *Classical in theme and sensuous in spirit, René Lalique's Thaïs, 1925, is a stunning frosted and opalescent glass illuminated statuette. Thaïs was an Egyptian sinner converted to Christianity. Ht 21.5cm/8½in.*
2 *Gabriel Argy-Rousseau revived the pâte-de-verre (glass paste) technique, and used Neoclassical motifs. Le Jardin des Hesperides, 1926, has a frieze of three maidens over a Greek key design. Ht 24cm/9½in.*

Strong Stylized Motifs

3 *Lalique's 1928 design for Canarina's perfume Les Yeux Bleus (blue eyes) is both primitive and modern, possibly inspired by the udjat, or all-seeing eye of the Egyptian sky god Horus, which warded off the "evil eye." Lalique may have been influenced by the 1922 discovery of Tutankhamun's tomb. Ht 5cm/2in.*
4 *A Baccarat bottle with a bow-tie shape held the Guerlain scent Coque d'Or (golden shell), introduced in 1938. Ht 8.5cm/3¼in.*

1 *The design of this strongly angled Lalique vase, Penthièvre, is attributed to Suzanne Lalique, René's daughter. Created in 1926 and introduced two years later, the vessel is moulded in low relief with opposing rows of highly stylized angelfish. Ht 25.5cm/10in.*
2 *A bold, kinetic design dominates Lalique's tour-de-force moulded-glass vase Tourbillons (whirlwinds or whirlpools), also called Volutes en relief. Created in 1926, the vessel was available in solid colours but made the strongest statement in this clear and black-enamelled version. Ht 20cm/8in.*

Internal Decoration

1 *François-Émile Décorchement, like Argy-Rousseau, used the pâte-de-verre technique. His vessels mostly feature thicker walls and minimal decoration. This miniature cast- and polished-glass bowl is from the 1920s. Diam. 8cm/3in.*

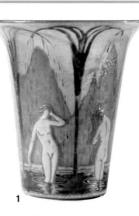

2 *Maurice Marinot's 1927 bottle and stopper (no. 1423) is deeply etched and internally decorated. He was one of the first artists to capture the beauty of air bubbles, previously considered flaws, and to make them an integral part of a vessel's design. Ht 18cm/7in.*

Enamelled and Etched Decoration

1 *Marcel Goupy enamelled the vase called* Les Baigneuses *(the bathers) around 1926. He often outlined solid areas of colour with another, darker hue, as on the women's bodies. Ht 26cm/10¼in.*

2 *Hand-decorated with enamel paints, this glass bowl, signed* Quenvil *or* Quenvit, *is decorated with stylized leaves and blossoms and a chequerboard pattern. Little is known of its maker, nor when and where it was made.*

4 *At once organic and abstract, the enamelled scallop motif on René Lalique's 1929 bottle for couturier Lucien Lelong's scent is, appropriately, evocative of drapery. The architectonic* flaçon *was used for at least three different perfumes and came with a matching enamelled-metal box (in silver with black, yellow, or green) that slipped over the bottle. Ht 12cm/4¾in.*

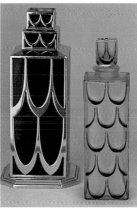

3 *Daum Frères of Nancy began making glass objects in the Art Nouveau period and continued to do so into the Art Deco era. The shade on this acid-etched glass table lamp has a rich abstract design, offset by the simpler spherical base. Ht 43cm/17in.*

Maurice Marinot and René Lalique, who created, respectively, exquisite one-of-a-kind vessels and a huge range of mass-produced wares, have come to exemplify French Art Deco glass. Marinot (1882–1960) originally trained as a painter. Initially he painted floral and figural motifs in rich enamel hues on finished pieces, but produced his blown creations in the early 1920s. These simply shaped, heavily walled, internally decorated vases, bottles, and jars were lauded for their beauty, originality, and craftsmanship.

Beginning with his 1890s experiments and peaking with the mass-manufacture of objects from the 1910s to the 1930s, René Lalique (1860–1945) came to be the unrivalled master of the medium. His first attempts at glassmaking were via the *cire-perdue* (lost-wax) process. From 1910 he began making perfume bottles in collaboration with the perfumer François Coty. Except for the rare *cire-perdue* examples, Lalique's vases, as with all of his mass-produced output, were blown or pressed into a mould. A piece could be clear, frosted, solidly coloured, cased, or sandwiched; opalescent, with a blue-yellow sheen; or externally decorated with staining. The most abundant motif type on the vases is stylized floral or foliate. Lalique also produced vases with strong abstract designs, most notably the *Tourbillons* (whirlwinds). There were also Lalique tablewares; car mascots; desk, dressing table, and smoking accessories; lighting devices; and architectural elements.

In the 1920s and 1930s the production of *pâte-de-verre*, a type of paste glass, grew, as did the variety of decoration on vessels, including many Art Deco motifs. The Parisian Gabriel Argy-Rousseau (1885–1953) decorated most of his richly hued, thin-walled vases and bowls with exotic, classical, or provocative figures. Also producing *pâte-de-verre* was François-Émile Décorchement (1880–1971), whose large vessels featured internal decoration in inventive colours. Daum Frères's main output in the 1920s and 1930s comprised acid-etched vessels and lamps, mostly thick-walled pieces with all-over geometric or stylized organic decoration.

British, European, and American Glass

Figurative

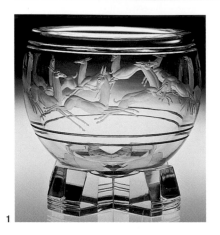

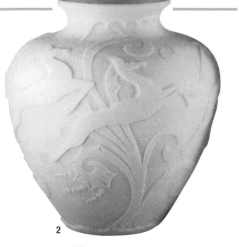

1 *Sculptor Sidney Biehler Waugh designed the Gazelle bowl for Steuben Glass Works in 1935. The crystal vessel was engraved by Joseph Libisch with a frieze of 12 leaping gazelles. Diam. 16.5cm/6½in.*

2 *This cameo-cut Steuben Glass vase, c.1920s, is in the Stamford pattern, its ivory glass cut with a motif of deer and gazelles. Ht 26.5cm/10½in.*

3 *A stylized figure occupies a small part of this plain crystal vase, c.1928, engraved by Richard Süssmanhand, a Dresden-trained glassworker from Penzig, Silesia. Ht 22.5cm/9in.*

4 *Ida Paulin of Augsburg produced this covered jar of enamelled and gilt blown glass, c.1925. Its exotic decoration is reminiscent of African art and Henri Matisse. Ht 12cm/4¾in.*

5 *Vicke Lindstrand's vase, Think No Evil, Hear No Evil, See No Evil, 1930, made by the Swedish factory Orrefors, is illustrated by three muscular female nudes. Ht 14cm/5½in.*

Among the British firms producing noteworthy glassware in the 1920s and 1930s was Moncrieff's glassworks in Perth, Scotland, makers of Monart ware. These thick-walled vessels featured internal decoration in the French manner.

The Wiener Werkstätte continued to market glassware until it closed in 1932. Noteworthy are the clear-glass jars, goblets, and other vessels hand-painted in rainbow hues.

As in the past, glassmaking in 1920s and 1930s Italy centred on Murano. Significant designers were Paolo Venini and Ercole Barovier. The varieties of glass produced were far removed from traditional millefiori- and filigree-type glass. Venini's *vetro tessuto*, for example, featured vertical threads of coloured or white glass.

From 1916 and 1917, when the painters Simon Gate (1883–1945) and Edward Hald (1883–1980), respectively, joined Sweden's Orrefors Glasbruk, the firm began to produce *moderne* wares. These were of engraved, etched, painted, and *Graal* glass (a technique wherein etched and engraved coloured vessels are cased in clear glass).

During the 1920s, Prague architect Jan Kotera created glassware whose geometric forms were Modernist, and other designers in the city produced Cubist-style glass from *c.*19210 to 1925. There were also two Czech glassmaking schools, at Nóvy Bor and Kamenicky Senov, producing Art Deco-style vessels, their output as handsome and varied as that of their Bohemian forebears.

In the 1920s, under Frederick Carder, Steuben Glass Works of Corning, New York, began to produce *moderne* glass, such as the *Cintra* and *Cluthra* lines, thick-walled clear- or coloured-glass vessels, with internal bubbles and other decoration; and the *Intarsia* range, inspired by Orrefors's *Graal* glass; and acid-cutback vases of hexagonal, ovoid, and other shapes. From the 1930s Steuben began to concentrate more on colourless crystal art glass and tableware. Designs of a figurative, often Neoclassical, nature, came from sculptor Sidney Biehler Waugh (1904–1963). Hugely popular also was the mass-produced, moulded "Depression" glass produced by, among others, Anchor Hocking, Diamond, and Federal.

Etched, Engraved, and Enamelled Decoration

2 *Steuben's acid-etched glass vase of c.1925 was designed in the Chang pattern by Frederick Carder. Of celeste blue overlaid with plum jade, the vessel features scrolling floral designs above stylized clouds. Ht 21cm/8¼in.*

3 *Made by Lötz Witwe glassworks, this covered jar, c.1924–5, was decorated by Marey Beckert (-Schider). Of blown clear glass and overlaid coloured glass, the vessel has been enamelled and acid-etched. The energetic floral and wave-like motifs echo contemporary designs from the Wiener Werkstätte, under Dagobert Pèche.*

1 *An example of Edward Hald's festive* Fireworks *bowl, c.1935, for Orrefors, first designed in 1921 and executed over the years by master engraver Karl Rössler and others, was displayed at the 1925 Paris Exhibition. Hald was with the Swedish glass factory for over 50 years. Ht 20.5cm/8in.*

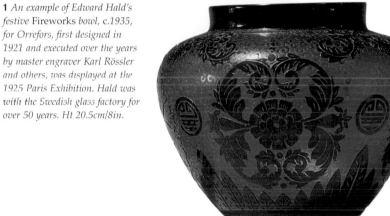

4 *Probably designed by Flavio Poli and made by Archimede Seguso, the Seguso Vetri D'Arte vase, c.1937–40, is a multi-layered vessel cased over silver-foil inclusions over reddish-orange glass over white. Ht 29cm/11½in.*

5 *Following the lead of Maurice Marinot, other Europeans began to make vessels with bubbles, metallic oxides, and other internal decoration. Karl Wiedmann created* Ikora *glass, such as this vase, 1929. Ht 18cm/7in.*

6 *A fine example of Scottish* Monart *glass, made by John Moncrieff Ltd of Perth, this coral red-cased vase, 1925, has cloisonné, crystal, and enamel decoration, the white enamel taking on a metallic lustre. Ht 14.6cm/5¾in.*

Silver and Metalwork

Figurative and Floral

1 *R.M.Y. Gleadowe's silver and mother-of-pearl* Mermaid *cup and cover was made in 1938 for the Goldsmiths & Silversmiths Co., Birmingham. The vessel has a frieze of sensuous intertwining mermaids amid rows of fish and seahorses. Ht 37cm/14½in.*
2 *Edgar Brandt's stunning silvered-bronze* potiche *features a frieze of nude musicians and dancers on an all-over ground of stylized flowers and leaves. Ht 2.07m/6ft 9⅜in.*

3 *Paul Fehér and Martin Rose of Ohio's Rose Iron Works designed this desk set in 1929–31. Made of steel, aluminium, brass, bronze, and black marble, the desk accessory also features* cloisonné *enamelwork. L. 58.5cm/23in.*
4 *Rose Iron Works produced this fireplace screen, designed by Paul Fehér, c.1930, featuring a central nude of gold-plated bronze and stylized floral and geometric elements of silver-plated iron. Ht 1.5m/5ft.*

A diverse assortment of Art Deco metalwork was produced by *ferronniers* (craftsmen in wrought iron), sculptors, enamellists, lacquerworkers, and factories. The French in particular excelled at creating a diversity of objects, both traditional and innovative. American individuals as well as established manufacturers made items in metal, often combining it with glass, wood, and other materials to produce handsome, largely functional pieces. Many products were the result of collaborations between factories and industrial designers.

Edgar Brandt (1880–1960) was France's leading *ferronnier*. His huge gates and firescreens alike comprised dense floral, foliate, and scrolled designs that often centred on bronze figures or figurative panels. One outstanding design was his *Cobra* lamp of *c.*1925. The *ferronnier* Raymond Subes (1893–1970) contributed furniture, clocks, lamps, and other pieces to the Paris salons. In the 1930s his wrought ironwork and bronze gave way to more pieces in steel and aluminium, and his scrollwork and other forms became simpler, larger, and

somewhat abstract. The small but stunning output of the Paris sculptor Albert Cheuret includes outstanding Art Deco pieces, such as his mantel clock in the form of an Egyptian headdress. The foremost maker of silver and plated objets was Jean Puiforcat (1897–1945), a skilled artist who approached his vases, tea and coffee sets, and other luxury goods with the precision of a Greek sculptor.

The Italian designer Gio Ponti (1891–1979) created significant pieces for the French factory Maison Christofle: made in electroplated metal known as *Christofle silver*; his best-known designs were his two-light candlesticks *Flèche* (arrow) and *Dauphin* (dolphin).

Jean Goulden (1878–1947) studied *champlevé* enamelling with Jean Dunand, the famous maker of *dinanderie* (decorative metal wares), and subsequently produced lamps, clocks, and plaques embellished with colourful geometric patterns, often arranged in Cubist configurations. Camille Fauré (1872–1956), another French enamellist, worked in Limoges. He covered base-metal vases and lamp bases with enamelled all-over patterns.

5 *Displayed at the 1937 Paris Exhibition, Norwegian Oskar Sørensen's handsome silver liqueur decanter was made by the venerable Oslo firm J. Tostrup. In the form of a highly angular stylized bird, the decanter is playful yet elegant, utilitarian yet luxurious. Ht 27cm/10½in.*

6 *The Hungarian-born American artist Wilhelm Hunt Diederich created a repertoire of distinctive, highly kinetic, elongated beasts in several media, including metal, ceramics, and fabrics. This Fighting Horses trivet, c.1916, is of hammered iron and brass. Diam. 30cm/9in.*

7 *This pair of wrought-iron sconces by Raymond Subes, c.1925, features shaped alabaster shades in imitation of vases for bouquets of stylized flowers and foliage. Ht 53.5cm/21in.*

8 *The snake was a popular Art Nouveau and Art Deco subject. Edgar Brandt's cast-bronze Cobra table lamp, c.1925, has a glass shade by Daum Frères of Nancy. Ht 53cm/21in.*

9 *Four panels of fruit-laden vines adorn this silver-coloured metal bottle holder, c.1920, by Danish silversmith Georg Jensen. Ht 12cm/4¾in.*

10 *Brandt produced this cast and wrought-iron firescreen, c.1925, with a graceful antelope or hind set amid scrolling tendrils and stylized blossoms, over a band of formalized flowers and foliage. Ht 93.5cm/3ft ¾in.*

Geometric

1

2 3

4

1 *France's finest Art Deco silversmith, Jean Puiforcat, was a Neo-Platonist whose love of pure, basic forms – he said that the circle was the ideal shape – reveals itself in works such as this 1937 silver and rosewood tea set. The master's quest for ideal mathematical proportion was also evident in his painstaking drawings. Teapot ht 18cm/7in.*

2 *Puiforcat's covered tureen, 1930s, is of silver-coloured metal, the bowl banded by a ring set with agate cabochons. Ht 21cm/8¼in.*

3 *Jean Després often included applied rings in his designs, as in this silver-plated metal and rosewood maquette for a pewter aviation trophy. The wing-like hammered metal handles are appropriate to the nature of the piece. Ht 22cm/8½in.*

5

4 *This silver, gilded silver, and oxidized silver* Cubic *coffee service (also known as* Lights and Shadows of Manhattan*), 1927, is by the Danish silversmith Erik Magnussen, for the Gorham Manufacturing Co. in Providence, Rhode Island. The geometric elements and the silver, gold, and brown-toned palette led one writer to call it "a cubist still life in precious metal." Coffee pot ht 24cm/9½in.*

5 *Napper & Davenport of Birmingham produced this silver and wooden teapot in the early 1920s, its handle and spout neatly incorporated into its cube shape. Ht 13cm/5in.*

6 *The British silversmith H.G. Murphy designed and produced this circular-themed six-piece silver and rosewood tea and coffee service in 1934. Coffee pot ht 22cm/8in.*

6

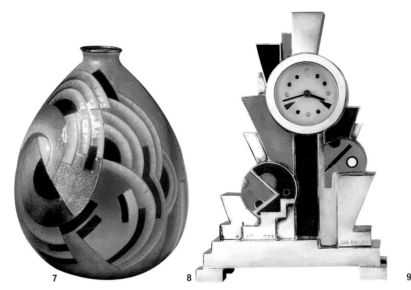

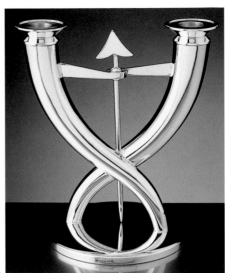

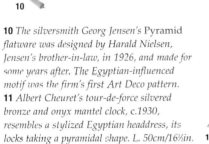

7 *Camille Fauré's vase, c.1925, has a low-relief geometric design in black, white, and blue enamel over silver foil on copper. Ht 30.5cm/12in.*
8 *Jean Goulden's silvered bronze and enamelled clock, 1928, like many of the talented enamelworker's designs, is not only decorated with an asymmetrical array of overlapping and partial geometric elements, but also takes on an irregular geometric shape itself.*
9 *The Italian architect, designer, writer, and teacher, Gio Ponti, provided designs for the French silversmith Christofle. His playful, silver-plated candlestick* Flèche *(arrow) dates from c.1927. Ht 20cm/8in.*

10 *The silversmith Georg Jensen's* Pyramid *flatware was designed by Harald Nielsen, Jensen's brother-in-law, in 1926, and made for some years after. The Egyptian-influenced motif was the firm's first Art Deco pattern.*
11 *Albert Cheuret's tour-de-force silvered bronze and onyx mantel clock, c.1930, resembles a stylized Egyptian headdress, its locks taking a pyramidal shape. L. 50cm/16½in.*

Aspects of Modernist design were taken up by some British silversmiths and designers of chromed and plated metal objets d'art. A cube-formed silver teapot with wooden handle was made in 1922–3 by Napper & Davenport of Birmingham. Wakely & Wheeler of London produced high-quality silver and electroplate; a stunning figurative design was its covered *Mermaid* cup of 1938, designed by R.M.Y. Gleadowe. Also working in a Modernist style was Henry George Murphy (1884–1939), many of whose creations were essays on the circle.

In Scandinavia, the silver hollow-ware, flatware, and jewellery produced by Georg Jensen was the best-known Art Deco metalwork to emerge from that part of northern Europe. Though various motifs first used in the early 1900s still appeared on Art Deco-period pieces – silver beads, openwork stems, and stylized leaf and bird forms – there were also articles with strong modern shapes and geometric motifs. Jensen's brother-in-law, Harald Nielsen (1892–1977), was responsible for the *Pyramid* flatware pattern of 1926. In Norway, silver manufacturers Tostrup

and David-Andersen produced Modernist designs, some of which included enamelwork; Oskar Sørensen's 1937 silver liqueur decanter for Tostrup in the form of a stylized bird is an example.

American Art Deco metalwork ranged from massive decorative pieces to small utilitarian wares. These could be hand-crafted or, more often, produced in a factory in varying quantities. From the mid-19th century the production of both precious and base metal objects, especially in silver and brass, was a huge US industry. Notable *ferronniers* included Hungarian-born Paul Fehér (1898–1992), who created figurative and floral screens and other wares for the Rose Iron Works in Cleveland; and Wilhelm Hunt Diederich (1884–1953), also from Hungary, whose animal-rich screens, andirons, railings, and standard lamps were distinctive, expressionistic works. Several makers and factories added Modernist designs to their repertoires. A Gorham coffee service, 1927, entitled *Cubic*, or *Lights and Shadows of Manhattan*, was designed and made by Erik Magnussen (1884–1961).

Textiles

Floral and Figurative

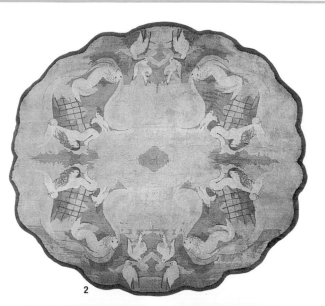

1 *A popular Art Deco motif in France, stylized fountains can be seen in abundance on a detail of Edouard Bénédictus's* **Les jets d'eau** *tenture (hanging), 1925, of satin, silk, and artificial silk, made by Brunet, Meunié & Cie.*

2 *A figurative marine theme marks this unique tufted-wool rug of 1934, designed by artist Marie Laurencin. Unlike other Art Deco sirens, Laurencin's ethereal women were unmistakably hers, and her pastel palette was well suited to moderne interiors. L. 13.8m/29ft 2in.*

3 *Painter and designer Paul Iribe created this block-printed fabric for André Groult in 1912. A very early example of Parisian Art Deco, the pattern is covered with roses and leaves that are more realistic and less stylized than in later manifestations of the style.*

4 *Based on a design by the French metalworker Edgar Brandt,* **Les Roses**, *this textile was made by Cheney Bros. of Manchester, Connecticut. The fabric, with its densely repeated design of stylized blossoms, would have been used for upholstery.*

5 *A near-abstract figurative motif appears on Donald Deskey's gouache-and-graphite-on-paper design for his* **Singing Women** *carpet, 1932, at Radio City Music Hall, New York. L. 1.04m/3ft 5in.*

6 *The provocative dancing girl figures on the British designer Frank Dobson's 1938 hand-block printed linen are linked by ribbons, which echo their stylized hair.*

Faunal and Figurative

1 *Ruth Reeves's block-printed cotton velvet wall hanging* Figures with Still Life, *1930, was designed for New York retailer W. & J. Sloane. Cubist paintings inspired Reeves, not surprisingly, since she had studied with Fernand Léger in the 1920s. Ht 2.33m/7ft 7½in.*
2 *Marion Dorn's screen-printed linen and rayon fabric,* Aircraft, *1936, made by the Old Bleach Linen Co., Randalstown, Northern Ireland, is not as simple as it might at first look. The pattern features stylized avian figures accompanied by their subtle, overlapped "shadows."*

3 Diana, *1930, an embroidered panel by the British designer Rebecca Crompton, features a classical figure accompanied by hound, bird, and blossoms, all strongly, simply Art Deco; white organdie over green hessian, with appliqué of white cotton, linen, and metallic braid embroidered in white cotton.*
L. 44.5cm/17½in.
4 *Also British Art Deco is F. Gregory Brown's roller-printed unnamed linen fabric, 1931, with a repeat of leaping deer amid stylized flora. It was made by W. Foxton Ltd of London.*

In the 19th century and up until around 1920, most carpets were traditional oriental types, with border designs and fringe, and Middle-Eastern motifs. But the 20th century saw more floor coverings, many without border patterns or fringed edges, being made in Britain, France, and Belgium. Square, round, and oval shapes, as well as the conventional rectangle, were produced, some with scalloped edges. Top Parisian designers were commissioned to create Art Deco rugs for specific rooms, such as Jacques-Emile Ruhlmann, Paul Follot, and Eileen Gray, who designed floor coverings with geometric, stylized floral and figurative, fountain, and other Art Deco motifs.

Many carpets, mostly asymmetrical designs, by Paris-based designer Ivan Da Silva Bruhns (1881–1980) were commissioned rectangular pieces woven by the Savonnerie factory. Cubist-derived geometric motifs abound, but he also found inspiration in other cultures and art forms, notably those of Native America and Africa.

In Britain three carpet designers stood out: American-born Edward McKnight Kauffer, better known for his graphic designs (see p.412); his wife, Marion Dorn (1900–64), in 1934 head of her own company specializing in custom-made rugs (see p.413); and Betty Joel, who designed her own furniture and carpets. The Russian-born architect-designer, Serge Chermayeff, in Britain during the 1920s and 1930s, was an influence on carpet design as well as furniture. Elsewhere in Europe, Art Deco-style rugs were made by De Saedeleer in Belgium, notably rich abstract and geometric examples by Albert Van Huffel.

In America, Donald Deskey (1894–1989) created pictorial and geometric carpets, including round bathroom rugs with marine motifs, Cubist-inspired rectangular designs, and the *Singing Women* carpet of 1932, an abstract design of wavy-tressed, open-mouthed vocalists for Radio City Music Hall. Ruth Reeves (1892–1966), a painter who had studied with Léger in Paris, also designed carpets in the Da Silva Bruhns mode (see p.415), and Scandinavian-style hand-woven rugs were made at the Cranbrook Academy of Art under Loja Saarinen (1879–1968).

1 *This French Art Deco woven wool carpet, c.1930, features stylized geometric patterns in shades of mauve, blue, and pale green reserved against a tan ground. L. 2.97m/9ft 9in.*
2 *The c.1927 geometric-patterned shantung fabric created by the Ukrainian-born artist-designer Sonia Delaunay (1885–1979) was called* Simultanée, *as were her Paris atelier and her boutique at the 1925 Exposition ("Simultaneism" was also another name for Orphism, the painting style associated with Delaunay's husband, Robert). In the 1920s the prolific Sonia Delaunay was best known for her vividly hued, geometric fashion, textiles, and interior designs.*
3 *Ivan Da Silva Bruhns's c.1930 carpet is woven in earth tones. Like many other floor coverings of the period by this, the most prolific of Art Deco carpet designers, this rectangular example is borderless and marked by both asymmetry and geometry – notably the ubiquitous zigzag motif.*

The variety of Art Deco motifs it was possible to reproduce on fabrics, textiles, tapestries, and wall hangings encompassed virtually the entire repertoire: floral, figurative, faunal, aquatic, geometric, and, in America, skyscrapers. Not surprisingly, *ensembliers* such as Ruhlmann and Donald Deskey designed fabrics and textiles, but there were others known primarily for their textile designs, notably Edouard Bénédictus (1878–1930).

Floral forms and more complex figurative designs predominated on the finest fabrics, but Modernist patterns were produced as well, like Eric Bagge's 1929 *L'Orage* (the storm), a block-printed linen with stylized lightning bolts and overlapping scallop-like clouds. The couturier Paul Poiret's Atelier Martine created attractive floral fabrics, and Paul Iribe designed a printed fabric for André Groult in 1911, with masses of stylized roses. Aubusson tapestries, both hangings and coverings for furniture, were decorated with rich figurative designs, as were Beauvais factory works. Many Raoul Dufy designs were produced by both manufacturers.

In the United States, some French-inspired fabrics, in rayon as well as silk and other materials, were produced by manufacturers such as F. Schumacher and Cheney Bros. The latter's *Les Roses* was based on Edgar Brandt's ironwork, but other floral designs were livelier, less sophisticated, and more *moderne*. A uniquely American theme, urban life, appeared on some fabrics, among them Ruth Reeves's *Manhattan* of 1930 (see p.415), a printed cotton made by W. & J. Sloane. Other indigenous American motifs found on fabrics were plants of the Southwest, such as cacti and aloes, and Native American floral and faunal motifs.

In Britain, too, a wide array of French-inspired, as well as wholly distinctive and unique, Art Deco fabrics were made. Stylized avian themes were depicted on, among other examples, Marion Dorn's *Aircraft*, 1936, a screen-printed linen and rayon whose overlapping patterns made by four birds take on a magical look. Other animals and humans also figured on a host of British fabrics.

1 *This highly kinetic screen-printed cotton and rayon fabric was designed by H.J. Bull and made by Allan Textiles of London, in 1932. Its repeat of diagonal stripes and meandering bands is hard-edged, "Machine-Age" Deco, albeit softened by its earth tones of brown, russet red, and beige. L. 2.23m/7ft 4in.*

2 *The British textile designer and weaver Alec Hunter designed this fabric, Braintree No. 5, made by Warner & Sons of Braintree, Essex. Of woven cotton, cotton gimp, and jute damask, the material has a dense pattern of geometric motifs.*

3 *With a simple geometric pattern and subdued palette, this textile sample was designed for Betty Joel Ltd, c.1930. The damask material is woven in buff cotton with orange wool and white silk weft. L. 1.32m/4ft 4in.*

4 *This is another Art Deco damask textile designed and woven for Betty Joel Ltd, c.1930. The geometric pattern on the blue cotton and yellow silk fabric is richer and more complex than that of the other Joel textile. L. 2.74m/9ft.*

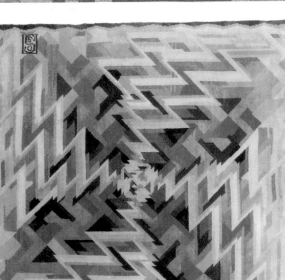

5 *Resembling a zigzag maze, this Belgian rug, Remous (eddies), or Les Fleurs Irisées sur l'Eau (iridescent flowers on the water) was by Albert Van Huffel, 1925, and woven by the De Saedeleer workshops. Ht. 2.16m/7ft.* **5**

Mass-Produced Wares and Industrial Design

Metalwork, Plastic, Glass, and China

1 *Rockwell Kent designed this champagne cooler, made by Chase Brass & Copper of Waterbury, Connecticut, 1930s. Its finish is all chromium, its motif a young Bacchus among grapes. Ht 23.5cm/9¼in.*

2 *The Art Deco cocktail shaker was available in both silver and inexpensive metals. This silver-plated shaker, cups, and tray were designed in the early 1930s by Lurelle Guild for the International Silver Co. of Meriden, Connecticut. Cocktail shaker ht 40cm/15¾in.*

3 *By Chase Brass & Copper, this chromed-metal, plastic, and laminate four-piece coffee service was part of their* Specialty *line, 1930–6. Coffee urn ht 31cm/12in.*

4 *This painted metal typewriter-ribbon box is a fine example of mass-produced American Art Deco. A leashed greyhound, symbolic of speed, appears on the lid. Diam. 6.5cm/2½in.*

5 *Many 1930s ladies' powder compacts were beautifully designed and engineered products in the Art Deco style. This enamelled-metal example, by industrial designer Robert L. Leonard for Vantine, is engraved* Zanadu. *L. 9.5cm/3¾in.*

Designing for industry reached dizzying proportions in the Art Deco period. Other than ceramics and metalware, many types of mass-produced objects featured Art Deco designs. Decorative powder compacts, for example, were made in huge numbers between the wars. Fine jewellers such as Cartier and Boucheron created exquisite gold and bejewelled compacts, but there were also cosmetic containers of base metal, enamelled metal, wood, plastic, and other inexpensive materials manufactured in the thousands by makers such as Evans, Volupté, and Elgin (in America), and Stratton (in Britain). Some of these, as well as related cigarette cases, were as expertly produced as the most precious Art Deco objects.

Numerous *moderne* plastic objects, made of a wide variety of this relatively new material (Lucite, celluloid, Catalin, Bakelite, and casein, among other types and trademark names), were produced. Radio cases; dressing table, smoking, and desk accessories; and bowls, lamp bases, trinket boxes, and other mostly small useful objects were made of plastic and featured geometric, stylized floral or figurative; or streamline-*moderne* motifs. In Britain, especially, much early plastic was colourfully mottled, speckled, or streaked.

Glass-fronted table radios of the 1930s are among the most striking and significant examples of American industrial design of the time. Walter Dorwin Teague's *Model 517* has a round front façade of blue mirrored-glass and chromium-plated metal. Besides these glass models, mention should be made of the various streamlined and Modernist designs in plastic, metal, and, less so, wood. These include Harold van Doren and John Gordon Rideout's Air-King radio, and Norman Bel Geddes's 1940 *Patriot Aristocrat 400* for Emerson.

Then there are those objects whose makers are unknown or anonymous; for instance, a series of American chromed-metal, glass, and wooden rectangular trays. These 1930s *Jazz Modern* (as a paper label on the back of one reads) trays sport bold geometric designs in deep red, black, and cream that have been silk-screened on the reverse of the glass.

6 Harold van Doren and John Gordon Rideout created this 1930–3 skyscraper-influenced radio for Air-King Products of Brooklyn, New York, made of Plaskon, metal, and glass. Ht 30cm/11¾in.

7 Esteemed industrial designer Walter Dorwin Teague created Model 517, a blue mirrored-glass, chromium-plated metal, and wood radio, for the Sparton Corporation, Michigan, 1934–6.

8 An elegant platinum geometric design on a cream ground adorns the Community China pattern Deauville, made in a Bavarian factory for the New York State-based Oneida community, 1930s. The matching Community Plate flatware also features a geometric design, in this case at the end of each piece's handle. Dinner plate diam. 25.5cm/10in.

9 The New York World's Fair of 1939–40 spawned thousands of products celebrating the exhibition and its attractions. This drinking glass features a transfer design depicting the Court of States pavilion. Ht 11.5cm/4½in.

10 Made in Brooklyn, New York, this chrome-plated metal and reverse-painted-glass Jazz Modern tray, c.1934–5, is an outstanding example of mass-produced "Machine-Age" American Art Deco. L. 45.5cm/18in.

11 In the official orange and blue colours of the 1939–40 New York World's Fair, plastic salt-and-pepper shakers take the shapes of the exhibition's signature structures, the Trylon and Perisphere. Ht 9cm/3½in.

Modernism
1920–45

The theory of modern design was deliberately simple as a response to the growing complexity of the world. Modernist objects look very different to those that came immediately before them: they have no ornament and no overt reference to historical style and they tend to emphasize materials and processes of constructing. Modernist designers aimed to use industrial processes to create objects with integrity that simplified and dramatized everyday life.

The architect Le Corbusier, growing up in Switzerland in the early years of the 20th century, was introduced to the writings of John Ruskin and held them in considerable reverence, not least because of the link they made between art and the moral condition of society. His work passed through a romantic nationalist stage, which influenced the villas designed by him around the age of twenty, with carved and painted ornament representing the pine trees of the Suisse Romande. Travelling and seeing more of the world, he learnt new ways of absorbing the great works of the past, not as text-book examples of historic styles, but as sources of a more generalized inspiration.

In his knowledge and awareness of history, Le Corbusier was typical of the first generation of modern designers. Even those who consciously declared a break with the past were often in search of a valid equivalent to ancient buildings and objects. Unlike their immediate predecessors, however, they believed that direct imitation produced the husk of the living objects of the past, but lost the life itself. Many of the pioneers of Modernism had, like Le Corbusier, lived through the period of Art Nouveau, but found it offered the wrong answer to the long-recognized problems. It was too obtrusive and attention-seeking.

The extraordinary technical advances of the late 19th and early 20th centuries provided a challenge to create a new form of Modernism: electric light, telephones, motor cars and, finally, powered flight. These found expression in German industrial design before 1914, as well as in the Art Deco of the 1920s, but the social conditions in Europe after the First World War added the impulse necessary to the realization of Modernism in its familiar form.

There was much that was straightforward about Modernism. In Germany during the Weimar Republic (1918–33), a major and overdue reconstruction pro-gramme was carried out with the same thoroughness that had characterized the rise of German industrialism fifty years earlier. The ghosts of the national past were suppressed – too thoroughly for the Conservatives, who

Left: aluminium and cork dressing cabinet by Eileen Gray, made for her villa, E.1027, in the South of France, 1926–9, designed by Gray and Jean Badovici. It is at the same time an abstract sculpture, a demonstration of the novel use of aluminium in furniture, a practical storage unit and, in its original position in the villa, a partition between the washing and sleeping areas. Ht 1.69m/5ft 7in.

Opposite: the Triadic Ballet, choreographed and designed by Oskar Schlemmer at the Bauhaus, Dessau, in 1926. The geometrical forms applied to the human body show the uneasy relationship between man and machine in Modernism, but a sense of humour and joie de vivre also come across clearly.

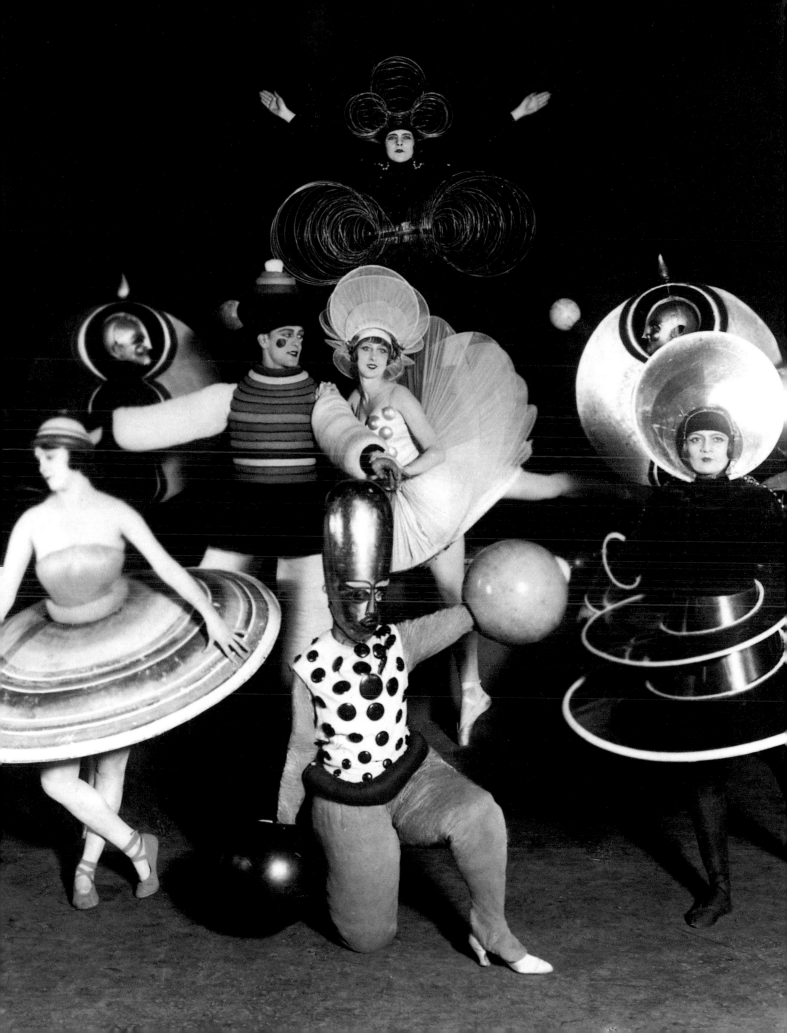

1 *British tubular steel furniture by PEL (Practical Equipment Limited), advertised in the 1930s to emphasize its feminine qualities.*
2 *Modern design reflected a cult of the lean and healthy body between the wars. The Massage Room at the House of Atlantis in Bremen, Germany, 1931, shows the quest for the body beautiful.*
3 *Industrial Designer's Office by Raymond Loewy and Lee Simonson, exhibited at the Metropolitan Museum of Art, New York, in 1934. The car acts as a focus for the shining streamlined future.*
4 *Architecture reduced to luxurious essentials: the German Pavilion, designed by Mies van der Rohe, with his* Barcelona *chair and stools at the 1929 Barcelona International Exhibition (seen here in the version reconstructed in the 1980s).*

brought them back with a vengeance under National Socialism after 1933. The housing programme in Frankfurt showed the rest of the world how architecture, design research, and a commitment to social improvement could create an image of paradise, although this proved to be short lived. In Sweden in the 1930s, the Co-Operative movement offered a newly urbanized population well-designed material goods at affordable prices, to be placed in homes that may have been small, but which always provided outdoor playing space for adults and children.

Modernism's mission to serve the mass of the population was seldom so simple, however. The correlation between functional-looking design and effective operation was sometimes rather loose. Un-designed objects could work just as well, while design could become self-seeking and purely aesthetic even under the excuse of function. Many objects scarcely needed the attention of a designer, as the early Modernists showed in their admiration for deck chairs, industrial glassware, and other "found objects."

While many designers could subscribe in theory to the availability of high-quality products for the greatest number, they soon discovered that the materials and craftsmanship needed to sustain quality were too expensive for realizing this aim. Ludwig Mies van der Rohe's *Barcelona* chair (p.382), originally produced in 1929 as a throne for the King and Queen of Spain visiting the German Pavilion at the International Exhibition in Barcelona, has never been a cheap object, although it was adopted in the 1950s and 1960s as one of the earliest icons of Modernism. There was an evangelical aspect to Modernism, promoted by the Museum of Modern Art in New York and later by the Design Council in Britain, that invited disobedience, while, for many people, the fine distinction between good and bad objects was simply incomprehensible.

Modernism had an ambiguous relationship to the professional industrial designer. In the early days of the movement, there were few opportunities for professional designers to train or practise. They tended to be over-burdened with knowledge of historical styles rather than having a fresh creative vision. It was therefore assumed that outsiders, such as architects or artists, might be better able to develop original ideas for products of all kinds. There were plenty of historical precedents for crossing

over from one field to another, but Modernism brought a new formal language based on abstract art and a new sense of social urgency in the aftermath of the First World War. The Bauhaus school, founded in 1919, introduced a re-structuring of design expertise based on a combination of workshop skills with abstract formal experiment, in place of the narrower vocational training of the past. The role of the architect was re-defined as that of a universal problem-solver, and many architects were happy to design furniture and other products as a means of earning extra income.

In the period around 1900, the complete architect-designed room, with furniture, textiles, and all other details designed or selected to create a stylistic unity, was the ideal for many designers, and this preference was carried unchanged into Modernism, offering freedom from the cultural baggage of the past in exchange for obedience to a new vision.

Many Modernists fully expected the world to be seized by communist revolution and thereafter provide a suitable setting for their designs, even when the Soviet Union turned its back on its initial links to abstraction. In America, the social experiments of the New Deal in the 1930s were, however, expressed in rather conservative visual forms, and Modernism mostly emerged through gaps in the market, sometimes as a prestigious European export, sometimes as a home-grown expression of commercial enterprise and salesmanship. Britain showed

5 *The desire to associate design with "masculine" values of rationality is seen in this page from a promotional brochure, by László Moholy-Nagy, for Marcel Breuer's long chair for the Isokon company, 1936. The modern man takes time off to scan the worrying news from Europe.*

a similar ambivalence, finding some of its most effective manifestations of Modernism in the corporate design style of the London Underground system, the apparently conservative re-styling of *The Times* newspaper in 1932, and a new light-heartedness which entered the expression of national identity in the British Pavilion at the Paris Exhibition of 1937. After the war, despite an apparent propaganda victory over reproduction styles, the social mission of Modernism became increasingly lost in the world of capitalist expansion, advertising, and obsolescence, from which it has never fully re-emerged, while the communist countries produced only kitsch.

The story of modern design used to be told in oversimplified terms, as a search for some promised land of platonically perfect forms, where the purification of the eyes would achieve a similar purification of the soul. More recently, Modernist design has been presented as a response to specific cultural and political conditions. Modernist objects that attempted to rid themselves of narrative and symbolism have acquired other values relating to status and what the French sociologist Pierre Bourdieu has called "social capital:" the knowledge that by owning a particular thing, you will present yourself to the world as a superior person.

Seen through this lens of additional meaning during the last 30 years, the "classic" objects of Modernism have effectively been incorporated within Post-modernism. Modernism's attempt to connect the material and social worlds is most apparent today in the Green movement, which holds that absence of objects can be as valuable to achieving its goals as their presence.

European Furniture

Steel Frames in Germany

1 *Marcel Breuer was probably the most famous student at the Bauhaus. His nest of tables in tubular steel and wood, B9, was produced by Thonet, 1925–6, and by Standard Möbel, 1928–9. Ht 44.5cm/17½in.*
2 *Breuer's Thonet side chair B32 of 1928, with tubular steel, wood and cane, is one of the most widespread and enduring modern classics, using the cantilever principle. After 1960, this design was marketed as the Cesca chair, named after Breuer's daughter. Ht 80cm/31½in.*

3 *Breuer's Club armchair, in tubular steel and fabric, evolved from a first version in 1925 to achieve a definitive form in 1927–8. After 1960, it was marketed as the Wassily chair by Gavina of Bologna. Ht 72cm/28½in.*
4 *Mies van der Rohe originally designed the steel and leather Brno chair for the Tugendhat house in the Czech city, in 1930. The shallow curve of the arm allowed the chair to be pulled up close to the table. Ht 79cm/31in.*

5 *The MR533 chair by Mies van der Rohe, 1927, is notable for the full curve of the steel frame in front of the chair, and the choice of woven cane as a seating material. Ht 80cm/31½in, w. 53cm/21in.*
6 *The MR90 Barcelona chair by Mies van der Rohe was conceived for the Barcelona Exhibition in 1929 and manufactured afterwards by Thonet. The crossed legs imitate the ancient Greek klismos chair. Ht 73cm/24¾in.*

1 *Le Corbusier and Charlotte Perriand's* Fauteuil Grand Confort LC3, *1928–9, is based on pieces by the British firm Maple's, and admired for its contrast with the traditional elegance of French design, re-interpreted in Art Deco. Ht 68 cm/26¾in.*

2 Fauteuil à Dossier Basculant LC4 *(chair with rocking back) by Le Corbusier, Pierre Jeanneret, and Perriand, 1928–9, shows the influence of German tubular steel designs. The calf-hide added an exoticism often found in inter-war furniture. Ht 65cm/25½in.*

3 *The* Siège Tournante *by Le Corbusier and Perriand was for the office. Le Corbusier held that office furnishings were truly modern products of the time, being un-selfconscious expressions of efficiency. Ht 71cm/28in.*

4 *Now a modern classic, the* Chaise Basculant LC4, *1927–8, emphasizes the separate articulation of its parts. The chrome-framed rocker can be positioned on the steel base as required. Ht 73cm/28¾in, l.1.56m/5ft 1½in.*

The history of Modernist furniture began with industrialization in the 19th century, particularly with the firm founded in 1819 by Michael Thonet. The bentwood chairs with cane or plywood seats, used in cafés and restaurants, that were produced by his sons after 1850, were cheap to make and lightweight in use, and unwittingly achieved the kind of anonymous look that became popular after 1900 in reaction against the more elaborate kind of Art Nouveau in Europe. The Thonet company went on in the 1920s to make tubular steel furniture after the prototypes of Marcel Breuer (1902–81) and Ludwig Mies van der Rohe (1886–1969), and these designs were imitated and adapted in Britain and America.

Breuer was the author of several classics of modern design that are still in production. His first experiments were carried out as a student, and then master, at the Bauhaus school in Germany in the mid-1920s, where he abandoned a hand-made wooden look and got a local craftsman to bend tubing manufactured for bicycles.

Breuer's *Wassily* armchair, 1925, with leather seat and arms, is like a skeletal diagram of a chair, while his *B32* side chair, with wood and cane panels, can now be bought in a flat-pack kit.

Mies van der Rohe's *Barcelona* chair, 1929, is equally well known, but was never designed to be cheap. Like much Modernist furniture, it derives from classical antiquity with its *klismos*-style crossed legs. It shares a look of relaxed comfort with his 1927 side chair in tubular steel and leather.

The Swiss architect Le Corbusier (1887–1965), an enthusiast for Thonet furniture in the early 1920s, wanted to escape from the luxury one-off character of French furniture exemplified in the 1925 exhibition of Arts Décoratifs. He was influenced by Breuer and Mies, and worked with Charlotte Perriand (1903–99) to produce a range of furniture including the *Grand Confort LC3* club armchair, 1928–9, based on the well-stuffed masculine furniture of the English firm Maple's, and the *Chaise Basculant LC4* recliner, 1927–8.

De Stijl and its Influence

1 End Table, *1923, in painted wood, by the Dutch designer Gerrit Rietveld, demonstrates his geometrical inventiveness. Ht 61.5cm/24¼in.*
2 *Rietveld's* Red/Blue *chair was first produced in monochrome in 1917–18; this example is 1918–19. It was meant to be simple to make from standard timber sections, but also achieves a logical consistency in construction that Modernists strived for. Surprisingly, it is more comfortable than it looks. Ht 87cm/34¼in.*
3 *Rietveld's left-hand* Berlin Chair, *1923, develops his formal language through the asymmetry of the arms, seat, and back. Ht 1.06m/3ft 6in.*
4 *This* coiffeuse, *or dressing table, in steel and timber was designed by Robert Mallet-Stevens, a popular French designer in the 1920s who showed an understanding of Rietveld's geometric principles with this open construction.*

The phrase "less is more" was coined by Mies van der Rohe, and applies to Modernism generally. Gerrit Rietveld (1888–1964), working in Holland, was inspired by Frank Lloyd Wright's simple straight lines in timber furniture before 1914 to carry the process further. Timber was his favourite material, and he aimed for simplicity of construction by using sawn sections and nailed joints, at a time when conventional furniture was abandoning much of its craft basis, but trying to hide the loss of workmanship behind "traditional" styling. The over-hanging ends at the junctions became the aesthetic signature of Rietveld's designs for simple household pieces. Most famous was his *Red/Blue* chair, first produced in plain wood in 1917–18, at a time of great poverty and deprivation in Holland after the First World War, and later painted in primary colours, following the principles of the De Stijl group of artists and designers.

Modern designers in the 1920s were inspired by lightweight folding furniture made for use on board ships, in the army, or on safari. These pieces could be bought from department stores rather than through the normal furnishing trade, and broke all the rules of decorum and craftsmanship because they were meant for use outside the home. The folding deck chair known as a *Transatlantique* was the inspiration for the *Transat* chair, 1925–30, by the architect-designer Eileen Gray (1878–1976), with its wooden frame, slung padded seat, and adjustable back. It represents the apparent paradox in Modernism, that less effort produces better design, for it fulfils all its functional requirements while also having an elegance and personality which are hard to pin down in words.

Eileen Gray's furniture was never mass produced. Born in Ireland, she spent most of her life in France, developing from producing Art Deco lacquer furniture towards a distinctive form of Modernism in the interiors for which her pieces were originally devised. At the end of her long life, her work was rediscovered and celebrated, and reproductions of her pieces are widely available.

1

2

3

1 Eileen Gray's S chair of 1932–3 was never produced in quantity during the designer's lifetime, but has become a modern classic owing to its visual and constructional ingenuity.

2 Gray's Transat chair, 1925–30, takes its name from the Transatlantique, a form of chair used on the decks of ocean-going liners. The straight lines of the wooden frame contrast with the lazy curve of the seat. Ht 73cm/28¼in, w.54cm/21¼in.

3 The folding block screen by Eileen Gray, c.1925, is an example of a simple idea rigorously applied. The lacquered wooden panels, a return to her first furniture designs in this medium, are linked on steel rods and allow many different forms to be created. Ht 2.15m/7ft ¾in.

4

4 The E.1027 table, 1926–9, was originally designed for Gray's own villa of the same name. This design has been widely reproduced since the rediscovery of Gray's work in the 1970s at the end of her long life. Ht 62cm/24½in.

5 Gray's sofa, 1926–9, is typical of her ability to make a simple visual idea into a perennially satisfying piece of furniture, in which function is neither obeyed as a master, nor denied as a tyrant, but plays a duet with fantasy. L. 2.04m/6ft 8½in.

5

Scandinavian Furniture

Wooden Furniture from Finland, Denmark, and Sweden

1 *Alvar Aalto's* Paimio *armchair, 1931–2, was originally developed for tuberculosis patients in the Paimio Sanatorium in Finland, which was his first great modern building, completed in 1933. Bent plywood was the basis for most of Aalto's furniture, manufactured in Finland. Ht 64cm/25¼in.*

2 *The idea of the cantilevered armchair (Chair 31) was based on tubular steel designs. Aalto's version of 1931–2 allows for a slight flexibility in the frame and seat to make the chair more comfortable. Ht 72cm/28¼in.*

3 *Aalto combined padded seats with a plywood frame in the Armchair 400, 1935–6, with a printed fake zebra covering. Ht 65cm/25½in.*

4 *Aalto's trolley for food or drink of 1935–6 shows how the earlier age of domestic service was giving way to a new simplicity of middle-class lifestyle, where elegance was still valued. Ht 60cm/23½in, w. 90cm/35½in.*

5 *This* Screen 101 *by Aalto, of 1933–6, based on a 19th-century pattern, is made of wooden battens glued onto a base of flexible cloth. The owner can set up the irregular curves which Aalto introduced into his architecture in imitation of nature. Ht 1.5m/4ft 11in.*

Modern furniture in Scandinavia forms an important strand in inter-war history. All the Nordic countries had a strong design culture during this period, with a special knowledge and love of timber. Compared to the hard smooth surfaces of German, French, or Dutch Modernism, designers in Sweden, Finland, and Denmark aimed for softer effects in material and colour, although their best pieces were no less rigorous in eliminating visually confusing or redundant construction.

The most famous representative of these trends is the Finnish architect Alvar Aalto (1898–1976). In 1933 he patented a method for bending plywood under steam, and developed a series of chairs, stools, and tables whose simple construction belies a precise understanding of visual balance, often enhanced by spray-painted finishes in colour. Aalto's furniture was and still is marketed successfully in many countries by the Artek company that he established in 1935.

The Swedish designer Bruno Mathsson (1907–88) was 27 years old when he designed the *Eva* chair, with its frame of solid bent beech wood and woven webbing seat, using material that in conventional furniture would be hidden with padding and fabric. Such simplicity comes with inherent hazards, although perhaps accidental drink spills that could ruin this chair are less disastrous in a beer-drinking country than a red-wine drinking one.

With the Dane Kaare Klint (1888–1954), the perfectionism of Scandinavian design reached a peak. His pieces are simple in appearance, but most do not allow for mass production, requiring a careful choice of timber, like his folding table and beautifully sculpted folding stool of 1930. Mogens Koch (1898–1992), trained as an architect but became a designer for a wide range of furniture, textiles, and silver. His folding *Safari* chair of 1938 resembles Klint's stool and is similarly beautifully detailed. Klint also produced a version of the *Safari* chair in 1933, a type originally designed to collapse and pack into a bag for intrepid travellers who wished to recline in comfort when they set up camp. Le Corbusier and Ernö Goldfinger were also influenced by this original model.

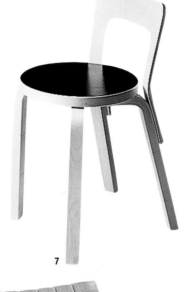

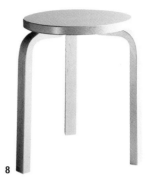

7 *This chair with a low back (Chair 65), 1933–5, by Aalto, shows the informal lifestyle that his furniture suggested. Ht 78cm/30¾in.*

6 *Aalto's* Korhonen, Model 611, *a stacking chair design of 1929, was traditional in construction, since the frame was jointed rather than bent. Ht 79cm/31in.*

8 *Aalto's three-legged stool (Model 60), 1932–3, works equally well as a side table. When stacked, the stools achieve a different beauty of repeating spiral forms. Ht 44cm/17¼in.*

9 *Mogens Koch's folding chair of 1938 carries Modernism's ideal of adapting anonymous products to a quiet perfection typical of Danish design. Aspects of the Safari chair (canvas supports and leather arm straps) are combined with the idea of the folding Director's chair with exquisite attention to detail. Ht 87cm/34¼in.*

10 *Bruno Mathsson's* Eva *chair, 1934, shows the independence of modern Scandinavian design and its attention to the pleasures of touch as well as sight. Ht 83.5cm/32¾in.*

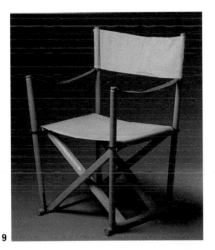

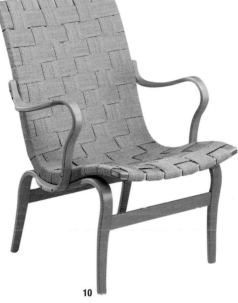

11 *Mathsson produced a light canvas lounge version of* Eva, *c.1938, achieving the same purity of visible construction. Ht 87cm/34¼in.*

American Furniture

Early Exponents of Modernism

2 Depression-beating desk by Frankl, c.1930, with a red lacquer finish, chromium-plated steel bands, and brushed chromium handles. Ht 78.5cm/31in.

3 A simple statement by Gilbert Rohde in a chest of drawers, 1933–4, emphasizing asymmetry in the placing of the handles, and playing with a two-tone colour contrast. Ht 91.5cm/36in.

1 The Skyscraper *chest of drawers, 1927, by Paul Frankl was an early example of American Modernism, representative of the Austrian-born designer's catchy adaptation of a typically American idiom. Ht 1.71m/5ft 7¼in.*

"After the First World War," wrote Dianne Pilgrim in *The Machine Age in America* (1988), "the decorative arts fell into a deep sleep of ignorance where machine-made copies of previous styles and periods reigned supreme." Despite the inspiration of Gustav Stickley and Frank Lloyd Wright from around 1900, American modern design was re-invented at the end of the 1920s on the basis of French and German examples. The designer Paul Frankl (1887–1958), who came to New York from Austria in 1914, saw the importance of Wright and was one of the few designers to pioneer Modernism in the 1920s, especially with his *Skyscraper*-style furniture, in which vertical elements of different heights are clustered together. Art Deco in concept, the skyscraper style was gradually simplified and refined by Frankl. It was a process similar to the transition in popular music from the angularity of 1920s jazz to the smoother sound and rhythms of swing.

The transition in design style around 1930, against the background of the Depression, can be seen in the increasingly horizontal emphasis of furniture design, similar to European Modernism, but often underscored with lines of chrome, or functional elements like the handles on the chest of drawers of 1933–4 by Gilbert Rohde (1894–1944). Donald Deskey (1894–1989) made the transition from luxury one-off pieces to designing for mass production for companies such as the Ypsilanti Reed Furniture Co. in Michigan, the centre of American furniture production. Here, several business failures in the Depression, combined with a shortage of timber, prompted a rethink of policy, where previously reproduction styles had reigned supreme.

As Deskey wrote in 1933: "The financial crisis which America is at present experiencing has so reduced the number of new buildings and products that each can receive more careful consideration from every point of view." The development of Modernism against a background of social questioning was accompanied by much discussion, in which the goals were efficiency, beauty, and economy, rather than "false style stimulation."

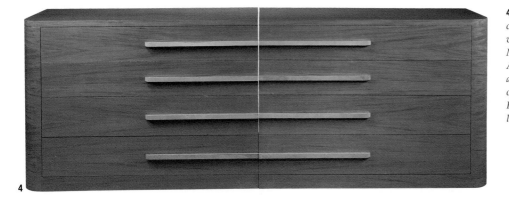

4 *Donald Deskey, matching chests of drawers in white holly veneer, 1931–5, for Estey Manufacturing, Michigan. An accomplished design in a popular Modernist mode of applied strip handles. Ht 82.5cm/32in, l. 1.12m/3ft 7½in.*

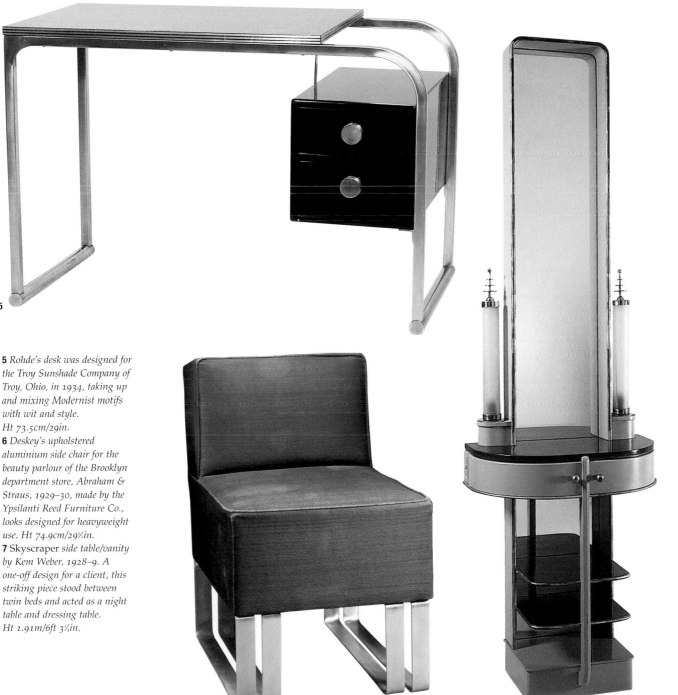

5 *Rohde's desk was designed for the Troy Sunshade Company of Troy, Ohio, in 1934, taking up and mixing Modernist motifs with wit and style. Ht 73.5cm/29in.*

6 *Deskey's upholstered aluminium side chair for the beauty parlour of the Brooklyn department store, Abraham & Straus, 1929–30, made by the Ypsilanti Reed Furniture Co., looks designed for heavyweight use. Ht 74.9cm/29½in.*

7 Skyscraper *side table/vanity by Kem Weber, 1928–9. A one-off design for a client, this striking piece stood between twin beds and acted as a night table and dressing table. Ht 1.91m/6ft 3¼in.*

MODERNISM | AMERICAN FURNITURE

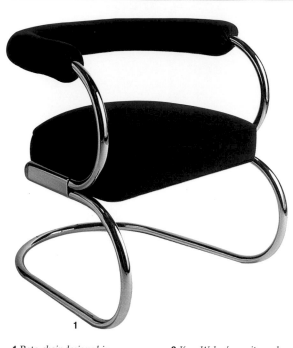

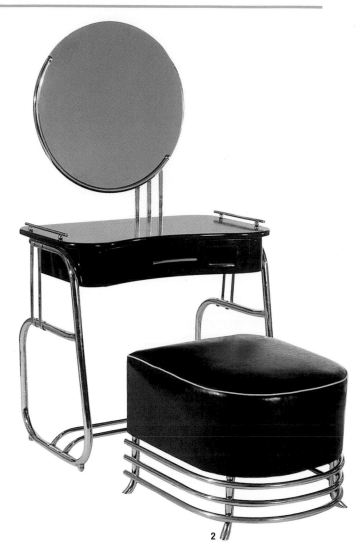

1 Beta *chair designed in 1930 for the Howell Company of Geneva, Illinois, by Nathan George Horwitt, showing the sturdy and curvaceous character of tubular steel furniture in America. Ht 60cm/23⅓in.*

2 *Kem Weber's vanity and stool, 1934, for the Lloyd Manufacturing Company, Menominee, Michigan, indicates how strongly the Art Deco characteristics of decoration persisted in American Modernism. Vanity ht 1.39m/4ft 7in; stool ht 44.5cm/17½in.*

Streamlining became a speciality of the newly emerging industrial design profession in America and its prominent practitioners, such as Raymond Loewy and Walter Dorwin Teague. While the results are enjoyable, they replaced the earnest search for moral and visual integrity in European design with a more superficial understanding of Modernism. Even Frank Lloyd Wright himself, in his office furniture for the Johnson Wax building at Racine, Wisconsin (1936–9), adopted, with typical originality, some of the characteristics of streamlining. American streamlined furniture often emphasizes the weight and volume of seat cushions, even when they are supported by chrome tubing or a wooden frame. This is combined with a preference for raking angles, whereas European Modernist furniture more often contains some reference to a rectilinear grid.

From the mid-1930s onwards, the smooth and reflective surfaces of the Machine Age were gradually replaced by a new concept of organic design. The word was used frequently by Wright to express what he believed was typically American, but the realization beyond his own work was inspired by Scandinavian design, with its use of curved wood. Organic design was in many ways a critique of machine-worship, and reflected the attempts during the Depression to renew the spiritual basis of American society by replacing its mechanistic and Darwinist assumptions about struggle and survival with a sense of the bounty of nature in the New World.

The organic trend reflected the development of plywood moulding in three dimensions, bringing back some of the comfort that had been lost during Modernism, without losing the advantages of visual and physical lightness. A moulded chair with aluminium legs and a wrap-around of upholstery, designed by Eero Saarinen and Charles Eames for the 1941 Organic Design show at the Museum of Modern Art in New York, exemplifies these trends, and both designers were to exert a major influence in the 1950s.

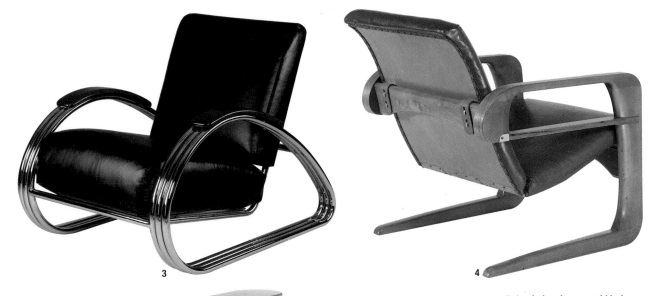

3 *A tubular chrome and black leather chair with curves like a 1930s car, by Kem Weber, 1934, for the Lloyd Manufacturing Company, Michigan. Ht 73.5cm/29in.*

4 *Aerodynamic forms in jointed and shaped timber characterize the Airline Chair by Weber, 1934–5, produced by the Airline Chair Co. of Los Angeles. Ht 77.5cm/30½in.*

5 *Frank Lloyd Wright, the founder of American Modernism, made a complex spatial game from streamlining in the office furniture designed for the Johnson Wax building, 1936–9, manufactured by Steelcase of Grand Rapids, Michigan.*

6 *A new look emerged in the late 1930s in this striking chair by the Pittsburgh Plate Glass Company, 1939, possibly designed in-house by Louis Dierra. Ht 73.5cm/29in.*

7 *American Modernism achieves classic maturity in the chair designed by Eero Saarinen and Charles Eames, exhibited at the* Organic Design *show at the Museum of Modern Art in 1941, and suggestive of the 1950s styles to come. Ht 84.5cm/33in.*

British Furniture

European Influences around 1930

1 *Serge Chermayeff's buffet for Waring & Gillow of London, 1928, signalled the move by this long-established furnishing company into modern design. It formed part of an exhibition room set and has a lifting top, felt-lined drawers, and side cupboards for bottles, faced in fine veneers. W. 1.38m/4ft 6in.*

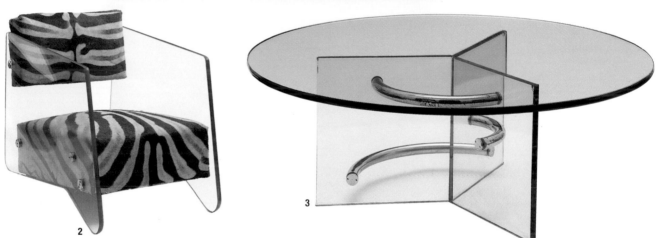

2 *Denham Maclaren's chair of 1931 brought the excitement of Paris to a conservative and cautious London. It was too far ahead of its time to be produced in quantity. Ht 68cm/26¾in.*

3 *A brilliant dilettante, Maclaren made only a few pieces before giving up his career. This 1931 table was found in several important interiors in Britain up to the end of the decade. Ht 46cm/18in.*

Modern design came late to Britain, where high-quality furniture was either a survival of the Arts and Crafts Movement, or a reproduction of Georgian. Art Deco styles had created an interest, especially with a large exhibition organized at Waring & Gillow, a famous London furniture store, by the young Serge Chermayeff (1900–96) in the autumn of 1928, with many room sets suggesting a continuity with traditional British values of reticence and comfort.

The exhibition included some pieces in tubular steel, and work by Denham Maclaren (1903–89), whose few surviving pieces in plate glass and exotic materials like zebra skin caught the contemporary mood in Paris without looking like provincial imitations. Gerald Summers (1899–1967) was another designer who is remembered for a few remarkable ideas. His armchair of *c*.1934, bent from a single piece of plywood, may be a response to the exhibition of Alvar Aalto's furniture in London in 1933, but is even more elegant in its simplicity of construction and visual form. These two designers, and others like

Wells Coates who were better known as architects, showed that there was potential for a native British school of modern furniture design prior to the arrival of Marcel Breuer and other émigrés from Germany, whose names have tended to dominate the history of the period.

The firm of Gordon Russell Ltd began in the 1920s, making furniture by hand. After the financial crisis of 1929 and the Depression that followed, Gordon Russell asked his brother Dick (R.D. Russell), who had trained as an architect, to make designs for machine-made furniture, often using plywood as a facing material. The designs became correspondingly more modern in character. This forced adaptation to a wider market was accompanied by a more entrepreneurial approach to selling and advertising, and Russell's London showroom was one of several shops that displayed a range of household goods exemplifying the slightly pallid good taste of the period. During the Second World War, Russell was Chairman of a government panel set up to create and licence "Utility" designs for manufacture from the scarce materials available.

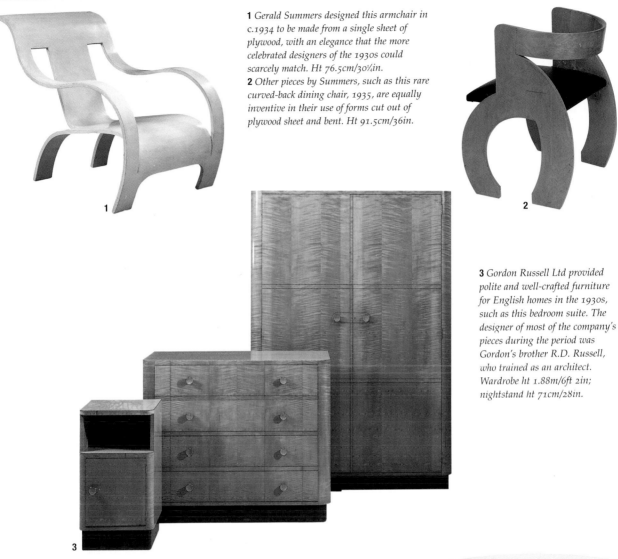

1 *Gerald Summers designed this armchair in c.1934 to be made from a single sheet of plywood, with an elegance that the more celebrated designers of the 1930s could scarcely match. Ht 76.5cm/30¼in.*

2 *Other pieces by Summers, such as this rare curved-back dining chair, 1935, are equally inventive in their use of forms cut out of plywood sheet and bent. Ht 91.5cm/36in.*

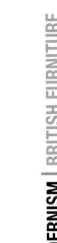

3 *Gordon Russell Ltd provided polite and well-crafted furniture for English homes in the 1930s, such as this bedroom suite. The designer of most of the company's pieces during the period was Gordon's brother R.D. Russell, who trained as an architect. Wardrobe ht 1.88m/6ft 2in; nightstand ht 71cm/28in.*

4,5 *A tension existed in British design polemics between the "pure" Modernists and others, such as Betty Joel, who were more influenced by Art Deco and streamlining. This desk and chair, and chrome, glass, and mirror occasional table, 1935, were all supplied by Joel for a country house in Scotland in 1937. Desk ht 75cm/29½in, w. 2.13m/6ft 11¼in; table ht 68cm/26¾in, diam. 76cm/30in.*

1 *Arriving in London as an émigré in 1935, Marcel Breuer was commissioned by Jack Pritchard's Isokon company to create a variety of plywood furniture. Breuer's Isokon bent ply long chair of 1936 was a complex adaptation of the reclining form introduced into Modernism in the 1920s. L. 1.35m/4ft 5in, ht 83cm/23¼in.*
2, 3 *This dining chair and table, 1936, were among the lightest pieces of wooden furniture ever made, introducing a family of matching forms. The chairs could be stacked. Chair ht 73.5cm/99in; table l. 67.5cm/26½in.*

4 *Breuer's Isokon nest of tables, c.1936, followed the tapering leg form of the dining suite. It is seen here in a white painted version. Ht (largest) 35.5cm/14in, l. 61cm/24in.*
5 *The Isokon stool, 1933, was exceptionally lightweight, with a dished seat that was both comfortable and structurally robust. Ht 45cm/17¾in.*
6 *Egon Riss, a German émigré architect, designed the Isokon Donkey in 1938, to house books and magazines. It was promoted by Penguin Books, a company that, like Isokon, aimed to make quality products available to a wide audience at an affordable price. Ht 43cm/17in, w. 60cm/23¼in.*

While Continental influences shaped the development of modern furniture in Britain, the presence of many émigré designers and architects accelerated the process of change, even though the market for their designs was very small. When Marcel Breuer came to Britain in 1935, he was immediately employed by the enterprising Isokon company in London to design a range of wooden furniture, using bent plywood for a fragile dining table and chair set, and stronger framing for his classic Isokon long chair of 1936. Isokon also produced items designed by Walter Gropius and Egon Riss. The use of timber, rather than steel, glass, and leather, was partly a response to a different culture, but also a consequence of changing fashion. Natural materials were coming back in modern architecture, a trend that may have been parodied by the Russian-born architect Berthold Lubetkin (1901–90), with his rough wood and cow-hide chairs for his own apartment in 1938.

The architect Ernö Goldfinger (1902–87) was born in Hungary and studied in Paris before moving to London in 1934. Being short of architectural projects, he designed many pieces of furniture, although only a few were ever made, and then only as prototypes for his own house. He showed how plywood could be made into furniture which was more solid in form and construction than the fragile pieces by Breuer. He enjoyed the found-object aesthetic of surrealism and would use sections of steel girder as supports for sideboards, and machine-tool bases for table pedestals.

Several companies manufactured tubular steel furniture, most notably the PEL company and Cox & Co. Such furniture was supplied to the new Odeon cinemas, to offices and to restaurants, and covered with leather or moquette. PLAN Ltd, a company which was founded by Serge Chermayeff in 1932, adopted German designs for chairs and storage "units," the latter a necessity for those who did not want the usual clutter of chests of drawers and wardrobes, but could not afford the built-in furniture that architects liked most of all to provide for their domestic clients.

Other Seat Furniture

1 *Ernö Goldfinger's plywood furniture was intended for production in the 1930s but never progressed beyond prototype until after his death. These versions are now produced by his grandson, Nick Goldfinger.*
Chair ht 68cm/26¾in.
2 *PEL was a company set up to exploit the mass market in steel tube furniture in 1932 at Oldbury, near Birmingham, Britain. Their chairs were found in cinemas, shops, and even pubs and were probably designed by Oliver Bernard, c.1932. Ht 77cm/30¼in.*

3 *The* Lamda *chair, named after the Greek letter "L", was designed by Hein Heckroth, a German émigré who worked at Dartington Hall, Devon, a progressive community involved in art, education, and rural regeneration. It was made by the building firm linked to Dartington and covered in cloth woven on the estate. Ht 65.5cm/25¾in.*
4 *The founder of the Bauhaus, Walter Gropius, left little mark in Britain during his three years' residence. This table for Isokon, c.1936, was one of his few product designs. Ht 80cm/31½in.*

5 *Berthold Lubetkin never intended his massive cow-hide chairs, 1938, for mass production. This example has been returned to its original setting in Lubetkin's former apartment, The Penthouse, in Highgate, north London, where its relationship to the rough grained wall surface and brown and white floor can be understood. W. 76cm/30in.*

British Ceramics

Factory Made

1 Design E/297, 1931. Coffee can and saucer made for Susie Cooper Pottery, 1928–9. An early piece by a British designer. Ht 6.5cm/2in.

2 Susie Cooper, teapot, jug, and sugar bowl, c.1935. Teapot ht 8.5cm/3⅓in.

3 Truda Carter, vase, c.1928, hand-painted pottery. Poole Pottery, of which Carter's husband was a director, was one of the more progressive British potteries in the 1920s. Ht 21.5cm/8½in.

4 Keith Murray, engine-turned vase, 1935, Wedgwood. One of Murray's most popular shapes, this vase was available for 12 years in a variety of colours and sizes. Ht 2.5cm/10¼in.

5 Murray, coffee service, Wedgwood, c.1934. Murray's no-nonsense shapes for tableware were suited to conservative British taste. Coffee pot ht 18.5cm/7¼in.

1 *Bernard Leach, bowl, 1924–5, stoneware with Tenmoku glaze. Japanese influences in Leach's work reflect his early childhood in Japan and later visits. The glaze is produced with oxidized iron and the addition of wood ash gives a rich black finish. Ht 5cm/2in, w. 15.5cm/6in.*

2 *Leach, cut-sided bowl, 1924–5, stoneware. Leach has deliberately left the foot of the bowl unglazed to show off the material. Leach wrote, "The foot is a symbol, here I do touch earth, on this I stand, my terminus." Diam. 13.8cm/5½in.*

3 *William Staite Murray, tall jar* The Bather, *1930, stoneware decorated with iron rust over cream. Murray saw himself as an artist who made pots. This large piece, nearly 28cm/11in tall, is bold and individual, thrown by Murray at his 69th attempt.*

4 *Michael Cardew, three-handled jar and bowl, 1931, slip-glazed earthenware. Cardew was inspired by traditional country potteries in the west of England. Jar ht 21cm/8¼in; bowl ht 7cm/2¾in.*
5 *William Staite Murray, vase with* Wheel of Life, *1937–9. Murray exhibited his pots alongside the paintings of Ben Nicholson, with which they share an interest in abstract texture. Ht 25cm/10in.*

In Britain in the 1920s, ceramics became one means by which a decorative form of Modernism entered a large number of homes. It is hard to make a clear distinction between Art Deco and Modernism in the work of famous designers such as Clarice Cliff and Susie Cooper, although the restraint of the latter, often expressed through simple lines and stars, meant that her work survived better the changing fashions of the 1930s.

Poole pottery, in Dorset, south-west England, far from the centres of ceramic production, also specialized in hand-painting, with simplified figures and flowers derived from Austrian and Swedish models. With strong artistic direction from Harold Stabler and Truda Carter, Poole had a leading role in design reform movements of the time.

In a search for modernity, Wedgwood employed the architect Keith Murray to design pure forms that were glazed all-over in a variety of greens and beiges typical of the early thirties, sometimes with incised lines. At the same time, Wedgwood's late 18th-century Queensware bodies were produced in plain colours suitable for modern use.

The studio pottery movement, during this period led by Bernard Leach (1887–1979), and by William Staite Murray (1881–1962) in the 1920s, believed that the industrial methods of Staffordshire had taken away the pleasure of individual craftsmanship which had raised some ceramics of the past to the level of high art. Leach and his pupil Michael Cardew (1901–83) saw pottery as a means of social regeneration in the countryside, as a valuable form of art education, and as a practical means of producing goods for wide-ranging consumption. They therefore mixed the production of one-off specials with long runs of tableware, establishing a tradition in Britain which had much in common with Modernism's aesthetics (particularly its links with Japan), while discarding its social and economic assumptions. They avoided fine porcelain clays and used the rough red clays of the south-west of England to make earthenware and stoneware, usually decorated with yellow and brown slips, loosely brushed or trailed to preserve a sense of spontaneity.

European Ceramics

Pioneers in Russia and Germany

1 *Nicolai Suetin, coffee pot, 1926, hand-painted porcelain. Suetin was a follower of the Suprematist painter, Kasimir Malevich. Existing factory shapes were overlaid with geometrical designs. Ht 25cm/10in.*
2 *Porcelain coffee set influenced by Russian and German designs by Nora Guldransen, 1929–31 and made by Porsgrund Porselaenfabrik. Coffee pot ht 20cm/8in.*
3 *Theodor Bogler, black teapot, 1923. Bogler was a Bauhaus student who produced the most notable designs from the school's pottery workshop before becoming a monk in 1927. Ht 20.5cm/8in.*

4 *Bogler, combination teapot with lateral pipe handle, 1923. This was one of Bogler's best-known designs, with a rough glaze recreating the effect of hand-made pottery. Ht 18cm/7in.*

Being such a ductile medium, clay does not impose its own shape on designers as much as other materials. The function of everyday tableware has changed very little over the centuries, even though the hand-throwing process that dictated roundness in plates, bowls, and dishes was largely superseded in the 18th century by casting in moulds, which technically can be in other shapes. In ceramics for practical use, therefore, Modernism has tended to be a process of purification and subtraction, reducing formal complexity and ornament, while trying to maintain the highest quality of body and glaze. The classic models of late 18th-century Wedgwood continued to be highly regarded for their refinement of shape, and many Modernist ceramics, like the pure undecorated pieces of Wilhelm Wagenfeld and Marguerite Friedlander-Wildenhain, resemble simpler Neoclassical work quite closely.

Both these designers were students at the Bauhaus, where the ceramic workshop, while less fully integrated in the school than some other departments, trained its students in hand-making, renewing a sense of the behaviour of the materials through the process of production, prior to designing prototypes for mass-production, rather than the idea of "applied art" in ceramics, which during the Art Deco period had involved designers in the ceramic industry more as decorators than as "architects" of form. Wilhelm Kåge (1889–1960) of the Gustavsberg factory in Sweden introduced the "Praktika" range in 1933, in which ease of stacking was an important design consideration for the smaller-size modern dwelling, as well as a useful marketing ploy.

Not all Modernist ceramics were so pure. More elaborate and exclusively ornamental pieces were produced, in which there was a search to re-interpret decoration with a more conscious sense of formal integrity. The 1927 tureen by the Norwegian designer Nora Gulbrandsen (1894–1978) is a delicious but simple formal invention, with its decoration of spiral lines adding a dynamic quality to the shape and unifying the bowl and lid.

1, 2 *Marguerite Friedlander-Wildenhain, pieces from the* Burg Giebichenstein *service, 1930, porcelain (produced by the State Porcelain Factory, Berlin, who manufactured many of Friedlander's designs) and a white porcelain pitcher, 1931. Both examples show a meeting point between classical "good form" and modern purity. Pitcher ht 22.5cm/8¾in.*

3 *Margarete Heymann-Marks Löbenstien, dinner plate, c.1930. The asymmetry of the decorative border gives dynamism to a simple shape. Diam. 25cm/10in.*

2

4 *Nora Gulbrandsen, tureen, 1927, porcelain, with enamel and gilded decoration. Porsgrunds Porselaensfabrik, Norway. An effective version of the favourite Modernist forms of the 1920s.*

5 *Wilhelm Kåge,* Praktika *dinner service, 1933, earthenware, Gustavsberg, Sweden. This plain service was specially easy to clean and stack, and soon became popular.*

6 *Kurt Feuerriegel, vase, 1932, enamelled metal. Not a typical modern design, but an example of the continuation of expressionist decorative forms in the 1930s, in this case in a work made at the Design School at Leipzig. Ht 16cm/6¼in.*

7 *Pitcher in glazed stoneware by Theodor Bogler (left) and a glazed terra cotta cocoa pot by Otto Lindig, c.1922. The rough glazes of these pieces contrast with the fragile elegance of much Modernist design. Pitcher ht 21cm/8¼in.*

American Ceramics

Exuberance and Eccentricity

1 *Ruba* Rombic *vase, c.1928, Consolidated Lamp & Glass Co., Pennsylvania. Rombic wares demonstrated the influence of Cubism in the decorative arts. Ht 16cm/6¼in.*
2 *Paul Schreckengost, pitcher and cups, c.1938, Gem Clay Forming Co., Sebring, Ohio. American ceramics show a liking for exaggerated forms. Teapot ht 19.5cm/7⅛in.*

3 *Frederick H. Rhead,* Fiesta *ware, 1936, Homer Laughlin China Co., West Virginia. Fiesta helped to popularize the idea of a china set with matching shapes and mixed strong colours. Coffee pot ht 20cm/8in.*
4 *Frederick H. Rhead,* Harlequin *range, 1938, Homer Laughlin China Co. A lighter and cheaper version of Fiesta, this range was sold in Woolworth stores. Tea pot ht 12cm/4¾in.*

When the Museum of Modern Art staged its *Machine Art* show in 1934, the purest examples of ceramics it could find were porcelain jars and bowls intended for use in scientific laboratories, designed apparently without any thought of being art. The ceramic industries in America were in a state of transformation during this period, with many business failures. At the top end of the trade, quality was almost automatically assumed to belong to imported European ceramics.

Design had played a small role hitherto in mainstream American production. The volatile ceramics trade was disciplined by the National Recovery Act of 1937, part of F. D. Roosevelt's New Deal, which insisted that selling prices should not undercut the cost of production and that no new shapes should be introduced for a year. This was a commentary on the desperate search for market share through novelty, and stimulated a greater commitment to investment in design, since there were fewer chances to test the market. A breakthrough came with Russel Wright (1904–76) and his *American*

Modern tableware range (designed 1937, produced 1939–59 by Steubenville Pottery), with streamlined shapes and an all-over speckled glaze. These combined aspects of streamlining with the biomorphic character typical of fine artists such as Jean (Hans) Arp, with a quirky sense of personality that might owe more to Walt Disney's *Fantasia*. The name of the range emphasized that modern could now be claimed as American rather than foreign. Brighter coloured glazes were developed for *Fiesta* ware, designed by Frederick Hurten Rhead (1880–1942) for the Homer Laughlin China Co. in West Virginia in 1936, with the idea of mixing colours in one table setting.

During the first years of the Second World War, Eva Zeisel (b.1906), an immigrant from Budapest, went even further than Wright in her curvaceous, exaggerated, organic forms, which were somewhat reminiscent of Art Nouveau. Her *Museum* dinner service was designed for sale at Castleton China in New York in 1942, although it was not produced until 1946.

5 *Russel Wright*, American Modern *tableware, 1939, Steubenville Pottery, Ohio. A streamlined set of forms that changed the way Americans used tableware, with new uses for dishes which could be heated in the oven. Pitcher ht 19cm/7¼in.*

5

6

7

6 *Raymond Loewy glazed porcelain tea service comprising teapot, sugar bowl, and creamer. The profiles, with their generous handles, have something of the quality of cartoon characters. Creamer ht 11cm/4¼in.*
7 *J. Paulin Thorley, earthenware refrigerator jug with lid, 1940, for the Westinghouse Electric Co. Streamlining applied to a fine deep blue, suggesting hygiene and new technology. Ht 19.4cm/9¼in.*

8

8 *Eva Zeisel, cruet set,* Town and Country *pattern. A quirky and humorous use of an organic shape. Ht 13.5cm/5¼in, w.9cm/3½in.*
9 *Eva Zeisel,* Museum *dinner service, c.1942–6, Shenango Pottery, Pennsylvania, for Castleton China, New York. The irregular geometry and exaggerated shapes of these pieces became typical of the post-war period. Coffee pot ht 27cm/10½in, 19.5cm/7¾in.*

9

British Glass

Coloured Glass

1

2

3

1 Ribbon-Trailed *vases, 1935–6, by Barnaby Powell of Whitefriars Glassworks, a third-generation member of the outstanding British glass firm. The decorative form derives from the making process. Ht (tallest) 25cm/10in.*
2 *Streaky glass tumblers, by Arthur Marriott Powell, c.1930, were an enterprising offshoot of the Whitefriars stained-glass speciality. Ht (tallest) 28cm/11in.*
3 *Barnaby Powell's classic design was the M60 sherry set, 1935, which gave novel shape to a traditional English drinking ritual, with a subtle use of colour. Glasses ht 7.8cm/2½in, decanter ht 19cm/7½in.*

The Arts and Crafts Movement in Britain laid the foundation for modern design in glass, with its attention to quality of materials and making. The firm of James Powell & Sons (Whitefriars Glassworks, est. *c.*1680) had a distinguished history in design and technical development. The factory had a number of in-house designers who thoroughly understood the processes, but were also aware of international trends. Barnaby Powell (1891–1939) was one in a succession of family members who contributed fine designs such as the *Ribbon-Trailed* range of 1932 and the *M60* sherry set of 1935, which looks more as if it came from the 1950s than the 1930s.

In parallel with the ceramics industry, there was an attempt to bring artists into glass design, since few professional industrial designers existed. In the case of glass, this usually led to their designing patterns for cut glass, many of them for Stuart Crystal, a long-established firm at Stourbridge. Artists employed there included Paul Nash, Eric Ravilious, and Graham Sutherland, all famous as painters, whose patterns were mostly abstract. More

significant was the Czech-born in-house designer, Ludwig Kny (1869–1937), working on shapes designed by Robert Stuart. Keith Murray, more famous for his Wedgwood pottery designs, also produced plain glass shapes and a variety of abstract and figurative patterns for lead crystal for Stevens & Williams. Pressed glass of similar design character, but much cheaper, was produced by Ravenhead of St Helen's. Engraving, the equivalent of hand painting in pottery, was a skilled process and only appropriate for luxury goods.

Robert Goodden (1909–2002), who trained as an architect and also practised as a silversmith, designed pressed table glass for Chance Brothers, Birmingham, in 1934, a range which was re-launched after the war. Chance sold their rights on Orlak heat-resisting glass to Pyrex, part of the American Corning company in 1933, which then became the major brand in this field. Chance were one of the main producers of decorative plate glass for architectural use, and in 1939 produced a short-lived range of *Aqualux* bowls based on the same textures.

1 *Keith Murray was a versatile designer of glass and ceramics. The Cactus vase for Stevens & Williams, c.1934, illustrates a plant that was popular in modern interiors. Ht 22cm/8½in.*
2 *Murray's glass vase for Stevens & Williams, c.1934, shows the abstract side of his design personality, closer to his ceramics. Rather than being cast in a mould, this piece was formed by the glassblower working with molten glass. Ht 19cm/7in.*
3 *The green cut glass vase by Murray for Stevens & Williams, c.1934, uses simple repetitive strokes to develop a more complex effect of tonal contrast. Ht 20.5cm/8in.*
4 *The Stuart Crystal company employed well-known artists to design cut glass in the 1930s. H.R. Pierce, the designer of this vase of 1939, was less famous but showed an effective use of rhythm. Ht 20cm/8in.*

5 *Robert Goodden designed the* Spiderweb *range of pressed glass, with its repetitive ribbed motif, for Chance Brothers in 1934. Bowl diam. 16.5cm/6½in.*

6 *Ravenhead Glass remains a major British producer for the mass market. The* Ripple *pattern, 1938, brought the modern look within the reach of a wide range of the population. Jug ht 28cm/11in.*

European Glass

Bauhaus Glass

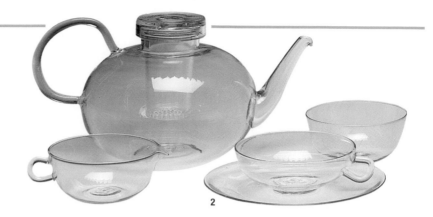

1 *Gerhard Marcks taught at the Bauhaus in the 1920s. His* Sintrax *coffee percolator, c.1925, by Schott & Genossen of Jenna, has no superfluous ornament but creates a formal pattern. Ht 31cm/12in.*
2 *Wilhelm Wagenfeld's pressed glass tea service, 1932, was developed at the Bauhaus and made by Schott & Genossen, using heat-resistant glass. Teapot ht 14.5cm/5¾in.*

3 *Wagenfeld designed his* Kubus *stacking containers, 1939, for direct transfer from refrigerator to table. The set makes good use of the principle of modular co-ordination, which was advocated as a way of rationalizing building production. Ht 21cm/8¼in.*
4 *Wagenfeld,* Heilbroon *plates, c.1937–8. Simple but beautifully calculated shapes in pressed glass. Diam. (largest) 34cm/13⅛in*

Like ceramics, glass does not follow a straight line of development towards Modernism. For similar reasons of tradition and the nature of the material, certain forms, like the tumbler, the stemmed goblet, or the bowl, are almost outside fashion and period. The basic forms of glass are very carefully nuanced, and small variations from the norm achieve a strong impact. Attempts to develop a modern look therefore tend to be eccentric and quickly dated, more representative of the applied decoration of Art Deco than the timeless purity of Modernism. As a result, Modernism in glassware figures less as an innovative movement than as an agent of reform, casting out the superfluous, adapting machinery to produce work of a more elevated standard, and attending closely to the experience of the user.

Glass exemplifies some of the basic principles of Modernism. The imaginative use of transparency in architecture was one defining characteristic. The Bauhaus had some influence in this area, with designs such as Gerhard Marcks's (1889–1981) *Sintrax* coffee percolator, a "Master

of Form" in the early years of the school, and particularly through the pressed glass tea service of 1932 designed by one of the most successful Bauhaus students, Wilhelm Wagenfeld (1900–90), which used the heat-resistant glass developed for laboratory use.

The architect Adolf Loos (1870–1933) helped to lay the foundations of Modernism, with his search for clarity of form, before the career of the Bauhaus founder, Walter Gropius, had even begun. His birthplace in Brno was absorbed after 1920 into the new nation of Czechoslovakia, where there was a strong Bohemian tradition of glass making. The Harrachov glassworks, where the designer Alois Metalák worked from 1928–30, was founded 300 years earlier. If Ladislav Sutnar's table glass represents Loos's idea of Modernism as reform, tradition did not deter other designers from joining in the artistic ferment of Czech Modernism. Ludvika Smrcková (1903–91) created tough architectural forms reminiscent of the architectural style Czech Cubism, and also made an important contribution to glass design after the Second World War.

1 Ladislav Sutnar's table glass service of 1930 was produced by the firm Krásná Jizba (meaning "useful forms"). Forms that follow function in glassware can allow for the classical elegance of these designs. Ht (tallest glass) 13cm/5in.

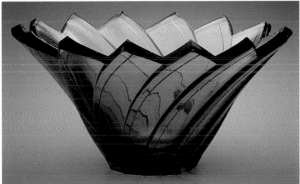

2 Vase, c.1933, by Alois Metelák, of smoked cut glass, has a dramatic form that shows off the beauty of the material under different lights. Ht 16cm/6¼in.

3 The breakfast service by Ludvika Smrcková, for A. Rückl Glassworks, was designed in 1930 but only produced in 1936. The pure geometry is similar to Bauhaus work, but the chunky handles are more expressionist. Ht (tallest cup) 9cm/3½in.

4 The Austrian architect Adolf Loos, born in Brno, in what later became Czechoslovakia, advocated formal simplicity in design in reaction to Art Nouveau. His set of jug and glasses, 1934, beautifully demonstrates his principles. Tallest glass ht 24cm/9½in.

5 The decorative bowl, 1936, by Smrcková for A. Rückl Glassworks, shows the us of a Modernist formal language for decorative effect. Ht 20cm/8in.

Scandinavian Glass: Classicism Meets Modernism

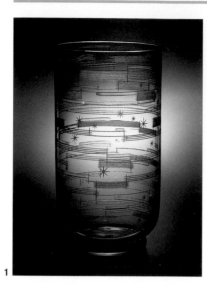

1 *Vase, 1931, designed by Jacob E. Bang for Holmegaards Glasverk, Denmark. The formal language of the engraving consists entirely of straight lines, but the result is lighthearted and elegant. Ht 25cm/9¾in.*

2 *Bowl by Simon Gate, 1930, for Orrefors. Gate was famous for figurative engraved designs in the 1920s but, like many Scandinavian designers, he converted to Modernism in 1930, when this piece was exhibited at the Stockholm Exhibition. Diam. 42cm/16½in.*

3 *Decanter and glass by Sverre Pettersen, 1929, for Hadelands Glassverk, Jevnaker, Norway. The classical elegance of 1920s Nordic design carries through into the Modernist forms. Glass ht 12cm/4¾in.*

4 *Pressed-glass banded jug by Aino Aalto for the Karhula Glassworks, Finland, 1932. The wife of the architect and furniture designer won a competition with this design for mass production. Ht 16.5cm/6½in.*

5 *Savoy vase by Alvar Aalto, 1936. Following his wife's success, Aalto won a design competition at Karhula with this mould-made piece, which bred a family of forms and has been frequently reproduced. Ht 14.5cm/5¾in.*

Glass was one of the fields in which Scandinavian factories and designers excelled in the inter-war years. The tendency in the 1920s was to concentrate on delicate, often historicist, figurative engraving, which was expensive. Engraving continued to be a popular form of decoration, but in 1927 the Norwegian Hadelunds company began to venture into simpler forms with the designer Sverre Pettersen (1884–1958). While the Orrefors company in Sweden had produced good tableware of medium price in the 1920s, they were best known for elaborate exhibition pieces by Edvard Hald (1883–1980) and Simon Gate (1883–1945). The much more formally and technically adventurous bowl by Gate for the 1930 Stockholm Exhibition marks an abrupt departure.

The Modernist tendency was reinforced by the economic and social changes around 1930, demonstrated in the competition for mass-production glass design held by the Finnish factory, Karhula, in 1932, which was won by Aino Aalto (1894–1949) with simple ribbed models that were immediately popular for their strength and elegance.

The ideas of pure form and function associated with Modernism might appear to be entirely alien to the historic glass traditions of Murano in the Venetian lagoon, with their reliance on strong colour, filigree detail, and decorative shape. In fact, Murano designers and makers made a distinctive contribution to the variety and richness of Modernist design. The appearance of Arte Vetraia Muranese in the year of its foundation at the Venice Biennale in 1932, with new designs by Vittorio Zecchin (1878–1947) was a landmark. The Venini firm has a complex history from 1921, involving sculptors and architects among its designers. Tommaso Buzzi (1900–81) was artistic director from 1932–43, and launched his *Laguna* series in which colour was cased under a layer of white or clear glass, with the addition of traces of gold or silver foil. Ercole Barovier (1889–1974), designer for the firm of Barovier & Toso, created in 1936, pushed technical experiment still further in the direction of decorative effects, and can be linked to the 20th century's rediscovery of the purely expressive power of objects.

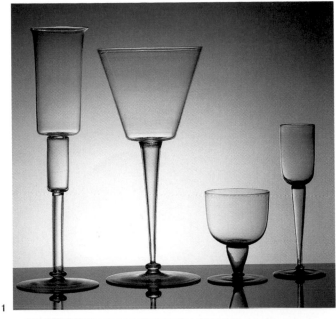

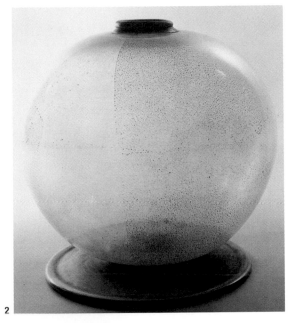

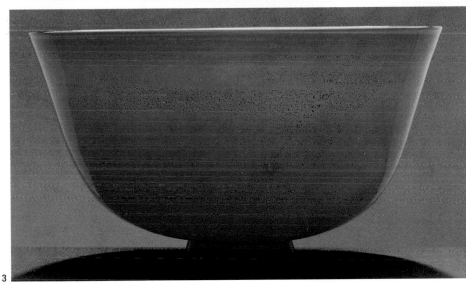

1 *Stemmed glasses by Vittorio Zecchin, 1932, for Arte Vetraia Muranese. Designed by a painter for a design-conscious collaborative of glass blowers on the island of Murano, these pieces with smoked glass and hollow stems combine the attenuation and delicacy of the Murano tradition with modern geometry.*
2 *Zecchin, large vase for Arte Vetraia Muranese, comes closer to transparent sculpture than functional object, with textured glass enclosed in a layer of clear glass.*

3 *Tommaso Buzzi, Laguna cup, 1932, for Venini, was one of a series of shapes available in colours suggestive of the Venetian lagoon. Ht 30.5cm/12in.*
4 *Ercole Barovier, Crepuscolo (twilight) range, 1935–6, for Barovier & Toso, was coloured by burning away iron threads in the molten glass. The forms are bold, with a sense of surrealism about them. Ht 16.5cm/6½in.*

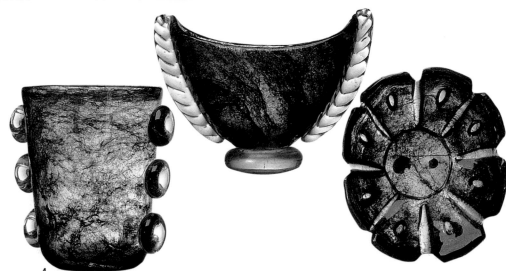

American Glass

Crisis and Recovery

1 Ruba Rombic, *produced by the Consolidated Lamp & Glass Co., Coraopolis, Pennsylvania, c.1928, was described as "something entirely new in modern table glass … so ultra-smart that is as new as tomorrow's newspaper." It soon went out of fashion, but is now avidly collected. Ht 16.5cm/6½in.*
2 *George Sakier's black glass vase, c.1930, a piece that looks good from the side as well as from above, showing the designer's architectural sense. Ht 13cm/5in.*

3 *Group of vases by Sakier, moulded glass produced c.1929 by Fostoria Glass Co., West Virginia. The fluted forms have a classical feel typical of the crossover between Art Deco and Modernism, and appropriate to the manufacturing technique. Ht (tallest) 25.5cm/10in.*

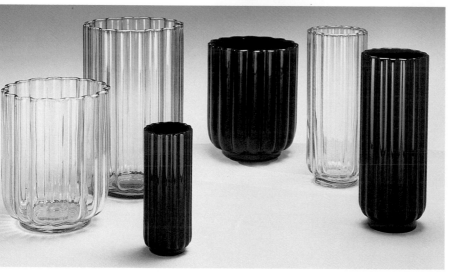

In the *Machine Art* show at the Museum of Modern Art in 1934, there were many examples of glass, but the majority were anonymous designs for laboratory glass from large firms like the Corning Glass Works, which could be adapted for use in the home. Such unconscious Modernism was often considered superior even to the best efforts of designers. Pieces in the show by Walter Dorwin Teague, for the Steuben Division of Corning, employed a similar minimal aesthetic, while others from the Owens Illinois Glass Co. were presented anonymously.

Machine Art was a deliberately extreme statement of a position, but it indicated the pressures on American Glass manufacture during the Depression. Many companies went bankrupt around 1931 but one of the few hopeful signs was the demand for re-equipping restaurants and bars when Prohibition was lifted in 1933, stimulating production of cheap wares. Design and technology offered a hope of revival. Steuben, which was nearly closed down in 1933, set up a Fifth Avenue shop in the following year, where thick-walled glass of great purity,

thanks to the discovery of a new lead-crystal formula by the technicians at Corning, was engraved with figurative designs for which the company became famous, under the direction of John Monteith Gates. By 1938, Steuben had an in-house design team, and also made table glass in plain more-or-less Georgian shapes. In 1939, Steuben launched *Twenty-Seven Artists in Crystal*, a set of applied engraved designs by Henri Matisse, Fernand Léger, Salvador Dalí, Georgia O'Keeffe, and other artists.

Steuben dominated the decorative market. Following bankruptcy in 1931, the Imperial Glass Co., Ohio, turned exclusively to everyday tableware, launching its long-running *Cape Cod* and *Candlewick* ranges, names suggestive of American values. In 1933, the Libbey Glass Co. in Massachusetts tried to compete in the luxury market, with its fascinating and original designs by A. Douglas Nash, but the effort was mistimed and led to a takeover. The Libbey name reappeared at the 1939 World's Fair with the rather mannered *Embassy* drinking glasses designed by Walter Dorwin Teague and Edwin Fuerst.

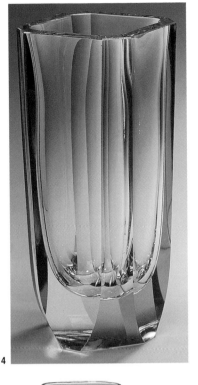

4 *Walter Dorwin Teague, tumbler from the* St Tropez *place setting. Ht 7.5cm/3in.*

5 *Russel Wright,* Tantalus, *a reworking of a traditional device for keeping spirits locked up in the home, transformed by Wright into an elegant geometric construction. Ht 29cm/11¼in.*

6 *Wright, white glass cup and spun-aluminium holder, 1929–35. Everyday practicality operates in Wright's combination of opaque glass and metal holder, with its appealing doughnut-style handle. Holder ht 4.5cm/1¾in.*

7 *Cordial glass from the* Embassy *range by Teague and Edwin Fuerst for Libbey Glass Co., Ohio. This rather conservative pattern was made for the New York World's Fair in 1939. Ht 22cm/8¾in.*

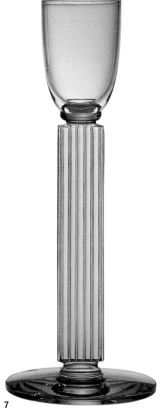

8 Knickerbocker *decanter, bowl, and set of cordial glasses, c.1939, by Fuerst for Libbey Glass Co. With their heavy mannered bases, these are only halfway to modern, belonging to a world of taste swept away after the Second World War. Decanter ht 28.5cm/11¼in.*

Silver and Metalwork

Early Innovations

1 *Marianne Brandt, tea infuser and strainer, 1924, brass, ebony, and silver. Made at the Bauhaus workshop by one of the school's most famous students, it is a study of pure geometric forms. Ht 7cm/2¾in.*

2 *Fritz August Breuhaus de Groot, centrepiece bowl, c.1930, chrome with ebonized wooden feet, WMF, Geislingen, Germany. A design by an architect famous for his ship interiors. Diam. 35.5cm/14in.*

3 *Louis W. Rice, teapot, c.1927, silver-plated copper and brass, from Bernard Rice & Sons' Apollo Skyscraper set, a decorative treatment of the theme that Americans equated with Modernism. Ht 16.5cm/6½in.*

4 *W. Rösseger and F. Marby, jug, 1923–4, silver (left); Wilhelm Wagenfeld, coffee pot, 1923–4, silver (right). These Bauhaus pieces show the craft influence of the school's early years.*

5 *Valéry Bizouard, tea and coffee service, 1931, silver with ivory handles, for Tétard Frères, Paris. This shows the adaptation of modern design forms for the French luxury trades.*

"Gold and silver are foreign to modern conditions, and while a few good designers work in them the majority prefer to work in metals which have a wider use," wrote the British design critic Anthony Bertram in 1938. Even so, silver's unique quality of reflected light and colour contributed to the aesthetics of the table in the inter-war years when, despite many social changes, dining was still a formal occasion and its accoutrements important status symbols.

Though the majority of the silver trade tends at all times to concern itself with the reproduction of earlier design styles, the existence of a body of skilled silversmiths has always been an invitation to designers both inside and outside the trade. While designers of the Art Nouveau and Arts and Crafts Movements enjoyed the ductility of silver when making attenuated shapes, the geometric forms typical of Modernism were less obviously adapted to the working methods of the silversmith, even though the simple shapes of modern design looked especially appropriate when rendered in silver or similar polished metals. The Danish silversmith Georg Jensen, working with the painter Johan Rohde as a designer, was employing a work force of about 250 in 1930, in a successful enterprise that moved slowly in the path of the avant-garde. More radical were the faceted forms for coffee pots by the Swedish designer Wiwen Nilsson (1897–1974). Elegant simple flatware was made in Germany by Andreas Moritz and Emil Lettré, which can be compared to the angular and eccentric designs by the American Russel Wright, manufactured by his own company in 1933.

The metal workshops of the Bauhaus and other German art schools produced a radically new look, less concerned with pure function than with the application of pure form, notably in designs by Wilhelm Wagenfeld, which match his designs in glass. British silver was only at the beginning of a long process of design reform that came to fruition in the post-war period, although against the dominance of re-interpreted classicism, there were occasional pieces of great formal purity, like the experimental silver and enamel ware by Jane Barnard of 1939.

1 *Harold Stabler, tea service, 1936, silver. The compact square forms mark a break in tradition, justified by the efficiency of packing them onto a tea tray. Tray l. 32cm/12½in.*
2 *Jane Barnard, bowl, 1939, silver and enamel, for Edward Barnard & Sons. It was rare to find such simplicity in British silver before the war. Diam 26.5cm/10½in.*

3 *Anna Zinkeisen, necklace, 1935, made by Catherine Cockerell and R.L. Simmonds. Zinkeisen was a painter, and this piece was specially made for exhibition, in the form of a neck ruff, with a matching bracelet. Diam 13cm/5in.*
4 *Four-piece stainless steel flatware designed and manufactured by Russel Wright, c.1950–8, illustrating the angular eccentricity of Wright's work in comparison with contemporary flatware designs. Knife l. 22cm/8½in.*

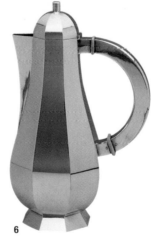

5 *Peter Müller-Munk, Normandie pitcher, c.1935–7, chromium-plated brass. This pitcher by the German-born but New York-based designer was named after the famous French liner, and is expressive of a ship's prow. Ht 30.5cm/12in.*
6 *Wiwen Nilsson, silver coffee pot, 1930. The pot, part of a coffee service, was made in Sweden and gives a modern twist to traditional forms. Ht 21cm/8¼in.*
7 *Emmy Roth, dressing-table set, c.1930, metal alloy, glass, and red bristle. The bright bristle adds effect to the Bauhaus forms of this German piece, although the brushes look difficult to grip. Tray w. 33cm/13in.*

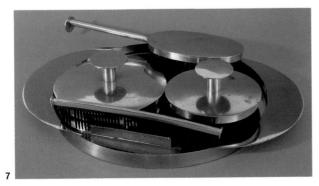

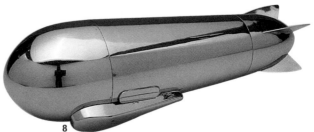

8 *Dirigible cocktail shaker, c.1930, nickel over brass. Design critics were suspicious of forms borrowed from one object, especially if they were streamlined. Ht (upright) 30.5cm/12in.*

MODERNISM | SILVER AND METALWORK

411

Textiles

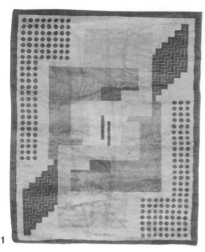

1 *Ivan Da Silva Bruhns, carpet. The French designer was important in developing the influential style of geometric rug for modern rooms in the 1920s.*

2 *Edward McKnight Kauffer, rug, 1929, made by Axminster Carpets. Designed by one of the best-known graphic artists of the inter-war years, this rug is more brightly coloured than most contemporary examples.*

3 *Serge Chermayeff, rug, c.1930, Royal Wilton Carpet Factory. Chermayeff included rugs in his early interiors in Britain, often using segments of circles as here, influenced by the paintings and textiles of Robert and Sonia Delaunay in Paris.*

Rooms in modern houses in the 1920s and 1930s tended to be austere, in line with the emphasis on health and purity. One concession to comfort was the use of floor rugs, which were placed on the permanent hardwood or linoleum surfaces. They could be taken up and cleaned by beating out of doors. Following a style established in France in the 1920s, these rugs usually had a non-repeating design on a large scale, more or less abstract, using no more than three or four colours. Designers often sought to provide a focus for the room in the rug, which would form part of a co-ordinated colour scheme. It is possible that such unusual attention was given to the floor because women's fashions had for the first time revealed the lower leg, so that a rug formed a visual background for displaying shoes and ankles.

Rugs were thus in many ways the pivotal point of a room, and were duly given prominence in interiors magazines. The designers of rugs, such as Eric Bagge, Djo Bourgeois, and Ivan Da Silva Bruhns in France, and their followers in Britain such as the famous poster designer

Edward McKnight Kauffer, his partner Marion Dorn (both American by birth), Marian Pepler, and Ronald Grierson, all became well-known names, and Dorn was even described as the "Architect of Floors." Her work was found not only in private houses, but in hotels, such as the Ballroom Suite at Claridge's Hotel, London, 1930. The designs were usually produced in cut pile, and made up by a number of different factories, including the Royal Wilton Carpet Factory, in Britain, while others were made in China for the designer and entrepreneur, Betty Joel.

The textile production of the Bauhaus between 1919 and 1932 concentrated on rugs and hangings, although for slightly different reasons. Hand weaving was considered the best hands-on introduction to textile design, because it dealt so directly with materials and techniques, and the results were usually too heavy for use as curtains or upholstery. The patterns, by Gunta Stölzl, Anni Albers, and others, were geometric but lively, and were exemplary demonstrations of the transfer of ideas from pure art to applied art.

4 *Marian Pepler, kilim, c.1932, Alexander Morton &*
Son. First made for the home of her brother-in-law,
the furniture maker Gordon Russell, this design by
Pepler was marketed through his company.

5 *Marian Pepler,* Plough, *c.1933, Royal*
Wilton Carpet Factory. This subtle but
satisfying design evokes the plough moving
over a field, leaving rich brown furrows.
6 *Ronald Grierson, carpet, 1935, woollen pile*
on cotton warp. This collage-like design of
overlaid shapes was made in India.
7 *Marion Dorn, rug. Royal Wilton Carpet*
Factory. Dorn, who like her partner Edward
McKnight Kauffer was American, became the
best-known rug designer of the 1930s. She
produced abstract and figurative patterns.
8 *Gunta Stölzl was the head of the weaving*
workshop at the Bauhaus. This hand-
knotted carpet, designed in the 1920s, was
first produced in 2000 by the London carpet
gallery, Christopher Farr.

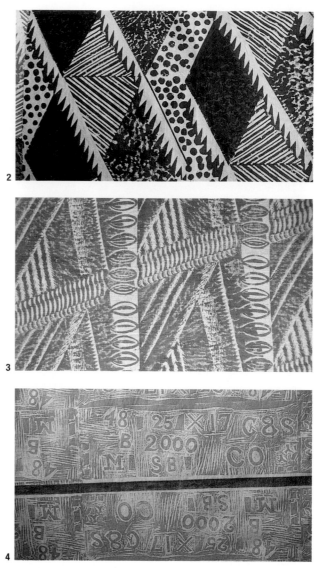

1 *Sergei Burylin,* Tractors, *late 1920s, printed cotton, Ivanovo, Russia. A striking pattern supporting mechanized farming.*
2 *Phyllis Barron and Dorothy Larcher,* Diamond, *c.1925, cotton hand-blocked in galled iron. Barron and Larcher re-discovered traditional printing dyes and applied them to abstract modern design.*
3 *Enid Marx,* Underground, *1933, cotton hand-blocked in iron rust. Marx learnt printing techniques from Barron and Larcher and developed more complex repeating patterns.*
4 *Ben Nicholson,* Numbers, *1933, cotton hand-block printed by Nancy Nicholson. The fact that his sister printed textiles for a living encouraged the abstract artist Nicholson in the same direction. And he designed for hand printing, textured weaving, and silk screen printing.*

The flat patterning of avant-garde art from Cubism onwards was well adapted for transfer into textile design. In breaking the naturalistic conventions established in the Renaissance, the art movements of the early 20th century established a new connection to the purely decorative traditions of the past, which included the study of repetitive patterns of the kind that are best suited for the production of textile lengths, whether by printing or by creating the design in the weaving process, with its possibilities of patterning in texture as well as in colour. Modern interior design was, by contrast, generally inimical to exuberant displays of pattern, so that some of the most interesting Modernist furnishing textiles exist at the chronological margins, either in the 1920s, when they are often legitimately classified as Art Deco, or in the later 1930s, when they anticipate the great 1950s revival of pattern design, in which contemporary art movements were allowed to provide a broader inspiration.

Designers in the new Soviet Union expressed their vision of a new society through abstraction and also through stylized representations of tractors and other symbols of modernity, creating designs of great vivacity and charm, in contrast to the physical privations of the time.

The leading British textile mills were open to new pattern ideas, although these were nearly always combined in a range with more traditional designs. A few firms specialized in modern design, such as Donald Brothers and Old Bleach Linen, with textural weaves and printed patterns. Edinburgh Weavers was known for commissioning leading artists like Barbara Hepworth and Ben Nicholson to design textiles. Allan Walton, himself a painter, used the relatively new technique of silk-screen printing with large-scale decorative patterns, including designs by the Bloomsbury artists Vanessa Bell and Duncan Grant. In America, the block prints of Ruth Reeves were enjoyable on a pictorial level. For upholstering modern furniture, leather cloth was popular, as well as hand-woven upholstery tweeds by designer-makers including Boris Kroll, Dorothy Liebes, and Dan Cooper.

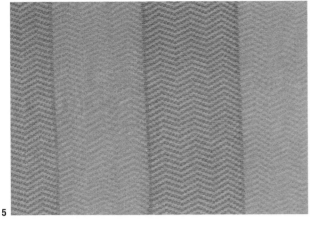

5

6

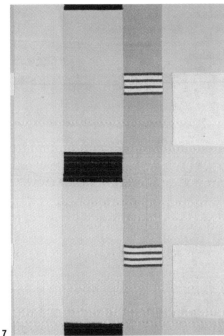

7

8

9

5 *Hajo Rose, textile, 1932, cotton crêpe. An example of a commercial design by a Bauhaus student, using varieties of weave in two colours of yarn.*

6 *Rita Beales, stole, c.1937, hand-spun linen. Craftswomen such as Rita Beales revived old skills like spinning linen and applied them to making simple designs which showed off the natural texture and colour of the material. Her return to the basic materials and construction of textiles, along with other studio textile designers like Ethel Mairet, later contributed to improving standards in industry.*

7 *Barbara Hepworth, Pillar, 1937, printed cotton, Edinburgh Weavers Ltd. Hepworth was becoming known as a sculptor in the 1930s, but also believed in the contribution artists could make to the domestic environment.*

8 *Marian Mahler, Tree Tops, 1939, screen-printed rayon. A portent of the post-war revival of pattern and decoration, Mahler's fabric portrays simple natural forms like enlargements under a microscope.*

9 *Ruth Reeves, Manhattan, 1930, hand block-printed, W. & J. Sloane, New York. A decorative evocation of industry, speed, and skyscrapers by a painter who trained with Fernand Léger in Paris.*

Industrial Design

Electric Appliances

1 *John Vassos, RCA Victor special portable phonograph, c.1935, aluminium and various metals, RCA, New York. Modern industrial design at its most seductive. Ht (closed) 20.5cm/8in.*
2 *Radio, Philco People's Set, Model 444, c.1936, moulded Bakelite cabinet designed to be mass produced. Ht 41cm/16in.*

2

3

4

3 *Walter Dorwin Teague, Sparton Bluebird radio, 1933, cobalt blue mirror, wood, and chromium steel, Sparton Corporation, Michigan. Circular forms of radio worked well with a rotating tuning dial. This is the most spectacular. Ht 23cm/9in.*
4 *Kem Weber, desk clock, c.1933, brass and copper, for Lawson Time Inc. Ht 9cm/3½in.*

Electrical goods were often designed by manufacturers without employing professional designers, although a successful product, having established its identity, would probably be re-styled at intervals as awareness of industrial design developed. This was especially the case in America, where much of the effort of the 1930s generation of industrial designers was directed towards electrical goods.

Many products still followed the familiar shapes of their non-electric predecessors. Hoover's 1916 vacuum cleaners, for example, imitated the broom and the carpet sweeper, with a motor on the end of a long handle. This long remained a dominant form, although the Swedish Electrolux company produced a cylinder type with a long hose and separate attachments in 1915, of the type that gradually replaced the upright models after the war. Electric irons retained the form of old flatirons in their base. On top, designers moulded the shape of the handle to the human hand, and newly developed plastics were valuable as materials for insulating the hand from heat,

with a safe entry point for the flex and some kind of calibrating dial. These elements have remained relatively constant into the present, although the iron as a whole has become lighter in weight. Hand-held electric hairdryers were first introduced in 1925, replacing curling tongs. Their design became gradually more sophisticated, with Bakelite replacing metal casings.

Radios were a completely new type of object which became increasingly commonplace. Their valve mechanisms were heavy, and the prestige of the radio required a stately housing, although in the best designs this could be presented with wit.

The architect-designers Wells Coates and Serge Chermayeff worked for the Ekco Company in Britain. The *Nocturne* radio by Walter Dorwin Teague of 1936 was a large circle, intended for use in public spaces, and dramatized with its blue mirrored glass. The virtues of portability and compactness began to enter radio design in the later 1930s, with Teague's neat but showy *Sparton* radio of 1936.

5

6

7

8

9

10

11

5 *Jean Puiforcat, silvered metal and marble clock. A luxury item using the stark geometric forms of more utilitarian contemporary objects. Ht 30cm/11¾in.*
6 *Gilbert Rohde, Z clock, c.1933, chromium plated metal and etched glass, Herman Miller Clock Co. A lightweight approach to time. Ht 28.5cm/11¼in.*
7 *Baird television receiver, 1936, Britain. Television was first demonstrated in 1926, but only became broadcast ten years later. Ht 1.07m/3ft 6in.*
8 *Post Office telephone, 1938, Britain. Based on moulded plastic case designs developed in Scandinavia, this example, which was supplied as a standard rental handset from 1937 to the 1960s, includes a drawer in the base for holding notes of telephone numbers. Ht 14.5cm/5¾in.*

9 *Raymond Loewy, pencil sharpener, 1933. One of America's star industrial designers streamlined the pencil sharpener to bring joy into drudgery. Ht 14cm/5½in.*
10 *Christian Barman, electric fan heater, 1938, chrome and steel, HMV Co., Middlesex, Britain. Diam. 29cm/1½ft.*
11 *Malcolm S. Park, vacuum cleaner, 1938, aluminium with cloth bag, Singer Manufacturing Co., New Jersey. A highly expressive version of the standard upright vacuum, with a headlight to search out dust. Ht 1.09m/3ft 7in.*

Lighting

Lighting Pieces

2 *Marianne Brandt and Hin Bredendieck, desk lamp, 1929, Kandem Co. This was one of the most widely produced designs to come out of the Bauhaus. Ht 48cm/19in.*

1 *Gerrit Rietveld, hanging light for the Schroeder House in Utrecht, c.1923. A simple but revolutionary use of the most elementary parts of a light fitting, arranged to make a pattern in space. Ht 1.4m/4ft 7in.*

3 *Karl J. Jucker and Wilhelm Wagenfeld, glass table lamp, 1923–4. One of the most celebrated examples of Modernist industrial design, created by students at the Bauhaus. Ht 36cm/14in.*

Electric light was well established as part of domestic life before the First World War, but light fittings tended to reproduce historical features or imitate other objects. Modernism never succeeded in driving out such designs, but lighting offered opportunities to designers and architects.

Perhaps the most radical of the designs shown here is also the earliest. Gerrit Rietveld's hanging light makes a geometric play with tubular lights, without any kind of shade. The other examples mostly involve a light bulb, a shade, a stem, and a base, although in some cases these parts are elided into one another. George Carwadine's *Anglepoise* is an example of an engineer's solution to a practical problem, with little thought about styling, although it achieves a considerable aesthetic effect through its direct expression of the mechanism that enables the light to be positioned. It was created for the British company Herbert Terry of Redditch, but the patents were later acquired by a Danish manufacturer, Jacob Jacobsen, and the shade and square base simplified.

The *Bestlite* was designed by R.D. Best, a British manufacturer and, like the *Anglepoise*, has enjoyed a long life as a product. The visual form was carefully considered, and it was available in various colours and as a standard lamp or wall-mounted bracket lamp. Marianne Brandt and Hin Bredendieck's 1929 desk lamp has the innovative feature of a push-button switch in the base, whose off-centre design allows the flexible arm of the lamp to achieve a wide variety of positions. Other table lamps, like those by Karl Jucker, Wilhelm Wagenfeld, Poul Henningsen, and Gio Ponti, have translucent shades to spread light around a room. Wagenfeld made poetic use of the clear glass of his stem and base, while producing an almost classical effect of balance. Henningsen was a Danish architect who designed lighting from 1927 onwards, culminating in his famous *Artichoke* hanging lamp of 1958 based, like nearly all of his designs, on concentric rings. The Italian architect Ponti's designs are seldom considered as pure Modernism, and his *Bilia* lamp has the playful character found in his many other designs.

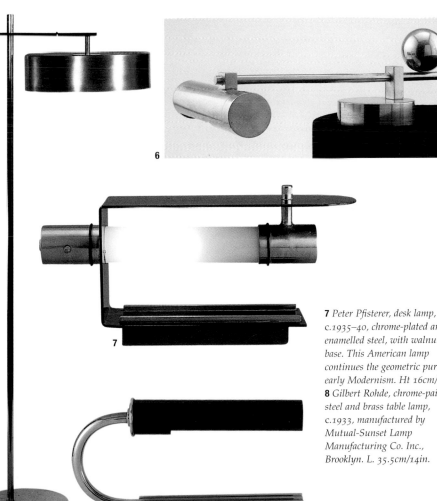

1 *R.D. Best,* **Bestlite** *desk lamp, c.1930. This articulated lamp, which was produced in standard and wall-fixing forms, was popular in Britain in the 1930s and has remained in production ever since. Ht 45cm/17¾in.*

2 *George Carwadine,* Anglepoise *lamp, c.1934. The spring counterbalance has made this one of the most enduring bases for lamp design in later years. Ht 50cm/19¼in.*

3 *Table lamp by Poul Henningsen and manufactured by Louis Poulsen. Tiered opalescent glass shades are supported with a patinated brass shaft. Ht 43cm/17in.*
4 *Gio Ponti,* Bilia *lamp, 1931, Fontana Arte, Milan. A humorous take on Bauhaus geometry by one of Italy's greatest and most versatile designers. Ht 43cm/17in.*

5 *Kurt Versen, adjustable floor lamp, c.1930, copper-plated metal, Lightolier. This elegant American lamp can be turned to shine up or down. Ht 1.52m/5ft.*
6 *J.J.P. Oud, piano lamp, 1928, nickel-plated brass. A beautiful example of pure geometry by a leading Dutch architect. W. 30cm/11in.*

7 *Peter Pfisterer, desk lamp, c.1935–40, chrome-plated and enamelled steel, with walnut base. This American lamp continues the geometric purity of early Modernism. Ht 16cm/6¼in.*
8 *Gilbert Rohde, chrome-painted steel and brass table lamp, c.1933, manufactured by Mutual-Sunset Lamp Manufacturing Co. Inc., Brooklyn. L. 35.5cm/14in.*

Contemporary

c.1945–60

The 1940s and 1950s were a period of transition between the austerity of the Second World War and its aftermath of rationing and shortages, and the youthful, exuberant design revolution of the 1960s. Impelled by the Modernist principles of functionalism, the Contemporary aesthetic was defined by new materials and the deveopment of technologies to use them effectively, as well as a spirit of optimism and confidence. It was a vigorous period in design, with bold shapes, bright colours, and practical solutions to the needs of daily life.

With the sweeping gesture of a new collection Christian Dior altered the face of fashion design and simultaneously gave a new name to the overall aesthetic that captured the post-war imagination. Dior's New Look collection took the world by storm. His curvaceous creations were the antithesis of wartime dress design. The new hourglass figure, created with skin-tight tailoring and well-placed padding, was a striking and extravagant change from the austere, unflattering square-shouldered jackets available during the war. However, Dior's sculptural fantasies required swathes of expensive textiles. With severe shortages of raw materials in most countries and rationing still in place in Britain, there was an international outcry over his new designs, but despite the critics' reservations, the New Look heralded a fresh start after the austerity of a harsh world war.

Dior's 1947 collection represented a turning point for international design. There was an aesthetic shift that influenced everything from the clothes women wore to the dishes they placed on the table. Designers worked with a rejuvenated spirit after the war and their designs represented everything that was new and optimistic. Materials and technologies that grew out of the war effort influenced contemporary design. Plastics and metals, laminated woods, and synthetics all impacted on the appearance of everyday objects. Foam rubber and stretch fabrics for upholstery allowed for the curving forms that characterized so many organic shapes. Cast-aluminium frames and steel rod for furniture pushed the boundaries of construction and form, with its combined strength and malleability.

The post-war American economy and the resulting consumer boom created expanded markets for new products. American manufacturers also had the wealth to re-invest in quality design. The Italians called the immediate post-war period *ricostruzione*, for the regeneration and revitalization of design that transpired there. In Sweden, Denmark and Finland the Scandinavian Modern aesthetic that marked so much of later 20th-century design took shape. The applied arts

Left: Atom *clock in painted wood and aluminium by George Nelson for Howard Miller, 1949. Wires and bobble terminals are typical features of the 1950s, and reflect the Contemporary preoccupation with science and the incipient Space Age. Diam. 33cm/13in.*

Opposite: Christian Dior, New Look range, 1947. The new fashion range from Dior signalled a sea change in post-war attitudes towards style. Dior promoted an optimistic viewpoint that was the antithesis of post-war austerity.

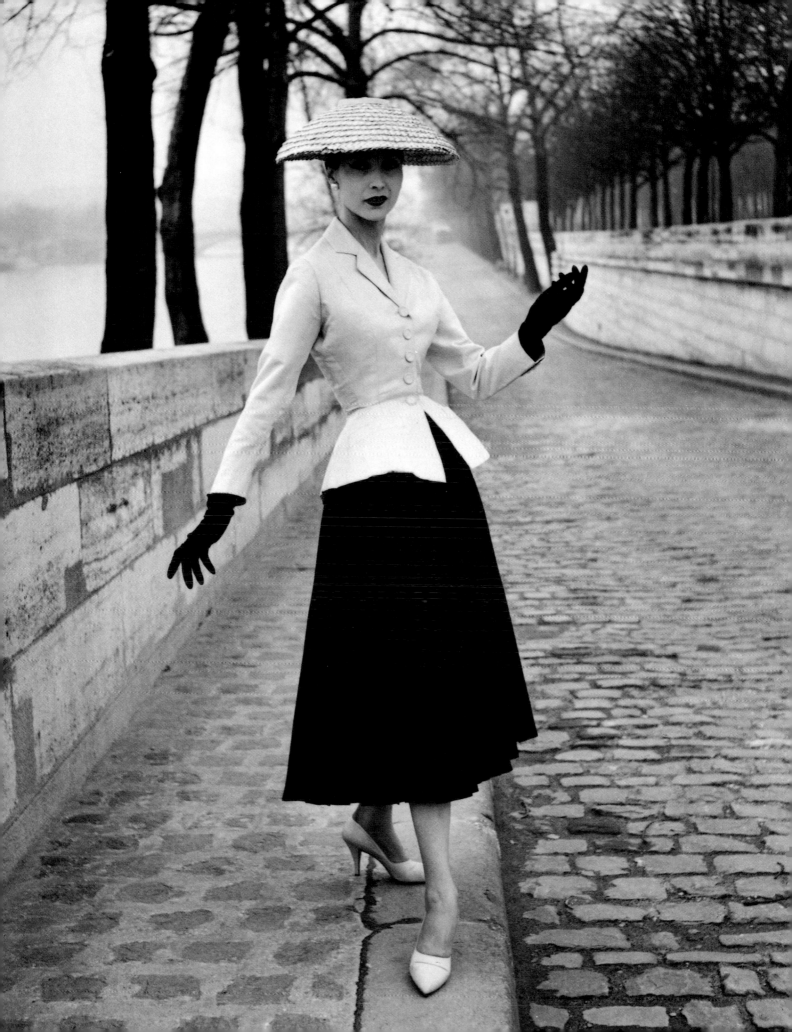

1 *The sensuous, organic curves of post-war Scandinavian design are exemplified in Tapio Wirkkala's* Kantarelli *vase, 1947, which was based on the form of the chanterelle mushroom. Ht 9cm/3½in.*

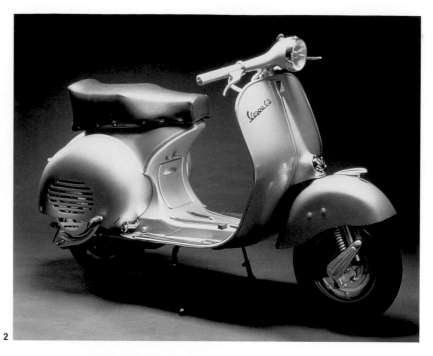

3 *Tapio Wirkkala was also famous for his laminated leaf-shaped dishes, which were produced in many shapes and sizes. W. (of example shown) 19cm/7½in.*

2 *The Vespa was pivotal in the Italian scooter culture of the 1950s. For the first time marketing and advertising strategies were devised to directly target the scooter at a female audience.*

4 Artichoke *hanging lamp by the Danish architect Poul Henningsen, designed in 1958 for Louis Poulsen. Over a metre in diameter, the lamp was a majestic piece of design, a Contemporary chandelier. Diam. 60cm/23½in.*

were also profoundly influenced by abstract art and sculpture. Nowhere was this relationship more thoroughly represented than in America, where a new cultural identity and hegemony surpassed any of its earlier artistic achievements.

In America during the 1950s there was a sense of invincibility and optimism and this was reflected in the way that people lived and arranged their homes. Consuming middle-class Americans emerged after the war, as if from a chrysalis, and this in turn supported the robust economy there. Technology and the cheapness of mass production meant that even urban living could be clean and orderly. New appliances for the kitchen and household cleaning transformed a woman's role in the home and altered the relationship between the sexes in a domestic context. Automotive technology following the war meant that cars were affordable for greater numbers of people. It was the beginning of jetliner travel and this blurred international boundaries, with the result that influences between countries occurred more seamlessly. Design was the catalyst for a whole new mode of living and international designers took their role in shaping the future very seriously.

At the heart of the Contemporary movement was the concept that function should be transparent in design, and that the intended purpose of an object and its design should be inextricably linked. This overriding theory was carried across mass-produced appliances as well as objects of limited production. The concept was essentially a continuation of Modernism begun before the war and originating in the ethos of the Bauhuas in Europe. The displacement of architects and designers before and during the war meant that design ideas and solutions stemming from Modernism became far more international and widespread.

Not only did enlightened manufacturing firms effect and encourage good design, but the international exhibitions helped to foster distinctive and dynamic ideas. In Britain, the Britain Can Make It exhibition in 1946 and the Festival of Britain in 1951 jump-started a severely depressed market for well-designed consumer goods after the war. The Milan Triennale was a litmus for new design. Many icons of the 1940s and 50s were first exhibited there. The programme of exhibitions and competitions at the Museum of Modern Art in New York, most notably Organic Design in Home Furnishing,

sparked a new aesthetic: Organic Modernism that simply picked up where Modernism left off before the war. The trend-setters for devising these new organic shapes in furniture and architecture were Charles Eames and Eero Saarinen. Organic biomorphic design was a dominant influence during the Contemporary period.

The organic post-war aesthetic of Scandinavia was best expressed in Tapio Wirkkala's *Kantarelli* vases for Iittala of 1946, based on the form of chanterelle mushrooms. These and other designs by Wirkkala captured the abstract essence of nature itself. Wirkkala was also championed for his laminated leaf-shaped bowls, and furniture that expressed a sublime natural beauty in shape and material. The sensuous curves and dramatic outlines of organic design, whether expressed in Scandinavian Contemporary forms, the more flamboyant pieces of the Italians, or the bold assertions by American designers, all influenced a generation of consumers who lived with and appreciated design in the post-war years.

Contemporary sculpture influenced the shapes produced by designers of furnishings. Artists like Jean Arp, Constantin Brancusi, Henry Moore, and Barbara Hepworth created sculpture in sublime curving sensuous forms. These were studied and often inspired 1950s designers who used the new technologies such as bending and laminating wood, manipulating metals into strong, curving forms and blowing glass into monolithic sweeping shapes. Designers favoured plain surfaces of natural wood, stainless steel, marble, leather and wool. Decorative ornamentation on furniture was almost non-existent as almost any pattern or texture was inherent in the material. Abstract painting and sculpture influenced

the design of all kinds of furnishings. The flowing shapes of ceramics and glass were often dictated by the new organic focus in sculpture, while the surfaces of ceramic wares, textiles, and wallpapers were patterned with abstract shapes or vibrant blocks of colour.

The period when Christian Dior's New Look took shape coincided with the time when a new generation of outstanding designers rose to prominence. Ceramics, glass, metals, textiles, and furniture were all influenced, and some designers worked across different media. Many came from architectural backgrounds while others were industrial designers first and foremost. But it was not unusual for one designer to be responsible for the look of a novel television and then create a design for one of Europe's most prominent porcelain manufacturers. Raymond Loewy was an exceptional polymath, excelling as a graphic artist as well as a designer of cars, light-fittings, radios, porcelain, textiles, and furniture.

The 1940s and 50s were extraordinary decades for design in the applied arts. Ground-breaking objects of this era were of course followed by dull imitations that biased an entire generation against the interior design of that period. There were uninspired, uncomfortable flat-slab sofas, the amoeba-shaped coffee tables, the boomerang, and the kidney shapes in abundance. All of this mediocrity has proven the lasting legacy of Contemporary design but has sometimes obscured what made this period truly inspiring.

5 *Developing post-war technology allowed the aerodynamic forms and lightweight monocoque aluminium structure of the Airstream trailer, which was light enough to be pulled along by the French road racer, Latourneau, in 1947.*

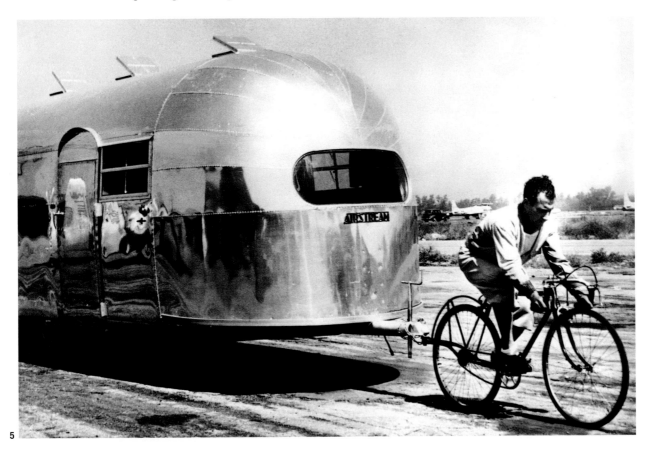

5

British Furniture

Chair Designs

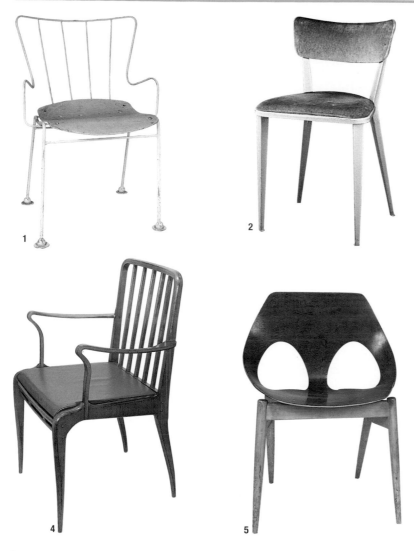

1 *Ernest Race's enamelled steel rod* Antelope *chair, first introduced at the 1951 Festival of Britain, was noted for its spidery frame and ball feet. The chair was also made with a moulded plastic seat, similar to the design of Charles Eames' moulded plywood chair already in production. Ht 79cm/31in.*

2 *Race had been experimenting with metal-framed furniture since 1945, as seen in his cast aluminium alloy range of BA chairs. The aluminium elements were produced by pressure die-casting, a technique developed during the war for bomb casings. Ht 73cm/28¾in.*

3 *Robin Day's* Hillestak *chair of 1959 was made of one continuous piece of pre-formed curved plywood. Ht 90cm/35½in.*

4 *Basil Spence's* Allegro *chair designed for Morris of Glasgow who changed the face of laminated plywood in Britain with their experiments in aeroplane plywood technology during the war. Ht 95cm/37½in.*

5 *The firm Kandya employed the Danish designer Carl Jacobs to design this ingenious beech plywood stacking chair whereby the seat curved round on itself to form the back. Ht 76cm/30in.*

In comparison with its European neighbours and American allies, Britain was not regarded as a hothouse of design after the war. Nonetheless, it did generate work of originality and enduring quality. Furniture designers such as the husband-and-wife team Robin and Lucienne Day and Ernest Race developed British design even with limited resources and the contracted post-war market.

The Britain Can Make It exhibition of 1946 and the Festival of Britain of 1951 promoted British art, design and industry and aspired to raise the nation's spirits after the devastation and austerity of the war. Certain pieces of British furniture from this period, objects that are today period icons, hark back to the design aesthetic of these two exhibitions. Designers of furniture contributed to post-war reconstruction by transforming the appearance of everyday life. They adhered to the Modernist philosophy that well-designed pieces sold at affordable prices would improve the quality of life of the nation. Firms like Parker-Knoll, Hille, Lebus, Kandya, and G-Plan produced cheerful, functional furniture which drew on recent developments in America, Scandinavia, and Italy as well as more traditional influences.

Laminated furniture that employed aeroplane plywood technology as well as innovative designs using the surplus steel and aluminium available after the war tapped into existing British resources, while newly developed synthetic materials such as plastics, fibreglass, and PVC gave unprecedented opportunities for moulded sculptural shapes, bright colour, and bold pattern in furnishings. Rubber was also exploited. As webbing it was used as a flexible support material for seating, while foam rubber increasingly replaced upholstery of springs and horsehair. Besides these new materials, plate glass, along with teak, rosewood, and other tropical timbers were favoured. Case furniture tended to emphasize the horizontal, while chairs were square and squat in their proportions; legs were typically splayed. Coffee tables of irregular boomerang, cloud, or palette shapes were popular, and the three-piece suite of sofa and armchairs became the prestige item of the 1950s home.

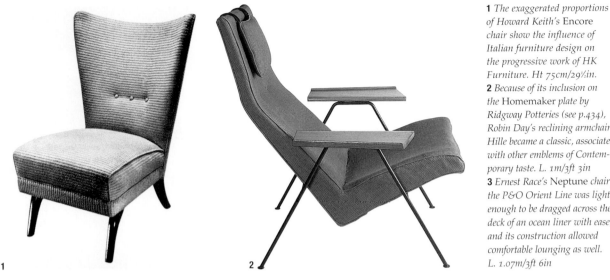

1 *The exaggerated proportions of Howard Keith's* Encore *chair show the influence of Italian furniture design on the progressive work of HK Furniture. Ht 75cm/29½in.*
2 *Because of its inclusion on the* Homemaker *plate by Ridgway Potteries (see p.434), Robin Day's reclining armchair for Hille became a classic, associated with other emblems of Contemporary taste. L. 1m/3ft 3in*
3 *Ernest Race's* Neptune *chair for the P&O Orient Line was light enough to be dragged across the deck of an ocean liner with ease, and its construction allowed comfortable lounging as well. L. 1.07m/3ft 6in*

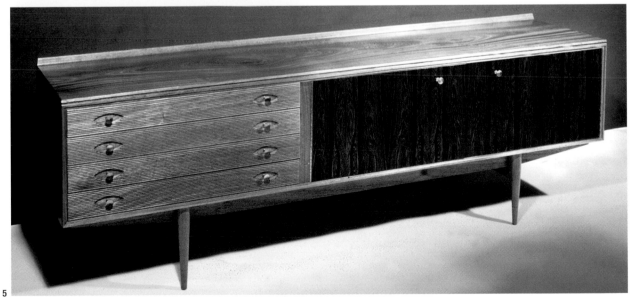

4 *Morris of Glasgow set the trend for British furniture in organic shapes with their cloud-shaped occasional table designed by Neil Morris. W. 99cm/39in.*

5 *Robert Heritage designed a low-slung sideboard for Evans furniture. The horizontal form balanced on short tapered legs was typically Contemporary. Ht 76cm/30in, w.2.29m/7ft 6in.*

American Furniture

Chairs

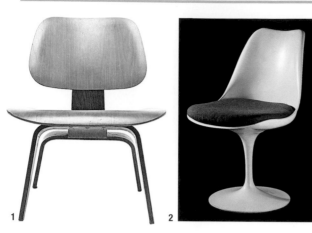

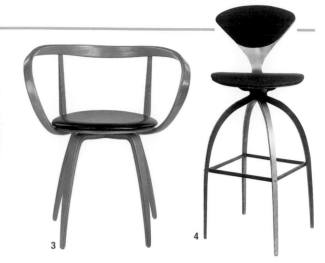

1 *Charles Eames' LCW chair, 1945, was one of his first attempts to mould plywood into complex curves and also to utilize cycle-welding, an electronic bonding process to join wood and metal. Ht 68.5cm/27in.*
2 *Eero Saarinen struggled to achieve a single moulded piece of plastic as the base of his Tulip chair of 1955–6, but he managed to clean up what he saw as a "slum of legs" in domestic interiors. Ht 83.5cm/33in.*

3 *George Nelson's Pretzel chair, manufactured by Herman Miller in 1955, was aptly named for the bending, twisting capabilities of the laminated birch frame. The seat was made of walnut. Ht 79cm/31in.*
4 *High stool by Paul Goldman for Plycraft. The arching legs and waisted back are typical of Goldman's sculptural use of plywood. Ht 94cm/37in.*

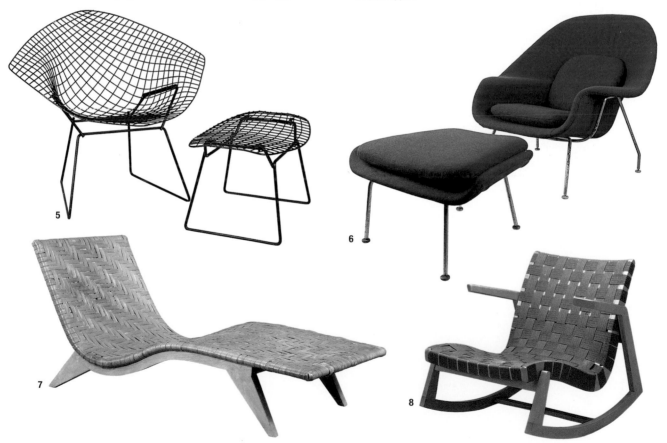

5 *Increasingly narrow gauges of steel enabled furniture designers like Harry Bertoia to create his spindly wire furniture like this Diamond chair and ottoman for Knoll from the early 1950s. Ht 83cm/32¾in.*
6 *Eero Saarinen called his Womb chair and ottoman, 1946–8, "biological." The technology behind its moulded fibreglass shell with foam rubber padding makes it part of the popular Contemporary organic abstraction. Ht 89cm/35in.*

7 *The undulating shape and splayed legs of this chaise longue by Edward Durrell Stone are hallmarks of Contemporary style. L. 1.67m/5ft 6½in.*
8 *Ralph Rapson designed a line of mass market plywood furniture for Knoll. His rocker, 1946–7, gained the most critical and popular attention but could not be manufactured with a continuous piece of wood because it exceeded the wartime restriction of 18 inches (46cm). Ht 77cm/30½in.*

Sofas

1 *The upholstery on the* Marshmallow *sofa demonstrates some of the bold, clashing colours that were popular in the 1950s, in this case red, orange and purple; designed by George Nelson Associates for Herman Miller, 1956 Ht 78.5cm/31in, W. 1.32m/4ft 3½in.*

2 *Florence Schust Knoll combined good design with methods of industrial mass production to bring objects of high quality and appealing design to as wide an audience as possible. This suite from the Florence Knoll collection was produced for her firm Knoll International in 1954. Chair ht 80cm/31½in; Sofa ht 76cm/30in, w. 2.28m/7ft 6in.*

The sudden consumer boom in America immediately after the war had a profound effect on design. This remarkable post-war economy of abundance opened new markets for products that looked fresh and new and also satisfied Americans' desire to consume. As a result, manufacturers attracted the best new talent and invested in groundbreaking design. Disruptions caused by the war resulted in the emigration to the United States of many displaced European architects and designers who ultimately became associated with American design firms. Suddenly, America was a cultural leader.

America made its most significant contribution to post-war design in the related fields of furniture and architecture. Some of the most influential furniture designers were architects, such as Charles Eames, the Finnish-born Eero Saarinen, Florence Schust Knoll and George Nelson. Sculptors also had a profound influence on furniture design; Isamu Noguchi and Harry Bertoia, for example, created some lasting icons of mid-century design. The pervasive influence of husband and wife designers Charles and Ray Eames cannot be overestimated. Their inspired furniture, film and photography at mid-century created a new language of design and had a huge impact both at home and abroad. Their work, which continued well into the 1970s, was as influential on the use of space within houses as on the design of furniture.

The Modernist aesthetic that had emerged in Europe in the 1920s changed significantly after it became the predominant influence on design in America after the war. Designers embraced the idea of industrialization and mass production and, as a result, their designs became more focused on utilitarianism and the efficiency of the manufacturing process. The overriding influence of functionalism, the idea that form followed function, continued to prevail in this late manifestation of Modernism in America.

It was mainly in America that the use of plastics, fibreglass and polyesters was pioneered, to be taken up with enthusiasm by major designers such as Charles

Steel Rod Construction

Lighting

1 *Steel rod was now used in place of tubular steel for lightness of construction. Isamu Noguchi used the new technology of metal wire to create the framework for his walnut and chrome rocking stool of 1953. Seat diam. 35.5cm/14in.*
2 *While director of design at Herman Miller, George Nelson created his own line of furniture of which this dressing table stool is an example. Ht 65cm/25½in.*

1 *The design of Isamu Noguchi's 1954 Akari lamp made of a paper screen stretched over a bamboo frame are based on his return to and examination of his native Japanese design. Ht 50cm/19½in.*
2 *This combined lamp and table by Tommi Parzinger reflects an emphasis on individual convenience in 1950s interior schemes. Ht 1.47m/4ft 10in.*

Eames, Eero Sarrinen, and George Nelson. Curving sculptural forms, slender splayed legs, and soft upholstery were all possible with the newly developed industrial techniques for working metal, plywood, plastics, or foam rubber; improved adhesives were also available. Furniture became lighter in weight, easy to move around and more flexible in its usage. It was strong and hard wearing as well as colourful and attractive.

Even though furniture manufacturing was decentralized throughout the country, a large proportion of American furniture came out of the Grand Rapids, Michigan, area.

Firms like Knoll Associates and Herman Miller attracted international and native talent and in turn dominated the furniture industry with their technical innovations. However, in terms of actual production, these firms only catered to a small proportion of the population. More mass-produced, less expensive furniture that was based on late Modernist design expanded these ideas to a broader market.

Architects working in America created airy, open and uncluttered spaces in which to display organic and clean-lined furniture to its greatest effect. Good design was not only supported by enlightened firms like Knoll and Herman Miller but was also championed by cultural institutions like the Museum of Modern Art in New York.

In 1940 MOMA held the design competition, Organic Design in Home Furnishings, which pointed toward new practical engineering technology in furniture and other domestic objects. The free organic forms by Eero Saarinen and Charles Eames emerged from this competition. They were finally produced after the war in the late 1940s. A similar competition held in 1948, MOMA's International Competition for Low-Cost Furniture Design, also facilitated new forms based on modern technology. MOMA held a series of Good Design exhibitions from 1950 to 1955 in collaboration with the Merchandise Mart of Chicago. The exhibitions were conceived to stimulate interest and influence public taste for objects that reflected sound design and practical function.

Organic and Geometric Forms

1 *No other piece of furniture more clearly demonstrates the sculptural aspects of the organic in contemporary design than Isamu Noguchi's glass topped table. W. 1.27m/4ft 2in.*
2 *The open, airy interiors of the 1950s required ways to divide space flexibly. Charles and Ray Eames' Panel screen could transform a room and also fit in with other organic designs with its undulating curves. Ht 1.72m/5ft 7½in.*

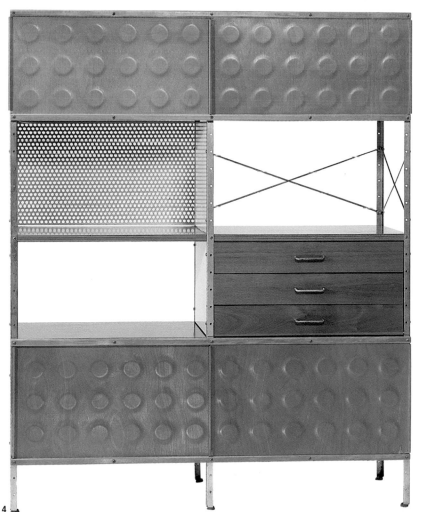

3 *This rosewood jewellery cabinet on its metal stand by George Nelson gave traditional materials and forms a distinctly Contemporary elegance. Ht 1.12m/3ft 7½in.*
4 *The ESU (Eames Storage Unit) by Charles and Ray Eames for Herman Miller, 1950. With primary colours on the sides, it would have been the focal point of any interior. It was also used as a room divider. W. 1.19m/3ft 11in.*

Italian Furniture

Surreal and Dramatic Forms

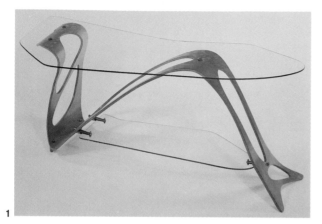

1

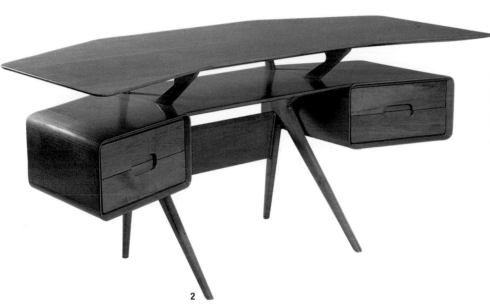

2

3

1 *Carlo Mollino's* Arabesque *table epitomizes Italian organic design of the 1950s. Like a flamboyant S-curve, this table designed in 1950 has all the movement and linearity that the Italians displayed most extravagantly. Ht 1.32m/4ft 4in, l. 1.47m/4ft 10in.*
2 *Wood and glass desk by Franco Cavatorta, 1952. The form combines the Contemporary characteristics of horizontal emphasis and splayed legs with the boldly sweeping lines typical of Italian design. Ht 81cm/32in.*

3 *The polymath designer Gio Ponti collaborated with Piero Fornasetti on furniture designs and interior schemes in the late 1940s and 1950s. This cabinet, 1950, shows the slightly surreal architectonic possibilities of Fornasetti's elegant designs. Ht 2.18m/7ft 8in.*

Wartime technology had a profound influence on the organic sculptural designs produced by Italian designers. The extreme curvilinear and contorted forms of desks, chairs and tables sometimes looked like surreal three-dimensional art. Aerodynamic streamlining, moulded plywood technology as used in aeroplane manufacture during the war, and the widespread availability of malleable metals profoundly influenced the work of Italian furniture makers. The Italian furniture industry was mainly centred in Milan, where the Milan Triennales, founded by Achille and Pier Giacomo Castiglioni, encouraged new, progressive designers. A large export market ensured the dissemination of the Italian style: by the end of the 1950s, Italy was the world's leading exporter of modern furniture.

As with other furniture manufacturers that revived production after the war, Italian firms like Cassina collaborated with leading architects to produce work of striking originality and wide appeal. Much of this work is notable for the organic shapes and sweeping lines with which Italian designers regularly experimented. Most notably, furniture by Piero Fornasetti demonstrates the close relationship between Surrealism and three-dimensional design. With his lacquered and screen-printed imagery on the flat surfaces of chairs, cabinets and desks, Fornasetti created chic, eccentric, and quirky theatrical effects.

Italian designers incorporated dramatic movement and energy into their furniture, more so than the Americans or the Scandinavians: the designs were curvilinear and sensuous. The contours of chair seats, for example, emulated the curves of the female body while the attenuated shapes of chair arms and legs were equally provocative. Carlo Mollino's elaborately structured bentwood furniture stands out as the most deliberately sculptural. From the *Arabesque* table by Mollino to the *Mezzadro* stool by the Castiglioni brothers, Italian designs for furniture were flamboyant, progressive, and radical.

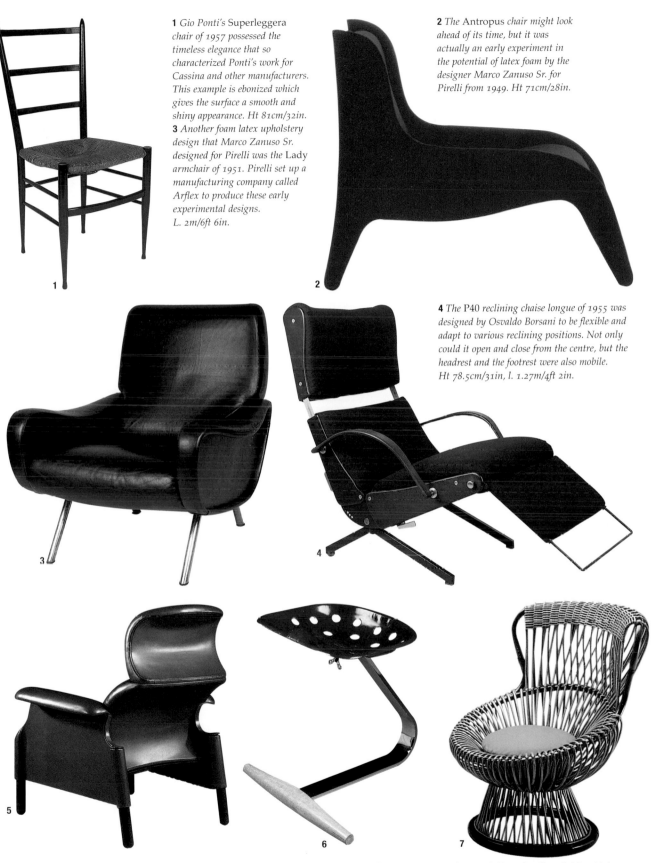

1 *Gio Ponti's* Superleggera *chair of 1957 possessed the timeless elegance that so characterized Ponti's work for Cassina and other manufacturers. This example is ebonized which gives the surface a smooth and shiny appearance. Ht 81cm/32in.*
3 *Another foam latex upholstery design that Marco Zanuso Sr. designed for Pirelli was the* Lady *armchair of 1951. Pirelli set up a manufacturing company called Arflex to produce these early experimental designs. L. 2m/6ft 6in.*

2 *The* Antropus *chair might look ahead of its time, but it was actually an early experiment in the potential of latex foam by the designer Marco Zanuso Sr. for Pirelli from 1949. Ht 71cm/28in.*

4 *The* P40 *reclining chaise longue of 1955 was designed by Osvaldo Borsani to be flexible and adapt to various reclining positions. Not only could it open and close from the centre, but the headrest and the footrest were also mobile. Ht 78.5cm/31in, l. 1.27m/4ft 2in.*

5 *The amazingly springy curves of the 1960* San Luca *armchair by Achille and Pier Giacomo Castiglioni exemplified the exaggerated curves and pure energy of flamboyant Italian design. Ht 96cm/38⅛in.*

6 *The Castiglioni brothers were prolific designers and launched their ready-made furniture in 1957 with the* Mezzadro, *or Sharecropper's Stool, ingeniously incorporating a tractor seat. Ht 50cm/19¼in.*

7 *Pierantonio Bonacina (founded in 1889) was a manufacturer of traditional wicker furniture, but produced this shapely* Margherita *armchair, 1950, following other curvilinear designs of the time. Ht 78.5cm/31in.*

Scandinavian Furniture

Organic Forms and the Influence of Handcraft

1 *Arne Jacobsen's design for the 1952* Ant *chair, the most successful mass-produced chair of the 1950s, demonstrates how he used organic forms to create a unified seat shape. Many of his subsequent chair designs were variations on this basic concept. Ht 85cm/33½in.*

2 *Jacobsen's chair designs from the 1950s are based on biological organic forms. The* Swan *chair exemplifies the movements of a large, graceful bird with enveloping wings. Ht 75cm/29½in.*

3 *Verner Panton first worked as an associate of Arne Jacobsen and collaborated with him on the* Ant *chair. After establishing his own design and architectural firm he became famous for his installations; among them was the* Komigen Inn *(Come Again Inn) where Panton designed an all-red interior and his famous* Cone *chair. It went into production in 1959. Ht 81cm/32in.*

Contemporary Scandinavian furniture is characterized by simple, elegant, and functional designs with a timeless appeal. During the postwar period Scandinavian design reached its pinnacle. Sweden, Denmark and Finland fed off each other and produced a unified aesthetic, marking the emergence of Scandinavian Modern. It was a renaissance for the Scandinavians, transforming every aspect of the applied arts.

Taking the best of handcrafted and machine techniques and combining the two, Scandinavian design ultimately became synonymous with good taste and high quality. From the pared-down elemental chairs of Hans Wegner to the swollen egg shapes of Arne Jacobsen and the lighthearted cone-shaped chairs of Verner Panton, the designs produced in Denmark, Sweden, and Finland captured the international urge to consume domestic goods with an innovative look.

Building on their tradition of local hand craftsmanship, many Scandinavians used wood to manufacture their designs – walnut and birch ply were common but teak imported from the Philippines became the wood most closely associated with Scandinavian furniture. The international use of plastics and metals did not escape the northern Europeans and many ingenious designs in new materials also came out of the region.

Scandinavian furniture design included two parallel strains: bold, industrial work employing state-of-the-art technology epitomized by Arne Jacobsen and Verner Panton, and craftsmen-designers such as Finn Juhl and Hans Wegner whose work grew out of the tradition of small cabinetmaking workshops that had continued to function unchecked throughout the war. This more traditional work in warm tones of wood created modern re-workings of existing furniture types using the materials and methods historically linked to Scandinavian craftsmanship. In the 1950s much Scandinavian furniture was exported to other parts of the world in flat-pack form or manufactured abroad under licence. Scandinavian influence on interior design was soon evident all over the world.

4 *Hans Wegner was one of the leaders of Scandinavian design and worked with the characteristic palette of smooth, warm-toned woods. His beech sawback armchair of 1951 was perfectly crafted to fit the contours of the seated body. Ht 81.5cm/32in.*

5 *Wegner's stackable three-legged dining chair from the 1950s was designed using the organic fluid shapes so dominant in the post-war years and favoured by Scandinavian Modern designers. Ht 72.5cm/28½in.*

8 *A stool for relaxing in a sauna is perhaps the most quintessentially Scandinavian seating form possible. Antti Nurmesniemi designed this horseshoe-shaped stool for the sauna at the Palace Hotel in Helsinki in 1952. Ht 51cm/20in.*

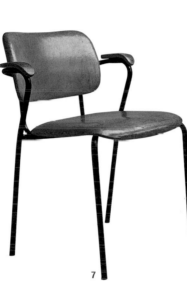

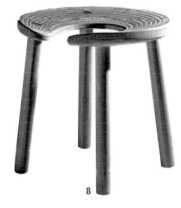

6 *Peter Hvidt and Orla Molgaard Nielsen designed the laminated AX armchair produced by Fritz Hansen in 1950. At the Milan Triennale, often an arbiter of a design's success, the chair won a Diploma of Honour. Ht 75cm/29½in.*

7 *In Finland, Ilmari Tapiovaara's* Lukki, *or daddy long legs chair emerged from a major commission for the Tech Student Villlage at Espoo in 1951–2. Tapiovaara went on to design many variants of this chair. Ht 90cm/35½in.*

10 *The quality of Danish furniture was unparalleled for its craftsmanship and thoughtful engineering. Finn Juhl's settee for Niels Vodder exemplifies qualities of the best in Scandinavian design. Ht 90cm/35½in.*

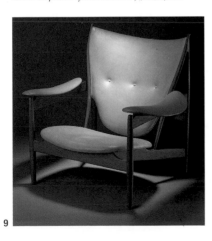

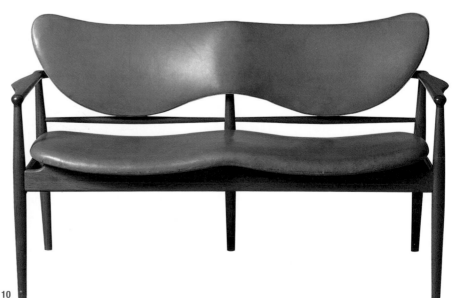

9 *The extraordinary wooden creations by Finn Juhl demonstrate the lightness and sculptural possibilities that wood offered. His Chieftain's chair has the rhythmic quality of Juhl's designs for interiors and furniture. Ht 91.5cm/36in.*

Ceramics

Elegant Shapes and Progressive Patterns

1

2

1 *The hourglass form was favoured in the 1950s. The Americans Richard Latham and Raymond Loewy created* Service 2000 *for Rosenthal: Margret Hildebrand's printed pattern,* Raffia, *decorated it. Coffee pot ht 24cm/9½in.*
2 *Staffordshire manufacturers jumped on the Contemporary bandwagon. The* Homemaker *tableware designed by Enid Seeny for Ridgway depicted objects of the time like Robin Day's armchair. W. (large dish) 38cm/15in.*

Organic Forms

1

2 *The Hungarian-born Eva Zeisel emphasized the fully fledged Organic Modernism after she went to America. As with her* Town and Country *tableware from 1946, forms often did not have handles; they were designed to fit perfectly in the hand. Ht (tallest piece) 11.5cm/4½in.*
3 *The tall, wavering* Grass *vases designed by Toini Muona in 1946 for Arabia used flambé glazes on tall, attenuated organic forms.*

1 *Jessie Tait was the head designer for Roy Midwinter's family firm of W.R. Midwinter who created new patterns in the Contemporary abstract style.* Capri, *like Midwinter's other products, was modern as well as marketable. W. (gravy boat) 21.5cm/8½in.*

2

3

Diverse Inspirations

1 *Piero Fornasetti could apply his designs to various media, including ceramics. His vocabulary ranged from newsprint to architectural drawings to designs of brightly coloured vegetables with surreal faces as on these salad bowls from 1955. Diam. (each dish) 24cm/9½in*

British Studio Pots

1 *The studio pottery tradition in Great Britain in the 1950s was upheld by leading ceramicists like Michael Cardew who worked in stoneware with elegant scratched decoration. Diam. 27cm/10⅝in.*

2

2 *Lucy Rie's studio pottery was modernist and simple, using Asian-inspired shapes and abstract sgraffito surface decoration. The light forms of these bottles, dating from 1950, one of stoneware, the other porcelain, were decorated simply with incised parallel bands and crosshatched vertical lines. Ht (tallest) 17.5cm/7in.*

Ceramic design in the post war era demonstrated an unwavering commitment to functionalism combined with cutting-edge experimentation with Organic Modernism. Many designers working during the period spread their talents across different media – furniture, glass, ceramics, plastics and metalwork – while others were still firmly ensconced in the studio pottery tradition.

Ceramic design developed from the prevailing geometric trends of Modernism before the war to the shapes of Organic Modernism that started to emerge with the work of designers such as the Eva Zeisel and Russel Wright, who were both working in America after the war. Organic forms were curvilinear and easy to hold even though sometimes they bore no handles. Some of the most inventive shapes of the time took the form of vases, reflecting the period's enthusiasm for flower arranging. The Poole Pottery and Wade in England were noteworthy in this respect. Some of these ceramic objects had a striking similarity to the biomorphic forms of

sculpture by Jean Arp and Henry Moore. This overarching influence on Contemporary ceramic design lent itself perfectly to the malleable properties of clay.

Pattern was as transforming and significant as the innovative shapes that gave ceramics an entirely new appearance. Pottery design in Great Britain was slow to progress after the war, and most of the large firms catered for a conservative market but one designer, Roy Midwinter with his family's firm, W.R. Midwinter, created shapes modelled after what he saw in America, and he encouraged his team to devise brightly coloured patterns in the abstract style. His efforts to bring Contemporary design in ceramics to Britain were influential and resulted in the rejuvenation of the industry after the depressed inter-war years. Ranges such as *Stylecraft* and *Fashion*, launched in 1952 and 1954, were characterized by rounded square shapes and either bold abstract patterns or colourful plant and animal designs. Jessie Tait and the then youthful Terence Conran were among Midwinter's innovative designers.

1

3 *Berndt Friberg,* Reptile *vessel, 1954. Also influenced strongly by the shapes of Asian ceramics, Friberg's designs while in the Gustavsberg studio in Sweden demonstrated that his strong aesthetic influence was Chinese Sung Dynasty ceramics.*

1 *Gertrud Vasegaard was a Danish studio potter who designed for industry. Her wicker-handled 1956 tea service for Bing & Grøndahl demonstrates the inspiration from Japan that influenced so much Danish studio pottery design. Teapot ht 21.5cm/8½in.*
2 *Like many talented designers of the post-war era, Russel Wright worked in many different fields. His ceramics for for the Iroquois China Company included his* Casual China *dinnerware range, 1946, which combined the innovative soft shapes of Organic Modernism with a strong ceramic body to stand up to everyday use. Diam. 30cm/11¾in.*

2

Even with great emphasis on colour, pattern, and shape, mass-produced by industrial ceramic firms, the studio pottery movement continued to hold sway on ceramics design, especially in Britain. Before the war the prolific Bernard Leach dominated the studio movement. Later, potters such as Lucy Rie and Hans Coper introduced a lightness of form and style of abstract surface decoration that was achieved by *sgraffito* – incised lines in parallel or cross-hatched designs – or with interesting glaze effects.

Two large firms dominated Scandinavian ceramics: the Finnish firm of Arabia and, in Sweden, Gustavsberg. Kaj Franck was head of Arabia's design department for utility ware and his experience in ceramics as well as glass design made him uniquely suited for his role. Franck had a profound influence on tableware designs in Finland for over half a century. Arabia had an enlightened view of ceramic design and production; not only were well-designed products manufactured on a large scale, but at Arabia's headquarters on the outskirts of

Helsinki there were facilities for a group of studio potters to create unique objects with no obligation to contribute to the industrial product line. This was distinctly different from ceramic production in Sweden where studio potters associated with manufacturers were expected to design for production rather than create one-off studio pieces under the patronage of a large firm. Gustavsberg did not halt production during the war and was already a decade ahead in manufacturing systems when other countries resumed their tableware business in the late 1940s.

Also from the studio tradition was Pablo Picasso's work as an artist-ceramicist. Although he was untrained as a potter, his designs were liberating to an entire generation of southern European ceramicists. In Italy especially, ceramics were sculptural and painterly and production occurred in small-scale workshops and studios, as opposed to the large manufacturers of Scandinavia and America where a more unified aesthetic tended to dominate.

Progressive Manufacturers

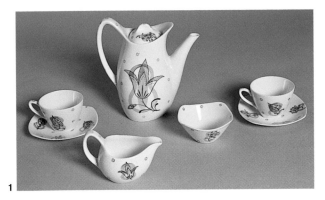

1 Roy Midwinter was one of the first British manufacturers to support the new curvilinear shapes in America. His daring Fashion range produced undulating forms and solid organic shapes for the table. Cup ht 7cm/2½in.

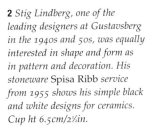

2 Stig Lindberg, one of the leading designers at Gustavsberg in the 1940s and 50s, was equally interested in shape and form as in pattern and decoration. His stoneware Spisa Ribb service from 1955 shows his simple black and white designs for ceramics. Cup ht 6.5cm/2½in.

Mix and Match

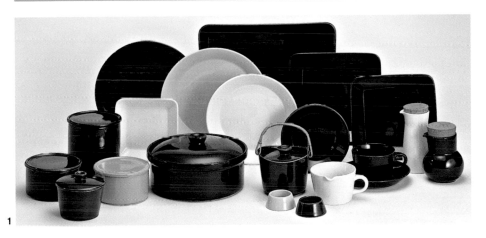

1 The idea behind Kilta tableware designed by Kaj Franck for Arabia in 1948 was that the consumer could mix and match colours: white, black, green, blue and yellow. It filled the post-war need to offer inexpensive functional tableware. Casserole diam. 20.5cm/8in.

Vase Forms

1 The porcelain manufacturing company Rosenthal adopted the expression New Look to introduce a line of porcelain. Beathe Kuhn's New Look vase, 1955, was one of a range of organic shapes. Ht 35cm/13¾in.

2 Bernard Leach inspired an entire generation of studio potters and yet his own work remained fresh and innovative even after the war. His stoneware vase from 1959 shows the strong influence of Japanese ceramics on his work.
3 The star of the studio tradition in southern Europe was Pablo Picasso. Like many painters from this period, he turned his hand to ceramics design, producing work of great originality such as this pitcher from 1955.
Ht 31.5cm/12¼in.

Glass

Nature-Based Forms

1 *Beginning in 1950, Timo Sarpaneva's association with the Iittala glassworks produced pieces of sublime beauty like his* Orchid *vase of 1953. One of his first technical innovations there was a steam blowing method. Glass being the most malleable of all the applied arts, it could be transformed into works of great sculptural asymmetry, characteristic of contemporary design. Ht 35cm/13¾in.*

2 *The* Bubble *vases by Kaj Franck for Nuutajärvi in 1954 resembled other Scandinavian examples with their smooth, simple round shapes. Design in Scandinavia was so successful and consistent that similarities appear in designs by different firms. Ht 26cm/10in.*
3 *Ingeborg Lundin designed delicately engraved glass as well as thinly blown tableware for Orrefors. Her best known design was her* Apple *vase of 1957. Ht 39cm/15in.*

Without question, northern Scandinavia constituted the main powerhouse of contemporary glass design. Characterized by its simple, abstract and sometimes asymmetrical shapes, Scandinavian glass has become virtually synonymous with design of the 1940s and 50s. Even the names of companies such as Iittala, Orrefors and Kosta hold lasting resonance today. Northern European glass designers sometimes worked for numerous firms, spreading their particular aesthetic across different manufacturers.

The drive toward organic forms and abstract masses had an immediate effect on glass design. Experimenting with the abstract organic, as Scandinavian designers did with abandon, dovetailed perfectly with the properties of glass itself. In its molten form glass was the ideal medium to shape into these liquid, innovative domestic manifestations, while the material could be infused with brilliant translucent colour.

It was without a doubt Finnish glass that leapt to the forefront of Contemporary design after the war. The transformation of this design-led, but nonetheless limited, industry into an internationally dominant force with widespread appeal for the style-conscious middle classes was nothing short of remarkable. Tapio Wirkkala, originally trained as a sculptor, began his career as a glass designer in 1946. Just a few short years later, at the Milan Triennale of 1951, or what became known as the "Milan Miracle" for Finland, Wirkkala exhibited thirty of his designs for Iittala and won medals for his glass, exhibition design, and for his laminated birchwood bowls. Even though some of Wirkkala's work was supremely practical and included functional jugs, bowls and tumblers, his other designs reflected his sculptural background. Glass in abstract forms based on natural objects like his lichen vessels, leaf-shaped bowls, mushroom vases, and bamboo vessels, dominated his design for industry and captivated the international scene.

A little later Timo Sarpaneva took the lead in Finnish glass design. Taking abstraction in design to a new level,

1 *Nils Landberg was one of a group of young designers working for Orrefors just after the war. In the mid-1940s Landberg developed his* Serpentina *range in which a coloured spiral was encased within the clear glass of the object's thick, organically shaped walls. Ht 25cm/10in.*

2 *The* Vaso Fazzoletto, *or handkerchief vase was the most popular design produced by the Murano firm of Venini, 1949. Paolo Venini and Fulvio Bianconi had developed the design together to include various innovative techniques that looked like lace or broad stripes within an undulating glass body of varying sizes. Ht 28cm/11in.*

3 *Bianconi and Venini together also developed* vetro pezzato *where squares of coloured enamels were suspended in a glass body to look like patchwork. This distinctive vase of 1951 is full of the colour and movement that characterized Venini's glass. Ht 33cm/13in.*

4 Kraka *vase in the "fishnet" technique by Sven Palmqvist for Orrefors. Ht 22cm/8½in.*

5 *Vicke Lindstrand's engraved designs for Kosta in Sweden were just one aspect of his diverse repertoire that included figural work, sculptures, coloured underlay glass, and numerous experimental works. His* Manhattan *vase evokes the geometric jumbled skyline of New York. Ht 22cm/8½in.*

6 *Floris Meydam was one of the designers that brought Dutch glass its distinctive quality of flowing, controlled vivid colours in thick walls of glass. Ht 16cm/6¼in.*

7 *Ercole Barovier's* Neolitici *vase of 1954 includes the characteristic colour and texture that he experimented with throughout the 1950s. The Italian firm of Barovier & Toso was one of Venini's few rivals. Ht 21cm/8½in.*

8 *The* Occi *vases by Tobia Scarpa of 1959–60 were produced by Venini with characteristic flair and ingenuity. The design created a dense mosaic-like appearance by using canes of enamel in cross-section. Ht 15cm/6in.*

1 *Asymmetrical footed bowl by Vicke Lindstrand for Kosta, c.1950, internally decorated with a geometric pattern in red and ochre. Ht 13cm/5⅛in.*

2 *The 1955 Harrtil ashtray by Milan Metelák and Milos Pulpitel from the Harrachov Glassworks has all the characteristics of art glass from the Czechoslovakia, where glass artists experimented with techniques that led the way after the war. Ht 5.5cm/2¼in.*

3 *Gio Ponti and Fulvio Bianconi collaborated to produce this flamboyant glass cocktail service, achieved by laying down enamel canes for a vibrant striped pattern. Jug ht 18.5cm/7¼in.*

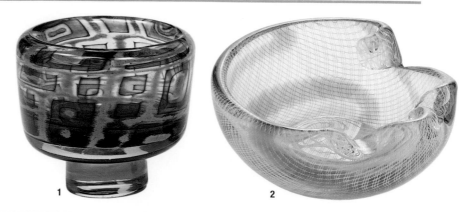

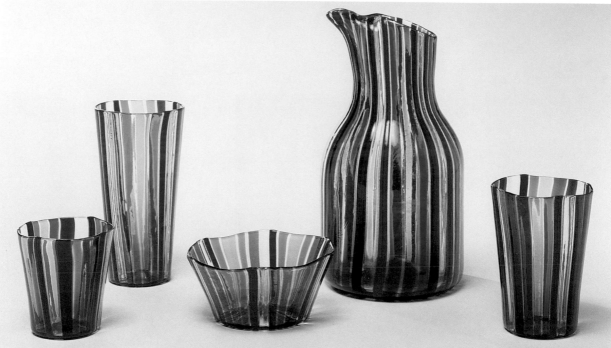

Sarpaneva achieved brilliance and acclaim with his pure, sculptural designs. With some of these he employed a technique whereby he injected air bubbles into the body of the glass. But Sarpaneva's subtly-coloured utility wares also attracted widespread attention. Fifty percent of Finnish contemporary glass was produced by Iittala, whose star designers were Wirkkala and Sarpaneva.

In Scandinavia, the highly developed manufacturing industry provided the impetus and structure out of which designers could create. There was little scope for the studio glass artist who produced in isolation. However, this was the norm for Czech art glass, which was virtually unknown until the late 1950s when it received widespread recognition at international exhibitions. Czech glass was unlike Contemporary types produced elsewhere. Instead of the emphasis being on the form, as with the abstract and liquid shapes of Scandinavian glass design, art glass from Czechoslovakia focused on decoration with enamelling,

engraving, and etching on the surface of the glass itself. The results sometimes resembled abstract paintings, and there was clearly a close affiliation between painting and designs for studio glass.

Italian designers also produced work of great originality and widespread appeal. Italian glass had been such a dominant historical force that it is no surprise to find designers in Italy creating objects of outstanding ingenuity in the late 40s and 50s. Like other Italian design of the post war era, glass was the most colourful and flamboyant on the international scene. Paolo Venini revived traditional glassmaking techniques, bringing the effects of handmade irregularities, varied colours, and unusual textures and shapes to his objects. His *fazzoletto*, or hankerchief vase was copied in many other countries and became an icon of 1950s design. Other designers working at Murano, one of the historical centres of Italian glass production, also revived historical techniques to create unique objects with a cutting-edge, contemporary design.

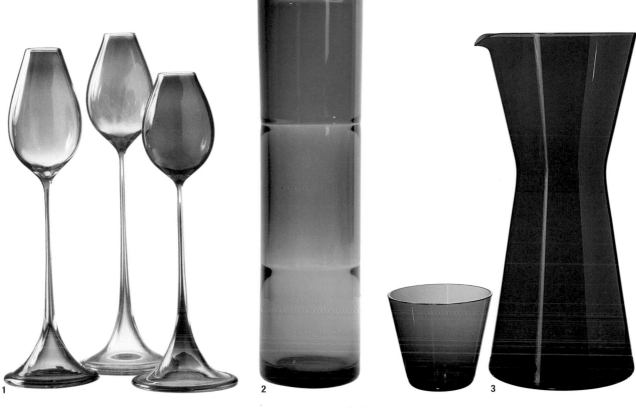

1 *The tulip shape was seen in everything from fashion to furniture in the 1940s and 50s. Glass was perfectly suited to the form, and Nils Landberg's* Tupanglas, *or tulip glasses of 1957 were stylish examples. Ht 45cm/17¾in.*

2 *Arne Jon Jutrum, one of the few Norwegian glass designers of the time, worked in different media but was best known for glass. He often worked with strong colours and muted matt finishes, as in this vase of 1959. Ht 23.5cm/9in.*

3 *The pared-down aesthetic and almost clinical quality of Kaj Franck's mid-1950s carafe and tumbler were influenced by his own research into domestic eating habits. Carafe ht 23cm/8¾in.*

4 *The German-born inventor, Peter Schlumbohm, worked in America in the early 1930s. His hourglass-shaped* Chemex *coffeemaker of 1949 was the best-known of his many products for the kitchen. Ht 28cm/11in.*

5 *The main contribution of British glass of the 1950s was engraving, and David Peace became known for his fluid, engraved calligraphic inscriptions as seen on this glass bowl. Diam. 35cm/13¾in.*

Metalwork

From Silver-Gilt to Stainless Steel

3

1

1 *Gerald Benney was the first silversmith to use a matt textured surface to decorate his vessels, as on his gilt chalice from 1958. This technique was widely copied in the 1960s. Ht 26cm/10in.*
2 *Robert Welch's remarkable seven-light candelabrum of 1958 was inspired by a visit to a Jackson Pollock exhibition in London. The knobbly forms of the silver look like the dripping paint of a Pollock but also allude to the molten wax of a candle. Ht 60cm/23½in.*

3 *As well as his work as a craftsman silversmith, Robert Welch provided designs for stainless steel manufacturers. Together with David Mellor, who designed the cutlery, Welch created his first table range, Campden, in 1956. Ht 28cm/11in.*
4 *The attenuated shapes of Stuart Devlin's coffee service of 1958 combined gleaming silver with the innovative material of nylon for the bases. Coffee pot ht 33cm/13in.*

4

Immediately following World War II there was little demand for luxury goods made of precious metals when factories' main initiative was focused on producing the bare essentials. As domestic habits changed in the middle of the century, so did the materials used. No longer were silver and silver plate the most practical materials for serving food and drinks. Metals had to be more durable. Stainless steel and steel alloys became popular new metals with which to work. Aluminium, used extensively in furniture design, continued to be used by designers of tableware as well. Eating habits changed with the sudden shifts in the way women conducted domestic work and according to the dwindling availability of household staff. Cutlery and other metals for the table were made to accommodate these changes.

The two main centres of striking and innovative contemporary metal design were Britain and Scandinavia. In Sweden and Denmark, and to a lesser extent Finland, the manufacturing system fostered the talents of a new generation of metalsmiths and designers.

The situation was markedly different in Britain where new design stemmed from individual workshops. Superlative teaching of metalwork at the Royal College of Art produced some brilliant young designers, and enlightened patronage by the Worshipful Company of Goldsmiths ensured a steady stream of dynamic and original work. Gerald Benney, whose attenuated forms virtually defined British metalwork design of the mid-century, produced designs in silver and pewter for the Sheffield firm Viners, while Robert Welch and David Mellor produced tablewares in stainless steel and some fine pieces in silver.

Scandinavian metalwork was dominated by the reputation of the Copenhagen firm Georg Jensen, where design after the war took on an organic sculptural emphasis. A host of artist-craftsmen were associated with Jensen. At the helm was Henning Koppel who had been trained as a sculptor and applied those methods to metal design, creating clay models for pieces to be manufactured in silver or a base metal.

1 *Henning Koppel's work in metal shows his devotion to sculpture. His 1947 silver bracelet for Georg Jensen resembles the interlocking bones of the spine. L. 14cm/5½in.*

2 *Perhaps the quintessential Scandinavian design of the 1940s and 50s, Henning Koppel's jug for Georg Jensen, 1952,* The Pregnant Duck, *illustrates the flowing rhythm and undulating curves of Koppel's supremely sculptural work. Ht 24cm/9½in.*

3 *This object is appropriately titled an Eel dish; it looks as if it might slither across the table. Georg Jensen produced this elegant silver design as one of a group of fish dishes by Henning Koppel, 1954. L. 68cm/26¾in.*

5 *Lino Sabattini was director of design at the French firm Christofle at the end of the 1950s and produced work of great originality. However, he was not trained as a silversmith. His fluid approach to the design of silver stems from his early work as a potter. His flower centerpiece of 1959 is a superlative example of the elegant, flowing lines of his designs. L. 37cm/14½in.*

4 *Arne Jacobsen achieved success with his famous chair designs but also worked on lighting, metal, textiles, and bathroom fittings. Jensen's main competitor, A. Michelsen, employed Jacobsen to design his sleek AJ cutlery of 1957; it remained in production long after its initial popularity. L. 20cm/8in.*

6 *Sambonet was a family firm, the principal stainless steel manufacturer in Italy. The firm dominated the market for cutlery and cooking utensils but the design by its director, Roberto Sambonet, for a fish kettle, 1954, was definitely its most famous object. L. 30.5cm/12in.*

Textiles

Bold Patterns

1 *Finland's textiles firm Marimekko grew out of the oilcloth firm, Printex. Maija Isola, a main designer, helped to transform the company with her large-scale bold designs in bright colours. This is her* Kivet *or stones fabric.*
2 *Dorothy Liebes was the first American to apply hand techniques to mass production, with bright colours and unconventional materials. These blinds, 1950, use bamboo splits, wooden dowels, rayon, cotton, and metallic threads.*

3 *Lucienne Day won all the accolades for her* Calyx *pattern of 1951. It was judged the best textile design on the American market in 1952.*
4 *The Swede Stig Lindberg loved vibrant designs in bright colours, as in this playful pattern of rows of pottery for a textile of 1947.*

Throughout Europe and America large textile manufacturers that were already established before the war picked up production, working closely with leading designers. A burgeoning group of freelance textile artists circulated amongst firms, including some of the trend-setting furniture manufacturers who expanded production to embrace furnishing fabrics. These included Herman Miller and Knoll in the US, and Heal and David Whitehead in the UK.

New textile patterns were abstract and linear. Bold and irregular patterns printed in strong blocks of colour exemplified contemporary textiles on the one hand, while the small and exacting repetition of motifs was also successful. Designers also experimented with weaving technology and design. At the forefront of this aspect of mid-century textiles was the American Jack Lenor Larsen, who successfully combined groupings of natural and synthetic fibres.

At one time the British textile industry was the leader in Europe. By the 1950s it was retracting and in decline.

Despite this the overall quality of textile design was on an upswing. The leading Briton was Lucienne Day, who often collaborated with her furniture-designer husband, Robin Day. The post-war years also saw burgeoning interest in artist-designed textiles. Henri Matisse, Pablo Picasso, André Dérain, Henry Moore, Barbara Hepworth, John Piper, and Graham Sutherland were among many who were persuaded to try their hands at textile design. Even Eduardo Paolozzi, while establishing his reputation as a sculptor, provided patterned cottons for Horrocks during the 1950s.

Marimekko, the widely known Finnish manufacturer of furnishing and dress textiles, did not become an international force in printed fabrics until the 1960s, yet Scandinavian textile design after the war was dynamic, accessible and, most important, new and refreshing. Numerous independent designers worked together with manufacturers, as in other countries, and the designer-weaver tradition perpetuated even the hand-weaving system that had existed before the war.

The Influence of Artists and Handweavers

1 *Alexander Calder's mobiles had a pervasive influence, as in this 1954 textile design for Heal's by June Lyon.*

2 *The furniture firm Herman Miller regularly commissioned designs for furnishing fabrics. This printed cotton,* Rain, *of 1953 is by Alexander Girard, an architect who specialized in interior schemes and exhibition design. Its planes of bold colours and abstract forms are typical of his work.*

3 *Like Herman Miller, Knoll produced upholstery fabrics. Finnish-born Marianne Strengell was one of the talented handweavers who designed textiles for machine production.*

More Abstract Designs

1 *After Christian Dior's 1947 fashion collection, other designs were entitled* New Look. *Friedlinde de Colbertaldo's abstract furnishing fabric for the manufacturer David Whitehead was inspired by abstract painting.*

2 *In 1959 Nigel Henderson and the sculptor Eduardo Paolozzi devised a black and white textile design called* Coalface *for Hull Traders. This was produced as a furnishing fabric, remarkable for its textural quality, in a two-dimensional design.*

Plastics and Appliances

Plastic Possibilities

1 Margrethe *bowls, designed in 1950, by Prince Sigvard Bernadotte and Acton Bjørn, continue to be the perfect kitchen vessels. Bernadotte also designed silver and furniture. Ht (bowl in foreground) 12.5cm/5in.*

2 *Aluminium, a metal developed at the beginning of the 20th century, is combined with a new plastic, melamine, in this Italian* Cubo *ashtray designed by Bruno Munari and made by Danase Milano in 1957. Ht 8cm/3⅛in.*

3 *Carl-Arne Breger's fruit juice pitcher of 1957–8 showed that plastic was an ideal material for food preparation and storage. Breger was a prolific designer of tableware, utility plastics, and sanitary fittings for the Swedish firm, Gustavsberg. Ht 33.5cm/13¼in*

4 *Earl Tupper's designs, such as these lidded bowls of 1949, revolutionized food storage through his twin inventions of a method for moulding polyethylene and an airtight seal. Diam. 15.5cm/6in.*

5 *There was real economy in the use of plastics for general domestic use, but Gino Colombini did not compromise on good design in even the most basic household implement, like this plastic dustbin of 1955.*

In today's world life without plastics is incomprehensible. Scientific research brought the first plastics to consumers at the beginning of the twentieth century. By mid-century, designers in Europe and America were firmly ensconced in the manufacturing process, bringing their knowledge of production techniques and an eagerness to work with new materials. Plastics grew into a major industry affecting almost every aspect of life – from providing improved packaging and new textiles, to permitting the production of wondrous products and cutting-edge technologies in such things as televisions, cars, and kitchen appliances.

Post-war social changes, particularly in Europe, led to an emphasis on the kitchen and its equipment. Fitted kitchens with colourful Formica-topped work surfaces and streamlined labour-saving devices such as refrigerators, vacuum cleaners, electric mixers and kettles, and washing machines were soon widespread. Pressure on space meant that design was often focused on compactness, and many of these new gadgets, made from combinations of metal and plastic, were simple and easy to clean, sometimes almost clinical in appearance.

Furniture design was also profoundly influenced by plastic as a new medium for achieving some of the striking abstract shapes that marked the post-war period. When plastic was used for furniture in the 1950s it was chosen not just for its amazing malleability but because it could be moulded into the extreme organic shapes that designers promoted. In addition it could be simply cleaned with a sponge. The furniture designer Charles Eames committed himself to understanding plastics technology, working closely with Zenith Plastics to perfect the resin-impregnated fibreglass shell that he wanted to use for his moulded plastic chairs. Additionally, furniture designers found that plastic laminates could be used in a similar manner to traditional veneers, except that with plastics the surface could be plain and brightly coloured or act as a replacement for a painted surface. Synthetic fibres were also used by textile designers and incorporated into their

6 *Woven brightly coloured plastic upholstery opened up entirely new possibilities for outdoor furniture as seen in these examples from the mid 1950s. Ht 85cm/33⅓in.*

7 Prolon *unbreakable dinnerware by George Nelson brought strong colours and durability to the dinner table. Assorted sizes.*

8 *Russel Wright popularized the modern style in America beginning in the late 1930s, and continued to bring inspired designs to the public through the 1950s. He worked in many media, including metals and ceramics, and ventured into plastic tableware with his* Melmac *dinnerware for Northern Industrial Chemical. L. (large platter) 37cm/14½in.*

9 *Designers often used new metals together with plastics. This desk clock for Herman Miller shows the fluid possibilities of plastic in a simple domestic object. W. 19cm/7½in.*

10 *The malleable possibilities of plastic allowed designers new freedoms never before experienced with other materials. This surreal looking pedestal ashtray by Caillon is on a bent metal stand ready to receive the hot ash. Ht 65cm/25½in.*

Streamlined and Serviceable

1 *If an appliance can be sculpture, then the design work of Marcello Nizzoli provides superlative examples. He designed the legendary* Lexicon 80 *and* Lettera 22 *typewriters for Olivetti but his work also extended to the swooping sculptural lines of his* Mirella *sewing machine for Necchi, 1957. L. 45cm/17¾in.*

2 *Gerd Alfred Müller designed some of Braun's best-known products including this kitchen machine KM3 of 1957 made of polystyrol housing. The clean lines and rational design brought a sense of order and efficiency into the post-war kitchen. L. 50cm/19¼in.*

3 *When Artur Braun and his brother Erwin took over their family radio manufacturing firm in 1951, they created a new design aesthetic stemming from functionalism. This table radio, SK2, designed by Artur Braun and Fritz Eichler in 1955, is a characteristic product. Ht 15cm/6in.*

4 *Raymond Loewy's work was pervasive and prolific. In the 1940s and 50s an estimated three out of four Americans came into contact with one of his products each day. Loewy's early push-button television of 1948 was one of the first examples of its kind.*

5 *Dieter Rams developed Braun into one of the most influential design firms of household appliances. This* Radio-Phono-Kombination SK4 Phonosuper, *designed with Hans Gugelot in 1956, was the first of a series of revolutionary combination phonograph and radio devices. W. 58cm/22¼in.*

weaving, together with traditional materials. And when woven as upholstery, plastics were a durable alternative to easily-worn textiles.

With domestic objects for the table, plastics served the post-war household perfectly. They were durable and mar-resistant and, together with the new appliances that were ostensibly created to make a housewife's work easier, they were also intended to streamline domestic life. Plastics were not derided as some inferior substance demoted for the kitchen alone: many products made of plastic were praised for fine design as early as the late 1940s. In 1947, in an article in *House Beautiful*, Earl Tupper's amazing containers with seals that made them airtight were compared to art objects and their material to alabaster and jade.

Other milestone objects include Sigvard Bernadotte and Acton Bjørn's *Margrethe* bowls of 1950, Carl-Arne Breger's covered bucket of 1959 and Russel Wright's *Melmac* dinnerware for Northern Industrial Chemical. Often, designers worked hand in hand with the scientists

to devise new materials but more frequently they created objects to suit them.

Designers in the post-war era wholeheartedly believed in the power of design for everyday living. Designers of unique studio pieces created items for industry and industrial designers generated ideas for objects made of glass and porcelain. Contemporary design was undertaken in the belief that the appearance of things affects the way that we experience life around us.

The first priority for designers of appliances was to shape an object that would fulfil its purpose. This overarching concern with functionalism was the ethos that led the design of everyday things like razors, radios, toasters, lamps, television sets, and even ballpoint pens. The sweeping curves of Marcello Nizzoli's *Mirella* sewing machine, the stark simplicity of Braun's radio of 1955, the graphic success of Raymond Loewy's push-button television, all miraculous in their capabilities, placed function together with form to create some of the most pleasing objects for the home.

6

7

8

9

6 *Women's work changed dramatically after the war and new materials and designs were part of that transformation. The 1955 Saunders iron of moulded pyrex was a completely new design that felt as sleek and easy to use as it looked.*

7 *These table fans of 1954 could easily be mistaken for parts of an aeroplane. The designer, Ezio Pirali, was the director of the Italian electrical appliances firm Zerowatt. Diam. 25.5cm/10in.*

8 *Even with new technology and design moving at today's rapid pace, this chrome toaster, manufactured by Dualit, still enjoys success and longevity in the market place for domestic appliances. L. 36cm/14¼in.*

9 *Television design in the 1950s had progressed from Raymond Loewy's push-button version of 1948 to this sleek television and stand designed by Robin Day, ultimately a furniture designer, for Pye in 1957. Television monitor w. 43cm/17in.*

10 *Table lamps produced by the Dutch firm Philips in the 1950s were similar in style to American lighting from the same period. This steel table lamp, 1950–60, bears all the evidence of its construction in its design.*

11 *Gaetano Scolari was a designer for the Italian firm Stilnovo. His designs, like this standard lamp of 1955, fit within the Stilnovo aesthetic of clean-lined and functional light fittings.*

10

11

The Space Age

1960–69

Terence Conran, the founder of Habitat, summed up a key aspect of design in the 1960s. "There was a strange moment around the mid-sixties when people stopped needing and need changed to want… Designers became more important in producing 'want' products rather than 'need' products." This fundamental change meant that design was no longer just about function, economy, reliability, and longevity, but equally embraced impact, identity, and stylishness. It became a subject that fascinated the increasingly affluent public with their greater disposable income, extended leisure time, higher expectations, and an apparently endless craving for novelty and excitement.

The 1960s were about change, which was almost invariably seen as "progress." Progress was one of the touchstones of the decade and was used to justify a rash of changes in different arenas from fashion to technology and morality. Indeed, progress was seen not only as desirable but inevitable, and, according to Harold Wilson, the new Labour leader in the UK, it would be delivered by the "white heat of the technological revolution to create a classless, meritocratic society." The spirit of progress was captured in the "space race" which commenced at the very beginning of the decade when the youthful president of the USA, John F. Kennedy announced: "I believe that this nation should commit itself to achieving the goal, before this decade is out, of landing a man on the moon and returning him safely to earth. No single project in this period will be more impressive to mankind." The space age was presented by politicians such as Harold Wilson, as "a time for a breakthrough to an exciting and wonderful period in our history, in which all can and must take part. Our young men and women, especially, have in their hands the power to change the world. We want the young of Britain to storm the new frontiers of knowledge…"

The post-war social revolution came to fruition in the 1960s. A society in which everyone knew their place was rapidly being superseded by a progressive, meritocratic one in which opportunities for the young were plentiful just so long as they had talent – which was now no longer defined by the established standards of the past. It was a time of great mobility – everyone seemed to be "on the move" both personally and socially. It was also a time of changing lifestyles and an expansion of moral codes and practices which frequently led to friction between traditionalists and the young and, indeed, to the "war of the generations." Because of the sense that anything was possible, and the sense of unbridled belief in the future, the decade was, without doubt, a great time to be young.

Left: Verner Panton, Panton stacking-chair, 1960. The famous 1960s futuristic chair seems to flow like liquid. It was produced in a wide range of different colours. Ht 83.5cm/33in.

Opposite: in the mass media and popular imagination, London's Carnaby Street conjured up everything that was supposedly "swinging" about the sixties – impact, energy, visual excess, brightness, boldness, clashing decoration, and, of course, youth. Tom Salter's period-piece graphics typify the sense of excitement and energy.

3 *President Kennedy declared "No single project in [the 1960s] will be more impressive to mankind" than landing a man on the moon. The quest indeed captured the popular imagination, and provided a rich source of imagery which influenced designers.*

1 *The Beatles represented all that was youthful and novel in the decade: they were assertive, brash, stylish, and witty. For one old-fashioned critic, their sound evoked "connotations of dinner music for a pack of hungry cannibals." Such criticism was music to the ears of the group's young audience.*

2 *Andy Warhol,* Soup Can, *1962, After the heroic spirituality of Abstract Expressionism, Pop Art, such as this, seemed a denial of all that was supposed to matter in art. But to the children of the mass media age its popular consumerist subject gave it true relevance and appeal.*

In 1959 *Vogue* magazine had noted that "young" was appearing "…as the persuasive adjective for all fashions, hairstyles, and ways of life." By 1963, the media had become obsessed with youth's values, trends, and idols. Pop music – whether by the Beatles, the Rolling Stones, the Who, the Beach Boys, or Motown – was youth's rallying call, and it frequently also became its battle cry. It was a tool of rebellion and a means of expressing identity. Innumerable records were released, some of which became hits, but most of which sank into obscurity. Pop music aspired to the condition of fashion in which change was the only constant. According to George Melly in 1962, the young demanded "…music as transitory as a packet of cigarettes and expendable as a paper cup." Young people wanted music that was for *now*. Fashion followed suit and quickly became a topic of widespread

interest and debate in 1963. It was at this time that the word "pop" became the catchword for any style or sound associated with the young – including the new painting style, Pop Art.

The young became an important consumer market group in the 1960s for two reasons. First and foremost was the economic factor: full employment and the increased affluence of their parents meant that teenagers and those in their twenties had disposable income in enticing quantities and so became a much sought-after consumer group. Secondly the "baby boom" following the Second World War meant that this new generation was a significant part of the population in demographic terms.

The consumer society had also given rise to changed attitudes among young people. The "children of the age of mass communication" were the first generation who

were born *after* the war and who had little memory of post-war austerity. They had the money to be extravagant and were encouraged by the consumerist society so to be.

Design reflected and expressed the decade perfectly. It was not only formed by the social and cultural forces of the time, but also helped to shape them. The mood of youthfulness, the spirit of novelty, and the ethos of desire were most seductively portrayed in the colour supplements – one of the symbols of the era. Their approach to design was epitomized in the first "design for living" feature in the British *Sunday Times* colour supplement. It appeared soon after the magazine's launch in 1962 and said "Poor design has become a target for anyone with a brick to throw: good design is treated as a sort of sacred cow. The attitude to function is racing to the same level of absurdity; testing is turning into an obsession. There are times when one longs to buy something plumb ugly and utterly unfunctional."

This was an attack on the refined Scandinavian taste of the 1950s, and the supposedly rational, objective product design examined in consumer-testing magazines. In their place the colour supplements encouraged an emotional and subjective approach to design based on novelty, desirability, and fashionable taste. It was an approach successfully adopted by stores like Habitat – a "shop for switched-on people" according to its founder Terence Conran – and exploited the aspirations of young, professional, upwardly mobile buyers for an eclectic ensemble of design which ranged from the fashionable, through the utilitarian, to design classics.

Design classics – such as Marcel Breuer's "Wassily" chair – were being reproduced in the 1960s, and major re-evaluations and exhibitions of the Bauhaus and de Stijl took place. By the end of the decade Modernist design was no longer the preserve of a few design proselytizers but was accepted by whole tiers of the middle classes and found its way into both the office and the domestic interior. However, a transformation had taken place. Modernism had lost its moral authority: what once had been a moral crusade become merely a style of design, part of a lifestyle of knowing sophistication. Modernist classics took their place in the colour-supplemented showroom alongside Italian gadgets, 19th-century "downstairs" cookery equipment, country pine furniture, disposable plastic cutlery, and Art Nouveau-styled paper carrier bags. Indeed what characterizes 1960s design is not any stylistic unity or shared aesthetic, but an increasing diversity of styles, forms, and – beyond them – diverse attitudes and values about the role and nature of design in society.

4 *Denys Lasdun, National Theatre, London, 1967–76. London's South Bank typified the architectural profession's love of inelegance, Corbusian-inspired raw concrete, and – as one important architect put it – "bloody-mindedness." It was a reaction against tastefulness and "good manners."*
5 *Psychedelic graphics, Victor Moscoso. The psychedelic style expressed the values of the counter-culture in their "purist" form and represented rebellion, eclecticism, youthfulness, sensuousness, and a general Dionysian outlook in which drugs, music, and sex featured prominently.*

Furniture

Cult New Chairs

1 *Carlo Scolari, Donato D'Urbino, Paolo Lomazzi, and Gionathan De Pas,* Blow Chair, *1967. This chair quickly became a cult object and represented the age of immediacy and novelty, although in reality its form was quite conventional. Ht 83cm/33in.*
2 *Piero Gatti, Cesare Paolini, and Franco Teodoro,* The Sacco, *1968. The chair's twelve million granules took the shape of the sitter's body and thus provided a variety of sitting positions. It came in a choice of eight colours. Ht 68cm/27in.*
3 *Joe Colombo,* Chair 4801, *1963. The three plywood elements, which are loosely slotted together, give a sculptural and even childlike feel to the chair, which is enhanced by its range of four colours. Ht 58.5cm/23in.*

In the 1960s, the critic Mario Amaya writing in *The Spectator* argued that contemporary experimental furniture designers "…parallel our painters and sculptors in inventing new shapes and forms through the use of new materials." The origins of this bold age of furniture experimentation dates back to the mid-1950s, when new thinking with materials and forms produced designs that reflected the affluence and greater individualism of the times. Charles Eames' moulded plywood shell and down-filled leather lounge chair 670 (and the accompanying ottoman), first manufactured in 1956, quickly became one, if not the chair most coveted by the design-conscious public, appearing countless times in interior design yearbooks and up-market magazines during the 1960s.

Glass-fibre had become an increasingly commonly used material at the experimental, up-market end of chair design in the 1950s. In furniture, the flowing, organic shape of Eero Saarinen's "Tulip" pedestal chair of 1956–7 had an enormous influence on younger generations of chair designers, while Verner Panton's "Panton" stacking chair of 1960 was the first chair to be manufactured in a moulded, continuous glass-fibre shell.

Chairs by Eames, Saarinen, and Panton may have graced the pages of design annuals in the late 1950s and early 1960s, but they inhabited a very small number of ordinary homes. Mass taste at this time was still attuned to "colonial," "rustic," and pseudo-antique styles. The emerging design-conscious young professionals, however, considered this type of popular conventional taste beyond the pale. For their part, they sought furniture that was modern and attractive, but not necessarily something which they would keep for decades. It was common to find Scandinavian furniture in the homes of the design-conscious middle classes of this period. This type of furniture was characterized according to one advertisement of the time as having the "…light, bright look of cool colours, crisp textures and simple, clear-cut lines." It appealed because it was elegant, refined, and appeared *natural*.

Storage Systems

1 *Joe Colombo, Additional System, 1968. One of the ideas in good currency in the later years of the decade was flexibility and adaptability in furniture. Colombo's standard components permitted a great variety of forms.*

2 *Joe Colombo, Boby storage, 1968. Many late-1960s Italian designs for plastic furniture were popular throughout the 1970s, although the fashionableness – and cost – of plastic was affected by the energy crisis.*

Italian Sculptural Chairs

1 *Sergio Mazza, Toga chair, 1968. The rounded shapes of the Toga combine with the smoothness of form, perfection of surface, and impact of the orange or white to express the design mood of the late 1960s. Ht 65cm/25½in.*
2 *Gaetano Pesce, Up 1 Chair, 1969. Pesce said that this sort of design was "against all that is finite, blocked, static, constant, predictable, programmed, probable, absolute, coherent, continuous, uniform, and monotonous…". W. 86cm/34in.*
3 *Cesare Leonardi and Franca Stagi, Dondolo rocking chair, 1967. This chair, described as a "semi-work of art," exemplifies the sculptural tendency in 1960s furniture. It was available in three colours. L. 1.25m/4ft 1in.*

1 *Habitat, interior of shop, 1960s. With the opening of the first Habitat in 1964, "lifestyle" design fully arrived. Terence Conran's aim was to run "a swinging shop for switched-on people."*

2 *Peter Murdoch, paper furniture, 1964. The paper chair may have been more symbolic than functional; it held a promise of truly disposable furniture that was fun. Ht 68cm/26¾in.*

3 *Robin Day, Polyprop chair, 1964. Day came from an older generation – his approach was essentially Modernist in seeking standardization, simplicity, and anonymity. Ht 81cm/32in.*

But the cultural changes that were occurring in the early 1960s meant that even contemporary Scandinavian design received its share of criticism in the new consumer journalism of the colour supplements. Priscilla Chapman, writing in the *Sunday Telegraph* colour supplement in 1965 attacked "…thin, weedy-looking rooms. Neutral rooms filled with bland teak sideboards, smooth stain-resistant table tops, and mean chairs, the whole 'brightened' with Swedish glass. Part of the trouble with these rooms is that they're dull."

One furniture trend in the 1960s was connected with the development of corporation culture. The new company headquarters and offices were furnished in a consistent, aesthetically sophisticated way with modular units and Modernist aesthetics.

There was also a boom in building institutional buildings such as universities and hospitals, which often utilized "knockdown" furniture. This had interchangeable components which made it economical to produce, and easy and cheap to replace. Such furniture also became available for the domestic market and could be assembled at home by the purchaser from a flat-pack kit of parts. Knockdown furniture had some appealing benefits for consumers. Compared with standard furniture, it was slightly cheaper, it was more likely to be in stock because it was easy to store, which made instant purchases possible, and it was also easier for consumers to transport home. The vast majority of knockdown furniture in the mid-1960s was, however, conventional in appearance and had limited appeal for those yearning for "young" and fashionable furniture. As one commentator observed in 1965, it was inevitable that the young who bought fashionable clothes and went to discos would "want furniture in up-to-the-minute colours, pop shapes and pop, op, or wild floral patterns: stuff which is cheap enough to repaint with a[n] …aerosol spray or throw away when a new style, pattern, or colour appears."

The most complete example of fashionable and disposable furniture in the 1960s was the so-called "paper" chairs, which usually comprised three different

4 *Max Clendinning, Maxima range, 1966. Clendinning aimed at the young, fashionable market and those "in touch." Nearly 300 pieces of "transformation furniture" could be assembled from the 25 standard parts which came in a number of lacquers. Ht 80cm/31¼in.*

5 *John Wright and Jean Schofield, Chair C1, 1964. With its dominant curves and strong colours, the chair was described at the time as "transitional, at a stage between the functional stuff and designs with a bit of wit and whimsy." Ht 80cm/31½in.*

6 *Bernard Holdaway, Tomotom furniture, 1966. Holdaway believed that furniture should be "cheap enough to be expendable." The white, red, blue, yellow, green or purple chair sold for about £2, with the table retailing at just under £7. Table ht 75cm/29½in.*

7 *Ernest Race, folding chair, 1960s. The growth of the public sector in the 1960s created a need for design that could be mass produced in keeping with a spirit of modernization. This chair was specially produced for a school museum service. Ht 75cm/29½in.*

8 *Allen Jones, table sculpture, 1969. This was part of a limited edition project by Jones that linked the subject matter of Pop Art with design. It serves to remind us that the imagery of the 1960s could be controversial in its sexism. Ht 61cm/24in, l. 1.85m/6ft 1in.*

1 *Eero Aarnio,* Pastilli *chair,
1968. Like many items of plastic
furniture, the* Pastilli *was
available in a range of bright
colours. Being so low made it
stable, but the sitter could
also make it rock or roll.
Ht 52cm/20½in, l. 93cm/36¾in.*
2 *Eero Aarnio,* Globe *chair, 1966.
The soft, padded interior not only
gave a feeling of almost womb-like
protection and calm: it contrasted
with the space-age, white exterior.
The* Globe *was one of the most
photographed chairs of the decade.
Ht 1.2m/3ft 11in,
w. 1.05m/3ft 5in.*

papers to make a board of five laminates, giving it a washable finish and the ability to stand prolonged wear for three to six months. The chairs were stamped out as a piece of flat card, which was decorated in bright Op or Pop patterns. These decorations were printed on to it at the same time as the card was pressed and scored. The most famous paper chair was designed by Peter Murdoch in the UK; it was manufactured in the USA, and received widespread international recognition.

Inflatable furniture, usually made from polyvinyl chloride (PVC), upheld the Pop characteristics of youthfulness and fashionability. Some pieces were also designed to be disposable. In the latter part of 1967 inflatable chairs by Quasar Khanh, the French team of Aubert, Jungman, and Stinco, and the Italian design team of Scolari, Lomazzi, D'Urbino, and De Pas became available in Europe and the USA, and were widely written about. Although it was expensive, the Italian designers' *Blow* chair (see p.456) became the best-known inflatable chair. Khanh's inflatable chairs were slightly

cheaper. The claims made for disposable furniture, however, were sometimes as inflated as the furniture itself. For example, one commentator – Lena Larsson, writing in the journal *Form* in 1967 – made the prediction that "…pretty soon our whole household can be moved in a big bag – when inflatable plastics and folding cardboard have become popular as furniture materials. The trend towards simpler and cheaper furniture is already under way and cannot be stopped. It will probably alter our whole attitude towards furniture and furnishings, leading to a freer, less pretentious, less status-conscious milieu."

Also evidence of the trend towards less formal, cheaper forms of furniture were "bean bags." These were chairs that contained as many as twelve million plastic granules or polystyrene beads, which adjusted to the shape of the sitter's body. The first, and one of the most stylish bean bags, was *The Sacco* (see p.456). It was available in eight colours, and was designed in 1968 by the Italian team of Gatti, Paolini, and Teodoro.

3 *Poul Kjaerholm,* Table PK 54A, *1963.
The simplicity of 1950s Scandinavian design
was continued into the next decade,
demonstrating that the furniture tradition
could remain alive and relevant.*

4 *Hans Wegner,* The Hoop Chair, *1965.
Although not put into production until the
1980s, this chair evokes a period of innovative
form and an experimental use of materials.
W. 1.05m/3ft 5in.*

5 *Antti Nurmesniemi,* Chais 001, *1968.
Nurmesniemi's chaise goes further than many
of its predecessors in being very low and
giving a sense of ease, while maintaining a
Modernist simplicity. Diam. 1.4m/4ft 7in.*

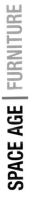

3 *Verner Panton,* Panton *stacking
chair, 1960. This famous design
went beyond Saarinen's Tulip
pedestal chair in making the chair
"all one thing again." Available in
a range of colours, it is not so
much organic as liquid in its
effect. Ht 83.5cm/33in*

1 *Ilmari Tapiovaara,* Wilhelmina *chair, 1960.
The chair looks like such a "one-off" that it is
surprising to learn it was designed to be
stackable. The design was awarded a gold
medal at the 1960 Triennale in Milan.*

2 *Nanna Ditzel and Jorge Ditzel,* Swinging
Chair, *1959. Although in keeping with the
"swinging sixties," it was designed in the late
fifites. The choice of materials contrasts with
Aarnio's* Globe *chair. Ht 1.25m/4ft 1in.*

SPACE AGE | **FURNITURE**

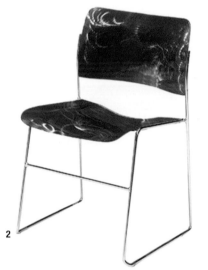

1 *George Nelson,* Sling *sofa, 1964. Nelson's designs provide a "softer" Modernism, which was much favoured by corporations as a symbol of their modernity and sophistication. L. 2.22m/7ft 3in.*
2 *David Rowland,* 40-in-4 *stacking chair, 1964. The stacking capability of Rowland's finely detailed and visually cool chair was virtually unequalled – 40 of these strong, fireproof chairs could be placed in a stack four feet (1.3 metres) high. Ht 76cm/30in.*
3 *Richard Schultz,* Leisure Collection *chair, 1966. There is a confident handling of form in this Knoll production, perhaps explained by the fact that Schultz was a sculptor as well as a furniture designer.*
4 *Charles Eames, lounge chair, 1958. This was one of the first variations on Eames' iconic lounge chair of 1956. Technically innovative, it also fulfilled a different function as corporate furniture. Ht 84cm/33in.*

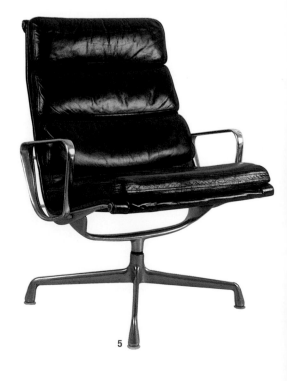

5 *Charles Eames, lounge chair, 1969. This was another variant of the 1956 chair. The make-over, utilizing "softpad" cushions, made it appear even more luxurious and comfortable. Ht 94cm/37in.*

6 Corporate office design. The role of design in representing efficiency and modernity was firmly grasped in the 1960s, and complemented the individualism and expressiveness of much personal design.
7 Estelle and Erwine Laverne, Invisible chair CH-1, 1962. The Lavernes' chair paid homage to Saarinen's Tulip chair, but married the organicism with the magic and appeal of transparency. Ht 1.37m/4ft 6in
8 Wendell Castle, Castle armchair, 1967. Castle combined sculptural forms with traditional craft techniques and materials. Appropriately, he described himself as a cross between an artist and a designer. Ht 61cm/24in.

8

7

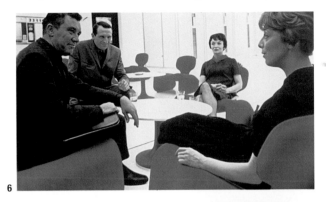

6

10 Roberto Sebastian Matta, Malitte lounge seating, late 1960s. Matta's design was almost infinitely rearrangeable to adapt to different spaces, or be combined as sculpture when not in use. Ht 1.56m/5ft 1in.

9 Olivier Mourgue, Bouloum chair, 1969. Mourgue specifically intended the chair to have a distinctive personality, and this thinking led to some of the anthropomorphic chair designs of the 1980s. W. 71cm/28in.

9

10

Derivatives of *The Sacco* quickly became available and were relatively inexpensive and popular.

Italy enjoyed leadership in furniture design throughout the decade. The designers Vico Magistretti, Joe Colombo, Alfa and Tobia Scarpa, and Mario Bellini, as well as others, all established or consolidated their reputations for elegant and increasingly adventurous designs. Their work was often manufactured by Cassina in Italy or Knoll or Herman Miller in the USA. Their work, praised by critic Mario Amaya as "semi-works of art," included forms that were part functional chair, and part sculptural object.

The majority of trend-setting chairs in particular came from Europe, and especially from Italy. Some, including the sculptor César's chair of 1969, made use of injection-moulded polyurethane foam. The majority of visually innovative chairs, however, exploited the myriad formal possibilities of various plastics, especially moulded glass-fibre. Alberto Rosselli's *Jumbo* chair of 1967 and *Moby Dick* chaise longue of 1969 both used moulded glass-fibre to

create a flowing, bulbous but light mass. Eero Aarnio's 1968 *Pastilli* chair, offered in a range of six colours, used moulded glass-fibre to create a solid and heavy-looking form that was circular in plan, while Cesare Leonardi and Franca Stagi's *Dondolo* rocking chair of 1967 developed the rigid structural strength of glass-fibre to create an elegantly twisting plane in space.

The sculptural innovation faded away at the beginning of the 1970s, partly because of the change of mood created by the energy crisis. However, already in the last years of the 1960s, experimental designers were moving away from designing furniture that was a "semi-work of art" to being concerned with total environments. In 1969 the British designer Max Clendinning argued that: "Followed to its extreme, furniture would be a series of versatile, interchangeable, multi-purpose cushions" and, in the final years of the decade, designers became interested in flexible designs and total environments – another innovation in an open-minded decade in which furniture design flourished.

Ceramics

Studio Pottery

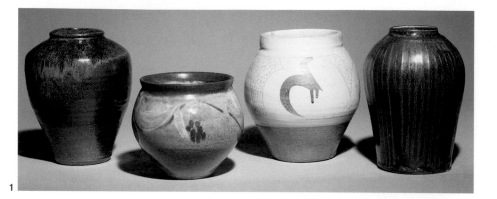

1 *Bernard Leach, stoneware vases, 1967. Leach – and all that he stood for in terms of truth to materials, sensitivity of handling, and form deriving from function – continued to influence traditionalists, but became a symbol against which to rebel by an anti-establishment, young generation of ceramic artists. Ht (from left to right) 22.5cm/8¾in, 15cm/6in, 20.5cm/8in, 21cm/8¼in.*

2 *Otto and Gertrud Natzler, vase, c.1962. The Natzlers brought European ceramic traditions to the USA when they emigrated there to escape the threats of the Second World War. The combination of elegant form and beautiful glaze gave their work enormous authority and influence. Ht 34cm/13in.*

3 *Lucie Rie, stoneware bottle, 1967. The liberation of sculptural form is apparent in Rie's work although, compared to the Funk pottery emanating from the USA, her work is restrained and balanced.*

By expressing modernity and freedom of expression, ceramics in the 1960s typified their times. Whatever the style, dinnerware was being modernized on a mass scale. The affluent young sought ceramics that were stylish, modern, and fashionable such as the industrially produced ranges from Scandinavian, Italian, and British companies which made use of bright colours, bold patterns, and graphic decoration. Here were items that were functional but fun.

Dinnerware also acquired a decidedly high art connotation in the decade, with Rosenthal's Studio Line by a range of artists from Lucio Fontana, through Victor Vasarely, to Eduardo Paolozzi. These were relatively expensive ranges and indicate that ceramics and art were moving closer together.

But it was in studio pottery where, in typical 1960s fashion, boundaries began to blur. In the 1950s, studio pottery had enjoyed a revival and traditional potters such as Bernard Leach were highly regarded. But in the early 1960s, initially on the West Coast of the USA, artist-potters such as Peter Voulkos created work that departed from ceramic tradition. Flat slabs were joined to wheel-thrown forms with epoxies to create hybrids of ceramics and art that seemed to owe more to Abstract Expressionism and Picasso than to any of the masters of the mainstream pottery tradition. The spirit of so-called "Funk ceramics" was summed up by Robert Arneson: there were to be "no academic hierarchies… no worshipful old timers whose word was law… everybody worked as they saw fit."

The new aesthetic of roughness, polychromy, and anti-refinement was in keeping with the wider rebellious aesthetic of the time. The forms emphasized the intrinsic properties of material and surface, and took on unusual imagery, from toasters and typewriters to the kitchen sink. Pop Art had a profound influence on this generation: for the 1960s avant garde, whether ceramics was craft or art was irrelevant. For them, the materials and medium took their place alongside other creative practices such as painting and fiber art. All were part of a continuum of possibilities and a means of personal expression.

4 *Jessie Tate, Midwinter dinner service, 1962. As a result of increased affluence and "design as lifestyle," owning a fashionable and desirable dinner service mattered to many young people.*

5 *Hans Coper, stoneware composite bottle, c. 1962. Coper's finely balanced shapes add up to a sculptural relationship of forms that create a Modernist-influenced but traditionalist-derived work. Ht 20.5cm/8in.*

6 *Peter Voulkos, vase, 1954. The guru of the 1950–69 ceramic revolution, Voulkos helped put ceramics on an equal footing with other art forms, replacing shapes inherited from functional vessels with sculptural forms. Ht 35.5cm/14in.*

7 *Robert Arneson, Toaster, 1966. Arneson was one of the leaders of the West Coast Funk movement. His ceramics paralleled Claes Oldenburg's soft, Pop Art sculptures in transforming everyday, banal objects into forms of – according to one critic – "brash and virulent social commentary."*

8 *Beatles mug, c.1964. The 1960s saw the rise of design ephemera, and what was to become memorabilia, selling at major international auction houses by the 1980s. Ht 8.5cm/3½in.*

4

5

6

9 *Ettore Sottsass, Burma totem sculpture, 1964. Sottsass' large ceramic and glass sculptures reintroduced ideas about symbol, iconography, and ritual in the context of Pop and innovation. Ht 2.08m/6ft 10in.*

7

8

9

Glass

New Organic Shapes

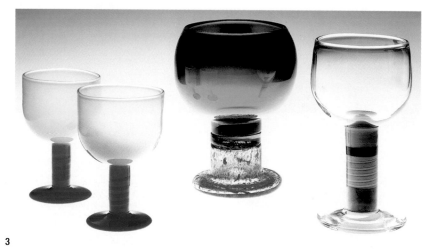

1 *Harvey Littleton, glass objects, 1975–6. Littleton was key in the creative development of glass. The invention of new formulae meant that the designer could also be a maker on a domestic scale. Littleton's work shows the new sculptural possibilities. Ht (tallest) 33.5cm/13¼in.*
2 *Tapio Wirkkala, Kanttarelli vase, 1947. In the 1940s–50s Wirkkala designed a piece that won him international recognition. A decade later, his work became more sensuous and sculptural, confirming Wirkkala's standing. Ht 8.5cm/3½in.*
3 *Gunnar Cyrén and Kaj Franck (middle), Pop goblets, 1965–6. Cyrén remembered that, "In 1965, after visiting several big aquariums with all their fantastic exotic fishes, I began to enjoy myself by doing these goblets with multicoloured stems. We made them in a hundred different colour combinations." Ht (left pair) 16cm/6¼in.* **3**

After the Second World War glass design became more organic, with silhouettes often simple and apparently functional. The "Glass 1959" exhibition at the Corning Museum in New York was a showcase for the dominant tendencies, but also a swansong. For, in 1962, the Toledo Museum of Art in the USA sponsored two seminars at which glass was blown from a new formula that could be melted at a temperature low enough to be workable in the studio or classroom. Very soon it was possible for designers to make their own glass.

In the 1960s and '70s there was a studio glass revival. Designers moved away from forms with a clear outline to more irregular, broken, and occasionally eccentric shapes with uneven colour and texture, and diverse decorations. Glass was treated as a medium of artistic expression, and even the nominally functional forms of the 1950s were superseded by decorative or sculptural experiments. Typical of the new tendency was a rediscovery of Art Nouveau and, in particular, the designs of L.C. Tiffany and Emile Gallé. Art Nouveau, with its sinuous,

sensuous, idiosyncratic shapes and often extreme asymmetry, was deemed to evoke the 1960s mood of rebellion and decadence. In glass, the technique of *pâte-de-verre*, associated with Art Nouveau, was redeployed and the Daum factory issued works by contemporary sculptors including Salvador Dalí and César.

Scandinavian design flourished in the 1960s. Finnish designers Tapio Wirkkala and Timo Sarpaneva created a free-flowing, adventurous style, reflecting the mood for individualism and experimentation. At the Kosta works in Sweden, Bertil Vallien and Goran and Ann Warff exploited the new aesthetic sensibility for colour and flowing form. But it was in the USA where a new attitude to glass was most pronounced. Sam Herman's work ranged from simple and formal free-blown lead glass, through abstract, sculptural mirrored glass forms, to Pop Art-influenced glass sculptures. In the 1960s, glass offered many creative possibilities, and a paper presented at the eighth International Congress of Glass in 1968 sums up the era: "Artist-produced glass: a modern revolution."

4 *Timo Sarpaneva,* Finlandia Bamboo *vase, 1964. The winner of several major awards, Sarpaneva designed many different objects – from cast-iron cooking ware to wrapping paper – but is particularly remembered for his highly sophisticated glass of the 1960s. Ht 15cm/5⅞in.*
5 *Kaj Franck,* Wartsila-Nuutajärvi *bowl, 1967. The nature of glass as an organic, almost living entity is captured here. Franck wanted the object to "stand on its own merits."*
6 *Oiva Toikka,* Lollipop Isle, *1969. Toikka, who became artistic director of the Arabia Works, designed domestic wares for factory production but also used glass as a sculptural medium for one-off artistic creations. Ht 38cm/15in.*

7 *Salvador Dalí for Daum,* pâté-de-verre *sculpture, 1970. Just as Rosenthal commissioned artists for their Studio Range, so Daum engaged sculptors including Salvador Dalí to design "artistic" glassware. Ht 76cm/30in.*
8 *Sam Herman, group of mirrored forms, 1970. These are essentially sculptures, and have a kinship with the experiments taking place in the fine arts in the 1960s. Ht 39cm/15½in.*

Metalwork

Stainless Steel

1 *Stuart Devlin, parcel-gilt silver mace, 1966. Commissioned by the Worshipful Company of Goldsmiths as a gift to Bath University, the mace fuses tradition with a commitment to the modern age sought by those responsible for expanding higher education in the 1960s. L. 85cm/35in.*

2 *Robert Welch, stainless-steel coffee set, c.1966. Welch and designers like him in the USA and Europe, were responsible for popularizing a conservative Modernist style within the middle class market. Coffee pot ht 27cm/10½in.*

3 *Keith Tyssen, silver candelabrum, 1966. Like the mace, it was also commissioned by the Worshipful Company of Goldsmiths, in this case for Exeter University, and combines tradition with a certain degree of innovation. Ht 46cm/18in.*

"The products of the ancient craft of the silversmith, however modern in design, however graciously pursued, will perhaps seem marginal to the mainstream evolution of metalware design and as such will assume the character of an essentially anachronistic luxury." So wrote the decorative arts expert Philippe Garner, summing up the situation of silverware in the 1960s and '70s. Modern, elegant silverware was, indeed, still produced in the 1960s by the likes of the Danish firm Jensen or the British Worshipful Company of Goldsmiths. It was seen to its best effect where designed for traditional ceremonial settings – maces or candelabra for modern universities, for example, and bowls or goblets for the Church. Similarly as happened in glassware, there was an Art Nouveau influence on silver design in the 1960s, but little was produced that broke boundaries and conventions as had been happening in ceramics and glass.

However, the adoption and development of stainless steel by medium to large manufacturers was to to be an exciting development for designers producing works for a society characterized by increasing mass affluence and a concern with style related to daily living. Although it had been in use since the 1920s, stainless steel was thought of as a "modern" material, and thus appropriate for the technological age. A new emphasis was given to it through flatware competitions such as the one organized by the Museum of Contemporary Crafts in New York in 1960.

In the 1960s, designing for companies such as Boda Nova, and Pott and Viners, designers such as Robert Welch, Gerald Benney, David Mellor, Folke Arnstöm, and Carl Pott brought into currency a modern aesthetic in metalware design. An undoubted modernity of simplicity and chunkiness was complemented by a range of finishes which were also relatively novel, and contrasted with "conservative" silverware. As Carl Pott has stated, a more modern society in which speed and convenience are expected requires materials that are "…much tougher, [with] utensils able to stand up to added abuse. Stainless steel, and then also steel mixed with nickel and chrome in special alloys, were introduced to meet these needs."

4 *David Mellor, stainless-steel* Thrift *cutlery, 1965. The cutlery was commissioned by the Ministry of Public Buildings and Works and testifies to an age when the public sector was a significant commissioning agent. The five-piece range was designed for relatively cheap manufacture.*
5 *Tapio Wirkkala,* Composition *cutlery, 1963. Wirkkala's* Composition *has a modern, sculptural feel to it, especially the knife, which resembles a Cubist sculpture and contrasts with the rounded forms of the rest of the cutlery.*

6 *Georg Jensen,* Acorn *condiment set. 1951. Jensen's designs are consistently elegant throughout the 1950s and '60s. He pursued dual interests of sculpture and silverwork, and maintained a creative dialogue between the two.*

7 *David Mellor, stainless-steel teapot, 1965, commissioned by the Ministry of Public Buildings and Works. It introduced modern, well-designed functional ware to a range of users in government canteens and prisons. Ht 14cm/5½in.*

8 *Arne Jacobsen,* Cylinda line *tableware, 1967. Combining tradition and innovation, it won several awards including the Association of Industrial Designers' International Design Award in 1968. Teapot ht 17cm/6¾in.*

Fashion and Textiles

Shapes and Styles

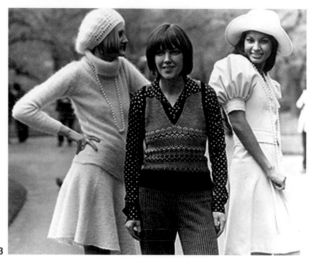

1 *Nina Ricci dress, 1962. At the beginning of the 1960s,* haute couture *showed little awareness of the social and cultural changes that were gathering momentum. This garment, from the Fall 1962 collection, owes its style to the preceding decade.*

2 *Designed by John McConnell, the Biba logo was clearly sourced from Art Nouveau, but became an undeniably 1960s symbol. A revamped, Art Deco-inspired logo was introduced in 1969.*
3 *Mary Quant (centre) with models wearing her* Ginger group *clothes which made use of simple but dramatic patterns. Completed by Vidal Sassoon's thick chopped bob, "the look" came into being.*

"What does fashion represent?," asked *Vogue* in 1959, "Decoration? Armour? A mood of society?" Whatever the answer, the magazine thought it beyond doubt that, "For millions of working teenagers now, clothes… are the biggest pastime in life: a symbol of independence, and the fraternity mark of an age group." Youthfulness was becoming central to fashion as the 1960s began, and sources of fashion inspiration were beginning to change, with styles now trickling *up* from the street to mainstream stores. In this, young fashion buyers rejected "good taste" and high style, and no longer did the Parisian *haute couture* fashion houses enjoy unrivalled authority.

In keeping with the mood for youthfulness and change, fashion became a topic of national interest and debate in 1963 – the year when "legs never had it so good." The emphasis on legs was underlined by the arrival of the mini, while skirts were flared or widely pleated for ease of movement. The significance of this was that it was the first mass fashion truly to belong to youth – it was clearly unsuited to the older generation.

In the public's eyes, Mary Quant epitomized the new mood in fashion. Her trip to the USA in 1962 was highly successful and helped to establish British leadership in young fashions. Quant realized that there was now a mass market for the type of clothes she was designing: "…there was a real need for fashion accessories for young people chosen by people of their own age. The young were tired of wearing essentially the same as their mothers." Conditions were ripe for development, and designers blossomed as the market grew. Marion Foale and Sally Tuffin were typical of the new young designers who rapidly rose to fame in 1962 and 1963. The pair left London's Royal College of Art with the cry, "We don't want to be chic; we just want to be ridiculous." Rather than dictating a new fashion trend to customers, they were themselves a part of it – so much so that they were able to say, "we only design clothes that we want to wear." It was not long before Laura Ashley arrived on the scene with her sprigged cottons for clothing and interiors. Her influence was to last for at least two decades.

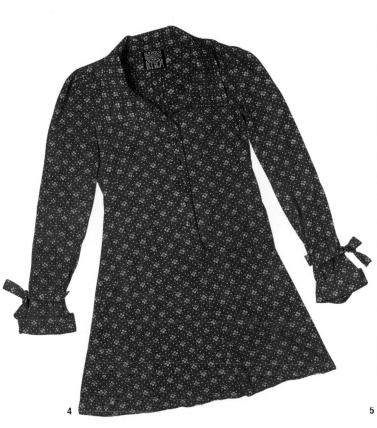

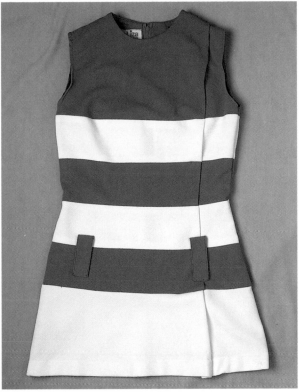

4 *Biba fashions. Barbara Hulanicki and Stephen Fitzsimmon initially sold "in a hypnotic atmosphere of pounding pop music and swinging short skirts…for girls who want lots of new, cheap, not very well made clothes…", according to one writer at the time.*

5 *Mini dress. By the middle of the 1960s, the mini was getting shorter and becoming the most obvious expression of the new age. Fashion determined by class and wealth was being superseded by fashion determined by age.*

6 *One of the most alluring contrasts of the time was the micro or mini dress and the maxi coat – a classic of concealment and display. Maxi coats partly derived from the fashion for military attire.*

7 *Courrèges, Space Age range, 1965. Courrèges was the first fashion house to rethink fashion in the 1960s, moving to something far younger – a "new way of dressing which fits the age," as the founder put it.*

2 *Ossie Clark and Amanda Pollock, gypsy style fashion, 1968. There was a rediscovery of ethnic styles in the late 1960s. Apart from offering flamboyance, ethnic styles expressed something of the "global village" thinking of the time.*

1 *Pierre Cardin, fur-trimmed, woollen, plaid coat with woollen gaiters, dark gloves, and dark hat, 1965. Cardin ranged from demure and elegant to expressive and sensationalist; from this to space-influenced helmets.*

"Mod," used both as a noun and an adjective, became the blanket term for these young styles. The International Fashion Council in 1964 acknowledged the youth market as a "style of fashion," and the trade journal the *Tailor and Cutter* said, "…for the first time ever, many fashion influences are emanating from the under-25 group." Fashion may have been breaking down class barriers but it was creating a new condition of membership: age.

Energy and movement became an early symbol of youthfulness. *Vogue* in 1962 called for "space-age clothes that can be launched to cram into suitcases, crush into narrow spaces for long journeys, and emerge at the end laboratory-fresh." The quotation captures several aspects of the mood of the time with references to space (with its technological adventure), journeys (the excitement of being "on the move" as opposed to "settled down"), speed of living (no time to pack well), and science (technology was glamorous and progressive). The new fashion had to serve today's lifestyle, which did not allow time for changing into outfits for different occasions in order to

conform to traditions and conventions. Young females were now told they needed clothes that could be put on "…first thing in the morning and still feel right… at midnight; clothes that go happily to the office and equally happily out to dinner." The pace of contemporary life was, supposedly, hectic; and – certainly if the fashion writers were to be believed – it was fun.

Energy and fun were closely related to sexuality. Quant stated "sex appeal has Number One priority" in female fashion design. One of the most extreme examples was the "topless" fad of 1964 which received sensational publicity, but there were also more socially acceptable dresses with sexy cut-away sections, and bikini dresses with netting panels. The dresses almost invariably revealed less than at first seemed the case, and were sometimes worn with a flesh-coloured body stocking.

It was in male fashion that the shock of the new had greatest impact. Up to the time of Pop, male clothes were sombre and discreet. Any extrovert display was taken as a snub at decorum and good taste. If a woman's clothing

Use of Materials

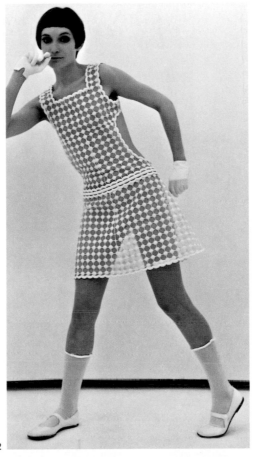

1

1 *Jean Shrimpton modelling woollen cardigan and matching tights, 1965. Chunky texture returned to clothing in the 1960s. It was particularly popular with the young because of its visual and tactile appeal.*
2 *Courrèges, day dress, 1967. Fashions often included materials cut in an unusual way, or worn provocatively. The body stocking was used to retain modesty.*
3 *Paco Rabanne, metallic dress, 1965. In the 1960s fashion used an innovative "expanded field" of materials. Metal dresses conveyed an image of modernity, progressivism, and a lack of softness, perhaps equivalent to Brutalist architecture.*

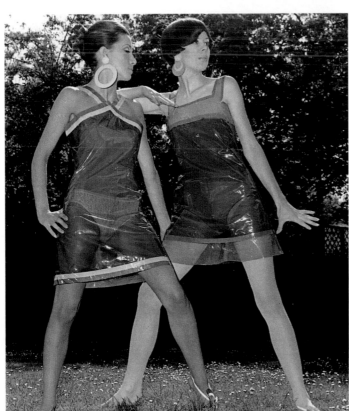

2

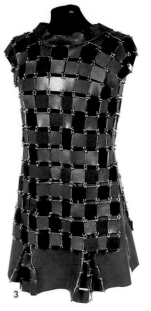

3

4 *Daniel Hechter, plastic dresses, 1966. Hechter's dresses were supposed to be disposable, conforming to the Pop ethos of "massive initial impact and small sustaining power." Untraditional fabrics showed commitment to a fast changing technological age.*
5 *Emmanuel Ungaro, aluminium bra and mini skirt, 1968. Ungaro's clothes were part clothing, sculpture, and body jewellery. Experimentation and extremism were accepted as part of what fashion was about in the decade.*

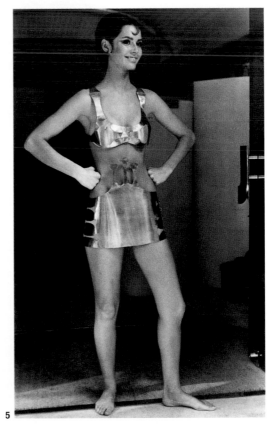

4

5

1 *Eddie Squires,* Lunar Rocket *printed cotton, 1969. Space was a direct inspiration for this bold and colourful design which was intended "to celebrate the hoped-for landing of a man on the moon."*

2 *Sue Thatcher,* Space Walk, *1969. Eddie Squires says it was influenced "mainly by the technology involved in attempting to place a man on the moon. Science fiction, also a strong influence in the 1960s, played its part as well."*

3 *Barbara Brown,* Expansion, *furnishing fabric, 1966. This Op Art design for Heals in London, shows how the Op Art craze in the mid-1960s had moved from painting to encompass not only graphics, but also furnishing textiles.*

4 *Maija Isola,* Melooni *fabric, 1963. Isola had a major impact on the Finnish textile industry. The boldness of scale and brightly coloured geometric patterns countered the decorum associated with Scandinavian design in the previous decade.*

5 *Eddie Squires,* Archway *textile, 1968. Squires has described how the inspiration for* Archway *came from "1930s cinema architecture, the painter Roy Lichtenstein [and] colour blind test charts." By the end of the 1960s, a retro style based on Art Deco was becoming a key ingredient in textile design.*

6 *Pierre Cardin, wool carpet, c.1968. Carpet designers were influenced by Pop colours and shapes. Carpets now clamoured for attention just as much as the furnishings that stood on them.*

8 *Ann Sutton, weaving, 1969. Sutton relates how, in the early 1960s "many weavers went to wildly uncontrolled limits but then became a key influence on the more flexible thinking in industrial textile design."*

7 *Peter Collingwood, weaving, 1960. Collingwood's textiles exhibit a sophisticated sensitivity toward colour and an exquisite use of materials.*

9 *Op furnishing fabric, 1966. This fabric, designed by Barbara Brown for Heals, demonstrates how the Op craze in the mid-1960s moved from painting to graphics and furnishing textiles.*

was supposed to make her attractive to the opposite sex, the motivation behind men's fashion was, conventionally, to denote status. However, red denim trousers, purple shirts, green sweaters, and even brightly coloured shoes were to appear, with fashion magazines reporting a wholesale plunder of ideas from female fashions. One commentator bemoaned the "new concentration on visual impact at the *complete expense* of quality." But expendability and the condition of continual change were the very essence of Pop.

The space race unsurprisingly influenced fashion design. PVC was a material that had to be used in a modern way – as designer Sally Jess said, "It's a material you can't work nostalgically, you have to make modern shapes." The forms – such as see-through visors – often came from the imagery of space. PVC was produced in "razzle-dazzle bright colours," Op and floral patterns, "hygenic white," and see-through. But it was silver PVC that most closely reflected the fashion for space. Courrèges brought out "moon girl" silver trousers in 1964

and, by 1965, *Queen* contended silver clothing "…fits into current fashion like an astronaut into his capsule."

The inexorable rise of the mini continued and, in 1967, it became the "micro," its length little longer than the level of the crutch indicating, according to Quant, that "…women are in charge of their sexual lives." From 1967 to 1969 there were annual autumn predictions that the mini would not survive the winter, but such a utilitarian approach to clothing overlooked the more important functions of clothing in pop fashion. At the end of the decade the maxi became fashionable but did not eclipse the mini. One answer to winter temperatures was the maxi plus mini: a mini skirt worn under a maxi coat. Other solutions were trousers worn under mini skirts, and the mini skirt made into culottes or, later, "hot pants."

The historical achievements of pop fashion were outlined by the design commentators Ken and Kate Baynes. The visual creativity of 1960s fashion was such, they argued, that "one day 'Carnaby Street' could rank with 'Bauhaus' as a descriptive phrase for a design style."

Industrial Design

Clean Modern Lines

1 *Office interior. The growing awareness of the appearance of everyday items led to an increase in corporate identity redesigns as companies communicated their up-to-dateness and sense of modernity and progressivism.*
2 *Capsule kitchen at the Design Centre, London, 1968. An influence of the space race can be seen in this kitchen, the space age equivalent of the fitted kitchen, with moulded plastics rather than wood or veneers to maximize every space.*
3 *AEI Hotpoint Automatic 1501 washing machine, 1966. The "1501" is an example of "cleanlining" in the design of white goods in the 1960s, giving an up-to-date appearance.*
4 *Joe Colombo, mini kitchen on casters, 1963. Even kitchens could be mobile in the 1960s. Compactness, efficiency, and miniturization had a deep appeal to the 60s' psyche. W. 113cm/44in.*
5 *Kenneth Grange, Egg table lighter, 1968. Designed for Ronson, the lighter epitomized three aspects of 1960s design: it was made of plastic and was white in colour – both connoting modernity – while its rounded form was typical of the decade. Ht 5cm/2⅛in.*

Innovations in Transport

1 *Moulton bicycle, 1964. A radical rethink of the bicycle led to the Moulton and, following it, a series of small-wheeled bicycles with springs. Rethinking the bicycle – unchanged for 60 years – was typical of the decade.*
2 *Ford Mustang, 1966. The Mustang offered excitement and appeal at an affordable price – high speed in high style.*
3 *Mini car, British Motor Corporation, 1959. Designed by Alex Issigonis and produced from 1959, the Mini became one of the icons of the period, combining the possibility of movement with the promise of fun.*
4 *Concorde, designed from 1956–62. The supersonic plane was hailed as a symbol of progress for its speed, and berated as a symbol of technological anti-humanism for its noise.*

1

2

3

4

The rise of private affluence and the subsequent growth of consumerism guaranteed a golden age for industrial design in the 1960s. No longer was it a question of whether or not you owned a car, TV, or refrigerator, but rather whether you owned the right make and model. Rather than competing on lowest cost, some companies began to pursue a high-profile design strategy in which sophisticated styling gave the product added value and desirability. Braun, for example, from the mid-1950s began to transform its image through the work of designers such as Dieter Rams. It created products which were not only desired but were collected by style-conscious individuals and even by aesthetically aware museums, predominant among which was the Museum of Modern Art in New York. The Pop artist Richard Hamilton once perfectly summed up this attitude. Writing of Rams' work for Braun, Hamilton declared that "…his consumer products have come to occupy the place in my heart and my consciousness that the Mont Saint-Victoire did in Cezanne's."

Industrial design occupied a prominent place in the consumer landscape, and was a recurring motif in the aesthetic life of the style-conscious individual. Mainstream product design by the likes of companies such as Braun, IBM, and Olivetti may not have been directly influenced by space travel, but it certainly connoted modernity and progress. The widespread use of undisguised plastics, clean-cut or novel shapes, and the absence of ornament and decoration in industrial design underlined just how much the 1960s was, at the time, viewed as a break with the past.

Form itself could indicate the image of modernity. On the one hand, the innovative forms of Italian lighting and objects appeared progressive because they were a radical break with conventions. Less innovative forms also appeared very modern when they exploited materials and colour in a certain way. Kenneth Grange's 1968 *Egg* lighter is a case in point, and epitomized three traits of a strand of later-1960s design. First, although it is sophisticated in finish and warm in tactile quality, the

4 *Brightly coloured plastic goods. The synthetic characteristics of plastic were no longer disguised but, in effect, were celebrated for their modernity, immediacy, and boldness.*

1 *Enzo Mari,* Pago-Pago *vases, 1969. A design innovation, this was a vase that could be inverted, offering a small container at one end, and a larger one at the other. The form evokes 1930s design, but retains a 1960s appearance. Ht 30cm/11¾in.*

2 *Ephemera by Dodo Designs. The eclecticism and decorativeness of ephemeral design are captured in this illustration of products made by Dodo Designs Ltd.*

3 *David Mellor, white disposable polystyrene cutlery for Cross Paperware, 1969. Disposability became a feature of design in this decade. It was assumed that there were more interesting and enjoyable things to do than clean or wash items for re-use.*

material is not seeking to be anything other than that archetypically 1960s material, plastic. Second, it is white, a "colour" associated primarily with space and, by extension, with hygiene, efficiency, purity, and clarity. Third, the form has the bottom-heavy, rather weighty proportions visible in much plastics design, especially in the furniture of the time. Such forms may have been facilitated by the characteristics of plastic as a material and the technique of injection-moulding, but it was more than technological determinism that accounts for the heavy shape. Taking the particular instance of the *Egg* lighter, the Pop sensibility and wit of using the inappropriate and incongruous image of an egg for a lighter obviously appealed to Grange, but the proportions of the object evoke a whole period. The rounded forms are to the later 1960s what rectilinear forms were to the 1920s and the streamlined shape to the 1930s. All signify modernity but with different associations. The rectilinear style referred to industrial mass-production and the machine; streamlining to the

fast movement through water and air; the rounded shape to structural strength, completeness, and perfection. Rounded, continuous forms look like technology in a futuristic state. Emphasis was no longer given to the rational and logical industrial processes of production (as it had been with Modernist design) but to a *gestalt* form which seems to have been as mysteriously conceived and magically produced as a seamless gown. These rather Mannerist formal tendencies are what now gives this style of 1960s design such a dated appearance.

However, the white technological look was only one of the main tendencies in product design in the 1960s. More evocative of the period were brightly coloured plastics. Plastics in the earlier part of the century had been largely dark or mottled because of the problem of blemishes and colour inconsistencies. In the 1930s lighter tones were used for radios and other consumer goods but, although bright colours were available in the period between the wars, it was not until the 1950s that they were used widely across a whole range of products. Bright

5 *Inflatable cushion with Pop graphics by Peter Max, late 1960s. At the more ephemeral end of design, impact was the salient quality. Pop and Op art became frequently quoted styles and were popular with the young.*
6 *Morphy Richards, toaster, 1961. Mary Quant immortalized the toaster in 1966 with her daisy print.*
7 *Kenneth Grange, razor, 1968. Designed for Wilkinson Sword, this safety razor was easy to use and looked good. Like the Kodak compact cameras by Grange, the razor gave stylishness at a moderate price. L. 13cm/5in.*

8 *Olof Backstrom, O-series scissors. Made for Fiskars, this humane design is based on typical Scandinavian ergonomic considerations and a sensitive feeling for form. L. 22cm/8½in.*
9 *Ronson, portable hairdryer, mid-1960s. The imagery of space with the astronaut's life-support system and helmet is evoked by this portable hairdryer. It satisfied the yearning for design on the move.*
10 *Paul Clark,* Perspective Design *clock, late-1960s. Functionality counted little compared to the fashionable impact of these novelty clocks, which drew on the stylistic trends and bold graphics of the day. Ht 23cm/9in.*

11 *Angelo Mangiarotti,* Secticon *table clock, 1962. The* Secticon *was typical of the undecorated, pure, organic, flowing style, facilitated by the use of plastics. Ht 24cm/9½in.*

SPACE AGE | INDUSTRIAL DESIGN

1 *Ettore Sottsass and Perry King,* Valentine *portable typewriter for Olivetti, 1969. Sottsass intended the* Valentine *to for "any place except in an office, so as not to remind anyone of monotonous working hours, but rather to keep amateur poets company on quiet Sundays in the country." Ht 35.5cm/14in.*
2 *Olivetti,* Tekne 3 *typewriter, 1965. Olivetti established itself as a company committed to stylishness as well as efficiency.*
3 *Marco Zanuso and Richard Sapper,* Grillo *telephone, 1965. The* Grillo *– meaning "cricket" – combined technological and mildly zoomorphic forms without sacrificing functionality. L. (open) 22cm/8½in.*

4 *"Standard" telephone, 1963. Following the introduction in the UK of STD (Standard Trunk Dialling) in 1959, there was a conscious effort to modernize the telephone system. Design played its part as seen here. Ht 12cm/4¾in.*

monochromes became available and suited the appetite of the later part of the 1960s for bold, unsubtle colours. In his celebrated *Mythologies* essay (1957), the philosopher and cultural commentator Roland Barthes expressed misgivings about the quality of the colour of plastic: "…it seems capable of retaining only the most chemical-looking [colours]. Of yellow, red, and green, it keeps only the aggressive quality, and uses them as mere names, being able to display only concepts of colour." Yet what for Barthes was plastic's "undoing" became a central part of its aesthetic in the 1960s.

Plastic in a range of bright red, purple, orange, green, yellow and other vivid colours were used for chairs, occasional tables, television and record-player casings, lamp bases, dinnerware, tumblers, jewellery, and many other things. The bright colours perfectly expressed the mood of the decade. Polyurethane – either wet-look or foam – glossy ABS, shiny and/or transparent acrylic, and PVC were not only used undisguised but seemed to flaunt their very "plasticness." This trend went beyond

the Modernist "truth to materials" principle to a stage at which the associations of plastic became part of the "meaning" of the product: plastic was, in a way, both form and content.

This had come about because of the two-way exchange of Pop culture. No longer was it a case of popular artifacts being influenced by high culture; in Pop culture, "high culture" drew heavily on "low culture." The most obvious examples were in art: Lichtenstein made use of the comic strip, while Andy Warhol plundered the supermarket shelves for inspiration.

During the 1950s plastic had been used in all manner of "cheap and nasty" ways to make toys and trinkets. Consequently it had become discredited in the eyes of discerning consumers who associated it with poorly made, easily broken, and visually tawdry goods manufactured in the Far East. However, views were to change. Consumers began to value expendability over durability in the mid-1960s. Especially when a self-conscious campness and tongue-in-the-cheek kitsch

1 **Acrylic Shades.** A simple shade, ideally hung low over a table. 14 ins diameter complete with flex and lampholder. 60–100 watt. Can be used with the rise-and-fall unit shown on page 57.
L21101—Red
L21102—Orange
L21103—Blue
L21104—Opal white Each **£4·10**

2 **Orb Light.** A two-part acrylic shade especially designed as a centre pendant where only one lighting point is available. Gives a soft diffused light. Complete with flex and lampholder. 12 ins diameter. Can be used with the rise-and-fall unit shown on page 57. 60–100 watt.
L21105—White/white
L21106—Smoke/white
L21107—Orange/white
Each **£6·97**

3 **Polyhedron** do-it-yourself card shade. 12 ins diameter. Each kit makes up into several shapes; two or more kits can be joined together to form additional designs. Price is for one kit.
L07106—White **80p**
L07107—Blue **90p**
L07108—Orange **90p**
L07109—Red **90p**

4 **Japanese paper lanterns.** The most versatile and cheapest form of lampshade. They fold flat when not in use, and are a very effective fitting when only one central lighting point is available. The wattage shown is the *maximum* recommended.
L22109—14 ins shade, white (100 watt) **82p**
L22101—14 ins shade, orange (100 watt) **82p**
L22102—14 ins shade, yellow (100 watt) **82p**
L22103—14 ins shade, green (100 watt) **82p**
L22107—14 ins shade, blue (100 watt) **82p**
L22104—16 ins orange (150 watt) **£1·10**
L22105—16 ins yellow (150 watt) **£1·10**
L22106—16 ins green (150 watt) **£1·10**
L22108—16 ins blue (150 watt) **£1·10**
L22110—19 ins white (150 watt) **£1·30**
L22126—24 ins white (200 watt) **£2·55**

5 **Spun aluminium shades** 17 ins diameter. Six stunning colour combinations, crisp white interiors. Complete with white 3-core flex and lampholder. 100–150 watt. Use low over a table.
L19101—Mustard/white band
L19102—Coral/light orange band
L19103—Mustard/coral band
L19104—Blue/white band
L19105—Purple/red band
L19106—Blue/green band
Each **£6·97**

2 *Achille Castiglioni, Toio floor lamp, 1965. There is an uncompromising technological look to the Toio. It was to become a favourite among high-tech devotees in the late 1970s and early '80s. Ht 1.65m/5ft 4in*

3 *Gae Aulenti, space age-influenced metal lamp, 1969. Designers such as Aulenti appreciated the light weight, strength, and difusing characteristics of plastics. They could be moulded to produce complex and sculptural forms. Ht 27.7cm/11in.*

4 *Achille and Pier Giacomo Castiglione, Snoopy lamp, 1967, manufactured by Flos. Achille Castiglioni admitted the interest of the time was "centred not so much on solving the problems of lighting in its fullest sense as on emphasizing the decorative quality of fixtures when they are without light." Ht 40cm/15¾in.*

5 *Bruno Munari, Falkland hanging lamp, 1964. A metal frame supports an elasticated fabric to create an idiosyncratic and sculptural form, which draws attention to itself as a designed object. Ht 1.6m/5ft 3in.*

1 *Habitat lighting, 1971. This page from Habitat's catalogue shows the variety of novel lighting available by the end of the decade. Lighting became fully stylized in the 1960s.*

1 *Marco Zanuso and Richard Sapper, radio, 1965. The ingenious design of this radio meant that it could be folded up to make a box, and thus it was ideal for the man or woman on the move. Ht 13cm/5in.*
2 *Phillips, Philitana transistor radio, 1963. The "trannie" was one of the great symbols of the age: it gave consenting teenagers wall-to-wall pop music and dissenting adults a headache. W. 20.5cm/8in.*
3 *Marco Zanuso and Richard Sapper, television, 1966. Here is the pure, technological "black box," the forerunner of many similar designs in the 1970s, and an important influence on high tech design.*

became fashionable in the latter part of the decade, plastic's *other* associations were eagerly embraced. Plastic was inexpensive and was associated with a feeling of impermanence, and – most importantly – a sense of immediacy, youth, lack of subtlety, and fun. The result was all sorts of gimmicky, eye-catching, attention-grabbing novelties made in plastic. These ranged from plastic-coated paper dresses to inflatable PVC cushions emblazoned with the legend "Pop" – all of which were likely to end up being thrown away into a plastic-coated wastepaper basket.

A whole range of objects was styled for youth's all-action lifestyle of energy and movement in the 1960s. Two items of industrial design in particular, however, typify the Pop spirit of the decade. One was Ettore Sottsass' *Valentine* portable typewriter for Olivetti which, with its style-conscious form and bright-red colour (and orange spools), looked more like a weekend case for the space-age *bon viveur* than a piece of mundane workaday equipment. The other great symbol of movement and

freedom was the transistor radio. As transistors became widely and cheaply available, the "trannie" changed radio-listening habits among the young. The image of the homogeneous nuclear family huddled around the piece of furniture that was the wireless became as anachronistic a concept as rationing. The trannie's essential portability meant that pop fans could listen to music in any room in the house: they need never be away from the Top 20 and need never be aurally isolated in an alien environment of nature or silence. The styling of some transistor radios, often in plastic, underlined their associations with portability. Radios often borrowed the imagery of the walkie-talkie or the army combat radio.

So, by the early 1970s, there was a wide range of product aesthetics for industrial design, deriving, at one extreme, from Modernist principles of "less is more," with connotations of purity, efficiency, and hygiene, to, at the other, the Pop sensibility, which subverted principles and conventions of "good taste" in favour of impact, novelty, youth, and fun.

Space Age Cameras and Televisions

1

1 *Marco Zanuso and Richard Sapper,* Acolor *television, late 1960s. The space age clearly influenced the design of consumer products such as this.*
2 *Murphy, television, 1968. In the 1960s graphics were sometimes applied to ordinary items, such as televisions, to give them a fashionable, up-to-date appearance. Television ht (not including stand) 53cm/21in.*

3 *Sony, portable television, 1959. The use of transistors reduced the size and weight of appliances and made them portable, which facilitated an all-action lifestyle. Sony often led the way in innovations such as this. Ht 24cm/9½in.*
4 *Kodak,* Carousel *slide projector, 1964. The solid, heavy-duty, "gut form" look of the* Carousel *gave a reassuring message about the projector's reliability and durability.*
5 *Kodak,* Instamatic 100 *camera, 1963. Photography became a popular mass activity in the 1960s, and a number of cameras were designed to look stylish and professional, while still being easy to use and excellent value for money.*
6 *Kenneth Grange, Kodak* Brownie Vecta *camera, 1966. The portrait form of this mass-market camera came about because Grange said it suited photographing people (the majority of photos taken).*

Postmodernism

Originally meaning "later than Modern," the word "Postmodern" has been subject to many interpretations. The term has at its heart a distrust of Modernist theories and approaches to design as being impoverished in terms of visual language and restrictive in terms of meaning. Postmodernist architect Robert Venturi, for example, argued for artists to work in an idiom that was readily intelligible rather than esoteric, in tune with the values of popular culture. Stylistic eclecticism is a key feature of the movement, and so is a deliberate incorporation of images relating to late-20th-century consumerism.

The term Postmodern has been taken up in many disciplines, including sociology, film, music, communications, literature, and cultural theory, where influential writers such as Jean Baudrillard and Jean-François Lyotard have explored its meanings. In his book *The Post-Modern Condition* (1984), Lyotard saw the "Post-Modern" as a rejection of the universal certainties of the Modernist world in favour of the local and provisional. Other writers, such as the Marxist Frederic Jameson, have seen Postmodernism as a form of American cultural imperialism, or an expression of multinational and consumer capitalism. Perhaps appropriately for the pluralist world of Postmodernism, it is evident that the term is one that has been adopted in many different ways and contexts and has a range of resonances and meanings.

In the field of design, definitions of Postmodernism have varied in their usefulness. An early use of the word can be found in the work of the British design and architectural historian Nikolaus Pevsner, author of the widely read *Pioneers of Modern Design* (1949). In a 1961 essay entitled "The Return of Historicism" he detected what he viewed as an unwelcome, but increasingly visible "Postmodern" trend towards stylistic eclecticism, a feature that was to become one of the defining characteristics of Postmodernist architecture and design.

A year later, the American architect and designer Robert Venturi articulated many additional qualities associated with Postmodernism in his seminal text *Complexity and Contradiction in Architecture* (1966). The book has subsequently given him a prominent position in Postmodernist practice and debate in the visual arts. He admired "elements which are hybrid rather than 'pure', compromising rather than 'clean', distorted rather than 'straightforward', ambiguous rather than 'articulated', … inconsistent and equivocal rather than 'direct and clear'." This firm rejection of the tenets of Modernism was taken further in his 1972 book, *Learning from Las Vegas*, written with fellow architects Denise Scott Brown and Steven Izenour. Taking exemplars drawn from the neon-rich, eclectic, and everyday language used in the visual

Left: George J. Sowden and Nathalie Du Pasquier, Neos clock, 1987. The design draws on Sowden and Du Pasquier's interest in colour and form as a means of enriching the visual langauge of design solutions for everyday products through fresh explorations of form, colour, and texture. Ht 26.5cm/10½in.

Opposite: Studio Alchymia, installation. This dramatic environment, and especially the excess of the chandelier, reflects the opposition of this experimental Milan-based group to the restrained elegance and "good taste" of mainstream Italian styling.

3 *Alessandro Mendini,* Kandissi *sofa, 1979. A rich fusion of colour, pattern, and non-functional elements, this sofa reflects Mendini's commitment to the possibilities of design unconstrained by mass-production technologies and orthodox solutions. L. 1.25m/4ft 1in.*

1 *Neville Brody, spread from* The Face *magazine, May 1983. The surface of this page from a leading style magazine is broken up visually with decorative devices and type in different styles and sizes, reflecting individualistic trends in the commercialized street-influenced style of post-Punk fashionable graphic ephemera.*

2 *Ettore Sottsass,* Lydia *glass vase, c.1980. This colourful and innovative exploration of the expressive and decorative potential of glass is indicative of the ways in which members of the Memphis Group saw crafts as a laboratory for the exploration of new ideas. Ht 49cm/19¼in.*

articulation of the façades of leisure and entertainment buildings in Las Vegas, Venturi argued for architects to work in an idiom that was readily intelligible and in keeping with the values of popular culture.

In fact, much of the genesis of definitions of Postmodernist design lay in the hands of architects and architectural writers, historians, and theorists. Charles Jencks, like Venturi an American architect and writer, for example, has been a defining voice in discussions of Postmodernism. He has elaborated his views in various articles and books, including *The Language of Postmodern Architecture* (1977) and *Postmodern Classicism* (1983), and has also been involved in the design of many Postmodern buildings, interiors, furniture, and other products.

Seen by many of its exponents as a radical current that opened up new expressive possibilities in architectural and industrial design practice, Postmodernism was also bound up with notions of the ephemeral and fashionable in graphics, clothing, and retail design. Geoff Hollington, a leading British industrial designer, saw it in the late 1970s as "a breathless eclecticism that encompassed mass-media imagery, arts and crafts, Art Nouveau and Deco, popular iconography and drug experience."

However, by the 1980s there were increasing doubts about the usefulness of the new term. Perhaps predictably, in his 1983 critique of the Modernist architectural aesthetic *From Bauhaus to Our House*, the American writer Tom Wolfe extended the focus of his trenchant opprobrium to Postmodernism, suggesting that the term had "caught on as the name for all developments since the general exhaustion of Modernism itself. As Jencks himself remarked with some felicity, Postmodernism was perhaps too comforting a term. It told you what you were leaving without committing you to a particular destination. He was right. The new term itself tended to create the impression that Modernism was over because it had been superseded by something new."

For several decades prior to the later 1960s Modernism had been the predominant form of expression in avant-garde design. However, it had evolved from its origins as an emphatically 20th-century avant-garde international aesthetic embracing new materials and technologies, wedded to a spirit of social utopianism, to being increasingly associated with the implied efficiency of multinational corporations. In an era of expanding global markets, these included such companies as IBM, whose

corporate identity was made visible in products and communication design by Eliot Noyes and Paul Rand. Modernism had been increasingly equated with notions of "good design" as seen in design collections at the Museum of Modern Art in New York or in the outlook of official bodies promoting "better" standards of design in industry – such as the Council of Industrial Design in Britain and the Rat für Formgebung in Germany. From the late 1950s, however, this essentially puritanical outlook was undermined by an increasingly consumerist society: people had plenty of disposable income and an increasing appetite for rapid change and the wider cultural horizons offered by television and the growth of foreign travel. Furthermore, the advent of Pop Art in design, the Anti-Design movement in Italy and a growing interest in semiotics and the significance of popular culture also undermined the tenets of Modernism. Writers such as Gillo Dorfles and Roland Barthes did much to challenge the restricted syntax of the Modernist visual dictionary. They opened up enticing vistas of colour, pattern, and ornament, and offered popular, exotic, and occasionally erudite cultural references which were increasingly attractive to architects and designers.

Although the history of Postmodernist design has often centred on the output of a number of American architect-designers – such as Robert Venturi and Michael Graves – or leading Italian designers – including Ettore Sottsass and Alessandro Mendini – it also found expression in many other design-conscious countries. These included Spain and the Czech Republic, where the rich colours, exotic references, and freedom of cultural expression of Postmodernism in many ways vividly symbolized the democratic freedoms that had been so constrained under Fascist and Communist regimes. It also proved attractive to avant-garde designers in Japan and Australia where it provided a radical departure from prevalent commercial styles.

Further invigorated by the iconoclasm of Punk, Postmodernist possibilities were explored across the full range of visual and design media, from fashion to furniture, interiors to graphic design, and cutlery to kettles. However, the initially radical, yet accessible fashion outlook of designers such as Vivienne Westwood or the graphic inventiveness of typographers such as Neville Brody, whose work was seen in the magazine *The Face*, were soon absorbed into the more conservative world of museum collections and exhibitions. In the later 20th century, a world more and more dominated by the mass-media was opened up further by the panoramas afforded by the Internet. In addition, an increasingly prevalent first-hand familiarity with diverse cultures and styles brought about by the tremendous growth in foreign travel led to a climate in which cultural eclecticism and visual quotation were perhaps as rife as they had been in Victorian design. However, the difference in the eclecticism of late-20th-century Postmodernist design lay in the fact that it was – at its most effective – a knowing and occasionally ironic or witty meeting of old and new, traditional and ethnic, esoteric and popular, and cheap and expensive styles and materials.

4 *Hans Hollein, interior of the Austrian Travel Centre, 1975. The interior's function is embraced by references to exotic travel including palm trees, an example of how the Postmodernists sought to link design and meaning.*

4

Furniture

International Postmodern

1 *Ettore Sottsass, Park table, 1983. The "functional" potential of decorative forms is explored in the "legs" of this table designed by Sottsass, the major catalyst of post-1970 avant-garde Italian design activity. However, unlike its Modernist counterparts, "form" clearly does not "follow function." W. 1.3m/4ft 3in.*

2 *Michele de Lucchi, Kristall table, 1981, in laminated plastic, wood, and metal for the Memphis Group. De Lucchi's colourful and original solution to the design of a small table reflects the innovative approach of the Italian avant-garde, with which he was involved from the 1960s. Ht 62cm/24½in.*

3 *Michael Graves, Stanhope bed, 1982. The volumetric forms reflect Graves' architectural pedigree. The combination of different materials and an eclectic range of stylistic sources endow the object with new expressive potential.*

Many of the ideas most commonly associated with Postmodern furniture derived from the experiments of American architect-designers who increasingly turned their hands to design in the later 1970s and 1980s. Equally significant were Italian designers such as Alessandro Mendini, Ettore Sottsass, and Michele De Lucchi who emerged from the experimental activities of the Milan-based Studio Alchymia and Memphis Group. The latter aligned themselves with the term "New Design," seen by Andrea Branzi as being "able to influence both the world of production and theoretical development," as well as breaking down what he described as "the barrier" that had separated mainstream design from avant-garde experimentation. Designers such as Borek Sípek – who studied furniture design in Prague and architecture in Hamburg and Delft – also explored the possibilities of Postmodernism in Eastern Europe.

Sottsass felt that Postmodernism was essentially American, academic, and restricted in the range of cultural differences upon which it drew. Nonetheless, its characteristic ability to draw upon both refined and popular cultural sources, to embrace kitsch, the everyday and the banal, and to exhibit qualities of wit, irony, and playfulness meant that it became a shared international language of design. Expensive materials and finishes were blended by Postmodernist designers with cheaper laminates and plastics, industrial techniques were combined with inspiration drawn from the crafts, while the mingling of references as diverse as African and Aboriginal, Baroque and Biedermeier, or Classical and coffee bars offered new aesthetic prospects.

Bolstered by its increasing appearance in museum collections, exhibition galleries, and style magazines and by its association with designer-celebrities, Postmodernism was explored as an increasingly fashionable commodity in much of the industrialized world. Appearing in countries as geographically dispersed as the USA, Japan, and Australia, Postmodernism brought about a radical change in the appearance of many everyday domestic furniture designs.

4 *Andrea Branzi,* Families of Objects for Domestic Animals *couch, 1986. Such designs continued Branzi's metaphorical critique of functionalism that began with his involvement with Radical Design in Italy in the 1960s. Ht 1.05m/ 3ft 5in.*

5 *Robert Venturi,* Sheraton *chair manufactured by Knoll International, 1982. The series of chairs that Venturi designed for Knoll from 1984 drew on many periods, from Queen Anne to Art Deco. This Sheraton-derived example is combined with patterns drawn from contemporary visual culture to create an original design solution. Ht 85cm/33in.*

6 *Aldo Cibic,* Sophia *writing desk for the Memphis Group, 1982. The combination of different materials, surfaces, and colours embraces the Italian "New Design" penchant for recasting everyday objects in imaginative ways that invigorate the contemporary interior. Ht 75cm/29½in.*

7 *Vignelli Associates,* Broken Length *table for Formica Colorcare, 1982. The broken end of the table symbolizes the way in which many progressive designers in the later part of the 20th century abandoned the certainties of Modernism in favour of a more linguistically rich design vocabulary.*

8 *Alessandro Mendini,* Calamobio *cabinet, produced for Nuova Alchimia, 1985–7. Mendini's commitment to design freed from functional constraints is seen in this cabinet with its richly patterned, colourful surface.*

9 *Borek Sípek, wardrobe with light for Vitra, 1989. Sípek produced original designs far removed from utilitarian principles, often characterized by an idiosyncratic, sensuous use of form and materials. Ht 2m/6ft 5in.*

British Furniture

Found Objects, Craft, and New Possibilities

1 *Fred Baier, music stand, 1968. This music stand has been endowed with a new persona through Baier's desire to "bring decoration back into furniture." He wanted it to "be structural, not just surface decoration." Ht 1.24m/4ft.*

2 *Ron Arad,* Cone *table and chairs, One-Off Ltd, 1986. Fashioned from materials associated with high technology – steel, glass, and aluminium – this furniture appears as if a relic from a past era, a symbol of urban decay.*

The 1970s and '80s saw the emergence of a number of furniture designers who reinvigorated the British design landscape through an incorporation of fresh ideas and a striking exploration of materials, form, and colour which challenged many conceptions of furniture-making.

Significant among the new group of designers was Israeli-born Ron Arad who, with Caroline Thorman, founded One-Off Ltd in 1981 in London. Arad's early work was typified by the use of "found" materials, as seen in his *Rover* chair (1981) and *Aerial* light (1981) in which he utilized redundant car seating and a discarded car-radio antenna. Such objects may be seen as critiques of industrial mass-production and Modernist affinities with new materials and technological sophistication. Indeed, the name of Arad's company, One-Off, indicated opposition to Modernist and conveyor-belt modes of production. Arad's 1986 *Cone* chairs in steel, glass, and aluminium defy conventional expectations of seating which make comfort and ergonomics a priority. Instead they seem to be an independent, sculptural – almost

totemic – archaeological remnant from the decay of urban society. Similarly, the *Cone* table contradicts everyday functional expectations, its implicit weight counteracted by its support on finely pointed legs.

Arad later became interested in exploring the possibilities of mass-production, and he designed products for companies such as Driade, Alessi, Vitra, and Kartell, as well as producing a number of striking interiors.

A second British designer who was interested in using "found objects" in furniture design and who also worked with scrap metal was Tom Dixon. His work became increasingly widely known in the later 1980s. In common with other designers of the period, including Danny Lane, Dixon explored the aesthetic possibilities of craft as an antithesis to the more polished forms of mass-production and the mainstream forms produced by the manufacturing industry. This could be seen in his *S* chair from 1986, a witty post-industrial critique of Verner Panton's celebrated injection-moulded plastic chair designed in 1960 and put into mass-production by Vitra for Herman Miller.

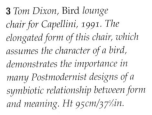

3 *Tom Dixon, Bird lounge chair for Capellini, 1991. The elongated form of this chair, which assumes the character of a bird, demonstrates the importance in many Postmodernist designs of a symbiotic relationship between form and meaning. Ht 95cm/37½in.*

4 *Tom Dixon, S chair, 1986. The rather crude woven surface of this anthropomorphic seat represents a commitment to individuality. In some ways this chair looks back to the clarity and sinuousity of Verner Panton's classic chair of 1967. Ht 99cm/20in.*

5 *John Makepeace, Throne, c.1988. The bulging contours and tapering legs combined with the curving lines of the perforated back provide a witty, decorative design solution to the functional problem of seating.*

6 *Danny Lane, Etruscan chair, 1992, plate glass. The use of crudely shaped sheets of glass and legs that almost defy their functional purpose reveal the way in which a crafts-oriented exploration of materials provides new decorative possibilities for everyday objects. Ht 85cm/33½in.*

7 *Danny Lane, low stacking table, 1994. Far removed from the cool, clean geometric austerity of Modernist design, Lane's decorative, seemingly casual use of glass reflects an idiosyncratic, individual interpretation of the nature and construction of ordinary things. Ht 40cm/15¾in.*

8 *Carl Hahn, Fat Lady chair, c.1992. An antithesis of the sleek "machine aesthetic" associated with Modernism and High-Tech, this design exhibits many of the attributes implied by the title and may be seen as a witty reaction to the "designer" ethos of the period.*

European and Japanese Furniture

Aesthetic and Political Freedoms

1 *Hans Hollein,* Mitzi *sofa, 1981. Made by the Italian company Poltranova, this sofa was one of a series by Hollein which drew on the glittering stylistic heritage and glamour of Art Deco and Hollywood. W. 2m/6ft 6in.*

2 *Philippe Starck, chairs, c. 1985. This witty and innovative hybrid design makes use of several styles and materials. Ht 83cm/32¼in.*
3 *Toshiyuki Kita,* Wink *chair, 1980. Kita drew on a wide range of sources, including Mickey Mouse for the ear-like head rests. L. 1.23m/4ft 1in.*
4 *Takenobu Igarashi,* Zao *stool, c.1990. Defying assumptions about form, the organic surface appears too fragile to support the sitter. Ht 46cm/18in.*

Many designers represented here reflect the ethnic diversity, cosmopolitan spirit, and cultural eclecticism that characterized this period. For instance, Japanese designer Toshiyuki Kita established offices in both Osaka and Milan, and Czech-born Borek Sípek, after studying in Prague, Hamburg, Stuttgart, and Delft, set up his practice in the Netherlands. Designers drew from many different sources and influenced each other: Sípek for example, was closely associated with the re-emergence of avant-garde design in the "New Europe" that emerged with the thawing of relationships between the former Eastern and Western European blocs. In 1988 the Czech group Atika (including Jirí Pelci) attacked the functionalist, conservative ethos of socialist design in their Gallery Dílo exhibition which featured a number of semantically charged Postmodern objects. They were influenced by Sípek who, although he had left Czechoslovakia in the political turmoil of 1968, began to establish contacts once more in his homeland from the mid-1980s onwards.

Following the death of the Fascist dictator General Franco in 1976 a similar invigorating new design vocabulary had developed in Spain, typified in the work and outlook of Javier Mariscal, based in Barcelona. In France, Philippe Starck emerged as a leading international designer in the 1980s. Although his work does not always fit easily into any straightforward design category, his prioritization of intuition and feeling over function, together with his insatiable stylistic, symbolic, and cultural eclecticism, align him with many key aspects of Postmodern design.

The way in which diverse influences may be embraced by a single Postmodern product may be seen in Kita's versatile *Wink* seating for Cassina. It is highly versatile, easily convertible from armchair to chaise longue, and in common with many other Postmodernist works draws on a wide range of sources. In its low configuration there are allusions to the Japanese tradition of sitting on the floor, while in its chaise longue reclining variant it draws on the sophistication of Western urban living. It also alludes to

1 *Shiro Kuramata, stool, 1990. The use of translucent material to provide a solid surface provides a refreshing response to Modernist notions of "form follows function." The form has almost "dissolved" in the poetic exploration of the material, and the function is challenged by use of a transparent medium. Ht 54cm/21¼in.*

2 *Borek Sípek, Bambi chair, 1983–6. Sípek helped link Western Postmodernism and the avant-garde in the Czech Republic. Here, he explores the aesthetic challenges of different materials and a-functional forms. Ht 76cm/30in.*

3 *Tomas Taveira, Sylvia chair from the Transfiguration series, 1990. In this chair the creative Portuguese architect-designer challenges traditional expectations of form, function, colour, and shape. Ht 74cm/29in.*

4 *Tomas Taveira, table, 1990. The assumed rectilinearity of the tabletop and literal functions of the supporting legs are challenged in Taveira's individualistic exploration of pattern, colour, and expressive form that in some ways echoes the concerns of progressive Italian designers in the 1970s and early 1980s.*
5 *Javier Mariscal, Alessandra armchair, 1995. The colourful design echoes the free-flowing forms of Mariscal's graphic design work and explores the sculptural possibilities offered by injected polyurethane. Ht 1.12m/3ft 8in.*
6 *Jirí Pelci, Atika group exhibition. The controversial Atika group in late 1980s Prague embraced Western Postmodern design ideas.*

1 *Forrest Myers*, The Pink Chair, c.1995. *Form and function have dissolved in unconventional construction, complemented by the unexpected use of colour. It is a visual statement that reflects the fine arts background of this American sculptor-designer. Ht 76cm/30in.*

1

2

3

4

2 *Forrest Myers*, Kilimanjaro *bed, manufactured by Art et Industrie, c.1995. This parody of the four-poster bed dispenses with the functional purpose of the four corner posts as carriers of the surrounding curtain, while the conventional solidity of the sleeping surface is denied by its apparent "floating" above the floor.*
3 *Bjørn Norgaard*, Sculpture chair, *1995. This anthropomorphic design shows the often close relationship between art and design in late 20th-century products. This was a collaboration with the Swedish manufacturer Källemo whose output emphasized artistic content rather than practicality.*
4 *Mats Theselius*, Iron Plate Easy Chair, *1994. Although largely fabricated from an industrial material, this deliberately old-fashioned-looking design is far removed from the clean machine-made forms of Modernism.*

travel, as seen in its adjustable headrests and ability to recline, which are reminiscent of aircraft and automobile seating. Reference is made to the exuberance of Pop in the vibrant colours of the almost casual, zip-fastened slip-over covers, and also to Mickey Mouse, seen in the amusing ear-like forms of the head rests.

Until the 1970s, Scandinavian design was widely associated with an aspect of Modernism that blended the manipulation of clean, elegant forms with a respect for traditional crafts and a strong sense of social democracy. However, in the 1970s design in Scandinavia was affected by industrial and economic uncertainties, and individualistic designers such as Jonas Bohlin and Mats Theselius in Sweden, and Stefan Lindfors in Finland, began to emerge. From the early 1980s, Bohlin's furniture proved to be a significant challenge to Swedish traditions of elegance in design, as his background in the contrasting worlds of civil engineering and interior design led to an adventurous exploration of contrasting materials. Källemo, a Swedish company founded by Sven Lundh in

1965, manufactured a number of Bohlin's designs. Its launch of the *Concrete Chair* in 1982 reflected the firm's embrace of individualistic, often fine-art-driven designs in limited editions, which caused considerable disquiet in conservative manufacturing circles. Theselius, another designer associated with Källemo, also exhibited an iconoclastic streak in the way in which he used traditional materials as, for example, in his *Iron Plate Easy Chair* of 1994 in which the material, rather than the form, questioned notions of function. Stefan Lindfors, an internationally recognized and often controversial Finnish designer, explored expressive, a-functional, and rather un-Scandinavian design possibilities in his insect-like *Scaragoo* table lamp for Ingo Maurer in 1987. Even large companies associated worldwide with the muted, affordable elegance of Scandinavian Modern were not impervious to international developments and sought to exhibit a more progressive face. Ikea's *PS* (*Postscript*) collection of 40 pieces, for example, which was not designed for mass-production, was launched at the Milan Furniture Fair of 1995.

1 *Alf Linder, table, 1995. Made from the front forks of bicycles with a tray-like tabletop surface, this is a parody of functionalism, almost appearing as an archaeological remnant. Ht 56cm/22in.*
2 *Nanna Ditzel, Seashell chair for P.P. Møbler, c.1995. Experimenting with form and materials this design extends the vocabulary of seating with its non-functional arms and sides. Ht 1.2m/3ft 11in.*
3 *Jirí Pelci, Flag sofa, made by Studio Pelci, 1990. Pelci, a leader in Czech Postmodern design, manipulated metal in many unconventional ways. Here, the broken flag profile of the sofa back is enhanced by the flowing, lanyard-like linear elements.*

4 *Neils Hvass, Yesterday's Paper easy chair, 1995. Designed by one of the experimental Danish Octo group, this chair, fashioned from a block of glued newspapers, is a Postmodernist comment on Le Corbusier's Modernist icon Fauteuil Grand Confort. Ht 75cm/29½in.*
5 *Stefan Lindfors, Scaragoo table lamp, 1987. The zoomorphic halogen lamp draws on a vocabulary of insect forms.*
6 *Ikea, Vago chair, from the PS collection, 1995. Unusually for Ikea, this collection of 40 pieces was not for the mass market. Ht 71cm/28in.*

Ceramics

America and Europe

1 *Nathalie Du Pasquier,* Carrot *vase, 1982. Like other Memphis Group designers, Du Pasquier used a variety of surface patterns, colours, and ornamental motifs to enliven a wide spectrum of designed products. Ht 30cm/11¾in.*

2 *Michael Graves,* Big Dripper *for Swid Powell Ltd, 1985. In common with many other Postmodern designers, Graves explored colour symbolism. In this drip-filter coffee pot the terracotta-glazed base represents heat and the colour of coffee while the blue wavy lines signify water.*

3 *Robert Venturi,* Village Teaset, *1986. This four-piece teaset for the innovative company Swid Powell explores the fashionable idea of table- or micro-architecture in a cultural melange of styles.*

4 *Heide Warlamis,* Siena *pepper pot, 1986. Warlamis explores the concept of micro-architecture in her fashionable porcelain salt and pepper pots. This visual fusion of architecture and design on a small scale typifies the Postmodernist blurring of disciplinary boundaries.*

Postmodernism found a particularly potent form of visual expression in what was sometimes referred to as micro-architecture – glass, ceramic, and metal products destined for the dining table or kitchen work-surface, sites of consumption that became almost the affluent domestic counterparts of the spot-lit museum plinth. As architect and historian Paolo Portoghesi remarked, "the objects which embellish a house and which we use in everyday life are like architectural details, they give a feeling in a room in which we live. And that expands the means of communication."

In the late 1970s and early 1980s the conventional outlook of many manufacturers was increasingly confronted by the experimentation and fresh thinking of avant-garde designers and collectives such as the Memphis Group in Milan. In their wake, innovative companies such as Swid Powell in the United States and Alessi in Italy were quick to realize that there was significant consumer interest in the purchase of designer dinner services, sugar bowls, and salt and pepper mills.

The commissioning by commercial companies of celebrated architects and designers made the designs of Robert Venturi, Michael Graves, and other internationally recognized individuals financially accessible to a much wider design-conscious consumer clientele.

Postmodernist designers celebrated their entrée to the domestic environment with the design of colourful, decorated, and visually sophisticated products that were intended to be seen as much as to be used. These three-dimensional objects often assumed a role equivalent to the painted conversation pieces of earlier periods at the dinner tables of affluent, style-conscious urban dwellers. Many celebrity designers such as Arata Isosaki, Richard Meier, Paolo Portoghesi, Ettore Sottsass, Philippe Starck, and Frank Gehry were commissioned to satisfy the voracious appetites of this new audience. The latter group enjoyed using – and being seen to use – products that were also to be found in the display cases of many museums and in the pages of lifestyle magazines featuring late-20th-century design.

5 *Memphis Group*, Colorado teapot, 1983. *The forms, colours, and decorative character of this teapot exemplify Memphis' wish to offer imaginative solutions for everyday objects and to challenge the conservative manufacturing industry. L. 29cm/11½in.*

6 *Ambrogio Pozzi*, Collector's Cup, *porcelain, manufactured by Rosenthal, 1988. The anti-functional configuration of the twin-handled motif is indicative of the freedom of form and expression available to Postmodern designers. Diam. 7.5cm/3in.*

7 *Dorothy Hafner*, Roundabout *punch bowl, 1986. The structure of this piece does not conform to traditional expectations. Hafner drew on many visual sources for her distinctively strident designs. Bowl ht 21.5cm/8¼in.*

8 *Peter Shire*, California Peach cup, *1988. This piece shows the extent to which function ceased to be prevalent in Postmodern design. The unconventional use of colour and form inspired Ettore Sottsass to invite him to join Memphis. Ht 20.5cm/8in.*

9 *Matteo Thun*, Cuculus Canorus *pot, 1982. One in the* Rara Avis *(Rare Birds) series for Alessio Sarri, the zoomorphic forms emphasize meaning over function. Thun creates a dialogue between product and consumer and emphatically embraces Venturi's rejection of Modernism, with the adage "less is a bore."*

495

Glass

Beyond Function

1 *Hilton McConnico, Nevada bowl for Daum, 1991. McConnico often draws on imagery, such as this cactus, relating to his native Arizona. His use of organic form recalls earlier crystal designs produced by the French Daum company. W. 30.5cm/12in.*

2 *Richard Marquis and Dante Marioni, goblet with teapot stem, 1990. The apparently nonsensical blend of goblet and teapot motif reveals how imagination and ornamental interest override straightforward function. Ht 26cm/10in.*

3 *Borek Sípek, glassware for Novy Bor and Ajeto. Such designs show how individuality, idiosyncrasy, and artistic expression inform Postmodern design in Eastern Europe and is typical of Sípek's imaginative work in glass. Ht (left) 28cm/11in.*

4 *Borek Sípek, Herbert crystal vase for Driade. The swirling decorative elements of this fantasy in glass have a strong neo-Baroque flavour and show the characteristic verve and visual inventiveness for which Sípek became widely known. Ht 25cm/10in.*

Progressive glass designers began to break away from the domination of traditional and Modernist patterns and forms in the Pop era of the 1960s. The possibilities of strong colour, for example, were seen in Gunnar Cyrén's "Pop" glasses produced by Orrefors in Sweden from 1966. Such adventurous approaches were taken much further by Postmodernist designers. Their work, which included large and small-scale pieces, ranged from decorative objects for fashion-conscious domestic environments, collectors, and museums to innovative furniture designs (such as those by Danny Lane).

Small-scale designs included the colourful blown glass bowls, drinking vessels, and containers by Memphis Group designers such as Ettore Sottsass and Marco Zanini; these were produced by Toso Vetri d'Arte in Murano in the early 1980s. More prevalent, though, were the exotic glass, metal-corseted perfume bottles by the French fashion designer Jean Paul Gaultier in the 1990s.

Glass was explored in the extravagant fantasies by the versatile Czech Borek Sípek, commissioned by many manufacturers and organizations, including the Centre International de Recherche sur la Verre in Marseilles. Following collaboration for several years from the early 1980s, Sípek together with the highly talented young Czech glassblower Petr Novotny, founded the Ajeto glassworks in 1989. This adventurous company sought to extend the technical and imaginative possibilities of glass fabrication, specializing in series of limited editions for companies such as Driade in Italy and the Steltman Galleries in the Netherlands and the United States.

Similar initiatives were undertaken by companies such as Daum in France, which invited leading designers, including Philippe Starck and the American stylist Hilton McConnico, to work on new ideas for its crystal products. Scandinavia also saw some shifts away from its characteristic Modernist clarity of form, brought about through exploration of greater freedoms associated with the art glass movement and an increased knowledge of American studio glass which impacted on work at Kosta Boda and other Scandinavian glass manufacturers.

1 *Hans Godo Frabel,* Hammer, *1980. Frabel's glass hammer and nails encapsulate the Post-modernist rejection of "form follows function." The fragility of the medium renders the hammer's function impossible in this piece of visual wit. W. 30.5cm/12in.*

2 *James Harmon,* Rodeo *bowl from the* Badger and Snake *series, 1981. This American glass designer stretches the meaning and function of bowl design. Experimentation in the crafts provided a hot house of new generation design possibilities. Ht 56cm/22in.*

3 *Oiva Toikka,* Visit of Old Lady, *1995. Toikka, a Finnish designer of glass, textiles, and ceramics with a pedigree in the Arabia, Rörstrand, and Marimekko companies, has become widely known for his originality, visual sophistication, and metaphors.*
4 *Markku Salo,* Journey to Troy, *c.1988. These idiosyncratic, anthropomorphic, and decorative pieces exude the flavour of archaeological discoveries from some distant era and exhibit some of the ways in which artistic and design activity merge in the later 20th century.*
5 *Markku Salo,* Colossus, *1989. This colourful piece, which was produced in Finland, echoes the ideas of micro-architecture and "table landscapes" that were being explored in Italy and the USA. The "Colossus" is in effect a micro-sculpture.*

6 *Jean Paul Gaultier,* Corset *perfume bottle, produced by Verreries Pochet Du Courval for Parfums, 1991. Challenging conventions in this continuing series of corseted perfume bottles, fashion designer Gaultier drew for inspiration on his own couture collections, in which high fashion and street culture merged in the unexpected and novel use of underwear as outer garments.*

Silver and Metalwork

Steam Icons

1 *Philippe Starck,* Hot Bertaa *kettle for Alessi, 1989. This sculptural aluminium kettle has become something of a design icon, reflecting a Postmodernist conflict between form and function. The design represents the metamorphosis of the everyday into a fashion statement. Ht 25cm/10in.*

2 *Frank Gehry,* Pito *kettle for Alessi, 1992. One of a series of Alessi kettles that are as much conversation pieces as utensils for boiling water, it is a pun on the fish kettle with its use of a flying fish for a whistle. Form follows style rather than function. Ht 18.5cm/7¼in.*

3 *Michael Graves,* Bird *kettle for Alessi, 1985. The close correspondence between form and meaning in the Postmodernist armoury may be seen in Graves' witty use of the bird-shaped whistle and the high-pitched sound it gives off when the stainless-steel kettle is boiling. Ht 26cm/10¼in.*

Just as they had in the media of ceramics and glass, Postmodern designers found opportunities in silver and metalwork to further their exploration of the domestic landscape in small-scale lighting and table-top micro-architecture. A notable instance of this was the Alessi company's *Tea and Coffee Piazza* series, launched in 1983. Under the guidance of Alessandro Mendini, 12 prominent international designers including Graves, Hollein, Jencks, Portoghesi, Tusquets Blanca, Thun, Tigerman, and Yamashita were commissioned to design a tea and coffee service inspired by architecture. In true Postmodernist fashion the resulting series drew on a variety of stylistic and cultural sources and, in keeping with the designer celebrity ethos of the decade, were initially produced in limited editions of 100 (largely destined for collectors and museums) and launched simultaneously in international centres of design.

Table lights, such as those in painted steel and glass designed by Matteo Thun for Bieffeplast in the mid-1980s, explored similar small-scale architectonic ideas.

The aesthetic boundaries of other domestic artifacts were also stretched further, notably in the field of domestic kettles, where Richard Sapper, Michael Graves, Philippe Starck, Frank Gehry, and others designed for Alessi.

Even refrigerators took on architectonic forms, as with Roberto Pezetta's 1987 *Wizard* designs for Zanussi (see p. 504). Many other previously mundane domestic items also received attention from designers from the 1980s onwards. These included door furniture, where companies such as the German manufacturer Franz Schneider Brakel (FSB) commissioned designers such as Alessandro Mendini, Mario Botta, Hans Hollein, and Arato Isozaki to focus their attention on handles and knobs.

Of course, fresh thinking revivified many other fields of silver and metalwork design activity, as, for example, in the jewellery of Spanish designer Ramón Puig Cuyás, who often blended valuable materials such as silver with more mundane materials such as Colorcore. In the same design field Norwegian designer Tone Vigeland also manipulated materials in fresh and witty ways.

From Microarchitecture to Madonna

1 *Paolo Portoghesi,* Tea and Coffee Piazza *service for Alessi, 1983. This six-piece limited edition reflected preoccupations with micro-architecture and echoed the decorative styles of the early 20th-century Wiener Werkstätte.*

2 *Matteo Thun,* Hommage à Madonna *cutlery, La Galeria Design International series 1986. Black polyamide and gilded decoration are used to evoke the glamorous world of US star Madonna. L. 20cm/8in.*

3 *Ramón Puig Cuyás, the* Choral Mermaid *brooch, 1989. Combining silver, ColorCore, and paint, Spanish designer Cuyás explores the tension between the poetry of the title and the contrasts of form, colour, and materials, reinforcing the hybrid nature of the mermaid herself, half-human, half-fish. L. 15.5cm/6in.*

1

2

3

4

5

6

4 *Tone Vigeland,* Necklace of Nails, *1982. Vigeland embraces the unexpected in his use of industrial elements, transforming functional into decorative components, and exploring the aesthetic possibilities of combining everyday and more expensive materials. Diam. 21cm/8¼in.*

5 *Tom Saddington, jewellery, late 1970s. In common with a number of experimental jewellers of the period, Saddington explores materials, finishes, and visual references in a graphic manner far removed from the elegant, polished forms of mainstream jewellery design.*

6 *Oscar Tusquets Blanca,* Salvador *candlesticks, manufactured by Driade, early 1990s. These asymetrical candlesticks have a crude, almost archaeological character and appear as if fashioned from dripping wax gathering in a pool. Ht 46cm/18in.*

Textiles and Rugs

Cultural Diversification

1 *Nathalie Du Pasquier,* Gabon *textile for Memphis, 1982. This printed cotton textile draws on Du Pasquier's experience of the richly patterned, geometric designs of a variety of cultures. The bright, busy surface reflects the Memphis commitment to invigorating the design of everyday things.*
2 *Memphis rug, 1986, sample of Wilton carpeting. Memphis participants drew on a wide variety of sources. Here the garish contrasts straddle the borderlines of kitsch and progressive taste.*
3 *Helen Litmann for English Eccentrics,* Gaudí, *1985, printed silk. The collage-like, busy surface of this design reflects contemporary interest in quotation and reinterpretation from the past.*
4 *Fiorucci scarf. Elio Fiorucci opened up Italian design retailing to the street styles of 1960s London, expanding from a single Milanese store to become an international fashionable enterprise. This eclectic mix of colour, pattern, and source material typifies the ephemeral thrust of Postmodernism.*

Textiles and rugs provided significant opportunities to explore the often brightly coloured, richly decorative, and culturally diverse references associated with the Postmodernist outlook. Barbara Radice, a key chronicler of Memphis design, described the textile designs of one of the group's founding members, Nathalie Du Pasquier, as embracing "Africa, Cubism, Futurism and Art Deco; India, graffiti, jungles and town; science fiction, caricature and Japanese comics."

The bringing together of diverse visual and cultural references, which was seen in much avant-garde design in Italy in the 1970s and 1980s, had also been a hallmark of many of those working in the fashion arena. This was typified by the influential work of British designer Vivienne Westwood who, in her immediate post-Punk phase, drew on imagery associated with buccaneering and patterns drawn from ethnic cultures and the Appalachian mountains for her fashion collections of the early 1980s. British companies such as Bodymap, established in 1982, The Cloth, established in 1983, and

English Eccentrics, established in 1984, also explored fresh decorative possibilities in textile design.

Surface pattern was also explored by graphic designers, including the influential Neville Brody, known for his innovative layouts for the British style magazine *The Face*. The rapidly changing world of printed ephemera provided designers with a considerable range of opportunities to explore new ideas, whether for record sleeves, magazine covers and layouts, or advertising. Similarly, in the United States, Californian New Wave graphics did much to influence and enrich the visual vocabulary of two-dimensional surfaces. Indeed, other internationally celebrated graphic designers such as the Barcelona-based Javier Mariscal explored a range of pattern-bearing media, including textiles, as a means of extending their design repertoire.

As was the case in many other media associated with Postmodern design activity, architects such as Michael Graves and Robert Stern were also extremely keen to turn their hands to textile and rug design.

1 *Alessandro Mendini, wall hanging for Museo Alchymia, 1980s. Closely associating himself with the concept of "Re-Design" in the 1970s, Mendini expressed the view that it was virtually impossible to design completely new forms. Here there are strong echoes both of the geometric forms of Art Deco and the flatness of much Pop design.*
2 *Robert le Héros, Le Pilleur d'Epave, manufactured by Nobilis Fontan, France, late 1980s, upholstery fabric/wall hanging. The graphic informality and visual content of this textile design underlines the importance of narrative in much contemporary design.*
3 *Helen Yardley, rug, 1985. Although Yardley's work recalls a number of the elements of Modernist design through her use of triangles, rectangles, and a muted palette, the shapes are loosely, almost casually drawn, and exude a personal language far removed from Machine-Age objectivity.*

4 *Timney & Fowler, Emperors' Heads from the Neo-Classical Collection, 1985. Timney & Fowler's use of fragmented motifs drawn from ancient Rome forms a decorative pastiche in this collage of busts.*

5 *Javier Mariscal, Munecos fabric manufactured by Trafica de Modas, Spain, early 1990s. Mariscal harnessed popular culture in the use of crudely drawn cartoon characters to create a lively, fashionable textile.*

Industrial Design

Breaking the Mould

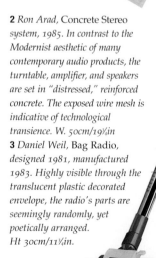

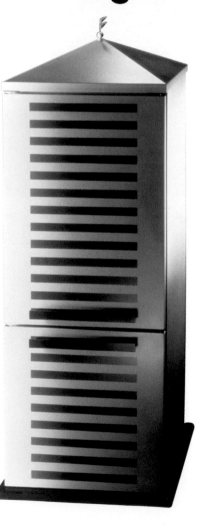

1 *Aki Maita*, Tamagotchi, *manufactured by Bandai, 1996. This interactive electronic toy is concerned with the care of a virtual pet, or "cyberpet." Manufactured in casing of many colours and patterns, it sold 40 million worldwide within two years of its market launch. Ht 5cm/2⅛in.*

2 *Ron Arad*, Concrete Stereo *system, 1985. In contrast to the Modernist aesthetic of many contemporary audio products, the turntable, amplifier, and speakers are set in "distressed," reinforced concrete. The exposed wire mesh is indicative of technological transience. W. 50cm/19¾in*

3 *Daniel Weil*, Bag Radio, *designed 1981, manufactured 1983. Highly visible through the translucent plastic decorated envelope, the radio's parts are seemingly randomly, yet poetically arranged. Ht 30cm/11¾in.*

4 *James Dyson*, DC02 De Stijl *vacuum cleaner launched in 1996. Using primary colours instead of the universal aesthetic, Dyson transformed the vacuum cleaner from utilitarian object to style icon. Ht (approx.) 50cm/19¾in.*

5 *Roberto Pezetta*, Wizard *refrigerator, Zanussi, 1986. Pezetta's design moves away from the largely functional forms of many kitchen appliances, becoming an architectural metaphor topped by an idiosyncratic flag. Ht 2m/6ft 6in.*

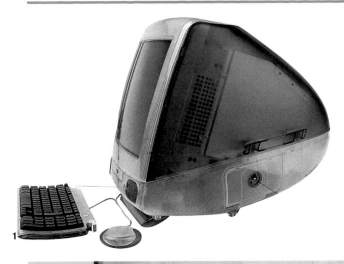

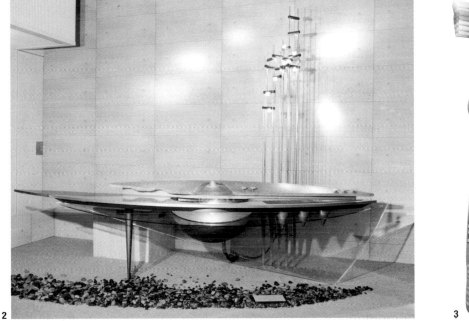

1 *Jonathan Ive and Apple Design Team,* i-mac *computer, 1998. The* i-mac *represented a design solution that humanized a hitherto functional object. It transformed the generally bulky desktop computer into a fashionable icon through the introduction of streamlined form and a choice of colour. Monitor ht 30.5cm/12in.*
2 *Masashito Takasuno, Izumi (Spring) kitchen, manufactured by Toshiba, early 1990s.*

3 *Oral-B,* Squash *grip toothbrush, produced in the 1980s and '90s. Although ergonomic in terms of the flowing "S" form of its handle and angled head, the use of colour endows this functional implement with a playful, fashionable, and ephemeral appeal. Ht 22cm/8½in.*
4 *Philippe Starck,* Fluocaril *toothbrush, manufactured by Goupil Laboratories, 1989. This functional object has become a design icon set on its "plinth," through Starck's interpretation of Constantin Brancusi's* Bird *sculpture. Ht 25cm/10in.*

Following a series of technological developments after the Second World War, industrial designers were increasingly freed from the Modernist constraints of "form follows function." The appearance of the transistor, followed by significant developments in microelectronics and the advent of the silicon chip allowed designers the freedom to explore forms that no longer needed to house cumbersome working parts. While Japanese designers at Sony responded in terms of innovative, miniaturized products such as pocket transistor radios (for example Model 610, 1958), portable televisions (including Model 80 301, 1960) and the ubiquitous Walkman (launched in 1979), Postmodernist designers were able to explore very different qualities in contemporary product design. Daniel Weil's Bag Radio, initially conceived in 1981, poetically revealed its component parts in a transparent but decorative PVC envelope. Witty, and an implicit critique of Modernist conventions, it embraced the essence of a fashionable consumer product. Ron Arad's Concrete Stereo was another design that attacked the rectilinear clarity of the modular black box units that comprised contemporary hi-fi systems. It had its electronic components set in rough, seemingly disintegrating concrete. A seeming archaeological relic of the Fordist production era, it embraced many of the characteristics associated with Postmodern design such as ambiguity, irony, and ephemerality. Such experimentation had coincided with the publication and impact of theoretical and critical design texts on both sides of the Atlantic by Barthes, Venturi, Eco, Dorfles, and others interested in the cultural significance of visual language.

The power of a design vocabulary that embraced popular culture both as a revitalizing force and a rejection of the Modernist canon proved attractive to many designers and consumers. Indeed, Postmodernist industrial design could be found throughout the domestic environment, whether in the bathroom (where such interventions included Philippe Starck's *Fluocaril* toothbrush) or the kitchen (the Italian Alessi company were quick to recognize the kitchen's cultural significance

1 Swatch *watches in fitted cases:* Eggsdream, Magic Spell, Hollywood Dream, Hocus Pocus, Leaf, *and* Encantador. *The fact that the name* Swatch *is a hybrid creation, amalgamated from the words Swiss and watch, lends it a certain Postmodernist cachet. From the later 1980s the* Swatch *became a highly popular fashion accessory through its variety of patterned faces and straps.*

2 *Julian Brown,* Vercingetorige *alarm clock for Rexite, Italy, 1994. This clock was designed with reference to the ancient Gallic chieftain Vercingetorix who rose up against Julius Caesar – allusion to the warrior is seen in the helmet-like form of the casing. Ht 9cm/3½in.*
3 & **4** *George J. Sowden and Nathalie Du Pasquier,* Neos *clocks, 1986–7. The almost totemic appearance of these clocks parallels the avant-garde exploration of micro-architecture and table landscapes. The use of colour and decoration for the structure and clock faces is typical of the Memphis designers. Diam. 34.5cm/13½in.*

as a domestic gallery in the homes of an increasingly affluent urban elite). In the latter, in many countries of the industrialized world, were displayed often brightly coloured and playful gas lighters, egg-cups, corkscrews, and other domestic equipment that complemented Alessi's range of designer kettles (see p. 500).

Even everyday cleaning equipment, such as vacuum cleaners, were increasingly seen as objects with style status and were designed as decorative items in their own right rather than necessarily stored out of sight when not in use. The British designer James Dyson, whose technologically innovative designs did much to boost this trend across a wider social spectrum, played with Postmodernist styles to decorative effect in his De Stijl-inspired "Edition" vacuum cleaner.

The surfaces of many other domestic products became bearers of rich and varied decorations. Iconic in this field has been the *Swatch* watch, launched in 1983. By the beginning of the 21st century, the *Swatch* had become the best-selling watch ever with sales of over 200 million.

Cheap enough to throw away rather than repair, each watch has the same mechanisms, thus rendering it capable of differentiation only through the design of its face and strap. From the late 1980s onwards the *Swatch* became a fashion accessory, with the Swatch Design Lab in Milan producing more than 70 designs per year, often using well-known designers such as Matteo Thun and Alessandro Mendini. Similar ideas have been explored in other product fields as, for example, in the decorative, brightly coloured, and patterned interchangeable covers for mobile phones produced by Nokia and others.

Such an interest in pattern had characterized the work of a number of avant-garde designers in the 1970s and 1980s in the United States and Italy, particularly those associated with Studio Alchymia and the Memphis Group. The design freedoms established by the Italian avant-garde in the 1970s, however, have created a climate today where almost anything goes and pattern, colour, and novelty tend to be used for for their own sake and lack the Postmodernist cultural depth of 20 years ago.

1 *Ernesto Spicciolato and Dante Donegani, razor, made by Creazoni Cavari, 1987. Rather like Starck's* Fluocaril *toothbrush, this razor has taken on a sleek, sculptural look, rendering it a styled commodity rather than a merely functional design solution for an everyday task. Form follows fashion. L. 19cm/7½in.*

2 *Guido Venturini,* Firebird *gas lighters for Alessi, 1993. This fanciful design with its brightly coloured, almost funky forms, typified Alessi's playful attitude to the design of many hitherto generally austere functional items for the domestic kitchen. Ht 26.5cm/10½in.*

3 *Marimekko and Turku TV,* Unikko Smooth 50 *television, 2001. The Finnish design company Marimekko collaborated with Turku TV to produce brightly patterned casings for televisions, making them items of interior decoration rather than anonymous pieces of technological equipment.*

4 *Toshiba,* Walky *slimline stereo cassette player. The decorative surface of this colourful product shows how the avant-garde explorations of surface and decoration by progressive designers in Italy, the USA, and elsewhere were taken up by mainstream manufacturing companies. L. 14cm/5½in.*

The Contributors

The Publisher would like to thank the following expert contributors to *The Elements of Design*.

Noël Riley, the General Editor of *The Elements of Design*, is a specialist writer and lecturer on the decorative arts. A part-time tutor at Sotheby's Institute of Art, London, and a lecturer for the Workers' Educational Association, she contributes a regular column to *Historic House*, the journal of the Historic Houses Association. Her books include *Tile Art, The Victorian Design Source Book, Gifts for Good Children: The History of Children's China 1790–1890,* and *Stones' Pocket Guide to Tea Caddies*. She was a contributor to *Sotheby's Concise Encyclopedia of Furniture* and *Miller's Antiques Encyclopedia*.

Patricia Bayer, the Consultant Editor and contributor for the Early Modernism and Art Deco chapters, is a specialist in 19th- and 20th-century European and American decorative arts and design. Among her books are *Art Deco Interiors, Art Deco Architecture, The Art Deco Source Book, Lalique Perfume Bottles, The Art of René Lalique,* and the *Sotheby's Collector's Guide to Art Nouveau and Art Deco*. She has contributed to *Sotheby's Concise Encyclopedia of Silver* and *The House of Liberty*. Since 1993 she has been the Arts Editor of *Encyclopedia Americana*.

Helen Clifford (Neoclassical silver and metalwork) studied History at Cambridge, followed by a PhD at the Royal College of Art. She has worked as a Course Director at the University of Essex, as a Leverhulme Research Fellow at Balliol College, Oxford, a Research Fellow at Warwick University, and is presently Course Tutor at the Victoria and Albert Museum and the Royal College of Art in London.

Max Donnelly (The Aesthetic Movement) gained an MA in Fine and Decorative Art from Sotheby's Institute in London in 1988. He is now Registrar and 19th-century decorative arts expert at the Fine Art Society in London. He was recently decorative art curator of *The Winter Antiques Show* in New York. Prior to his current position, he researched and catalogued 19th-century American and European decorative arts for Hirschl and Adler Galleries, New York, and was consultant for Victorian property for The National Trust of Scotland. He contributes essays to exhibition catalogues for The Fine Art Society and has written for various journals, including *The Magazine Antiques*, New York and *Furniture History,* the journal of the Furniture History Society.

Jane Gardiner (Renaissance, Baroque, and Rococo pottery) is a specialist in early European ceramics and glass, 17th- and 18th-century architecture and design, the court art of Louis XIV and Chinese export porcelain; she teaches and lectures widely. She began her career at the Victoria and Albert Museum in London, later becoming a tutor on the 17th- and 18th-century Decorative Arts course at Sotheby's Institute; she is now a Senior Lecturer. She is a member of several societies including the French Porcelain Society, the Society of Court Historians, and the Furniture History Society.

Mary Greensted (Arts and Crafts Movement) has a postgraduate diploma in gallery studies and became an Associate of the Museums Association in 1976. She has curated a number of touring exhibitions, including *Alan Peters, Furniture Maker* and *Alfred and Louise Powell, Happy Workmanship with Good Thought*. She is now Decorative Arts Curator and Visitor Services Manager at Cheltenham Art Gallery and Museum.

Sally Kevill-Davies (Baroque, Rococo, and Neoclassical ceramics and porcelain) is a freelance writer and researcher based in London. She has been responsible for the re-cataloguing of English porcelain at the Fitzwilliam Museum, Cambridge, since 1991, and a resident expert on the BBC *Antiques Roadshow* since 1997.

Rachel Layton Elwes (Contemporary) is a curator in Medieval and Modern Europe at the British Museum, and curatorial assistant at The Gilbert Collection, London. She was formerly assistant curator in the department of decorative arts at the Carnegie Museum of Art, Pittsburgh. Her exhibitions there included *Three Contemporary Metalsmiths: Intimate Traditions* and *In Pursuit of Objects: A Tribute to Decorative Arts Collectors*. Prior to this she held research assistant posts at the Metropolitan Museum of Art and the Philadelphia Museum of Art. She lectures widely on the decorative arts.

J.R. Liefkes (Renaissance and Baroque glass) gained a masters degree in art history from Leyden University in 1986. Curator of Glass and Metalwork at the Hague Municipal Museum from 1990–2, he is now acting Chief Curator of the ceramics and glass department at the Victoria and Albert Museum, London. He has been president of the ICOM International Glass Committee since 1995 and editorial adviser of the Corning Museum of Glass *Journal of Glass Studies* since 1998. He is a regular contributor to *Vormen uit Vuur* (a Dutch quarterly magazine on ceramics and glass) and is a speaker at international seminars on Renaissance glass and pottery.

Andy McConnell (Rococo and Neoclassical glass) is a professional writer, researcher, and lecturer specializing in antique glass. He owns a large collection and writes regularly for magazines on both sides of the Atlantic. His book, *The Decanter, An Illustrated History,* is published by the Antique Collectors' Club.

Dr. Alan Powers (Modernism) studied history of art at the University of Cambridge, completing his PhD in 1983. He was Vice-President of the Twentieth Century Society from 1995–9. He has curated many exhibitions including *Modern Britain, 1929–39* (Design Museum, consultant curator), *Sir Albert Richardson 1880–1964* (RIBA Heinz Gallery), and *Serge Chermayeff* (Kettle's Yard, Cambridge and the De La Warr Pavilion, Bexhill); and he has written for magazines such as *Apollo, Vogue, RIBA Journal,* and *World of Interiors.* Dr Powers has been a senior lecturer at the University of Greenwich since 1999.

Daru Rooke (Historical Revivals) specializes in Victorian arts, industry, and social history. He has a postgraduate degree in Art Gallery and Museum Studies from the University of Manchester and has been the Senior Curator at the Leeds Industrial Museum since 1996. He has given radio presentations for BBC Radio 4, contributed to the BBC programme *Home Front,* and curated and presented the Channel 4 documentary *1900 House.*

Mary Schoeser (Renaissance, Baroque, Rococo, and Neoclassical textiles) studied design at the University of California and completed a post-graduate course in Museum Studies at California State University before gaining an MA in History of Art at the Courtauld Institute of Art. A textile specialist, she is consultant archivist and curator at the London Institute and Liberty of London Prints. Her most recent exhibition was *Making Their Mark (1896–1966)* at Central St Martins, London, where she is also a research fellow. She is a member of the RAE Art and Design panel and an examiner for various universities in the UK. She is textile adviser to the Biltmore Estate, North Carolina, English Heritage and The National Trust.

Timothy Schroder (Renaissance, Baroque, and Rococo silver) worked for Christie's London from 1976–84, latterly as Director of the silver department, and later became Curator of Decorative Arts at Los Angeles County Museum of Art. From 1989–91 he ran his own business, dealing in silver and works of art and, after selling it to Partridge Fine Arts, developed their specialist silver department. From 1997-2000 he was Curatorial Consultant and later Keeper of the Gilbert Collection, London. He is a liveryman of the Goldsmiths' Company and a former chairman of The Silver Society.

Adriana Turpin (Renaissance, Baroque, Rococo, and Neoclassical European furniture) read history at Oxford University before undertaking studies in Medieval Art at the Courtauld Institute in London. A Deputy Director of Sotheby's Europe, she is tutor on the 17th and 18th-century Decorative Arts course at Sotheby's Institute in London, specializing in furniture and design.

Lisa White (British Rococo and Neoclassical furniture) read Modern History at Oxford and later worked at the Victoria and Albert Museum in London, specializing in English furniture and upholstery; later she taught History of Decorative Art at Bristol University. Since 1994 she has worked in Bath, at the Building of Bath Museum and is currently Curator of Decorative Art at the Holburne Museum of Art, Bath.

Nigel Whiteley (Space Age) is a professor in the Department of Art at Lancaster University and has recently returned from a period at the Getty Institute in Los Angeles. He has been a visiting professor at the National Institute of Design in Ahmedabad, the Indian Institute of Technology in Bombay, and the Central Academy of Art and Design in Beijing.

Jonathan M Woodham (Postmodernism) studied Fine Art at Edinburgh College of Art before undertaking postgraduate studies at the Courtauld Institute of Art in London. He has been an editorial board member on the internationally-renowned *Journal of Design History* since its launch in 1987 and also serves on the international advisory board of a number of leading periodicals including *Design Issues.* He lectures frequently and and is currently Professor of History of Design and Director of the Design History Research Centre at the University of Brighton.

Ghislaine Wood (Art Nouveau) attained her MA from Birkbeck College, University of London. A specialist on Art Nouveau and Art Deco, she has lectured at the Oslo School of Architecture and The Royal Academy as well as the Victoria and Albert Museum in London where she has been a curator in the research department since 1993. She is the Curator for the Art Deco Exhibition at the Victoria and Albert Museum.

Sources

The following is a list of the contemporary publications mentioned as sources in *The Elements of Design*, together with page references. A number in italics indicates that the citation accompanies an illustration.

Renaissance

Ovid, *Metamorphoses*, Venice, 1497; p.20

Pellegrino, Francesco, *La Fleur de la Science de Pourtraicture*, Venice, 1530; p.10

Picolpasso, Cipriano, *Three Books of the Potter's Art*, Italy, c.1557; p.22, *p.23*, *p.24*

Sambin, Hugues, *Oeuvre de la diversité des termes*, Burgundy, 1572; *p.16*

Vasari, Giorgio, *Lives of the Artists*, Italy, 1550; p.12

Zoppino, *Gli Universali di tutti e bei dissegni, raccami e moderno lavori*, Venice, 1532; *p.39*

Baroque

Chippendale, Thomas, *The Gentleman & Cabinet-Maker's Director*, England, 1754 (further eds 1755 and 1762); p.94, *p.95*, p.98, *p.98*, *p.99*

Gribelin, Simon, *New Book of Ornaments*, London, 1704; *p.72*

Marot, Daniel, *Nouveau Livre d'Orfevrerie*, The Hague, 1712; *p.73*

Moelder, C. de, *Proper Ornaments to be Engraved on Plate*, London, 1694; *p.73*

Rabel, Daniel, *Cartouches de différentes inventions*, c.1625; *p.70*

Stalker, John and Parker, George, *Treatise of Japanning and Varnishing*, England, 1688; p.58

Vianen, Christian van, *Modelli Artificiosi*, Utrecht, 1650; *p.70*

Rococo

Blondel, Jacques-François, *De la distribution des maisons de plaisance et de la décoration des édifices en général*, France, 1737; *p.82*

Darly, Matthias and Edwards, George, *A New Book of Chinese Designs*, London, 1754; *p.95*

Decker, Paulus, *Chinese Architecture, Civil and Ornamental* and *Gothic Architecture Decorated*, London, 1759; p.108

Germain, Pierre, *Eléments d'Orfevrerie*, France, 1748; *p.117*

Ince, William and Mayhew, John, *The Universal System of Houshold Furniture*, London, 1762; p.94, *p.94*, *p.97*

Johnson, Thomas *One Hundred and Fifty New Designs*, London, 1761; *p.95*

Lock, Matthias, *Six Sconces*, London, 1744; *p.94*

Manwaring, Robert, *The Chair-Maker's Guide*, London, 1766; *p.96*

Mariette, Jean, *Architecture Français*, Paris, 1727; p.84

Meissonnier, Juste-Aurèle, *Oeuvre*, France, 1748; p.114, *p.115*, p.116

Roubo, André-Jacob, *l'Art du Menuisier*, Paris, 1772.; *p.85*

Rudolph, Christian Friedrich, *Einige Vases*, Augsburg, p.118

Saint-Auban, Charles Germain de, *L'Art du Brodeur*, France, 1770; *p.125*

Sayer, Robert, *The Ladies' Amusement or, the Whole Art of Jappanning made Easy*, London, 1762; p.110

Upholsterers, Society of, *Genteel Houshold Furniture*, London, 1760–2; p.94

Vardy, John, *Some Designs of Mr Inigo Jones and Mr William Kent*, London, 1744; p.121

Neoclassicism

Ackermann, Rudolph, *Repository of Arts*, London, 1809–28; *p.139*, p.142, p.156

Adam, Robert and James, *The Works in Architecture*, London, 1773–1822; p.140, *p.140*, p.177, *p.177*, *p.189*

Beunat, Joseph, *Designs for Architectural Ornaments*, Paris, c.1813; *p.203*; *p.208*, *p.209*

Carter, J., *The Builder's Magazine*, England, 1774–78; *p.140*

Catalogo degli Antichi Monumenti, Italy, 1759; p.149

Chambers, William, *A Treatise on Civil Architecture*, London, 1759; p.177

Cochin, Charles-Nicolas, *Supplication aux Orfèvres*, Paris, 1754; p.192

Della Bella, Stefano, *Raccolta di Vasi Diversi*, Paris, 1639–48; *p.188*

Delafosse, Jean Charles, *Nouvelle Iconologie Historique*, Paris, 1768; p.130

Delle Antichita di Ercolano Esposte, Italy, 1755–92; *p.152*

Denon, Vivant, *Voyage dans la Basse et la Haute Egypte*, Paris, 1802; p.161

Diderot, Denis, *Encyclopédie ou Dictionnaire Raisonné des Sciences*, Paris, 1771; *p.159*

Dugourc, Jean-Démosthène, *d'Arabesques*, France, 1782; p.206

Hepplewhite, A. (George Hepplewhite), *The Cabinet-Maker's and Upholsterer's Guide*, George Hepplewhite, England, 1788 (first edition); *p.134*, p.140, *p.141*, *p.142*, *p.143*, *p.145*, p.154

Hope, Thomas, *Household Furniture and Interior Decoration*, London, 1807; p.129, p.142, *p.143*, p.156, ; p.183, *p.183*

Hugues, Pierre François, Baron d'Hancarville, *Antiquités Etrusques, Grecques et Romaines*, Naples, 1766–67; p.177

Ideen zu geschmackvollen Möbeln, Leipzig, 1805, p.147

Laugier, Abbé, *Essai sur l'Architecture*, Paris, 1753; p.126

Meissonnier, Juste-Aurèle, *Oeuvre (Livre des Legumes)*, France, c.1750; p.188

Mésangère, Pierre La, *Collection de Meubles et Objets de Goût*, France, 1802–35; p.136, p.156

Neufforge, Jean François, *Receuil Elémentaire d'Architecture*, Paris, 1757–80; p.126

Pastorini, B., *A New Book of of Designs for Girandoles and Glass Frames*, England, 1775; *p.140*

Percier, Charles and Fontaine, Pierre-François-Léonard, *Recueil de décorations intérieures*, Paris, 1801; p.128, *p.135*, *p.193*

Piranesi, Giovanni Battista, *Le Antichità Romane* and *Vedute di Roma*, Italy, 1756 and 1748–78; p.126

Richardson, George, *New Designs for Vases and Tripods*, London, 1793; *p.139*

Sheraton, Thomas, *Cabinet Dictionary*, London, 1803; p.142

Sheraton, Thomas, *The Cabinet-Maker and Upholsterer's Drawing Book*, London, 1791–4; p.142, *p.143, p.145*, p.154

Smith, George, *A Collection of Designs for Household Furniture and Interior Decoration*, London, 1808; *p.141*, p.142

Tatham, C.H., *Etchings of Ancient Ornamental Architecture*, England, 1799; *p.139*

Tatham, C.H. , *Designs for Ornamental Plate*, England, 1806; p.191, *p.191´*

Vien, Joseph-Marie, *Suite de Vases*, Paris, 1760; *p.192*

Winckelmann, Johann Joachim, *History of Ancient Art*, Rome, 1764; p.126

Wood, Robert and Dawkins, James, *Ruins of Palmyra* and *Ruins of Baalbeck*, London, 1753 and 1757; p.126

Historic Revivals
Arrowsmith, A. and H.W., *House Decorator's and Painter's Guide*, London, 1840; p.210

Bridgens, Richard, *Furniture with Candelabra and Interior Decoration*, London, 1838 (2nd ed); *p.213*

Conner, Robert, *Cabinet-Maker's Assistant*, U.S., 1842; p.214

Dolmetsch, Heinrich, *Ornamentenschatz*, Stuttgart, 1887; p.213

Downing, A.J., *The Architecture of Country Houses*, New York, 1850, p.210

Gleason, *Pictorial Drawing-Room Companion*, U.S., 1854; *p.212*

Jones, Owen, *The Grammar of Ornament*, London, 1856; p.213, p.250

King, Thomas, *The Modern Style of Cabinet Work Exemplified*, London, 1829; p.220, *p.220*

Loudon, J.C., *Encyclopaedia of Cottage, Farm and Villa Architecture and Furniture*, London, 1833, p.210

Journal of Design, London, 1849–52; p.210

Knight's Vases and Ornaments, c.1833; p.242

Rickman, Thomas, *An Attempt to Discriminate the Styles of English Architecture*, London, 1817; p.210

Shaw, Henry, *Specimens of Ancient Furniture*, London, 1836; p.216

Viollet-le-Duc, Eugène, *Dictionnaire du Mobilier Française*, Paris, 1858–75; p.214

The Aesthetic Movement
Booth, Charles, *Modern Surface Ornament*, New York, 1877; *p.269*

Cook, Clarence, *The House Beautiful* and *What Shall We Do With Our Walls?*, New York, 1878 and 1880, *p.250, p.253*; p.250

Eastlake, Charles Locke, *Hints on Household Taste*, London, 1868; Boston, 1872; p.252, p.254

Edis, Robert W., *Decoration and Furniture of Town Houses*, London, 1881; *p.256*

Talbert, Bruce, *Gothic Forms applied to Furniture*, Birmingham, 1867; Boston, 1873; p.252, 254, *p.254*

Watt, William, *Art Furniture*, London, 1877; p.258, *p.259*

Arts and Crafts
Cabinet Maker and Art Furnisher, The, England, 1880–89; p.284

Cobden-Sanderson, A.T.J., *Ecce Mundus: Industrial Ideals and the Book Beautiful*, England, 1904; *p.276*

Craftsman, The US, 1901–1916; p.284

Studio, The, England, established 1893; p.284

Art Nouveau
L'Art décoratif, Paris, 1898–1914; p.301

Art et Décoration, Paris, 1897–1938; p.301

L'Art moderne, Brussels, 1881–1914; p.301

Dekorative Kunst, Munich, 1897–1927; p.301
L'Emulation, Brussels, 1874;. p.294

Kunst und Kunstandwerk, Vienna, 1898–1924; p.308

Grasset, Eugène, *Plants and their Applications to Ornament*, London, 1897; *p.301*

Haeckel, Ernst, *Kunstform der Natur*, Leipzig and Vienna, 1898; *p.301*

Jugend, Die, Munich, 1896–1920; p.301

Moser, Kolomon, *Die Quelle*, Germany, 1901; *p.326*

Pan, Berlin, 1895; p.301

Ver Sacrum, Vienna, 1898–1903,; p.301

Modernism
Pilgrim, Dianne, *The Machine Age in America*, U.S., 1988; p.388

The Space Age
Sunday Times Colour Supplement, Britain, launched 1962; p.453, p.456

Spectator, The, Britain; p.454

Tailor and Cutter; Britain, p.470

Vogue, U.S.; p.452, p.470

Postmodernism
Face, The, Britain; p.500

Jencks, Charles, *Architecture, The Language of Postmodern Architecture and Postmodern Classicism*, 1977 and 1983; p.484

Lyotard, Jean-François, *The Post-Modern Condition*, France, 1984; p.482

Pevsner, Nikolaus, *Pioneers of Modern Design*, 1949; p.482

Venturi, R., *Complexity and Contradiction in Architecture*, U.S., 1966; p.482

Venturi, R., Scott Brown, Denise, and Izenour, Steven *Learning from Las Vegas*, U.S.; p.482

Wolfe, Tom, *From Bauhaus to Our House*, U.S.; p.484

Glossary

* see separate entry

Abstract Expressionism a painting movement fusing abstract art with expressionism and allowing the subconscious to express itself – a form of automatic painting.

acanthus a stylized leaf ornament based on the Mediterranean plant, *Acanthus spinosus*, often seen in classical architecture and one of the most widely used ornamental forms in the decorative arts.

acid etching technique to engrave a design into glass using hydrochloric acid – the longer the vessel is exposed to the acid, the deeper the relief.

Adam Revival the late 19th-century revival of 18th-century Neoclassical style.

Adam Style the British form of 18th-century Neoclassicism, introduced by the Scottish architects, Robert and James Adam in the second half of the 18th century.

Aesthetic Movement a development of the design reform movement during the 1860s and 1870s in which "Art for Arts sake" was the chief impulse. The style was much influenced by Japanese decoration, late 17th- and early 18th-century English domestic design, and blue and white Chinese porcelain. Simple forms and uncluttered surfaces were a reaction to the hightly elaborate products of mainstream Victorian taste, while ornament was often placed asymmetrically. Typical motifs included sunflowers, fan shapes, peacock feathers, and bamboo.

air twist a bubble of air drawn out to form a twisted or spiral channel, or channels, in the stem of a glass; a type of decoration used from the mid-18th century, especially in Britain. Other types of twists incorporate strands of white or coloured glass rods.

à la cathèdrale a French chair, introduced *c*.1825, with sculpted Gothic architectural details such as crenellated top rails, crockets*, pinnacles*, and folate spandrels.

all'antica from the Italian for "after the antique," decoration derived from classical inspiration.

alpaca an alloy of sterling silver with nickel added for strength.

amaranth also known as purpleheart or palisander, a fine-textured tropical timber from Central and South America used for veneers and marquetry since the 18th century. Purplish in colour when first cut, it becomes a rich dark brown when seasoned.

amphora a type of two-handled vase with a spreading mouth and foot, narrow neck, and rounded body used to store wine or olive oil in ancient Greece and Rome; the form is imitated in Neoclassicism.

anthemion a stylized floral motif based on the honeysuckle, seen in classical design and much used in the Neoclassical period, usually as a repeating ornament. The term is often used, interchangeably, for the palmette* which it closely resembles.

appliqué from the French for "applied," ornamentation made separately and then applied to an object. On fabrics, decorative stitching or seams are usually used to hide the edges around the appliqué.

apron the "skirt" of wood joined to the bottom of a piece of case furniture, tabletop, or seat rail of a chair. It may be shaped and decorated or a simple band.

arabesque originating in the Near East, a pattern of intricate and stylized intertwining leaves and scrolls, popular in 16th- and 17th-century Europe and revived in the 19th century. In 18th-century France, the term was applied to grotesque* designs of figures and scrolling foliage.

arborescent design used in textiles, a pattern resembling or based on a tree.

arcading derived from architecture, decoration composed of a series of linked arches; often found on furniture and panels in the late 16th and 17th centuries.

armoire from the French, a large cupboard with two doors and usually a shelf or two, used for storage especially of linens or clothing.

armorial a coat of arms or heraldic decoration.

armorial ware silver, ceramics, or glass decorated with a coat of arms, family crest, or other heraldic ornament.

Art Deco prevalent from *c*.1910 to 1940, a design style known for its bold colours and geometric shapes. The name comes from the 1925 Exposition des Arts Décoratifs et Industriels Modernes in Paris.

artificial porcelain another term for soft-paste* or imitation porcelain.

Art Nouveau popular in Europe from the 1890s to *c*.1910, a decorative arts style based on sinuous curves, flowing lines, asymmetry, and organic forms, often incorporating flower, leaf, and insect motifs.

Arts and Crafts Movement led by the British designer William Morris, a 19th- and early 20th-century movement by artists advocating a return to simplicity and functionalism in design and quality of materials and craftsmanship.

Auricular style thought to be originally based on the shape of the human ear, decoration in an undulating, rippling style found on late 16th- and 17th-century northern European silver and furniture.

aventurine from the Italian *avventura*, meaning accidental, a type of translucent dark brown glass with gold specks produced by the addition of copper crytals to the molten glass; the term also applies to glazed finishes such as lacquer* with a similar speckled, metallic appearance.

baluster probably derived from vase forms, a columnar support such as a table or chair leg, or the stem of a drinking glass, formed from a series of curves or knops*, giving a decorative undulating profile.

banding in furniture, a decorative veneer or inlaid strip in a contrasting colour or material such as mother of pearl or metal, applied around the edge of a drawer front, table top, or panel. The direction of the grain on the wood determines the type of banding: straight banding, cross banding, or herring-bone (or feather) banding.

Bargello (also called flame stitch, Florentine stitch, and Hungarian stitch) a simple form of embroidery, using stitches in a zizag or flame pattern in graduating shades of colour; it was first used in Hungary during the middle ages and later spread throughout Europe where it was especially popular for upholstery in the Baroque period.

Baroque originating in Italy, a heavily sculptural late 17th- and early 18th-century classically based style found on architecture, furniture, and other objects incorporating an extravagant use of plant forms such as the acanthus, human forms

such as putti, and other motifs set in curvaceous shapes, often making use of strongly contrasting tones and colours.

Baroquetto a style in Italy based on the Rococo but influenced by the Baroque.

bas armoire a type of low bookcase or cabinet, introduced in the early 18th century.

base metal any non-precious metal such as brass, bronze, iron, and steel.

bas-relief (or low-relief) a sculptural form that projects only slightly from the surface, with none of the design being undercut (see also high relief).

Bauhaus founded by Walter Gropius in 1919, a German school of architecture and applied arts that aimed to create prototype designs for mass-produced everyday items, using austere, geometric forms, and modern materials such as tubular steel and plastics. Its funtionalist approach grew out of the Arts and Crafts Movement* and led to Modernism*.

bead and reel a classical border ornament formed from alternating groups of beads and oblong spindles or reels.

beading a decorative border of cast and applied or embossed beads of the same or graduated size, used especially on 18th- and 19th-century ceramics and metalwork.

beaker a cylinderical drinking vessel sometimes tapered or with an everted rim, without a handle or stem, often with a foot rim.

bellflower see husk

bentwood a process of furniture-making, by bending lightweight, solid, or laminated* wood with steam. It was developed by the Austrian Michael Thonet during the 1830s and 1840s. Earlier, the American Samuel Gragg of Boston had patented a method of bending solid wood for the frames of chairs, and, later John Henry Belter exploited a laminated form for his elaborately carved furniture.

bergère a term derived from the French word *bergerie*, meaning sheep fold, to describe a type of deep-seated armchair with back and arms enclosed, often with caning or leather upholstery; sometimes the arms and top rail form a continuous curved enclosure.

Berlin woolwork popular in Europe and the US during the 19th century, a type of canvas embroidery using coloured wools and designs originally imported from Berlin; manufacturers provided the patterns, which were then transferred to canvas, as a way of marketing the wools.

Biedermeier a bourgeois style of decorative art practised in Austria, Germany, and other parts of Eastern Europe *c.*1810 to 1850, characterized by bold, classical shapes with restrained, well-executed decoration. The style was influential on later design, especially in the early 20th century.

biscuit a ceramic body that has been fired but not glazed. Biscuit porcelain, used for statuettes and sculptures, has a crisp, dry matt appearance.

blanc-de-Chine a type of white Chinese porcelain, usually in the form of figures, left unpainted and covered in a thick white glaze; it was exported to Europe from the 17th century onwards, and was influential in the development of European porcelain the early 18th century.

blanc de Pouyat a type of white hard-paste* porcelain produced at the Pouyat factory, Limoges, France, in the mid-19th century.

blaze a type of fan-shaped cut-glass decoration.

block print a long-used method of applying a pattern to fabric or paper, using a wooden block with the design carved into it in reverse, leaving the design raised. Dye is applied to the block, which is then positioned and pressed on the fabric; the pattern is extended by repeating the process.

bluejohn a contraction of the French, *bleu-jaune*, to describe the decorative fluorspar mined in Derbyshire in the 18th century; mainly purple and blue in colour, someties with streaks of brown or yellow, it was also popular in France, where much was exported. The metalworker, Mathew Boulton, made spectacular use of it in combination with ormolu* for candelabra, perfume burners, and other ornamental items.

bobbin lace a type of lace made throughout Europe in the 17th and 18th centuries, especially in the Low Countries, where threads on bobbins were passed around pins projecting from a hard pillow.

bocage from the French word meaning "thicket," used to describe the trees or foliage surrounding or supporting a figure made of porcelain or pottery.

bombé a French word meaning "bulging," used to describe the swelling convex shape found in furniture made during the Rococo period, escpecially on commodes and chests of drawers. A similar shape in the US is known as "kettle shape."

bone china a durable British porcelain consisting of kaolin (china clay), petuntse (china stone), and dried bone. The Spode factory began using it in 1794 to compete with Chinese imports made of hard-paste porcelain; bone china is still used today.

bonheur du jour a lady's writing desk, established by the late 18th century, often fitted with toilet accessories, with shelves and pigeonholes at the back, a flat writing surface at the front, and a drawer underneath.

boteh leaf-shaped or pine-cone motif derived from 17th-century Persian and Indian textiles, which was the inspiration for European paisley patterns.

Boullework a type of marquetry, named after André-Charles Boulle (1642–1732) who developed it, which was used to decorate high-quality furniture from the late 17th century onwards with ebony or tortoiseshell and brass cut into intricate designs. Pewter, mother-of-pearl, and ivory were sometimes incorporated into the work, and bright colours, especially red, blue, or green could be introduced by painting or staining the tortoiseshell from behind. The technique continued in use during the 18th century and enjoyed a revival during the early 19th century, when it was sometimes referred to as Buhl work.

bow front the convex curved front on case furniture.

bracket foot a support for case furniture in which two wooden pieces shaped like brackets are mitred and joined together; popular in the 18th century.

breakfront a term for a piece of case furniture with a protruding central section.

bright-cut engraving popular during the Neoclassical period, a type of engraving used on metal where the surface is cut at an angle to form facets that reflect light.

brilliant cut a term derived from a technique of diamond cutting and used to describe the complex, deep, and highly polished cutting of glass developed in the United States during the second half of the 19th century. New techniques and materials, as well as skilled immigrants from Europe, allowed the development of cut-glass techniques that created a material known for its clarity and brilliance, while new technology enabled curved lines to be made in a cut-glass pattern.

Britannia metal a type of pewter containing a relatively high amount of tin with added antimony and copper but no lead; developed in the late 18th century it was a harder and stronger pewter than had been used previously.

Britannia standard from 1697 to 1720, the compulsory amount of silver used in making silverware, which was 95.8 per cent pure (sterling silver is 92.5 per cent pure); the higher standard was set to prevent the melting down of sterling silver coins to make silverware for the domestic market.

brocatelle a 17th-century French term, taken from the Italian *broccatello*, for a type of woven fabric, usually silk or wool, with a raised pattern on a smooth background. Or a variegated marble used for table tops in the 18th-century .

broncit (also known as bronzite) a type of glass mainly made at the Lobmeyr factory in Vienna, *c.*1910, incorporating matt black metallic decoration of animals, flowers, figures, and geometric shapes on clear or matt glass.

bucranium applied ornament in the form of a ram's skull.

buffet an early form of a sideboard, orginally a tiered structure for displaying valuables; 16th- and 17th-century English examples might incorporate an enclosed section or a drawer, and are known as court cupboards. More generally the term is used for sideboard or side cabinet.

bunting a lightweight, loosely woven cotton fabric, usually used for making flags or festive decorations in swagged or draped form.

bureau made from the early 18th century, a type of writing desk with a sloping fall front, enclosing a fitted interior with pigeonholes and drawers, and usually with drawers below.

bureau à cylindre (or *secrétaire* à cylindre*) a type of bureau with a slatted cylinder top that rolls up to expose a flat writing surface. Probably first designed by Jean-François Oeben (c.1721–63) it became a popular form in England as well as France later in the 18th century.

bureau cabinet a bureau (see above) with a cabinet enclosed with doors above the writing section.

bureau Mazarin named in the 19th century after Cardinal Mazarin, chief minister to Louis XIV, a type of late 17th-century writing desk with eight legs joined by stretchers and decorated in boulle* marquetry.

bureau plat French term for a flat-top writing desk, often covered with leather, with a drawer in the frieze below.

cabochon a gemstone in a smooth domed shape; also a raised circular- or oval-shaped motif.

cabriole type of leg found on European furniture from the late 17th century that has a gently curving, attenuating S-shaped profile, wider at the top and tapering towards the bottom.

caddy a decorative wood, metal, ceramic, or glass container for storing tea.

calcedonio first produced in Italy in the 15th century, a type of glass imitating the colour and veining of chalcedony (or agate) and other semi-precious stones. It was popular during the Renaissance and again in the 18th century, and was produced in Britain and Bohemia in the 19th century; known as *Schmelzglas* in Germany.

camaïeu, en a French term for describing a painting of the same colour but using different tones, simulating a cameo.

cameo a classical ornament revived in the Renaissance and Neoclassical styles, consisting of a gem, hardstone, or shell carved to show a relief design such as a classical group, head profile, landscape, or deity against a contrasting background.

cameo glass cased glass, consisting of two or more layers, in contrasting colours, with a carved or etched design in relief. The technique was known in antquity and revived in the 19th century.

carcase (carcass in the US) the basic structure of a piece of case furniture, often a foundation for veneering.

cartouche from the French for "scroll," a decorative motif in the shape of a sheet of paper with scrolling ends, bearing a monogram, inscription, or picture in the centre; it may take the form of a shield or tablet with a decorated frame and was especially popular in the Rococo period.

caryatid of Greek classical origin, a draped female figure acting as a column support, found on Neoclassical and Empire-style furniture.

cased glass glass of one colour covered with a layer or layers of a different colour; the surface could then be engraved or partly cut away to reveal the layers beneath. The technique was developed in Bohemia in the early 19th century and later copied elsewhere.

case furniture pieces with a box-like carcase structure which may be fitted with drawers, shelves, or doors. Examples include chests of drawers, cupboards, bookcases, and bureaux.

cassone an Italian chest from the Renaissance period, often incorporating elaborate carving, painting. or inlays. They were often made in pairs as wedding presents.

Celtic style a decorated style associated with Celtic peoples, who spread from central Europe to Spain, Italy, and Britain *c.*250BC, incoporating curvilinear patterns, especially interlacing knots, with stylized sinuous animal and human forms; it was the inspiration for much Art Nouveau design, especially at the Glasgow School.

centennial see Colonial Revival

centrepiece item designed to decorate the centre of a dining table; see epergne.

ceramics from the Greek for "clay," the term used to describe clay-based products hardened by heating at high temperatures, including earthenware, porcelain, stoneware, and bone china.

chamfered the surface created by cutting or planing an edge at an angle, especially in wood and stonework.

chair en cabriolet (or *fauteuil en cabriolet*) armchair with a padded and curved back.

champlevé an enamelling technique where areas of metal are hollowed or etched out and filled with an enamel paste, then fired in a kiln before being polished down to the level of the metal.

chasing a technique for creating relief decoration in metal, especially silver, by using hammers and punches to push the metal into a pattern; unlike engraving, no metal is removed. Embossing and repoussé are forms of chasing.

cherub an architectural motif used from the 15th century onwards consisting of a winged child or child's head; it was a popular motif on furniture, silver, and ceramics, especially in the Baroque period.

chevron a zigzag pattern.

chiaroscuro from the Italian meaning "light" and "dark," the placement of lights and shades in a pictorial work of art.

chiffonier from the French term *chiffonnière*, for a small chest of drawers, or side cabinet introduced in the early 19th century, with one or more shelves above a sideboard, usually a drawer in the frieze and a cupboard below.

chinoiserie the fanciful Western interpretation of Chinese ornament, consisting of figures and motifs such as pagodas, birds, dragons, and fretwork applied to all kinds of decorative art from the 17th century onwards and particularly popular in the Rococo period.

cire-perdue see lost-wax casting.

classical see Neoclassicism

cloisonné an enamelling technique where fine metal wire is attached to metal, forming a network of *cloisions* (compartments), which are then filled with enamel paste before the object is fired in a kiln.

coffee can a cylindrical, straight-sided cup for drinking coffee, made during the late 18th and early 19th centuries.

Colonial Revival also known as Centennial in the US, a period 100 years after the signing of the Declaration of Independence in 1776 in which American furniture was made as an authentic

reproduction of high-quality colonial-style furniture; patriotic motifs include buffalo heads and American eagles. Centennial may also refer to items made especially for the celebrations that took place in 1876.

Colonial style a furniture style found in the American colonies from *c.*1600 to 1780, characterized by turned baluster decoration, surface carving, and painting; also the 18th-century European furniture style as interpreted in the Spanish and Portuguese colonies of South America.

commedia dell'arte lively, sometimes ribald characters from the Italian folk theatre, including Harlequin, Columbine, Pantalone, Pulcinella, and Pierrot, modelled in porcelain at Meissen, Nymphenburg, and other European factories.

commode a French term for a chest-of-drawers, especially a grand or decorative one; also, a piece of furniture made for storing a chamber pot.

composition an inexpensive plaster-like material made of whiting (chalk) and size or glue (or resin, sawdust, or ground rags), used to make relief mouldings and carved effects on furniture.

Consulate style a French style of Neoclassicism prevalent during the political Consulate period (1799–1804) and leading into the Empire style*.

coquille d'oeuf the French term meaning "eggshell"; see eggshell porcelain.

crackling/crazing describing the effect on glass when its temperature is abruptly reduced during firing, creating an over-all decoration of fine cracks; or a similar result on ceramics caused by differences in the expansion and contraction of body and glaze during firing.

cranberry glass (also known as ruby glass) a 19th-century British or American glass with a pink hue created by adding copper oxide or gold chloride to the glass.

credenza the Italian term for a sideboard; in the 19th century it was often used to refer to a side cabinet with a central cupboard and open shelves on each side.

cretonne a type of heavy, unglazed cotton or linen fabric with a slightly ribbed surface and printed designs, used for curtains and furniture.

crewelwork embroidery with two-ply crewel wools, usually on a linen background, popular especially for bed curtains in the 17th and 18th centuries, and revived in the 19th.

cristallo a soda glass developed in Venice in the 14th century that remained malleable long after heating, allowing it to be formed into elaborate shapes; it could be decorated with enamelling, gilding, trailing, or engraving but was too brittle for cutting.

crizzling a defect consisting of a network of fine cracks, resulting from deterioration in old glass.

crocket an ornament shaped like a curled or bent leaf or cusp projecting from a gable or spire in gothic architecture and used in furniture and metalwork in the Gothic style.

crystal glass a type of colourless, transparent lead glass, also known as "quartz crystal" because of its light-reflecting property; it is often heavily cut and engraved.

cup and cover a type of bulbous turning, resembling a deep bowled cup and domed lid, found on furniture supports from the mid-16th century.

cut-card decoration a technique used on silver, in which flat sheets of metal are cut into a pattern such as leaves or swirls, then soldered to the body or cover of a piece to form relief decoration; the technique was popular among Huguenot silversmiths in England and France in the late 17th and early 18th centuries.

cut glass decoration made into glassware by cutting grooves and facets by hand or with a wheel. First developed in ancient Egypt, it was employed by Bohemian glassmakers in the 16th and 17th centuries. The development of soft lead glass led to its popularity in England and Ireland in the 18th and 19th centuries. Styles include blazes, fluting, splits, hobnail, and diamonds. "Brilliant" cut* glass was developed in the US in the 19th century.

Czech Cubism an early 20th-century architectural style developed by architects and designers in Prague who were influenced by the geometric arrangements, angularity, and distortion of Cubism; some of the designers experimented with the use of prisms, triangles, and pyramids.

damask a reversable woven patterned fabric, usually of silk or linen.

damascening a decorative metal working technique where fine metal wire made of gold, silver, or copper was inserted into grooves cut into a brass, bronze, or iron body, then flattened by hammering; originally developed in the Middle East, the technique spread to Europe in the 16th century.

dauphin the eldest son of the king of France.

dentil from the Latin *dens* (tooth), a decorative ornament found in Classical architecture underneath cornices, consisting of a row of small rectangles that give the appearance of teeth.

De Stijl from the Dutch for "the style," an early 20th-century group of radical Dutch artists and architects, linked with the German Bauhaus school, who rejected the excessive Art Nouveau style in favour of a simple style with an emphasis on logical function and construction; forms were asymmetrical, using strong lines, squares, and rectangles, in pure primary colours.

dinanderie originally brassware from Dinant, near Lièges, but during the Art Deco period a term used for hammered and chased ornamental metalwork, whether silver, copper, pewter, or steel.

Directoire style a Neoclassical French style, especially in furniture, reflecting the political Directoire period (1795–99) and recognized by austere classical forms, sometimes decorated with revolutionary symbols such as the fasces (an axe bound by a bundle of rods) and the cap of liberty.

duchesse a type of long upholstered armchair with a rounded back – an early version of the chaise longue, having evolved from the daybed; the type with a separate part which can be used as a seat on its own is called a *duchesse brisé*.

earthenware pottery made of a clay body and fired in a kiln at low temperatures, creating a porous object that requires a glaze to make it waterproof.

ébéniste a term derived from the word for ebony, denoting a French cabinetmaker specializing in veneered furniture.

ebonized wood that has been stained black to simulate ebony.

eclecticism the indiscriminate use of historical revival styles during the 19th century.

eggshell porcelain a type of thin, delicate Chinese porcelain imitated in Japan, England (Minton), and Ireland (Belleek) in the 19th century.

electroplating a method patented in 1840 in which silver is plated onto a base metal, such as copper or nickel (EPNS), using an electric current, to produce a modestly priced item with the look of a more expensive metal.

Elizabethan Revival a style popular in England between the 1820s and 1850s, inspired by the so-called Elizabethan style*.

Elizabethan style the name sometimes given to the architectural and furniture style predominant in Britain during Elizabeth I's reign (1558–1603); it was actually a continuation of the Renaissance style, and characterized by symmetrical facades, arcaded friezes, strapwork, grotesques, arabesques, heraldic motifs, and bulbous supports.

embossing the technique of creating raised designs on metal (or leather), by means of machine or hand work; it can be carved, chased, or repoussé*.

Empire style the name given to late Neoclassicism in France, much influenced by Napolean's designers Percier and Fontaine, and, in turn, influential on styles in the rest of Europe and America.

enamel a type of decoration that involves fusing a glassy substance coloured with metallic oxides to a metal surface by means of heat; techniques include *champ levé*, and *cloissonné**.

enamel colours pigments made from metallic oxides mixed with powdered glass and used for decorating porcelain, pottery, glass, and metal. They are fixed by firing in a low-temperature or muffle-kiln.

encaustic tile a clay tile decorated with inlays of a contrasting coloured clay; a Medieval technique revived in the mid-19th century notably by Herbert Minton.

engraving a technique to decorate metal or glass by cutting fine lines or dots into the surface using a sharp tool such as a diamond point or rotating wheel. Making a print involves a similar process of engraving on a metal plate before transferring the design to paper.

ensemblier the French term for an interior designer.

epergne an elaborate centrepiece for a dining table, made of silver or glass, with a central bowl and branching arms that support removable bowls, used from the mid-18th century for fruit, sweetmeats, and condiments.

étagère the French word for a type of table with two or three tiers used to serve food or display objects, similar to the English and American whatnot*.

Etruscan style the Neoclassical style of c.1760–1800, based on the decoration of classical Greek vases, at the time thought to be Etruscan in origin.

étui a small decorative case made of silver, gold, enamel, lacquer, tortoishell, or other material and often of tapering form with a hinged lid, designed to carry useful personal items.

façon de Bohème from the French, meaning "in the style of Bohemia," referring to glass made in the Bohemian style, often brightly coloured.

faience French term for tin-glazed earthenware. The word is derived from Faenza, where much early Italian maiolica (tin-glazed earthenware was made). The German term is Fayence; the Dutch, Delft; the British, delftware.

fall-front secrétaire a door or closure for a cabinet, desk, or bureau which is hinged at the bottom and drops down to form the writing surface, supported in one of several ways: by cords at the sides, lopers or struts pulled out from the carcase or metal quadrants attached to the sides.

fauteuil the French term for an armchair introduced in the early 18th century.

Federal style the American Neoclassical style, popular from c.1789 to c.1830.

ferronier French craftsman working with wrought iron.

festoon looped ornament consisting of themes such as a flowers, fruit, leaves or drapery generally with suspended ends, and sometimes punctuated with lion masks, bucrania*, rosettes, or other classical motifs.

filigree fine silver or gold wire twisted to form lace-like decorative openwork.

finial a decorative knob found on furniture, metalwork, ceramics, and glass, sometimes used as a handle. Popular shapes include the acorn, pinecone, and urn or more elaborate forms such as animals, fruits, and flowers.

flame stitch see bargello.

flashed glass the technique, developed in Bohemia in the early 19th century, of applying a thin film of coloured glass to a vessel, by dipping, and then decorating it with light engraving. Ruby red was the usual colour but amber and green are also found.

flint glass the name given to English lead glass, developed by George Ravenscroft in the 1670s, which was made with ground flints or sand with the addition of lead oxide.

fluting the opposite of reeding, a pattern of vertical concave grooves on a column or other surface, sometimes painted or inlaid in trompe l'oeil* style.

fretwork pierced geometric decoration with intersecting lines, usually repeated to create a band or border. If the work is not pierced, it is known as "blind" fretwork.

frieze specifically the horizontal band found below the cornice on a piece of case furniture or, more generally, any horizontal strip of decoration on furniture, silver, or ceramics.

gadrooning a continuous pattern of vertical or diagonal convex curves or lobes, found on furniture, silver, and ceramics; an irregular form is known as knulling.

Galanteriewaren derived from the German word for "courteous," small, precious accessories made for personal use such as scent bottles and *étuis**.

galuchat the French term for shagreen*, named after M. Galuchat, who used it in the 18th century for covering sheaths.

garniture usually vases, but sometimes other ornaments used for display, made in sets of three, five, or seven.

gasolier a decorative fixture for gas lighting, used from the 1820s until the introduction of electric lighting in the 1880s. Usually made of brass, it resembled a chandelier, with a central shaft, through which the gas travelled, with branches which supported plain or coloured lampshades covering the gas burners.

genre pittoresque the fully developed Rococo style from c.1730, characterized by exaggerated asymmetry and scrolling ornament incorporating naturalistic themes such as shells, rockwork, the seasons, or Aesop's fables.

Georgian a largely meaningless term referring to furniture and other decorative arts during the reigns of the four kings of England of that name, George I (1714–27), George II (1727–60), George III (1760–1820), and George IV (1820–1830).

gesso a mixture of plaster of Paris or chalk and glue size, applied to create a smooth surface for painted decoration and gilding or, built up in layers and sometimes carved, for relief ornament.

giallo antico from the Italian meaning "antique yellow," a marble-like substance containing calcite or aragonite found in caves or near springs; iron oxide gives it the yellow colour. It was used for the tops of commodes and tables in the 18th and 19th centuries; *verde antico* is a green type.

gilding the application of a gold finish to metal, ceramics, wood, or glass. The methods are: water gilding and oil gilding for furniture; acid gilding and size gilding for ceramics; honey gilding for ceramics and glass; and mercury or fire gilding, matt gilding; and electrogilding for metals.

girandole from the Italian for Catherine wheel, a candelabrum, elaborate wall sconce*, or carved bracket with a mirrored back.

Glasgow school a late 19th- and early 20th-century group of architects and designers led by Charles Rennie Mackintosh and his wife Margaret Macdonald based at the Glasgow Scool of Art. They were known for their version of Art Nouveau, which included Celtic ornament and stylized floral motifs, using

straight or gently curving lines, and were especially influential in Europe.

glaze a glassy coating applied to porous ceramic bodies to waterproof them, creating a smooth shiny surface; a lead glaze is transparent, while tin glaze is opaque. Decorative effects can be produced with the addition of other substances such as wood ash, salt, or metallic oxides, and by varying the kiln temperature during firing.

gold leaf wafer-thin sheets of gold used for gilding.

Gothic a style based on Medieval architecture, characterized by pointed and ogee* arches, tracery*, pinnacles*, cusps, crockets*, trefoils*, and quatrefoils*.

Gothick a decorative strand of the 18th-century Rococo style, inspired by Gothic* architecture but without concern for historical accuracy.

Gothic Revival (also known as Neo-Gothic) a rebirth of the Gothic* style revived in Europe in the 1820s and in the US in the 1840s. The variety known as Reformed Gothic, led by A.W.N Pugin, was influential on the Arts and Crafts Movement.

Goût Grec from the French "Greek taste," the contemporary term used in France in the 1760s to describe the early Neoclassical style, with emphasis on geometric forms and decoration based on the ancient architecture of Greece; motifs include volutes*, bay leaf swags, vitruvian scrolls*, palmettes*, and guilloche*. Sometimes known as Louis XVI style.

Grand Tour a tour of Europe, and sometimes further afield, usually lasting one or two years, made by affluent British men on completion of their formal education, allowing them to absorb the culture and history of the major European cities, especially those in Italy, as well as to collect works of art and antiquities; these tours were at their most popular in the 18th century.

Great Exhibition, The shortened version of "The Great Exhibition of the Works of Industry of All Nations," the first international exhibition, held in the Crystal Palace, London, from May to October 1851, to include manufactured items from around the world. The goal

of the exhibition was to promote trade and improve public taste.

Greek key a pattern based on ancient Greek decoration consisting of inter locking right-angled lines; it was often used in a continuous band in classically inspired ornament.

griffin or gryphon a popular Neoclassical motif consisting of a mythical animal with the head, wings, and claws of an eagle with the body of a lion; it originated in the ancient East and was associated with Apollo, god of the sun, which is why it often appears on lighting forms such as candelabra.

grisaille a type of painted decoration with a colour palette restricted to black, white, and grey, creating the impression of a sculpted stone relief or cameo.

gros point from the French (*point* meaning "stitch"), cross-stitch embroidery, usually on canvas.

grotesque an elaborate type of ornament consisting of linked figures of humans, animals, mythical beasts, or birds among intertwining scrolls and foliage, often in a vertical structure incorporating candelabra forms; based on ancient Roman painted decoration found in Italian *grotte*, or subterranean ruins. The decoration was first popular during the Renaissance.

guéridon a small table or stand on a pedestal foot for holding a candelabrum, tray, or basket, introduced in France in the 17th century. Louis XIV forms were sometimes carved in the shape of an African figure bearing a round tray.

guilloche a pattern of continuous twisting bands forming interlacing circles, sometimes enclosing rosettes or other motifs; derived from classical architecture, this ornament was revived in the Renaissance and was widespread in the Neoclassical period.

guttae a decorative element representing stylized drops of water, usually taking the form of a row of triangular beads occasionally used in Neoclassical furniture.

gutta-percha a type of rubbery material developed from the resin of a Malaysian tree in the mid 19th century. It was moulded to make furniture decorations as a substitute for carving, as well as for dolls' heads and golf balls.

hard-paste porcelain (or true porcelain), the high-fired translucent ceramic body used by the Chinese from the 8th century AD and rediscovered at Meissen, *c*.1709.

hardstone see pietre dure.

Hausmaler the German term for "home decorator," a freelance porcelain or faience painter who worked in his own studio independently of a factory.

heraldic decoration ornament representing elements of heraldry such as coats of arms, sheilds, emblems, and crests.

hessian (burlap in US) used in the upholstery of seat furniture.

highboy an American variant of the chest-on-stand or tallboy, usually with cabriole* legs and a broken pediment* made throughout the 18th century. The form consisting of a side table fitted with drawers and similarly supported on legs is known as a lowboy.

high relief decoration that protrudes from the surface of the work with undercutting.

Historicism the recreation of historic styles in a spirit of scholarship and a search for authenticity.

Holzshnittblumen from the German for "woodcut flowers," a type of floral decoration used by the Miessen factory from *c*.1740, with individual flowers copied from botanical engravings.

hôtel a French term for a mansion.

Huguenots French Protestants, many of whom fled after the revocation of the Edict of Nantes, which had allowed freedom of worship, in 1685. Huguenot refugees were often highly skilled craftsmen, and they were influential in other countries such as Britain, especially in the fields of silversmithing and textiles.

husk (or bellflower*) a Neoclassical motif based on a stylized husk of corn or a bell-shaped flower used in bands, swags, or vertical drops, sometimes with alternating beads.

Hyalith glass a type of opaque Bohemian glass made in scarlet or black, developed in the early 19th century.

incised decoration a pattern or inscription created by scratching a surface with a sharp tool.

Indiennes floral embroidered and printed cottons from India popular in 17th-century France and England which continued to influence European textile design in the18th. Flowers with stylized patterning n the petals and splaying fern-like leaves were typical elements.

inlay a decorative technique in which one type of material such as bone, horn, ivory, marble, metal, mother-of-pearl, tortoiseshell, or coloured wood is set into recesses made in the surface of another, usually the solid wooden surface of a piece of furniture.

intaglio an Italian term for incised decoration in which the design is cut into the surface being decorated, as opposed to cameo, in which the decoration protrudes; intaglio decoration can be found on glass, ceramics, metalwork and hardstones. The German term for this type of decoration is *tiefschnitt*, meaning "deep cut."

intarsia an Italian term for a type of inlaid decoration or an early form of marquetry in which woods of different colours and sometimes other materials form a realistic architectural picture or still life; it is found on panelling and furniture from the 15th and 16th centuries.

istoriato the Italian word meaning "with a story in it," referring to the painted decoration of mythical, biblical, or genre scenes found on Italian maiolica.

Japanesque term referring to the decorative style popular in Europe, *c*.1862 to 1900, inspired by Japanese art. See also Japonisme.

japanning the European technique developed in the 17th century of decorating case furniture or small objects such as boxes or trays with coats of varnish in imitation of Chinese and Japanese lacquer*, usually in black, green, or scarlet but occasionally white. Unlike true oriental lacquer, the varnish used was made of shellac, gum-lac, or seed-lac (from the *Coccus lacca* insect); relief decoration was achieved with a composition of sawdust and gum arabic and parts were often gilded.

Japanisme (or *Japonaiserie*) a style inspired by Japanese art and design that flourished in Europe and the US from the 1860s, encouraged by the renewed trading between the West and Japan and the display of Japanese wares at international exhibitions. Designers of the Aesthetic Movement were particularly influenced by the style, using Japonese motifs such as birds, sunflowers, chrysanthemums, prunus blossom, bamboo, fans, and *mons** on furniture, ceramics, and metalwork.

Jugendstil literally meaning "youth style," the German and Austrian term for Art Nouveau, which was adopted from the Munich-based art publication *Jugend* (first published 1896).

Kakiemon derived from the name of a 17th-century Japanese potter, fine white porcelain sparingly and asymmetrically decorated with flowering branches, birds, and rockwork, in a distinctive palette including iron red, blue, turquoise, yellow, and black. The imported Japanese wares were much copied in Europe in the first half of the 18th century.

kas from the Dutch word *kast*, a large cupboard or wardrobe for storing clothes, originating in Holland in the 17th century, and introduced by immigrants America, particularly New York and New Jersey, in the 17th and 18th centuries. .

kettle shape US term; see bombé.

kilim a tapestry woven rug without a pile with clear colours and bold patterns.

klismos a type of chair developed in Ancient Greece, with a concave back and inward-curving splayed, or sabre legs. The form was adopted in the early-19th-century Neoclassical period.

knop a decorative knob on a lid, often used as a handle, or the finial* at the end of a spoon handle. The term also refers to the decorative bulge on the stem of a drinking glass.

kneehole desk a writing desk with a with a central recess for the user's legs, usually flanked by drawers; the recess is sometimes fitted with a shallow cupboard.

Komai a Japanese technique for decorating combinations of different metals in geometric shapes with various scale, fret, and other patterns to form a patchwork effect. It was imitated in Britain and America from the 1870s, at the height of the Aesthetic Movement.

krater a two-handled pottery vessel with a wide mouth used for mixing wine and water in Ancient Greece, and adopted in the 18th century as a suitable classical shape.

kylix an Ancient Greek pottery two-handled drinking vessel with a shallow bowl and a stem. The form was used as part of the Neoclassical decorative vocabulary in the 18th and 19th centuries.

lacca povera from the Italian meaning "poor man's laquer," a type of decoupage (also known as *arte povera*, or "poor man's art" and *lacca contrafatta* or counterfeit laquer) that originated in Venice in the 1750s. Contemporary artists could not meet the demand for lacquered work, so printers made sheets of engravings that were coloured, cut, then pasted onto the prepared furniture before numerous layers of varnish were applied to re-create the high gloss found on lacquer decoration The technique was copied in France, where it was renamed decoupage, from the French *couper*, meaning "to cut."

lacquerwork a Chinese and Japanese process using a varnish made from the sap of the lacquer tree, or *Rhus verniciflua*, to form a hard, smooth, lustrous surface to protect and decorate objects made of wood and fabric. The lacquer is applied in as many as 100 thin layers, which may be of different colours, especially red and black, and may include designs of figures, from nature, or with emblems. European imitations are known as japanning and vernis Martin*.

ladder-back term describing a chair with a series of horizontal bars on the back.

lambrequin from the French for pelmet, originally a heraldic term for the scarf or mantle on a knight's helmet. The word has come to describe a lace-like scalloped border pattern of swags* and tassels, often used in grotesque* decoration and also popular in the early 18th century.

lamination the process of sandwiching thin strips of wood together, with the grain running in the same direction, to form a stronger material for making furniture; Thomas Sheraton was aware of the technique, and it was most successfully exploited by Michael Thonet, John Henry Belter, Charles Eames, and Alvar Aalto.

lapis lazuli a type of semi-precious, opaque blue stone with flecks of pyrite (or fool's gold), used in pietre dure*.

latticino from the Italian *latte* (milk), a type of clear glass with an embedded pattern of opaque white threads of glass; it was made from the 16th century.

lattimo known as *Milchglas* in German, a type of opaque white glass, or an object decorated with it.

Laub-und Bandelwerk the German term for "leaf and strapwork," a popular early 18th-century decoration of interwining leaves and strapwork, often surrounding a cartouche.

leather paper as the name suggests, a paper with the texture and gloss of leather. The Japanese are renowned for their paper, or *washi*. They called leather paper *yookanshi* and *takeya shibori*, and these were strong enough to be used for making pouches and lining boxes. Japanese paper was sometimes lacquered to strengthen it, and during the Edo period Japan exported leather paper to Europe where it was hung on walls like wallpaper.

lemon squeezer the shape of a pedestal foot on glassware resembling a kitchen tool for squeezing lemons.

lion's-paw foot a foot carved or cast in the shape of a lion's paw, found on furniture, metalwork, and other wares especially in the 18th and 19th centuries.

linenfold a type of woodcarving, resembling folds of hanging fabric, often found on room panelling and furniture in northern Europe from the 15th and 16th centuries.

lithyalin an opaque marbled glass made in imitation of precious stones, developed by the Bohemian glassmaker Friedrich Egermann *c*.1830.

lit en bâteau from the French meaning "boat bed," an early 19th-century Empire-style bed with curving foot and head-boards, often in S-shaped scroll form. The bed was designed to be set lengthwise against a wall, with the exposed side elaborately decorated.

loggia an open-sided gallery with a roof, usually overlooking a courtyard; a loggetta is a small version.

lost-wax casting a method of casting to form objects made of glass or metal such as silver and bronze, using a wax model encased in a clay mould. The wax is melted, and escapes, or is "lost," through holes made in the mould, allowing room for molten metal or glass. Once the metal or glass has cooled and hardened, the mould is separated to remove the object. The technique is known as *cire perdue* in French.

Louis XIV style architectural and decorative arts style fashionable in France during Louis XIV's reign (1643–1715), emphasizing grandeur, symmetry, formality, and luxury, using motifs inspired by classical art.

Louis XV style architectural and decorative arts style fashionable in France during Louis XV's reign (1715–74), including the Régence period (1715–23) when the king was a minor, characterized by smaller, lighter forms with naturalistic motifs such as shells and rockwork and progressing to the full-blown Rococo taste.

Louis XVI style see Goût Grec.

maiolica Italian tin-glazed earthenware, developed from the 14th century and reaching its peak in the late 15th and early 16th century. The term was first coined in Italy in the 14th century from Hispano-Moresque lustrewares imported to Italy from Majorca; these wares were an inspiration for the Italian potters.

majolica a corruption of the term "maiolica," 19th-century British and American lead-glazed earthenwares that were elaborately modelled and decorated in the strong, rich colours found on maiolica.

maki-e from the Japanese for "sprinkled illustration," a decorative technique in which gold powder or coloured filings are sprinkled onto a design in wet lacquer*.

marchand mercier a member of a separate Parisian gild combining the roles of dealer in furniture and works of art and interior decorator, exerting great influence on taste and fashion through his patronage of designers and craftsmen,

especially in the 18th century.

Mannerist style from the Italian *maniera* meaning virtuosity or sophistication, the late Renaissance decorative style developed in the 16th century, making much use of perspective and attenuated forms, and incorporating exaggerated, twisted, and fantastical animals, sea creatures, and birds ensnared by grotesques and strapwork. This type of improvization on classical conventions was seen at its most highly developed in Florence and Fontainebleu. The style evolved into the Auricular and led to the Baroque.

marquetry decorative veneers on furniture, comprising different coloured timbers and sometimes other materials such as ivory, metal, or mother-of-pearl, arranged to form patterns, motifs such as flowers, or pictorial subjects.

Mary Gregory glass called after a glass decorator at the Boston & Sandwich Glass Co., to describe at type of 19th-century coloured glass painted with designs of children, using a white or pink-white palette. It originated in Bohemia and was also produced in the US and Britain.

meander in textiles, a wave-like pattern.

menuisier the French term for a joiner or maker of furniture in solid wood; distinct from an *ébéniste**, who made veneered furniture.

meuble à deux corps French term for a cupboard with upper and lower sections, sometimes called an *armoire** *à deux corps*.

micromosaic a type of pietre dure* decoration made up with minute segments or tesserae of coloured stone, popular in the 19th century for Italian souvenirs ranging from small brooches to whole table tops depicting views in Rome. The term is also applied to the wood mosaic techniqe used in Tunbridge ware.

millefiori from the Italian for "thousand flowers," a glassmaking technique in which glass canes of different colours are embedded into a glass body in such a way that their cross section forms a pattern. The technique originated in ancient Rome and was revived in 16th century Italy, but it is often associated with glass paperweights made since the 19th century.

Moderne contemporary French term for

what is now (since the 1960s) known as Art Deco*.

Modernism inspired by a need to escape from past excessive decoration, a style of the early 20th century that embraced machine technology and favoured geometric forms and smooth uncluttered surfaces.

Modernismo a Spanish term for Art Nouveau.

mon a Japanese heraldic badge, originally for identification on the battlefield or to distinguish families, but later used as decoration on export wares and adopted as a motif in the Aesthetic style.

monteith a large ceramic, glass, or silver vessel with a scalloped or notched rim to hold the stems of wine glasses while suspending their bowls in cold water to keep them cool.

Moresque decoration see arabesque.

moulé en plein pressure-moulding technique for French Decorative glasswares produced from the early 19th century.

Nancy School the group of French artists, headed by Émile Galleé, Louis Majorelle, and Victor Prouvé, dominating French Art Nouveau at the end of the 19th century.

navette from the French word for shuttle, but usually translated as boat-shaped: a horizontal form with pointed ends.

Neoclassism the style based on the forms and ornamentation of ancient Greece and Rome which lasted, with variations in emphasis, from *c*.1760–*c*.1830.

niello a compound consisting of silver, lead, copper, and sulphur, inlaid into metal, usually silver, and heated to form a design on the surface. The technique was developed in Renaissance Italy and was very popular in 19th-century Russia.

nymph in classical mythology, one of the minor dfvinities of nature represented by a beautiful maiden living in a mountain, tree, forest, or body of water.

ogee a shallow S-shaped curve such as that found in a moulding profile; also used to form a Gothic-style pointed arch with reversed curves on either side of the apex.

Omega Workshops a London-based design enterprise led by the art critic Roger Fry (1866–1934) from 1913 to 1920, with the aim of encouraging young artists and improving the quality of design generally. It was strongly influenced by Fauvism and Cubism and by African art, and although commercially unsuccessful, it led the way in the application of abstract design to furniture, ceramics, and textiles.

opaline a type of translucent white, or coloured, glass opacified with tin oxide or bone ash. It was developed in France in the 1820s and later made also in Bohemia and Britain. Opaline glass was produced in a range of novel colours and was often decorated with painting or gilding.

openwork a general term for pierced decoration.

ormolu a derivative of the French *or moulu*, meaning "ground gold," mercury-gilt bronze, used for decorative furniture mounts and items such as clocks in the 18th and 19th centuries.

overlay glass see cased glass.

oyster marquetry a type of veneer created with wood from the branches of trees sliced across to form circles or ovals.

paktong an alloy of copper, zinc, and nickel used in China for small domestic items such as bells and door hinges and in Britain during the 18th and early 19th century as a replacement for silver in candlesticks, salvers, and fireplace ornaments. It ceased to be used when the less expensive nickel silver was developed.

palisander see amaranth.

Palladian style inspired by the 16th-century work of the Italian architect Andrea Palladio (1508–80), a classical style of European architecture of the first half of the 18th century, which particularly affected furniture in England where the movement was led by Lord Burlington (1694–1753) and the architect Colin Campbell (1673–1729); William Kent (1685–1748) was its chief designer. The style is recognizable by its solid, symmetrical forms with pediments*, columns, and scrolled brackets and decorated with carved acanthus*, swags*, masks and lion paws and other forms derived from classical architecture; the furniture is often grand with considerable use of gilding, especially for chairs, pier tables, and mirror frames.

palmette a classical ornamental motif derived from a stylized palm leaf, closely resembling the anthemion* and much used in the Neoclassical period.

papier-mâché a substance made from paper pulp which could be pressed to from panels or moulded into shapes and decorated with paint, japanning, gilding, or inlays of mother-of-pearl. It was used for small domestic items such as trays and tea caddies from the 1770s, and also for furniture in the 19th century.

parcel gilding or partial gilding, furniture or silver gilded in parts to contrast with the ungilded areas of decoration.

parian a grainy white porcelain named after the Greek island of Paros (famed for it's white marble), used for busts and figures in the 19th century, also known as statuary porcelain.

parquetry marquetry* of geometric form.

pâte-de-verre from the French, meaning "glass paste," a translucent glass made from powdered glass mixed with colour and fired in a mould. The technique was used in ancient Egypt and revived by the French in the late 19th century for decorative reliefs, statuettes, and ornamental vessels.

patera a decorative classical medallion or rosette in a circular or oval shape.

pâte-sur-pâte from the French, meaning "paste on paste," the method developed at Sèvres *c.*1850 in which low-relief decoration was created on ceramics by building up layers of slip, sometimes in different colours, and then carving the design into the surface.

patina (also patination) the fine surface sheen on furniture, created when age and use builds up a layer of dirt and polish, and on metal such as bronze through oxidization.

pediment the triangular gable surmounting case furniture such as cabinets, bookcases, and long-case clocks; it may be "broken" with a gap at the apex, or "swan-necked" with opposing S-scrolls.

pembroke table a small square, oval, or round table with two drop leaves, and a central frieze drawer, thought to have been named after the countess of Pembroke; produced from the mid-18th century.

Pennsylvania Dutch the American folk-art style of a community of Germans (Dutch is a corrupton of *Deutsch*, or German) and other northern European immigrants who settled in Pennsylvania and produced colourful decoration with stylized motifs from nature such as tulips, birds, and the spiralling rosette (or pinwheel).

penwork a 19th-century painting technique used for decorating furniture and small items such as boxes with designs in black or colours, originally to imitate inlaid ivory or lacquer work.

petit point tent stitch embroidery on canvas.

pier the section of wall found between two windows on the same wall. A pier glass is a tall, narrow mirror designed to for this space and often surmounting a side table or pier table.

pietre dure from the Italian for "hard stones," a form of inlaid decoration with semi-precious stones and marble such as agate, chalcedony, onyx, jaspar, lapis lazuli, and malachite. The Medici workshops in Florence were famous for pictorial forms but it was also produced in Rome. The technique was used mostly for table tops and for panels set into cabinets. comprising of individaully shaped slivers of semiprecious stones such as agate, chalcedony, jasper, and lapis lazuli.

piggin a small wood, ceramic, silver, or glass vessel with a rod-like handle, originally for transferring cream or milk from a larger container.

pinnacle a slender upright structure found on top of a buttress, gable, or tower, usually ending in a spire; often found in Gothic architecture.

plate items made of gold or silver for domestic or ceremonial purposes.

plique à jour an enamelling technique similar to cloisonné* but without a metal backing, allowing the enamels to appear transparent.

plush stitch a type of needlework stitch popular in the 19th century for creating a raised design by cutting the stitch to sculpt an animal, flower, or other subject.

pomegranate a widely used decorative motif in plasterwork, furniture, silver, textiles, and wood carving, symbolic of fertility and abundance.

Pop Art a style that emerged in Britain in the mid-1950s but reached its peak in New York in the 1960s, where the everyday and the mass-produced was given the same recognition as the unique. Advertisements, product packaging, and comic strips part of the aesthetic.

porphyry derived from the Greek word *porphyros*, meaning "purple," a hard volcanic rock usually of reddish colour and used for the tops of tables and commodes.

portière a French term for a door curtain.

Portland vase a blue-and-white Roman cameo* glass vase, *c*.100BC, once owned by the duchess of Portland; it was the inspiration for Wedgwood's jaspar ware, as well as for imitations by 19th-century glass and ceramics manufacturers.

Post-Modernism a 1970s and 1980s movement that started as a reaction against Modernism, it promoted the use of bright colours and decorative elements from both the past and present.

pressed glass a mass-production glass-making technique that involves pressing molten glass in a patterned mould; it first came into use in the US from the mid-1820s and in Europe from the 1830s.

prie-dieu from the French "pray God," a low upholstered kneeling chair with the back forming a padded desk or armrest.

printie decoration on glass consisting of a shallow, concave oval, or circular cut.

prunt a decorative blob of molten glass applied to a glass vessel.

purpleheart see amaranth.

putto (plural putti) either a cherub or a winged infant's head, a popular ornamental motif from the 15th-century onwards and often seen amid scrolling foliage bearing festoons* or in panels of grotesques*.

punto in aria from the Italian "stitch in the air," an early type of needlepoint lace with the pattern built up from tiny buttonhole stitches.

quatrefoil a four-lobed shape seen in Gothic tracery.

Queen Anne style the restrained form of the Baroque classical style seen in domestic design during the early 18th century, and revived as part of the Aesthetic Movement in the later 19th century.

rail a horizontal member in a piece of furniture designed to support the vertical members, such as a rail in the framework of a piece of case furniture or the seat rail in a chair.

redware a type of rustic American 17th- and 18th-century stoneware with a red clay body and covered with lead glazes.

Régence the French style of *c*.1720–30, during the regency of Philippe duc d'Orléans (1715–23) for the young Louis XV style*; the early period of Rococo*.

Regency style named after the British Prince Regent, who ruled for his father 1811–20 before becoming George IV, a generic term for the Neoclassical style in Britain *c*.1800–30.

relief any decoration that is raised above the background surface; see bas relief or high relief.

Renaissance from the Italian, meaning "rebirth," the revival of classical Greek and Roman art and ideas that began in Florence in the 14th century and eventually spread throughout Europe. The style is based on symmetrical architectural and sculptural forms with classical motifs such as trophies, acanthus* leaves, and human and mythological creatures and grotesques*.

repeat a continuous pattern designed so that the pattern along the edges on a section of fabric or wallpaper will match up with the pattern on a neighbouring section, allowing the pattern to continue seamlessly.

repoussé a French term, meaning "pushed back," for embossed decoration on metal made by hammering from the back so that the design projects from the front surface.

reserve an area of a design, usually on ceramics, that is left free of over-all decoration, to be filled with a choice motif or scene.

Restoration style also known as Carolean style, the decorative arts style linked to the reign of Charles II (1660–85), after his restoration to the throne. In contrast to the previous austere Cromwellian style, it reflected a taste for opulence with French, Dutch, and Portuguese influences.

reticello glass from the Italian for "network" a type of *latticino* glass in which the opaque threads form a fine pattern of crossing or reticulated threads.

reticulation a net or web-like pattern created by lozenge-shaped, pierced, interlaced, or interwoven decoration.

rinceau the French term for a continuous scrolling motif, usually consisting of acanthus* or vine leaves; used in carved, moulded, and painted Neoclassical decoration.

rocaille from the French, meaning "rock-work," asymmetrical decoration derived from rock and shell forms originally used in grotto decoration, especially popular during the Rococo period.

rock crystal a mineral consisting of pure silica and found worldwide, it has been used as a decorative material for many centuries, and was imitated in the 19th century in a form of high-relief glass engraving.

rockwork see *rocaille*.

Rococo the style which evolved from a lightening of Baroque formality in early 18th-century France, to embrace more naturalistic and non-classical decoration characterized by asymmetry, scrollwork, exoticism (for example chinoiserie*) *rocaille** and pale colours; it affected all the decorative arts in Europe and America at least until the 1770s.

Rococo Revival (also known as Neo-Rococo) a revival of the Rococo* style.

Roemer (or *römer*) a type of German drinking glass with a wide hollow stem which was often decorated with prunts*

usually made of waldglas*, produced from the 15th century onwards and was the inspiration for the British rummer*.

roundel a flat, circular shape used as a motif.

rummer a British short-stemmed drinking glass with a wide bowl and solid, sometimes square, foot, made from *c*.1780.

rya rug or ryijy rug, from the Finnish, meaning "coarse" or "rough," a type of thick rug will a shaggy pile from Scandinavia; traditionally part of a bride's dowry.

sabre leg a chair leg shaped like the curved blade of a sabre, with a concave curve, popular on late 18th-century Empire and Regency* style chairs in Europe and early 19th-century Federal style* chairs in the US. See also klismos.

salon French word meaning "drawing room" or "parlour."

Samian ware or *terra sigillata* a type of red glossy Roman pottery which was imitated in Silesia in the early 17th century and by Wedgwood in the 18th.

sang-de-boeuf from the French term "ox blood," a plum-red glaze for ceramics, developed in China in the early 18th century and imitated in Europe in the 19th.

satiné or *bois satiné*. A tropical timber from Guyana and Guadeloupe ranging in colour from greyish red to ruddy brown, and with a fine-grained satiny finish, much used in 18th-century French furniture.

scagliola a type of polished imitation marble made from powdered or chipped stones mixed with plaster of paris and colouring matter, first used in ancent Rome and developed in 16th century Italy; used extensively in the 18th century to simulate pietre dure* decoration for table tops and panels.

Schulz codex the design sketchbook created by Johann Gregor Hörldt (1696–1775), a Meissen decorator noted for chinoiserie-style designs and patterns; it was the primary source for Meissen's chinoiserie decorations *c*.1720–40 and was used at the factory until the end of the 19th century.

Schwartzlot from the German "black lead," a type of decoration on glass and ceramics in black or brown enamels; popular *c*.1650–1750 and revived at the end of the 19th century.

sconce a candleholder designed to be hung on the wall, consisting of a bracket or arm with a socket to hold the candle and a backplate to magnify and reflect the light; sometimes called a girandole* in the Rococo period.

secrétaire French term for a writing desk, also used in English for a cabinet with a desk section hidden behind a drawer front.

serpentine an undulating curved form seen on case furniture, tables, and chairs especially in the Rococo period.

settle an early form of seating for two or more people, consisting of a bench with a back and arms; used from the Medieval period to the 19th century, especially in farmhouses and taverns and revived as a household piece by the Arts and Crafts designers.

Sezessionstil see Vienna Secession.

sgabello a type of chair originating in Renaissance Italy with a solid carved back and board supports instead of legs.

shagreen the granular skins of sharks, rays, and other fish, usually died green and used to cover small items of furniture such as boxes and tea caddies or the writing surfaces of desks; the material was used to great effect in the Art Deco* period.

Shaker a style of furniture made in the American Shaker community from the 18th century, based on simplicity, functionalism, sound craftsmanship and economic use of materials without ornament.

Sheffield plate a thin layer of silver that has been fused to a sheet of copper (or copper sandwiched between two layers of silver) before being constructed into a useful object; it was made in Britain between *c*.1742 and *c*.1840 as a less expensive substitute for solid silver, until it was replaced by electroplating, which required less skill and labour.

side chair a chair without arms, originally placed against a wall when not in use, often part of a set.

singerie an ornamental theme incorporating monkeys found in most areas of the decorative arts in the 18th century.

snuffbox a small, lidded box made of gold, silver, porcelain, ivory, tortoiseshell, or other precious material, often finely decorated, for keeping snuff – a finely ground, scented tobacco – fresh and dry.

soapstone or soaprock. Smooth, carvable, steartite with a slightly waxy appearance; a component of some 18th-century English porcelains.

sofa table designed to complement a sofa, a long, narrow table made from the early 19th century, usually with two frieze drawers and a flap at each end; early types had decorative end supports, later styles pedestals.

soft-paste porcelain also known as imitation porcelain (or in French *pâte tendre*). Made in Europe as a substitute for hard-paste porcelain before the secret of hard-paste was widely known.

sphinx a mythological creature of Egyptian origin, with a woman's head and a lion's body, sometimes with wings; used in classical ornament.

spill vase a cylindrical vase for holding spills, slivers of wood for lighting candles; sometimes made in pairs for the mantelpiece.

squab cushion a loose flat stuffed cushion used on a seat.

steartite see soapstone.

stipple engraving a technique for decorating glass by means of tiny dots made with a diamond or other hard point, producing light and shade effects.

stoneware a hard, non-porous pottery body made of clay mixed with stone.

strapwork a decorative feature based on ribbons or strips of leather, consisting of interlacing straps and scrolls, sometimes with grotesques* or incorporated into *Laub und Bandelwerk**, much used from the Renaissance onwards, especially in northern Europe.

stretcher the horizontal rail or bar between the legs of chairs, stools, tables, and cabinets, designed to add strength; it may be carved, turned or plain.

stria a stripe or line; striations are irregular parallel or swirling lines that occur in glass for example when being manipulated by shaping tools.

surtout de table a French term for an epergne* or centrepiece for the table.

swag a festoon* of imitation drapery or a garland of flowers, fruit, or leaves. A popular Neoclassical ornament.

sweetmeat dish a shallow dish for holding candied fruits, preserves, and pastries, made of silver, glass, or ceramics.

tazza a shallow bowl on a stemmed foot, made from the 16th to 19th centuries of glass, silver, and ceramics.

temmoku an iron-brown glaze used on oriental pottery since early times, and by 20th-century European studio potters.

tent stitch (also known as petit point*) a plain diagonal stitch going over one or more threads of the ground fabric, which is usually canvas.

term a male or female bust or half statue surmounting a tapering pillar to form a support or simply as applied decoration; used from the Renaissance onwards.

terracotta from the Italian, meaning "baked earth," a type of low-fired unglazed earthenware, using an iron-rich clay that provides a reddish colour.

tête-à-tête (also known as a cabaret) a French term for a tea or coffee service made for two people, consisting of a pair of cups and saucers, a teapot, sucrier, cream jug, and a tray; also a type of sofa with curved ends, or a 19th-century "love seat," in the form of two armchairs joined side by side but facing in opposite directions.

thyrsus a rod with pinecone terminals often entwined with ribbons of vine leaves; an attribute of bacchus, used as a Neoclassical motif.

tôle from the French *tôle peinte*, meaning "painted iron," japanned* or painted metalwares, usually small items such as trays and boxes.

tracery delicate lattice shapes with interlacing lines derived from Gothic architecture and ornament and used in architecture and furniture during the Gothic Revival in the 19th century.

transfer printing a method developed in the mid-18th century, in which a ceramic object is decorated by covering an engraved copper plate with ink, transferring the inked design to a sheet of paper, then pressing it onto the vessel.

trefoil a Gothic* decorative motif, consisting of three lobes, resembling a clover leaf.

trompe l'oeil from the French, meaning "trick of the eye," painted or inlaid decoration intended to imitate a three-dimensional image in two dimensions, or to simulate another type of surface, as in marbling, ebonizing, or graining.

Troubadour style the French version of the Gothic Revival*, but more in keeping with the Gothick* style, popular from *c.*1815 into the 1840s.

trumeau a French term for a pier* or pier glass; also the Italian name for a bureau* with a tall super structure.

veilleuse the French term for a tea or food warmer kept on a bedside table.

veneer a thin layer of a decorative wood or other material applied to an item of furniture made of a plain, less expensive wood. The technique of making and applying veneer was widely used from the late 17th century; machine-cut veneers were first used in the early 19th century.

vernis Martin named after Guillaume Martin and his brothers, the French technique for japanning*.

verre eglomisé named after a French picture framer Jean-Baptiste Glomy (d.1786), a technique of glass decoration by applying gold leaf or paint to the back and engraving a design which is then protected with another layer of glass, metal foil, or varnish. Made in ancient Roman, Medieval, and Renaissance periods. It was again popular in the 18th century.

Vienna Secession founded in 1897, an anti-establishment group of avant-garde artists, designers, and architects including Josef Hoffmann and Koloman Moser, the founders of the Vienna Werkstätte*; *Sezessionstil* is the Austrian version of Art Nouveau.

vitruvian scroll a wave-like patter of repeating volutes*, much used in classical ornament.

volute a spiral scroll or coil, supposedly inspired by the shape of a ram's horns, as on an Ionic capital; a common classical motif.

Waltglas or forest glass, an early type of glass with a greenish tinge developed in eastern Europe during the Medieval period.

whatnot (french etagère*) a display stand consisting of open shelves and sometimes a drawer or two, popular in the 19th century.

wheel engraving a technique known since Roman times for decorating glass, using a small rotating wheel fitted with a disc of stone or copper and an abrasive paste.

Wiener Werkstätte The Secessionist workshops (1903–32) founded by Josef Hoffmann, Koloman Moser, and Fritz Wärndorfer with the aim of fusing architecture and interior design into a total "work of art." Furniture, metalwork, glass, ceramics, jewelry, and graphics were produced in a distinctively functionalist and often rectilinear style of the Vienna Secession artists.

worktable a small table fitted with shallow drawers or shelves and a pouch below for sewing equipment.

zoomorphic ornament based on animal forms.

Zwischengoldglas from the German for "gold between glass," an ancient technique developed by Bohemian glassmakers in the 18th century, consisting of engraved gold leaf sandwiched between two layers of glass.

Index

527

Picture Acknowledgments

Mitchell Beazley would like to acknowledge and thank the following for providing images for publication in this book.

Key: b bottom, c centre, l left, r right, t top

Ajeto: 496 bc; Albany Institute of History and Art: 54 below l, 157 bl; Apple Macintosh: 503 t; Airstream Inc: 423; AKG-Images, London: 15 b, 35 tr, 45 tl, 65 cr, 67 tl, 166 bl, 322 tr, 417 bl, photos S Domingie 26 bl, S Domingie-M Rabatti 30 l below, Udo Hesse 165 br, Erich Lessing 10 bl, 32 tl, 52 tr, 83, 88 tl, 100 tr, 103 br, 164 tc, tl, Joseph Martin 322 tl, Visioars 59 tl; À La Vieille Russie, New York: 170 br, 171 tr, c, & b; Alessi: 498 t & bl, 499 t, 505 c; Alscot Park: 224 tl; Amsterdams Historisch Museum: 69 bc; Antikvarisk Tografiska Archvet, Stockholm: 77 c below; Antique Collectors Club: Spode Museum, Stoke on Trent 168 cl; Antique Trader: 395 tr; AP Skyscraper, NY: 460 cl; Apter-Fredericks, London: 183 bl; Arabia Museum, Helsinki: 434 br; Ron Arad Associates: 488 r, 502 cr; Arcaid: photo Richard Bryant 285br; Archivio Fotografico del Comune di Genova: 45 br; Arflex International SpA: 431 tr; Art Archive: photo Dagli Orti 219 tc, © ADAGP, Paris and DACS, London 2003 417 tl, Musée des Arts Décoratifs, Paris 350, 355 tr, © ADAGP, Paris and DACS, London 2003 363 cl, 364 tr, 365 cl, Musée du Château de Versailles, photo Dagli Orti 131 bl, Musée National de Céramiques, Sèvres, photo Dagli Orti 314 bl, Museo di Palazzo Venezia, Rome 22 tl, Museo Vetriano de Murano, photo Dagli Orti 236 b; Art Resource: 174 br; Artek: 386 tl, tr, cl, bl, & br, 387 tc, 387 tr; Ashmolean Museum, Oxford: 71 tr, 72 bl, 73 cl; Asprey & Garrard: 176 br, 183 cr; Association Willy Maywald, © ADAGP, Paris and DACS London 2003 421; Associazione Bancaria Italiana, Palazzo Altieri, Rome: 150 br; Aurelia PR: 443 bl; Fred Baier: 488 l; Badisches Landesmuseum, Karlsruhe: 344 bl; G P & J Baker: 203 bl; Bandai UK Ltd: 502 tl; Galleria Marina Barovier: 407 b; Bastin & Évrard, Brussels: © DACS 2003 323 tl, 323 tc, © DACS 2003 299; Bauhaus-Archiv, Berlin: 382 tl, 398 bl & br, 399 tc, © DACS 2003 418 r, photos Firma van Delden 415 tl, Photostudio Bartsch 398 br, Gunter Lepowski 399 tc, 418 c; Patricia Bayer: 376 tl, cr & br, 377 cl, cr, bl & br; Bayerisches Nationalmuseum, Munich: 308 cl, photo Marianne Franke 28 tl; Bayerische Verwaltung der Staatlichen Schlösser, Gärten und Seen, Munich: Photo BSU 89 bl, Residenz, Würzburg 90 bl, Residenzmuseum, Munich: 31 br, 35 bl, 74 br, 88 b; Beauté Prestige International: 497 br; Beaverbrook Art Gallery, New Brunswick: 68 c; Bernard Quaritch Ltd: 184 tc; Birmingham City Library, Boulton Archive: 190 br, 196 bl; Birmingham Museums & Art Gallery: 201 tr, 288 tl; H Blairman & Sons, London: 250, 254 tr, 257 tr, cl, & bl, 269 cr, bl, & br; Bolton Museum and Art Gallery: 205 br; Bonhams, London: 64 tl, 101 tc, 161 bc, 162 br, 163 tr, 168 bc & br, 169 c, 280 tr, 290 tl, 293 bl, 376 tr, 388 tl, 389 t, 393 tr, bl & br, 404 br, 408 b, 409 br, 411 cbl, 425 cl, 426 tcr & tr, 428 r & bl, 429 tr, 439 cl, 440 tl & b, 447 bl, br, cl, cr & br; 457 bl, 460 bl, 479 bc, 487 tl, 489 tl, cr & bl, 491 tc; Böttcherstrasse GmbH, Bremen: 380 tr; Boughton House, The Living Landscape Trust, by kind permission of his Grace the Duke of Buccleuch and Queensberry, KT: 47 br, 49 b, 59 cr; Bradbury & Sheffield Assay Office Library: 180 l; Braun GmbH: 448 tr, c, & br; Christine Bridge: 177 r, 178 tr, 179 cl, 182 cl; Bridgeman Art Library, London: American Museum, Bath 233 tr, 236 tl, 475 b, Ashmolean Museum, Oxford, UK 31 bl, Badisches Landesmuseum, Karlsruhe 398 tl, Bethnal Green Museum, London, 231 br, © ADAGP, Paris and DACS, London 322 bc, 341 bcr, Birmingham Museums and Art Gallery 198 c, Bonhams, London 319 tr, Giraudon/Bibliothèque Nationale de France, Paris 46 l, British Museum, London 26 tl, Ca' Rezzonico, Museo del Settecento, Venice 45 bl, Château de Versailles, France 132 b, Cheltenham Art Gallery & Museums, Gloucestershire, 278 c, bl, & br, 279 bc, 282 l, 286 br, 287 tr, 289 tr, 290 br, 291 br, 295 tr, 336 br, 413 tl &tr, Corning Museum of glass, New York, USA 237 t, Design Library, New York 326 tr, Detroit Institute of Arts 193 br, Dreweatt Neate Fine Art Auctioneers © ADAGP, Paris and DACS, London 2003 364 tcl, Éditions Graphiques, London 317 cl, Fitzwilliam Museum, University of Cambridge, UK 20 tc, 63 tl, 107 tl, 168 t, Galleria dell' Accademia, Venice 11, Glasgow University Art Gallery 325 br, Guildhall Library, Corporation of London 211, Henry Francis Dupont Winterthur Museum, Delaware 154 tr, Harold Samuel Collection, Corporation of London 51 bl, The Fine Art Society, London 335 bc, 410 t, Haworth Art Gallery, Accrington, Lancashire 321 tr, Hermitage, St.Petersburg 91 tr, 160 tr, 247 bl, Hôtel Solvay, Brussels © DACS 2003 306 tl, Kedleston Hall 198 r, Kunstgewerbe Museum, Zurich 327 t, Leeds City Art Galleries 191 br, Leeds Museum and Art Galleries, Temple Newsam House 60 b, 189 bc, 199 tc, 243 br, Musée Condé, Chantilly 130 br, 153 tr, Musée d'Orsay, Paris 303 tl, Musée de la Révolution Française, Vizille 134 tl, National Gallery, London 130 l, Nationalmuseum, Stockholm 283 br, New York Historical Society 212 b, 321 cr, Oakland Museum, California 337 br, Château de Fontainebleau, Seine-et-Marne, photo Peter Willi 13, Prado, Madrid 26 br, 28 bl, Private Collection 102 l, 103 t, 189 br, 197 tl, 240 r, 245 tr, 300 r, 380 tl, 394 tl, 412 l,